THE ART OF PALMYRA

STUDIES IN ANCIENT ART AND ARCHAEOLOGY

GENERAL EDITOR: PROFESSOR D. E. STRONG

MALCOLM A. R. COLLEDGE

THE ART OF PALMYRA

WESTVIEW PRESS, INC.

To my parents
and in memory of Harriet Edith Sadler

Published 1976 in London, England
by Thames and Hudson Ltd.

Published 1976 in the United States of America
by Westview Press, Inc.
1898 Flatiron Court
Boulder, Colorado 80301
Frederick A. Praeger, Publisher and Editorial Director

Printed in Great Britain

Library of Congress Cataloging in Publication Data

Colledge, Malcolm A. R.
　The art of Palmyra.

　Bibliography: p.
　Includes index.
　　1. Art, Ancient—Palmyra, Syria.　2. Art—
Palmyra, Syria.　3. Palmyra, Syria—Antiquities.
I. Title.
N5460.C64　　709'.39'4　　76–12473
ISBN 0–89158–617–2

Contents

Preface

The art of Palmyra has long fascinated, and puzzled. Since much of the repertoire is derived from that of Greek and Roman sculpture and painting, and since Palmyra was for long within the eastern frontiers of the Roman Empire, its art has sometimes been regarded as a provincial version of Roman – erroneously, for the principles and connections of Palmyrene art are wholly un-Western. But the true extent to which this is so can only now begin to be assessed, as the recent exploration of other ancient cities and sanctuaries of the Near East has provided striking discoveries with which to compare Palmyrene work. Over the past half-century an international brigade of scholars has studied portions of Palmyrene art in depth, and produced brief general reviews. It is time to pull this work together, fill in some gaps and assess the whole anew. This book represents an attempt to do so.

The primary subject of the book is the art of Palmyra. But this art was inspired by the beliefs of the Palmyrenes, and much of it was intended for a particular architectural context. So if regarded in isolation it loses much of its meaning. A proper understanding, then, demands an exploration of Palmyrene ideas and building forms; and this need has influenced the organization and content of the book. As a result the study falls into two parts. In the first, what remains of Palmyrene art is described and arranged according to its function, context and period. This means that in each main area of Palmyrene life – religious and funerary, urban and domestic – basic ideas must first be elucidated, in so far as this is now possible. Then, architectural forms associated with each set of beliefs are traced; and finally the art relevant to each area of life is arranged according to type and period. In the second part of the book this art is analysed. The artists' techniques, ideas, motifs and style are probed. Foreign imports, foreign patrons and their effect on Palmyrene art are traced, and Palmyrenes are followed abroad to see to what extent they insisted on the incorporation of Palmyrene ideas in works they commissioned far from home. Finally, Palmyrene art is placed in its ancient context. In Appendices, the types of funerary relief figures and busts are set out in detail.

This task could not have been completed without much help, which it is a pleasure to acknowledge. I am extremely grateful to the Director-General and members of the Antiquities Service of Syria, without whose many kindnesses this study could not have been attempted. I am deeply indebted also to the Directors and staff of the many museums and institutions who have so willingly rendered assistance of all kinds, including the National Archaeological and

American University Museums of Beirut, the Iraq Museum, Baghdad, the Ny Carlsberg Glyptotek, Copenhagen, the British Museum, London, the Louvre, Paris, the Kunsthistorisches Museum, Vienna, the Istanbul Archaeological Museum and the French Institute of Archaeology in Beirut. Professor H. Ingholt and M. Gawlikowski have generously read and improved the text. Invaluable help and advice have come also from Professor K. Michalowski, Professor J. M. C. Toynbee and the late Henri Seyrig. Mr Adnan Bounni very kindly allowed me to include a drawing of an unpublished relief found by the Syrian Archaeological Service under his direction, and Mr Necati Dolunay generously permitted me to reproduce photographs of unpublished reliefs in the Istanbul Archaeological Museum. To Anna Czerniawska I am also most grateful for unstinting assistance over publications in Polish, and to the late Professor D. E. Strong for his continual interest and encouragement. As for faults which remain, *mea culpa*.

Faced with the perennial problem of transliterating oriental names, I have tried to respect both tradition and accuracy. The use of the numbered bibliography system for the notes was dictated by the needs of economy.

In October 1973, and so marking almost to the month the seventeen-hundredth anniversary of the Roman destruction of 'historical' Palmyra, a first conference of Palmyrene studies was organized at Strasbourg by E. Frézouls. One important result of this meeting was the unanimous expression of a wish to see all the extant works of Palmyrene art fully catalogued and published, and it is to be hoped that this may become possible before long.

MALCOLM A. R. COLLEDGE

Sources of the illustrations

Grateful acknowledgment is made to the following institutions and persons who have provided photographs and the permission to reproduce them:

Institut français d'archéologie, Beirut, 6–11, 13, 17, 18, 21–6, 28–34, 36, 37, 39–47, 50, 53, 55, 59, 67, 70, 78, 92, 93, 95, 101, 103–7, 112, 113, 118, 124, 125, 127, 128, 129–32, 134, 135, 137–9, 142, 146; Museum of the American University, Beirut, 65; Trustees of the British Museum, London, 27, 54, 63, 76, 81, 85; Directorate-General of Antiquities and Museum, Damascus, 23, 31, 38, 100–1, 103, 126–8, 131, 134, 135, 139; Istanbul Archaeological Museum, 80, 83; Ny Carlsberg Glyptotek, Copenhagen, 51, 60, 64, 71, 73–5, 77, 84, 87, 89, 90, 91, 94, 97–9, 110, 123; Louvre, Paris, Service de documentation photographique des musées nationaux, 14, 35, 52, 61–2, 68, 79, 82, 86, 88, 96, 109, 121, 144–5; Muséee des Beaux-Arts, Lyon, 147; South Shields Public Library, 149–50; Royal Ontario Museum, Toronto, Canada, 66; Kazimierz Michalowski and the Polish Archaeological Mission to Palmyra, 56, 69, 108, 133, 136, 143; Paul Collart and the Swiss Archaeological Mission to Palmyra, 12, 15, 16, 48, 49, 122 (= P. Collart, *Le sanctuaire de Baalshamin à Palmyre*, vol. II, 1969, pls. XCVII, CII, CIII, CVIII; vol. IV (forthcoming), pl.); Photo Kersting, 2, 4; Oscar Savio, 147; Henri Seyrig, 23, 31, 34, 101, 123, 127, 131, 135, 137–41; Jean Starcky, 72; H. Ingholt, *Acta Archaeologica*, III, 1932, 114; Holle Bildarchiv, Baden-Baden (D. Schlumberger, *L'Orient hellénisé*, 1970), 115, 116. Other photographs were taken by the author.

The line drawings were prepared by the author, except where otherwise indicated in the accompanying captions (with references to the numbered bibliography). Mr Adnan Bounni kindly gave permission for the inclusion of figure 23.

Geographical and historical introduction

'Palmyra is a city famous for its position, for the fertility of its soil and for its attractive springs. Its fields are surrounded on every side by a vast circuit of sand, *1* and it is as it were isolated by Nature from the world, having a destiny of its own. . . .' Pliny, viewing it from imperial Rome in the mid-first century AD, writes a fitting description.[1] Palmyra lies at the centre of the Syrian desert, at *1** the hub of the arc formed by the Fertile Crescent. The spine of limestone mountains that runs north-east from Damascus passes immediately west of it, but allows passage through a valley westwards to Homs, the ancient Emesa. South of the valley opening appear the plentiful if somewhat sulphurous waters *2* of the spring anciently known as Efqa. With these advantages the site was destined to provide a place not only for pause in the desert crossing, but also for habitation.

Already Stone Age Man knew the spring, leaving numerous flint flakes and a Neolithic arrowhead in his wake. And another area apparently occupied in prehistoric times was what became the low mound or *tell* on which the temple of the great god Bel now stands. Pottery fragments suggest a settlement here from *c.* 2300/2200 BC which flourished throughout the Bronze Age. From the opening of the second millennium BC the site begins to crop up in Near Eastern documents, where it already bears the apparently pre-Semitic name it still has today, Tadmôr. The archives of Kültepe and Mari mention it; so does a campaign report of Tiglath-Pileser I of Assyria, who fought the Aramaeans in the desert *c.* 1110 BC. These Aramaeans, now installed at Tadmôr, remained there throughout the first millennium BC. By *c.* 300 BC their community had reached a sufficient size to earn a passing Biblical mention; and they were still at Tadmôr as our era opened.[2]

But the first millennium also saw new arrivals. Drifting in from the hard life of the desert to the oasis settlement came Arabs, in sufficient numbers to supply more than half the known inhabitants' names of Roman Palmyra, as well as some ten terms of tribal organization for the local Aramaic dialect. Officially, political ownership changed hands: Assyrian, Persian, Macedonian Greek. Then, from 301 BC, Palmyra fell within the gigantic Hellenistic Greek Empire of Alexander's general Seleucus and his successors, which stretched from the Mediterranean to Afghanistan. In the early Hellenistic period the Palmyrene community apparently levelled the rising tell to build an early, and doubtless mud-brick, temple of Bel; the settlement probably developed along and south of the large

* Numerals in italics refer to text figures

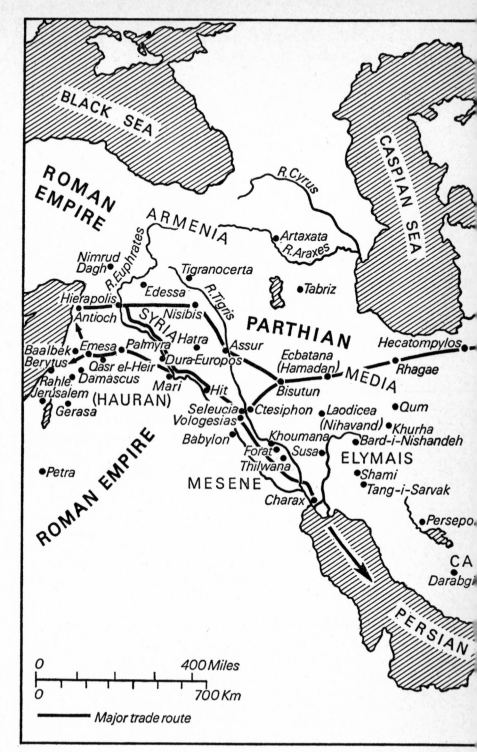

BLACK SEA

CASPIAN SEA

ROMAN EMPIRE

ARMENIA

R.Cyrus

Artaxata
R.Araxes

Nimrud
Dagh

R.Euphrates

Tigranocerta

Tabriz

Hierapolis

Edessa

R.Tigris

PARTHIAN

Antioch

Nisibis

SYRIA

Hecatompylos

Baalbek

Emesa

Palmyra

Hatra

Assur

Ecbatana
(Hamadan)

MEDIA

Rhagae

Berytus

Qasr el-Heir

Dura-Europos

Rahle

Damascus

Mari

Hit

Bisutun

Jerusalem

(HAURAN)

Seleucia

Ctesiphon

Laodicea
(Nihavand)

Qum

Gerasa

Vologesias

Khurha

ROMAN EMPIRE

Babylon

Forat

Khoumana

Bard-i-Nishandeh

Petra

Thilwana

Susa

ELYMAIS

MESENE

Shami

Tang-i-Sarvak

Charax

Persepo.

CA

Darabgi

PERSIAN

0 400 Miles

0 700 Km

——— Major trade route

1 Map showing the
position and the commer-
cial and cultural contacts
of 'independent' and
Roman Palmyra

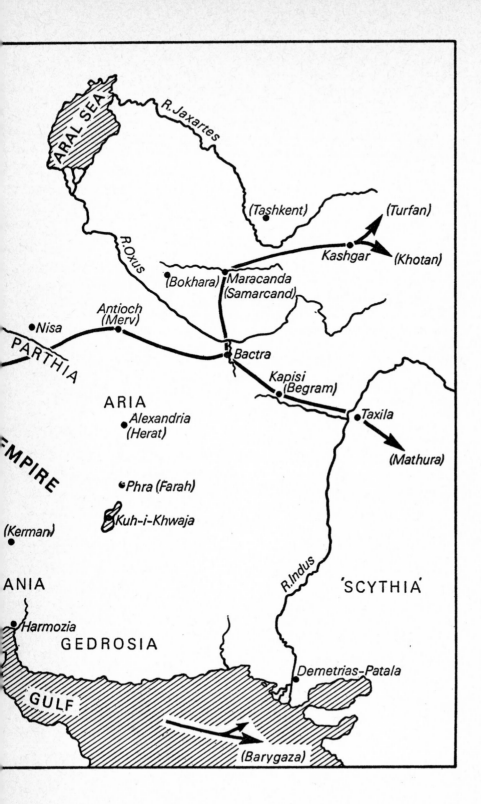

ARAL SEA

R.Jaxartes

R.Oxus

(Tashkent)

(Turfan)

Kashgar

(Khotan)

(Bokhara)

Maracanda
(Samarcand)

Nisa

Antioch
(Merv)

PARTHIA

Bactra

Kapisi
(Begram)

ARIA

Alexandria
(Herat)

Taxila

(Mathura)

EMPIRE

Phra (Farah)

Kuh-i-Khwaja

(Kerman)

R.Indus

'SCYTHIA'

ANIA

Harmozia

GEDROSIA

Demetrias-Patala

GULF

(Barygaza)

wadi that passes close to this temple. From *c.* 150 BC a vaulted brick-built tomb of Near Eastern type, sunk half underground, stood outside the occupied area. It was used until the first century AD. Its architecture doubtless reflected contemporary housing; and the small objects found with the corpses testify to importation from East and West, as well as to a local pottery industry.[3]

Meanwhile the Seleucid Empire was crumbling. The eastern possessions were steadily eroded by Iranians, the Parthians. From the west the Romans pressed in. By the early first century BC the Seleucids were left just with Syria; and in the 60s BC came their ignominious extinction by Rome. Beyond the Euphrates now lay the Iranian realm of the Parthians; and it may have been to a Parthian monarch that a fragmentary Greek inscription of this period was addressed.[4] Coastal Syria was transformed into a Roman province. Between the two extended an area, including the Syrian desert, where political boundaries and control were as yet undecided.

It is from this moment that the 'historical' era of Palmyra really begins, the period of commercial success and of cultural and political significance which lasted from the latter half-century BC until AD 273. The comparative quiet which followed the Seleucid demise must have been beneficial to commerce, for Palmyra was now rising rapidly. The community found itself on an expanding trade route between the Persian Gulf and the Mediterranean. The presence of the oasis permitted short cuts across the Syrian desert between the sea coast and the Euphrates. The increasing prosperity of the Roman and Parthian Empires, and their growing demand for goods from ever further afield, gave Palmyrenes of initiative a magnificent opportunity to act as middlemen, which they seized.

2 Plan of the site of Palmyra (after *180*, 33)
1) Sanctuary of Bel
2) Temple of Nebû
3) Theatre 4) Grand Colonnade 5) Monumental arch 6) Temple of Ba'alšamin 7) Agora
8) Funerary temple 86
9) Transverse Colonnade
10) Camp of Diocletian
11) Tower-tomb of Iamlikû 12) Tower-tomb of Elahbel 13) Towertomb 19 14) Towertomb of 'Atenatan
15) Temple of Belḥammôn 15a) Temple (?)
16) Early wall, *c.* 41 BC–AD 89 (?) 17) Damascus gate 18) Wall of Roman period 19) Funerary temple of Marônâ
20) Roman camp
21) Museum 22) Ditch, from siege of Aurelian (?)
23) Arab or Turkish castle

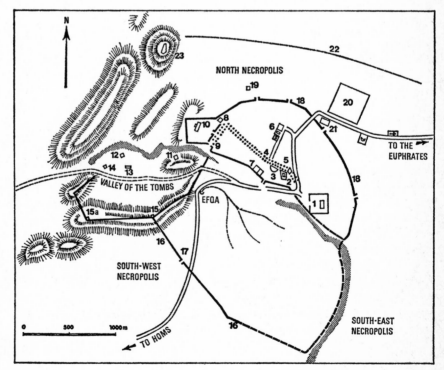

A	B	C	D
𐡀	𐡀	K	ʾ
			b
			g
			d
			h
			w
			z
			ḥ
			ṭ
			y
			k
			l
			m
			n, n (final)
			s
			ʿ
			p
			ṣ
			q
			r
			š (sh)
			t
			1
			5
			10
			20
			100

3 The Palmyrene Aramaic alphabet and numerals A) Early first century AD B) Early third century AD C) Cursive D) Transcription

Fine limestone buildings, concentrated in an increasingly 'monumental' sector north of the wadi, gradually dominated the inhabited area. Workshops of artists flourished, and large numbers of inscriptions were put up which throw light upon Palmyrene life generally. The inscriptions deal mainly with religious, funerary and honorific matters, but they reveal much else incidentally. Ancestry is scrupulously recorded; a date is commonly attached, always reckoned according to the Seleucid era which began on 1 October 312 BC. The language normally used is Aramaic, once an official language of the Achaemenian Persian Empire. The choice of Aramaic was surely a sign of Semitic nationalism, accompanying Seleucid decline. The language was almost entirely supplanted by Greek after the Roman destruction of AD 273, when presumably it was deliberately suppressed. The script is cousin to Hebrew and Nabataean. By the second century AD the Palmyrene version had developed both a monumental form and a cursive, connected with later Syriac. The relationship of the written texts to the type(s) of Aramaic spoken at Palmyra is problematic. Greek, the official language of the Seleucid domains, appears early on, and presumably

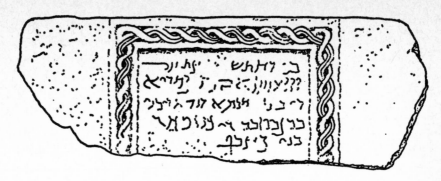

4 Inscription from the sanctuary of Bel, dated 44 B C (PM A959; ht. 24cm.; after *185*, no. 100)

144 reflects the presence of Greek-speakers. But before AD 273 it is widely used only in bilingual inscriptions; and until the second century AD inscriptions in Greek often provide merely a résumé of an Aramaic text. Oriental names are frequently translated or given a Greek equivalent in Greek texts. Latin, implanted by Roman intruders, is occasionally employed in local inscriptions from the mid-first century AD; sometimes the inscriptions are trilingual (Latin, Greek and Aramaic). But Latin is always rare.[5]

4 In 44 B C the priests of Bel erected the earliest dated Palmyrene inscription, an Aramaic text dedicating an 'image'. It is carved on a limestone block within an ornamental framing, so clearly a school of masons and sculptors had been established, able to produce inscriptions and probably sculpture also. In the following decades texts in Aramaic continued to be engraved, and fragments of actual sculptures start to occur. In the architectural field builders were already

55 employing stone, to raise the striking towers that the Palmyrenes now began to use for the burial and commemoration of their dead.[6]

During the Roman civil wars that followed the assassination of Julius Caesar, the growing wealth of Palmyra attracted the notice of Mark Antony. In 41 B C he led a cavalry raid on the (unwalled?) town, for plunder. But the inhabitants, warned of his coming, had withdrawn beyond the Euphrates with their belongings, and he retired empty-handed. Evidently the Palmyrenes of this era were largely independent, but looked eastwards for protection; their goods were still comparatively few, and portable.[7]

It was not long, however, before independent Palmyra was brought under Roman control, and included in the Roman province of Syria set up by Pompey in 64-63 B C. When did this happen? Controversy has raged over the question, for no ancient historian or text has anything specific to say; and Pliny confuses the issue by speaking of Palmyra, in a work dedicated in AD 77, as still independent. Pliny often relied on earlier sources and his source concerning Palmyra seems to have been out of date, for the evidence offered by Palmyra itself, although inconclusive, points to a far earlier loss of independence. Creticus Silanus, governor of Roman Syria from AD 11/12 to 16/17, set up boundary stones delimiting Palmyra's western territory. The name of Germanicus, moreover, nephew and adopted son of the Roman Emperor Tiberius (AD 14–37) crops up in three local inscriptions. He sent a Palmyrene named Alexandros to Mesene, a kingdom at the mouth of the Tigris and Euphrates, doubtless on trading and political matters. Statues were raised to Germanicus,

and to Tiberius and the Emperor's son Drusus, in the Bel temple court by the imperial military legate Minucius Rufus. And a provision of Germanicus is mentioned in the Tariff Law of Palmyra, a lengthy inscription of AD 137 which records a collection of earlier and contemporary fiscal measures and taxes. Germanicus' presence in the East can be closely dated to AD 17–19. The Tariff Law also quotes from a letter of Corbulo, Nero's principal Eastern general, written forty years later; the preamble preserves the opening of the first such Law, in which an otherwise unknown governor of Syria, Mari[a]nus, is mentioned – did he antedate Germanicus? These references record Roman interference in Palmyra from at least *c.* AD 18.[8]

There is further evidence for a Roman presence at an early date. It is under Tiberius that the first use of the Greek and Roman name for Tadmôr, 'Palmyra', is encountered (AD 17–19). (The name 'Palmyra', probably derived not from Greek but from the Latin *palma*, 'date-palm', may have been based on the false derivation of 'Tadmôr' from the Semitic word for the same tree, *tamar*.) Further, the Treasurers and the Assembly of the Palmyrenes are now mentioned for the first time (AD 24–5). Greek was gradually being used more openly, and bilingual texts in Aramaic and Greek appear. And under Tiberius, again, Palmyrene building received a great stimulus: a spacious sanctuary was laid out for the god Ba'alšamin; Bel's old, probably mud-brick, dwelling was transformed into a magnificent stone temple, dedicated in AD 32; and Palmyra's first (known) wall was perhaps constructed at this time. All this evidence suggests that from the era of Tiberius, at least, Palmyra depended upon, and was perhaps even officially included as an annexed tributary within, the Roman provincial administration of Syria with its capital at Antioch. But a likelier date for full annexation would be during the reign of Nero (AD 54–68), when the Senate and four municipal tribes were most probably instituted.[9]

When did the Roman army arrive? Inscriptions attest its presence in the second century AD. But detachments must have been there much earlier. They can hardly have been absent after the Roman Emperor Vespasian, in AD 75, brought Palmyra into his reorganization of the Syrian frontier and the desert tracks. And another quotation fossilized in the Tariff Law of AD 137, from a Roman edict of *c.* AD 68/9, refers to a Roman representative at Palmyra of a kind normally supported by troops. There are indications of a Roman military presence even earlier, around the mid-first century AD. Nero's government erected an inscription in Latin. Private individuals in AD 52 and 58 suddenly added a *Latin* version to texts in Aramaic and Greek; the Senate and People followed suit in AD 74. And the texts of AD 52 and 74 are framed with the Roman *tabula ansata* (swallow-tail) ornament. Further, an important sculptural form, almost certainly of Roman derivation, the funerary relief bust, is first recorded in AD 65/6. These curiosities surely imply the presence, and influence, of numbers of Latin-speaking residents, the bulk of whom must have been soldiers. Can we go back further? By Nero's time, possibly earlier, a local (?) tribe was named 'Claudias' after the imperial Julio-Claudian house. And, significantly, Minucius Rufus, who erected the imperial portrait statues in AD 17–19, commanded the Tenth Fretensis legion. So perhaps a detachment of troops was stationed at Palmyra from Tiberius' day. Whenever the army arrived, it would have been additional to a local, and doubtless at least partly

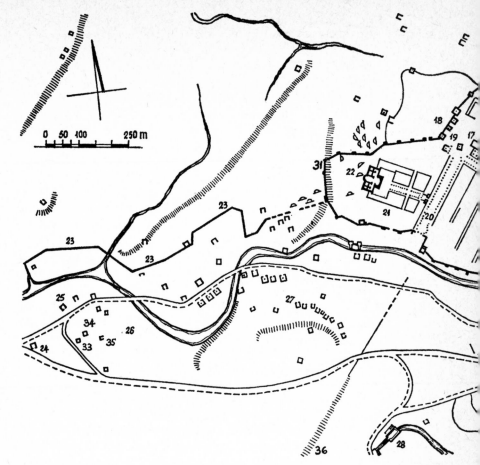

5 Plan of the 'monumental' area of 'independent' and Roman Palmyra (after *114, 12–13*) 1) Sanctuary and temple of Bel 2) Houses with mosaics, *c.* AD 150–270 3) Bel sanctuary gateway, turned into an Arab bastion 4) Honorific column 5) Spring 6) Monumental arch, *c.* AD 220 7) Grand Colonnade 8) Public baths 9) Theatre 10) Agora 11) Senate House (?) 12) Tetrapylon 13) Sanctuary and temple of Ba'alšamin, beside the early mud-brick tomb 14) Christian basilica 15) 16) 17) Houses

mounted, militia that the Palmyrenes almost certainly maintained throughout the 'historical' era.[10]

By the early first century AD the importance, and the organization, of the caravan trade is beginning to emerge from a series of texts. These were mostly once appended to honorific statuary, now gone. They mention only the eastern commerce with Mesopotamia, never the western trade with the Mediterranean. The reason is clear from their content: the routes eastwards, running across open desert, were dangerous. Caravans were threatened by nomads; the merchants needed patrons to organize their protection, and frequently expressed their gratitude after successful journeys by means of statues. At first the destination was customarily the old Greek capital of Seleucia on the Tigris, or Babylon. But later in the first century AD the Parthians founded Vologasias close to Seleucia so as to ruin that city's trade; and thereafter Vologasias became the favourite Palmyrene target. From Babylonia the Palmyrenes began to penetrate to Spasinu Charax on the Persian Gulf, the great emporium on the sea route to India. It was to the king of this area, Mesene or Characene, that Germanicus sent the Palmyrene Alexandros in *c.* AD 18; and merchants were properly established there perhaps by the mid-century.[11]

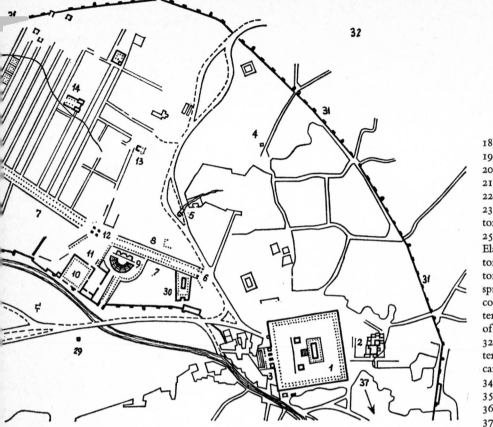

18) Tower-tombs
19) Funerary temple 86
20) Transverse Colonnade
21) Camp of Diocletian
22) Underground tomb
23) Aqueduct 24) Tower-tomb of 'Atenatan
25) Tower-tomb of Elahbel 26) Underground tomb of Iarḥai 27) Tower-tomb of Iamlikû 28) Efqa spring 29) Honorific column 30) Sanctuary and temple of Nebû 31) Wall of Roman period
32) Area of early cemetery and of Roman army camp 33) Tower-tomb 14
34) Tower-tomb 15
35) Tower-tomb 19
36) South-west necropolis
37) South-east necropolis

Throughout the first century the proceeds from this trading were shared between enterprising individuals and the city, which took its portion in carefully regulated taxes. Indeed, the city Treasurers were an important body, taking precedence over the Assembly; tribal organization continued to flourish, but was probably reformed (under Nero?); and the Senate, first actually mentioned in AD 74, was clearly insignificant until the following century. The growing resources of Palmyra were devoted primarily to the building of temples and improvement of sanctuaries (often along Western lines) particularly in the 'monumental' area, to the laying out of the market place, and to the erecting of the funerary towers of stone that give the Palmyrene landscape its present unique aspect. Artists were busy carving and painting for these projects, and raising statues of the successful and the important.[12]

In AD 106 the Roman Emperor Trajan annexed the kingdom of the Nabataean Arabs. With its impregnable capital at Petra and its Red Sea port at Leuke Kome, it had long profited from the trade routes that crossed the area. This traffic was now largely ceded to Egypt and to the more northerly Palmyra. So Palmyra was launched into the era of her greatest prosperity. Towards AD 129 the Emperor Hadrian paid a visit: the city received the title Hadriana, 'free'

5

status and a *curator* for her finances. And in AD 137 the current state of the Tariff Law was set out in a long, bilingual inscription, placed beside the market place or Agora, dealing with municipal taxes on merchandise consumed or transformed in the city. The Senate and People now loom large in urban inscriptions; tribal organization lived on but is less noticeable. A cavalry wing of the Roman army – the *ala Thracum Herculania* – was stationed just outside the city for much of the century, and its prefect seems to have exercised political control.[13]

103

The Palmyrenes themselves were roaming far afield. The energetic commercial endeavours of merchants and their patrons are commemorated in numerous inscriptions, which record journeys overland to Babylonia and western Iran, and by ship from the Persian Gulf to India. Some idea of the commodities in which these merchants dealt is given by the Tariff Law, and by finds. Oil, myrrh, skins, bronzes – it was a luxury trade.[14] Other Palmyrenes found employment abroad. In Babylonia, they held official posts: an *archon* (magistrate) and a *satrap* (governor) are recorded. Westwards, their occupations were humbler. Around AD 100 a Palmyrene, possibly an artist, visited the

62–5

Greek island of Cos; and others were toiling in granaries at Rome, the Horrea Galbae. Most, however, entered the Roman army; as common soldiers they usually died abroad, but officers sometimes returned. A corps of Palmyrene cameleers was formed by Trajan. Thereafter Palmyrenes served mostly in their native area, and in north Africa and the Danube lands, although some of them

149–50

reached Britain.[15]

5

In Palmyra itself the adornment of the principal sanctuaries was largely complete by the mid-second century. Porticoes entirely ringed the precinct of Bel, and a monumental entrance was built. Ba'alšamin and Dûrahlûn acquired a Western-looking temple and another colonnaded court. Funerary building proceeded apace: the towers gave way to sumptuous 'funerary temples' and to cheaper, but often ornate, subterranean galleried tombs. But the immense profits of the caravan trade were now showered mainly on public architecture. The market place was completely rebuilt, a theatre arose and the main thoroughfare was dramatically transformed into the Grand Colonnade. A forest of honorific statues ornamented every public area. The wealthy erected spacious houses for themselves, centred in the Greek manner around an internal columned court. The stuffs they wore, the adornments they hung on their womenfolk, became ever more costly and ostentatious. Immigrants were attracted, even from Greece and Egypt. And the wealth of the city spilled over into the villages within Palmyrene territory, where temple buildings and sculptures reflected, albeit dimly, those of the metropolis.[16]

One of the effects of the Palmyrenes' current cosmopolitanism can be seen in the number of terms now adopted from Greek and Latin into their own Aramaic. Greek heads the field with about fifty words, half to do with political and social organization, eight with commerce, and some ten, most interestingly, with architecture and art, including *exedra* (recess), *pronaos* (porch), and words for sculptor, image and statues. Latin terms denote coins or are drawn from administrative expressions, especially military: doubtless they emanated from the barracks. At the same time, a number of Iranian names enters into use.[17]

With the Emperor Septimius Severus (193–211) came administrative changes. The province of Syria was split into two; Palmyra fell in the 'Phoenician'

sector. Control was probably also tightened, as elsewhere in the Empire. A Palmyrene unit was created for the Roman army, the twentieth cohort, posted to neighbouring Dura-Europos on the eastern frontier. At Palmyra statues of Septimius' family were positioned by the Agora. About 212, Caracalla, Septimius' son and successor, granted Roman citizenship to all his free subjects; and, soon after, he dignified Palmyra as a Roman colony. Towards 232 came a visit by the last of the dynasty, Alexander Severus.[18]

The Severan age prolonged late second-century opulence. Caravans were still plying, and reaching Vologasias. But there are signs of a changing political kaleidoscope. Not a single third-century caravan text mentions Spasinu Charax or Mesene; so Palmyrene business activities were presumably being restricted to Babylonia. And the labours that protecting the caravans from nomads entailed are mentioned in texts of 198 and 199, a hint perhaps of deteriorating security.[19]

Senate, People and tribes continued to function, and magistrates are recorded. Greek became more firmly established, although Aramaic never ceased to predominate in both public and private spheres. A Jewish element in the population became noticeable; Persian names increased as the century progressed. Latin, however, died away. Palmyrenes were still flocking westwards and into Roman army service, while foreigners continued to migrate to Palmyra itself.[20] *144*
The city was steadily embellished with more public and domestic buildings. The Grand Colonnade marched east towards the temple of Bel, ending in a *5*
monumental arch raised around 200. Houses east of the temple were furnished with fine mosaic floors, and 'funerary temples' were lavishly decorated.[21]

But the days of Palmyra's greatness were already numbered. With the passing of the Severan era the established order began to crumble, and, from the 230s, visibly to disintegrate. In the Roman world, for four bloodstained decades, the central government lost control. And in the Near East the patterns of commerce were changing. The rise of Edessa and Nisibis in the northern section of the *1*
Fertile Crescent marked a gradual shift in the routes of trade that was to prove fatal to Palmyra's prosperity. In the city the rate of building slowed, and sculptors became slapdash. The Palmyrenes' reaction was dramatic: they attempted to seize areas where commerce now flourished. In the 250s, at a time when whole provinces of the Roman Empire had been detached by petty usurpers, Septimius Odainat, from a family long prominent in Palmyra, emerged as governor of 'Phoenician' Syria. In 260 he defeated the retreating Persian monarch, the Sasanian Šapur (Sapor). The current Roman ruler, Gallienus, rewarded him with the distinction of 'Corrector' of all the East. He rewarded himself, however, with the title 'King of kings', and assembled a court of notables. He subsequently ventured twice into Sasanian Mesopotamia, but with little profit, and was murdered in 267/8. One of his sons, Wahballat, inherited his titles and position. But the true ruler was now his 'most illustrious queen', Zenobia (Batzabbaï) of immortal fame. In the winter of 271-2, to the astonishment of the ancient world, her army entered Egypt and conquered it. Her troops then overran Anatolia. Meanwhile coins were issued in the names of *66*
Wahballat (in Greek 'Athenodorus'), and then of Zenobia from Antioch and Alexandria. But the tide was turning. The Roman army had proclaimed Emperor a tough cavalry officer, Aurelian. In 272 he entered Anatolia, and the Palmyrenes fell back successively on Antioch, Emesa and finally Palmyra itself,

2 where they were soon besieged. Zenobia slipped away to beg help from Šapur, but was taken while crossing the Euphrates; and Palmyra capitulated around August 272.[22]

Aurelian was merciful – this time. Zenobia was led off towards Rome; some notables, including the Greek philosopher Longinus, were put to death; and a garrison was left. But in 273, within months of Aurelian's departure, rebellion erupted. The garrison was slaughtered. The Emperor raced back, entered the city without opposition, and let his troops pillage, massacre and burn.[23]

The damage inflicted by Aurelian's troops was perhaps not great; but Palmyra never recovered from the blow. Manifestations of her individual life – written Aramaic, architectural development, art – ceased virtually overnight. And the rise of the northern trade routes spelt economic doom; revival became impossible, although decline was slow. Towards 300 the Roman Emperor

2, 5 Diocletian refurbished an area at the west end of the city, making of it a large military camp designed to support his eastern frontier with Persia. A reduced town was enclosed; civil occupation crept into the Baʿalšamin sanctuary. Some of the tombs remained in use. In 325 Marinos, bishop of an increasingly Christianized Palmyra, participated at the Council of Nicaea, and two years later restoration work was proceeding in the Grand Colonnade. Two Christian basilicas arose: in the early fifth century the Baʿalšamin temple was turned, like Bel's, into a church, and a century later Justinian, eastern Roman ruler at Constantinople, ordered the restoration of the churches and fortifications of Palmyra. It was still, therefore, a notable township. Then, as Islam swept through the seventh-century East, the town was seized by the Arabs; Palmyra again became Tadmôr. The settlement was concentrated in the Camp of Diocletian area; any surviving spoken Aramaic was doubtless wholly supplanted by Arabic. Seekers of building materials began plundering the Roman town; hunters of metal started to chip their way into the joints between the stone blocks of the remaining buildings, to extract the clamps. Further destruction was inflicted by the last Ummayad Khalif, Marwân II, in 745; and an earthquake in the tenth century wrought more havoc. But the twelfth century was brighter. Tadmôr had become largely an Arab village centred on the Bel temple, which now echoed to the sounds of Muslim worship. In 1132/3, during the Seljuk period, the Bel precinct was converted into a fortress. In 1192 a Spanish rabbi, Benjamin of Tudela, visited Tadmôr, and found a community of sufficient size to include two thousand Jews; Arab houses were crowded into the Baʿalšamin temple court.[24]

The engulfment of Syria by the Ottoman Turks in 1516 had little impact on Tadmôr, although it may have bequeathed to the site the huge fortress that glowers down upon the oasis from a neighbouring hilltop. In the following century European travellers began to penetrate, surviving countless trials and dangers. Learned antiquarians succeeded these in the eighteenth century, and in 1753 the Englishmen Dawkins and Wood published their justly celebrated *Ruins of Palmyra*. Their accurate reproductions of inscriptions allowed decipherment that same year. Although others followed them, scientific exploration and recording did not begin properly until this century. Ottoman rule lasted until 1918, succeeded by the French mandate and then the government of Syria. Between the two world wars exploration proceeded apace, and the

Arab village was transferred from the sanctuary of Bel to its present site. More recently, the Syrian Antiquities Service has directed operations. Palmyra today, beside an oil pipeline and drawing an ever-increasing number of tourists, is once again achieving prosperity – no longer through trade, but through the splendour of the many ancient buildings and through the strangely attractive works of art that have survived so many vicissitudes.[25]

Palmyra supported its own flourishing artistic activity, therefore, between the late second century BC and AD 273. Who were the artists who worked at Palmyra in this 'historical' period? What records have they left of themselves? Just a few, but not unrevealing, inscriptions. Three men with Greek names all worked on the temple of Bel: Antiochus 'the master' wrote his name on a peristyle ceiling beam, Miltiades carved a lion-head, and Alexander was an architect employed to maintain the temple.[26] Others bear Palmyrene names: Iarḥai the relief carver, Moqîmû the 'artisan', the pious temple decorator Ḥairan, and some less important stoneworkers. And a corporation of workers in gold and silver is mentioned in a text of AD 258.[27]

The broad criteria for dating examples of Palmyrene art have long since been worked out. The basis is provided by a series of dated inscriptions, many of them attached to works of art. An important and early key point is supplied by the text which tells us that the great temple of Bel was dedicated on 6 April AD 32. From this period onwards numerous dated texts provide secure chronological pegs for the remainder of the 'historical' era, through the information they give both directly and indirectly. On the basis of this information, undated works may be approached from various standpoints. Content, style, the architectural context (if known) and the lettering of inscriptions provide pointers. So do sculptural materials: soft limestone was the first to be used, but the Bel temple of AD 32, the Ba'alšamin porticoes of 67, funerary towers of 83 and 103 and a number of sculptures illustrate the growing use in the first century AD of the hard varieties that became almost entirely universal from *c.* AD 100. As a result, four main chronological periods are now generally recognized: an early (or 'archaic') period, lasting until *c.* AD 50; a first group of works, *c.* AD 50–150; group II, *c.* AD 150–200; and group III, *c.* AD 200–73.[28]

What, then, were the kinds of art the Palmyrene workshops produced, and how did each type evolve?

2
Religious sculpture

Religious beliefs

The beliefs of the 'historical' Palmyrenes were wide-ranging. They possessed not only an abundance of deities, most – if not all – of them imported, but also certain places long held sacred, over which deities presided. No comprehensive ancient text exists, however, to explain their beliefs, so information about Palmyrene religion, or rather religions, has to be culled from the few ancient literary references together with an ever-growing wealth of inscriptions, tokens (*tesserae*), statuary and reliefs from Palmyra and its environs. Deities' names also help. But the history, theology and ritual of the Palmyrene religions remain largely enigmatic.[29]

The pantheon that emerged in late Hellenistic and Roman Palmyra was overwhelmingly (but not entirely) Semitic. Most deities were commonly represented in human shape, with characteristic costumes and attributes. Often worshipped singly, they might be joined in pairs, triads or larger groupings. Sanctuaries, although normally dedicated to leading deities, often accommodated their lesser companions also.

Apparently, there were few indigenous deities. Ancient Bôl was now largely forgotten. The gods Iarḥibôl and 'Aglibôl belonged to ancient strata of Palmyrene religion. Malakbel was also local, but of more recent creation. The great god Bel, however, like others such as Beltî(s), Nebû, Nergal and Nanai, had arrived from Babylonia. Ba'alšamin had travelled eastward from Phoenicia along the trade routes, as, probably, had Belḥammôn. Šadrafâ and Elqônerâ seem Canaanite; Atargatis and Ištar (known as Astarte in the West) were more generally Aramaean. Arab divinities, moreover, were crowding in from the desert: Šamaš the sun god, the great goddess Allat, and a host of lesser deities, Ma'an(û), Ša'ar(û), Abgal, Raḥm, Manawat and the rest, who were commonly paired, like the twins Arṣû (or Arṣâ) and 'Azîzû. Sometimes the guardian spirits or deities of a place were addressed, such as the Gad or the similar *ginnayê* (or *genii*). Some deities arrived from further afield, like Iranian Anahit. From the Greek and Roman world, numbers of divine names were adopted. But bilingual inscriptions show that such names as Zeus, Apollo or Athena were normally used to denote oriental deities; only exceptionally are Western divinities invoked under their own names in an Aramaic text.[30]

The origin of a deity had no direct effect on its relative importance or standing in the pantheon. We measure this importance today by studying sanctuary sizes, and frequency or type of inscriptional address and sculptural representation.

In the city itself, Babylonian Bel, west Semitic Ba'alšamin and an unnamed god were the most popular, with Arab Allat, Babylonian Nebû and the local Iarḥibôl, 'Aglibôl and Malakbel not too far behind. Among the rural communities north-west of Palmyra, however, although several city gods were represented, Arab and local deities proved most important. Many of these were unknown in the metropolis, while Bel was scarcely to be found outside.

Heading the pantheon were two major triads, composed of gods from very different sources. Babylonian Bel had as his companions the probably indigenous Iarḥibôl and 'Aglibôl. West Semitic Ba'alšamin had 'Aglibôl again, and Malakbel. The creation of these triads, possibly around the turn of our era, may have been inspired by the astral theology of Hellenistic Babylonia, perhaps locally interpreted. Conversely, gods from the same background, like the Arab Arṣû and 'Azîzû or the ginnayê, might also be paired or grouped. The inspiration for such masculine groupings was probably Arab religion. There was little place for goddesses in these schemes; they had to be content, primarily, with intermittent association.[31]

The precise nature and function of these divine beings is often obscure. There were deities of the sky, and of nature and fertility; there were those who acted as protectors. Some had one function, others two or more, and changes could occur: many deities, for example, became militarized during the early first century AD. Several, especially the city divinities, adopted armour, and appeared heavily cuirassed. Others, usually the Arab or local gods, carried weapons at least. Presumably they were all armed to protect their devotees better, whatever other functions they might also have performed, and doubtless they acquired these arms through influence from the skirmish-loving Arabs.[32] Bel, for instance, the 'Lord' or 'Master', was always cuirassed. Tesserae hint at his association *28* with the olive tree at an early date. But in Greek inscriptions he is equated with Zeus; and his association with the (armed) sun and moon gods, Iarḥibôl and 'Aglibôl, can only mean that he had become a great cosmic god, presiding over the movements of the stars and so over human destiny, which the stars were *17, 18* believed to control. Sculptors depicted him as such in his temple. Iarḥibôl and 'Aglibôl may also betray signs of earlier aspects, partially obscured by later development.[33]

A second great cosmic god, also equated with Zeus, was Ba'alšamin, the 'Lord of the Heavens'. He was considered a newcomer beside the Palmyrenes' 'ancestral god' Bel, who takes precedence at their rare joint appearances in art. Sometimes Ba'alšamin is symbolized by a huge celestial eagle spreading wide *12* his wings over sun, moon and stars. In human form, he is dressed either in civilian clothing, or in armour. The thunderbolt and ears of corn are his attributes, *16, 35, 45* so he is also the god of crop-producing showers.

During the second and third centuries AD, numerous dedications were made to an unnamed god, called 'Lord of the World' or 'Him whose name is blessed for ever'. But as some of his epithets correspond with those of Ba'alšamin, and as they both have 'Aglibôl and Malakbel as associates, it seems clear that Ba'alšamin and this 'Nameless god' must be identical, although dedications to the latter may represent a more spiritual aspect of the cult.[34]

From AD 67 onwards, Ba'alšamin, dedicatee of the second great sanctuary of Palmyra, is commonly paired in his own dwelling with Dûrahlûn, possibly 'He

of Rahlê' (Rahlê is west of Damascus), another aspect of himself. With the lunar 'Aglibôl and with Malakbel he may have formed a second important triad.[35] In this context Malakbel is the sun, but elsewhere he has another aspect, associated with vegetation, fertility and renewal. 'Aglibôl and he are also shown paired as 'two holy brothers' clasping hands.[36]

19

Šamaš provided a third solar god for Palmyra, Arab in origin.[37] Other divinities are more shadowy, although clues are supplied by equations between local and Greco-Roman deities, where made, and by armour and weapons. Nebû's counterpart was Apollo, and Nergal's, probably Heracles. Arab Allat was being represented by the second century AD as the armed Athena. Other deities often appear mounted on horses or camels, especially outside Palmyra itself, in areas where an Arab religious atmosphere prevailed. These deities favoured local costume, and the sword, spear and little round shield as weapons. Often represented in pairs, they surely protected the recently settled or half nomadic Arab breeders and caravaneers of the steppe and desert.[38]

33

The sanctuaries

A large open court bounded by a wall seems to have been a fundamental require-ment for a Palmyrene sanctuary of any importance. Within this area the cult installations would be variously arranged. The divine owner or owners would have a dwelling, a hall often illuminated by windows and accompanied by other rooms. Elsewhere in the court would stand altars for ritual sacrifices; wells, cisterns and piping provided water for ablutions and the cleaning away of blood.[39] Against the precinct walls, niches framed effigies of the sanctuary deities and their companions who 'dwelt with' them. Such were the deities' quintessen-tial needs. But Roman influence caused a considerable remoulding of the mud-brick sanctuaries. This meant, primarily, adding a limestone temple of Western style, colonnades, and quantities of free-standing and relief sculpture. Leading citizens contributed generously.

2

2, 5

The greatest of Palmyrene sanctuaries was, fittingly, that of Bel. His abode lay on a low hill beside the Efqa stream, and was the first shrine to be transformed, into a resplendent temple of creamy limestone in the Corinthian order. Its ruins today are still among the finest of the Near East. The dedication, to Bel, Iarhibôl and 'Aglibôl, took place on 6 April AD 32. The temple design was largely Greek with stepped platform, main hall or cella and surrounding colon-nade or peristyle. The proportions seem influenced by the work of the Hellenis-tic architect Hermogenes. The fluted columns had capitals of bronze (now vanished) on a stone core, linked with the cella walls by twenty-ton stone beams. The walls and the stone ceilings bore reliefs, brilliantly painted. The temple court, ultimately paved with limestone blocks, contained an altar and basin. Beneath it were concealed old, unwanted stone carvings, notably in a trench (Foundation T). Gradually, the court was ringed with colonnades and an outer, windowed wall; entry lay through a majestic gateway or propylaea. Projecting column brackets carried innumerable honorific statues. With pride, the Palmyrenes could now call this 'the dwelling of their gods'.

6

3

But its Greekness was superficial. Cornice merlons, the entrance off-centre in one long side (although on the propylaea axis), pedimented windows, and at

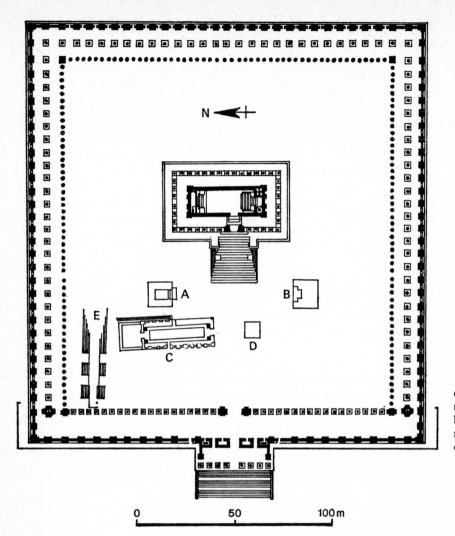

6 Plan of the Bel sanctuary: A)–D) Subsidiary buildings E) Tunnel and ramp for sacrificial processions (after *147*, fig. 29)

0 50 100 m

each end of the cella interior a special chamber or *thalamos*, reflected oriental religious needs. The northern thalamos, with its symbolic ceiling, may have housed divine statues, and the southern, approached by a ramp, perhaps a portable idol. From the thalamoi three staircases ascend – originally, perhaps, to turrets or a roof terrace.[40]

Meanwhile, similarly generous new quarters on the north side of the city were being laid out, between AD 11 and 23, for Ba'alšamin. The plan, inspired by his dwelling at Sia, consisted of three adjoining courts enclosed by a wall or *peribolos*.[41] Ba'alšamin himself lived in the northern section. Gradually, colonnades and a ritual banquet room arose. Then in AD 130/1 came a dramatic addition: a limestone temple of Roman type, constructed by Hadrian's host, Malê Agrippa, for Ba'alšamin and Dûrahlûn. Again, the ancestry was mixed: the building was Roman in its prostyle plan, Vitruvian proportions, Corinthian

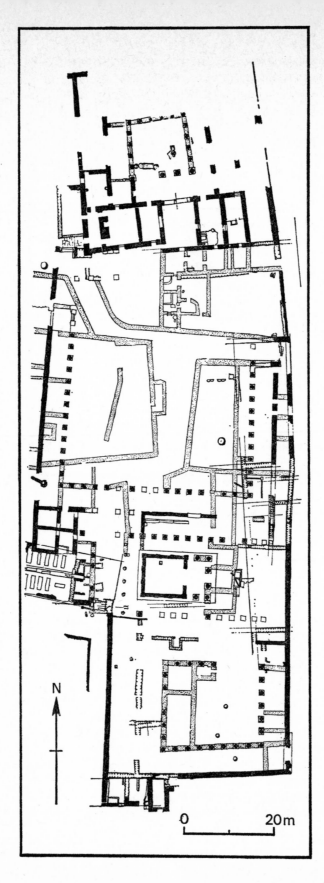

7 Plan of the sanctuary of Baʻalšamin, with buildings of the Roman period (in black) (from *Archeologia* (Paris) 1967, XVI, 52–6, fig.)

N

0 20m

order and much of its ornament, but oriental in its windows, column brackets, merlons, curved thalamos and measurements in a local foot.[42]

Elsewhere other sanctuaries developed. That of Nebû, sandwiched awkwardly into a trapezoidal court, received another ostensibly Roman temple; but again an oriental thalamos can be discerned.[43] Against the sanctuary walls were placed relief sculptures of gods and priests. West of the Transverse Colonnade, inscriptions record an important temple of Allat.[44] Beyond it lay another sacred area with altars to the 'Nameless god', militarized by Diocletian towards AD 300. Theatrically positioned on the hillside stood the third-century temple of the Standards. Sacred, too, was the spring Efqa.[45] Inscriptions and sculptures testify to other temples. One, the sanctuary of 'Aglibôl and Malakbel, is even pictured on a Bel temple relief.

5

21

2

19

The rustic shrines of the area north-west of Palmyra were mostly simple, little more than a single chamber. But that of Abgal at Khirbet Semrin reflected metropolitan kinds. An altar court, with chapels and rooms, existed by AD 154; in 195 a temple was constructed, embodying Greco-Roman tiles, lion gargoyles and moulded door-frame, but a Near Eastern asymmetrically placed door, stepped merlons and windows. Through altars, bowls and reliefs the life of the sanctuary can be followed until 270, the eve of disaster.[46]

Cult practices

Cult images were dotted among the Palmyrene sanctuaries. Some were statues. Rather more popular, however, was the carved limestone relief. Special votive niches against precinct walls framed a separately made relief or painting. Later, independent plaques with divine images were apparently able to stand alone as objects of worship, 'cult reliefs'; but the only evidence comes from north-west of the city, where reliefs were found in place against the inner wall of a shrine – no doubt this echoed city practice.[47] Palmyra also knew the cult of sacred stones, *baetyli*: three are pictured side by side on a little terracotta token or tessera, and a Bel temple relief may show one being carried in procession.[48]

20

Much of Palmyrene ritual must have been performed in the open air, within the sanctuary courts. The monuments indicate processions, sacrifices and ritual meals. The procession was probably a normal ritual, for one is depicted on a Bel beam relief, and ramps in the temple would imply the passing of portable idols.[49] The Bel and Ba'alšamin sanctuary courts were well equipped with altars, runnels and water systems for sacrificial slaughter and ablutions.[50] A 'holocaust', furthermore, was connected with the cults of Bel and Ba'alšamin.[51] But artists ignored these ceremonies, representing most commonly a priest or devotee casting incense into an altar flame. Many such altars in limestone have been found; others in bronze have perished. They were used for ritual, or as offerings.[52]

20

26, 39, 41-3

Ritual banquets followed the blood sacrifices. Special chambers for the banquets existed in the Ba'alšamin sanctuary, the Agora and rustic shrines of the north-west where mixing bowls and basalt slabs for grinding grain have also been found.[53] Sculptors depicted other ritual accessories. Participation in these banquets and the subsequent distributions of food and drink was controlled with tokens or tesserae, usually of terracotta and authenticated with names,

54

66 images, seals and symbols of deities and organizers. Participants reclined on benches or couches. Priests wore distinctive headgear, a high cylindrical cap or *modius*, and belonged to hierarchically organized colleges. One of the best known is that of the priests of Bel, whose president, the *symposiarkhos*, occupied a position of special dignity.[54]

The frequency of monumental dedications in April, notably on the sixth, and in September, perhaps implies that these were propitious periods of celebration, spring and harvest festivals.[55]

Types of religious sculpture

Palmyrene religious sculpture embellished both sanctuaries and individual buildings. The cult statue was perhaps quite rare. Reliefs, however, were ubiquitous. In the first centuries B C and A D divine effigies in relief (or paint?) were commonly framed within elaborate niches set against sanctuary walls.

8 Torso of an early cuirassed statue (PM; ht. *c.* 45cm.; after *160*, 37, fig. 7)

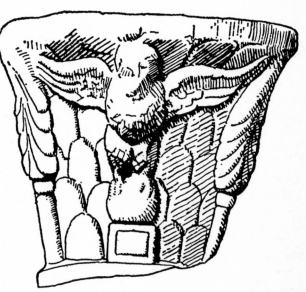

9 Headdress from a divine statue, perhaps of Ba'alšamin (NCG; ht. *c.* 10cm.; from *162*, fig. 4)

Other early reliefs depict cult scenes, especially the casting of incense into an altar flame.

The first and only really elaborate decorative scheme applied to a building was that devised for the temple of Bel, dedicated in AD 32. Peristyle beams, ceiling coffers and thalamoi were covered with religious figures and scenes. By comparison, the few figured relief carvings on other temples of Western style seem tentative indeed.

2, 4, 17–22

Instead, sculptors seem rather to have produced smaller, simpler reliefs depicting the local divinities. From one to eight deities may stand side by side, or ride an animal – usually the horse or camel – or chariot. Frequently the dedicant or dedicants appear also, usually casting incense or sometimes raising hands in adoration. Or again, an attribute or object may symbolize a deity (or worshipper).

27, 28, 31–44

The addition of similar reliefs to the main face(s) of a limestone altar became normal from *c.* AD 50. The little tesserae also bore reliefs. Much of the repertoire coincides with that of major sculpture: divine figures, relief busts and symbols, priests reclining, accessories. But some tesserae present scenes unique in Palmyrene art.

48–51

54

CULT STATUES

Pieces of statuary in soft limestone were found beneath the Bel court, discarded in Foundation T. They were of two kinds. The first consisted of crudely hewn stone torsos, with holes for the insertion of limbs (of which pieces and stumps survive) or pitted, to take plaster. The second was quite different: thin plaques, carved on the front face with details of cuirass armour and made so as to fit side by side. Pitting and plaster traces reveal that some if not all the torsos, and all the carved plaques, were used to build up statues; the torsos acted as cores, to which the plaques were attached. The military costume shown on these statues, if it signifies the same as later at Palmyra, would imply divinity, for the cuirass is a divine prerogative. They must antedate the laying of the Bel pavement around AD 50, perhaps by fifty years, perhaps by more; for the curious technique betrays unfamiliarity with large-scale work and hardly matches the competence even of early first-century sculpture.[56]

6, 7

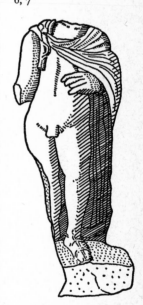

The idiosyncratic type of cuirass, of juxtaposed strips, dates other torsos and statue fragments from elsewhere, of soft limestone and with mortises, to an early period. But a more confident technique indicates that they belong to, perhaps, the first half-century AD.[57] The cuirass statue tradition continued sporadically later, although more Western cuirasses displaced the strip variety.[58]

Perhaps not all these early divine statues wore armour, for another probably first-century fragment from the Bel sanctuary presents the lower section of the cloak and the upper calves of a male figure in civilian dress; but this piece may have been honorific. Later, the male divine statue could assume various forms. One fragment features a headdress with Ba'alšamin's eagle and ears of corn. In Ba'alšamin's sanctuary was found a headless, Westernized statue of a young god in light cloak and sandals. This poised, Apollinine figure might be Nebû.[59]

Of the statues of goddesses, the head is generally all that remains. A couple seem to represent the guardian spirit of Palmyra, the (Semitic) Gad or (Greek)

10 Second- or third-century statue of Apollo/Nebû (?) from the Ba'alšamin sanctuary (DM C. 7452; ht. *c.* 50cm.; after *43*, II, pl. CIX.5)

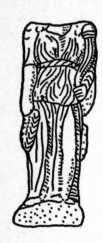

11 Second-century
statuette of winged
Victory (PM; ht. *c.*
35cm.; after *15*, pl. *5*)

8 Tyche. Each head has Tyche's characteristic cylindrical crown; one is also veiled, while the other exposes curls and coquettish forehead locks.[60] A third and smaller female head with a leafy headdress has leaves and fruit interwoven with her hair. Other heads survive, seriously damaged.[61] Two probably second-century torsos each represent a religious (or funerary?) winged Victory carrying a cornucopia.[62]

Most of this statuary has been lost. Occasionally, a now vanished statue of a particular divinity is represented on a relief. Many of these statues were in limestone; but doubtless there was bronze-work too, of which, perhaps, a scrap or two survives.[63] But the quantity gone may not have been vast. There are not many obvious positions for divine statues among the architectural ensembles. Instead, relief work was immensely more popular.

RELIGIOUS NICHES

Set into the mud-brick walls of Palmyrene sanctuaries were numbers of special niches of carved limestone. These bore reliefs, and perhaps also enclosed paintings, rich in religious content. Fragments of some early examples were found beneath the Bel court; so they were doubtless being erected at least by the late first century B C. The following half-century was their heyday; afterwards came decline, apparently hastened by Westernization of the sanctuaries.

9 Most of the niches were rectangular, built up from several blocks carved separately. Three monolithic niches from Ba'alšamin's sanctuary demonstrate how the various elements were composed into an ensemble, which remained standard until *c.* AD 50. Across the top stretches a lintel, normally bearing divine symbols and figures. Below this the central, and principal, part of the field is framed by a rich border of vegetation; beneath this is a plinth. The crucial central portion is divided into two sections, the lower one forming a single or double socle, the upper – the key to the whole – the image of the deity whose niche it was. The forms taken by this central element are at least three. In the first, the central niche occupies a small area within an ample frame; its own inner lintel is arched, and the background is carefully smoothed because, doubtless, it remained at least partly visible behind a narrow cult statuette or panel. For the second, the area of the central niche is proportionately greater; its shape is rectangular, and the background is left comparatively rough. The third type is similar to the second, except that the central space is empty, like a window; the wall behind acted as a background. In both the second and third types the rough background was clearly intended to be wholly masked by an inserted panel – a stone *stele* with relief, an icon of painted wood or perhaps even a tablet of bronze.[64]

9 The monoliths exemplify the typical rectangular niche form shortly before the mid-first century. One, well preserved, belongs to the first type, the central niche with small area but large frame. On the lintel a symbolic eagle shelters four rosettes with its wings; at each end is another eagle, standing with wings open. Around the frame twist vine and acanthus spirals, and seven rosettes in three varieties fill the plinth. On the socle three frontal griffins, the beasts of Malakbel, rear up, surmounted by the draped frontal bust of a god in a cylindrical headdress. Another monolith, now mutilated, is similar; but the arched niche

is hollow. Another, of the second type with larger central niche, differs more. It has the eagle lintel, and busts on the socle – three this time: the solar Malakbel (?) between a veiled female, and an indistinct male. But on the plinth is a rosette enclosed by oak leaves, and the central niche is rectangular.[65]

Otherwise, sections and fragments alone remain – lintels, jambs, plinths, socles and what probably constituted some of the divine images at the centre.

The lintels almost invariably follow one basic design. Across the central section a great eagle spreads its wings; beneath these it may shelter starry rosettes, further eagles or busts of the sun and moon, which confirm that cosmic symbolism is intended. At each end, a small panel or space is customarily reserved for a lesser eagle with open wings, a figure or some other item. The early Foundation T fragments conform to this pattern.[66] Other sanctuaries possessed similar pieces; and the design recurs on a tessera.[67] The finest of these lintels, from Ba'alšamin's enclosure, is of astonishing magnificence. A superbly imperious eagle, here without doubt the symbol of Ba'alšamin himself, overshadows with his spread wings the lesser busts of 'Aglibôl, the moon, and Malakbel, the sun; other eagles, surely messengers from the sky, hover around their master. The design is typical in its elements, its hieraticism and its symmetry. But gentle rhythms are set rippling: the eagles change direction, the divine busts incline inward. These rhythms merge here with the dexterous carving and fine detail into a masterpiece of Palmyrene art.[68] `12`

The best of the jamb or framing fragments are also probably the earliest, namely the sections from Foundation T. Here the bands of ornament range from single to quadruple – pleasing, intricate designs, again from richly embellished niches.[69] `10`

The niche plinths and socles beneath the cult image attracted further reliefs. An early piece was lying on top of Foundation T; another, strikingly similar and manifestly by the same hand, is now in the Louvre. Both are damaged. Each relief is divided into two superimposed registers; the upper is slightly narrower than the lower, creating a 'stepped' effect. Between pairs of columns and rosettes, and surrounded by architectural decoration of Greek origin, eagles, or goats or griffins in profile, frame the central bust of a god. Each deity wears a 'strip' cuirass and cloak; two clasp a jewelled sword-hilt to the chest, and on one the head is surrounded by a radiate nimbus, symbol of the sun. Who are these gods? The attributes all proclaim Malakbel: perhaps he is represented four times over in his different agrarian and solar aspects. Carving, detailing and hieratic symmetry all argue Palmyrene competence at the turn of our era.[70] `13` `14`

Malakbel has been seen again, less surely, in the two armed and frontal gods on the lower portion of a niche from the Agora. On the plinth the trees (or pomegranates?) and griffins could be his. But the shield and helmet are unexpected. Above, on the socle, the god appears on a curving base – shown as a statue, therefore? On each side is a huge lion, with an eagle perching on its head; the central figure holds the lions on chains, as he does one of the two six-petalled flower-heads beside his head. He, then, must be the mysterious 'Master of the Enchained', the Rab Asirê whose temple is mentioned in the great Tariff Law inscription found hard by.[71] Other socles are less informative. One preserves a radiate bust of 'Aglibôl, placed, unusually, above his crescent instead of before it: this suggests archaism. A second presents three male divine busts `11`

above six frontal lions. Others show a frontal figure of Gad or Tyche, and bulls in profile, or again, winged Victories holding up a medallion bust – the Westernization apparent here argues for a second-century date, later than most.[72]

15 Alongside the rectangular varieties another, but rarer, type of niche developed. An arched cavity provides the focal point, with figures in the spandrels, mostly of winged Victories. The earliest balances on a globe; later they carry palms and proffer crowns. The last of the niches, from Abgal's temple north-west of Palmyra, dates perhaps from 192/3. Frontal busts of modius-capped priests fill the spandrels, framed within giant Corinthian half-columns.[73]

The rarity of religious niches of any kind after the late first century must mean their heyday was by then already over. The standardization of the cosmic symbolism of the lintels, and the frequency with which Malakbel seems to appear among the reliefs, is remarkable. Could these niches have been largely confined to the worship of the great cosmic deities and their acolytes alone?

9 What of the cult images themselves? None have been found in place, but clues to their nature remain. The monolithic 'three-griffin' niche preserves in the centrepiece a smooth background and remnants of plaster. These point to a slim stele or statuette as the lost representation. The Ba'alšamin monolith of the second niche type is provided with a groove for the insertion of a plaque.[74] Do any such stelae survive, now separated from their original context? The Ba'al-
16 šamin sanctuary sculptures include some likely candidates in an attractive, if headless, high relief of Ba'alšamin himself and a stele of Šadrafā. Doubtless many other extant stelae once belonged to niches.[75]

ARCHITECTURAL RELIEFS

The embellishment of a particular religious building sometimes included the provision of architectural reliefs. But only once was such decoration attempted on a major scale, for the dramatic new temple of Bel, dedicated in AD 32.

6 The Bel ornamentation was concentrated on two parts of the temple: on the
2, 4 upper part of the surrounding colonnade or peristyle, and on the thalamoi

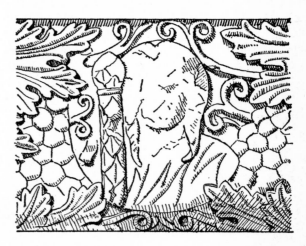

12 Bel temple relief bust
of Dionysus, c. AD 32
(from *169*, 105–6, fig. 8)

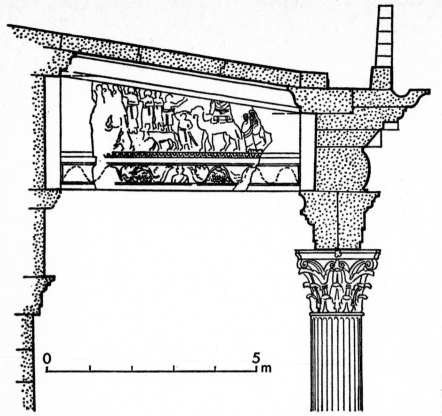

13 Bel temple peristyle beam arrangement, *c.* AD 32 (*128*, F852)

inside. Only a tenth of the original decoration now remains; but clearly the ensemble was once of a grandeur and richness quite unparalleled at Palmyra, and hard to match throughout Syria. On the ceiling of the great portal, motionless, stand three frontal, divine figures. Centre and left are gods cuirassed, booted and armed in Hellenistic Greek style. The left figure is 'Aglibôl, lunar crescent above his forehead. In the centre poses a radiate solar god, probably Iarhibôl, Bel's only solar associate. On our right stands a goddess – Beltî, or Astarte (Ištar)? The folds of the goddesses' tunic show through the 'transparent' cloak at knee height, while the lower hemline is rigid. On the lintel soffit, recalling another aspect of Bel's divinity, was placed a bust of Dionysus, with a leafy staff or *thyrsus.*[76]

 The portal pillars and peristyle columns were joined to the temple cella wall by colossal limestone beams, which offered three faces to the relief designer: the two sides, and the soffit beneath. The inclination of the peristyle roof above forced the beams into a trapezoidal shape. Somewhere immediately to the visitor's left as he stood beneath the portal, on its northern side, was a long, sober relief representing pairs of priests beside a date palm, casting incense upon a tall burner. Poses are unremittingly frontal, but costumes vary. Two paired priests wear voluminous cloaks with leggings beneath, two more, cloaks and belted tunics. Curiously, the position of the Greek egg-and-tongue decoration

17

12

13

14

14 Bel temple 'Offering' scene, *c.* AD 32 (*sub situ*; ht. *c.* 2m.; from *153*, pl. XXIII)

beneath implies that the relief was originally placed horizontally – unless it was inadvertently rendered upside down.[77]

19 The opposite beam portrays the sanctuary of two Palmyrene gods. To our right is a Corinthian temple, hung with a cluster of dates. Before it stands 'Aglibôl, frontally, in a striking military attire. His cuirass is moulded in Hellenistic fashion, with even the navel marked, and over it is pinned the conventional short cloak. But the shoulder-tabs are unmodishly long, and his limbs are covered by an oriental long-sleeved tunic and leggings. Over an altar heaped with fruits of the earth he clasps the hand of a fellow god. Two other reliefs picture this pair, and the attributes agree: 'Aglibôl's partner is certainly Malakbel. Unlike his companion, Malakbel has no cuirass, lance or nimbus; he is here in agrarian guise. Behind him stands a second altar (also heaped with produce) carved with a goat, and shadowed by a sacred cypress with a lopped branch. To our left are two damaged figures in profile, dressed in 'boiler suits' – attendants, surely. Were their heads in profile also? Here, perhaps, we can faintly sense the leafy stillness of the 'holy brothers'' actual sanctuary.[78]

15 By contrast, all is action on the opposite face of this beam, which faced southwards down the peristyle. A giant 'anguiped', with his five snake legs crushing a boy in their coils, is vigorously attacked by a divine charioteer (Malakbel?) and a horseman; a dog assists. A veritable cornucopia of serpents is pictured beside the giant's head. Six frontal deities also attend, perhaps meant to be interpreted as taking part in the struggle. Four are cuirassed. First is Šadrafâ, his serpent entwined around his lance. The second is female, a helmeted Artemis-like figure with a huge fish at her feet, possibly Atargatis, or Nanaï. Beside her is another helmeted fish-deity, but male: Elqônerâ, equated with Poseidon? The fourth carries the small round desert shield, and might be Arṣû; the fifth, Heracles' nude figure, appropriated here perhaps for Nergal, is at his side. Lastly stands a battered goddess in a trailing gown. Above the combatants the sloping field of the relief allows the insertion of two winged genii with serpent bodies, writhing to our right. One carries a palm (of Victory?), so their role seems beneficent. Some forgotten Syrian myth must underlie this strange battle.[79]

Facing this was an equally singular religious procession. The designer exploited the unusual shape of the field. Clustered to our right is an extraordinary group of three figures. Swathed completely in ritual veils, leaning their heads on their hidden right hands, their feet alone appearing, they form a superbly decorative motif. These are female onlookers at the spectacle which unfolds leftwards. A camel walks forwards, bearing a high pavilion (like the leather *qobba* or *hoja* of the later Arab world) which probably housed the idol. The covering was originally painted red, and the pavilion rests on a rich camel-rug enhanced by patterns and green and yellow colouring. The camel's halter is held high by a man half-leaning on a staff. Here the base line diverges into two. Ahead of the cameleer wanders a horse or donkey, dragging its halter. To our left kneels a woman, apparently in profile. On the upper plane stand more spectators, in a row facing frontally. Above the horse or donkey three men are shown, their feet appearing to rest on the animal's back. The first man half-turns towards the camel, raising his right hand in salutation or benediction. All three seem to carry a short sceptre in the left hand. A fourth man's feet seem to float in a void, which confirms that the artist must have intended an upper plane. All four, like the cameleer, wear the local costume of the steppe: the short, sleeved tunic, the cloak slung over the chest and the sarong-like garment rolled around the waist and covering the legs. Their hair is in startling disarray. Finally, half-obscured, three more of the veiled women look modestly on. What is taking place? It might be an Arab religious procession, or the arrival of the god Ba'alšamin, whose great sanctuary had just been laid out.[80]

On the back of this beam, all is quiet once more. Two tall, flaming burners are attended by pairs of sacrificers, with pairs of priests between; all carry ritual utensils and are posed frontally. Here, to fit the trapezoidal field, the figures simply vary in size.[81] Other small beam fragments show more worshippers. But at least one other scene, now largely vanished, was designed in two planes.

15 Bel temple 'Battle' relief, *c.* AD 32 (*sub situ*; ht. *c.* 3m.)

16 The calves and feet of a figure apparently suspended, but surely meant to be on another plane, interrupt a row of standing figures.[82]

19, 20 Beneath these well-populated scenes a broad vegetation scroll, selected from a repertoire of tendrils, leaves, vines, grapes and occasionally flowers too, twists and spirals across the beam. The quality varies remarkably from mediocrity to
20 finesse. Drillwork points up the leaves, and a priestly bust may mark the axis.

18 On the soffits were still more lively scrolls. In and out of the leafy spirals scramble Cupids and animals busy with the chase; winged Victories preside. The Hellenic atmosphere and composition are startlingly alien to the formality of the vertical reliefs.[83]

22 The beams carried a thick stone ceiling, in which deep-sunk coffers of various geometrical shapes offered the artists further scope. Curious, youthful winged genii, for instance, hover frontally within lozenges. Clad in pointed cap and a variety of 'boiler suit' that leaves them naked from neck to genitals, they raise one hand in benediction and in the other grasp a kind of trophy – a tall pole hung with a suit of Hellenistic armour. Other recesses harbour just the heads of these strange beings, and others again, different heads, floral motifs, and bulls.[84]

 Inside the temple, the northern chamber or thalamos probably housed statues of Bel, Iarḥibôl and 'Aglibôl within its central niche. The soffit of the niche lintel is carved with a theme already familiar: a gigantic eagle spreads wide its wings over star-like rosettes, six globules (surely planetary) and a snake that could symbolize the wavering annual course of the sun. To our right stands a cuirassed, radiate Iarḥibôl; near him one of the rosettes is marked by an enclosing circle. 'Aglibôl and another star-flower may have counterbalanced these at the now smashed left end. So the cosmic deity Bel/Zeus, symbolized by the eagle, presides here over the stars and planets, attended by his companions.[85]

21 On the ceiling over the central compartment, above the supposed statues of the divine triad, geometric motifs surround a large, central cupola. This is
18 divided into seven hexagonal medallions, each of which encloses a divine astral bust. Rays identify the sun, and armour and weapons, Mars (shown as the Greek Ares). Next, above a crescent, we see the moon – but here it is female, in astonishing contrast to the Palmyrene 'Aglibôl's incontrovertible masculinity. A veiled Venus (Aphrodite), Saturn with his reaping-hook and Mercury (Hermes) carrying his messenger's staff complete the outer ring. In the centre, a god without (surviving) attributes can only be the seventh planet Jupiter, who must here represent Bel/Zeus. Again, the vocabulary of figures is strikingly

16 Bel temple peristyle beam fragment with a 'raised' figure, *c.* AD 32 (*sub situ*; ht. *c.* 1m.; after *128*, 193)

17 Soffit relief of the Bel temple north thalamos lintel, *c.* AD 32 (*in situ*; width *c.* 1·50m.; from *151*, 255, fig. 2)

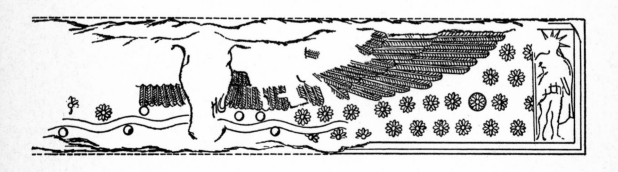

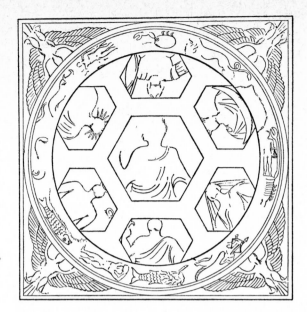

18 Bel temple north thalamos ceiling relief: busts of Jupiter (centre), Mars (above him), and (anticlockwise) the sun, Mercury, Saturn, Venus and the moon, with the Zodiac and eagles around, *c.* AD 32 (*in situ*; width *c.* 3m.; from *151, 258,* fig. *5*)

Hellenic. Around the cupola circumference runs a Zodiac, representing the fixed stars of the sky. In each spandrel a messenger eagle spreads its wings. This cupola is balanced in the southern thalamos by a huge floral motif in a geometric surround.[86]

The surviving sculptures of the Bel temple are remarkable for the range of ideas and styles they display. Was just one group or workshop of artists involved, or several, trained in opposed traditions? And where, and how, did they receive this training? We must consider these questions at a later stage.[87]

Other fragments of architectural relief from the Bel precinct reflect a similar East-West oscillation. The symmetrically opposed sphinxes and masks along a 24 cornice are decidedly Hellenistic in vocabulary and even, somewhat, in execution, as is the small fragment of a floral scroll with figures entwined, found re-used in the later 'Niches monument'. But this spot also yielded a boy's head in the low relief and with the huge eyes of Near Eastern tradition.[88]

No other building at Palmyra possessed such a profusion of sculpture as the Bel temple. Malê's neat little temple of Baʿalšamin and Dûrahlûn in the Baʿal- 5 šamin sanctuary, dated AD 130/1, can boast only a carved niche lintel for the thalamos. Seven busts, now mutilated but doubtless planetary, are framed by two outward-facing eagles with open wings. Other fragments depict a bearded head, a large vine overshadowing a pair of overlapping 'cymbals', and torsos of an Attis-like figure and of a winged Victory flying sideways to our left, but with her breast and head to the front.[89] A further fragment seems to have part of another 'inhabited scroll'. Some slabs, although more complete, remain puzzling. One places three youths in mid-third-century tunics around a gigantic 23 central urn, with other utensils around and above them. Two others, now embedded in the Bel propylaea façade, form a pair. On one, Hermes, nude but 25 for a light cloak, is seated on a rock facing our left. He grasps a bag in his right

hand, and doubtless once held a staff in his left. Before him, a ram passes two palms. The other slab depicts Heracles in a similar, but reversed, attitude; in front of him stands an animal before a tree. Perhaps the slabs once embellished a gymnasium or *palaestra*, of which Hermes and Heracles were patrons.[90]

RELIEFS OF PRIESTS AND WORSHIPPERS

Besides statue and niche fragments, Foundation T beneath the Bel court also yielded some small pieces of relief which, to judge by the lack of divine attributes, portray mortals. The most curious relief fragment, probably the earliest, contains the head and right shoulder of a man in a sleeved tunic – hardly noteworthy, except that the figure is portrayed in profile, a view rare at Palmyra. The piece, of soft limestone, could date from the late first century B C.[91]

The profile view links this piece with three other damaged reliefs, all incorporating profile figures, from unknown findspots. The fragments come from the centre-right sections of the original reliefs. One presents two figures. At the right-hand end stands a woman in profile, wearing a 'patterned' tunic and cloak, a fold of which is cast over her head ('patterned' in the sense used here and throughout this book means 'with drapery folds arranged in patterns'). A lock of hair falls to her shoulder; she carries a jug. Before her stands a man in similar costume beside an altar, with incense box and libation jug, seen in three-quarters view.[92] The second relief presents a woman in profile to our right. Her right hand is raised in worship. Again, a man or priest with the implements of sacrifice appears at an altar, but wholly in profile and balanced by the mutilated figure of a fellow officiant, apparently in a three-quarters pose.[93] The last relief is the best preserved, with four figures remaining; it was found, out of context, in the Agora. To the extreme right, in profile, a cloaked female worshipper holds up a two-handled cup. Before her an almost identical woman proffers a cup with a pointed lid – doubtless a perfume burner. Next is a similar male figure; cloaked, seemingly wearing a rather low priestly cap or modius, he grasps a wreath. These three could be processing towards the fourth figure, another priest, who casts incense on to an altar while gripping the customary box and jug in his left hand. His figure echoes the others, but traces indicate a frontal head.[94]

The striking similarity between the figures, subjects, poses, costumes and dimensions of these latter three reliefs is notable, as is the generous use of the profile view. This view is demonstrably early in the case of the similar Foundation T fragment: surely, all antedate the mid-first century A D. There is no sign that any divine figures were ever included.

Two other sculptures from Foundation T can be connected with this series of sacrificial scenes; both are damaged. A frontally placed man in relief perhaps once attended another ritual scene. And a male torso presumably represents a priest, for a palm appears in his right hand and ritual utensils in his left.[95]

A last relief depicting priests, of the mid-first century A D, was found in the precinct of Nebû. A priests sits between his son and grandson; the latter raises a wreath. This could be honorific, or represent heroïzation.[96] After this period reliefs depicting priests and worshippers alone apparently ceased in favour of those which showed immortals.

29

26

19 Early relief with two figures (DM; ht. 39cm.; after *140*, pl. I)

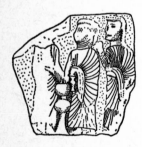

20 Early relief with a scene of offering (DM; ht. 33cm.; after *160*, 31–3, fig. 2)

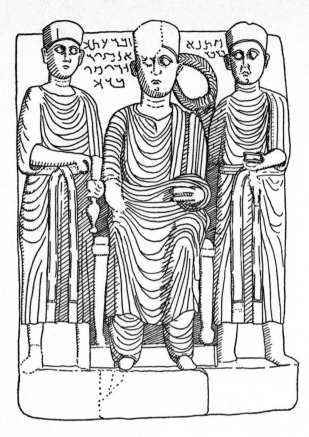

21 First-century relief
from the sanctuary of
Nebû with three priests
(PM 2228/7957; ht. *c.*
50cm.)

RELIEFS OF DEITIES ALONE

Some of the many Palmyrene reliefs which portray divinities alone were no
doubt made as cult images to be fitted into the central portions of religious niches.
The stelae of Ba'alšamin and Šadrafâ from the former's precinct could be ex-
amples. Others were placed by themselves against the walls of temples and
doubtless of the sanctuaries also. The discovery of two such reliefs in place –
crude portrayals of warrior deities, found against a bench in a rustic shrine
north-west of Palmyra – indicates this clearly enough. And this latter kind
could obviously act as 'cult reliefs'. But as regards most, one can only speculate
on their original position and function.[97]

The deities might be shown in the civilian dress of town or countryside.
Weapons, however, and often armour too, were customarily added from the
early first century AD onwards to enhance the gods' protective powers.[98]

The vast majority of these reliefs depict a single male divinity, standing,
seated or mounted. A couple of early stelae portray gods in urban dress who are
quite without weapons. Around the head and shoulders of one, who stands
frontally, spread the flat disc and rays of a sun god – Iarhibôl, Malakbel or
Šamaš. His globular hairstyle and strongly patterned drapery argue an early
date, perhaps a little before the mid-first century AD. Another of similar date,

16

22

16

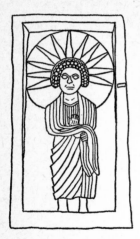

22 First-century Nebû sanctuary relief of a sun god (PM 2227/7956; ht. *c.* 45cm.; after *168*, pl. IX.2)

likewise frontal but seated and holding fruits of the earth in his lap, belonged to the sanctuary of Ba'alšamin and probably represents the god himself.[99]

Militarism of some sort became the norm from the early first century AD. It may consist only of the accoutrements. An interesting group of stelae, half of which turned up in the countryside north-west of Palmyra, present the god in the local dress of the city and steppe – a sleeved tunic, an (optional) cloak and a 'sarong' tucked around the waist. The right hand supports a tall lance; the left commonly rests on the hilt of a short sword, and on the left arm may be slung a small, round desert shield. Several gods wear this uniform. A couple, in costume and hairstyle of mid-first-century type, also have the *polos* or *calathos* (cylindrical cap) headdress; another carries a shield built up of strips; others have sword and spear alone, for example the god with moustache (Ša'ar, here spelt Ša'arû) depicted on a stele apparently commissioned by one Taimarṣû, whose name appears on the plinth. The Arab gods Abgal and Ašar also sometimes adopt this guise.[100]

Other gods, more blatantly militarized, sport a full-scale cuirass of Hellenistic form normally worn over a sleeved tunic and beneath a short military cloak. Again the lance, sword and sometimes the circular shield form the accoutrements. Those reliefs carved in the first century depict the curious breastplate of strips already familiar from the early divine statues. Šadrafâ in particular favours this dress. One stele, where his shield and accompanying scorpion and snake are all clearly to be seen, was dedicated in March AD 55; two others of similar date, now damaged, once enhanced the precinct of Ba'alšamin.[101]

In the following century this 'strip' cuirass became transformed into a breastplate of conventional Hellenistic or Roman design. One of the sun gods, cupping a globe in his left hand, wears a Roman type, as may the warrior gods depicted with naïve clumsiness on several stelae from the region north-west of the city.[102]

Certain representations stand somewhat apart. A rustic Heracles holds the Nemean lionskin, its paws dangling. And an almost equally nude figure, ithyphallic and Priapus-like, clasps a mass of fruits of the earth – principally grapes – across his stomach. The carving is shoddy, but Palmyrene attempts at the nude are rare enough for this relief to be noteworthy.[103]

The gods may also be represented in bust form; again, the costume is normally military. The best of these, inscribed and dated AD 30/1, is a riddle. First of all, although of Palmyrene style and content, it is not definitely from Palmyra. Secondly, although dedicated to the sun (Helios), the crescent behind the radiate bust's shoulders would indicate, as elsewhere at Palmyra, that this is the *moon* god, 'Aglibôl. Thirdly, who are the seven genii shown below as naked profile busts in heavy collars? Spears are engraved obliquely behind them. Perhaps they are the planets. And why is the dedication in Greek (alone), and the patron's name Roman? Other busts do indeed represent a sun god. Two came to light in Nebû's sanctuary. One shows the god between two messenger eagles, each with its wings open (but not spread); the god's enormous nimbus and archaic hairstyle put him perhaps somewhat before the mid-first century. His companion, with smaller nimbus, neater rays, carefully curled locks and 'strip' cuirass beneath his military cloak, could be slightly later in date. The remains of a similar piece were re-used later as foundation rubble.[104]

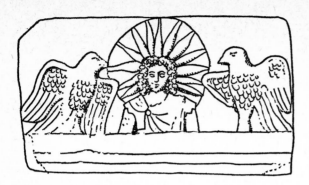

23 First-century Nebû sanctuary relief bust of a sun god (PM 1724/6534; ht. *c.* 35cm.)

Some smaller fragments give no clue as to whether they originally existed as busts or at full length. One contains the head and chest of a bearded deity in cylindrical headdress before an arched background; the beard, headdress and sceptre clasped in the left hand are all characteristic of Ba'alšamin. Several more heads are surrounded by the radiate nimbus typical of solar and lunar gods; the most extraordinary of these, rendered in green-glazed terracotta, looks very like the youthful Egyptian god Horus.[105]

Gods are sometimes mounted, particularly on horses or camels. Some early reliefs portraying riders on horseback had been thrown into Foundation T before the mid-first century A D. One horseman rides to our right, the other to our left; although damaged, both are still elegantly apparelled with patterned tunics and trouser seams and horse trappings decorated with spiral and circular ornamentation. The profile view extends at least up to shoulder height; but the heads are gone. No inscription or attribute remains to establish whether deities are actually represented here, but later parallels make it likely. Another relief with a horse-rider came to light elsewhere in the Bel precinct; a trace of yellow paint survives on the horse's trappings. And the profile view dates a further horseman – an archer, with a huge bowcase fixed behind the saddle – to an early period.[106]

Later 'cavalier' reliefs are also disappointingly incomplete, but inscriptions make it clear often enough that these are depictions of gods. Most were discovered in the rural sanctuaries of the north-west. One carries the date A D [2?]30: an archer again, in a fringed 'sarong' and with an engraved bowcase and quiver. But a curious relief in marble of the god [Ca]stor on horseback, framed between Corinthian pilasters, must be a Western import, for material, style and artistic vocabulary are eastern Roman, despite the relief's discovery in Abgal's sanctuary at Khirbet Semrin.[107]

Reliefs portraying single cameleers were also to be seen in the Bel precinct. Around their waists and over their thighs is rolled a short cloth with a fringed vertical fold; above, they wear a sleeved tunic. Their mounts are hung about with the paraphernalia of battle – quivers, bows and bowcases, and the small round shield. Reins and a short stick are used to guide the animal, to right or left. Decoration is reserved mainly for the saddle cloths.[108]

The goddesses are similar, if not so often bellicose. One inscribed stele fragment, with only a standing goddess' feet and cloak hem left, provides us with

24 Religious relief fragment with a bearded god, *c.* A D 100–250 (Lou 18.175; ht. *c.* 30cm.; after 24, fig. 187)

32

33

the earliest dated Palmyrene figure yet known. The year number is damaged, but the surviving characters, together with letter forms and sculptural style, combine to make the latest possible date, 22 B C, the likeliest. A full figure, draped and sceptred, survives on a crude stele of the early first century A D; the divine name Beltî is just visible on the plinth. Another early image presents a female draped in sleeved tunic and cloak between half-columns; her right hand grips a short stick, perhaps a sceptre. A later figure of dubious sex, but with some typically feminine jewellery, personifies the guardian spirit or Gad of an unspecified village of the north-west region; it is dated 149/50. A leaf is pressed against the midriff by the left hand. The north-west also produced other pieces. One is fragmentary: part of the head and right arm of a jewelled deity is visible. A sceptre is propped up by the right hand, and beside it stands a curious ensign capped by a crescent and bells. Another, third-century in style, gives us the figure of Nemesis beside her fateful wheel.[109]

25

34

Allat provides the transition to militarism. A damaged stele from the end of the first century depicts her in civilian guise with sceptre or lance, seated between two lions. Representations of this kind were still current a century later, as a rustic fragment reveals. But by the second century her traits had often become those of the armed Athena, with helmet, *aegis* (or Medusa-head breastplate), spear in the right hand and the left resting on a circular shield at her side. She had this aspect in both urban and rural areas.[110]

In order to depict the pairs, triads and groups into which so many of the deities were frequently marshalled, sculptors often simply multiplied the formulae devised for single divinities, especially the standing, fully frontal pose. The pair, as it happens, is a rarity. But one relief, at least, portrays twin warrior gods, in local garb and carrying the small, round desert shield; their 'triangular' and wavy hairstyle is particularly striking. This formula was repeated on another relief, now broken, although it probably had further figures. So the pair formula was current when both these reliefs were made, perhaps somewhat before *c.* A D 50. A relief with a god on horseback and a goddess was found some 100 km. west of Palmyra, but may not be from the metropolis.[111]

37

26

The group of three, usually combined as an official triad, is commoner. It had entered the artists' vocabulary by about A D 50. An early example, now in the Louvre, was executed neatly with claw and flat chisels and was lightly rasped. Three aligned gods face us sternly, clad in identical long-sleeved tunics, 'strip' cuirasses and short military cloaks pinned on the right shoulder. The figures are broken at the knees, and their lost right hands, added separately, perhaps once held metal spears. The central god's beard, cylindrical and beaded headdress, stiff diadem, luxuriant 'triangular' coiffure and leggings mark his predominance. 'Snail' curls, beardless faces, a heavy torque, bare legs and a magnificent radiate nimbus distinguish his companions. And the crescent that cuts across the nimbus of the god on our left identifies the trio, for similar portrayals indicate that in such a group of three the central position is the leading one, that to our left is the second most important, and that to our right, the least important. The moon god to our left must be 'Aglibôl; he takes precedence over a solar deity (Malakbel) only in the triad of Ba'alšamin, so that triad must be the one pictured here. Later, devotees filled in the background with graffiti.[112]

35

The central god of a similar and slightly later, but much cruder, triad is more clearly differentiated from his two companions. His headdress, hairstyle, beard and costume correspond to those of the Louvre Ba'alšamin. But whereas he retains the 'strip' cuirass, the flanking gods have adopted the moulded, metal Hellenistic breastplate. Here the lunar god stands to our right; the normal laws of precedence would therefore most naturally establish the triad as that of Bel, Iarḥibôl (second) and 'Aglibôl (third). But Bel is usually beardless, so this might be an idiosyncratic version of Ba'alšamin's group.[113] More problematic still is a damaged relief (*Fig.* 27) which is Palmyrene in material and style, although it was allegedly found near Lake Constance in Germany. Here again the central figure wears a diademed headdress and 'strip' cuirass, and supports a spear; the wavy coiffure recurs, but the figure is beardless. To his right a female holds a large leaf. She is balanced by a spear-carrying male in long-sleeved tunic and short cloak, whose head was (re-?) done (very differently from the other two heads) in stucco in ancient times. His spear, scarcely ever carried by mortals in Palmyrene reliefs, and the palm and unveiled condition of the female, all suggest divinity. But to name names is hazardous. This, like the preceding relief, was carved perhaps *c.* AD 60–120.[114]

The juxtaposition of four deities was less common. One relief, re-used in the construction of a well for the Bel temple, would provide an early example, if complete; but the framing visible to our left is missing on the right, which raises doubts. On the block as we have it, a narrow central space divides the

25 Relief fragment with a religious standard from north-west of Palmyra, *c.* AD 150–250 (DM; ht. 21cm.; after *24*, fig. 173)

36

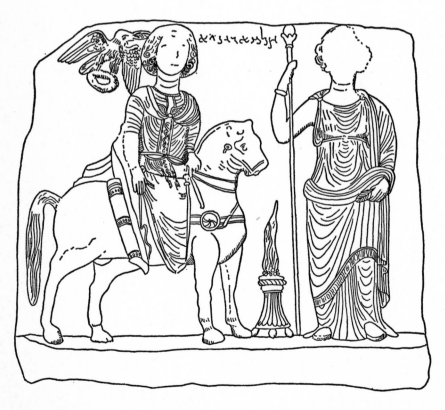

26 Relief depicting a god on horseback with a goddess from Djoub el-Djarrah, *c.* AD 100–50 (DM; ht. 59cm.; after *171*, pl. XI)

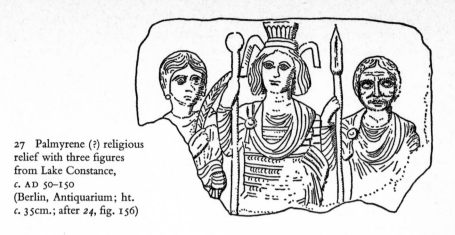

27 Palmyrene (?) religious
relief with three figures
from Lake Constance,
c. AD 50–150
(Berlin, Antiquarium; ht.
c. 35cm.; after *24*, fig. 156)

frontal deities into two pairs. To our left is a nude Heracles, and beside him a
cloaked and radiate goddess of doubtful identity. To our right are twin males,
radiate and holding leaves: a crescent, placed high over the hair, identifies the
probably predominant one as 'Aglibôl. Might they not, therefore, be the two
'holy brothers', 'Aglibôl and Malakbel? Enormous piles of stylized hair, rigid
patterning of drapery and limbs, huge, lentoid eyes and multiple neck striations
indicate archaism, as does the goddess' stiff, wide hemline. Varying widths
of line suggest the differing textures of tunic and cloak. A later relief groups the
triad of Bel with a fourth god (Arṣû?) on what was once possibly a ceiling block;
all wear moulded breastplates and carry sceptres, but Bel is marked by a smooth
nimbus and trousers, and the fourth god by an idiosyncratic helmet.[115]

Five oddly assorted divinities stand together symmetrically on a relief from
the country area of Al Maqate'. Thoughtfully, they have been labelled. Bel
provides the pivot, in headdress and archaic 'strip' cuirass; 'Aglibôl, in a moulded
'muscle' breastplate, predictably flanks him to one side; and on our far left is the
likewise military Iarḥibôl – so the full triad of Bel is present. But between Bel
and Iarḥibôl is the civilian figure of Palmyra's second supreme god, Ba'alšamin,
also in headdress and clasping a sheaf of corn. This is most surprising, for Bel
and Ba'alšamin are not usually shown together. Bel's retention of the old 'strip'
cuirass, despite his companion's progressive Western costume, is equally
remarkable. In a trailing gown, the sceptred goddess Astarte completes the
ensemble. Lettering and drapery style suggest a date of *c.* AD 100.[116]

28 Another intriguing piece originally depicted six deities within a pedimented
frame or *aedicula*. Four of the deities survive: the triad of Bel, and a mantled and
sandalled goddess crowned by a headdress. On the axis of the pediment looms
the cuirassed bust of a solar god, between huge palms and a floral scroll. Enough
remains of the dedication only to place the relief in January AD 19, 119 or 219.
Bel's archaic 'strip' cuirass suggests that 219 is not correct. The most plausible
date would seem to be 119, on the evidence of the moulded 'muscle' cuirasses
worn by Bel's companions (as on the quintuple Al Maqate' relief of *c.* AD
100–50), the comparatively advanced letter types, the Westernization apparent
in the aedicula form and, indeed, the general sophistication of the relief.[117]

Frontality is relaxed to a certain extent for a sextet of divinities from the eastern desert. At each end a goddess – Allat, and an unknown – turns her head slightly inwards. A military god in a headdress is the focus of attention; he is completely frontal, attended by two companions, whose heads incline towards him – this is probably Ba'alšamin with 'Aglibôl and Malakbel. The fourth god, in headdress and trousers, is a puzzle. The light internal rhythms set up by the inclination of heads and leg positions, together with the poorly executed drapery, look late.[118]

Other such reliefs are now broken, so that it is not always clear how many deities were depicted on them. A few early pieces show gods in local dress with spear and round shield. One row, ended by a standing Allat in warrior guise and framed by a competent vine scroll, could have been of considerable length. An equally bellicose Abgal and 'Azîzû stand in the midst of another row. And a further portion of relief places Ba'alšamin, unusually, beside his companions, instead of between them.[119] The triad motif lived on. A late and substandard relief which includes a cuirassed triad of Ba'alšamin, either as himself or in his 'Nameless' aspect, occupied a temple cella at Khirbet Ramadan, to the northwest. Headdress, stiff diadem, trousers, the sword slung from the belt and a Gorgon-head shield mark the leading figure. Curiously, 'Aglibôl's sword (and doubtless Malakbel's also) is hung from his shoulder in Roman fashion, in contrast with Ba'alšamin's Iranian method. Five figures at least occupied a relief in Palmyrene style purchased in Rome and now in Brussels. The triad of Bel, received the dedication, and 'Aglibôl is visible to our left; filling the centre is the figure of Nemesis (with the name of Athena added above her, perhaps later); while on our right stands a god in Palmyrene local garb, labelled Keraunos (inaccurately?). The composition is conventional, and the date surely third century.[120]

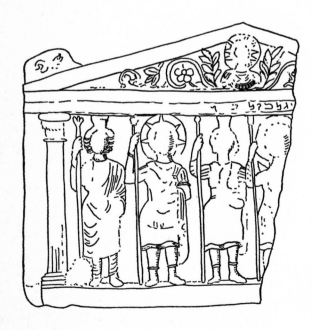

28 Relief depicting gods within an aedicula, AD 19 or 119 (DM (?); ht. 53cm.; after 24, fig. 126)

29 Relief fragment with a bull, *c.* AD 150–270 (DM; ht. 24cm.; after *144*, fig. 36)

A curious piece decorated the god Abgal's temple enclosure at Khirbet Semrin. A bull emerges from the damage, pacing to the right behind another animal; behind is a stylized rocky landscape. On the bull's back is a large human foot; the rest is lost.[121]

Two other reliefs depict a goddess seated at a slight angle to the spectator. In each the transition from a largely profile chair or throne to a frontal head and torso is masked by drapery. The first, of the late first century, reveals a finesse of carving that places it immediately in the front rank of Palmyrene pieces. Relief is low, and the gradations of plane skilfully managed. The seated goddess occupies a central position on a cushioned throne, a dog at her side, and beneath her foot the personification of a stream or river – Efqa, the lifeblood of Palmyra? A decorated headdress rests on her carefully plaited hair; twisting locks fall to her shoulders, and her left hand draws aside her veil. Around her ankles a Greek

38

wave-pattern enlivens her tunic hemline, curving over her sandalled foot. The inscription is damaged: the words *'štr' tbt'* could mean either 'the good Ištar' (Astarte, an ancient goddess of the city), or simply 'the good goddess', with the proper name lost. If the central figure is Ištar, the goddess beside her in similar robes carrying an olive branch and crowned with a turreted city-wall head-dress could be Gad or Tyche, the guardian spirit of Palmyra. If the name is lost,

146, 60

the central figure, by analogy with representations from Dura-Europos, could be Gad, while the other's identity would remain a mystery. On our left an eagle with open wings perches on a high pedestal; in its beak is an oak branch, and its wing interrupts the careful vine scroll of the frame. With great precision, the sculptor's tools have created in the soft limestone a delicate interaction between symmetry and naturalism in the draperies, and an amazing detail of ornament. Red colouring completes the work.

40

The second relief is mediocre by comparison, but does hold some surprises. The goddess, now placed to our left and seated on a basket chair, is clad in conventional Palmyrene dress. She clasps a huge branch, and a basket of wool lies between her feet. An altar decorated with a bird, perhaps a crow, separates her from a standing god, naked but for a short Greek cloak (*chlamys*). The surprises lie in the dedication; for not only is it in Latin, and commissioned by foreigners – cavalry soldiers stationed at Palmyra in the second century – but the goddess turns out to be the Western Leto, accompanied by Apollo.[122]

RELIEFS WITH A SCENE OF SACRIFICE BEFORE A DEITY OR DEITIES

Throughout the scenes on the peristyle beam reliefs of the temple of Bel, divine and mortal figures are normally separated, as they are in other early reliefs. From the mid-first century AD, however, the artists began regularly to combine these figures in a series of smaller, independent reliefs, where the mortals cast incense, and often liquid also, on to a small altar or burner before chosen divinities. Dedicatory texts reveal that such reliefs were offered by individuals to deities, and both dedicants and deities concerned usually appeared in the actual scene. Pride of place, naturally, went to the gods and goddesses; dedicants were normally pushed to one side and were shrunk slightly in scale.

An early example, badly damaged, is dated in the decade AD 68–78; the inscription mentions 'Aglibôl, so he at least must have stood before the worship-

per. The motif of a single devotee before a single god, both standing, lasted for some time; another relief, dating probably from the 260s, treats us to the scene of a Palmyrene grandee, Worôd the *argapet* (magistrate), before a god virtually identical in stature and dress.[123] A considerable number of dedicants preferred to address themselves to a single rider god. The god is normally shown to our left, on horseback, although one at least is mounted on a lion. His accoutrements and weapons are indigenous or Greek dress, and the lance, circular shield, bow and quiver, and harness. A cloak may float stiffly behind him, and an eagle may hover nearby. This scene was introduced by *c.* AD 100, and continued into the third century; it was most common in the rural north-west.[124]

Alternatively, the donor might have himself portrayed beside a goddess, as did one Rab'el in the mid-third century. The relief was made 'for Allat and Raḥm', but only Allat is represented, seated frontally. Her arms and costume are those of Athena, but she has borrowed Atargatis' lions. Women rarely appear as sacrificers, although one is clearly engaged in this rite before an indistinct deity on a rural relief.[125]

For the artists, multiplication of the basic scheme was easy, although in fact, no matter how many divinities are ranged alongside them, the number of worshippers never exceeds two. The worshippers' dress is almost invariably the Greek tunic and cloak, even on rural reliefs.

The sacrificer before two deities was a comparatively popular motif, current in the second and third centuries. It took three principal forms. The first shows us the worshipper to one side (usually to our right) of two standing, frontal divinities with lance or sceptre. This theme permitted slight variations. Two gods may clasp hands, or one of them may be raised on a pedestal, like – or as – a statue. If one of the two is a goddess, she is usually Allat disguised as Athena; 39 one sun god who accompanies her raises his right hand in a gesture probably of benediction. Allat again seated between lions, is joined by another warrior goddess on a fragment.[126]

A quite extraordinary graffito from the rural north-west provides a transition 30 to the second form. Enthroned between the two porch columns of a pedimented temple front sits a bearded god, perhaps Ba'alšamin, a sphere with a cross on it balanced in his right hand. To our left rides a male figure on horseback, accompanied by an eagle, which could indicate his divinity; before him is an altar. Moqîmû, who dedicated this curious piece in August 147, is drawn to our right. The second form of motif proper is simpler. The worshipper is placed at one end, and two rider gods with normal accoutrements advance on their mounts towards him; at the same time they turn their heads to the front. In each of the two known cases the mounts are the horse and camel; one is dedi-cated to Arṣû and 'Azîzû, and dated October AD [2]13.[127]

The third kind of motif also includes two rider gods. But here the worshipper has been moved to the centre, and a rider god advances towards him from each side. A symmetrical or 'heraldic' composition is thus created. These reliefs come from the countryside. The gods are Arab, and form pairs. Their dress is local. On one, Abgal and Ašar confront a worshipper named 'Attai. Puffy hairstyles, 43 moustaches, earrings, necklets, bracelets and sandals give the gods a rustic, and somewhat Iranian, look. Behind the head of each floats a star-like rosette, and

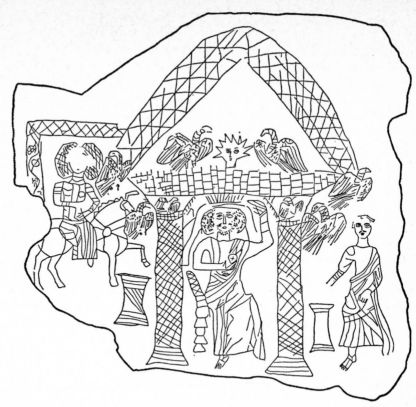

30 Graffito of god(s)
from Khirbet Abû Dûhûr,
north-west of Palmyra,
dated AD 147 (DM; ht.
52cm.; after *144*, fig. 36)

between them writhes a snake – doubtless astral symbols. Curiously Maqqai,
who dedicated this relief in October 154, is not the person shown sacrificing.
A second heraldic relief of perhaps half a century later, with the horse-riding
Ma'an and the cameleer god Ša'ar, is less crowded.[128]

Three deities together, the next logical stage, are represented by some late
reliefs. One depicts the handshake of 'Aglibôl and Malakbel; the female to our
right also looks divine. Another, now broken, was dedicated to a strange trio,
the Gad (or guardian spirit) of the Gardens, Arṣû and Raḥm, of whom only the
Gad survives. Before her stand a father, sacrificing, and his son, who raises his
hands in adoration. Carving and patterning are naïve. A third relief, from the
rural north-west and dated February AD 263, is quite remarkable. According to
the inscription it honours the god Malkâ, but no fewer than three gods, each
associated with a different animal, are portrayed before the two dedicants. To
our left a moustached figure in Persian tunic, trousers and cloak confidently
rides a griffin, which we have met as the creature of Malakbel; this god may
well be Malkâ, of whom Malak-bel is a form associated particularly with Bel.
The central god, poised with a lance and protected by a scale cuirass, stands in a
chariot drawn by fabulous winged and cheetah-like felines. The chariot is
frontal, but its wheels are splayed out sideways; the 'cheetahs' are in profile,
but with what appear to be frontal heads. The god's companion, likewise
apparently beardless and wearing a cylindrical headdress, is seated between two
rather squashed bulls and rests his feet on a footstool or pedestal. His dress is odd:

over a seemingly ankle-length tunic he wears what looks like an animal pelt, for it is 'mottled' with circles as are the felines. And in his raised hands he holds indistinct objects, probably thunderbolts. Unfortunately, the dedicants omitted to name the latter two, but the bulls, headdress and thunderbolts are strongly reminiscent of Ba'alšamin.[129]

The scheme with four deities was current by *c.* AD 100, as a relief of the triad of Bel, accompanied by Arṣû, confirms. All the gods are in military apparel, but Bel in particular is distinguished by his archaic 'strip' cuirass, sword and leggings. His acolytes sport more up-to-date moulded breastplates, lack swords and are, furthermore, bare-legged. Still greater numbers of divinities are pictured on other reliefs which, like the Bel triad, come from the countryside and desert. From Umm es-Salâbih in the Wadi el-Miyah comes a broken relief with five deities preserved, offered in June 225 by an officer. The shrunken sacrificer, however, is in the customary civilian dress. Beside him are two gods in rustic costume. The cuirassed figure beyond them, with pointed helmet, may be Arṣû; the female at his side vaguely resembles the Astarte (Ištar) of the Al Maqate' piece. To our right stands a cuirassed solar god, probably Iarḥibôl, whose presence would imply that of Bel and 'Aglibôl beyond, making a total of at least seven divinities. And precisely this number recurs on a relief commissioned by one Taimê, dedicated in November 191 to the genii (ginnayê) of the north-western village of Bet-Phaṣi'el. The six identical genii occupy the centre, crowding out the worshipper and a diademed goddess. Their long, centrally parted locks are bound by leaf crowns with a cabochon at the middle; their curling moustaches are distinctive. The sleeved tunic, cloak and fringed 'sarong', together with the round shield and lance, clothe them in a familiar rustic uniform. A last relief, dated November 152, not only originally presented eight divinities, but also placed the two great triad leaders, Bel and Ba'alšamin, once again in rare juxtaposition. Fortunately, the dedicant named them all. He himself offers incense to our left; then the parade commences with Ištar, leaning on a knobbed sceptre. 'Aglibôl and Malakbel follow, both in moulded cuirasses; Bel is similarly dressed, but distinguished by a calathos headdress and sword. The bearded Ba'alšamin is seated between bulls, one of them humped; a calathos, sceptre and ears of corn mark him out. Nemesis, at his side, draws aside her garment to spit on her chest, so averting the Evil Eye. Arṣû, now damaged, held a lance, and a large shield, as elsewhere, rested beside him; Abgal, who ended the row, is gone. The portrayal may be conventional, but the collection of deities is remarkable.[130]

There are some interesting fragments of similar stelae. A couple simply preserve the image of the worshipper, and another adds a portion of a military god. Another presents a male figure in Parthian dress, whose left hand rests on a sword hilt and whose right grasps a wreath-like object; his weapon presumably indicates divinity. Between him and a circular burner crouches a poorly carved little dog, an unusual animal attribute. Or again, a figure in Parthian trousers stands beside a goddess (?) on an oval pedestal; between them is a curious chair-like item with curved legs recalling the Roman magistrate's *sella curulis*, placed where an altar is normally represented. A most unexpected scene fills another stele: a military god poses beside a couch, on which a figure, now vanished, once reclined.[131]

LEGENDARY RELIEF

A stele set up in the temple of Bel was decorated with a most unusual relief: although now damaged, it clearly pictured the Roman she-wolf beneath the fig tree, a scene from Roman legend.[132]

RELIEFS WITH SYMBOLS OR ATTRIBUTES ALONE

As an alternative to the actual figure of a deity or worshipper, a symbol or attribute could be substituted – not a particularly common practice, but one spanning the second and third centuries. A relief of *c.* AD 200, for instance, shows an eagle standing with open wings on a curving platform, against an arching background; the particular deity whose attribute the eagle is meant to be is not specified in the inscription, but was perhaps obvious from where the monument was originally placed.[133]

Ba'alšamin received several dedications of this kind. One, offered by two brothers in January 228, presents simply a hand protruding from the sleeve of an Iranian tunic and clasping three ears of corn. The corn clearly evokes the god; the hand, however, might not be his, but mortal. Part of an inscribed and carved stele also survives, dealing with ritual matters, (hence the name, 'Sacred Law' stele) and dated 6 April 163. Between a pair of pilaster capitals is hung a garland surmounted by a winged thunderbolt. This again is characteristic of the cults of Ba'alšamin and the 'Nameless god', although no deity is actually mentioned in the fragmentary text. Ba'alšamin himself was the recipient of a little relief which pictures a lion in profile, with head turned frontally, before an altar; a certain Bonnê offered it in April 216. Perhaps the lion is intended to be an attribute of the god – but not necessarily so, for it is not unknown for one deity to be offered the image or symbol of another. [134]

The one altar shown in this last relief presumably evokes the absent worshipper and the rite of sacrifice. So its occurrence elsewhere probably carries the same significance. The flaming burner before a cavalier god on a late second-century relief from Khirbet Ramadan is a good example. And perhaps two other single altars – the one below the rider god on the weird graffito from Khirbet Abû Dûhûr, and that between Leto and Apollo on the foreign soldiers' relief – have the same meaning.[135]

The worshipper, in an attitude of reverence or prayer, could also be recalled simply by a pair of upraised hands. This was a symbolic abbreviation of the whole figure.[136]

These and similar symbols and attributes were used in the same way, as we shall see, on altars raised to the deities.

LIMESTONE ALTARS

From an early period it was the custom for limestone altars, varying greatly in size, to be offered by individuals, and occasionally by the city, to deities of their choice. The altars often carried a bowl-shaped depression sunk into the top element; this is particularly characteristic of those dedicated to the 'Nameless god'. But these depressions do not necessarily imply a function as incense

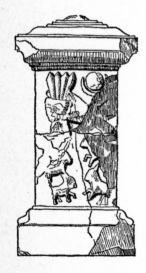

31 Altar with a relief from Gdêm, AD 187–95 (DM (?); ht. *c.* 50cm.; from *151*, 267, fig. 7)

burners, for their condition is often pristine.[137] The shape is usually square, rarely hexagonal or octagonal, and the central shaft is embellished with large and elaborate mouldings at top and bottom. Quite frequently the main face or faces of this shaft bear relief sculptures of deities, symbols, attributes or worshippers. Some of the most careful work on these altars was done in the first century; later pieces tend to be of poorer quality, particularly in the third century, with mouldings reduced to broad chamfers.

Those altars which include divine figures are usually done with care. An attractive example, a complete altar of the late first century, comes from Ba'alšamin's sanctuary. Malakbel is the subject of the principal face; he stands 48–9 frontally in a profile chariot drawn by griffins. A trousered dedicant fills the remaining space, proffering a wreath. On the side face to our left stands Ša'ar (here Ša'arû), a moustached figure in local dress supporting a lance. Allat balances him to our right. Her chair and accompanying lion are in profile, but she is twisted almost wholly frontally, to make a gesture of benediction. All three gods are in civilian costume, and labelled above. The whole is neatly executed.

A decorative octagonal piece, doubtless of the late second or third century, bears portrayals of three standing gods, including a solar figure. The less usual bust form is that selected for the triad of the 'Nameless god' on a late altar, dated 50 AD 240. The central figure, bearded and clad in a Greek cloak, contrasts with his beardless, radiate and cuirassed companions. Oddly, each bust is shown over a crescent; this may explain why the lunar 'Aglibôl lacks his usual crescent behind the shoulders. Below them poses their priestly devotee, adoring.[138]

The scene of a worshipper sacrificing to a deity recurs, but rarely.[139] Much commoner is a large, symbolic hand grasping a thunderbolt, associated at least once with leaping goats (on an altar found at Gdêm (Qdêm)); wherever a text 31 survives, this specifies the 'Nameless god'.[140] Curiously, animal and bird attributes are otherwise largely absent from extant altars, although a goat and indistinct bird are shown on altars belonging to Malakbel and Apollo respectively in other 19, 40 larger reliefs.[141] Other attributes can also accompany dedications to the 'Nameless god'; a horizontal wrist and open right hand, for instance, or an item of furniture, perhaps a symbolic bed.[142]

Worshippers may also be depicted alone. In September AD 85, two brothers offered an altar to Šamaš; their tall figures cast incense into the high flame of a burner set between them.[143] But the majority of such altars belong to a later period, the last century of Palmyrene production, and the worshippers appear in a different attitude – frontally again, but with the hands raised, palm forwards, in adoration. The worshippers may be civilians – one is set before an arch, and 50 accompanied by his son – or one or two priests; a wreath, laid on a kind of cushion, may be carved beside them.[144] Still more frequently the action of adoration is abbreviated to a pair of hands, turned palm forwards – or two pairs 51 if there are two dedicants. Both adoring worshippers and hands occur most commonly on altars made for the 'Nameless god'.[145]

Many other altars are without figured decoration, but have attractive ornament of architectural type – stepped merlons, volutes, beading, rosettes and leaves, for example. A particularly pleasing hexagonal piece, now in Damascus, with a 'bowl' at the top, unfortunately lacks both provenance and inscription.[146]

ANIMAL PLAQUES

In the early first century, stone slabs with animals in relief were made to fit into the decorative schemes of religious niches. Some two centuries later, a number of plaques were carved on which we see an animal placed within a frame of 52 beading and Greek leaf-and-dart ornament. The humped bull, seated with its head turned to the front, or a large, crouching feline – a leopard, panther or cheetah – are the usual subjects. Another plaque has a frontal lion's head inside a luxuriant wreath. No findspots are recorded, but presumably they were executed for decorative ensembles, perhaps religious ones.[147]

BIRD AND ANIMAL SCULPTURES

The eagle, bull, lion and dog, in various forms, both free-standing and in relief, helped to embellish the buildings, and not least the temples, of Palmyra and its environs.

Eagles clearly decorated several types of building. Fragments have turned up in tower-tombs and near the Tetrapylon; a particularly good head was re-used in the foundations of the Camp of Diocletian; and the remains of another eagle in basalt were found in Abgal's temple at Khirbet Semrin.[148] Bulls were similarly scattered, used as projecting *protomai* (brackets) or in ceiling coffers.[149] Lions were likewise popular for funerary, secular and religious purposes; Abgal's temple at Khirbet Semrin possessed a good head, used as a waterspout.[150] And at Marzuga a 53 running dog in bronze was found, perhaps once a utensil handle.[151]

TESSERAE

Ritual banquets and distributions of foodstuffs customarily followed certain religious sacrifices at Palmyra. Access to these had to be controlled. This was done 54 by the issue of little tokens, tesserae, to those privileged to attend. Occasionally, these tesserae were made in metal (bronze, iron or lead) or glass, but the vast majority which survive are of terracotta. Designs fill each side – pictures, words, or both together – but these, together with the shapes, vary constantly, so that no two issues are identical. Well over a thousand separate issues are now known, sometimes in more than a hundred examples. Unfortunately, few are dated; the dates all fall between AD 89 and 188. So lettering, and to a lesser extent style and content, become our chief guides to period.[152]

The designs were executed in two principal ways. Most commonly, motifs and legends were engraved on to a smooth matrix; these then appeared in relief on the tessera. Otherwise, an impression from the carved gem of a private person's signet ring would be used. The two methods could be employed separately, or in combination. The former method is the one which springs directly from, and best illuminates, Palmyrene art, for the work, reflecting local religious practices and incorporating texts in Palmyrene Aramaic script, was surely done on the spot, whereas carved gems could have been obtained from afar, although some look local.

The shapes are numerous. Square, circular, oval, diamond, triangular, polygonal forms and a 'temple-front' (or aedicula) type predominate, often with

curved indentations. Less common forms include an ivy-leaf and key. With such a variety of shapes, the appropriate one could be found to enclose a particular engraved design tightly. A particular shape might serve a special purpose; thus an 'arrow-head' embraces an Artemis-like figure with quiver and bow, an 'altar' contains a standing priest, and a 'bull's head', a bull's head.[153]

54 z)

The engravers of tessera-moulds used many individual motifs already, or soon to be, familiar from major sculpture. The divine bust is here, as is the standing deity, alone or (less often) with one or two companions. Two other tessera figure-types recur frequently among the funerary sculptures: the bust, and the full-length, reclining figure of a priest, often before a vine. Frontality is the norm. Dress, both divine and priestly, civilian and military, is almost always Greek, and the calathos headdress crops up repeatedly. Iranian and local costumes are hard to find.[154] The fluidity of divine iconography, moreover, is notable. Arṣû, for instance, can be pictured in Greco-Roman or Parthian military costume, or in flowing Bedouin robes, and as a bust, standing or on camel-back; he may also have a nimbus, and perch on a celestial sphere. Nebû oscillates between Western and oriental guises. The bearded Šadrafâ sometimes wears a cylindrical headdress and may dispense with one or both of his usual attributes, the serpent and scorpion. Attributes such as the eagle, camel, lion, bull or palm are shared between several deities.[155] As a result, divine images are remarkably interchangeable, and often cannot be securely identified unless they are labelled.

54 k)
54 l) t)

Noteworthy also is the comparative frequency with which the profile view is used both for divine and for mortal figures. The head alone may be involved, or the whole bust or figure. Deities, when seated in profile, often turn their heads towards the spectator. Two standing genii in Phrygian bonnets appear wholly in profile, as do some Victories. And so do several servants or officiants, just as in the Bel beam relief depicting a sanctuary.[156]

54 q)

19

What otherwise unknown motifs do these tesserae reveal? Most are already familiar – the figures, animals, vines, the cypress, rosettes, crescents and beading. Perhaps we may point first to a difference of emphasis, for subjects which sculptors and painters reproduced infrequently, such as the divine bust or astral symbols, are here liberally represented. Occasionally, new variants surprise us; who, for instance, is the long-eared god adored by Malakel, the deity seated on a bull, or the human-headed cock? New attributes appear – a tiller, hammer, trident, sacred ensigns of curious forms, or the divine couches of Bel and Ištar. And the paraphernalia of banquets and distributions is clarified.[157] But really significant novelties are of a totally different kind; these are scenes of everyday life. One appears to show a jeweller at work, wielding a hammer; the text mentions 'the treasury of Bel'. A second depicts the sinking of a well; a third a man kneeling. A bull leaps; and the camel is treated with an appreciative eye, seated, rising, standing, drinking. These tiny scenes merit a pause, for their genre quality is extraordinary in surviving Palmyrene art.[158]

32

54 d) e) i) v)

54 b)

54 n) o)

54 f)
54 m)

The tesserae made in engraved moulds share many stylistic traits with major sculpture, notably the use of alignment and frontality. But decorative framing is commoner on the tesserae, and the field is apt to be filled with symbols or lettering; symmetry is more prominent too.[159] Other design problems are variously solved. Where a priest reclines, any standing servant shown may be half-hidden behind the couch; but by a convenient fiction he more often joins

54 a) q)
54 n) o) s)

54 l)

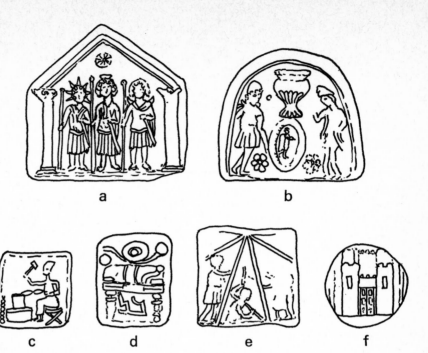

32 Selection of tesserae, nos. a) 118 b) 463 c) 36 d) 60 e) 722 f) 515 (various museums; scale *c*. 1:2; after *100*)

<div style="margin-left:2em">32 f)</div>
<div style="margin-left:2em">32 e), 54 p) q)</div>

<div style="margin-left:2em">54 bb)</div>

<div style="margin-left:2em">54 h) l) s) x)</div>

<div style="margin-left:2em">54 x)</div>

<div style="margin-left:2em">54 w)</div>

his superior on the mattress. A city wall is represented on two levels, and a derrick with its legs spread out fanwise.[160] Temple façades, profile heads and figures and vertically-placed wreaths often remind us of Greek and Roman coin designs. Most curious of all, however, is a design which assembles two altars and a cypress on the base line, and suspends above them a seated bull attacked by a scorpion, and a crescent.[161]

Impressions from carved gems set into finger-rings were freely used to authenticate the moulded tesserae. When impressed on one or both sides of the tesserae, they could form part or all of the design. Here the principal artistic language changes utterly, into that of the Romanized East. Originally Hellenistic designs abound – divinities, including the female moon, Selene, creatures, Socrates. Romulus and Remus evoke Rome, and two ancient scarabs, dynastic Egypt.[162] But at least a dozen of these intaglio designs include or consist of, a text in Palmyrene, implying that they were made on the spot. A fantastic creature (*gryllos*) of Hellenistic kind, and a figure of Nemesis, for example, have Palmyrene names attached.[163] Perhaps many others were also locally engraved, as successful imitations of eastern Roman style. The ring owners were presumably Palmyrene officials; their taste in intaglios was remarkably Western.

TERRACOTTA PLAQUES

Some twenty terracotta plaques, originating from Palmyra, are similar to the tesserae, but they are larger, and the image, imprinted from a matrix, is placed on one side only: the other face remains undecorated. One plaque bears a text dedicating it explicitly to Ba'alšamin, so it is a votive offering, as presumably the rest are, since they all represent divine images.

The artisans used the current repertoire: divine busts, male and female, radiate or with headdress; single deities and a triad, standing frontally; a cameleer god, mounted; a seated goddess, with a lion. A female sphinx, however, surprises us; she squats sideways, but turns her head to the front, displaying her necklace and earrings. And the plaque dedicated to Ba'alšamin bears a bust not of the Lord himself but of his acolyte 'Aglibôl. Most striking of all, however, is a terracotta mould for making plaques. A Parthian god confronts us, complete with flared tunic, bulging trousers and puffed-out coiffure. He is not a local god, but must be of Mesopotamian origin, like the mould.[164]

Similar plaques – cheap demonstrations of piety – are found all over the Roman and western Parthian worlds.

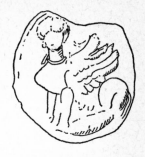

33 Terracotta plaque with a sphinx in relief (DM; diam. 8·4cm.; after *164*, pl. II)

STUCCO WALL DECORATION

The northern court of the sanctuary of Ba'alšamin yielded hundreds of fragments of an enormous composition in stucco which had once covered the walls behind the porticos there. A considerable range of motifs was employed, many of them, such as the Gorgoneion, drawn from Greek and Roman sources. Some curious fragments of Westernized plaster figures, found in a private house, were perhaps intended for another composition. But the decoration itself is of a kind dear to Palmyra's eastern neighbours, the Parthians, who used it to variegate building façades with designs of great intricacy. One wonders how much more of such work at Palmyra is now totally lost.[165]

3
Funerary sculpture

Graves and tombs

Confused notions of an afterlife have haunted the peoples of many cultures, and the ancient Semites were no exception. Throughout the first millennium B C, in Semitic Syria and Palestine, these notions tended to be expressed in funerary monuments of a peculiar and dual character. The corpse was laid in a grave or tomb. But in association with (usually above) the burial itself a special stone, plaque, relief or even whole monument would be erected, often marked with the name of the deceased. This was the *nefeš* or *nafšâ* (spelt *npš* in Aramaic), essential to survival. The word can signify 'personality' or 'soul', and this object, of whatever form or substance, was variously regarded as the residence of the deceased person's soul after death, or at least as his or her memorial, so that the name might be remembered by the living. The arrival of Hellenistic Greek culture Westernized monumental forms, but not Semitic conceptions. The Palmyrenes shared these Semitic beliefs with the rest of Syria, but while sharing them created remarkably individual types of tomb and nefeš.[166]

2, 5 The manner and location of burials at Palmyra varied according to period and purse. But burial customarily took place outside the quarters of habitation. Doubtless Palmyra always knew the simple inhumation, identified by a pile of stones above as the nefeš – one such desert burial is dated A D 160.[167] But already in the second and first centuries B C, the earliest period of which anything definite is known, more complex forms were evolving. The simplest of these was the

5 grave. An entire cemetery lies beneath the modern village; when found, the dead were laid in tapering, rounded 'slipper' sarcophagi of terracotta or plaster, with glass bowls and cheap jewellery for the afterlife. Over almost every burial

67 was raised a little gravestone, rectangular but often rounded at the top, and normally inscribed. The lettering, and a dated example of A D 140/1, show that the cemetery was in use by the end of the first century B C, flourished in the next and had declined by the mid-second century A D. [168]

Immured and unviolated in a corner of Baʿalšamin's precinct where, over-taken by urban expansion, it had been piously preserved, stood a more organized sepulchre, a *hypogeum*, now severely ruined, sunk half into the ground. An arched doorway in stone led into a corridor (*dromos*) vaulted and roofed in brick, which

51 linked nine burial compartments and five graves. Lamps, pottery, alabaster vases, jewellery and Hellenistic coins accompanied the corpses; much had been imported from Mesopotamia and coastal Syria. The sepulchre was in full use from

c. 150 B C until its probable closure in A D 11; a graffito of A D 57/8 (?) probably refers to a brief reopening. The tomb was surely not unique.[169]

A third variety of funerary monument – the soaring, rectangular tower of stone, introduced in the last century B C – dramatizes the oasis skyline. The earliest to bear a date is 'Atenatan's, of 9 B C; but others look older. They line the ancient, western track to Homs through the Valley of the Tombs. Tomb 52, of rough construction, has some twenty burial recesses sunk into the base exterior, but the upper part is solid and probably constituted a nefeš. In the next stage of development, a staircase penetrated this central mass, with occasional burials off it. By 'Atenatan's time this staircase ran up the tower inside the outer walls; narrow, inward-leaning chambers, almost triangular in section, were super-imposed inside, with some burial compartments sunk into their walls. Several compartments included a special funerary chamber; the foundation text occupied the entrance lintel. Henceforth, all burials were made inside, in tall, narrow slots (*loculi*) running from each chamber floor often to the ceiling. Normally, each loculus was subdivided internally for the corpses by shelves of limestone or terracotta. When filled, each compartment was plastered over, walled up or sealed with a terracotta plaque, and then inscribed.[170]

Soon afterwards, an underground burial complex or hypogeum might be attached to the tower. Steps led down from the tower vestibule to its doorway; inside, a corridor was flanked symmetrically by galleries. Burial loculi, as usual, were placed at right angles to the walls.[171]

In the period *c.* A D 1–50 towers were put up along other tracks, to the north and south-west. Their capacity was expanded; and founders such as Kitôt (A D 40) sometimes added a decorative, carved niche high on one sober façade.[172] But masonry was still irregular, chamber walls leaned inwards and staircases con-sumed space.

55–6

2, 5

34

2

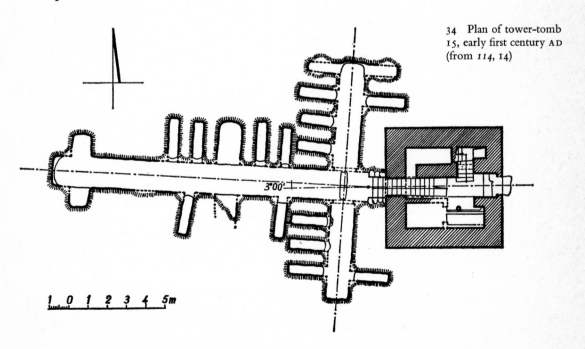

34 Plan of tower-tomb 15, early first century A D (from *114*, 14)

By AD 79, with tower 63, these problems had been surmounted. The neat staircase occupied the width of two loculus slots. The masonry was regular, chambers uniform in plan, and chamber walls now vertical. Each burial slot might be sealed by an almost square plaque of limestone, carved usually with a bust in relief, and labelled. Hypogea, where attached, were small. And rich architectural ornamentation of entrances, walls and ceilings in stone and plaster rapidly supplanted the earlier, tentative moulding of doorways and cornices.

2, 5 Already by AD 83 a certain Iamlikû had built one of the best designed and most finely ornamented towers. High on the façade a handsomely decorated niche encloses the founder's relief sculpture and text. Below, a pedimented portal leads into the astonishing ground floor chamber. Tall, rectangular loculi disappear into the walls; each shelf opening, neatly squared and moulded in limestone, awaits its sealing plaque. Corinthian pilasters

113 'support' a fine cornice; and crowning the whole is the deeply coffered ceiling, with coloured reliefs in plaster. Above, the first-floor ceiling has geometrical motifs, and the second-floor ceiling a fine cornice. Two decades later Elahbel and

2, 5 his three brothers answered Iamlikû with Palmyra's largest tower. Again the

56, 57 Corinthian order dominates the interior, but with additional sculpture and two Ionic pilasters to outdo its rival; on the ceiling, rosettes and busts in plaster are gaily painted.[173] But the great days of tower building were already passing; the last definitely dated belongs to AD 128.[174] Although most remained in use, other building forms were taking over.

The first of these was the independent hypogeum, existing by itself apart from the tower, and cut into the soft limestone around Palmyra. The earliest known is dated AD 81/2; a great number belong to the following seven decades, but the spate was reduced to a trickle thereafter.[175] A few (rock tombs) are cut straight into hillsides, but most are sunk deep into more level ground, and approached down a flight of stone steps. They appear in every necropolis, but are commonest in those to the south-west and south-east. They are carefully arranged so as to avoid colliding with, or undermining, the towers. Hard limestone and mouldings make door and doorway a focal point. Texts above commemorate the foundation

Cf. 34 and subsequent transactions. Within, a corridor forms the axis, and galleries and chambers may be disposed symmetrically each side of it. Generally the plan includes galleries, and resembles an inverted T. Loculi are sunk into the walls, sealed with plaster, terracotta or sculpted limestone. Often these tombs were not completed immediately, but were extended as needed. Thus a chamber or *exedra* of especially rich ornamentation could be added, with decoration in limestone, plaster, paint or a combination. The chamber might contain a sarcophagus, or a

Cf. 60, 102 group of three sarcophagi disposed around the three walls to form a 'dining room' arrangement or *triclinium*. Or again, as texts reveal, the owner might decorate it

115 solely to attract buyers for any surplus loculi; for, from the mid-second century, such sale and re-sale of funerary slots became common. This perhaps explains why the simple cemetery was apparently abandoned, as even the poor found themselves able to purchase an eternal dwelling inside someone else's tomb.[176]

58, 35 Last came the essentially ground-level and box-like but luxurious 'funerary temple', usually of one storey. An interior colonnade or peristyle might be included; if so, the centre was sometimes open to the sky. Inside, the burials were made either in loculi or in sarcophagi placed on stone benches round the walls.

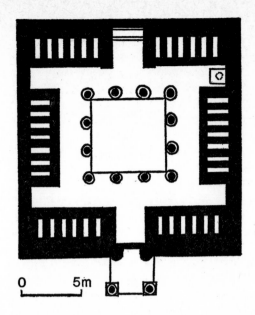

35 Plan of 'funerary
temple' 'de l'Aviation',
c. AD 140–260 (from
66, fig. 7)

The sober exteriors, sometimes enlivened by a portico, concealed lavish architectural decoration within. Dated examples range from AD 143 to 253. Most seem to have been reserved for single families. [177]

Where did these ideas originate? The early coffin inhumations and brick tombs show close Mesopotamian connections. The funerary tower is more puzzling. It has cousins on the middle Euphrates, notably around Edessa and at Dura-Europos. One line of ancestry can perhaps be traced back through tall, elongated western Syrian intermediaries to the famous Mausoleum of Halicarnassus. It also evokes the Zoroastrian funerary 'towers of silence' of nearby Iran; but there may be no connection, as forms and purposes differed. Were the Palmyrene towers, like the Syrian, crowned by pyramids? Not one has survived to its full height, but the quantities of rubble remaining around the best preserved ones seem insufficient for such a sizeable addition. The hypogeum with galleries has links with coastal Syria and Egypt, but shows adaptation. Closest to tombs elsewhere are the 'funerary temples', with imperial Roman parallels. [178] But the Palmyrene builders were never slavish imitators, and seem to have been capable of considerable originality.

Most of the tombs, once built or undertaken, were apparently maintained at least until AD 273. Rather fewer, however, seem to have remained in use beyond that date. [179]

Funerary beliefs and customs

What beliefs inspired such efforts? Buildings, sculptures, inscriptions and other discoveries provide clues. That the Palmyrenes believed in an afterlife is shown, first of all, by their careful treatment of the human corpse, often mummified or preserved. Unfortunately, few have survived natural destruction or Arabs in search of 'healing substances'. A true Palmyrene mummy now in Copenhagen 59

was wrapped in bands of linen soaked in a bituminous substance. This and other fragmentary remains show that the corpse itself was bound in strips of used linen steeped in a mixture including myrrh and water. This formed a hard protective cover, over which sections of fine cloth, even silks, were wound. Neither process much resembles Egyptian practice.[180]

A great variety of small objects, a further indication of Palmyrene belief in an afterlife, was frequently placed with the dead in every kind of tomb: glassware, lamps, jewellery, pottery, coins, trinkets, toys, even a pipe.[181] Concern for the dead may also have prompted the early transposition of burials from tower exteriors to the inside.

Inscriptions add further clues. Several early, free-standing gravestones of *c.* AD 50–100 have an engraved text connecting the afterlife with sun worship. In Aramaic inscriptions a tomb is often described as *bt 'lm'*, 'house of eternity', and the founder builds for his descendants 'for ever'. The word 'nefeš' occurs at Palmyra in two main funerary contexts: it may denote an entire tomb as a 'monument';[182] or, accompanying a person's name or image, it probably signifies 'soul' or 'personality', and indicates that what it describes is that person's eternal dwelling-place. Admittedly, its occurrences in the latter sense are rare. But the belief may have been so widespread as to need no restatement.[183]

What forms did the personal nefeš take at Palmyra? Between the simple, smooth stone, and the huge, extravagant tower lay a range of carved and painted monuments. Over outdoor graves a little stele was customarily raised, sometimes 67 carved with a full-length human figure. Inside the tomb a labelled compartment sealed with plaster (sometimes painted), terracotta or brick was often enough. 61–95 But from *c.* AD 50 wealthier patrons preferred a limestone plaque sculptured on its front face, usually showing a human bust in relief.[184] Other patrons preferred 112 a funerary statue. Every form of nefeš was scrupulously labelled to distinguish eternal dwelling-places and avoid confusion in this world and the next. The system was widely respected, and cases of the usurpation of one person's nefeš by another are rare.[185]

Some of these carved and painted funerary figures and reliefs look remarkably lifelike, and they have often been considered portraits of the deceased. A more sophisticated view sees their early significance as nefeš gradually giving way to the new function as portraits. Nor would the two functions necessarily be incompatible. In favour of the interpretation as portraiture the not infrequent occurrence of the word *ṣlm'* ('image, representation [of]') as prefatory to the name of the person shown has been quoted.[186] But the funerary sculptures themselves demonstrate that *ṣlm'* is used as 'image' only in the most general sense. For, taken as a whole, the sculptured and painted features are remarkably undifferentiated, exhibit a notable regularity and stylization, and are usually without the modelling and characteristics that distinguish young from old, male from 61, 62 female. And the matter is clinched by the limestone funerary reliefs. There are depictions of different persons, whose features are identical; there exist pairs of 63, 64 representations of the same person with entirely different features; and a priest who died at 76 looks half that age.[187] The conclusion seems inevitable: these busts, these figures, are *not* portraits. The sealing blocks of plaster, terracotta or stone must be dwelling-places, as inscriptions indicate, and any figures on them are merely symbolic approximations to the actual appearance of the deceased.

A little male bust, with or without a priestly cap, is commonly included as a central emblem on a Palmyrene priest's headgear. This might be a miniature image of one of the wearer's forebears, indicating an ancestral cult.[188] 66

Of rites in the tomb, traces remain. Comparatively easy access to the chamber was maintained. Inside, pottery lamps diminished the gloom. Offerings were made to the dead: little altars for burning incense, both movable and fixed, and bowls of cinders have come to light, sometimes placed directly before a sarcophagus. Old Semitic mourning rites lived on; relief sculptures depict women, their hair dishevelled, arms and torsos bared and breasts and shoulders scarred, 65 consoling the dead with food and a comforting hand. Time and again, moreover, a funerary banquet is represented, at which dead and living participate. Wells, 61, 62, 98, 102–7 vessels and special chambers also hint at meals taken in the presence of, or in honour of, the departed.[189]

Types of funerary sculpture

The Palmyrenes developed three main types of funerary sculpture: the plaque with relief carving, the sarcophagus and the funerary statue. Of these, the carved plaque was by far the most popular, and most protean. At first we find it as a humble, free-standing gravestone. Then, carrying a banquet scene, it was set high in tower façades, or occasionally within the tomb. Finally, and probably between AD 33 and 65/6, the carved plaque began a serious invasion of the tomb interior, where it was normally used as an expensive kind of sealing and nefeš for burial compartments. On its front face a figure in bust form appears most frequently, a full-length figure or banquet scene less often, and anything else rarely. Why did the carved plaque come into use at this time? Its introduction corresponds remarkably well with the appearance of the new, rationalized tower-tomb between AD 40 and 79. This was the first kind of tomb in which the older, inward-leaning chamber walls were superseded by strictly vertical construction. It was now possible to set heavy stone sealing plaques in the walls.

Sarcophagi, to judge by traces, had been placed in tombs, and sometimes in special chambers, since before the turn of our era; but these early examples were normally made of plaster. Not until the mid-second century, apparently, did the Palmyrenes produce the stone sarcophagus with carving on lid and base. This, as a costly item, was often placed in a particular recess, exedra or chamber built for the purpose. Three (or five) might be housed together and so placed that, with banqueters carved on their lids, they evoked the triclinium arrangement of the Greek or Roman dining room.

The funerary statue, never popular, seems to have led a precarious existence during the first two centuries AD. Some, at least, stood on wall brackets.

How did the Palmyrenes treat these sculptural forms?

THE FREE-STANDING STELE

Perhaps the first type of funerary sculpture to be developed was the small, free-standing gravestone with relief. Many of these stelae came to light in a cemetery immediately north-east of the city. They are rectangular, normally with a curved top and a shaft to sink into the ground. They fall into three groups. Each is carved

properly on the front face only, and a raised 'frame' or listel commonly surrounds the relief field. The first group, which began at an early date and lasted at least until AD 140/1 when the cemetery was apparently losing popularity, has grave-stones with nothing but a text giving the deceased's name and ancestry. The second group has symbols in relief, as well as a text; scripts span the first century AD. In low relief a curtain is visible, hung across the field by two circular pins; beside and over this arches a pair of palm fronds which meet at the top, immediately above any inscription. A double-stele may include two such representations side by side. And on some early examples, just below the inward-bending palms, a row of mysterious, circular symbols may be added. [190]

Finally, some time before *c.* AD 50, the third group was created by the intro-duction of the human figure. Relief remains low. Two early pieces show a standing man placed *behind* the hanging curtain, which cuts him off at chest height. But normally the entire, full-length human figure stands frontally in the foreground, with curtain and palms behind. The formulae for these representa-tions of men and women changed little, although at first their frontality was uncompromising, with even the feet pointing forward and ears protruding sideways. After the mid-century, attitudes became more relaxed, and feet were gently angled. Men seem always to wear the Greek tunic (*chiton*) and cloak (*himation*), as do women, except that they drape the cloak in a complex manner and add a veil. Drapery is highly patterned, and hems are 'stiffened' each side of women's ankles. Embroidery and jewellery add diversity.[191]

To be sure that we are dealing with tombstones that were intended to stand free, we should include here only those with the shaft attached to hold the stones steady in the ground. But soon after the mid-first century AD stelae began to lose this shaft, becoming completely rectangular. Although the figures in the relief field were still those of the canon for free-standing gravestones, it seems likely that the stones had been adapted for use as sealing plaques-cum-nefeš inside the family tombs that were now proliferating around the city. So the further history of this kind of stele must await our entry into the tomb.[192]

TOMB FOUNDATION RELIEFS

The tower-builders seem to have been slow to apply sculpture to their monu-ments. Outside, they began by commemorating the building of a tomb with a simple inscription, and then with a niche containing figures and text added to one façade. Kitôt's tower in the Valley of the Tombs, dated June AD 40, has an early, typical niche, untypically still in place. The proportions, tall and rectangular with curving top, recall the early gravestones. Around the curve winds a vine *rinceau* (scroll). Within this field the artist has crammed the priestly builder himself, who reclines awkwardly on a thick mattress, and his wife and two sons, who stand behind him, clearly, if illogically, on the same mattress. Supporting the mattress is a couch, and between its turned legs the inscription is placed. Behind the figures climbs a delicate painted vine; and the sculptures are finished with colouring. The two youths wear priestly hats; their ladle and vessels, and Kitôt's reclining posture, indicate a ritual banquet scene.[193]

'Ogeilû's tower-relief, dated April 73, is more skilfully handled. The arched design has been widened, and accommodates the reclining founder better.

36 Early gravestone with symbolic reliefs (PM; ht. 42cm.; after *154*, pl. 33.2)

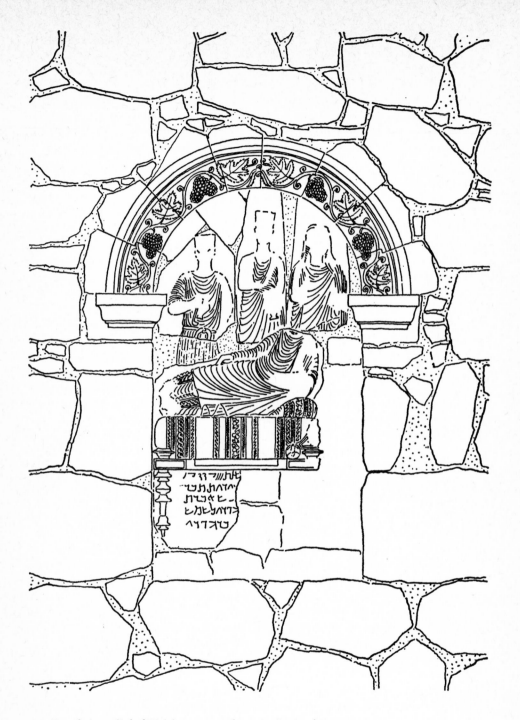

37 Foundation relief of Kitôt's tower-tomb, AD 40 (*in situ*; ht. 2·80m.; from *200*, fig. 1)

Iamlikû, whose foundation sculpture has vanished, might have had a rectangular niche scene. The projecting mouldings which supported the niche below and above are upheld by Victories and bearded heads respectively, as consoles. But with Elahbel (AD 103) we are back with the arching top; the couch survives, with five rosettes carved between the legs. An early second-century block, now detached from its original context, with a similarly curving top, shows an anonymous priest and family grouped at the banquet. Perhaps of similar date are the two fragments of another relief of this shape, with three priests standing before a vine. Such niche sculptures are few; possibly the expense and difficulty of seeing a relief so placed accounts for this. [194]

Hypogeum builders occasionally commissioned plaques for the same purpose, to be placed inside the tomb. Iarhai ordered one in 108 for his southern exedra, showing ordinary little male busts set each side of a central text. Zabdâ, who built his hypogeum some forty years later, selected the 'banquet' pose for his own 'representation'. In his flowing Greek robes he is a figure of some elegance. The majority of hypogeum founders, however, were content with a factual text above the outer doorway.[195]

TOMB STELAE WITH FULL-LENGTH FIGURES

When limestone relief plaques began to invade tomb interiors around AD 50, it was natural for the sculptors to take over for this purpose the pre-existing type of free-standing funerary stele with the full-length figure. Its shape, however, with rounded top was ill-suited to close the end of a rectangular compartment; and so, between c. AD 50 and 100, adaptation began. The shaft for sinking into the ground, although occasionally still found attached to stelae inside tombs, generally soon disappeared. The curved top survived for a while, sometimes with its 'frame', sometimes without.[196] Artists began, however, to square off the top of the relief, so that it became fully rectangular within its 'frame'.[197] Stylistically, these stelae developed along the same lines as other art forms. Depth of relief increased, and drapery folds grew fewer and broader, although patterning persisted strongly. Some motifs altered; the curtain and palms ceased to be shown alone, and their appearances even in the background became rarer. Men and women dressed and posed much as before; but while one foot remained frontal, the other was increasingly turned to one side. Representations of children appeared: here again, the early types became canonical. In fact, the small stele was henceforward normally selected for a dead child: adults already preferred the funerary relief bust. Boys sported a loose-fitting, calf-length tunic bound at the waist. The right hand at the side often held grapes, and the left might clutch a bird across the chest.[198] Girls were almost indistinguishable, except that the tunic was ankle-length and possibly ungirdled. The artists might now combine two figures who link hands, as do a mother and daughter from Ta'ai's hypogeum.[199]

But not all the stelae of the mid- and late first century AD were so conventional. Occasionally, reliefs on a rather larger scale were produced. One of these, datable from its inscriptions to between AD 33 and 83, was found near the tower-tomb of Ḥairan (no.67), and doubtless belonged to it. Three figures appear; the central one is a woman, who lays a consoling hand on the shoulder of the youth on our left, and is accompanied by a standing man.[200] Among other reliefs of small

scale, one seems to depict a warrior in armour, and another, now fragmentary, represents an archer, Taimarṣû, on horseback.[201]

The period *c.* AD 100–50 includes some dated pieces. The relief was now normally rectangular; the raised 'frame' became rarer, and was more commonly reduced, sketched in or omitted. The projecting base of the 'frame' was preserved, however, to provide a support for the figures. The depth of relief might vary from moderate (AD 114) to considerable (AD 130). Earlier poses continued in use. Two, three or even four figures might be combined.[202] A new, seated position was introduced for women and girls, and a different costume for boys – the Parthian, belted knee-length tunic and trousers.[203] Men occasionally wore a similar costume, and one had put over this a curious coat.[204] Girls became more readily distinguishable from boys – they had different hairstyles, and displayed more jewellery. If two children were shown together, they often had joined hands, holding a central bunch of grapes.[205]

<div style="text-align: right">73, 74</div>

<div style="text-align: right">Cf. 72</div>

<div style="text-align: right">73</div>

<div style="text-align: right">*38*</div>

<div style="text-align: right">73</div>

Between AD 150 and 200 these plaques declined in popularity, but development continued. Men sometimes wore the priest's distinctive headgear. The seated pose continued in use for women. 'Framing' and the curving top were extremely rare. Relief was deep, and stance and rendering more naturalistic.[206] Children might be shown in a pose new for them, with the chin resting on the right hand. If they wore Greek costume, they might be entirely wrapped in a himation; their Parthian style of tunic and trousers kept pace with fashions further east.[207] The stele without figures reappeared in the second century: one man's name was encircled by a wreath within a 'frame'.[208]

<div style="text-align: right">71</div>

Third-century stelae are scarce. A couple represent boys in Iranian costume. Another shows a standing man in Greek costume, now headless, separated by a central pilaster (which supports a priest's hat) from a younger man in a tunic. A large lock of hair falls to the latter's right shoulder; he carries a couple of document holders, and so is presumably a servant or slave (Plate 75).[209]

RELIEF BUSTS

The relief bust arrived on the funerary scene apparently in the mid-first century AD. The earliest known example – with a woman's head (Plate 76) – is dated 376 (AD 65/6), and the relief bust rapidly ousted the stele with full-length figures as a preferred resting-place for adults.[210] Why? The stele had been designed originally as a free-standing grave-marker, and tended to be tall; when decoration was desired a small-scale human figure, it was found, could fit into such a shape admirably. But a tall rectangle (especially one with a rounded top) was not well suited to close off a virtually square burial compartment when sealing-plaques came to be required inside the tombs. Nor could this rectangle conveniently be made squarer without marooning the figure in a sea of space, or multiplying the number of figures. So a new form was needed: the answer was found in the relief bust. It fitted well into a square field, and the loss of the lower portion of the body was compensated for by the great increase in scale of the more important upper part, thus providing more opportunity for detail and decoration.

The canon was based on a rigidly frontal relief figure in bust form, sliced off at the midriff. The forearms are held across the chest, and often some article is

38 Funerary relief of Apollonios, *c.* AD 100–50 (PM; ht. *c.* 45cm.; after *155*, 22, fig. 13)

grasped in one or both hands. The figures customarily wear the tunic and cloak, in one of several standard arrangements. The name and genealogy of the deceased is added above one or both shoulders, often just engraved, or engraved with red colouring in the letters to pick them out, or else simply painted. Aramaic is the language chiefly used; Greek is rare, and often merely supplementary. Sometimes the number of busts on a block was increased, though seldom by more than one, for instance, to depict a man and wife or two brothers. Children rarely appear in bust form. More often, if they are shown on these reliefs at all, they are represented either at full length and in miniature above and behind the shoulders of their parent or parents, or else on their mother's arm. A 'curtain' is commonly included, 'pinned' behind the deceased.

144
65, 76, 94
78
83
86
65, 93, 94, 96

The sculptors remained remarkably faithful to the models established early on, and their range of motifs stayed narrow. Completely different workshops of sculptors often reproduced the same types of bust, even in considerable detail. Conversely one workshop, or an individual sculptor, would possess a certain freedom of choice within the accepted range of motifs. It is clear from the groups of relief busts found in certain family tombs that each workshop tended to offer a particular range of relief bust types; thus ateliers which imitated Western styles, for example, modelled their subjects in high relief and reproduced specially Roman motifs. And just like the workshops, the individual sculptor was sometimes content with repetition, and sometimes he preferred variation within the canon.[211]

80

So much for the norm. Almost the full range of poses and attributes for men is present already in group I (c. AD 50–150).[212] Most of the male figures wear an ordinary tunic, sometimes long-sleeved, under an enveloping cloak. A bunch of folds often falls vertically from the right shoulder to the wrist and then passes up diagonally to the left shoulder, like a sling. Other figures have the smaller cloak, the chlamys with embroidered edgings, pinned on the right shoulder with a brooch. The wearers are usually priests, recognizable by their cylindrical cap or modius. The sculptors made great play with the decorative possibilities of the drapery. Out of the folds they devised pleasing, if unnatural, patterns; they were particularly fond of adding little patches of semicircular folds, and delighted in ornamental edging and embroidery. Later, naturalism developed. Hairstyles show a similar love of linearity, with separate locks done as groups of striations or as 'snail' curls. The old unrealistic protrusion of the ears persisted. As had been common practice since the early first century AD, the pupil and iris of the eye were rendered as engraved concentric circles, and the eye as a whole was over-large. The chisel-cut features of the deceased seem ageless; from their great eyes, gazing fixedly into the unknown, shines out an unworldly, even fanatical, spirituality.

70, 76
66

The earthly occupations of some are reflected in the objects they hold, usually in the left hand. Those with nothing, a 'book-roll' (schedula, volumen) or a leaf alone, reveal little. But others clasp the hilt of a sword, and sometimes also a whip in the right hand – surely, they are men of the desert. Priests proclaim their calling not only by their cap, but also by holding ritual vessels, a jug (alabastron) and a bowl heaped with pearl-like grains.[213]

76

With group II (c. AD 150–200) came a striking change of artistic direction. New motifs appeared – notably, the beard, whose locks were usually arranged

65, 79

with care and symmetry. The hair often became thicker and longer; the sculptors loved exploiting its possibilities, and the newer styles even allowed a slightly receding hairline. Wrinkles or furrows across the brow and 'plastically' indicated eyebrows added further realism. Some youths, furthermore, had distinctive 80 child and slave locks. Many, however, including the priests, remained steadfastly beardless and short-cropped. The eye changed; sculptors tended to shape it more realistically and to indicate tear-ducts. Within the eye, the gaze might turn upwards, and the iris and pupil might be shown as an engraved circle and single drill-hole respectively, or else omitted. The features were more naturally integrated into the face. The head was sometimes turned well to one side, so that 79 the person no longer looked directly to the front. The sculptors played with drapery, varying old themes and inventing new ones; occasionally the cloak was discarded altogether. The objects the figures held continued to be mostly the schedula, leaf, sword-hilt and ritual vessels. But behind certain desert-dwellers 65, 145 now lay the profiles of their horses or camels. Other figures, in whose right hand we see the *stylus* for writing on wax tablets, or who were accompanied by writing equipment, were obviously scribes – one is specifically described as a military 80 administrator (*beneficiarius*). On their tunics both priests and laity sometimes proudly displayed a stripe – in fact, they deliberately dropped the cloak from the 79 right shoulder to show it. A wreath was also worn now and again. Stylistically, patterning retreated somewhat before the forces of realism. The patches of semi-circular drapery folds had all but vanished. The ruthless schematization of the features tended to be softened by hesitant modelling; drapery folds became broader and looser. But the underlying approach had not changed.[214]

Group III (*c.* AD 200–73) reflects mixed attitudes and intentions. Few subjects except the priests still resisted the beard. A new way of rendering it crept in beside the old: the beard surface was raised from the surrounding face, and the 81 locks were marked by gashes or striations in the stone. The hair might be short or abundant, as the wearer chose, and the two basic types of lock formation, the straight or slightly curved and the 'snail', both survived. Touches of realistic 'balding' at the temples and wrinkled brows continued to occur. The eye was shown as before, except that the lower lid was occasionally omitted. The plastic rendering of eyebrows, however, became scarce; a curved groove sufficed, as in group I. And among the cloak arrangements, a retrenchment appears to have taken place from the range and vitality of second-century experimentation: hardly more than four modes were in common use. Again, in the left hand hardly a bust holds anything except the 'book-roll', or else a looped fold of the himation 81 (an innovation), although scribes are still occasionally seen. Priestly busts were 82 also simplified. The tunic stripe and wreath continued in general use, and sometimes a striking diadem was worn. An underlying patterning of drapery per- 81 sisted, but it suffered from increased realism and a tendency to poor workmanship. Imagination and quality were declining.[215]

The female relief busts set before us a gallery of fashionable Palmyrene women. An austerity of dress and ornament permeates group I (*c.* AD 50–150). The 63, 64, 76, 82 tunic, cloak and veil are all visible. Very many opt for the basic pose, with veil folds falling vertically from the shoulders and forearms resting horizontally 76 against the chest. A sizeable minority varies this by raising the right arm, either 63

turning it palm forwards or clutching the veil at shoulder height. Drapery folds
are often not far from the rigidly vertical; they tend to be almost parallel, and
symmetrically disposed. Then, in the first half of the second century, the sculptors
experimented with groups of semicircular folds, as on the male busts. Jewellery
for most consists of just a brooch, earrings, and later finger-rings also. The brooch
is almost always of one type: trapezoidal, and surmounted by an animal head or
rosette. For ear decoration to begin with the sculptors preferred an extraordinary
series of 'hooks', sunk in all around the outer edge and worn alone, or combined
with more conventional earrings. This fashion had passed by the early second
century. Other early earrings, circular, crescent- and bell-shaped, also largely
vanished. Two basic types survived, one, a tiny bunch of grapes, and the other, a
horizontal bar with two or three little pendants. On to each shoulder tumbles a
prominent lock of hair. Most of the women carry in their left hand a spindle and
distaff symbolizing their domestic tasks, like the little child or the keys that are
sometimes shown. On the head they customarily wear two items beneath the
veil: a stiff band or 'diadem' immediately over the forehead, and then above this
a turban. The diadem progresses gradually from plain to striped and then to
decorated kinds with floral and geometric motifs set into neat rectangles divided
one from another by beading. Sometimes, however, the veil rests directly on the
hair; occasionally, the diadem alone is abandoned. Bare-headedness itself is rare
indeed. Where the full headdress is not worn, a delicately coquettish little lock or
two may appear on the forehead. A few women are shown in a totally different
guise, with no tunic at all, and breast ritually gashed; they are in mourning.
These women were seldom depicted, but their representations lasted throughout
all three groups. Towards AD 150, several of the female busts began to blossom
with ornament – bracelets, forearm clasps, row upon row of necklaces, pendants
to cabochons and the left shoulder brooch, chains of ornaments attached to the
headdress and embroidery running riot over the tunic.[216]

Group II (c. AD 150–200) saw a burst of inventiveness. Ideas hitherto unusual
were picked up and developed. For poses, sculptors made particular play with
the right arm which was raised for the hand to hold the veil at shoulder height.
Soon the right hand moved up from shoulder to neck level to increase the effect.
A few sculptors preferred to reverse this, with the left hand at neck height. Other,
and still rarer, earlier experiments were also selected for greater dramatization.
Where the veil was slung across the chest the subject was now often made to
raise her right hand to hold the veil near the centre, below the neck. Where the
right hand crossed the chest to pull the veil from the left, increased naturalism
and deeper carving created a really dramatic crossplay between flesh forms and
drapery, light surfaces and shadow. A similar effect was produced where the
right hand rested against the cheek, sometimes with a finger elegantly extended,
and where the right hand held the two sides of the veil together over the centre
of the chest. These effects were heightened by the widespread abandonment of
the old long-sleeved tunic in favour of a 'short'- or false-sleeved variety, thus
exposing the flesh of the forearm. Like the face and neck, the forearm provided a
smooth surface to contrast with the complicated interplay of fold-patterns and
ornament. Deep undercutting might bring a hand, even a forearm, free from the
figure – daring in such friable stone, and possible only as a result of improved
technique, especially in the use of the drill. The drill could hollow out deep areas

between veil and head, and help to free earrings and limbs; it could part lips, and 86
provide pupils, nostrils, even tear-ducts.

Many of the older fashions now faded away. The old trapezoidal brooch
had to compete with polygonal and circular kinds. Almost the whole gamut of
earlier earrings was replaced by a simple pair of pearls or beads, united by a bar
and worn vertically – a kind of miniature 'dumbbell' on end. Some women even
discarded earrings altogether. A modest multiplication of necklaces, pendants
and headdress ornaments was not uncommon, but a really lavish display, includ-
ing bracelets, was for a minority only. A curious new hairstyle came in, shaped 88
like half a melon with a flat bun on top. But it was not widespread, and the vast
majority kept to a simpler style with central parting, as before. The old shoulder
locks gradually diminished to one on the right shoulder only, and then vanished
altogether. But the coquetry of little forehead and cheek locks continued. The 87
spindle and distaff were seen in the left hand less and less until they disappeared;
and both the child supported by the left hand and the depiction of the household 86
keys remained uncommon. These were, after all, reminders of domestic drudgery,
perhaps not consonant with an age of increasing luxury. Instead, the hands
contributed to the new modes of drapery arrangement, grasping here, pulling
there, and altogether creating a degree of movement never seen hitherto.[217]

In group III of the third century AD domesticity declined further. A little child
still occasionally nestled in the bent left arm; but the spindle and distaff, and the
pendant keys, had vanished. Instead, the artists concentrated almost exclusively
on the permutations of arm and drapery arrangements. Once again they built
on the achievements of the previous group, but this time the theme was not so
much development as reversal. For now women most commonly raised their 89
left hand to take the veil at neck height; or they rested the hand, with one or more
fingers outstretched, on the left cheek. The right hand, normally occupied with
the veil, was then laid across the chest. Even the less usual group II poses are
apparently seen in reverse (unless wrongly assigned), especially the one where the
hand catches the veil centrally below the neck, and the one where the hand holds
the two sides of the veil together over the middle of the chest. The main modes of
group II lingered on – indeed, the two latest of the dated busts of women
(AD 240/1 and 241/2) each exemplifies one of them.

Technical skill continued at a high level, but the mason's drill was increasingly
eschewed and sculptors tended to hasten. Women of this group often omitted
the stiff diadem above the forehead, so emphasizing the predominance of the
hairstyle with the central parting. One woman, most unusually, is bare-headed, 93
with crimped locks; but her bust is unusual altogether. The 'melon' hairstyle 94
apparently survived for a while. The shoulder locks have gone, but the little
forehead and cheek locks were more popular than before. The 'dumbbell' earring
preponderated; brooches were mostly circular. Certain *grandes dames* put on really 89
bold displays of self adornment. These were built up, first of all, through jewellery:
so many chains or ornaments and pendants might be attached to the turban and
diadem, so many rows of diverse necklaces might cover the breast, so many
decorated clasps might be clamped to the arm behind the heavy bracelet, that the
costume and figure beneath were scarcely visible. And, secondly, the displays were
created by means of embroidery and trimmings, reproduced in stone: the long-
sleeved tunic that is quite commonly seen normally boasts broad bands of

92 decoration on chest and forearm sections, and a woolly fringe; sometimes the sleeves became as huge and loose as a mandarin's, to enlarge the area of display.

90 An earlier garment proliferated: a richly embroidered headcloth, replacing (or covering?) the turban. When hung with a waterfall of jewels, it must have created a truly glorious effect, sparkling with light and colour.[218]

The full corpus of relief busts includes a slightly eccentric group. A few busts, while otherwise normal, combine features taken from both male *and* female figures. The person is shown beardless and bare-headed. The hairstyle is fairly short and indisputably masculine; but both costume and pose are ones used for female representations. Thus some have the tunic and cloak arranged as on the busts of the second group with the 'melon' coiffure, and wear jewellery – earrings, necklaces and bracelets in varying combinations. One also has a lock flowing down behind each shoulder, a mark of servile status. Another, with tunic oddly arranged and left hand raised to the chin, is attended by a sinister funerary siren. The names, where inscriptions give them, are female. From style, motifs and lettering they should date from *c.* AD 200. Are these some of the eunuchs that have long been such a feature of the Semitic world? If so, it seems strange that one of them, for instance, should be shown with a small child.[219]

(In margin: 91, 95 ; 91 ; 95)

THE RELIEF BUST AS PART OF THE ARCHITECTURAL ORNAMENT OF THE TOMB

The relief bust motif was sometimes used as part and parcel of the architectural decoration inside the tomb. Do these examples differ from those carved as limestone nefeš, and was their function the same?

The ornamental bust is usually shown in one of the standard poses known from the funerary reliefs; it may be larger or smaller than these. Unfortunately many examples are now divorced from context, but some retain clues to their function.

96 One definitely acted as a funerary nefeš, for the male bust above the Pan-head console has a curtain hung behind, and, below, the inscription, 'Alas! 'Atenûrî, the son of 'Ogeilû.' To him we may perhaps add the busts which line the bench of the tomb of A'ailamî and Zebîdâ; their purpose could have been similar.[220]

It is equally certain that other busts were not intended to be nefeš. Male and female busts are liberally distributed around the upper walls of the ground-floor entrance chamber of Elahbel's tower-tomb (AD 103). Fifteen survive out of at least twenty-four, all scrupulously labelled. The reliefs, which doubtless formed part of the original decoration of the tomb, are built into the wall proper, and are not connected with the burial loculi. Instead of the word ḥbl, 'Alas!', that sure indicator of a funerary text, these inscriptions begin with ṣlm', 'likeness [of]'. The persons depicted are all members of the builders' family. We seem to have here a representation of each person entitled to use the tomb apart from the four co-founders themselves, who were probably shown in the façade niche.[221]

The coloured stucco busts of priests and women, and of priests and men, that ornament the ground-floor chamber ceilings of the towers of Iamlikû and Elahbel respectively, would appear to be decorative. But the fine bust of a priest, immured within multiple mouldings, on the large limestone slab which formed the centrepiece to the ceiling of 'funerary temple' 39d has a less clearly ornamental

(In margin: 57 ; 113 ; 57)

function.[222] A little bust projecting from a leafy background of rosettes within triangles, squares and lozenges, lying in the ruins of the once sumptuously appointed 'funerary temple' of A'ailamî and Zebîdâ, really does look decorative. So too does a diminutive pair of busts in Copenhagen, set within medallions against precisely the same background. And another slab, re-used as foundation rubble, encloses a man and a woman together inside the wide leaf-and-dart frame more usually reserved for certain small-scale banquet reliefs, as we shall shortly see.[223] So the precise purpose of these busts varies, while the motifs remain true to the known canon.

<div style="text-align:right">97</div>

LARGE BANQUET RELIEFS WITHIN THE TOMB

During the first century AD the banquet scene was an uncommon subject for the Palmyrene sculptor, and he seems to have represented it only on a large scale. As such, it would sometimes accompany a tomb foundation text, set high in a tower façade. But it may also have entered the tomb at a comparatively early date. A fragmentary rectangular banquet relief was found lying inside the tower of Ḥairan, built in AD 33. The then two sons of the protagonist, Belšûrî, stand in the Greek manner on the same base line as Belšûrî's couch. The relief was carved probably around or soon after AD 33; for by AD 83 Belšûrî had four grown-up sons. But was it intended for the interior? Another relief, similarly composed, lies near towers 17 and 18, but it is also now divorced from its original context.[224]

<div style="text-align:right">37</div>

<div style="text-align:right">39</div>

From the early second century, however, it gradually became normal practice to introduce the banquet scene among the other types of internal tomb relief, usually to close off pairs or groups of burial slots. The norm had by now been established. The shape of the block's front face is rectangular, wider than it is high. To our right reclines the protagonist, male and commanding, and with

<div style="text-align:right">98</div>

<div style="text-align:right">Cf. 61, 62</div>

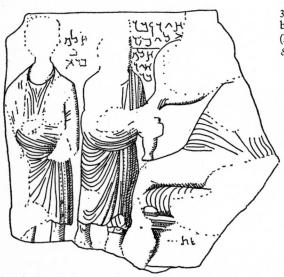

39 Fragment of Belšûrî's banquet scene, c. AD 33 (PM; ht. c. 60cm.; after 83, fig. 12)

him any other figures of prominence. His left hand holds a cup across the centre of his chest, and leaning on his left elbow he props himself on cushions. His right hand rests on his raised right knee, sometimes holding a laurel sprig or wreath, while his left leg bends and vanishes beneath his right. Parthian costume is far and away his favourite fashion. The rarer Greek costume, or Greek himation worn over a Parthian tunic, offers less opportunity for decorative display.[225]

Time and again this leading figure, where the head survives, turns out to be a priest. To our left the protagonist's wife appears on a smaller scale, seated on a high-backed chair or on cushions that rest actually on the same mattress as the reclining male. Sometimes she is frontal, sometimes she is turned slightly towards her lord. Between these two appear the diminutive figures of their children, if any, standing frontally and again on the same mattress. And this, apparently, sometimes comprised the whole sculpture. But, more often than not, the couch with elegantly turned legs on which the mattress rests is also represented, either on the same stone or on a separate but juxtaposed rectangular block. This posed the problem of how best to fill the space between the couch legs. Where the banquet scene had been set into a tomb's outer façade, the foundation inscription was the obvious filling. In the form used for tomb interiors, however, it was normal to place a short identifying inscription beside the head of each individual shown, thus depriving the area between the legs of informative texts. But by c. AD 100 this space was usually filled with a row of between two and six relief busts of members of the family. Later in the century, full-length figured scenes began to appear, but busts always remained popular.

An early banquet scene made for a tomb interior, both precisely dated and still in place, is to be seen in the tower of Elahbel (AD 103), on the upper part of the back wall of the main chamber. The top section is gone, but the couch remains, and between the legs we see four women's busts with spindle and distaff. The scene is framed between Ionic pilasters.[226] Also within handsome architectural surroundings and dated 142/3 is the reclining figure of Malê, one of the Three Brothers whose hypogeum his monument still enlivens.[227] Two more roughly contemporary reliefs were inserted into the socle of the south exedra deep in the hypogeum of Iarhai, below two fine niches crowned by ingeniously decorative shell-like semi-domes.[228] Two further pieces are dated in the 140s, one depicting a priest and his wife, between whom the artist has placed a lion's head gripping a ring in its mouth, the other (a base section) an 'artisan' ('mn'), Moqîmû, with a ruler beside his head. These busts on the base section are shown armless, a convention which by now had become almost universal, although exceptions occur, such as a woman of c. AD 140–60 with a standing child each side of her.[229] Two more (probable) base sections from Šalamallat's hypogeum each bear the armless bust of a priest, his wife and son enclosed by moulded medallions, a device about to become enormously popular for this basal position.[230] Embroidered Parthian costume, sometimes richly decorated, is almost universal among the protagonists, while Greek dress is preferred for lesser figures.[231]

In the early second century, experiments were made in crossing the reclining banquet figure with the funerary bust to produce a truncated hybrid. The main figure or figures are shown from the navel upwards, holding cups and resting their left elbows on cushions, while any attendant or cup-bearer appears at full length but much smaller and with his feet beside the diner's midriff.[232]

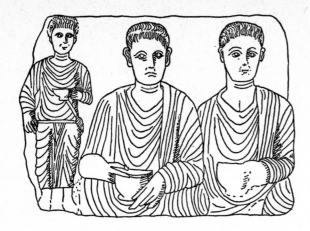

40 Relief of two ban-
queters with a 'page'
from Iarḥai's tomb, c.
AD 108–50 (DM; ht.
42cm.; after 4, pl. 48.1)

A puzzling fragment of this period may also be part of a banquet relief. A
headless boy is seated frontally, with knees apart and ankles crossed, wearing full
Parthian dress and carrying an enormous bunch of grapes in his lap. The word
'his daughter' is carved on his right arm, so he has been detached from a group.
Perhaps he occupied one of the lesser positions of a banquet scene.[233]

A certain adventurousness marks banquet pieces from c. AD 150 to 200, with
patterning of drapery beginning to give way to a certain naturalism in flesh and
folds. On the whole, there are few innovations in the upper part of the relief.
Ornamentation continues to flourish. Among the reclining men, Parthian dress
still preponderates. One diner leans on a curiously spiralling bolster.[234] The
seated wives and children standing in the background adopt the arm poses and
attributes of contemporary relief busts and funerary stelae. One family group,
where costume and inscriptions imply a date after the mid-second century,
curiously retains the curving top and semicircular drapery folds of late first- and
early second-century work.[235]

For real innovation we must search not in the upper part of the relief but
between the turned legs of the couch. Here the usual armless busts are prevalent,
with or without a background 'curtain' or surrounding moulded roundel. But
one base, to which two sizeable fragments probably both belong, is extraordinary.
On one piece the naked rider of a lively mount, in a helmet and possibly a short
Greek cloak (chlamys), hauls along a second horse by the bridle. On the other,
identical in style and proportion, stands a male figure in heroic nudity, with a
woman in long tunic beside him. A dog launches itself at a beast with tufted coat.
The style is astoundingly Western; and the scene, if a genuine whole, is remark-
ably close to that Roman funerary favourite, the hunt of the Caledonian boar,
attended by various deities. One of the Dioscuri has been recognized in the horse-
man of the Palmyrene fragment, and Meleager and Atalanta in two of the
figures.[236]

But the most productive years by far for banquet reliefs, to judge by survivals,
some of which are dated, were the early and middle decades of the third
century. This was an age, too, for placing three (or five) such reliefs together
around three sides of a chamber to form a 'dining group', the triclinium. These

99

41 Banquet base relief
fragments including a hero
and a horse-rider, c. AD
150–225 (PM; hts. 68 and
53.15 cm.; after 111, 1960,
figs. 156–7)

100 third-century banquet representations show some imagination. Of course little could be done, iconographically, with the banquet scene itself. Poses of subsidiary figures were kept up to date, Parthian costume became ever more decorative, and a customer's girth might be immortalized with unwonted realism.[237] And there seems to have been a tendency towards symmetry, which could be roughly achieved by making two figures recline, the one to our right shown as head and torso only and balanced by the usual seated wife on the left; this device had been in use since the early second century, but rarely until now. The other method was more ruthless, and was used on a large relief with base, dated AD 238/9. Here the central figure is not only central, but has on each side a seated woman each of whom adopts a symmetrically opposite arm pose.[238] We can also spot some reversals of position – a woman reclining, a man standing on the left-hand end of the mattress. Two other figures, which appear to have been cut from large banquet reliefs, carry objects, one a box, the other keys.[239]

But this was tentative indeed, compared with the experimentation now taking place between the bed legs. Certainly, conservative patrons continued to demand 100 the conventional row of armless busts, although often the busts' surrounding medallions were richly elaborated, and around the busts might be hung deeply drilled wreaths, attached to lions' heads with rings in their mouths.[240] But for more adventurous patrons, figured scenes began to proliferate. An artist of lacklustre imagination could repeat the banquet scene from above. Another 101 supported two central medallion busts with a symmetrical pair of flying Victories. Another artist again preferred to place huge stone wreaths between the legs, upheld by eagles and with a lion head with ring above the centre of each wreath.[241] Others were happy with standing figures: certain reliefs consist of a row of them, identically dressed and of doubtful function, and there are more, badly weathered, lying about the site. This motif recurs as a frieze within the tomb. What are these silent watchers doing?[242] Others, clearer, represent young men or 'pages', several of whom carry adjuncts to the banquet, such as a large jug or vessel with god-rooning as decoration, or a sacrificial lamb. The 'pages' wear knee-length himatia, often with a broad stripe to right and left.[243] Another youth clasps a musical instrument, a syrinx.[244] Other young men prefer full Parthian costume: decorated tunic and trousers, sword, and usually a long-locked hairstyle as well. At least one raises high a (diner's?) wreath. Others have hunting (or fighting) equipment, the bow and quiver.[245] Another artist has depicted two men beside a camel on his base section; although both wear Parthian costume they are carefully distinguished. One, with cropped hair and beard, may be a military officer; on his right stands his long-haired companion, presumably a subordinate cameleer, holding the halter. A further relief shows two cameleers riding to our right; the decidedly human name 'Lišamš, the son of Ḥarûṣ' engraved beside one of them discounts their divinity. And, if this is funerary, so too, probably, is another fragment with a cameleer proceeding in the opposite direction.[246] Finally, there is an arresting piece (Plate 103), carved between AD 236 and 272 and again broken. To our left there seem to be the forefeet of an animal, a horse or camel; its halter is held by a man at the centre, clad in an unusually short tunic and sword, who grips with his left hand something quite unexpected: a ship, fully rigged and under sail, guided by a pair of great rudders. Nothing could speak more eloquently of the Palmyrenes' far-flung tentacles of trade.[247]

42 Third-century relief of a 'page' with a syrinx (PM (?); ht. c. 30cm.)

Ironically, the table from which all the banqueters are dining, so commonly shown in Greek and Roman representations, hardly ever appears in Palmyrene versions. Presumably it was awkward to accommodate among the motifs usually employed in the space beneath the couch.[248]

105

SARCOPHAGI

From an early period Palmyrenes of importance had enjoyed the unusual luxury of a complete sarcophagus to themselves inside the tomb, placed against a wall or even in a special chamber. For a long time, these sarcophagi seem to have been simple, and normally of plaster. But eventually something more elaborate was required. So from the West, *c.* AD 130–50 to judge from survivals, the notion of the stone sarcophagus with figure carving was imported. If, however, the idea was Western, its adaptation was peculiarly Palmyrene. The artists took as their immediate model the existing, large-scale banquet reliefs. The back of the sarcophagus was intended to be placed against the tomb-chamber wall to conceal loculus openings, so it could safely be left rough. For the base, the artists attempted to conceive the funerary couch in the round, and reproduced its turned legs at the corners, at least on the long front face. About the sarcophagus ends, however, the artists were not so confident and often they simply left them blank; but for a fine job, and especially for the exposed ends of a triclinium or group of three, they would reproduce the details of the couch here also, sometimes including a standing figure or a lion between the couch 'legs'.[249] As for filling the spaces between the legs, what better than to appropriate the ideas currently in use for banquet scenes? The real difficulty, however, lay in the cover.

102

No complete sarcophagus with lid, and no displaced cover, can be confidently assigned to the second century. Only bases can be dated to this period, and they are normally decorated with a predictable row of three or four armless relief busts within moulded or wreath medallions, although on one base there is a square frame and a 'curtain' hanging behind the central three busts.[250] The second-century cover, however, was surely of the type almost universal at Palmyra from *c.* AD 200: a truly illogical hybrid. For the artists simply transferred the upright slab with banquet scene to the top of the sarcophagus, placing it level with the front plane of the base and extending it far enough back at the bottom actually to cover the corpse and its container. Thus the 'lid' was a tall, L-shaped slab with a banquet relief on its front face – not an obvious solution, but so close to the banquet scene from which the whole sarcophagus decoration is derived that it must have been the first type of cover invented.

102

Eventually a few third-century artists, again under Western stimulus, turned the lid into a sculpture fully in the round. But these sculptures are rare. Hardly one has survived complete, although from what remains it seems that the artists placed just a single reclining figure on the lid.[251]

104

The third century was the heyday of the triclinium. Convenient chambers, usually in hypogea, were utilized or specially hollowed out to receive groups of three (or five) sarcophagi arranged around three sides of a square, so echoing the owners' own elegant dining rooms. Such triclinia rarely yield dates, but tomb lintel inscriptions often record when exedrae were created to accommodate them: thus 'Abissai's triclinium was installed *c.* AD 219, and Maqqai's *c.* 229.[252]

102

To decorate the lids of third-century sarcophagi, the motifs familiar already from the large banquet reliefs are repeated. And between the couch legs we find precisely the same conservative, armless relief busts, and just the same kind of experimentation, encountered already among the banquet representations. Again we meet the banquet scene, repeated; again there are lines of now indecipherable male figures. Some rows of attractively carved 'pages', however, are better preserved; two came to light in the south-eastern necropolis. The youths, in

106

knee-length himatia, stand frontally, but in poses that alternate rythmically; they carry all manner of banqueting items – jugs, bowls, a platter heaped with food, a ritual crown. On a sarcophagus in Maqqai's exedra were found some colleagues

102

of theirs in Parthian dress, clasping a similar assortment of wreaths, bowls, an amphora-shaped vessel and a pine-cone. Although very similar at first glance, the figures have been carefully distinguished by variation of the poses and of the costumes' decorative strips. On the short side of the sarcophagus stands another figure, alone. The adjacent sarcophagus, with Maqqai's own representation on the lid, contains an interesting base scene showing three men in rich Parthian costumes with a horse in profile to their right. The central figure is marked out by luxurious dress, a stylish coat and the special distinction of a priest's cap on a cushion beside his head. Is this Maqqai himself, appearing again, between servants? If so, perhaps he is preparing to depart to the hunt. The attractive execution is complemented here, as often, by lavish colouring.[253]

How far did the number and sex of the persons shown at the banquet and as busts below correspond with the actual family group, living and dead? The very existence of the triclinia might lead one to suspect that such correspondence was not exact, since the number and arrangement of the sarcophagi is so formal, and the three banquet scenes are usually strikingly similar, sometimes even identical. Often not all the figures are labelled. Yet one group that is quite fully inscribed, that of the family of 'Abissai, dispels some doubts at least; for the three main characters turn out to be 'Abissai himself and two of his brothers, and other prominent figures might also be part of the family. What is more, those who were dead at the time of carving are distinguished by the prefixing of the word ḥbl, 'Alas!', to their names. Even so, the inscriptions on this sarcophagus still leave certain figures unaccounted for, and the busts between the legs are uninscribed. On Šoraikû's sarcophagus base, however, each of six busts is labelled, and the dead are distinguished from the living by a curtain hung behind.[254] So we may imagine a complex system of patronage. Sometimes, perhaps, a standard scene was ordered or purchased ready-made, and then the different images were allocated to the different members of the family concerned as seemed best. At other times the patron may have issued fairly detailed instructions beforehand, and the images would have corresponded quite closely to the members of his family.

SMALL-SCALE BANQUET RELIEFS

The introduction of large banquet reliefs into the tombs stimulated smaller imitations after c. AD 200, and these small reliefs became popular in the following decades. They present just the essential part of the scene – the deceased reclining on a mattress, usually with one or more subordinate figures. They come in two principal varieties.

The first is without any 'framing' of any kind, and includes some very poor pieces.[255] Some of the larger reliefs are better technically, if not stylistically.[256] But two, of the early third century, have more quality. One was once in the hypogeum of Ta'ai and shows a brother and sister reclining together on the mattress, and to our left an enormous jewel box on a pedestal; the carving is crisp and attractive. The second pictures a certain Malkû, attended by two more of the 'pages' we have already met beneath the large banquet reliefs, who bring cup, ladle and amphora.[257]

The second variety is more elaborate altogether. Here the banquet scene is enclosed within a wide moulded 'frame', bearing, as ornament, beading within a leaf-and-dart motif. Well over a dozen of this type survive, some mildly adventurous. Naturally, the reclining 'burgher' and seated wife predominate. More commonly, however, the left-hand end of the design is occupied by a 'page' elegantly apparelled in Parthian tunic and trousers. His master may wear Parthian or (less often) Greek costume, or sport Parthian dress while wrapping his lower limbs in a Greek cloak; occasionally he dons a priestly headdress, or a conical cap.[258] The 'pages' carry the usual items – jugs, bowls, a tambourine (?), a libation horn or a modius headdress. Sometimes a certain swing enters their pose.[259] Women rarely appear as protagonists; they are attended by female servants proffering jewels.[260]

These 'framed' reliefs are carefully detailed, although none are inscribed: is this accidental? One of them at least – the finest of all – has extra architectural decoration adhering to its top and bottom; so some 'framed' reliefs, such as this one, may have functioned as architectural ornament rather than as *nefeš*.[261]

107

109

SERVING-YOUTH STELAE

A small but mysterious group of stelae shows us young men in Parthian dress carrying food, vessels and other items appropriate to a banquet. One stele-top is squared, others are curved; the figures stand on a projecting 'platform'. Style and costume point to the early third century, but not one of the reliefs has had its findspot recorded. Where are they from, and why were they made? One youth carries a large lamb in his arms, a second, a small one on a platter, a third, a plate with some offering on it, and a fourth, a cup. Another holds a flat bowl in his right hand and with his left supports a tall, ornamented drinking horn (*rhyton*). Finally, there is a headless and legless fragment (Plate 108), well executed: the youth's right hand grasps a bunch of banana-like wheat heads, and his left balances a huge bowl overflowing with grapes, apples (?) and pomegranates or pine cones (?). These youths are clearly attending a meal: is it religious, or funerary? Either is possible; but the occurrence of so many other 'pages' among third-century funerary banquet and sarcophagus reliefs hints that these stelae may also have once decorated some lavishly appointed tomb interiors.[262]

FUNERARY STATUES

That the Palmyrenes produced funerary statues is suggested by discoveries made in tombs, ranging from bits and pieces to complete figures, and by an inscription on the base and feet of a statuette bearing a name and the indicative word *ḥbl*,

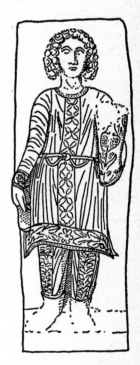

43 Third-century relief of a 'serving-youth' (Lou 4084; ht. *c.* 50cm.; after *92*, pl. 33.1)

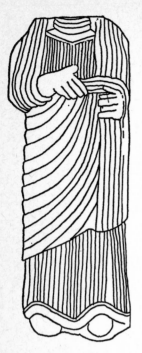

44 Early funerary
statuette of a woman
(PM 2026/7224; ht. 67cm.;
after *111*, 1959, fig. 203)

'Alas!'.[263] But when did the series begin and end, and how many of these surviving statues whose findspot is not recorded are funerary?

The statues were in vogue by *c.* AD 50, for two damaged ones, painted in red and green and found (out of context) in Zabdâ's tomb, cannot stylistically be later. A man's lower limbs in trousers and cloak and a headless woman in patterned draperies survive. The rough backs indicate an original position against a wall or recess. The nearby tower-tombs 15 and 19 once boasted statues rather closer to natural size, again boldly painted (usually in red). Along with garment fragments some heads remain, crude but forceful, perhaps not all from statues; close-cut hair and huge, melancholy eyes suggest a late first-century date.[264]

Full Parthian attire, completed by outer leggings, characterizes some slightly later pieces. One man has a jug and ladle: is he therefore another banquet attendant? A different man, bare-headed, clasps a non-committal scroll to his chest and a leaf to his thigh; his statue might be honorific. Closer to the priesthood are those who hold the ceremonial libation jug and bowl together in the left hand, across the chest. One statue lies abandoned and mutilated in a tomb near that of Ḥairan, son of Belšûrî. Two others, a fine and virtually identical pair, once lent a touch of grandeur to the interior of 'funerary temple' 3, the 'White Castle' (Qasr el-abiad), towards the western exit from the Valley of the Tombs. Now, all that remains of the statues are two headless torsos, one unattached pair of feet and a fragmentary head bearing the priestly cap or modius. The two brackets that projected from half-columns opposite the tomb-entrance perhaps once supported the two figures. They are similar enough to be by the same hand; the balanced composition, the rippling patterns of folds, the surface finish given to the high-quality limestone, and the intricate detail of the restrained ornament of the costume reveal a control and a delicacy that few other Palmyrene artists could match. Even the backs of these two statues, although meagrely worked, are better finished than most of their kind. They probably formed part of the tomb's original decoration. Their costume places them before *c.* AD 150; perhaps they were carved not long before.[265]

The female statues and statuettes of the first half of the second century, of both standing and seated figures, are conventional and mediocre. A headless woman in a highly embroidered tunic stands holding a child on her left arm; a more soberly clad female, seated on a stool, once occupied the unfinished eastern recess of the hypogeum of Iarḥai.[266] Some of these statues, including a large local version of the Western 'Pudicitia' type, appear to belong to the latter part of the century.[267] After this, however, they become extremely rare, although at least one woman, holding her veil demurely with her left hand, adopts a pose seen among third-century funerary relief busts, and is also of a better quality than usual. [268]

The few of these statues found more or less in place had been put inside the tomb: outside, obviously, weather and vandalism threatened.

Animals in stone also inhabited the more generously furnished tombs. In 'funerary temple' 176 stood a richly caparisoned horse, of which the forepart remains, and which once presumably carried a rider. Another large fragment, similar to this if less decorated, perhaps served the same purpose. And the roaring lion in Copenhagen, like so many of its breed elsewhere in the Roman realm, was surely funerary.[269]

Other tomb sculpture with religious symbolism

Some themes already familiar, and others new to the funerary repertoire, are offered by some of the less common types of sculpture outside and within the tomb.

In the exterior wall of Ḥairan's tower (no. 67) is a carved plaque, presumably of the first century, which although now badly weathered possibly represents a gorgon's head to ward off evil. Each column pedestal of the surviving portico of the once sumptuous 'funerary temple' 86 has a garland depicted on it. [270] But the exterior, as we have seen, was not really the place for sculpture. Inside, apart from the nefeš, any stone-carving would normally be restricted to purely architectural features. Occasionally, however, these features would be elaborated so as to include figure work. Consoles, for instance, were altered in this way: one of lion-head form supported a male bust, a pair in tower-tomb 65 represented bearded male heads, and two others portrayed a youth's head surrounded by foliage and grapes. One of these consoles, from Iarḥai's hypogeum, has a slot *46* cut in its upper surface to hold a statuette. [271] Reliefs of winged Victory (over Death), holding palms or standing on a sphere, decorated certain tombs; perhaps the several smallish statuettes of Victory which survive were originally inserted *Cf. 11* into the console slots. One carries a downward-pointing palm branch, another perches on a half-globe, her back against a pillar; a third carries a wreath and cornucopia. Another is mentioned in an inscription of AD 240 as standing within the exedra of a further subterranean tomb. [272]

Rather harder to explain is the symbolism or purpose of the friezes of standing, frontal, motionless male figures which were sometimes placed high on a tomb's internal wall. But others are more obviously funerary, like the three priests before an arching vine of one relief, and the snake on the pilaster capital that gave 'funerary temple' 150 its local name, the 'Castle of the Serpent' (Qasr el-Hayye). [273]

For special effect a niche or niches in stone could be inserted among the tomb decoration. Those in the hypogeum of Iarḥai have shell ornament filling the semi-domes. But four other such semi-domes which also survive include figure work; to judge by the riotous use of the mason's drill all four date from the time of the drill's popularity, the late second or early third century. Each semi-dome is severely damaged. One depicts a female divinity, striding forward with her left leg from a deeply hollowed background of foliage. The leaves twist and curl so as to produce five circular medallions in the field each side of her figure; but

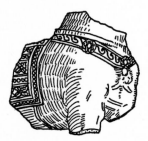
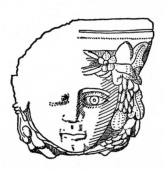

45 Fragmentary funerary sculpture showing a horse, c. AD 150–270 (PM (?); ht. c. 37cm.; after *197*, fig. 67)

46 'Bacchic' console from the tomb of Iarḥai, c. AD 108–50 (DM; ht. c. 30cm.; after *128*, F676)

their central motifs are now obliterated. A large fragment contains the 'silhouette' of a figure now destroyed before a thick, branching vine. Another less ostentatious vine fills the spaces between the three figures of a third. The last is the least obscure: a dolphin, accompanied by flying fish, passes towards our right, carrying the seated figure of Aphrodite or Amphitrite, in an unoriginal posture.[274]

111

Finally, the really egocentric tomb constructor might order an especially personal ceiling. Diocletian's builders re-used one such ceiling. Most of what remains is taken up with rosettes within squares. But at the centre we see a section of the Zodiac, arranged in a circle with a Wind in the spandrel, and part of a figure on an animal. The details of the Zodiac reveal that the whole once presented the patron's horoscope.[275]

These last few reliefs and figures show an unwonted variety of motif. The vast bulk of Palmyra's surviving funerary art indicates, however, that its executants were chary of straying far beyond the normal canons. When they did, they seem to have done so with the co-operation only of the wealthiest and most sophisticated of patrons.

4
Funerary painting and stucco work

Colouring, as we have seen, often enhanced funerary sculptures, although its role was usually a subsidiary one.[276] Sometimes, however, it was allowed to come more into its own: architectural or sculptural features might be finished in coloured stucco, or the surfaces of walls and vaults plastered and smoothed to receive painting proper. Sculpture, stucco and painting were all employed, separately or combined, but the latter two tended to be used as cheaper substitutes for the first.

Paint and coloured stucco were in vogue at least by AD 40. Kitôt's tower-tomb of that year has a colourful façade niche depicting a family group with green-blue clothing, red faces and brown-red hair, and, behind them, a vine-arbour with green leaves and black grapes. The lower portion of the left young man is executed in plaster, through a fault in the stone or a mason's error.[277]

The barrel-vaulted vestibule ceiling of another early tower-tomb (no. 19) bears painted designs on a foundation of thin plaster. Rows of rectangles, divided by broad yellow bands, contain for the most part circles in various colours alternating with elaborate masks. Now and again a four-leaf rosette replaces a circle. The painting is careful and the circles compass-drawn. But we cannot be certain that these imitation 'coffers' are contemporary with the erection of the tomb early in the first century AD.[278]

Other scraps of painting, equally difficult to date, are scattered along the southern side of the Valley of the Tombs. In one a large painted garland in dark red and dirty yellow is 'hung' between a pair of loculi; a green 'pole' with red ribbons cuts across it. Another tower further along (tomb 18) has two loculi surrounded by vegetation. Green leaves are outnumbered by grey; occasional red flowers set off the ensemble. Finally, tomb 62 is enlivened by some cursory painting in its attached rock-cut hypogeum. The arched entrance is emphasized by two red stripes around it; across the top run 'triglyphs' in red and yellow. In the spandrel to our left flies a winged, female Victory in orange, red, yellow and dark grey; she balances on a sphere and stretches out her left hand, proffering a wreath.[279]

The west necropolis is more impressive. Its lavishly ornamented tombs combine stucco and painting with sculpture to produce an effect that is, on a small scale, magnificent. Two such tombs remain – the towers of Iamlikû (AD 83) and Elahbel (AD 103). In each, resources have been concentrated above all on the entrance chamber. Iamlikû's explodes in a wealth of carving and colour. The loculi open between elegant Corinthian pilasters. The crowning glory, however, is the ceiling, divided into deep rhomboid and triangular coffers and completed in

37

47

113
57

113

47 Selection of panels from the painted vestibule ceiling of tomb 19, first century AD (?) (*in situ*)

coloured stucco. Red sets off the cornice dentils, and stripes of red, blue and grey surround the coffers. Within each of these, reserved in white against the pastel blue field, is a figure or group, mythological or symbolic. The outermost triangles contain eagles with spread wings, the inner row male and female busts. Finally, each central lozenge encloses a group: first, two Erotes; secondly, a combat between a griffin and what may be an Arimasp; thirdly, two more Erotes; and finally, a panther, tussling with another Arimasp (?).[280]

Elahbel's ground-floor chamber, similarly designed, has ceiling stucco work that is conceived less imaginatively, but is more subtly coloured. One-third survives. Five-leaf rosettes fill a mass of small rectangles; in the centre of the ceiling four larger squares each enclose a male human bust in the severe style of the first sculptural group. Two of these busts wear the priest's cap. If this design was repeated over the entire ceiling, as is likely, there would have been twelve such busts in all. Dark red striping divides the coffers; the motive within each is framed by a yellow square, and the background is again a pastel blue. The rosettes are picked out with dark red, and the busts with basically two colours each: the tunic is usually light red with a white central strip, and the cloak a contrasting white, pale green, or light or dark brown. A brooch cabochon in blue may complete the costume. The whole interior so recalls Iamlikû's that perhaps the same workshop executed both.[281]

Further painting lay underground. Ḥairan, son of Iaddai, founded a hypogeum in AD 106/7. A small exedra was added later to the right of the central gallery – probably in AD 149/50, for this date is included among the decoration. Walls and ceiling are painted. In the ceiling-centre an eagle, in medium-brown with dark brown lines and red edging, spreads its wings. On the left wall, before a grape-laden vine, stands a beardless man, sketched mainly in patterned red-brown strokes, with brown shading on the left side of his neck (Plate 114). The lighter drapery folds are yellow, and where the right knee projects no folds are indicated. Eyelids and pupils are done in black; there may possibly be a white dot, a reflection of light, in his right pupil. The man's frontal pose and costume recall the funerary reliefs; his tunic has a black stripe, and his left hand two enormous rings. Below him is a red, rectangular base; above, a label, 'Ḥairan, son of Taimarṣû', presumably the exedra builder (and founder's grandson?). Opposite him stands a woman, surely his wife; within a thickened contour line of brown her cloak has patterned folds of brown and her tunic of green, with a red stripe. Her hair, shoes and two keys dangling from a trapezoidal brooch are black. A circular medallion enclosing a male bust is painted above the four niches of the exedra back wall, flanked on each side by a winged and flying but front-facing youth in a red Phrygian cap, nude to the waist, carrying a wreath and a palm. Below are green vine scrolls, and the date.[282]

Commercial enterprise appears to have stimulated the creation of the most splendid of these painted exedrae. The brothers Na'ma'în, Malê and Sa'adî built a hypogeum in the south-west necropolis. This, the tomb of the Three Brothers, was in existence by AD 142/3, and still in use in AD 259. Here the inscriptions tell an extraordinary story of the sale and re-sale of funerary loculi. And it was surely to attract buyers that the brothers commissioned some arresting painted decoration for a chamber strategically placed to face the entrance portal.[283] The exedra boundary is marked by an arch, supported by flat and slightly projecting pilasters;

115

84

inside, beneath a vaulted ceiling, four loculi open into each wall. The outer faces of the pilasters bear a complex vine rinceau (repeated inside) topped by a small circular medallion, in which noxious creatures and instruments attack the Evil (or 'much-suffering') Eye. Around the curve of the arch above runs a scanty floral spiral. Human figures occupy the opposed principal faces of the pilasters. On the left (the south) stands a frontal, almost life-sized woman. In her left arm, assisted by her right, she carries a child soberly clad in a tunic of grey and a hat of brown. Her costume is crowned by a high turban hung with frontal jewels. On her slightly outward-turning feet are sandals. From shoulder level upwards the background is blue; the remainder is green, and on this green 'wall' rests a brown casket (to our right) and to our left a bowl with criss-cross decoration. The figure representation is strikingly linear; a light red-brown contour encloses it, and flesh is rendered as a flat pink wash. Directly opposite poses a second woman, similarly clad, equally linear, with 'dumbbell' earrings and a circular brooch, set against the same background. Her right arm rests across her midriff, and her vanished left hand once drew the pale brown veil over her breast. Her sandalled right foot points forward. Behind her a white curtain hangs from two pins; folds are indicated by lines of dirty yellow. Beside her left calf, a stemmed cup is balanced on a square brown casket.

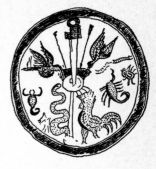

48 Painting of the Evil Eye in the tomb of the Three Brothers, probably AD 160–91 (*in situ*; ht. *c.* 20cm.; after *38*, pl. XVI.3)

Inside the chamber proper figures proliferate. A central ceiling roundel encloses an eagle carrying off a naked youth in Phrygian cap – surely Ganymede. Between the loculi float winged female figures, delicately poised on grey spheres which themselves rest on leaves shaped into crescents. These females are frontal, but with the head turned slightly to their right; the draperies dance around them. Their arms are raised to hold a green wreath and support a yellow-leafed medallion, inside which is a male or female bust; one also includes the bust of a child. These busts are set against a background of uniform blue; the men are bearded and the women's locks fall to their shoulders. Finally, six rosettes fill the odd spaces left by each figure and medallion. But the *pièce de résistance* is reserved for the back wall lunette. Here is a scene crowded with figures, showing on our left a hero in hat and Greek armour, beside him a child, and then some half-dozen figures in women's clothing. Without doubt it is an episode from the life of the Greek hero Achilles. To avoid the Trojan war he has taken refuge on the island of Scyros, skulking in female dress among the daughters of King Lycomedes. Through a ruse, Odysseus (to our left) and Diomedes (once to our right) have unmasked him. The boy is Pyrrhus, his son. Holding high a shield and tearing off his female robes, Achilles has decided to join the expedition.

The same liking for strong lines and broad areas of paler colour that is visible in the pilaster paintings permeates every scene within the exedra. The ensemble is unified by architectural features simulated in paint. A cornice with a Greek meander in perspective is supported by Corinthian columns, red with dark yellow capitals, at the chamber corners. Above the chamber section of the cornice, large dentils protrude. Coffers cover the ceiling, circular and intersecting under the arch, and hexagonal beyond. Round the bottom of the pilasters and chamber walls runs a double dado; both sections consist of individual rectangular panels. The upper row houses 'incrustation' work: a lozenge enclosing a (compass-drawn) circle. The lower row shows animals or birds prowling or stalking; least expected are some Nile waterfowl.

117

116

115, 117

115, 116

85

When were these remarkable paintings added? Figures and inscriptions give clues. The limestone funerary reliefs offer a chronologically well-founded picture of how figure representation developed in funerary sculpture. But do style and motif in painting run parallel? Proof requires dated examples. The coloured stuccoes of the towers of Iamlikû (AD 83) and Elahbel (AD 103), if they may be regarded as paintings, the frescoes of Ḥairan's tomb (AD 149/50) and Maqqai's exedra (c. AD 229), all indicate that relief and painting motifs were indeed related.[284] Any painting motifs, therefore, which can be paralleled among the funerary sculptures will help to date these paintings.

Let us take the medallion busts first. The homogeneity of the group, and their similar blue backgrounds, as well as the regular alternation of male and female on the side walls, are enough to show that the busts were all painted at the same time, not gradually as individuals died and needed a nefeš. Nothing, moreover, identifies any of the busts as nefeš: the inscriptions nearby refer to the neighbouring burial compartments, not to the busts, which have no texts attached. Rather, these busts are purely decorative, like the ones we have already encountered amidst the sculptural ornament of tombs.[285] As regards dating, the men who carry scrolls or writing implements can be placed after c. AD 150 by their thick hair and thin, curly moustaches and beards. The women tell us rather more. Poses and circular brooches can be paralleled in sculptural groups II and III (c. AD 150–273). But two of the women have 'keys' dangling from the brooch, while all of them display curling locks that fall on to each shoulder. These two motifs, characteristic of group I, die away during group II, around AD 180 or 190. Furthermore, the drapery style is somewhat more naturalistic than that of Ḥairan's figures of c. AD 149/50. So motifs and style together would indicate a date between c. AD 160 and 190. The lintel inscriptions confirm this conclusion. Two inscriptions of October and November AD 160 were put up by the three brothers 'who have hollowed out this hypogeum'. Another, directly beneath and dated May 191, mentions the brothers 'who have hollowed out *and decorated* this hypogeum' (my italics).[286] What were these 'decorations', added apparently between AD 160 and 191? The elaborately carved portal? But this must be earlier than the inscriptions cut on it from AD 160 onwards. The northern chamber with three sarcophagi? But this exedra is plain; sarcophagi hardly constituted 'decoration', and they are third-century anyway, as style and motif show (the seated woman holds her veil with her *left* hand). That leaves the painted exedra, to which, surely, the inscription of 191 refers, confirming the dating of the medallion busts from style and motifs.

The bulk of the exedra decoration, therefore, had been executed by 191. The Ganymede, Achilles and pilaster paintings need more probing. Ganymede, enclosed within a medallion like those of the busts, is presumably contemporary with them. The Achilles lunette might be also, although its manner – heavy lines and broad washes of paint, freely handled – could equally well be paralleled in Severan Roman painting.[287] What of the two pilaster women? The manner is similar to the busts, but the loose handling looks different from, and later than, the busts' clear-cut style. The motifs provide further evidence. Neither woman has shoulder locks. The child-carrier's pose can be paralleled in groups II and III (c. AD 150–273); that of the other woman, with the *left* hand pulling the veil across the chest, is of undeniably third-century type. Their turban jewels have mainly

late parallels, and the inscriptions associated with each are third-century.[288] The similarity between the two figures suggests they are contemporary, and perhaps by the same hand. But if they are of third-century date, how do we explain the fact that the painted cornice and dado of the original design continue around the pilasters, above and below these figures? Perhaps the pilaster-front faces alone were left blank when the exedra was painted, and filled in later; or pehaps they have been overpainted; or they may have been contemporary with the rest, but done by a 'progressive' artist.

The Three Brothers' chamber is of a richness unique among known Palmyrene hypogea. But other tombs were given pleasing painted decoration. ʿAbdʿastôr's nearby hypogeum includes an exedra with an attractive ceiling, probably of the early third century. Moulded friezes, embodying the eastern Roman egg-and-tongue, astragal and cable designs, frame the main feature, an elegant, naturalistic vine in relief, with birds pecking at grapes. On the back wall remain the traces in black of winged figures holding up a medallion bust, recalling Ḥairan's exedra. The chamber furniture was completed by a sculpted triclinium.[289] The three richly carved and lavishly coloured sarcophagi of the exedra of Maqqai, more-over, added in AD 229 to ʿAtenatan's hypogeum, were complemented by wall and ceiling paintings. Over the arched entrance a lengthy floral rope with central rosette is grasped at each end by a winged and flying Victory, who lightly touches a blue globe with her foot (on our left) or feet, and turns her head to the front. This scene is repeated on a further arch, but with apparently wingless figures. The exedra ceiling is covered with circles, recalling the Brothers' tomb. Painted on the wall behind Maqqai's sarcophagus, within the exedra, the funerary banquet recurs yet again. The protagonist luxuriates on his couch in a red coat, left open to reveal his blue tunic with red central band beneath it; his trousers are also red, with a central yellow strip. He is attended by a small, boylike figure and a bare-headed youth in red tunic and blue trousers; what they were proffering is gone.[290] Finally, in the 'tomb of Dionysus' is another reclining male figure, nude save for a himation over his legs; around his head is a divine nimbus, and over him arches a vine which springs from a huge jar. In his outstretched right hand he clutches a shallow cup. This must be the god Dionysus. The picture is little more than a rapid sketch in red lines, with some yellow underpainting; its linearity hints at a mid-third-century date. Within the tomb, moreover, few loculi have been hollowed out: the catastrophe of 272–3 probably destroyed the market for them.[291]

Such tomb decoration forms almost the whole sum of extant Palmyrene painting. Who executed the work? Its closeness to sculptural style and motif, and the artists' techniques, which recall those of neighbouring Dura-Europos and differ from Roman methods, confirm that this is local work.[292]

5
Honorific and monumental sculpture

Urbanization and defences

Four vital factors shaped the growth of Tadmôr, the later Palmyra: geographical setting, food production, commerce and political position. For a long time the cultivation of the oasis and its palm groves must have been the main occupation of the inhabitants. But from the second century BC at least, commerce rose in importance until, under the Romans, it became the mainstay of prosperity and urban development.

Until the Hellenistic period Tadmôr was probably just a typical Near Eastern village of mud-brick dwellings. These dwellings have long since vanished, so that even the Seleucid town has to be reconstructed largely by deduction from later evidence. The Efqa spring may have provided one focal point, and the Bel temple mound another; perhaps the Hellenistic heart lay between the two. Possibly another quarter straggled along the north bank of the wadi. But if the Ba'alšamin sanctuary tomb lay, as was normal Western and not infrequent Near Eastern custom of the time, outside the inhabited area, then the urban boundary was not far north of the wadi. Tracks, as the placing of tombs along them indicates, radiated north to Sûra (and perhaps also Dura-Europos) and south-east to Hît, all on the Euphrates; others ran west and south-west to Damascus, the westerly route (through the Valley of the Tombs) leading also to Homs. To judge by the ease with which Antony raided Palmyra in 41 BC, the town was probably then still unwalled. Before long, however, the Romans brought about a profound transformation. Under Tiberius the Bel temple was constructed and Ba'alšamin received a precinct north of the old town. Perhaps now (or later, under Vespasian?) the urban area was delimited for the first time by a wall, some twelve metres high, built variously of stone blocks, mud brick and clay, with a southern gate facing Damascus. It enclosed a large area south of the wadi, and a narrow one to the north; its northern extent is problematic, but it perhaps ran roughly along the line of the later Grand Colonnade. During the first century AD, the sanctuaries of Bel and Ba'alšamin were embellished, and new ones, such as Nebû's trapezoidal precinct, added; a business centre or Agora was laid out immediately north of the wadi. By AD 89, when a temple of Belḥammôn was built into a right-angled bend, the city wall obviously no longer functioned; and soon afterwards the erection of the Transverse Colonnade near another sanctuary area obliterated a section of the wall, and ushered in a new age of monumentality. Now a whole collection of stone buildings, typifying Roman urbanization and con-

trasting with the still largely mud-brick city, arose north of the wadi: the Senate
House (?), Theatre, rebuilt Agora, Baths, and Grand Colonnade (which provided 119, 120
a zigzagging and far from central thoroughfare, lined by hundreds of columns).
An awkward bend in the Colonnade was disguised by a monument, the 'Tetra-
pylon'. Work on the monumental areas continued into the third century. West
of the Transverse Colonnade a new quarter developed. Around AD 200 a monu-
mental arch, ingeniously trapezoidal in plan, arose to mask the strangely angled
junction of the Grand Colonnade and a street from the temple of Bel. And east of
the temple were built some exceptionally comfortable houses. But in spite of its
monumentality, this Romanization of the north part of Palmyra remains
curiously piecemeal. Its various sectors are aligned according to at least half a 5
dozen different orientations. The northern side of Nebû's precinct was lopped off
to make way for the Grand Colonnade; and, confusingly, this section of the
Colonnade (alone) has an alignment almost identical with that of the main street
of the extreme western quarter. How was this opulent city defended? Perhaps
by the earth rampart of which few traces survive, embracing an area far larger than 2
that of the first wall. Aurelian's destruction of the city, however, meant retrench-
ment. There is little doubt that it was under Diocletian, who had the extreme
west quarter turned into a military headquarters, that a reduced Palmyra north
of the wadi was ringed with the powerful stone wall still prominent today. It
was this part of Palmyra that Justinian refurbished, and here that the medieval
and later township was mainly concentrated.[293]

Sculpture

A commemorative sculpture in a public place became a standard way for a
prominent person, whether local or foreign, to be honoured in 'historical'
Palmyra. Most of these sculptures have vanished; but fortunately a few com-
plete and fragmentary pieces in limestone, marble and bronze, and hundreds of
inscribed texts, survive to give us some idea of their nature.

What do the inscriptions record? Honorific sculpture apparently began at an
early date. Already in 44 BC the image (presumably a statue or relief) of an indi- 4
vidual had been raised in the old sanctuary of Bel, and many more were to follow.
The same court was chosen by the Roman military legate Minucius Rufus in AD
17–19 for propaganda statues, perhaps of bronze, showing the Emperor Tiberius
with his proposed successors Germanicus and Drusus.[294] And as the public areas
expanded and multiplied, so did the opportunities for siting statuary. From an
early period the Palmyrenes set up free-standing statues on bases, and occasionally
on honorific columns, and attached commemorative reliefs to columns and
walls. But from the early first century AD they liked most to place the statues on
stone brackets (consoles) which projected midway up columns, or from walls. As 3
the choice of sites increased, these memorials tended to gravitate towards the
appropriate setting, a process which necessitated some re-arrangement of pre-
existing commemorations. Sometimes earlier honorific texts were re-inscribed
on the new brackets, complete with the original date: this transference is always
betrayed by a discrepancy between the date given and the advanced letter forms
of the text.[295] As the process developed, we see priests and religious benefactors
appearing in the sanctuaries, as well as along the Transverse Colonnade, which

49 'Parthian' shoe from a bronze statue (PM; length *c.* 18cm.; after *128*, F3008)

lay close to more shrines. One side of the Agora was occupied by the great caravan leaders and organizers; the brackets along its other three colonnades, as well as on the walls behind, were filled with high officials, military commanders and senators; while eventually its central gate was adorned with the Emperor Septimius Severus and family. Ultimately, the Agora alone contained some two hundred statues. More politicians spread along the Grand Colonnade and into the great sanctuaries, notably the family of Septimius Odainat and his consort, Zenobia. Doubtless the majority of these sculptures took the form of standing figures, although equestrian monuments are occasionally mentioned. Most of them were erected not by individuals but by one group or another, whether a tribal clan, priestly association, band of merchants, corporation of gold and silver workers or the city council.[296] Console texts are normally given both in Aramaic and in Greek. Where the erection of a statue was anticipated the console could be left blank. There was no restriction on the number of statues that might be raised to a deserving figure; the record on present evidence was held by Marcus Ulpius Iarḥai, the mid-second-century caravan chief, with ten. [297]

The Tariff Law of Palmyra (AD 137) stated that incoming bronze statues were to be taxed at the ordinary rate for bronze, one statue being regarded as half a camel load.[298] Clearly bronzework was being imported at a significant rate; unfortunately, the Law discloses neither origin nor purpose. Perhaps some of it was for honorific use; but the quantity, and influence on local sculpture, remain obscure. With information so scanty, the few bronze statue fragments and stone figures that still survive take on an added significance.

What, first of all, is left of Palmyra's bronzes? They form a sorry, though valuable group, and none are indisputably honorific. A section of drapery and a hand of natural size, with the nails indicated, could be ordinary Roman work. A

124 calf and foot, clad in a complex Western sandal, is certainly Roman: found in the Bel court, it might even be a relic of Minucius Rufus' dedication. But two life-

49 size feet from the Agora, hidden in soft Parthian shoes, clearly belonged to figures in oriental dress; while the miniature bust of a priest in Palmyrene style and priestly cap seems to be of local manufacture, suggesting a local industry. Did this industry really exist, and if so, how flourishing was it?[299]

Of the stone and more definitely honorific statues something has survived. The lifesize figure, usually standing, was preferred. The Ba'alšamin precinct has

122 yielded more than half a dozen male figures in Greek tunic and cloak carved *c.* AD 90–150; one is complete from neck to base, the rest are more or less truncated. The right hand protrudes from the cloak over the chest; the left rests against the left hip, clasping a leaf, or less often a 'book-roll' or section of drapery. One figure at least has leggings; the backs are lightly worked. With this group we may associate a couple of priests' heads from the court, together with the lower part of a draped female. These men must be the gods' ministers, perhaps with families. Their repetitious figures must surely be the products of one workshop, with a lucrative contract.[300]

No such group remains from any later period, but scattered pieces testify to a continuing production of priests' statues. The half-size priestling in Istanbul is poor work, but some heads, perhaps funerary, exemplify higher standards. One has moulded features, another plastically detailed eyebrows; both possess a miniature bust at the centre of the sacerdotal cap.[301]

The earliest of the apparently secular sculptures to have survived are doubtful both in origin and purpose, and datable hardly before AD 100. To this period, approximately, the bottom part of a female statue would seem to belong; her oval base implies that she comes from a niche. Two lifesize male heads, with simplified features and enormous eyes, may be roughly contemporary. Two more such heads, one bare-headed, one wreathed, also of unknown origin, should be dated possibly half a century later.[302]

From *c.* AD 150, however, secular statuary is more plentiful. Two male figures are conventional in their Greek dress and frontal standing posture; one still possesses his head, and has unusually detailed sandals.[303] Others prefer to be seated, such as the man of *c.* AD 150 who sits stiffly on a stool with turned legs; trousers emerge below his Greek costume. 'Ogeilû, however, who occupies an attractive stool with carved animal-head finials, is more relaxed.[304] Some detached heads (which might equally well be from funerary banquet scenes) are striking; one, bearded, gazes commandingly to his left. More notable is a pair of almost identical heads, obviously from the same hand, sharing huge, bearded faces, with eyes upturned and lips parted, and wreaths with a miniature bust at the centre. The foreheads are lined, beards and hair carefully symmetrical, each eyebrow plastically rendered and the space between hair and wreath deeply drilled. The pupils on one head are hollowed out, possibly to receive inset coloured stones. And, astonishingly, even the eyelashes are indicated.[305]

But the most startling of these male limestone statues are two late pieces of life size. They present men in the Roman toga, and are Westernized conscientiously. The toga folds are abnormally undercut, and the general hang of the garment is reproduced. But both material and technique are local. Minor folds are patterned, and the finish is Palmyrene. The male figure on a semicircular base, moreover, has beside his left calf an object that confirms his local origin: a priest's hat, wreathed (with oval jewel at the centre) and resting on a polygonal colonnette topped by a strange 'Ionic capital' (a cushion?), as in some funerary reliefs. Who are these headless, uninscribed dignitaries?[306]

Women, too, could receive the honour of a public statue, in their own right or as adjuncts to their menfolk. The hemline, feet and base remain of one datable to *c.* AD 100, enough to reveal her conventionality. A somewhat later torso embodies the pose with right hand turned palm-forwards, as on certain funerary relief busts.[307] Pieces of the late second and early third century, however, are more Westernized: the lower half of one, whose lost left forearm was fixed with a dowel, resembles the common Roman 'Petite Herculanaise' type, while another, on a tall, semicircular base, is closer to the 'Pudicitia'. Each, again, has folds deeply undercut, but is locally made.[308]

One group of statues and fragments stands apart from local honorific and monumental products, both in material, which is Mediterranean marble, and in workmanship, which is clearly Western. Several such statues came to light in the Senate House, and others in the Agora and Public Baths. They must have looked impressive to the Palmyrenes, though by Mediterranean standards they are mediocre. The senators would have enjoyed two togate statues, one of striking rigidity, complemented by female figures – a fine 'Pudicitia' type and a substandard 'Petite Herculanaise'. Another of the latter type overlooked the crowds in the Agora.[309] Two female heads are half-veiled, one with the coquetry

121

125

123

127

128
126

of forehead and cheek curls. The hairstyles and flattened facial planes look late Antonine or Severan (*c.* AD 160–230); and the statues, from Roman parallels, also clearly belong to this period. The rest are fragments. Several were clearly honorific, such as three pieces from two males in cuirass, and the lower legs and circular moulded base of another standing woman, well worked at the back.[310] Whom do they represent? The imperial family possibly; we may recall the texts of the Agora central gate, where a Severan family group was set up. But the two female portrait heads are hard to assign; moreover, workmanship is variable, so they may not form a single group. Another fragment comprises the abdomen and upper thighs of a once full-size nude female (Aphrodite?). A normal Roman technical progression from flat chisel to the rasp and light polish with an abrasive can be traced on this piece; the buttocks have been parted with the running drill. Apart from gracing private houses such statues, according to Roman custom, would frequently adorn less formal municipal buildings, such as baths, in an (often vain) attempt to dignify the public's ablutions.[311]

Two fragmentary heads, one of marble and the other of alabaster, were also found in the Agora. These, with their large, sad eyes and unexpected headgear, are so unlike any local Palmyrene work either in subject or in material, and so reminiscent of late third- and fourth-century Roman sculpture, that they perhaps arrived considerably after the sack of Palmyra by Aurelian.[312]

Relief busts and figures, apparently of mortals, sometimes adorned the public buildings of Palmyra: perhaps these, too, were honorific. Among the more convincing honorific examples is an architectural block lying near the Theatre: below an egg-and-tongue design appears a routine male bust within a circular wreath-medallion. Another male bust, armless, is carved on an arch keystone west of the Theatre. And at one end of the Transverse Colonnade lies another block showing a man seated above rows of carved ornament. These all look like second-century work. Other reliefs have a less certain purpose. Two sections of a curious frieze lie near an entrance to the Theatre stage. One presents four and a half identical busts in 'short'-sleeved tunic and chlamys, with a strange, crouching, horse-like beast to our right. The second begins with this animal's counterpart (here a sphinx?), and continues with two and a half busts, separated by huge, stylized leaves: much drill-work is apparent.[313] Two other reliefs, presenting standing men, less than life size, have an equally obscure function. One man is conventionally frontal and clad in Greek dress. The other, whose legs, feet and 'platform' alone remain, sports a decorated coat of late style over his embroidered Parthian tunic and trousers.[314]

The Palmyrenes also had figures carved in relief on limestone columns. One, erected by Maʻanai before AD 150, shows his two sisters at full length, one holding a wreath. Another later one has the battered armless bust of Ḥad-dûdan, a freedman.[315] Lastly, on a mysterious, monumental base relief, three seated dromedaries are depicted in left profile and 'framed' with leaf-and-dart; on each side is the moulded bottom section of a smooth pilaster. The dromedary figures are repetitious, but their martial harness, trappings and appurtenances are detailed knowledgeably, if not always logically. Perhaps the base supported the statue of some great cameleer.[316]

Figures of various kinds were also inserted into the architectural ornament of other types of monument. Heads appear: early ones show a pop-eyed female,

130

129

a child peering from a cornice, and chubby boys wearing pointed caps. A sizeable block bears an elegant urn, beside a vine motif. In a large ceiling coffer a horse leaps sideways, its head twisted frontally. And included in the ornament of the Agora was another plump boy's head in a cap, and a fat little figure of 131 Eros, set against a pillar: what business did he have here?[317]

When the temple courts, public buildings and avenues of Palmyra had been completed, and when the honorific and monumental sculpture of bronze and stone was all in place, the serried ranks of statues that lined the colonnades, graced the façades of buildings and glinted in the Syrian sunshine must have lent, even to this most commercially based of communities, an aura of ineffable grandeur.

6
Art in private houses

What standards of luxury in personal surroundings and dress were achieved by the Palmyrenes? Most of the little evidence now remaining relates to the grander bourgeoisie of each period, for they alone had the resources to purchase and commission work of quality and durability. Much of this evidence originates from tombs.

Of what kind was the housing itself? To judge by the architecture of the Ba'alšamin sanctuary tomb, contemporary Palmyrene dwellings of the second century BC were of mud brick and reflected Mesopotamian types. By the first century AD this modest standard had risen: severely ruined rooms excavated in the western quarter of the city had plastered flooring and walls of large polygonal blocks.[318] As the city developed under the Roman aegis and urban planning improved, the richest merchants built themselves spacious houses of a widespread eastern Roman type, of Hellenistic Greek origin. These were centred around a small internal colonnaded court, the peristyle, in the Corinthian order, occasionally with one side of the colonnade raised higher than the rest. Off this court opened the living rooms, one of which, larger than the others and aligned to catch the sun, represented the Greek *oikos* or principal room. To the east of the temple of Bel, in the late second and third centuries AD, lay a quarter of particularly sumptuous houses of this kind.[319] What forms of art penetrated the high, blank walls of these dwellings?

Pottery was obviously ubiquitous. Palmyrene tastes in this can be followed from the second century BC. In the late Hellenistic period a considerable proportion of the wares in use were imported. Many pieces came from the West: lamps of kinds also found at Antioch, jugs and jars, including one from Rhodes. But others were brought from Mesopotamia, notably some green-glazed pottery, comprising amphorae, pots and bowls. By 100 BC a local pottery industry was also at work, manufacturing household vessels and imitating Greek wares, especially lamps. In Roman Palmyra local production had grown sufficiently to render importation unnecessary. The inhabitants now used a comparatively wide range of locally made wares. One of the smaller types was a kind of cup (a *thymiaterion* for burning incense?). Cups and bowls have been found with rims turned in or flared; the cup sometimes has a foot. Jugs with a single handle have also appeared, although among the larger wares the shapes most popular, as in the Hellenistic period, were those with two handles, ranging from globular cooking-pots to other vessels closer to the old Greek amphora. None of these vessels were adorned; not one survival from the

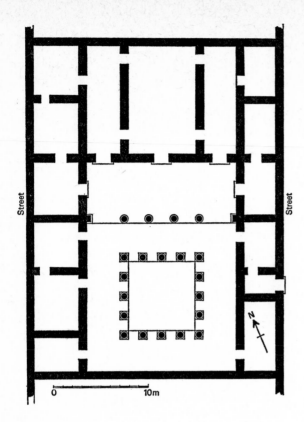

50 Plan of 'peristyle' house no. 35, late second or third century AD (after 66, pl. XV)

first three centuries AD approaches the richness of the decorated bowls, jugs and amphorae shown by the sculptors, which were perhaps originally of metal if depicted at all accurately. In fact, pottery decoration was confined almost entirely to the domestic lamp, which had the familiar sculptural repertoire applied to its top surface. Beading, godroons and vine spirals abound; sometimes a 'wreath' of foliage is substituted instead. One group of lamps, at least, presents figures of various kinds. Animals are popular, especially the running bull, with a goat or cock as alternatives. Masks appear, including a Satyr and Gorgon, and figures such as Pan and a lyre-playing Cupid. Unfortunately, many of these designs are rather seriously rubbed or effaced.[320]

132

Glassware must obviously have been prized by such a trading community, but little remains. Three bowls of the first century BC in brownish glass had been laid with the dead in the tomb adjoining the Ba'alšamin precinct. An attractive amphora of the Roman period and a couple of similarly greenish bottles, one with a nozzle (an *infundibulum*), are also worthy of note. Glass was eventually worked at Palmyra, for lumps of it came to light in the artisans' quarters. But all these pieces of quality were surely imported, doubtless from the flourishing glass factories of coastal Syria.[321]

Other vessels, again found in the late Hellenistic mud-brick tomb, were carved from a costly, alien and rare material: alabaster. Some, such as a tulip-shaped piece and a *balsamarium* (balsam jar), are undecorated. But three dishes

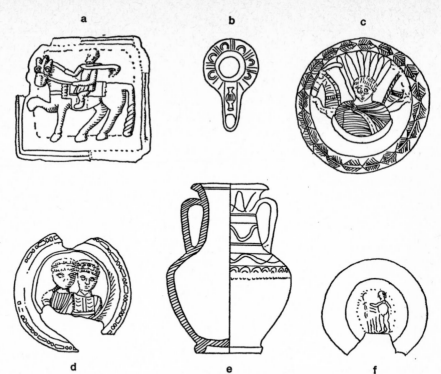

a b c

d e f

51 Grave goods from the early mud-brick tomb a) c) d) Alabaster toilet trays of the second century B C, first century B C and first century AD respectively b) Hellenistic Greek lamp, second century B C e) Parthian 'amphora', first century B C f) Plate with Erotes (embracing) in relief, first century B C (PM; after 59)

51 d) for cosmetics – 'toilet trays' from datable contexts – are carved with remarkable figured ornament. The first, which could date back as far as c. 125 B C, shows the frontal busts of a woman (left) and a man within the circular tray; their arm positions hint that they are drinking. Around the rim runs an astragal 51 c) decoration. A second circular tray, of the first century B C, has instead the bust of a sun god with a crown of rays, pictured above a 'crescent'; each side of him prances the front portion of a plumed horse; leaves decorate the perimeter, 51 a) and a rosette the back. The third tray is rectangular: datable c. AD 50, it shows us a rider god in full profile, his horse's head turned towards us. The foreign substance and superior craftsmanship of all these items suggests that they too were imported; the iconography of the figured trays, as we shall see, supports this impression.[322]

The Palmyrenes took a great interest in jewellery, as the artists' depictions show clearly. But the tombs and site have yielded little. The Palmyrenes seem to have been reluctant to bury ornaments with their dead, for even unlooted tombs of moneyed families have produced few pieces. Items that have appeared include earrings, one in the form of a naked woman but mostly crescent-shaped or semicircular and of silver, bronze and iron; a simple iron brooch; and a circular, rosette-like brooch of bronze, with pearly globules around the circumference. Early necklace beads were mostly of glass paste, although some-134 times of glazed terracotta or semi-precious stones. A later, entire necklace, found in the tomb of Zabdâ, consisted of nine pearl-shaped beads of yellow,

green and black faience with others of grey glass and cornelian; four elongated beads of limestone; three cone-shaped elements in schist; and a pendant with a frog in relief. Other beads, found separately, were made of limestone and bronze. Bracelets in bronze, both simple and twisted, have also appeared, as have finger-rings in silver and bronze, with cabochons of white stone and glass paste. The imprints from Palmyrene officials' rings seen on tesserae (and so of the Roman period) reveal that many rings of this era had an intaglio inset; most of the designs, and so no doubt the rings themselves, were Western. Finally, small bronze amulets have been found, bell-shaped, and phallic.[323]

The artists of the Roman period illustrated jewellery in use. From them we learn that male fashion rarely permitted more than finger-rings and a brooch to pin the smaller mantle; earrings are seen, but normally outside the metropolis. The women compensated for male reserve by distributing jewellery liberally over their heads, necks, chests, arms and even ankles. Immediately above the forehead rose a stiff, tiara-like 'diadem', with simple or enriched decoration, to which, after *c.* AD 150, chains of ornaments might be attached. In the first century ear-hooks were popular, later supplanted by a series of earrings. Necklaces increased steadily in number and elaboration, until they might cover a large portion of the chest with chains of square, oval and diamond-shaped ornaments, from which hung pendants and amulets. A brooch, usually trapezoidal until *c.* AD 150, thereafter largely circular, pinned the cloak on the left shoulder. Bracelets were popular; a favourite was a twisted and beaded variety. Next to this, grander ladies liked to wear a panelled armlet or clasp. Occasionally anklets are also shown.[324]

77

74, 85, 89, 92

85, 89

How truthfully was the Palmyrenes' actual jewellery represented by the artists? The additional jewellery finds made at Dura-Europos will help us to decide this question, for these pieces clearly belong to the same cultural orbit. The Palmyrene crescent-shaped earrings, and some circular Duran pieces, are of kinds seldom shown in art. The Palmyrene beaded necklaces roughly correspond, although the pendant frog does not. A Duran necklace of plaited gold wire is close to types shown at Palmyra. Fine trapezoidal and oval brooches from Dura-Europos offer welcome confirmation that the Palmyrene types must actually have existed, although the intricate designs of the Duran brooches, in silver and gold with semi-precious stones inset, are far more complex than the types the artists show. Finger-rings seem to tally well enough, and Dura-Europos has also produced bronze examples; but traces of colouring on Palmyrene funerary busts sometimes indicate a costlier kind, of yellow (gold) with a red inset stone. Again, bell-shaped amulets are sometimes shown attached to third-century bracelets. But the closest correspondence of all is that between Duran bracelets of alternating beaded and plain spirals of silver and the Palmyrene ladies' 'twisted and beaded' variety, known from representations in painting and sculpture; here again, however, yellow paint indicates Palmyrene originals in gold. The general impression created is that the Palmyrene artists based themselves on fact, but produced their own, usually simplified, formulae. And it is also noteworthy that the beads of necklaces and the granulations of actual brooches and bracelets, although often pearl-like in shape and sometimes described as pearls, consist in no known instances actually of pearls but always of other substances.[325]

Where was this jewellery made? Some of it could have been produced locally. The women's cabochon ornaments, hung in long chains, generally bear traces of red paint. These cabochons look too large to have been precious stones; more likely they were made from flat, round and oval discs of glass with the upper surface convex, which have been found in various parts of Syria. Glass was extensively manufactured along the coast of Roman Syria, and large, unworked lumps of it were found in the artisans' quarters of Palmyra itself; glass ornaments, therefore, could have been made on the spot, and the red paint could imitate their commonest colour. What of the metalwork? An inscription of April 258 was erected by 'the corporation of gold and silversmiths' at Palmyra, indicating that here again the possibility, if no more, of local manufacture exists. But much of the jewellery has parallels far afield to east, west and north; so the likelihood of considerable importation remains.[326]

A range of minor arts was doubtless practised in private houses. Finds from the tomb of Malkû, for instance, which included a small wicker basket, bronze pin, leather soles, knuckle bones, three combs of bone, two loom weights and a wooden musical instrument of syrinx type, show that wood and bone carving, and leather and basket work were carried out. In addition, the hypogeum of the Šalamallat family produced what may have been a doll, and the modern Beirut art market, a (Palmyrene?) cake(?) mould.[327]

The wealthy Palmyrene was willing to spend liberally on dress. Sculpture and painting give a good idea of the styles in fashion, particularly among the richer classes. Most popular were tunics of various lengths, with long or 'short' (false) sleeves, and a large enveloping cloak, worn by both sexes but in differing ways. The women added a veil. Boys and men often bound their tunic at the waist with a narrow belt, whose ends hung loose; and, if they wished, they might add Iranian garments – trousers, leggings and coat – or substitute a small cloak for the large. Some idea of the decoration of these garments is given by the artists. Each type of clothing had its own style, suited to its shape. The tunic often possessed ornamented borders and cuffs, and vertical stripes of varying number and width, sometimes plain, sometimes enriched; occasionally the sleeves ended in fringes. The large cloak was usually plain, but at times bore an ornamental motif, such as a large H. The leggings and trousers often displayed one broad, vertical decorated stripe, and sometimes another around the top or bottom. The coat was treated much like a tunic.

Cf. 68, 72, 76 Much of the material must have been thin, for it is depicted falling in a multitude of folds. But these representations all involve simplification; they can tell us little of colour, decoration or materials. It is fortunate, therefore, that three tower-tombs, those of Iamlikû, Elahbel and no. 46, have yielded numerous scraps of ancient cloth. For not only are these discoloured remnants, along with the mostly coarser fabrics from neighbouring Dura-Europos, almost the sole textiles to have survived from their period throughout the entire Near East; when examined they provide remarkable confirmation of Palmyra's opulence.

59 These textile fragments have all been rescued from corpse wrappings.[328] They must date from around the second century, when these tombs were most in use. The main part of the bandaging was done with sections of unwanted linen clothing, either used as they came or deliberately torn into strips for the

52

52 Portion of a frag-
mentary linen tunic with
motifs, from the tower-
tomb of Elahbel, *c.* AD
100–250 (DM; width *c.*
80cm.; from *127*, I, fig. 2)

purpose and soaked in preservative. For the outer wrapping, however, finer, and even multicoloured, materials were employed to give an attractive cover-ing. As a result, the costlier materials were the most vulnerable, and far fewer of them have survived than the coarser linens. The latter were probably of regional, and sometimes local manufacture. The linen was never dyed. At least three important types of clothing were woven from it. The tunic was generally of linen; it was usually woven in one piece, and a gap might be left at the sides below waist level to allow the legs free movement. From a graffito in the house of Nebuchelus at Dura-Europos, datable to *c.* AD 235–40, we read of three qualities of tunic, priced at 60, 40 and 30 denarii respectively, and of a similar garment at 17.5.[329] Then again, a large, rectangular mantle is found, with fringed ends; this is priced at 23 denarii in the same graffito. Even the large cloak, it would seem, could be of linen, to judge by the sheer size of one such fringed rectangle (2.87 m. by 1.67 m.). The decoration of these linens consists of small striped or rectangular patches, a fat H, a complex shoulder medallion or a long vertical stripe – vaguely resembling the Roman *clavus* – which may end in a rounded leaf motif before it reaches the lower hem. This decoration is inserted almost invariably in purple wool, sometimes offset with gold striping.

Other materials are rarer, but still more revealing. Cotton is extremely scarce, and must have come from afar, presumably India; one fragment has a long fringe twisted into tassels.[330] For coloured fabrics we turn first to wool. Both natural shades and dyed varieties (especially in reds and indigo) occur. Wool, like linen, is used for a variety of garments. A child's tunic in beige, the head-opening decorated with twisted wool and an embroidered fillet to mark the shoulder, exemplifies one kind, common at Dura-Europos.[331] A tube of pale brown wool 8 mm. wide, obtained by circular weaving, looks extremely like the narrow belts with hanging ends which bind so many tunics at the waist on funerary reliefs. Numerous woollen fragments bearing simple motifs of T- and H-like shapes would seem to be the remains of cloaks. But wool

53 Linen cloak from the
tower-tomb of Iamlikû, *c.*
AD 100–50 (DM; 2.87m.
by 1.67m.; from *127*, III,
fig. 7)

54 Woollen fragments from the tower-tomb of Iamlikû, *c.* AD 100–250 (DM; from *127*, III, figs. 11–14)

was also employed for rarer kinds of dress, notably Iranian. The Persian sleeved riding coat, flared out at the bottom, that was sometimes worn at Palmyra *54* (the *kandys* or *scaramangion*) was surely of wool; those shown in Maqqai's exedra are painted red (twice) and blue (once).[332] And wool was used for the elaborate stuffs of Near Eastern style, the tunics, trousers and mattress and cushion covers, of which some pieces reveal the original richness. These are densely woven, and juxtapose dark and contrasting colours in hot tones. Parallel bands, filled with complex leaf patterns or geometric forms, are separated by zones of a deep wine colour; even camel hair is sometimes introduced into

the intricate designs for special effect. The style is known also from Dura-
Europos, and appears to be characteristically Syrian.[333]

But the true opulence of dress attained by certain Palmyrenes is revealed only
by the last group of fragments, shreds of once sumptuous silk clothing. No *55*
hint of the presence of silk is given in the texts or the art of the city, yet all
three towers examined produced samples. The fragments are mostly too small
to indicate the type of garment they came from, but one at least retains some
sewing and perhaps belonged to a shirt. Colouring is bright and variegated.
The arresting, repetitive woven designs with their endless geometric patterns,
fantastic animals in confrontation and other strange imaginings are totally
alien to contemporary Mediterranean or Near Eastern taste. As if these designs
were not gorgeous enough, embroidery was often added too, itself multi-
coloured, in coarse or floss silk; stylized flowers and plants extend spikily
upwards, and weird animals stretch out their claws. The origin of these mag-
nificent fabrics, as we shall see, lies far to the east.[334]

How far does textile decoration correspond with its representation in art?
Only the garments of linen and wool seem to be shown in the little coloured
sculpture and the few paintings still extant. Kitôt's greeny-blue trousers, and *37*
his wife's similarly coloured drapery (AD 40) must imply that these clothes
were woollen, for linen is undyed. Two early and fragmentary funerary statues *44*
tell a similar story: the man wears green trousers with a red central stripe, the
woman a green tunic with a wide central band of off-white enclosed by thin
red stripes. The painted stucco busts of Elahbel's tower (AD 103) show tunics *57*

55 Woven and em-
broidered designs on silk
fragments from the
tower-tombs of Iamlikû
(a) woven, b) embroid-
ered) and Elahbel (c) d)
woven,) *c.* AD 100–250
(DM; from *127*, I, figs.
8–11)

114–17

of light red with a white central stripe, over which are worn small cloaks
(chlamys) of widely varying colour – white, pale green, light or dark brown.
Again, except perhaps for the white (linen?) mantle, these clothes were surely
of wool, in which this (and a wider) colour range is found among the textile
fragments. With the mid- and late second-century paintings (those of the
exedrae of Ḥairan and of the Three Brothers) the off-white garments are
presumably linen – and their dark stripes agree with the fragments – whereas
the coloured ones, such as the green tunic (with red stripe) of Ḥairan's wife,
must again be woollen. Around AD 229, the painting on the back wall of
the exedra of Maqqai, and the painted sculptures near it, show figures in
Parthian costume in which the prominent areas of red and blue could echo
the wine-dark dyes of the richest woollen weaving.[335] The carefully rendered
decorative motifs of this painting, however, are taken from the sculptural

repertoire. How close do the motifs represented come to the reality revealed by the fragments?

It is not difficult to find some agreements. Many a funerary relief figure sports a plain tunic stripe visible on his right side, and sometimes on both sides, like those done in purple wool on linen tunics.[336] A few figures wear a triangular edging decoration around neck and cuffs that could be a simplification of one of the woollen garment hems. A reclining banqueter from the tomb 'de l'Aviation' combines this decoration with a pair of ornaments of arrowhead shape, again resembling closely one of the purple ornaments in linen, as well as a motif in wool.[337] A narrow band with decoration in the form of horizontal S's divided by groups of four tiny squares could perhaps be a woollen equivalent of the Greek 'running dog' seen on the sculptures. The extremely common beaded garment border of so many reliefs, again, could be a sculptural

version of the squarish 'beading' that sometimes encloses decorated bands on
the woollens. Other banqueters display on their cloaks the fat H ornament
which can appear in dark wool on linen. But here the sculptor has eclipsed
the fragments, on which the H-motif is rendered simply as a plain dark shape,
for he has filled the motif with rosettes and a curling vine, and enclosed it
within a beaded border.[338] These formulae were all selected from the sculptors'
ordinary decorative repertoire, and were commonly used as ornament for
sculptured dress. But where the same formulae occur among the decorated
textiles, they are found in more complicated forms. Indeed, the woollens posed
great problems for any sculptor, since the alternation between dark and
coloured bands and the sheer intricacy of the floral decoration were both
obviously far too complex to imitate in stone. Instead, the sculptors adopted
some sensible remedies: they simplified the true complexities of textile orna-
mentation, and fell back on their own sculptural formulae, creating their own
standard ways of indicating the positions and extent of textile decoration.
As a result, Palmyrene sculpture cannot be relied upon to reproduce the details
of native dress accurately. This limitation also applies, to a lesser extent, to
painting.[339]

Cf. 79

A curious discovery was made within a private house of the Roman period;
about forty plaster figurines and objects were found together in one room –
torsos, masks, heads, fruit and a box. Such a motley collection all in one place
would seem to imply that the occupant of the house was a maker, or at least
a seller, of plaster objects. Their presence is not so surprising, for at Palmyra
and Dura-Europos the limestone, which, when burnt, produced the powder
from which the objects were made, was easily available nearby. Consequently,
in this region plaster figurines replaced the common terracottas of Greece
or Mesopotamia for religious and domestic use. The figures were more usually
carved out of the plaster than made in a mould.[340] What is astonishing, however,
is that the majority of these pieces were sculptured in an amazingly vigorous,
almost Hellenistic Greek style. The heads, male and female, bearded and
beardless, have deep-sunk eyes and tumbled hair. Poses are contorted. The
draperies of the striding and bending women swirl around them with an
energy and a depth of relief that recall the Great Altar of Pergamon.[341] But
the flattened facial planes of the women and some apparently oriental head-
dresses belong rather to Roman Palmyra. The homogeneity of the group
is impressive: is it also significant? None of these figures seem to be moulded
fully in the round; and one bearded head, at least, has one side of the face so
distorted that we are reminded of those Roman statues where distortion is
deliberately introduced, so as to counteract the distorting effect of a high
architectural position. We have only to think of the large stucco composition
that ornamented the Ba'alšamin sanctuary: perhaps these plaster figures were
intended for a similar composition.[342]

136

On the other hand, a few of these pieces are true figurines, made in a frontal
and linear way far closer to Palmyrene sculpture. A rather cylindrical standing
woman, for instance, who holds what appears to be an outsize wreath, has
drapery folds symmetrically arranged across the surface of her costume.[343]

Certain sculptures, although few, problematic and of uncertain provenance,
are somewhat more light-hearted in vein than usual. As they do not seem

particularly appropriate to a religious or official context, perhaps they once enhanced the citizens' personal surroundings.

To grace their houses, rich and educated Romans collected large and small replicas and versions of well-known works of art, and especially of statuary – 'apartment sculpture', as it is often, and rudely, called. Two small, fragmentary torsos from marble statuettes found at Palmyra may have belonged to imported Roman sculptures of this kind. One of these statuettes represents a burly, muscular and originally bearded figure, nude and polished, hard up against a colonnette: perhaps Zeus, or Heracles? The polish points to the second or third century. The other statuette lacks this glossy finish: a man, naked but for a cloak loosely draped over his left shoulder and legs, rests his left arm on an unclad youth at his side.[344]

Local sculptors would sometimes treat such foreign themes: we may recall the togate statues, and the Eros from the Agora. Another sculptor attempted a Pan, of which the lower half remains, part of a relief.[345]

Female nudity occurs in two bits of a decorative frieze; garlands are held high by girls whose clothing is transparent where it covers them at all. Then again, a curious capital possesses the bust apparently of a naked woman on each of its four sides; modesty is served, however, by the long locks of hair that fall below the shoulders, and by headdresses. Near the Grand Colonnade, the right shoulder, upper arm and thorax of a girl in a sleeveless chiton was picked up; a little below the shoulder she wears an elegant armlet decorated with stylized leaves and pearls. But by far the most extraordinary of all these unusual pieces is one found near the Camp of Diocletian Tetrapylon: it is an essay in the female nude by a local sculptor, a high relief or statue of perhaps half natural size. Her body is preserved from neck to upper thighs; the proportions are of the later Hellenistic and Roman canon, with breasts placed close and torso elongated; but here Romanism ends. Below her throat hangs a heavy necklace, with a pendant of special form; her breasts are boldly rounded, her naval deeply marked; and her abdomen displays a most un-Roman and almost Indian protrusion, its heavy weight of flesh emphasized by a row of creases. Her arms are held away from the body, and her hips swing vigorously to her right. Perhaps this sculpture once represented one of those numberless dancing-girls for whom the East has long been justly famed.[346]

To recapture the flavour of the luxurious surroundings that the richer bourgeoisie eventually created for itself, let us visit two grand houses of the late second or third centuries excavated to the east of the Bel precinct. The rooms were entered through expertly hinged doors; elegantly moulded pilasters punctuated the wall surfaces, which bore frescoes of a standard imperial sort – geometrical designs and marbling, arranged in large panels. Ornamental stucco work, architectural and figured, gave added enrichment. The floors were lavishly enhanced with mosaic. In one of these houses the peristyle walk, separating a small open central court from the surrounding rooms, was laid with an elaborate series of multicoloured square and rectangular mosaic panels. Every panel has a setting of assorted geometrical elements; some, indeed, consist of nothing else. One, however, contains a Medusa-like head and another, better preserved, pictures the Greek god of healing, Asklepios, seated at an angle but facing front; he is labelled in Greek, and placed in an octagon.

Balancing him is a similar figure, now partially defaced. Around the corner from these lay the *pièce de résistance*, a large panel, crammed with figures.

140 The mosaic is damaged, but we can still read the names of Odysseus and Deidameia in the mosaicist's shaky spelling. Here again, as in the Three Brothers' tomb, Odysseus has reached Scyros and is recruiting for the Trojan War.[347]

139 Nearby lay a still larger mosaic floor with an even more spectacular scene from Greek legend. About one-quarter survives. An enormous circular field is inscribed in a square; in the centre of one side a nude woman of mature proportions faces the onlooker; her name is misspelt above in Greek: this is Cassiopeia, the queen of Joppa, who boasted that she and her daughter Andromeda were more beautiful than the Nereids. To strengthen her point she has adopted the attitude of Aphrodite drying her hair, to the astonishment and evident chagrin of the Nereid each side. To the left we see Poseidon's punishment approaching, in the form of a Centaur-like monster, rippling with muscles. After a gap in the mosaic there is another fragment: surrounded by figures in action, a naked young woman, clearly Andromeda, is bound to a rock; we may imagine the arrival of Perseus off left, to save her. In the spandrels were busts of the four Seasons, of whom Spring alone survives, winged and clasping a kid; again the Greek name accompanying her is misspelt. One surviving border panel contains Centaurs and wild beasts in a confused struggle; two others had huge, stylized leaves.[348]

It is remarkable how high a proportion of those arts which penetrated the richer home, and which must therefore have expressed, however approximately, the personal tastes of its inmates, were the products of foreign artists, or were at least made in imitation of such foreign work. The tradition for such importation and imitation was already established by 100 B C, as pottery reveals. And even though the Palmyrene artists created from the late first century B C a strong style of their own which was used for religious and official purposes, it was far from all-pervasive. Once within their houses, leading Palmyrenes often used pottery and glassware of essentially foreign – especially Western – kinds, and dressed themselves in Greek or Parthian costume; later they erected peristyles, imported Western marbles and artisans, and even strutted about in rustling silks that had been brought from the easternmost ends of the known earth.

The artists' techniques

Painting

Painters of surviving wall and ceiling decorations at Palmyra used a simple technique. A single coat of mortar acted as a surface. Palmyrene mortar contains a sizeable proportion of plaster, together with an admixture of limestone, sand and magnesium carbonate; further east, at Dura-Europos, the proportion of plaster rises to 90 per cent. The mortar was allowed to dry out; the artist then applied his paints in the form of powdered metallic oxides, such as red and black iron oxides, suspended in water, to the dry surface. Often enough, the painters seem to have done without any organic medium: the mortar was porous enough to retain the oxide powders. This technique, also in use at Dura-Europos, owes nothing to Roman fresco methods and ignores Roman organic media. Traces of some sort of binding medium, however, appear to remain beneath the paintings inside the Three Brothers' tomb. The painters proceeded by drawing the outlines, using a compass for circles, and then filling these in with colours, again as at Dura-Europos. This method had already had a long history in the Mesopotamian regions, and was currently popular across – and beyond – Parthia.[349]

For the colouring of sculpture, the artists appear again to have been sparing with binding media, often relying on the porosity of the local limestone to hold the colours. These Palmyrene paintings and painted sculptures, therefore, are extremely susceptible to fading and damage.

114

115–17

Cf. 89

Mosaic

The individual tesserae of the late second- or third-century mosaics at Palmyra are reasonably well cut in a variety of stones which cover a wide colour range, including off-white, yellows, orange, reds, green-grey, light and dark brown, grey and black. Glass tesserae seem to be absent. Execution resembles that of contemporary work elsewhere in Syria.

138–41

Ornamental and figurative stucco

Stucco was apparently prepared much like the plaster for painting, and worked with the hand, stamps and other tools.

Metalwork

Whether metalwork flourished on any scale in ancient Palmyra is hard to say. A corporation of workers in gold and silver existed in AD 258, and the tiny bronze bust of a priest was doubtless locally made. Otherwise we hear of the importation of bronze metal and statuary, taxed under the Tariff Law. The extant scraps of bronze statues were hollow cast in the normal Roman and Parthian way. In the light of the Tariff Law's provisions, these could well have been imported. As regards small metal objects, such as mirrors, tweezers and items of jewellery, it is no easier to decide where they were made.[350]

124

Textiles

There is no proof that any of the textiles found in Palmyrene tombs were woven in the city, and some – the more exotic – were clearly manufactured elsewhere. But the absence of spinning and weaving is hardly imaginable, especially when so many of the women are shown with the spindle and distaff. Presumably, therefore, coarse fabrics at least were produced at Palmyra. The textiles provide six types of clue to their origin and history: the thread material, the direction in which the thread is spun (the torsion), the dyes (if used), the manner of weaving, any motifs employed and the type of garment.[351]

64, 76, 83, 85

As regards materials, linen, wool, camel hair and gold thread could all have come from nearby regions. Cotton probably originated in India, silk and 'gilded membrane' – a band of organic membrane, gilded and spun round a silk core – in the Far East.[352]

The coarse, undyed linen fabrics are probably local; the thread has a strong left-hand or S-like torsion. Tentatively, therefore, we may deduce from the torsion of other fabrics whether they were made locally or not. The wool is spun in either direction, so no doubt some was spun locally, and some (with the opposite torsion) was imported. The cotton has a torsion opposite to that of the linen. The silk fibre varies in thickness and quality; it is unspun, as was the practice in contemporary China under the Han dynasty.[353]

Linen is never dyed. Wool was often left in its natural state; its tawny and brown shades, Greek and Latin authors assure us, were much appreciated in antiquity. For dyeing, madder and indigo were popular, separately or together; cochineal, and the more precious kermes, were less often employed. Sometimes these dyes were ingeniously combined with the natural tint: thus indigo on a natural yellow wool produced a dark green. Other colours were used more rarely; a dark, purply shade, for instance, was most popular for adding to linen clothing as decoration, and was produced by that most precious of ancient dyes, true *Murex brandaris* purple. The purple-dyed threads have a torsion opposite to that of the linen; no doubt they came from the homeland of true purple, the east Mediterranean coast. The Tariff Law taxed wool dyed in purple with the same price levied per fleece at entry and exit; quite clearly, therefore, purple wool was being traded into and out of the town. True purple is rare at Dura-Europos and in Coptic Egypt, and lay beyond more vulgar pockets.[354] Camel hair is not dyed. Gold thread is wound around a strand of linen or silk, or 'gilded membrane' is used.[355] Dyes for silk are cheerful

52, 53

and varied: red and blue are most favoured, with beige, yellows, greens and browns less so. The range and dyes (especially madder, for red) are characteristic of Han China.

The linens, and the cotton also, are woven simply. The wool manufacturers, however, used various weaves – some of them, such as a fine diamond twill, the result of considerable skilfulness. The wool was often carded to produce a silky surface, which made even the coarser fabrics attractive. The rich, Near Eastern stuffs, in particular, were densely woven in 'tapestry'. Camel hair was sometimes introduced. These tapestries are especially supple, from the combination of a fine and densely packed weft with a thicker warp. Sometimes the warp was of linen. But more commonly a woollen weft of particular fineness was maintained by a warp of silk. Much of this work seems to have been carried out in Roman Syria during the second and third centuries A D. Textiles of silk seem to have been of two major kinds. Damask cloth in '2-over-2' and '3-over-1' twill seems to have been produced in Syrian workshops, from imported thread. Other silks, however, and particularly those with unusual designs, were manufactured on good drawlooms; the number of warp fibres always exceeds that of the weft, and it is the warp that produces the design. These processes are again typical of Han China. Finally, embroidery could be added. Linen clothing was given various motifs, usually done in purple wool, sometimes in gold thread. The silks, too, were sometimes embroidered, with additional motifs placed over the basic designs.[356]

55

52, 53

Pottery

Palmyrene pottery is of a clay that becomes reddish after firing; it is unglazed. Larger vessels were made on the wheel, with attachments such as handles added before firing. Small decorated vessels, such as oil lamps, were made in moulds.[357]

132

Glass

The glass is mostly of greenish shades. Larger vessels were blown, following normal Roman practice.[358]

Limestone sculpture

Palmyrene sculptors used their local limestone, quarried 12 km. north of the city. Until *c.* A D 30 their almost universal preference was for soft types. The Bel temple builders introduced hard limestone, and the following seventy years witnessed a slow but general change to harder varieties, which became normal after *c.* A D 100. Colouring varies between white and grey, often shading into yellow or pink. To denote hard limestone of high quality, the Palmyrenes seem to have used the Greek term *parinos*, which to a Mediterranean sculptor meant '[of marble] from Paros'.[359]

The tools most used were those of the Hellenistic Greek and Roman workshop: pick-hammer, hammer, punch, point, claw chisel, flat chisel, curved chisel, mason's drill and rasp.[360] Doubtless they were of iron. Palmyrene

56

sculptors rarely troubled to remove the marks and traces of their tools by means of a final smoothing, and have consequently left abundant clues to their methods of work.

TOOLS AND THEIR USES

A pick-hammer was doubtless used for quarrying and rough shaping.

The hammer was normally used solely as an auxiliary tool, to provide a driving force for the punch, point and chisels. The cutting tools were held in the hand at any angle to the surface from vertical to nearly horizontal, the power of the cutting strokes, varying from a light tap to a heavy blow, being controlled by the strength with which the hammer was brought down on the opposite end. Each tool and each type of blow produced its own characteristic striations and flaking.

The punch, a blunt instrument narrowing almost to a point but with a squared-off end, seems mostly to have been used in the earlier stages of the work, for the general shaping of the block. Its traces are usually to be found where the sculptor did not proceed beyond this preliminary stage: that is, at the sides, top, bottom and back of the block. It leaves a characteristic rectangular channel, often surrounded by large areas of flaking where it has been used for rough, rapid work. It was also frequently employed to 'outline' a figure and to hollow out spaces.

The point was similar, but sharper, and more popular. It was used in the same way as, and more often than, the punch for preliminary shaping. Deep channels, scored by large points, are still to be seen on the roughly shaped portions of sculptures. But in its various sizes it could carry the work considerably further than could the clumsier punch. It was often used on the sides, top and bottom of a relief to smarten up the shape. However, its principal use was clearly to rough out the main forms of the sculpture, removing the stone to within a few millimetres of the final surface. It could also be employed as a compass to delineate a circular item, such as a rosette. Its traces are often left on top of the bowls held by men reclining at the funerary banquet, as well as in the hollows of the men's palms, and around the edges of figures.

Ancient punch and point marks around the edges of funerary reliefs, in particular, must be distinguished from the signs of implements used rather more recently to prise the sculptures from their settings within the tombs.

The claw chisel, a tool apparently invented by the Greeks specially for carving marble, was in wide and constant use at Palmyra. Shaped something like a fork with exceedingly short prongs, it could be held vertically to the surface of the stone to produce a row of dents, or at an angle to create a group of parallel furrows of differing depth and length. Its width varies considerably, and may be most conveniently measured by quoting the number of teeth either to the centimetre or to the full width of the head, if this can be ascertained. At Palmyra it was normally used for the work between the preliminary rough shaping and the later carving. There is little evidence for its use until the erection of the temple of Bel, dedicated in AD 32, when it was employed by skilful craftsmen, not only on the sculptures but also on the cella blocks and in the fluting of columns.[361] The backgrounds to the great beam reliefs were smoothed

2, 19, 20

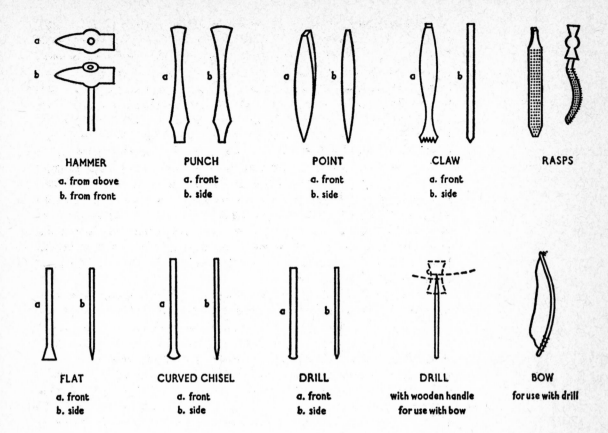

HAMMER	PUNCH	POINT	CLAW	RASPS
a. from above	a. front	a. front	a. front	
b. from front	b. side	b. side	b. side	

FLAT	CURVED CHISEL	DRILL	DRILL	BOW
a. front	a. front	a. front	with wooden handle	for use with drill
b. side	b. side	b. side	for use with bow	

with claws that were remarkably small for work on such a scale, and already we find evidence of the carving of drapery folds and accessories with the tool. Medium- and small-sized claws were popular for carving early funerary stelae. Sometimes claws of more than one size were used on one stele: their marks are left on the bases and architectural 'framing', but smoothed over with the flat chisel, not always efficiently, on the background. Claws remained in common use after AD 32. Sufficient traces survive on the funerary relief busts, particularly those of group I (c. AD 50–150), to show that the sculptors were using the claw actually to carve the rough figure, a technique introduced by late Hellenistic Greek sculptors.[362] These claws vary from light (c. 5 teeth to 1 cm.), preferred for flesh, to heavy (c. 3 teeth to 1 cm.), of which traces are more usually found on the background. Sometimes we find an artist differentiating his funerary relief bust from its background by deliberately cutting the background with the claw and then leaving it, as on the Bel temple beam reliefs.[363] During the second half of the second century AD, particularly among funerary reliefs, there seems to have been a tendency to cut out the claw work and to proceed directly from the point to the flat and curved chisel. This became most common among funerary reliefs of group III. The claw was not abandoned altogether, for it continued to be used for modelling awkward parts of the relief, and for carving altars.

56 Ancient sculptors tools (after 1, fig. 1)

85

64, 84

The most popular of the chisels was the flat chisel, with its straight-ended blade. It came in various sizes: there were large ones for slicing away sizeable flakes from the edges and backs of sculptures; and there were smaller ones, perhaps *c.* 1 cm. wide or less, for finer work. The angle at which they were held was naturally of great importance to the result. If they were placed almost horizontally to the stone's surface, a blow from the hammer would produce a small flat area on the stone. Dozens or hundreds of such facets could be juxtaposed at appropriately differing angles to mould and fashion the curving surface of a face or hand. For drapery, a similar technique might be used, but often the craftsman seems to have held the chisel at a somewhat higher angle. This, combined with a series of taps, could produce a neat angle and recess for a drapery fold. So popular was the flat chisel that many sculptures have few or no other kinds of marks. By using it at various angles and being careful with the hammer, the artist could carve quite complicated and tiny forms, notably jewellery, with its sharp edges, and locks of hair, with their parallel lines. When applied to eyes, noses, ears and mouths, the flat chisel produced a characteristically angular effect.

The curved chisel with its rounded end was likewise always in use. Its traces are not always easy to distinguish from those of the flat chisel, but the two tools are so similar in purpose and effect that this hardly matters. Indeed, curved chisels may often have developed out of flat ones as the corners became worn. Where they have left definite traces, these chisels seem to have had two main functions: to increase the depth of folds in drapery, and to model parts of the face – to carve a recess below the lower eyelid, another below the lower lip, a dimple in the centre of the chin, and occasionally grooves on the neck. Many curved chisels seem to have been very narrow, *c.* 0·5 cm. in width.

The mason's drill was used only to a limited extent. The smaller sizes were the most popular, from *c.* 5 mm. to under 2 mm. in width. Larger sizes found little favour except in architectural work; even in sculpture, however, examples up to 8 mm. broad are met with.[364] There were two principal ways in which the drill was used for Roman marble sculpture of the period: as a simple drill, spun with a strap or bow at all angles from vertical to almost horizontal, to bore single holes; and as a hand-spun 'running' drill, held usually at an angle of about 45 degrees, to score grooves in the stone. At Palmyra, drilling among early pieces is rare, of the simple kind and apparently only decorative.[365] But, like the claw chisel, the drill suddenly came into common use on the Bel temple beams, although it seems to have been confined to the architectural ornament. 'Running' drills of *c.* 4 mm. were often employed to score channels around the rows of eggs, which were themselves sometimes worked over with the flat chisel; while similarly sized drills, and others *c.* 7 mm. wide, were handled in the simple manner to bore single holes which helped to emphasize leaf points. For architectural decoration exuberant use of the drill remained permissible, and later even increased, to conform with contemporary Roman taste. It is striking how often, even here, the masons preferred the simple to the 'running' drill. For sculpture proper the artisans confined themselves almost entirely to the simple drill, which they normally held at the least potentially damaging angle, namely, vertical to the surface. The jobs the drill performed were likewise limited. Sometimes shallow holes remaining around a relief

Cf. 77

19, 20

figure indicate that the artist began by outlining the figure on the block with
a number of simple drill holes, driven in as far as where he intended the back-
ground to be. Sometimes the remains of arcs on the sides of deeply cut recesses,
such as around the female veil or to bring a limb free from the background, 85, 86, 89
show that the sculptor must have weakened the stone here with a series of
single bore-holes. But simple drill marks are normally found only in details:
in eye pupils (and very occasionally the lachrymal caruncles), ears, nostrils,
across or in the corners of mouths, and in jewellery – particularly female 86
jewellery in funerary reliefs, where the traces are seen most often in and around
the earrings, and less frequently on brooches and pendants. The drill, often the
'running' drill, was also used to give greater definition to certain lines, notably,
to differentiate a wreath from hair, or the veil from the turban, and to outline 86, 123
a figure lightly.

The greatest blossoming of sculptural drillwork occurred between *c.* AD 150
and 250. Many of the practices in this period are recognizable as those of
Hellenistic Greek and of Roman ateliers; and many of those sculptures, especially
the funerary reliefs, on which the drill has been used are Westernized in other
respects as well. Why, when the Palmyrene sculptors were so close to Western
workshops, did they not use the drill more? In Egyptian and in Greek and
Roman work the wide employment of the drill is concentrated on marble
and still harder stones. At Palmyra the softer local limestone was presumably
either considered to be unsuitable for drilling, or else (and more likely) was
found to be so easily worked by the chisel that drilling was unnecessary.[366]

It was common enough for Palmyrene sculptors not to proceed beyond
the chisel (and drill) stage at all. If smoothing were required, however, the
rasp lay to hand. The teeth seem to have been regularly spaced, and positioned
roughly 1 mm. apart. What shapes the rasps were it is impossible to say, but
they probably varied; some were narrow enough to be used in the recesses
of drapery folds. They could be used in long strokes, producing stretches of
parallel lines, or in criss-crossing movements. Their only function was to
smooth: they were not used to model. Palmyrene sculptors were, on the whole,
chary of employing rasps, perhaps because they had taken the tool from marble-
workers, and found the marks it left on their softer limestone too savage and
obvious; or perhaps because they so rarely, if ever, went on to the final stage of
rubbing-down, for which the rasp often prepared the way in Greek and Roman
sculptors' hands, that its use was pointless. The tool had two principal func-
tions. First of all, from the period of the Foundation T reliefs, it was used to
round off the sharp ridges of the most prominent drapery folds (the other
folds were left roughly chiselled); the rasp was run along parallel with the
ridges to achieve the rounded effect. Secondly, the rasp was not infrequently
used for flesh, whether human or animal. It is far rarer to find its marks else-
where, on other items of dress or ornament, on the priest's modius, on other
objects held or worn, and on the background. Most of this rasp work is fairly
crude, carried out with rather large tools. Sometimes, however, on pieces
that are carefully carved, a fine rasp has delicately smoothed wide areas of the
work. Sometimes, again, only the flesh of a figure is rasped; but generally
the rather indiscriminate use of the tool indicates that the sculptors did not
often consciously seek contrasts of texture.

How frequently did the Palmyrene sculptors go beyond the rasp stage to the use of abrasives, to remove tool marks and give their work a smooth, Western finish? A number of sculptures, particularly funerary reliefs, show a slight smoothing especially of the flesh surfaces that could be due to a rubbing with a smoothed piece of limestone, or with a wet cloth impregnated with limestone powder. More careful abrading, possibly done with the Western emery, pumice or quartz sand, is rarely met with, and seems confined to really Romanized pieces.[367]

89

STAGES OF WORK

Now let us take a number of sculptures chronologically, and try to distinguish the stages of carving.

4 The earliest dated Palmyrene carving known, the inscription of 44 B C in soft limestone, is unfortunately weathered. But its entire surface and decorative frame have apparently been finished with the flat chisel.[368]

30 The 'priest's' torso from Foundation T, and so datable somewhere around the turn or early years of our era, is also in soft limestone. The artist presumably roughed out his figure with the point, evidence for which survives in the socket for the separately carved head. He may have continued with the claw, but no trace remains. For the main work he used the flat; and in this instance he completed his figure by rasping it all over. The rasp lines follow the drapery folds, rounding them in section.[369]

A relief fragment with a horseman of c. AD 1–50 in soft stone was presumably shaped with the point, but no signs survive. Next came the claw; the teeth marks of a fine one remain under the horse's front rosette. The flat chisel completed the figure except for light drill-holes added afterwards to deepen the centres of decorative circles. A drill of 4 mm. width was used on the trousers, and of 6·5 mm. on the horse trappings.[370]

13, 14 The backs of the two early 'stepped bases' preserve rough point work. The front of each relief has been crisply and thoroughly carved with the straight-bladed flat chisel. The figures on each have been outlined, apparently with the point. The bottom left rosette on the Louvre relief has a compass-drawn line marking its upper extent, and the Palmyra example appears to have been rasped on its rosette and nearby colonnette.[371]

12, 14–18 The Bel temple, dedicated in AD 32, introduced hard limestone to Palmyra.
18, 19 The beam reliefs, moreover, show something else new: while figures, most objects and vegetal spirals are finished with flat chisels, the backgrounds (and the altars of 'Aglibôl and Malakbel) are left in the preceding stage, covered with the teeth-marks of fairly small claw chisels – one behind the 'Priests sacrificing' may have been of the size 9 teeth to 15 mm. This creates a contrast of textures, as sometimes seen later at Palmyra. Most of the chisels used were straight-bladed, but a curved one deepened the folds of the 'Battle' horseman's flying drapery. Below, in the architectural decoration and spirals, drillwork appears. The eggs have been carved with a tool c. 4 mm. in width, and some of the leaf-points have been emphasized by drills of c. 4 mm. and c. 7 mm.[372]

37 Kitôt's tower façade relief (AD 40) has been finished with the flat chisel over the whole scene and background to the inscription. Drapery folds are

sharp in section or with the top neatly flattened. The curved chisel deepened fold recesses. The architectural surround, however, has been left at the stage of the claw chisel (medium-sized) – a late classical and Hellenistic Greek habit. The roughly contemporary 'eagle' lintel from Ba'alšamin's sanctuary shows the same idiosyncrasy. The whole relief – the architectural surround, mouldings and relief field – was carved with a medium claw. Then the field, including the background, was worked over with the flat, although claw traces remain. Finally, the artist rasped the gods' heads, the rosettes and rays. He drilled groups of holes on the eagles' heads, and drilled again lightly in the beak and leaf of the left eagle, with a little instrument only 2·5 mm. wide; a broader one, 5 mm. in diameter, picked out the leaves along the top.[373]

12

On the early triad of Ba'alšamin (?), done in soft limestone, the artist set to work with a fine claw, of the order of 5 teeth to 8 mm., after preliminary shaping which has left no traces. With the claw he carved the block and figures, leaving marks on the block sides and on the sixth ray above 'Malakbel's' right shoulder. He proceeded to the flat, cutting his figures neatly. Touches of the rasp completed the work – perhaps on the gods' faces, and certainly on the central god's neck and on their trouser legs and lower cuirass lappets.[374]

35

Funerary sculpture has more to contribute. An early stele of soft limestone with a curtain in relief shows much claw work, typical for this group of monuments. A medium claw shaped the base, a smaller one the sides. The artist continued with the flat, erasing the claw work, and then gently rasped the arch and vertical drapery folds, following the fold lines.[375]

Cf. 67, 36

The superb funerary statue of a priest with base from Qasr el-abiad, carved towards AD 150, shows Palmyrene skill at its best. A fine, hard pale limestone was selected. Presumably the point or punch was used early on. But the earliest stage of which traces survive is that of the claw, whose marks appear on the base, partly erased by the flat. Perhaps it was used to model the whole, as often on contemporary relief busts. Final shaping on figure and base was done with the flat, exceedingly carefully. Turned on edge, flats were also used to pick out ornament. A last smoothing and softening was then given to all the drapery with a medium rasp, whose strokes run parallel with the drapery folds, rounding off their top edges. The flat and rasp were similarly used on the Ba'alšamin sanctuary statues, although hardly with comparable results.[376]

112

122

An invaluable opportunity to study the practices of entire workshops of Palmyrene sculptors has been provided by discoveries of whole groups of busts in family tombs. Palmyrene families clearly liked to patronize the same workshop over several decades; and the members of one workshop used strikingly similar techniques. Let us take the workshop which worked for the family of Zebîdâ, son of 'Ogeilû, between AD 113 and 150. These artisans did their preliminary carving with the point, and progressed to one of the range of larger claws – 5 teeth to 10 mm., even c. 6 teeth to 20 mm. – whose traces remain on figures and backgrounds. Figures were then hewn out of the stone with the flat, with which the background was also normally smoothed. Signs of curved chisels are visible in drapery recesses. Some of the craftsmen went on to rasp the flesh and drapery, where the strokes follow the folds.[377]

Similarly, the hypogeum of Šalamallat abounded between c. AD 150 and 200 with Western-style busts, which display exceptional modelling, drillwork

and an unexpectedly careful finish. The best, a woman, exemplifies the procedure. Some light drill holes around the figure seem to indicate how the sculptor marked her out on the block, drilling to the depth of the background. Then the point was used for shaping, assisted by a medium-sized drill *c.* 5 mm. in diameter. The drill was also used between the earrings and cheek, between cheek and hairline, in the ear lobes, to hollow out between the cheeks and veil, and between the turban and veil; to remove stone from behind the figure's right hand, leaving a strut shaped by the flat, and to create shadow between and beneath the fingers of her right hand; and likewise to cut out stone from behind her left hand. There is no sign of a claw. The bulk of the modelling was done with flats, with some curved chisel work also, but to an extent extraordinary at Palmyra the sculptor continually resorted to the drill to deepen and hollow out the relief. When finishing he rasped the face, neck and right forearm very carefully, treating the left forearm and drapery folds less carefully, as being not so prominent. He also added further delicate touches to the bust with a small drill *c.* 2 mm. in diameter: he gave her nostrils, holes at the corners of her mouth and a line across it, parting the lips.[378]

A group of heads from lost relief busts or funerary figures shows a further refinement. All the heads are Westernized, all strikingly drilled; and several possess in common one remarkable detail: the lachrymal caruncle is drilled, with a tool *c.* 2 mm. in diameter. This suggests that all the heads emanated from one workshop, in which it was the practice to add this detail.[379]

A similar care enhanced the bust of Aḫâ, daughter of Ḥalaptâ, dated 161. But here the sculptor may have gone even further. Rough shaping was executed with the point, and detailed modelling mostly with flats; much of the relief was given a rasp finish. Not only did the sculptor use drills of three different sizes, however, for hollowing, features and jewellery, but he appears to have smoothed the face finally with an abrasive.[380]

109 Two banquet reliefs illustrate the range of third-century techniques. On a small one in hard white limestone, elaborately 'framed', point marks from the early stages survive on the sides. The side angle with the front face is, however, sharpened with the claw, and traces of an intermediate stage with this are still visible on the architectural surround and in the background. The relief is carefully executed with flats, and some curved chisel work deepens the drapery. Finally, the whole is delicately rasped; on the drapery the rasp as usual follows the folds.[381]

But more revealing still is a large banquet relief, whose unfinished state is particularly helpful. Work began with the point, which shaped the back roughly and the sides more carefully. Then drilled holes sunk to the depth of the background outlined at least two figures – the reclining man and the child nearest the woman. Next the sculptor attacked the relief field with his point, adumbrating his figures. Some portions of these were left half-formed, such as the three children and the man's hair and ears; others, like the man's face and neck, were partly shaped. Now the sculptor had a choice: he could continue shaping gradually with large claws, or resort directly to flats. His method varied in different parts. Generally, he preferred to approach drapery and ornament with claws first, before flats; but for features and flesh he turned directly to his flat chisels. At this juncture the relief was abandoned.[382]

ORIGINS AND DEVELOPMENT OF LIMESTONE CARVING TECHNIQUES

Perhaps some tentative general observations may now be made concerning the sculptors' methods.

Until the period of the Bel temple the sculptors were working on a small scale and in soft limestone. They seem to have begun work with the punch or point, continued (in some cases at least) with a fine or medium claw, and modelled finally with flats. Rasp work over flesh and along drapery folds, together with a few decorative drill-holes, completed the task. Where did they learn these methods? Surely not in any ordinary Hellenistic Greek atelier. Admittedly, the tools were the same, and so was the basic procedure: punch or point, claw chisel for modelling, and then the flats. But there were important differences of technique, especially in the later stages of work. The late Hellenistic artist used his drill freely, both as a simple and above all as a 'running' drill, throughout the process of carving.[383] The early Palmyrene sculptor only ever used the simple drill, and this to apply decoration when the work was almost complete. When rasping, the late Hellenistic sculptor sought to eradicate the traces of chisel work (except where it was left for deliberate contrast), whereas the Palmyrene often left the hard edges made by his flats to create a special stylistic effect. The former always finished his work with abrasives, the Palmyrene used them comparatively rarely, at least before c. AD 100. True, the Palmyrene was using a different and much softer stone, but if his training had come directly from a Greek workshop, his methods, even when dealing with soft stone, would surely have reflected this teaching more closely. Perhaps the early Palmyrene sculptors learned their techniques from a tradition of craftsmanship derived ultimately from Hellenistic practice, but which had gradually adapted Hellenistic methods for its own ends and types of stone. Where had this adaptation taken place? Obviously, not so far away that the tradition could not travel to Palmyra; but a dearth of Near Eastern monuments of the period frustrates inquiry.

On to this rather humble sculptural scene the Bel temple reliefs suddenly erupted. The scale is monumental, and the handling sophisticated. The use of tools is similar to that of earlier periods, but there are striking differences of emphasis – for instance, the backgrounds covered with claw marks, the curved chisel in drapery folds, the drillwork. Why the differences? Was a whole army of Palmyrene sculptors sent away to improve its methods? Or was an army of more skilful sculptors imported temporarily from outside? We will consider these questions at a later stage. 18–20 12–18

The 'eagle' lintel from Ba'alšamin's sanctuary echoes the Bel techniques, if less exuberantly. In the main this method – punch or point, claw, flat and curved chisel, and then rasp and drill as desired – remained popular until the mid-second century AD. No significant change seems to have accompanied the general switch to hard limestone after c. AD 100. But from c. AD 150 certain developments are discernible. First of all, there seems to have been a considerable tendency to omit the claw stage and to move directly from point to flats. Secondly, and particularly – but not only – in Westernized work, we see a much greater reliance on the drill, which was introduced to outline figures on the limestone block, and to improve the detail of features, fingers 12

and ornamentation. Its period of greatest use fell between *c.* AD 150 and 200, when the final stages of work often received unusual attention, even to the extent of smoothing with abrasives. These techniques were obviously imported from ordinary eastern Roman marble-carving ateliers, where they were normal.[384]

89 The third century continued to see the production of work of quality, although there was a certain decline in standards, combined with a tendency towards haste. This haste could, however, be put to positive use: the 'gashed' 81 renderings of hair and beard, for instance, imitate contemporary Roman work.[385]

Marble and alabaster sculpture

The Palmyrenes rarely strayed from limestone into showier stones, such as marble, which would all have had to be imported from considerable distances. Only one instance seems reasonably sure: the clumsy, late marble stele from the Baʿalšamin sanctuary dedicated to Šadrafâ and Dûʿanat, where the technique resembles Palmyrene limestone work.[386]

Otherwise, the few marble sculptures found in and around Palmyra are carved with the same tools used on the limestone sculptures, but in a totally different technique. Works executed in marble include some architectural wall-veneers, the Castor relief, the statuettes and the marble statuary prin-
126, 128 cipally from the Agora area. The statue of *c.* AD 200, for instance, showing a woman standing uncomfortably, exhibits point and claw work on the plinth. The statue was carved with flats, curved chisels and the 'running' drill. Crude flat strokes remain on the back. The front was rasped, stopping at the sides, and was then smoothed with abrasives. The channels between fingers and toes were drilled, and the feet were isolated from the rather rough plinth with a further, flat-cut channel. A marble female head from this area under-went the same process. One drill, *c.* 3·5 mm., hollowed out the stone between veil and cheeks, which was then cut out with the curved chisel; another drill (*c.* 1·75 mm.) gave her crescent-shaped eye-pupils and parted her lips. A cuirassed torso preserved at Palmyra was also flat-cut, drilled, rasped and smoothed; so was the lumbar portion of a naked Aphrodite (?), whose buttocks were divided by the drill. All of these practices were alien to Palmyra, but were characteristic of eastern Roman workshops, whence these sculptures, or at least their creators, must have come.[387]

Other statues of 'Parian' marble are mentioned occasionally in texts, if this is what the Greek *parinos* means at Palmyra; but the interpretation of the word is disputed. Another exotic material is represented by a small group of works in alabaster, mostly vessels, but these were probably imports.[388]

The colouring of sculpture at Palmyra

The addition of painted colouring to sculpture, widespread in antiquity, was commonly practised at Palmyra.

Some early sculptures were lavishly endowed. Red and green enliven the Foundation T Victory fragment. The 'Red Head' of obscure purpose in

57 Early red-painted
female head (PM 180/
1272; ht. 18·5cm.; after
154, pl. 31.3)

Palmyra Museum is covered with paint: red for the features, and brownish- 57
red for the hair, irises and earrings. An early head of 'Aglibôl is also red. The
woman shown as an early polychrome statuette wears a plain cloak and a 44
green tunic with one red-bordered pale stripe down the centre, and another
across the ankles; her neck is red.[389] The Bel reliefs are equally bright. Take the
'Battle' scene: red survives below the giant's belt, blue on the cloaks of the 15
horseman and the second deity to the right of him, and red on the cuirass
and black on the cloak of the third deity; beneath, there is more red inside
the eggs and all over the background of the spiral. Kitôt's funerary banquet
scene (AD 40) preserves greeny-blue on Kitôt's trousers, the waistband of the
young man on the left and the woman's drapery; the faces are clear red, the
hair brown-red, and a brownish-red stripe adorns the left man's tunic. The
vine behind, moulded in plaster, has greeny-blue stems and leaves and black-
blue grapes. A horseman relief, also of the first century AD, adds another
colour: yellow, preserved on the horse's trappings at the back of its head.[390]

Less is known of second-century practice. Polychromy, however, clearly
continued. A little relief dedicated to Abgal has black above the god's upper
lip; red covered his garment folds, the pommel and scabbard of his sword,
and one of the two rows of beading around his cloak (the other was blue).[391]

Relief-bust producers varied in their practices. Some used considerable
colouring, especially red for heads. Others confined paint, if used at all, nor-
mally to eyes and ornament, picking out pupils, eyelashes and eyebrows in
black, and intaglios in red. Two busts from the Ta'ai hypogeum group have
had their pupils similarly done in black: so presumably such painting was
executed in the workshop, and each workshop had its own habits. One woman
has a red tunic stripe. A more colourful second-century female piece, however,
possesses black on pupils, eyelashes, eyebrows and two of her chest ornaments.
Her necklaces and bracelets carry a rich yellow, simulating gold; her tunic,
too, has a decorative stripe. Even more fully coloured is the battered head
of a priest, with black pupils, eyebrows and cap, and red face and wreath;
another priest had a yellow sacerdotal crown.[392]

Third-century method was similarly varied. Pupils, eyelashes and eyebrows
100 are blacked on one large banquet relief, and a female bust has colour on necklaces
and brooch. The triclinium of Maqqai (c. AD 229), however, is differently
102 treated. Costumes, appurtenances and couch are lavishly coated in red and blue.
Indeed, they are treated remarkably like the almost identical figures of the
wall-painting behind. But the subtlest colouring is that which enhances an
89 already superbly carved relief bust of an unknown woman, the 'Beauty of
Palmyra'. Her plethora of jewellery is generously covered with yellow to
imitate gold; her head ornaments include pieces in red. The locks of hair
which escape her headdress are black, her lips are red and – an arresting detail –
a circular red patch on each cheek even conveys the impression of rouge.
The intricate ornament and yellow paint of her arm clasp recall a collection
of forearm fragments with clasps of a similar quality and colouring, found
mostly in Elahbel's tower-tomb. Perhaps one workshop, one of the foremost
of Palmyra, produced them all.[393]

Too few examples of colouring survive for any general development to be
perceptible. In all periods paint seems to have been used both lavishly and
sparingly, or sometimes not at all.[394]

The practice of inserting red (and occasionally black) paint into the letters
of an engraved inscription began at an early date, and lasted throughout
'historical' Palmyra.

Additions to sculpture in other materials

Besides the normal colouring, Palmyrene sculpture sometimes preserves traces
of additional work in other media.

Plaster had been used by the artists of some of the Foundation T statuary
6,7 to attach outer limestone plaques to the central core of a statue. This procedure
was soon abandoned, but plaster remained in occasional use to finish relief
figures which, for whatever reason, could not be completed on the stone
37 block. On Kitôt's banquet relief, for instance, the lower part of the body of
the young man on the left was modelled in plaster. The right-hand head of
the Berlin Antiquarium triad was also done in plaster, clearly in the West.
And the right shoulder of a banqueting priest in the Ta'ai hypogeum was
similarly rendered.[395]

35 The right hands of the three gods on the early 'Ba'alšamin' relief projected
so much that they were each carved separately and attached by a stone tenon
and mortise. There is no sign on the relief of the lances they probably held,
so these were perhaps of metal, and attached. Rows of holes round the cuirass
waist lappets of a couple of second-century gods look more than merely
decorative, and were possibly intended for metal additions. Two second-
123 century heads have eye pupils so deeply drilled that they recall the sockets
sunk into the eyes of numerous earlier and contemporary Near Eastern sculp-
tures to receive inlay; but no trace of inlay remains, and the parallel may be
misleading. However, one funerary relief bust of a priest from the family of
Ta'ai definitely has some inlaid work. The normal decorated brooch pins
his cloak on the shoulder: but into its centre the artist has inserted a circular
piece of terracotta with green glaze or enamel on it.[396]

Places of work

Obviously, work that could not be transported, such as wall-painting and large-scale mosaic not prefabricated, was carried out on the spot. Portable pieces were doubtless mostly executed in workshops and taken where they were needed: but not always. In the hypogeum of Iarḥai, 'Atenûrî and Zabdibôl were found two large and almost identical banquet reliefs. One, however, is unfinished, except for the central reclining figure whose lower limbs are wrapped in a Greek cloak. On the completed relief this Greek cloak has been removed from the figure, to expose a splendid Parthian tunic hem and trousers. Clearly, the unfinished relief was imported into the tomb first, with the figures blocked out. The sculptor began with the central figure. Then the patron visited the work, and objected to the voluminous and uninteresting cloak. The relief was cancelled, and another brought in and completed to his satisfaction. The first relief, however, was left in the tomb. Many other large sculptures were probably also carried out more or less *in situ*, to obviate the formidable problems of transporting them without damage. Likewise, the Bel peristyle beam reliefs could have been carved in place like some or all of the Parthenon frieze in Athens.[397]

18–20

8
Iconography

Change and development in the art of antiquity occurred normally through the refinement of existing models, or when an idea or motif from one source fell upon receptive ground elsewhere. The individual genius who forged a truly original model was rare. Further, such originality as actually existed is often hard to define, has scant documentation, and usually formed part of a chain of development. Adaptors of originals were, however, more numerous, and copyists plentiful. A motif might continue in a repertoire for decades, centuries or even millennia; and when adopted elsewhere it might already have a long and complex history behind it. How great was the debt owed by Palmyra to other sources for the vocabulary of her art?

Art forms and positioning

(A) Religious art

Religious art at Palmyra was placed mostly in sanctuaries. The divine statue had appeared by the turn of our era. It had existed earlier in the Near East, but never so abundantly as in the Greek and Roman worlds; nor was it popular
8–11 at Palmyra. In the sanctuaries, the siting of the divinities perhaps within wall-
4, 9–15 niches, and more certainly in the temple thalamoi, seems oriental. The rarer appearances of the statues outside, for example in the Agora and Baths, indicate Western influence.[398]

4, 9–15 The sanctuary wall-niche, likewise an early form, has no Western ante-cedents; and even though it was almost certainly derived from the East, its exact parentage is obscure.[399] Similar niches were popular in contemporary southern Syria.[400] At Palmyra itself, however, they became rare after the first century AD.

4 The temple thalamos makes its first known Palmyrene appearance in Bel's shrine, dedicated in AD 32, where it bears carved relief. It recurs in the temples of Nebû and Baʿalšamin. The Bel examples evoke the basic design of the wall-niche, and all are related to thalamoi of southern Syria. Assyrian ancestry has been claimed for them: if correctly, the discovery of further intermediate stages would be welcome.[401]

Near Eastern thinking reappears in monumental temple decoration. The most extensive decoration undertaken was that of the Bel temple. The horizontal, downward-facing relief above the entrance occupied a large ceiling

coffer, a blown-up version of a common Western type. Each side of it were placed vertical reliefs of rectangular shape which were continued round the peristyle, where they filled the fields of trapezoidal beams. Reliefs of this form are unparalleled in antiquity. What was intended by the designer(s)? The reliefs were placed at the level of the very top of the cella wall, immediately beneath the ceiling – the height at which a Greek or Roman temple frieze would be placed. So the reliefs could be the Palmyrene equivalent of a Western frieze, but for obscure reasons put crosswise instead of along the peristyle. Parallels among architectural reliefs elsewhere are hard to find.[402]

13–16
20

The stone coffering of the peristyle ceiling was subdivided geometrically and filled with motifs inspired by Greek and Roman predecessors, but of a richness and variety more closely paralleled in the Roman East.[403]

22

The positioning of the thalamoi carvings is again curious. Lintel reliefs were common enough in the ancient Near East, but were not favoured by Greeks or Romans. The exposed underside or soffit of the lintel, however, was the unusual choice of site made for one north thalamos relief: an idea which links Palmyra with northern Mesopotamia, and Hatra.[404] The coffered stone thalamos ceilings were conventionally Western, apart from their huge central portions.[405]

21
18

How early did the independent religious relief appear? Many, or all, of the early pieces perhaps belonged to wall-niches. Independent reliefs may have appeared by the end of the first century BC, or not for another half century or more, when the wall-niche was apparently declining. Deities are depicted on the reliefs, with or without the rite of sacrifice, and in such cases the reliefs acted, sometimes at least, not merely as votive offerings but as cult images too.[406] The use of the independent cult relief seems to have become widespread only in the first century AD, and only in the Near Eastern area. In developing this form, the Palmyrenes were sharing in a practice that extended north into Anatolia, westwards to the limits of the desert, and eastwards at least to nearer Iran. From this area the cult relief travelled west, principally in the service of the gods Mithras and Jupiter Dolichenus; the conception lived on for centuries, eventually emerging transmuted into the Christian icon.[407]

16, 30–44

The altars, great and small, that were erected in such profusion to the deities belong to a genre of Greek origin widespread in the Roman Empire; the commonest types have close Hauranese counterparts. Some of the little tesserae, as tokens for entry or participation, also show Roman parallels. But they appear in such great numbers, responding to a special local need, that many or most types must be of Palmyrene origin.[408]

48–51
31
32
54

(B) FUNERARY ART

Palmyrene funerary monuments, as we have seen, grew out of various Near Eastern traditions; but some of the decorative ideas apparently came from further afield.

The repertoire for tomb doorways, arches, lintels and the rest was derived chiefly from the Hellenistic and, after *c.* AD 100, the Roman East. But what of the niches with sculptures that began to enliven the exteriors of tower façades from the early first century AD? They seem to recall those of late

56

Republican and early imperial Rome, although the frequent choice of a banquet scene for this position was more a Syrian phenomenon.[409]

57, 113 Internally the coffered stone ceilings, finished in stucco and paint, that bear human busts, mythological scenes or severely geometrical designs, seem like their temple counterparts to fit fairly happily into late Greek and eastern
114-18 Roman tradition. Painting pure and simple was mostly to be found in hypogea, as elsewhere in the Mediterranean world, past and contemporary; much of it was minor work.[410]

The nefeš demanded by Semitic burial custom assumed various forms. Early
67-8 on the scene came the free-standing stele with arched top. This has been regarded as inspired by the nefeš of western Syria; but although some parallels exist here, Parthian Mesopotamia – Assur, to be precise – has yielded some strikingly similar pieces, one dated probably 89/8 BC, or possibly a century later.[411] The general change to the flat top seems to have been dictated by the subsequent transference of these stelae into the tomb. The rectangular block with a bust
63-6, 76-94 or busts in relief, however, again strikingly conjures up the similar stelae of late Republican and early imperial Rome and Italy.[412] The block with a
62, 98-100 funerary banquet scene, on the other hand, would seem to have been taken rather from the east Mediterranean stock of ideas.[413] But the use of figured nefeš to close off tomb burial compartments looks like a local phenomenon.

The funerary statue, never popular in antiquity, maintained a fitful existence in the Greek world but was hardly to be found under the Roman aegis. Its early appearance and two centuries of precarious life at Palmyra is, therefore, interesting; perhaps it represents a local adaptation of the ubiquitous honorific statue to the needs of the nefeš. Its position, sometimes at least, on a projecting
112 wall-bracket within the tomb echoes local Syrian and northern Mesopotamian
110 practice.[414] The Copenhagen lion, on the other hand, belongs to a breed well known in Roman funerary art.[415]

102, 104, 106 The carved stone sarcophagus, when it eventually evolved, c. AD 150, was given a figured decoration which had developed out of the funerary banquet relief. The commonly L-shaped lid and the representation of the couch on the base set it well apart from both Greek and Roman traditions. The undecorated back, normally a Roman feature, here resulted from the transmutation into stone of plaster forerunners, themselves placed against walls. The rare placing of a reclining figure in the round on the lid was more a Greek practice than Roman.[416]

The painted exedra began to be introduced as a special feature into hypogea
114 also towards AD 150: that of Ḥairan is dated AD 149/50, and the Three Brothers'
115-17 commission followed not long after. This was again a Western idea, adapted to local needs.[417]

(c) LOCAL SECULAR ART

The honorific statue constituted a major secular art form at Palmyra. In the Greek world it had originally been employed to commemorate the leaders of society; but by the second century BC the middle classes were using it as well. It then spread to Republican Rome, and Rome introduced some of the early examples at Palmyra, c. AD 17-19. Within a few decades of this it was

firmly established locally – free-standing, sometimes on its own pedestal or 121–3, 127
column in the Western way, but mostly positioned on projecting column and
wall brackets in the manner characteristic of the Syrian, southern Anatolian
and northern Mesopotamian region.[418] But honorific figures carved in relief
on limestone columns are characteristic only of the western Syrian area, and
those apparently honorific busts affixed to lintels and arches of public buildings 130
seem even more strictly local.[419]

Other sculptural forms belong to both Roman and western Parthian cultures.
The figured capital, although comparatively rare everywhere, provides an
example.[420] So does the plaster figurine: here material locally available has
obviously ousted the normal terracotta, or bronze. The 'dancing girl' statue 135
could be the Semitic equivalent of the ubiquitous Olympian deities of Western
'apartment' sculpture.[421]

Pottery design, for amphorae, lamps and the rest, has much in common 132
with that of other eastern Mediterranean and western Parthian sites. Glazing,
so popular in Parthia, is absent. The few remnants of glassware show a faint
connection with Greek models. Some items in alabaster look like imports.[422]

The finer textiles were imported. But coarser kinds, probably of local
manufacture, are so akin to comparable fabrics found at Dura-Europos both 52–3
in design and ornament that they must stem from a style general to the region:
likewise much of the jewellery.[423]

Composition of scenes: types and devices

The basic types of composition employed by Palmyrene artists for scenes on a
plane surface were two.

The 'processional' type of composition shows a group or row of figures
arranged in profile one behind the other, as if in procession. This arrangement
was confined to the early period of Palmyrene art. It was used both for humans 13, 26, 19, 20
and for animals on pieces from Foundation T and related fragments, for the
two attendants to the left of the Bel 'Sanctuary' relief, and for the Helios 19
relief genii of AD 30/1. It stems straight from immemorial Near Eastern practice;
but at Palmyra it had vanished by the mid-first century AD.[424]

For the second, 'paratactic' composition the figures are turned to the front
and set side by side, an arrangement which, by the canons of Greek and Roman Cf. 41–3
art, severs any relationship between the figures in the design. But from the
fact that complex scenes are built up in this way at Palmyra, it emerges that the
Palmyrenes must nevertheless have viewed the figures as if they were inter- Cf. 15
connected. This 'frontality' also affects the poses of animals, which often turn 46, 52
their heads towards the spectator. The paratactic arrangement appeared around
the turn of our era, and thereafter reigned supreme until the demise of Pal-
myrene art. Its rise, intimately connected with that of frontality (which we
are about to discuss), may perhaps be attributed to a 'frontal' interpretation
of the processional. Parataxis was usually applied in its full rigour, but oc-
casionally it was relieved by certain variations, particularly from the mid-
second century onwards. Heads and trunks, for instance, were sometimes 98, 100
turned at an angle, or the outermost figures of a row made to face slightly 102, 106

inwards; or again the figures might set one foot forward, alternating right and left and so creating a delicate rhythm.[425]

Several compositional devices were used in the processional and paratactic designs.

(A) FRONTALITY

Frontality means the turning of a figure or animal to the front, so as to face the spectator. It can be seen in operation most clearly in two-dimensional art – relief, painting or the like – and especially where more than one figure is present. But its rise at Palmyra can best be followed, and dated, in sculpture.

In the first century B C the ancient profile view still dominated Near Eastern art. Palmyra provides the earliest signs of change. The Foundation T relief fragments, probably of the late first century B C or the turn of our era, include one with a male figure in total profile, and two others with wholly frontal men. With these fragments can be associated the three other reliefs, found out of context, which mix profile with frontal, or nearly frontal, figures. Later the 'Helios' relief of A D 30/1 combines a frontal 'Aglibôl with seven profile genii, and the Bel 'Sanctuary' scene has two (entirely?) profile attendants before two frontal gods.[426] After this, frontality was used almost universally throughout Palmyrene figured relief and painting, for groups as much as for single figures. Exceptions are not numerous, and are easily explained. Western influence accounts for most of them, such as the profile Victories of a religious niche socle, slight turns of the head and trunk in religious and funerary reliefs, the commonly three-quarters or nearly profile position of the seated female of the funerary banquet scene, the varied positions of Greek mythological figures, and most of the profile figures of the tesserae, many of which must have been imitated from Roman coins. The few remaining profile tesserae figures are mostly attendants, as on the Bel beam relief, and may therefore have lived on in minor art after the general abandonment of the profile figure elsewhere.[427]

Frontality soon spread further east. Dura-Europos knew it by A D 31, and throughout the second and early third centuries it held complete sway over the art of western Parthia. Its overthrow of the ancient profile figure was revolutionary. But with the accession of the Sasanian dynasty to power in Iran came an equally remarkable, almost total reversion to the profile view throughout the realm.[428]

Upheavals of this sort are often due to factors beyond the immediate sphere of art itself, so a proper explanation of the rise of frontality must take into account the cultural backgrounds involved. So far, three attempts at explanation have been made, and each argument has its flaws. The first derives Palmyrene and Parthian frontality from sporadic manifestations in earlier Near Eastern art, where it is believed to have lent a vivid 'living presence' to certain figures; unfortunately, no clearly discernible line of connection with earlier examples exists.[429] Secondly, a Greek origin has been strongly argued; but two important drawbacks to this have been overlooked. The first consists of the position of the feet of Palmyrene standing figures. On paratactic religious and funerary stelae the feet are (both) turned frontally until the mid-first century A D. The only exceptions are the fully Greek figure of Heracles, beside

completely frontal deities on an early relief, and the figures of the Bel temple 19, 20, 14–16
beam reliefs, which, like all Palmyrene figures after the mid-first century,
adopt an old Greek posture with one foot more or less frontal and the other
turned slightly or strongly to one side. This detail could imply that Palmyrene
frontality was of non-Greek, or at most very distantly Greek, origin, but
became somewhat Hellenized after its arrival. The other drawback is simple:
why was *frontality* chosen from the plethora of Greek poses? The Near Eastern
desire for a 'living presence' has been suggested as the answer; but there is no
proof that this was in fact the ancient Near Eastern view, nor that it still sur-
vived. And neither hypothesis explains why frontality arose at this particular
time, the late first century B C, and in this particular area.[430]

A third theory seeks to explain both the cause and the timing of the rise of
frontality; it alone takes into account psychological, political and religious as
well as artistic factors. Authorities agree on the psychological effect: frontality
brings the spectator into close, even personal contact with the figures before
him. But why did it appear here, and at this time? In the 60s B C, the Seleucid
kingdom fell to the Romans. The 'liberated' Semitic populations saw in this
the failure of the foreign, Seleucid deities; their own baals had finally triumphed.
Nationalistic feeling arose; by 44 B C Aramaic was being used as an official
language at Palmyra, and soon afterwards it spread across northern Syria and
Mesopotamia into official and private spheres. Probably by the turn of our
era frontality had appeared in art, in a religious context. Can we discern how
it is being used? Palmyra provides most of the evidence of transition from the
profile view. Early reliefs show profile worshippers behind a frontal, or three- 19, 20
quarters frontal, sacrificer. The Bel 'Sanctuary' relief has two (entirely?) profile 19
attendants before frontal gods. The 'Helios' relief shows a large frontal 'Aglibôl 28
above seven lesser, and smaller, profile genii. What principle is operating?
Surely, one of differentiation of status: the sacrificer, in contact with the
divinity, is shown to be more than an ordinary mortal; and gods are also
shown to be greater than mortals – some are greater than unimportant *im*mortals.
But why *frontality* in this context? Perhaps, it is suggested, a change was taking
place in religious consciousness, as part of the new nationalism; the old Semitic
deities were honoured afresh (the triads of Bel and Ba'alšamin may have been
organized at Palmyra at this time). But combined with this was a new realization
of personal individuality, and a new hope of the after-life: gods now listen
to mortals, and in order to have greater contact with them, turn with the
officiants to look directly at the worshippers. This would account for those
monuments which mix frontal, or nearly frontal, with profile views. Still
unexplained is the rapid spread of frontality to every figure, divine, priestly
or mortal, in every scene, whether sacred, funerary or secular. Perhaps the
living worshippers, and then the deceased, adopted the frontal pose at first
so as to be like the gods and their officiants, to partake of their immortality.
And then this could have become established subsequently as a convention for
the representation of every kind of figure. Even if Greek art in some form had
shown the artists a way to achieve frontality, Semitic needs had guided them in
their use of it.[431]

Frontality, like Aramaic, was tolerated by the Romans in Syria, and adopted
by the Parthians and their vassals. When the Sasanian dynasty overthrew the

Parthian in the AD 220s, frontality was obviously regarded as associated with the vanquished, and so, apart from its use in 'Investiture' and 'Homage' scenes, it was rejected in favour of profile figures, as in the art of the Achaemenians with whom the Sasanians wished to associate themselves. And when the Romans put paid to Zenobia's ambitions in AD 272–3, independent Palmyrene art, like Aramaic, was suppressed.

So the rise of frontality has to be seen against a wider background than that of art alone.

(B) SYMMETRY

The symmetrical arrangement of the components of a scene was commonest in the early period of Palmyrene art, but lasted throughout. It could be combined with either processional or paratactic compositions, and was sometimes employed for part only of a paratactic design.

Symmetry was habitually used for the various fields of relief on sanctuary votive niches – lintels, socles, bases. Processional animals characterize some of these socles and bases; and it is an interesting question whether the early figured processional frieze fragments were likewise originally symmetrical. Independent reliefs show the symmetrical method in use for the representation of a triad; and where a triad is placed among other figures, symmetry could be regarded as being present if not dominant. Two striking reliefs, one dated AD 154, the other clearly later, represent a different type. Opposed rider gods in 'heraldic' confrontation hem in a worshipper placed, most unexpectedly, at the centre of the relief. Symmetry is also not infrequently found among tesserae compositions. In funerary reliefs, its use is rarer: the lower portions of banquet scenes sometimes display it; once at least the protagonist of a banquet relief is moved to the centre, and framed by a seated woman at each end – but this is most unusual.[432]

Symmetry had long been a component of Near Eastern art, well favoured in Achaemenian times and currently present, along with frontality, in the relief work of centres further east, such as Hatra. Greek artists, by contrast, had tended to avoid, or at least to disguise it. Much Palmyrene symmetry, therefore, must be derived from the Orient. But the 'heraldic' composition so resembles the standard Dioscuri scene of the Roman east Mediterranean and Anatolia that it is hard to believe there is no connection.[433]

(C) VERTICAL PERSPECTIVE

'Vertical perspective' or 'high viewpoint' are terms used to describe the ancient device whereby the background of a scene is raised up above the foreground. This enables the artist to show the spectator what lies behind the foreground; figures or objects are arranged as if they were placed on a steep bank.

The only sculptural specimens of this kind of perspective at Palmyra are to be seen among the Bel beam reliefs. The 'Procession' provides a remarkable example: the upper figures to our left are, to our eyes, floating in midair; but the women, in particular, are clearly behind the foreground figure, and so these upper figures are all obviously meant to be interpreted as standing

Margin references:
13, 14
26, 29
35
43
54
101
20

further back; similarly, the central woman of the group to our right is surely intended to be behind, not taller than, the others. The fragment of another scene includes two 'floating' legs, doubtless to be understood as behind their fellows on the base line. A tessera also shows vertical perspective: the back portion of a city wall rears up above its frontage.[434]

16

32f)

Stunning examples of composition on several levels within the same scene exist in late Assyrian reliefs, but the conception is different from Palmyrene work: foreground and background are apparently not so strictly defined, if at all. And Achaemenian relief designers preferred everything on a single base line. So precise antecedents for Palmyrene vertical perspective seem absent from earlier Near Eastern work. Instead, late Hellenistic reliefs would appear to be a more likely source. In the Telephos frieze of the Great Altar at Pergamon, carved *c.* 160 BC, precisely this device is applied in a major sculptural composition. It reappears in Roman imperial reliefs. Vertical perspective, therefore, would seem to be derived from late Hellenistic art.[435]

(D) THE THIRD DIMENSION

Any attempt to introduce the idea of a third dimension, of 'recession', into the thoroughly two-dimensional context of Palmyrene art, with its profile or frontal views, went directly against the fundamental nature of that art and was consequently uncommon.

A third dimension first appeared during the formative period of Palmyrene art around the turn of our era. A sacrificer on one of the processional scenes is shown in three-quarters view. Then *c.* AD 32 horses at the same angle leap within the coffers of the Bel temple peristyle ceiling. The lower portion of 'Ištar' on her late first-century relief is similarly turned; but she is seated, with her upper part frontal, on a profile throne. Behind her the square pillar is at an angle. A century later Leto's seated position is likewise twisted; nor is Ba'alšamin, of the Khirbet Abû Dûhûr graffito, comfortably seated. On the Louvre relief of six aligned deities, the outer two turn slightly inwards. Tesserae contribute a bull's head and the four legs of a bed.[436]

19

38

40

30

Funerary art offers slight angles, slight differentiation in foot postures, primarily among the 'pages' and servants of third-century reliefs, to create illusions of depth. And a number of late second- and third-century relief busts have heads turned somewhat to one side, usually to their left. But the seated women of banquet scenes provide the widest range of angles. The majority are frontal. After *c.* AD [1]46/7, however, some are almost completely profile. Among various objects depicted in funerary art, boxes, vessels and so on, are again normally frontal; but several jewel caskets, of between AD 150 and the early third century, and a third-century *triptychon* (writing tablet), are shown in three dimensions. Finally, the 'Aphrodite' and 'Meleager' reliefs, and the Achilles, Ganymede and dado fauna paintings of the Three Brothers' tomb, obviously following Western models, embody considerable 'recession'. Secular art has little to offer, apart from the group of extraordinary plaster figurines, which twist with a violence worthy of Hellenistic Greek art.[437]

102, 106

79

61, 62

98

80

74, 75

A method of a somewhat different kind is used in the Three Brothers' tomb pilaster paintings. Here the standing women are placed against a background

117

of two plain colour washes – green up to shoulder height, blue above. Objects are sometimes placed on top of this green 'wall'. The device is a simplified version of the Hellenistic Greek painters' system of receding planes usually called 'stage space', also seen in the Dura-Europos Synagogue.[438]

So the Palmyrene artists introduced a third dimension in two main ways. First, figures or objects might be placed at an angle to the background: standing male figures early and late, relief bust heads after AD 150, seated females occasionally in the first century but more often later, and some usually rectangular box-like objects; occasionally, Western models were closely followed. Secondly, 'stage space' might be used. Both kinds most often occur between c. AD 140 and 250. Alien to the principles of Near Eastern art, they must all be the result of Hellenistic and Roman influence.

(E) ANALYTICAL REPRESENTATION

For this device the individual elements of a subject are analyzed and represented together as a collection of characteristic aspects, not from one uniform angle as seen by the eye. The device was used sparingly by Palmyrene artists. Perhaps the often out-turned ears of relief figures result from it. On one tessera a derrick is spread out fanwise; on another, the temple of Belḥammôn seems to be shown from front and side; and, on a third, all the elements of a composition are scattered over the field. On two third-century reliefs, Nemesis' wheel is oddly angled.[439] The surest example, however, is that encountered on the relief dedicated in 263 to the god Malkâ. A chariot is turned frontally, but its wheels are splayed out sideways. This motif has a curious history. The frontal chariot occurs in archaic and classical Greek art, then disappears. It re-emerges on Roman imperial coins and medallions from the early third century AD, crops up at Palmyra in 263 and carries on into later Roman and Sasanian art, with one new detail: the chariot wheels appear side-on. This later scheme looks very like an 'analytical' version of the earlier. Palmyra could have drawn it from eastern Roman or western Sasanian sources, whether or not the conception behind it was understood.[440]

If this conception genuinely underlies some or all of these examples, clashing as it does with the principles of Western representation, it would seem most likely to be Near Eastern in origin.

Individual motifs

(A) SCENES

Early Palmyrene art is linked firmly with the ancient Near East through its processions of animals and figures, and its eagle lintels. But at Palmyra these scenes have been modernized, and new elements introduced. Frontal deities are now sometimes placed between the animals. The processional figures, worshippers, are interrupted by priestly sacrificers who cast incense on to an altar set beside them. This scene of incense burning is also used by itself, repeated so as to fill a relief, as on the Bel beams; by the late first century AD, however, we find it regularly set before one or more deities. Of very ancient Near Eastern

Margin references: 64, 70, 77 / 54 bb) / 42 / 19, 20 / 13, 14, 12 / 26, 29

origin, the scene had more recently been current in the Hellenistic and Republican Roman worlds. The eagle lintels, likewise ancient, are similarly updated with frontal busts, figures and standing eagles.[441]

9, 12

From an early period deities might constitute scenes in their own right, singly or combined, as standing figures or busts. Then, from c. AD 50–70, deities and mortals might be juxtaposed in votive scenes. Both types had Near Eastern and Hellenistic precedents, but the juxtaposition began to occur at Palmyra roughly at the time when deities entered (Flavian) Roman state reliefs.[442]

39, 41–3

The Bel temple artists introduced new scenes, for many of which it is difficult to find parallels. The frontal gods and sacrificing priests we know. The 'Sanctuary' scene could have been derived ultimately from Hellenistic votive reliefs, with their similarly statuesque deities and mortals, and landscape and architectural background. The 'Battle' scene exists in a simplified relief version at Soueida, south Syria, and the 'Procession' scene, apparently, in an equally shorthand version from Dura-Europos; so both were doubtless current in contemporary Syria in various forms.[443]

19

15

20

The Bel artists also introduced the 'inhabited scroll', a Hellenistic (Alexandrian?) acanthus spiral in the coils of which Erotes hunt, watched by Victories; with this they embellished the peristyle beam soffits. The Bel examples constitute the richest combination of these elements known from so early a period in the Roman world. At Palmyra, the motif recurs occasionally as architectural and textile ornament.[444]

18

Among smaller votive reliefs, the row of frontal deities became standard. This arrangement, although it echoed earlier Near Eastern composition, may in fact have been derived from similarly paratactic compositions in Greek and Roman art. A rider god either side of a central worshipper at an altar can be paralleled in the Dioscuri reliefs of Roman Anatolia.[445] Other scenes are more definitely of Western origin: the handshake between gods, the crowning with a laurel wreath, and the profile deity seated on a rock.[446]

41, 44

43

19, 21

25

The zodiac arrived from the West, in the form established in the first century BC, to decorate carved ceilings. One encloses the planetary busts in the Bel temple north thalamos. Another, with planetary symbols beside the Signs, surrounds a figure astride a feline (Dionysus on a panther or tiger?) and gives an individual's horoscope. It probably embellished a 'funerary temple' of c. AD 160–260.[447]

18

The banquet scene in Palmyrene religious and funerary art was derived from Hellenistic Greek reliefs. The Palmyrenes retained the essentials – the male reclining on his couch, the seated wife often at his foot, and additional standing figures – but rejected such items as the three-legged table almost totally; and they proceeded to evolve their own local version of the scene. At first, couch and figures all rested in the Greek way on the same base line, as on Belšûrî's relief of c. AD 33, on Kitôt's relief of AD 40 (the slave originally shown to the right), on a later, severely weathered piece and on a tessera. But the main part of Kitôt's relief illustrates the 'flagrant illogicality' which reigned after c. AD 40. Additional figures were ranged henceforward usually along the couch mattress itself, standing behind or at the foot of the reclining man, and the seated woman was lifted up on to the mattress also. The small,

39, 37

98, 100, 102

independent third-century banquet reliefs added a further idiosyncrasy: the most important figures reclined on the mattress, but servants sometimes stood on top of the couch. Where the couch legs were shown, the empty space between was filled with inscriptions, busts, servants and (after *c.* AD 160) whole scenes. Inscriptions and busts seem local ideas, although the not infrequent elaboration of the busts from *c.* AD 150 with wreath medallions, garlands and so on look very like the result of influence from Antonine Roman reliefs and 'garland' sarcophagi. Servants and scenes, however, and scenes of everyday life in particular, whether symbolic or not, were typical of Western work, especially of the Antonine period onwards. But the association of banquet and horseman, as on Maqqai's triclinium of *c.* AD 229, reminds us also of numerous funerary stelae of Roman Asia Minor.[448]

The banquet scene occurs frequently on religious tesserae, with priests as the main subjects. In funerary art it appears most often as a relief, used to accompany tomb-foundation texts, to stand alone or to close off tomb burial slots. Even when applied to sarcophagi it remained essentially a relief, except for those few lids with a reclining figure in the round. What did it signify? No text specifies. Was it a rite of heroïzation? A ceremonial commemoration of, or incident in, the life of the person(s) pictured? Bliss hereafter? Or does its meaning vary with the context? This cannot yet be solved; particularly confusing is the not uncommon mixture of living and deceased in the funerary scenes, revealed by the accompanying inscriptions.[449]

The funerary stele with one or more standing figures, which developed early in Palmyrene funerary art, had long been a commonplace in Greek art; but it may have arrived at Palmyra in an orientalized form, with rounded top. Order of precedence among the figures does not seem absolutely rigid. On a stele with two figures, the most important one often appears to our right, in the Roman way; likewise, in a threesome, the central figure predominates.[450] The holding of hands differs from the divine handshake: right may clasp left, or be held in other ways.[451]

Funerary art offers a number of mythological scenes, obviously taken from some of the copy- or pattern-books that must have been widely used in the Roman world. On the ground-floor ceiling of Iamlikû's tower are Erotes, and Arimasps (?) confronted variously by a griffin or panther.[452] Similarly, the Ganymede and Achilles paintings in the Three Brothers' tomb must have been developed from Roman models. The rape of Ganymede, often enclosed in a circular design, had become a stock subject in Roman art during the first century AD. In a funerary context it could carry symbolic meaning: the ascension of the spirit to the stars, or the rape of the soul from the body at death.[453] The exploit of Achilles, who threw off an effeminate existence for a short but glorious career, might be equally symbolic. This laudable episode is repeated often in Roman funerary and secular art, although never in quite this version.[454] In this tomb and elsewhere, winged figures hold up medallions – a Roman commonplace. One relief originally set beneath a funerary banquet scene seems to present us with Meleager and the Calydonian Boar hunt, so popular in the West for its symbolism of trials in this world as preparation for the next. The Aphrodite (?) on a dolphin and Dionysus on a panther (?) of late tomb reliefs also reproduce Western models.[455]

margin references:
101
102, 104–6
102
54 l) n) t)
69, 107
102
104
67, 68
73, 75
72
73
113
115
116
41
111

The fauna of the animal dado in the Three Brothers' tomb similarly recall 115, 116
the Western repertoire, the Nile waterfowl in particular. But the choice of
animal combats surely harks back to Assyrian and Persian traditions, however
enfeebled the participants have become.[456]

Genre scenes are the hardest to parallel, and may sometimes be due to local
inspiration. Several involve camels: the base with three dromedaries, the 129
cameleer with his subordinate and mount, and those observed on tesserae. 143, 54 m)
The latter also include everyday scenes.[457] 32

(B) FIGURE TYPES AND POSES

(i) Standing

The earliest standing figures are clad in civilian dress and are represented in 19, 20
profile, with feet turned sideways. Frontal figures, until the mid-first century 19
AD, normally turn both feet forward, except for the Bel temple and the early 14-17
Heracles figures, which, like almost all figures after c. AD 50, adopt the common 36
Greek position with one foot forward and one sideways. The position with
both feet forward may be Near Eastern.[458]

Gods sometimes wear civilian dress, in which case they normally reveal 22
their divinity in their poses, attributes and (occasionally) types of dress. The
raised arm with lance or sceptre, and military accoutrements, became a com- 16, 19, 27
mon hallmark of divinity from the early first century AD. Divine dress is
usually Greek, although ordinary local costume is sometimes worn; Parthian 37
dress is not popular. Such standing gods in civilian dress are common in Hellen-
istic Greek art. The snake-legged monster of the Bel 'Battle' scene, with an 15
apparently male hairstyle but female chest, and with an acanthus leaf masking
the join at the waist, is clearly derived from Greek serpent-legged giants and
figures of Scylla.[459]

After the turn of our era the male figure in a cuirass of Hellenistic form
became popular, with cloak, tunic and often trousers and leggings as acces- 17, 19, 35
sories. The cuirass is clearly reserved for gods: all the many verifiable instances
support this. The common pose with lance or sceptre is derived from Hellenistic
art. But the donning of the cuirass over Parthian tunic and trousers is a Near 19, 35
Eastern idiosyncrasy. And the pose of the god (?) who perches on a bull's
back recalls that of the cuirassed Syrian deity, Jupiter Dolichenus. Such wide- 29
spread militarization of deities is neither Greek nor Roman, but is characteristic
of the Hellenistic East, and particularly of Syria. It may well have resulted
from the old Semitic need to feel that divinities were protectors, a need which
was expressed by wrapping the gods in Western military costume. The earliest
instance so far known is on a petty dynast's coin of 73/2 B C.[460]

Male nudity is also a sign of divinity. The figure of Heracles – more Western 25, 36
than at Dura-Europos or Hatra – was adopted early on, and remained popular.
Eros, Dionysus and Apollo figures, Hermes, an ithyphallic Priapus and a 131, 40, 25, 31
strange winged siren came similarly from Western stock; an 'Attis' figure 21, 95
arrived at an early date from Anatolia.[461]

It is remarkable how many different guises, usually civilian or military, are
adopted by the same gods. Admittedly, some divinities, such as Bel, are con-
sistent in their dress; and others, such as Malakbel, wear different clothes 58-61

19, 48 probably to express different aspects of their character. 'Aglibôl's early civilian dress is soon permanently supplanted by the cuirass. But the majority of the gods vary their clothing, particularly on tesserae, for no apparent reason.[462]

26, 29, 19, 20 Without marks of divinity, Greek or Parthian male civilian dress denotes a mortal. The early processional figures in profile, despite their Greek costume, conjure up Achaemenian and Phoenician forebears through their pose and the

67, 75 fall of their robes. The frontal figures often simply stand, the right arm protruding from the cloak, in an originally Greek pose now commonplace in the eastern Roman provinces. For this pose Greek costume is the commonest, Parthian,

127 or a combination of the two, less so; the toga is worn on two statues derived from late Antonine or Severan Roman models, but mortals are rarely, if ever, shown in local dress.[463] This basic standing pose is subject to certain standard

39, 41-3 variations. The gesture of casting incense was currently a commonplace of Western and Near Eastern relief; the arm movements of third-century 'pages'

102, 108-9 look Western. The lamb-carriers prolong a tradition which had enjoyed a furtive existence in ancient Syria and in Archaic and Hellenistic Greek art, to reappear in Parthian Dura-Europos in AD 31 and at Rome and Palmyra in the third century AD; from here it entered early Christian art. Arms raised in

50, cf. 51 adoration seem Semitic in origin, but later spread westwards.[464]

 Female standing figures are much less numerous than the male, but they are equally varied. They normally wear essentially Greek dress. Armour again

15 denotes divinity, but it is rarer than among the male figures. The cuirass is of the masculine Hellenistic kind worn by the gods. The commonest type of

49, 39 female figure, however, is the Athena appropriated by the second century AD for Allat, after her fully civilian (seated) stage. The Athena standing posture had been current in Hellenistic art; here at Palmyra it was adapted to the standard position for Palmyrene deities by moving the right hand up to just below the spear blade.[465] When in civilian costume, goddesses can usually be

41, 44 identified by this Athena stance, with the customary lance or spear normally in

36 the right hand. Again, the poses are Western: least obviously on the early Heracles relief, but more clearly later. Adaptations of the widespread Greek

17 'Petite Herculanaise' type occur on and after the Bel entrance ceiling. Reliefs of winged Victories came early: one appears among the Foundation T frag-

11 ments, and they are intermingled in the Bel decoration, and used widely thereafter; although affected by frontality, they still remain more Western

34 than their cousins at Dura-Europos. Finally, a Western Nemesis figure appears, first recorded in AD 152.[466]

20 To begin with female civilians are shown posing in a less Western manner;
26 the profile figures look almost Achaemenian. On early funerary reliefs they
68 stand frontally, with hands resting across the chest, a posture at several removes
71-2 from its probably Hellenistic original. On later examples they preserve this basis, but follow current bust trends for arm positions. For honorific and some funerary statuary of the second and third centuries, however, the Western 'Pudicitia' type, and perhaps also the 'Petite Herculanaise', provided inspiration.

135 And both the nudity and the elongated proportions of the 'dancer' must be due to direct Western influence.[467]

 Children, apart from the boy (?) in the snake-legged monster's coils, are
73 portrayed only in funerary art. When standing, they echo and complement

the essentially Hellenistic Greek poses of their elders. They traditionally grasp a bird or grapes; when in company with an adult or another child, they often hold hands. As standing figures they may occupy their own stelae, accompany one or more older persons on their stelae, appear as diminutive figures behind the shoulders of persons shown as relief busts, or be ranged behind the reclining figure(s) of a banquet scene.[468]

<div style="text-align: right">80</div>
<div style="text-align: right">100, 37</div>

(ii) Flying

Winged, flying figures were imported at an early date into Palmyrene art from ultimately Western sources: they are already present among the Foundation T fragments. They come in two varieties, the Victory, often on a globe, and the youthful male Attis-like figure. They perform two main actions. In the first century they carry the palm branch and wreath, separately or together, in religious sculpture. In the second and third centuries they hold up medallions or garlands, in symmetrical pairs, mostly in funerary art. They have two main poses, one nearly upright, the other almost horizontal. In each, the head is normally twisted to face the front, as was usual in Syria; the profile head is a Western intrusion, not seen before the second century. A third, wholly upright pose hardly differs from the ordinary frontal standing position.[469]

<div style="text-align: right">22</div>
<div style="text-align: right">15</div>
<div style="text-align: right">101</div>

(iii) Seated

The masculine seated figure in relief and on tesserae is normally divine, and seems usually to be Ba'alšamin. Greek dress and frontality predominate. This frontal seated position is adopted by a priest, Zabd'ateh, on a first-century stele. It seems to have grown out of the awkward three-quarters position, with frontal head and angled legs, that emerged in late Hellenistic reliefs. The Westernized Hermes and Heracles ornamenting the Bel Propylaea are also shown sitting, but in profile. And the tesserae include a seated mortal, again in profile: the genre figure of an artisan, hammering.[470]

<div style="text-align: right">16</div>
<div style="text-align: right">21</div>
<div style="text-align: right">25</div>
<div style="text-align: right">32 c)</div>

Carved in the round, the seated male figure in tunic and cloak becomes mortal, and honorific. Arriving only in the second century and never common, it basically follows an ordinary eastern Roman model which had evolved out of a Hellenistic type in use to commemorate philosophers and poets, and later learned and distinguished men.[471]

<div style="text-align: right">125</div>

Boys rarely appear seated, and then only in second- and third-century funerary reliefs. They may sit on their mother's bent left arm, an ancient and still flourishing motif. Or they may occasionally adopt a striking pose with knees apart and legs crossed at the ankles; this was a Parthian innovation, used for royalty, which was later passed on to the Sasanians.[472]

<div style="text-align: right">86</div>
<div style="text-align: right">99</div>

The seated female apparently occurs only in relief. Several goddesses adopt this pose. 'Ištar' and Allat already appear in this position in mid- or late first-century reliefs, with frontal head and torso, and legs turned awkwardly so as to accommodate profile thrones. Both goddesses in civilian dress are derived from Hellenistic Greek prototypes, although their poses are influenced by frontality. 'Ištar' has borrowed the swimming figure at her feet from the iconography of the influential early Hellenistic statue of the Tyche of Antioch, and Allat her lion from the iconography of Atargatis. Allat develops; retaining Atargatis' lions she is first turned frontally, and then in the second century

<div style="text-align: right">38, 49</div>

she is militarized as Athena. On tesserae another figure – a Tyche – is shown seated.[473]

The seated female appears on funerary reliefs during the early second century or before. She is most frequently seen in banquet scenes, at angles ranging from frontal to nearly profile; she normally appears to our left on the relief, but may occupy both ends, representing a wife or occasionally a daughter. On indepen-
61, 102 dent stelae she is usually frontal. The figure has obviously evolved out of the same Hellenistic repertoire as the goddesses' pose; it is common on eastern provincial Roman funerary reliefs.[474]

(iv) Kneeling

Kneeling figures are rare. A man is shown kneeling on a tessera, and a woman
20 on the Bel 'Procession' relief. The figures are hard to parallel, and could have come from Western or local stock.[475]

(v) Reclining

The reclining figure is used only in funerary art (for the participants in a banquet scene), and on tesserae (for Heracles and priests). There are four variants.
39 The first appears on Belšûrî's early banquet relief of c. AD 33, and remains popular till the end of Palmyrene art. The left leg is straight, the right bent at the knee to support the right hand. This variant is usually associated with Greek costume – or, in the case of a standard 'Hercules Cubans' figure, with Greek nudity. It developed out of a pose common in Hellenistic art; but here the left foot is usually in front of the right. The Hellenistic type was wide-spread in the Roman East and in western Parthia.[476]
37 The second variant is visible on Kitôt's tower façade relief of AD 40, and on an (early?) tessera. A priest in Parthian dress reclines with both legs straight. This pose must be a variant of the first; it had long been current in western Parthia.[477]
62, 100 The third variant reached Palmyra by the early second century AD, and achieved considerable popularity. The right knee is raised, and the left leg bent to pass beneath it. These banqueters usually wear Iranian costume, rarely Greek. Again, the pose seems a Near Eastern variation on the Hellenistic theme; it was in use also in western Parthia during the second and third centuries.[478]

The third century witnessed the arrival of the fourth variant: the left leg is outstretched, the right bent sharply at the knee, and the right foot is hidden behind the left leg. Again, dress is Parthian. This pose is a slight variation of the first, and not easy to parallel.[479]
107 Women rarely recline; but there are some examples of the third variant belonging to the late second and third centuries.[480]

(vi) Riding

32, 43 Only gods and dead men ride in Palmyrene art. Their mounts are shown in three ways: walking, stepping or leaping, attitudes all current in Assyrian, Phoenician and Persian reliefs, whence they passed into Greek art. In the Palmyrene versions, most of the animals move to our right, and their riders face to the front. On tesserae, rider gods are usually shown dismounted.[481]

(vii) Statues in art

A figure (usually a standing deity) is sometimes represented on a relief as if 11
raised on a plinth. This seems to imply that a statue is meant to be shown,
art within art. And the repetition of the 'Handshake of 'Aglibôl and Malakbel' 19, 147
in three reliefs argues that all three are quoting from a lost group or 'cult
relief'. Such figures differ in no way from their colleagues, but perhaps provide
an idea of the statuary now vanished.[482]

(viii) Parts of figures

Heads alone were not particularly popular with Palmyrene designers. The
winds are abbreviated as four bearded heads in the spandrels of a westernized
zodiac ceiling. The head in the pediment shown on the Abû Dûhûr graffito 30
is solar. Other heads, Bacchic and bearded, acted as architectural consoles.[483] 46
Greek theatre masks ornamented the Bel temple and tomb 19 during the first 24, 47
century, and the tesserae include another. Arising from decorative and sym-
bolic commonplaces of the Hellenistic West, these masks were widespread in
the Roman Orient and travelled still further east. Medusa heads (?) embellish
a tomb façade, and the Ba'alšamin sanctuary stucco decoration; Western masks
of Medusa and Pan, and local ones of Semitic deities, decorate other tesserae.[484]

The Evil ('much-suffering') Eye is depicted among the paintings inside the 48
Three Brothers' tomb. As with its common representations in the Roman
West, to neutralize its venom it is surrounded by creatures and objects regarded
as dangerous: here a scorpion, snake, crab, knife and so on. Such protection
was necessary, for it was thought that the Eye could catch a man at any time,
even when he was satisfying his daily needs.[485]

A divine hand crops up on votive reliefs, altars and possibly tesserae of the
second and third centuries. Normally the right hand and wrist appear hori-
zontally, clad in a long-sleeved Parthian tunic. An altar of c. AD 100–50 to
the 'Nameless god', and perhaps a tessera, have the hand alone. Two altars
of AD 114, publicly erected at Karassi near Palmyra, are the first of a series
from in and around the city on which the 'Nameless god's' hand grasps a
thunderbolt. On a plaque of AD 228 to his other aspect, Ba'alšamin, the hand 45
holds three ears of corn. No other cult seems involved. Such symbolism, a
practice with early Near Eastern antecedents and current elsewhere in Roman
Syria in various cults, underlines the Palmyrenes' Semitic attitude towards the
functions of art.[486]

The divine hand should be distinguished from the pair or pairs of human
hands raised in worship, held vertically and palm forwards, on votive altars 51
and plaques (and possibly a tessera) of the late second and third centuries.
These hands abbreviate a reverential gesture sometimes performed by figures
shown in worship. The 'Nameless god' is again the dedicatee, occasionally
with his acolytes 'Aglibôl and Malakbel. The symbolism of the hands echoes
that of the divine hand, but their representation seems peculiar to Palmyra.[487]

The portion of the figure seen most frequently, however, is the bust, re-
presented in relief and painting. Its forms are treated as abbreviations of standing
figures. Divine busts, usually armless, are present on the 'stepped' and Helios 13, 28
reliefs, and among the Bel, Nebû and Ba'alšamin sanctuary reliefs of the first
century AD. Busts of a later date show more of the body, down to the midriff, 23

or to the thighs. Thereafter, the divine bust is found only occasionally in major sculpture – on the Ba'alšamin temple thalamos lintel, for instance, and an altar to the 'Nameless god' of AD 240; but it remained popular for a long time on tesserae, both in profile and frontally. The divine bust almost certainly developed out of the abbreviated divine figures of classical and Hellenistic Greek art. There are two links of particular importance: the variation in the amount of the figure shown and the frequency with which the sun and moon are pictured as busts. The divine bust lived on in the Roman and western Parthian worlds, again associated particularly with solar and lunar deities.[488]

Priestly busts sometimes ornament religious monuments such as the Bel beams or the late niche arch from the countryside. Occurring first as early as *c.* AD 32, they set a problem. Are they an offshoot of the (normally armless) divine bust, or of the quite similar Roman funerary bust? Derivation from the divine bust in the context of frontality, local religious belief and the priestly busts' armlessness in this position would seem more comprehensible: the priests, greater than ordinary mortals, take on divine characteristics. But in that the priestly busts are normally funerary and are mostly shown with both arms, they are more like some of their Roman counterparts.[489]

As the divine bust apparently declined in the mid-first century AD, so its funerary equivalent sprang into life. The funerary relief bust is so close to Roman types of the late Republican and early imperial eras that a Roman ancestry seems clear.[490] The Palmyrene figures have unexpected affinities with provincial Roman variants. The Roman bust is normally either armless, or at most with one arm and hand represented. These two types spread across Greece and Asia Minor, although in the Greek provinces they never rivalled the full-length figure in popularity. The bust also went north, to the Rhine and Danube regions; here its development corresponded with the Palmyrene in at least three ways. First, both hands may be shown; secondly, these hands are often held as at Palmyra; and thirdly, additional figures, children or *liberti*, may appear at full length and on a diminutive scale at or behind the shoulders of the deceased. Did these ideas develop independently in the two areas, or was there some common factor present, such as the Roman army?[491]

The forms of bust found at Palmyra were in sculptural use elsewhere in Syria, particularly for funerary commemoration; but they appear later than at Palmyra and examples are far less common.[492]

(ix) Gestures

Palmyrene figures often perform one of a number of characteristic gestures. The offering of incense or oil on an altar set beside the sacrificer was an old Near Eastern gesture widespread in the Hellenistic, Roman and Parthian worlds. Another which had already had a long history in the Near East was the raising of the right hand, palm forwards; no doubt this had apotropaic connotations, symbolizing guardianship and benediction when performed by gods, and worship, when by mortals. The gesture was common also in western Parthia, and travelled westwards primarily with the 'saviour' gods. It is to be distinguished from the raising of both hands palm forwards, which is sometimes abbreviated to the two hands alone. This is a gesture of invocation or supplication, which became common in the Roman West, and may be of Semitic origin.[493]

A languid gesture contributed by Greek tradition is that where the right arm rests across the head. In and around Palmyra this is the prerogative of Dionysus figures.[494]

Funerary art has more to offer. Arms are normally in the conventional position of the Roman relief busts, both metropolitan and northern provincial. But other ideas were introduced after *c.* AD 100, and blossomed after 150. The comforting hand or hands laid on the shoulder(s) of a relative or spouse has Italian antecedents and contemporary Roman parallels. The proffering of objects by servants had been common in Greek funerary art since classical times, as had the resting of fingers against the cheek to signify sorrow, an action performed at Palmyra by women and, occasionally, children.[495] Most of the individual female gestures, in fact, had an unbroken ancestry traceable back to Greek art of the fifth or fourth centuries BC; many, for instance, are present on the 'Pleureuses' sarcophagus from Sidon (*c.* 325–300 BC), such as the holding of the veil at neck or shoulder height, the drawing of its two sides together with one hand over the chest, and the pulling of it from one side to the other, still used in various Roman regional repertoires, but with differing frequency in different areas. What remains puzzling is precisely why, as time passed, the fashions in these gestures at Palmyra changed as they did: were the impulses external, or from within?[496]

Margin references: 81-3; 66, 94; 107, 109; 71, 107; 64, 85; 87; 89

(c) Figure details

(i) *Headgear*

Palmyrene deities are distinguished by a variety of exclusive types of headgear. The cylindrical Greek polos or calathos, whether smooth or decorated, of leading gods and goddesses was currently widespread in Syria and Mesopotamia; perhaps it preserved something of its older symbolism of power and fertility.[497] Likewise from Greece came the turreted city-wall crown which marked the Tyche or Gad of Palmyra, as of other Eastern cities.[498] Some gods sport a thin band which isolates the central portion of the thick Iranian hairstyle. It recalls both oriental forerunners and the Hellenistic band or *strophion*, but its close association with Iranian coiffure suggests that whatever its origin it arrived through oriental intermediaries. Similar to this is the rarely seen Greek *stephane*, for goddesses.[499] Western again was the idea of helmeted deities. But at Palmyra the divinities usually wear Iranian helmets, somewhat bell-shaped, splayed out over the nape of the neck, and sometimes crowned by a button. Exceptionally a Hellenistic model is followed for an Ares, Athena or similar figure, and a Western-looking type with cheek-pieces occurs on tesserae.[500] More exotic headgear is rare. The Phrygian bonnet worn by *dadophoroi* (torch-carriers) on a tessera is a copy of the kind associated with Mithras' attendants; and a little head of 'Horus' seems clad in the Egyptian double crown, the *pschent*.[501]

Other types of headgear the divinities share with mortals. A headband or diadem of some apparently stiff material stands out rigidly each side of the head, perhaps imitating metal originals on statuary; it binds the locks of several deities, mostly of the first century AD, represented in relief. Tesserae also reproduce headbands, and late examples show the diadem around the

Margin references: 35, 42; 9; 8, 38; 13; 11, 15; 39, 18; 35

priestly headdress. The bands recall Hellenistic royal versions, visible in coin profiles, which were adopted by Parthian monarchs, and proliferated in the Syrian and western Parthian regions for divinities and royalty, particularly from the first century B C onwards.[502] Another type of headgear shared by gods and mortals is the laurel wreath, long a mark of distinction in the Greek world, which in the Roman Empire came to symbolize salvation or heroïzation. Victories, a guardian goddess and priests hold them up in early Palmyrene sculpture, and they are common on tesserae. But in sculpture none are represented as worn round the head until *c.* AD 130–40, when priests have the wreath bound round their high cap or modius. The central point at the front is rarely without an ornamental fastening: the oval cabochon, four- and six-leaf rosette, the bare-headed or modius-wearing miniature bust. Men sometimes adopt the wreath as a headdress after the mid-century (the commonest fastenings here are the rosette types); or as funerary effigies they may have the wreath beside them on a cushion, together with the usual ornaments or bare-headed bust, or else a whole wreathed modius. It is likely that these ornaments had special associations, as in the Roman world; the miniature busts, for instance, possibly represented the heroïzed ancestors of the wearers or possessors; and indeed, the wearing of the wreath by men may always have had religious connotations. Women also wear laurel wreaths, on the evidence of the circlets, interpreted as wreaths, shown on some second-century relief busts. And minor gods have wreaths too: the six genii of Bet-Phaṣi'el (AD 191) ornament theirs with the central cabochon.[503] Another type of headgear is the Iranian-looking pointed cap sported by some young male genii and boys.[504] Those goddesses who wear no other headdress at all veil their heads with their cloaks as women do. But gods and mortals often go bare-headed.[505]

Mortals, too, have their exclusive headdresses. The sacerdotal cap or modius is normally cylindrical and flat-topped, widening slightly from base to top. Sometimes it is completely smooth, but more often it shows one or two vertical cuts from top to bottom, like seams, perhaps indicating an attached cloth. From *c.* AD 130–40 it is normally encircled by a laurel wreath. It is almost identical, even down to the vertical lines, with the sacerdotal headdress of Hellenistic Phoenicia, itself possibly of Persian ancestry. Beneath the bottom of the modius the edge of a second head-covering, doubtless a skull-cap, is usually just visible. The tall, cone-like priestly cap seen elsewhere in the Syrian region is very rare and shown on tesserae only.[506] New types of headdress are represented in the third century. One comprises a large, conical cap, worn by a reclining master and his standing servant. A second is hemispherical, covering the scalp, and was in fact probably of metal; at the front of it is a cabochon ornament, or a miniature bust. This headgear may have marked social distinction; the design could be local.[507]

Women, on early reliefs, are shown with the cloak placed directly over the hair, in the Greek way; and this is sometimes seen later, among the funerary reliefs. But from AD 65/6 at least, women are normally represented with two items between hair and veiling. Across the forehead runs a stiff decorated band, a diadem or tiara. Above this is a thick, twisted band or turban, with a long ancestry in the Near East, and regional counterparts; from AD 96 it is often knotted at the centre. The turban could be replaced by a simple, local

headcloth, or, from *c.* AD 130, by an elaborate, bag-like decorated cap orna-
mented with rosettes. Parallels for the cap with the fashions of Parthian and 　　90
Sasanian royalty have been claimed, although without much justification.[508]
Later in the second century the turban sometimes takes on a curious shape, or is
replaced by a local semicircular 'tiara' (a comb, fixed vertically?), worn without 　87, cf. 44
the diadem. And in the third century the decorated cap becomes more popular,
with the rosettes regularly set between beaded listels.[509] 　　90

The complete covering of the face with the cloak used as a veil is depicted
once, in the Bel 'Procession' scene. This seems to be unique in Near Eastern 　　20
art.[510]

(ii) Hairstyles

Gods are often characterized by hairstyles with locks covering the ears. Many 　　36
of the exceptions, if not all, consist of figures, such as Heracles, closely derived
from Western models. Most of the divine fashions are present at an early
period. Always popular is a 'halo' style which simply encircles the head; the 　12, 19
hair normally reaches the nape of the neck, and is often composed of 'snail'
locks. Occasional variants, before *c.* AD 50, show a dip below the neckline and 　　36
include a central parting; from the second century the ear-lobes sometimes
appear. Otherwise, the locks are long and wavy, and are either parted at the 　　43
centre, or arranged in groups at contrasting angles – horizontal with diagonal
or vertical – a fashion favoured by the desert gods. Again, the hair
rarely falls below the nape. This 'halo' shape was popular with Achaemenid
princes, and common in west Parthia.[511] A second fashion hardly outlasts the
first century AD. Long, often wavy locks, with a central parting, splay out
behind the head, again normally down to nape level, to create the triangular 　35, 37
mode. Gods with calathos favour it. The Assyrian and Achaemenian Near
East knew similar, if longer, styles, and contemporary Parthia a usually nape-
length version.[512] Finally, a voluminous mode, popular only in the rural 　　42
north-west, appears during the mid-second century. The hair is puffed out
above and each side of the head, in tripartite fashion; sometimes a band holds
the central section in place. Parthian royalty and their vassals developed the
style from the first century BC, and the Sasanians exaggerated it.[513] Apart from
Westernized figures, the only male deities to reveal their ears are short-haired
young gods and genii; the style, including the child-lock of one, is Greek.[514] 　　22

The 'halo' form also seems universal among the bare-headed men of early 　　20
reliefs; arrangement in tiers, striations and – on one occasion, at least – dishevel- 　19, 20
ling provide variety. Although gradually overtaken from the AD 30s by other
male fashions, it never dies out. 'Snail' curls normally accompany it. Oc-
casionally, in the late second century AD, it is Westernized: locks are striated
and ear-lobes, even whole ears, become visible. Men of the desert and others
in Iranian costume like it.[515] During the first century AD, however, the
'halo' style is largely supplanted by a more closely cut, short-haired style, 　67, 70
similar to that of young gods and genii, of manifestly Greek origin. The hairline
is lightly curved, and the ears are invariably exposed. The shape is built up
from striated tufts or 'snail' curls, and was both widespread and long-lasting.
Its popularity was enormous in the Roman East, unlike in western Parthia.[516] 　79–81
From *c.* AD 150, however, a rival mode, still with the same locks and hairline,

is introduced and long remains fashionable. Its comparative luxuriance imitates contemporary Roman fashion, the Antonine style; and to prove the point it is usually associated with a beard. Here again Palmyra follows the Roman East, not Parthia.[517] In the third century contemporary Rome again makes itself felt: either the short-haired or Antonine manner may be combined with a clearly

66, 98 receding hairline.[518] No hair, however, ever escapes from the caps of Palmyrene
78, 80 priests: perhaps their heads were shaven.[519] For boys, the short-haired Greek fashion is almost universal, the Antonine rare.

Male eyebrows are rendered in various ways. On the earliest reliefs, as in Hellenistic art, there is no specific indication of treatment. But the 'stepped'
13, 14 reliefs already show the normal method: a curved groove, which has numerous earlier oriental parallels. Sometimes, c. AD 100–50, an additional chamfer increases the effect. Then, with the Antonine hairstyle, comes the plastic
123 indication of eyebrows. This infiltrated imperial Roman portraiture particularly from Flavian times, and reached Athens during the Antonine era. But the stylized Palmyrene version, with its parallel wavy lines or herring-bone patterns, reminds us more of heads of Gudea or Hammurabi. And while in the third century at Rome the practice reached its peak, at Palmyra it declined.[520]
123 One sculptor at least in the late second century even indicated eyelashes, a detail taken surely from Western bronze-work.[521]

The moustache alone, worn without the beard, is an uncommon fashion
42 of local origin, confined to gods of the steppe. The equivalent style for mortals,
65 typical of men of the desert c. AD 150–200, is a prominent moustache with a light beard, developed out of Arab or Parthian versions.[522]

Moustache and beard are limited at first to certain gods, notably, Baʿalšamin,
27, 35, 36 Šadrafâ and 'Heracles', who prefer long, short and button-like ('snail'?) locks respectively on reliefs before c. AD 50. In the third century a rural sun god joins them. Otherwise, Palmyrene gods are beardless, as was the divine fashion in Syria. 'Heracles'' beard is obviously Greek; Baʿalšamin's may have been inherited from Zeus, and Šadrafâ's is also probably foreign. Beards had long been fashionable for gods and men in the ancient Near East; mortals still commonly wore them in Parthian regions, gods to a lesser extent.[523] For a long time men are normally clean-shaven, in the Western manner. But from c. AD 150
79, 81 beards suddenly become popular. This happened soon after the adoption of the beard by the Roman Emperor Hadrian, his successors and the Roman public. And most Palmyrene beards are not only Roman in shape, but are frequently combined with the Antonine hairstyle, even though they are rendered with the local tufts, or, less often, 'snail' locks. This luxuriant Antonine variety
65 lasts for over a century.[524] Other types are less common. A light beard, typifying habitués of the desert in particular, is sometimes seen between c. AD 130 and 200; and a full but close-cut beard, done with long, closely parallel striations, is also occasionally worn at this time: both have Parthian relatives. Finally,
81 some third-century beards are rendered in a new technique, by gashes or chipping, which obviously imitates contemporary Roman fashion. Many men, however, and notably priests, never wear beards at all.[525]

Hair and beards comprise locks drawn from a wide variety of sources.
14, 81 The common 'snail' (or 'snailshell' or 'corkscrew') curl was probably contributed by Assyrian and Achaemenian art. It remained popular further east;

Greek and Roman examples were altogether less formalized. First seen on gods at Palmyra, it soon spreads to numerous mortals for hair and, sometimes, also for beards. It remains a favourite divine fashion; and so its spread to mortals may possibly have been connected, as perhaps was frontality, with the new religious consciousness.[526] A variant of the 'snail' curl is a group of concentric semicircles, largely confined to gods before c. AD 60.[527] Long, striated and usually wavy locks characterize a minority of gods and men from the early first century onwards: this seems to be a contemporary Parthian style, like the practice of ending a long lock of hair or the sides of the moustache in a 'snail' curl.[528] Finally, there is the shorter tufted lock, always very popular, although usually only for mortals. The tufts vary in shape from trapezoidal to triangular, and are often carefully distinguished. The arrangements are usually neat. On Foundation T reliefs and often later, horizontal tiers are preferred, rising up from the forehead. The lowest lock-ends usually point to our right, and the rows above alternate with these. This constitutes the schematization of a common late Hellenistic mode, which was formalized in a similar manner at Rome in Nero's *coma in gradus formata* and remained fashionable there into the second century. After c. AD 150, however, Palmyrene sculptors tend to rearrange the tufts in different patterns, to wave the tufts and even slightly to disorganize them, out of deference to Antonine and Severan styles. And in the third century the rendering may become cursory, again through Roman influence.[529] Hellenistic art contributed two further items after c. AD 100: a looped child-lock, and a flowing slave-lock.[530]

For females the classical Grecian mode is almost universal: the hair is brushed back in waves from a central parting to a (hidden) knot at the back. The wearer may be bare-headed, or have a headdress. Until c. AD 150 goddesses often, and mortals usually, wear an accompanying shoulder-lock, a long, spiralling or wavy lock which falls to each shoulder. During the three decades or so after AD 150 mortals on funerary stelae gradually abandon them: some wear a lock on both shoulders, some a lock on the right shoulder only, and others none. Goddesses abandon them entirely c. AD 150. Similar plaits had been sporadically fashionable earlier in the Near East, Greece, Etruria and Republican Rome. They lost favour, however, in early imperial Rome, but lived on in the provincial fashions of Asia Minor and the Syrian region.[531] An alternative appears in AD 149: the central parting and waves remain, but the locks each side of the parting are themselves now carefully waved and braided, and a coil of hair is shown resting on top of the head. This is often called the 'melon' coiffure. At Palmyra, it is largely or exclusively reserved for mortals, and, although never popular, it lasts for a century. No headdress ever covers it but jewellery may be attached. A Greek origin in Silanion's portrait of Corinna has been claimed: but her hair-knot sits at the back of her head. Perhaps the strikingly similar hairstyle of Faustina the Elder, Empress to Antoninus Pius until her death in AD 140/1, was the source of inspiration. After all, this was imitated in other Roman provinces; and the simultaneous arrival at Palmyra of Antonine hair and beard styles for men is surely significant. The style went no further east.[532] Finally, in the early third century a stylized version of the simpler, Severan Roman hairstyle is occasionally seen.[533] Girls are cropped short in the Greek way, while teenagers copy their mothers.

Margin references: 14, 27 — 20, 37 — 65 — 67, 75 — 79 — 80, 94 — 84 — 49, 63, 84 — 88, 94 — 93

Even coquetries, divine and mortal, are mostly Greek. At the centre of the
forehead one or two little forehead locks may be worn, and likewise a cheek
lock in front of each ear. Roman traits are rare, but a row of forehead hairline
curls is occasionally introduced from the late second century onwards and
accompanies the schematized Severan hairstyle.[534] Curiously, female eyebrows
are never shown plastically, but retain the oriental curved groove.

(iii) Features

In rendering faces, as we have seen, the Palmyrene artists were not attempting
realistic portraiture. The true anatomical structure received scant attention,
facial planes were smoothed and simplified, and features were standardized.

The furrowing of brows reached Palmyra from the West in the early second
century AD, and became a common trait used mainly for men in funerary art.
It was little used in Parthia. Eyebrows, as we have just seen, apart from some
Westernized caterpillar-like examples for men after 150, retained oriental
grooving, if they are indicated at all.[535]

Eyes received varying treatments. At first they are bulbous, lentoid and
emphasized by surrounding listels, without iris, pupil or tear-ducts, in a some-
what sub-Achaemenian way. But already the 'stepped' reliefs show striking
innovation. The overlarge and still thick-lidded eyes are now triangular, and
engraved concentric circles mark iris and pupil, with the iris touching each,
but later only the upper, eyelid. This engraving is an interesting detail, possibly
inherited from Western or Eastern bronze sculpture. In the West, the inlaying
of coloured stones and glass paste for the purpose of indicating eyeballs had
long been practised, and from Augustus' time engraved iris and pupil are
found. In Parthia, similar engraving was done. The huge eye, with engraved
circles and varying in shape from triangular to more oval, remained the norm
until c. AD 150; occasionally it is left blank, or the iris alone is indicated. After
c. AD 150 Roman methods obtrude and the eye usually assumes a more natural
shape, the engraved circle for the pupil being replaced by a lightly bored hole.
From the late second century this hole may rise to just beneath the upper
eyelid; sometimes a cup-shaped depression, not necessarily for inlay, replaces
iris and pupil, and the lachrymal caruncle may be shown. During the late
second and third centuries a local practice arises beside these, in which the eye
is left blank and the lower lid omitted, ready for paint.[536]

The mouth is at first small and deep-set, perhaps under Hellenistic influence;
soon, however, the lips protrude less. After c. AD 150 much Roman naturalism
is visible, and in some cases the lips are even parted. From the early second cen-
tury a strong facial groove curving downwards from nose to chin makes
many male and female features even more Western. Lips are mostly smooth,
but several funerary heads and busts from the mid-first century onwards have
an extra line engraved just within the outer edge, another detail which was
surely taken from Western bronzes, where such lines marked the extent of
inlay; here it might have been intended to indicate the boundaries of any
paint subsequently added to the lips.[537]

Throughout Palmyrene relief and painting ears have a tendency to project
unnaturally, as in earlier Near Eastern frontal reliefs. Neck depressions are of
two kinds. The first, two or more horizontal grooves, common throughout

Palmyrene art and Roman Syria, was almost certainly derived from wrinkles on fleshy Hellenistic necks. The second is V-shaped: Heracles (alone) has it on an early relief; but otherwise this Hellenistic trait is hardly to be found before the second and third centuries, its heyday.[538] 36

(iv) Rendering of flesh

Nude figures are rare: Semites disapproved. But some gods appear naked. Their figures are mostly borrowed from Greece – notably, Heracles, Apollo, 36, 40
Eros and Priapus. The winged genii of the Bel temple peristyle ceiling expose 131, 31, 22
their torsos. Male genitals are poorly indicated; Priapus is ithyphallic. Mourning women bare one or both breasts. A naked female was perhaps a dancing girl: 65
her bodily proportions belong to the slender, elongated canon of many Hellenistic and some Roman artists; and the omission of the genital cleft is of course a 135
Western idiosyncrasy. Un-Roman, on the other hand, is the protrusion of the belly, and the creases indicating the weight of flesh.

Normally, however, only the extremities appear. Hands and wrists rarely reveal much sign of the bones within. But the nails are customarily indicated on all works of reasonable size at least from the mid-first century, as in both East and West. The feet are often more casually treated, so that it is frequently not clear whether shoes are being worn or whether the foot has merely been left in an unfinished state. But careful artists rendered the toenails.

The breasts of mourning women, as shown on funerary reliefs, usually bear small groups of incised strokes, in which traces of red paint sometimes survive. 65
These surely represent real lacerations, a traditional Semitic funeral custom forbidden in the Old Testament.[539]

Throughout our period, the Palmyrene artists were consistent: no sense of structure is apparent. Limbs are represented out of proportion, and anatomical details, wherever possible, are turned into patterns and made symmetrical.

(v) Clothing

Greek and Iranian dress predominate in Palmyrene art; local garments are unusual, and Roman rare. No doubt this reflects the status and tastes of the urban élite who commissioned most work.

Both gods and men almost always wear a tunic. The type first seen is the old Persian sleeved variety customarily combined with trousers, always popular 26, 30
at Palmyra and further east. In the first century it tends to be clinging, with many folds. From c. AD 100 to 150 it is shown as a looser smock, bound by a 112
thin and rather low waistband, with a curved bottom edge and usually decorated at neck, wrists and lower hem. A central, undecorated strip also appears sometimes: in painting by 103, and sculpture towards 150. Thereafter the tunic is 57, 73
transmuted again, cut so as to produce a wide skirt beneath the now higher waistband. The central strip becomes common (although in the third century 108, 109
it is sometimes omitted or replaced by two strips), and the other decorations become broader. Occasionally the decoration is different: triangles round the hems, arrows on the tunic; a ribbon or triangular flap is occasionally shown 82
beside the neck opening; the bottom hem is often slit at the sides, particularly 94
in the third century. In general these traits follow contemporary Parthian 24, 102
and Sasanian fashion. A simpler tunic, a long-sleeved local garb, perhaps of 32, 44

Arab origin, clothes divine and mortal horsemen, cameleers and perhaps others who are wrapped in the local fringed 'skirt'.[540] A plain, calf-length tunic, with false or 'short' sleeves and bound by a broad waistband, characterizes certain *14, 21* priests in the Bel and Nebû temple reliefs of the early and mid-first century AD; after this date it vanishes. This robe, probably of Persian origin, was worn by priests and others in late Hellenistic Phoenicia, Hierapolis-Bambyce and Com-*79-81* magene. The calf-length Greek chiton, again with false or 'short' sleeves, a garment almost universal in the Roman East, seems to flourish only in the second and third centuries, and much more among men than gods. A stripe of varying width, normally plain, usually descends from each shoulder. The *127* rare toga-wearers have a similar Roman tunic.[541]

Trousers (*anaxyrides*), a favourite Iranian garment, usually accompany the Parthian tunic, rarely (and not after AD 150) the Greek chiton. Until *c.* AD 150, *19* however, they are often largely or wholly concealed beneath voluminous leggings. Malakbel's trousers on the Bel 'Sanctuary' scene have a decorated strip down the side. By *c.* AD 100, however, this strip has been transferred to *99* the front, where it remains. After *c.* AD 150 trousers are represented without *102* leggings, tapering downwards and tucked into the shoes; as in Parthia, the strip is rarely omitted.[542]

Baggy, tube-shaped leggings, made of stiff material or leather and tucked into the shoe, usually cover trousers in art until *c.* AD 150. They are cut back *19, 37* at the thigh, and until *c.* AD 50 have a broad strip of decoration. On the Bel *32* beams and Kitôt's relief this cut is at the back and the strip (and attachment) at *73* the front. But all the other representations done before *c.* AD 50 show the strip at the side. Later this disappears, and the gap, when visible, is frontal, indicating attachment behind. This garment is again Iranian, perhaps from central Asia. It occurs in northern Syria, Mesopotamia and further east, and became popular Sasanian wear. Related but different types of leg protection are depicted in earlier Parthian and Commagenian royal reliefs.[543]

A strange garment that covers the legs, arms and back alone and resembles *22* an open boiler suit is worn with shoes by the trophy-carrying genii of the Bel ceiling, and later by two youthful genii supporting a funerary medallion. They are otherwise naked. It is an imitation of the costume of Anatolian Attis.[544]

The cuirass appears first among the Foundation T sculptural fragments and soon becomes favourite divine wear, mainly for gods, rarely for goddesses; but not all its wearers adopt it immediately or consistently. Until the early second century it is always of a late, eastern Hellenistic Greek form, with flat shoulder-straps, fringed epaulets, a broad knotted waistband (*cingulum*) and two equal rows of long, rectangular, fringed straps or lappets below *14, 35* (*pteryges*). But at first the breastplate materials are peculiar to the region. *8, 28* Superimposed rows of small, vertical strips, doubtless representing originals in leather or metal, are joined by horizontal bands (of leather, as with vaguely similar greaves found at Dura?). The method might be of Assyrian, Parthian or local origin. Beading ornaments the top and bottom. This 'strip' cuirass is popular until the mid-first century, and survives into the second.[545] The *17, 19* Bel reliefs introduce the common undecorated metal Hellenistic breastplate, moulded to the body, with even the navel indicated; and from the mid-first

century this steadily ousts its local rival. During the second century the form is updated to accord with Romanized Hellenistic types. The lower straps may become of unequal length, and at the join with the cuirass is placed a single row of semicircular tabs. In the third century a Roman scale cuirass is occasionally shown. Of whatever kind, the cuirass is worn over a tunic, with trousers, leggings and occasionally a waistcoat if appropriate. It is seen further east – at Dura, Hatra and once elsewhere; in the West, apart from Ares and Mars, it is associated particularly with deities of Syrian origin.[546]

41

42

Almost every male figure shown wears a cloak. From earliest times the voluminous Greek himation commonly engulfs both gods and men. It is worn with either the Greek or the Parthian tunic. After *c.* AD 150 it is occasionally ornamented, for instance with an H-design, and shorter forms, sometimes tasselled, appear on boys and servants. Second in popularity is a considerably smaller cloak, a version of the Greek chlamys, fastened by a circular brooch normally on the right shoulder. It usually accompanies the cuirass, as in late Hellenistic and Roman art, as well as the Iranian sleeved tunic. Priests in particular favour an ornate version with florid edging.[547] Horse and camel riders, divine and mortal, wrap themselves in a desert cloak, looser and less homogeneous. Essentially it is thrown around the shoulders and floats out behind; the usual circular fastening may be absent, or visible either on the right shoulder or centrally over the chest. In the third century a longer and thicker local type sometimes appears, with woolly fringes. Also in the late period, a Roman toga is occasionally seen.[548]

16, 41–3

79
106
14, 27

65, 98
32, 43

26

127

Waistbands of several kinds are shown. Until the late first century AD both the Hellenistic cuirass and the male chiton, where the waist is visible, are usually bound by a Hellenistic girdle (with fringed ends) knotted at the navel. The girdle travelled with the cuirass to Dura and Hatra, but simpler belts were preferred further east. An exaggerated form of this girdle, with a wide band and calf-length fringed ends, binds the early priestly tunic of the Bel and Nebû reliefs; similarly broad kinds were characteristic of other Syrian priesthoods. By *c.* AD 100, however, a more elaborate version is represented at Palmyra: the ends of the knotted girdle are hooked over it to create a characteristically semicircular loop each side of the knot. Normal Hellenistic and Roman practice included such loops, but made differently; similar examples, however, occur in Antonine art. This looped variety is often depicted, binding the Iranian tunic above all, but also the boy's chiton and the Romanized cuirass.[549] Sometimes the cuirass has a simple, unknotted band, or no belt at all. A simpler, narrow band may bind the cameleer's tunic. In the third century even the servant's short himation may be belted, but the girdle itself is hidden. Finally, a quite different type of binding, a broad and decorated or embroidered floral band, is shown on second-century funerary relief busts of priests.[550]

35, 37

14, 21

73, 102

41
106

66

The sword-strap was customarily hung at an angle to the belt in the Iranian way. The Hellenistic and Roman baldric, suspended from the right shoulder, was adopted briefly by cuirassed gods among the Bel temple reliefs, and then again occasionally after *c.* AD 150 by gods both in cuirass and in local dress.[551]

27
17

Other items of masculine wear are less often seen. A coat, crossed over from the wearer's right to his left, appears on a funerary stele of *c.* AD 100–50. A simpler, open version is reserved for distinguished persons in funerary art a

38
102

century later. These are updated versions of the old Persian kandys. Parthian kings, their vassals and their successors liked similar coats, worn open, or similarly crossed over and secured by a waistband.[552]

13
80
Other male clothes seem more local. Malakbel (?) on the Palmyra 'stepped' relief twice sports a curious sleeveless waistcoat over his cuirass but under his cloak; perhaps the similar garment worn by a late second-century scribe is related to it. The circular, beaded neckline of a shirt, worn beneath the tunic, crops up here and there after *c.* AD 100.[553] And one of the clothes favoured by local and Arab standing and rider gods throughout Palmyrene art is a

33, 44
striking, skirt-like garment, also worn by men on the Bel 'Procession' relief, wound round the legs and forming a characteristic roll of material at the waist, with a fringed border down the front. The skirt normally reaches the ankles, but may be hitched up to the knee for riding, and is usually worn with the local tunic and desert cloak. Its origins may be Hittite, as a similar garb existed at Zinjirli and Tell Halaf, or perhaps Arab, as its wearers' ancestry or milieu often hints. Also rare at Dura-Europos and Hatra, it is hard to find elsewhere.[554]

Remarkably often, male footwear is obliterated, not indicated, or simply not worn. Cuirassed figures with bare legs in Bel temple reliefs wear laced

17, 15
75, 121
calf-boots possibly closest to the Greek *endromis*. Later, figures in Greek dress sometimes wear the simple Greek sandal, while bare-legged military gods use the endromis or the similar top-boot, the *embas*. The rare toga-clad figure

127
naturally sports the Roman boot or *calceus*.[555] But far commoner altogether is Parthian wear, of (perhaps mixed) oriental ancestry. A soft Persian ankle-boot

102
without sole, often highly decorated, was doubtless for indoor purposes; a ribbon and circular buckle fastens the boot over the ankle. A low shoe with

19, 61-2,
102, 114
sole, laced over the foot, accompanies or replaces the ankle-boot outdoors. The shoe is worn with Greek, Parthian or local costume, the boot perhaps exclusively with Parthian; the Iranian trousers and leggings are tucked into this footwear at the ankle. To go barefoot is apparently characteristic of certain

36, 75
divine figures, notably Heracles, and of some mortals in Greek dress.[556]

Female dress in some respects resembles the male. The tunic is normally ankle-length, and until *c.* AD 100 there is a strong tendency for it to splay out at

17, 26
the bottom, and for the lower hem to be emphasized. A long-sleeved oriental type is almost universally worn until the early second century, and remains popular

25
thereafter. From *c.* AD 50 decoration is often added to the tunic, and later

68
the sleeve may be bound with straps. Alongside this a new version is developed in the third century for mortals only: huge sleeves with woolly fringes, baggy

92
as a mandarin's, and a riot of embroidery remind us of modern Hauranese

15
dress. The Artemis-like figure of the Bel 'Battle' scene prefers a knee-length version.[557] A sleeveless long Greek tunic with frontal overfold, the *peplos*,

18
fastened on each shoulder and bound beneath the breasts, if not already present on the Bel north thalamos ceiling, has been introduced as occasional wear for

15, 38
goddesses by *c.* AD 50. Allat, in particular, comes to favour it, as does the

39, 41, 44
Western Athena, and she even wears it over the oriental type, as happened in western Parthia.[558] But the commonest tunic by far is the ankle-length chiton

89
with false or 'short' sleeves, which enters art in the early second century, and from *c.* 150 becomes really fashionable among mortals and progressive goddesses. Decoration is normally absent; a stripe may fall from each shoulder,

but anything more elaborate is rare, and usually occurs before AD 150.[559]
Girls wear simply the long- or false-sleeved tunics; they have a waistband less 83
often than boys. The complete absence of any tunic beneath the outer clothing 65
is a sign of mourning.[560]

The earlier sculptures show the female tunic covered only by an ankle- *26, 36*
length cloak used as a veil, in the Greek way; and goddesses later preserve *20*
this fashion. The cloak is customarily thrown over the top and back of the 88
head; less often it is merely attached behind, is pinned on one or both shoulders,
or covers the entire face; later funerary reliefs show further variations. This is *20*
clearly the Greek himation answering Semitic needs.[561]

From *c.* AD 40, however, mortal women are almost always depicted with
extra clothing between the tunic and veil. In its most complex form this 68
'garment' is shown with several layers: a triangular piece over the chest that
is pinned on the left shoulder, a horizontal piece roughly down to knee level,
and an ankle-length piece several times clearly distinguished from a (usually
decorated) tunic beneath. The most plausible explanation for this is that it is
all one garment: the triangular section is an overfold at the top (*apoptygma*),
and the knee section, the lower part of which forms the ankle section, is another
overfold possibly caused by a hidden waistband. Such an arrangement is at
least feasible, given a large, thin piece of cloth. Again, this is probably an
adaptation of the Greek himation, forming an over-tunic as worn elsewhere in
Syria and western Parthia.[562]

Some women, especially those with a 'melon' coiffure, substitute for the Cf. *93*
veil a heavy fringed cloak, cast around the shoulders, which may be of quite
local, or Parthian origin.[563]

Among females the cuirass is worn only by a goddess – the 'Artemis' figure *15*
of the Bel 'Battle' relief – and is of Hellenistic type. The Greek aegis graces the
tunic of 'Athena' figures. Waistbands, where visible, follow the simple Hellenis- *39*
tic fashions. Footwear varies: goddesses seem to like Greek kinds, such as the *38*
simple sandal or its more complicated sister, the *crepis*; mortals, when not
barefoot, prefer the oriental shoe – Ḥairan's wife wears a black pair.[564] 114

The intermingling of garments of different origins at Palmyra is remarkable,
but it is also a characteristic of contemporary Syria and western Parthia.

(vi) Drapery

Until *c.* AD 150 drapery folds are strongly patterned. Those on the early profile,
processional relief fragments remind us particularly of Achaemenian work, *29, 19, 20*
and the patterning in general is in tune with that of contemporary western
Parthia. The little groups of decorative folds so popular on male himatia and 65
women's veils between *c.* AD 90 and 170, however, have no precise counter-
parts in the East or the West and may have been local creations. But Western
motifs abound. The upper 'Malakbel' of the Louvre 'stepped' relief has the
slight fold at the centre of the tunic neck present in Greek art from the classical 14
period onwards and characteristic of countless Western and Palmyrene funerary
relief busts. The Bel beam soffit reliefs show some relaxation in patterning,
as a result of Western influence. And several mannerisms beloved of late
Hellenistic sculptors are reproduced on various reliefs. The goddess of the Bel
temple entrance ceiling has a himation sufficiently 'transparent' to reveal the 17

15, 39
69

17, 38

folds of the chiton beneath. The peplos-wearing goddesses display on each side of the chest a long fold tucked into the high waistband.[565] The heavy, marked central drapery folds that emerge between the legs of women and children especially between *c.* AD 30 and 150, dying away later, seem a particular product of an 'Asiatic' version of late Hellenistic classicism, which travelled eastwards (from Anatolia?). The accenting and splaying out of the lower hemline around the feet until *c.* AD 100 is interesting: it looks very like a descendant of an old and widespread Near Eastern and east Greek motif, most visible in ivory work, which could have passed to Palmyra from oriental Hellenism.[566]

Cf. 136

The general moves towards naturalism that take place after *c.* AD 150 are obviously the result of strong Western influence. Lengthy, linear folds, especially over the arms and legs, tend to be chopped up. But even here the realism is subordinated completely to the oriental sense of rhythm and pattern. The only works which follow Western models extremely closely are many of the strange little plaster figurines found together in a house; here the draperies swirl with Hellenistic intensity. But these are quite exceptional.[567]

(vii) Jewellery

107

A steady overall growth in the wearing of jewellery can be observed among Palmyrene ladies, developing from the comparative austerity of the first century to increasingly lavish displays. Divinities and men, however, do not usually wear ornaments. Jewellery was obviously kept in the boxes sometimes visible in funerary scenes.

77

63, 76

85, 92

A coronet- or tiara-like woman's diadem is first shown in AD 65/6. It is a stiff band, probably in reality of metal, customarily worn across the woman's forehead. At first it is smooth; by 96 it has several vertical lines as decoration, and within two decades it develops stylized leaves, rosettes, criss-cross patterns and sometimes Greek 'running dogs', done probably in *repoussé*. Panels of decoration are usually divided by listels, most often in pairs with beading between. Such diadems had long been fashionable among Near Eastern and Greek élites. Hellenistic varieties, of which the Palmyrene is one, survived in – and beyond – the Roman East.[568]

86, 89, 92

89, 90

87

After *c.* AD 150 ladies of fashion wear further hair ornaments. A head chain, seen also at Dura-Europos and Hatra, is the commonest, attached centrally over the diadem and looped around the temples It consists normally of circular cabochon jewels, joined by globules or dumbbell-shaped elements, but may, instead, comprise a simple chain or beading, or be elaborated with pendants.[569] A distinctive frontal ornament can be pinned over the head chain or be used separately. It has from two to four superimposed plaques of oval, diamond or rectangular shape, and three, sometimes four, pendants dangled over the brow. A similar piece was discovered in Tunis, so it seems to be Roman. For those with simple tastes who eschewed even the diadem and turban, a semicircular ornament, perhaps a sizeable local comb, might be attached on the crown. And an ear ornament, perhaps a pin or hairslide, of various Western forms akin to earrings, could be placed above the ears.[570]

26

Earrings, for males, were not an urban fashion, doubtless through Greek influence. Simple, tapering hoops are, however, sometimes worn by gods in

reliefs from the villages around Palmyra.[571] For females, earrings are usual, and a variety of them can be seen until *c.* AD 150. Funerary reliefs of the period *c.* AD 50–125 frequently represent women with their ears surrounded by small 77 rings packed closely together to form ear-covers, with or without normal earrings besides. These extraordinary ornaments may be of Semitic or Greek origin. 'Ištar's' earring, an amphora hanging from a disc, imitates a Hellenistic 38 Greek type. Plain and tapering hoops and the miniature bunch of grapes are 64 Romanized versions of Hellenistic earrings. The bell, ball and (after *c.* AD 125) 76, 87 the horizontal bar with two or three globular pendants are Roman, invented in the first century AD.[572] After *c.* AD 150, however, all of these except the ball 85 and the bar with pendants die away, and a new kind becomes virtually supreme: two little balls joined by a vertical bar, making the dumbbell so fashionable 89–94 also in Roman Egypt. Any other types, such as the ball, bar or the new triple balls in a vertical row and two superimposed cubes, are remarkably rare. And many females now spurn earrings altogether.[573]

A necklace is rarely worn by males. But gods, men and particularly boys do sometimes put on the heavy Iranian collar, called *streptos* by the Greeks, 80, 82 usually with an oval or circular central ornament like the Italian *bulla.* Or a boy may have an amuletic bell on a necklet.[574] Females are not often shown with necklaces in the first century, although 'Ištar' wears several Romanized Hellenis- 38 tic pieces, including the recently invented knobbed crescent worn upside down as a pendant. Shortly before 150, however, necklaces begin to appear in pro- fusion in funerary art; and by the early third century up to seven may be dis- 89 played, arranged to avoid overlapping. Most belong to the Romanized Hellenis- tic repertoire. Simple bead necklaces, with or without a central pendant, are 86 often worn round the throat or interspersed with other necklaces over the chest. Chains with pendants and simplified strap-necklaces hung with vaguely jar-like 85 elements abound. Linked plaques, principally oval, rectangular and diamond shaped, whether of metal or cabochon jewels, remind us of other Hellenistic and Roman types. Bead pectorals are sometimes visible, and seem more local. 85 The pendants, doubtless often amuletic, are usually circular or oval, or some- times resemble an inverted crescent; most curious is a large, oval, beaded plaque, 89 apparently local, often with three or four pendants of its own. Finally, an odd medallion necklace, seen occasionally in the third century, evokes Hellenistic and Roman parallels; but some medallions clearly contain the busts of Pal- myrene priests. Red, black and yellow paint sometimes adds to the gaiety of the sculptured pieces. Related necklaces are also depicted on sculptures of the great ladies of western Parthia.[575]

Brooches are used by both sexes to pin cloaks. Males prefer simple, circular or sometimes oval or polygonal types. Gods like sparsely decorated button types, as do many mortals. But between *c.* AD 100 and 150 a fashion develops among 12, 27, 61 men for brooches with a hexagonal motif surrounding a central circle (a cabochon?) as ornament. This dies out towards 200, leaving the field to simpler round and oval varieties, often with beading. Female brooches take a different 66 course. 'Ištar' uses a button type to fasten her tunic; but normally brooches 38 are visible only on mortals, pinning the himation on the left shoulder. Until *c.* AD 150 these brooches are almost invariably of a striking, trapezoidal form, 64, 83 with an animal head, usually a lion, or rosette as a finial, and linear or acanthus

leaf ornament below. After 150 they give way to circular and polygonal kinds which resemble, or are enriched by, the masculine types. Hexagonal, octagonal

89 and indented circumferences are often inscribed within an outer circle; beading and a round, central depression are common additions. Women also differ from men in quite frequently hanging pendants of local type from their

80 brooches: a key or two with the early trapezoidal brooch, and three little

85 chains each ending in an ivy-leaf with the later varieties. The male circular brooches are doubtless derived ultimately from Hellenistic Greek types and probably arrived at Palmyra with the chlamys; in design they sometimes approach the brooches worn by Roman emperors. The women's trapezoidal kind is regional, as the similar brooch found at Dura-Europos proves, used to pin the himation in an un-Greek arrangement. The female circular and polygonal types develop the apparently Greek male type, but in a way closer to Sarmatian work than Roman. The general change to Greek types after c. 150 is noteworthy.[576]

Bracelets can occasionally be seen on the wrists of gods just outside Palmyra, but they are normally reserved for women, and occasionally goddesses. Some goddesses before c. AD 150 wear varieties based on hoops, doubtless of Greek

38 origin: 'Ištar's' companion, for instance, seems to wear a two-part type. Women, on the other hand, almost always prefer Eastern kinds worn in Syria and western Parthia. A first-century relief may depict a bracelet of juxtaposed globules. Particularly popular throughout the following two centuries is a twisted

74 bracelet of alternately plain and beaded spirals; silver examples turned up at Dura-Europos: so it is clearly a regional bracelet, perhaps evolved from Hellenistic prototypes.[577] In the late second century a simpler alternative of plaited wire appears, and in the third, the twisted variety is supplemented or supplanted by bracelets of several kinds: a plain hoop, a cabochon chain of local type, or an undoubtedly Roman hoop with a circular centrepiece. The simpler hoops usually have a pendant, an amuletic bell, widespread in eastern Mediterranean lands.[578] Behind the twisted bracelet fashion permitted a broad, panelled clasp

85, 89 or armlet on the forearm, of Iranian origin. Second-century ornament on the armlet is normally floral, but in the early third century animals and even figures appear. A graceful armband ornaments a fragment of a female upper arm.[579]

Finger-rings are for mortals only. They begin to be shown somewhat

64, 80 before AD 150. Most men and women who wear them are content with one ring on the left little finger. But by the late second century rings may be worn

85, 89 on either hand, at either the centre or base usually of the fourth or little fingers, and sometimes two to a finger. Roman types are worn, usually the thick hoop with circular or oval bezel, rarely one of filigree.[580]

Finally, a feminine penchant for anklets manifests itself briefly between c. AD 100 and 150. Usually these anklets are heavy hoops, with an oval or eye-shaped central cabochon.[581]

(viii) Weapons

Characteristic both of militarized gods and, later, of certain standing men in

35, 44 Parthian dress is the great, long-handled, Iranian sword. This is worn on the left and normally hung by four rings from a loose strap around the waist in the Iranian way. Its typical, bulbous handle-top with globular bosses or tongued

ornament can also be seen in the hands of several divine and mortal relief busts. 65
A large, Hellenistic Greek type is worn briefly by a few cuirassed deities among 15
the Bel temple reliefs, suspended from the right shoulder in the Greek and
Roman way: one has a handle ending in a horse's head, like an example
depicted earlier at Pergamon. Then, after *c.* AD 150, its Romanized successor, 17, 41
with pommels of vaguely bird's-head form, is sometimes selected for cuirassed
and even local gods. Parthian costume, as seen after *c.* AD 100, is rarely complete 61, 109
without a dagger of Iranian type, the *akinakes*, with a blunt sheath and four
lateral lobes, attached to the lower right side (rarely both sides) of the tunic.
These, and perhaps also the swords when on civilians, were surely ornamental,
for the Palmyrenes felt in no need of arms when in Greek dress.[582]

A plain spear with triangular blade is held upright by most standing deities, 27, 41–4
and at an angle by many rider gods, normally with the right hand. A cameleer
on a late funerary relief holds one with his left. An idiosyncratic blade on the
Bel temple entrance ceiling and elsewhere has Roman parallels, but is perhaps 17
of Hellenistic origin like the sword in the same relief. A club is associated with
'Heracles' figures, as in Greek art, and a double-headed axe with ancient 25, 36
Babylonian Nergal.[583]

Another offensive weapon is the bow. This is greatly favoured by rider
gods, and a particularly long one, perhaps a regional or Iranian type, is clearly 33, 43
shown attached to a mortal cameleer's mount. Otherwise, a shorter, compound
kind with double curve, perhaps of Greek origin, is carried, for example, by 15
the 'Artemis' figure of the Bel 'Battle' scene and a third-century youth. A
bow-case with Arab affinities normally hangs on the flanks of horses and 25, 36
camels, and beside it a quiver. A Bel Foundation T statue shows the quiver
fixed beside the sword; the 'Artemis' figures of the Bel beam and tesserae
wear it, *à la grecque*, behind the right shoulder; while third-century young men
in Parthian dress suspend it behind the left shoulder.[584]

For defence, whether cuirassed or not, many lesser gods – and particularly
those in local dress – hold frontally in their left hands a small round shield of 37, 43
Arab design, light and handy for the desert skirmish on horseback or on foot.
But rider gods and mortal cameleers sometimes hang the shield from the
animal's haunch. Otherwise, the only shield seen at Palmyra is the tall, Greek 39
one resting beside 'Athena' figures.[585]

(D) OTHER OBJECTS AND ATTRIBUTES

(i) *Other objects associated with figures in art*
Apart from the lance and the small, round Arab shield already considered as
weapons, deities may hold other items in their hands. A sceptre is not un-
common, surmounted usually by a knob but occasionally (and particularly 28
for goddesses) by a floral motif. Although the sceptre is of Near Eastern origin, 26
the Palmyrene kinds are surely derived from the Hellenized versions current
in Hellenistic Greece and Parthia.[586] Much rarer, and mostly on tesserae, is the
Semitic ensign or *semeion*, a staff surmounted by religious symbols. The crescent, 25
from which streamers or pendants may hang, is often used to crown the staff;
other ensigns have statuettes or different emblems.[587] The thunderbolt belongs
to cosmic gods, and appears mostly in the 'divine hand'. It comes in two varieties:

31 a wingless kind occurs on altars (and a relief?) erected around Palmyra from
 AD 114, and a winged type on urban dedications of 163 and 233. They have

15 Greek antecedents, and were popular in the Syrian area.[588] Similarly Western
 is the trumpet(?) wielded by a winged genius above the Bel 'Battle' scene.

45 On a plaque of 228 the 'divine hand' holds three ears of corn, a Syrian idio-
 syncrasy with Hellenistic antecedents seen also on tesserae. A bouquet of ears

16, 31 of corn and fruit-laden branches, held in the lap by a god on an early stele,
 recalls the one often carried by such Western deities as Priapus and Abundantia.

13 The chains by which 'Malakbel' holds two lions and a star-rosette on the
 Rab Asirê relief seem entirely local.[589] Many other items are taken directly

11 from the Greek repertoire. The horn of abundance accompanies winged
 Victories in sculpture, and 'Tyche' and 'Dionysus' figures on tesserae. The

14 thyrsus already appears in the hand of 'Malakbel' on the Louvre early 'stepped'

12 relief; thereafter it is confined to 'Dionysus' figures on reliefs and tesserae. In

34, 25 both spheres, Nemesis has her wheel, and Hermes his bag and staff (*caduceus*).[590]
 Other objects are found only on tesserae: Apollo's lyre, the dadophoroi's
 torches, and Tyche's tiller all accompany appropriate figures. Poseidon's trident
 has gone to an unknown god, and Saturn's sickle (*harpe*) to Malakbel.[591]

 Other attributes are shared by deities and men. One example is the Western

31 bowl laden with fruits of the earth, carried by figures from a later period –
 a Priapus, who cleverly balances the bowl with his left hand on his upright

65, 145 phallus, and a third-century servant. The Iranian sword-hilt crops up among
 men on funerary reliefs, in belated imitation of numerous gods. A stick or

145 goad is wielded by desert riders; so is a plaited whip, which may be hung from

26 a mounted god's wrist – a Syrian idiosyncrasy.[592] The balance forms part of
 the zodiac, and is used by persons on tesserae. The hammer and tongs, on tes-
 serae, may be wielded by gods or men. A leaf, usually small and sometimes

40, 122 interpreted as a palm, may be held by deities of either sex, by priests and by
 deceased men. Occasionally, the funerary leaf is joined by a branch with
 berries, or replaced by a flower or fruit.[593]

 Mortals reserve other items exclusively for themselves; these are depicted
 mostly in funerary art.[594] In the left hand, throughout the second and third

75, 76 centuries, men may hold a curious object like a stick or cylinder, or two sticks
 juxtaposed. The 'sticks' are, surely, the ends of the book-roll or schedula that
 is sometimes more clearly shown resting on a pilaster above one shoulder of

80, 144 busts *c.* AD 150–250. The holding of the schedula is doubtless symbolic, but of
 what? Of the deed which gave the deceased rights over his grave, his 'house
 of eternity', as one is inscribed? Or, as in the Roman world, of devotion to
 study in preparation for the afterlife? The book-roll motif was also current
 elsewhere in Roman Syria and, held in the hand, is paralleled in the Roman
 volumen seen particularly on gravestones of the Danube area.[595] Large, rec-

80, 82 tangular writing-tablets of Western type occur sporadically throughout the
 second or third centuries, held by or placed beside the figure, and after *c.* AD 150
 a pointed writing-implement or stylus is occasionally pictured. These objects
 are present surely to indicate the earthly employment of the deceased, for ex-
 ample the ruler shown, in Roman fashion, beside the head of Moqîmû the
 'artisan', and the Western book-roll box or *capsa* and triple tablet or *triptychon*

75 held by a third-century slave. Tesserae also show knives, and a whetstone.[596]

The utensils for banquet and sacrifice are pictured on lamps, tesserae and reliefs. Most imitate popular Greek shapes. Several are common on tesserae, but rare and late in major art. The large container for mixing wine and water, the *krater*, is one;[597] others include the two-handled amphora, jugs, ladles and smaller vases of differing shapes which appear on lamps and tesserae to begin with, and later in funerary sculpture, but only from the early second century and usually in ornate versions.[598] One tessera seems to depict a rarer vessel, a wine-cooler or *psykter*, and others a barrel and water-skin. Conversely, a two-handled cup with foot, often attractively decorated, is virtually confined to reliefs, religious at first, funerary later. This cup is usually seen in one hand, normally the left, of reclining banqueters (and occasionally mourning women) from the first until the late second century, after which its popularity diminishes.[599] It is related to the Greek *kantharos* shape, of which examples occur in relief. The early Agora relief pictures a cup with lid, probably a perfume burner. Until *c*. AD 200 priests and sacrificers on reliefs often grasp a deep bowl, again usually ornate, filled with grains of incense, and this is normally accompanied by a small, slim vessel for liquid, a libation jug or alabastron.[600] From the late second century changes occur. A shallow bowl appears: banqueters often balance a chiselled version elegantly between their fingers. A cup without handles is sometimes seen. A tall drinking-horn or rhyton is held by a priest on a late tessera, and by some third-century 'serving-youths', while another raises high a libation horn. Other 'serving-youths' carry a probably more local platter heaped with lamb, and a huge bowl, or rather a basket, piled with fruits. Actual discoveries of pottery enlarge the known range of common Western types used at Palmyra, notably the thymia-terion and decorated oil lamp, together with (if from Palmyra) what may have been a cake mould.[601]

Greek musical instruments also enlivened ceremonies. Tesserae depict two: the double-pipe, and the syrinx, which is also shown in sculpture.[602]

Besides the two-handled cup, men and women share other attributes. The funerary pine-cone (?), widespread in the West as an emblem of immortality, is occasionally depicted. Curious right-angled objects, surely keys, can be seen in the hands of one male and several female funerary relief busts, and dangling from a number of women's shoulder-brooches. A few are inscribed, one with 'house of eternity', otherwise cryptically. The idea of the symbolic holding of keys has a Greek background: but are these symbolic merely of possession on earth, or are they the keys of the tomb, the entry to eternity?[603] Men and women also share the motif of holding a loop of drapery, in the hand or pinned by the forearm; women have this throughout our period, men only from the late second century. An early stage of the motif is visible on the Greek 'Pleureuses' sarcophagus from Sidon.[604]

Females have their own exclusive attributes. The goddess Leto and several women of the second and third centuries are depicted beside or with a ball of wool.[605] From *c*. AD 80 to 190 deceased women are commonly shown holding a spindle of Near Eastern type and a distaff together in the left hand, obviously an allusion to their earthly status as housewives. In sporadic representations in Hittite, Greek and (Danubian) Roman art, a spindle is generally held in one hand and a distaff in the other; otherwise, their appearances in the Roman

Margin references:
23
102, 105

26
60, 98

23
26
66, 72

66

62, 100

43

108

132

83

64, 93

81

40
93, 107

64, 83

period were virtually confined to Phrygia and Syria. The Palmyrene manner, with both in the left hand, is a Syrian trait.[606] From *c.* AD 100 a number of

86 women carry a child on their left arm. This ancient Near Eastern motif had continued life in Hellenistic Greek and then Parthian terracotta. Next it turns up, mostly in bust form, in Romanized Syria and Egypt, and is finally transmuted into the Byzantine 'Hodegetria' composition.[607] Others in the second century hold an odd circlet (a wreath?) or an obscure object like a small box.[608]

74, 107 In association with full-length representations of women in funerary relief and painting a flat-topped casket, probably a jewel-box as in Greek funerary reliefs, is sometimes shown, either beside the figure or offered by a servant. It is usually rectangular, occasionally polygonal, and may have panels and knoblike legs; the shapes could be Western, but the legs are unusual. Now and again a tall basket or vase of Greek or local origin rests beside the deceased. And a servant holds up a circular object, perhaps a mirror.[609]

73, 88 Children and adolescents have two attributes of their own: the bird, and the bunch of grapes. Both have Greek antecedents, and both were widespread in the Roman Empire, as symbols of childhood: it is not clear whether they meant much more than this, nor whether they had the same meaning at Palmyra as elsewhere.[610]

(ii) Figures' surroundings

Buildings are not often included within a figured scene. As regards major

19 sculpture and painting, the Bel 'Sanctuary' relief shows part of a little temple in the only Western order depicted at Palmyra – the Corinthian. But if, as seems possible, the temple possesses a monumental entrance which interrupts the peristyle, it is repeating a local idiosyncrasy of plan of the temple of Bel

30 itself. Corinthian again is the temple front with eagle capitals framing the principal god of the Abû Dûhûr graffito, the pilasters and architrave of the

28 Sacred Law stele dated 163, and probably the pedimented aedicula of AD [1?]19. Simpler pilasters occasionally fluted but usually plain, and crowned by

38 standard Western mouldings, support such items as an eagle or bookroll in the first-century 'Ištar' scene and in a number of funerary reliefs, mostly of the

75, 80 period *c.* AD 150–225. An altar and a tessera depict shell semi-domes above the heads of figures, with the conch radiating upwards, as was normal in Syria and

54 p) Asia Minor. On tesserae the Corinthian aedicula and capital is popular, as are arches; temple façades are probably taken from Roman coins; buildings of more oriental forms, crowned by merlons and crenellations, are much less popular.[611]

Landscape hardly exists in Palmyrene art. Occasionally, a religious relief

14 will include a tree: the Bel 'Sanctuary' and 'Offering' scenes, and the seated

18, 25 Hermes and Heracles reliefs, are examples. The latter pair also include a rock,

29 visible again on a curious, but battered scene from north-west of Palmyra. The way these features are used recalls the integration of Hellenistic reliefs rather more than the rigidity of those of the earlier Near East.[612]

Altars are set beside sacrificers in religious art; if gods are present the altar normally separates them from mortals. Throughout our period, the altars

14 are essentially of two types, both Western. First to appear and always popular

39, 41-3 is the cylindrical altar, the burner (thymiaterion) with moulded rim, of varying

height and design, doubtless in reality of metal and portable. The Bel 'Sanc- *19*
tuary' scene introduces the second, the cubic altar proper, with Western mould-
ings at top and bottom: local details include the relief of a goat on one, and the *40, 46*
old Assyrian and Persian stepped moulding on another. The cubic altar is
shown rarely in sculpture and tesserae, but many stone originals survive.[613]

A mysterious item recurs frequently throughout funerary art: a curtain
(*dorsale, dorsalium*) suspended by two circular pins or rosettes and accompanied *72, 91*
by twin palm leaves which rise above it, often curving inwards. On the earliest
stelae it may appear alone, or in front of a figure; thereafter it is always fastened *67, 36*
behind a figure, at or above shoulder height. About one-sixth of the nefeš
include one of these curtains; whether or not they are shown seems to have
been a matter of taste. When more than one figure is present, and the curtain
is suspended behind only one of them, it seems to indicate that the marked *65, 94*
person died before the other(s), or that the other(s) were still alive when the
relief was carved. Curtains hung in a similar way behind the deceased, but
lacking palms, are scattered through Roman religious and funerary art from
c. AD 100; the only close parallels, however, come from Roman Syria.[614]
The curtain must be symbolic, but of what? No satisfactory answer has yet
emerged. One interpretation works forward from the Hellenistic Greek artists'
habit of draping a curtain (*parapetasma*) behind figures to indicate a house
interior: the Palmyrene curtain might signify the interior of the tomb, the
deceased's eternal house, or the boundary between the world of the living and
what lies beyond. Another interpretation, starting from the fact that the
curtain is a cloth, suggests that it is part of the ritual apparel of the funeral, or
the glorious garment with which the deceased's spirit will be wrapped to enter
its celestial rest. A third explanation sees in the curtain the eschatological sky,
Paradise.[615]

Furniture of various kinds accompanies Palmyrene figures. The goddess
'Ištar' rests on a curious, solid-sided throne, apparently of masonry. Illogically, it *38*
supports an arm-rest and cushion as well as a pilaster; the design looks essentially
Western. Likewise in the first century, a more conventionally Hellenistic and
Roman throne, high-backed with curving arm-rests and solid sides, is adopted *49*
(once) by Allat. During the second century, the most popular female seating
is a fairly high-backed throne, again with curving arm-rests, made of plaited *40, 94*
fibres. This imitates a contemporary Roman type fashionable in Italy and in the
Danube, Rhine and British provinces. The chair is rare, but one may be visible
on the Abû Dûhûr graffito and another, the Roman *sella curulis* (used as an *30*
altar?), on a damaged relief. Monumental stools are in common use for divine *21*
and mortal purposes: the commonest kind, with turned legs, is descended *16, 125*
from the Greek *diphros*; a rarer type, encountered after *c.* AD 150, borrows
animal-head terminals from standard Western thrones. The folding stool, of
Greek design with straight crossing legs, is used by an artisan in a tessera scene. *32 c)*
The innumerable banqueters' couches are of a Hellenistic Greek form extremely *100–2*
popular throughout the Roman world. The multiple turnings on the legs, the
miniature busts, crouching bulls, rosettes, floral spirals and other ornaments
along the fittings and frame proved irresistible to Palmyrene artists, who
detailed them lovingly. Divine couches, as seen on tesserae and in a curious
relief fragment, look similar. The table, so often placed before the couch in *105*

Western banquet scenes, hardly ever appears; when it does, it is of the circular, three-legged Greek form much liked by Romans. On the couch, until the mid-second century, is laid a single, thick mattress usually with three or four broad bands of beaded decoration and floral ornament, as in Hellenistic and Roman examples. But towards 150 the sybaritic Palmyrenes began to lay over this a second, thinner mattress of their own, covered with rosettes between listels; in the third century both mattresses could be rolled into one, with bands and rosettes combined as decoration. Palmyrene cushions and bolsters swell to a seemingly un-Western size, and are often shown covered with textiles of Eastern design. Male banqueters usually prop themselves on a pair of cushions; females may have one on their chair or stool. But in the third century most seated women in banquet scenes sit merely on two high bolsters. After *c.* AD 150, a curious local cushion or bunch of drapery is sometimes seen in the background of a funerary relief, supporting a priestely cap, less often simply a wreath.[616]

Means of transport by land and sea, other than walking and animal-riding, are rarely depicted. A few chariots of Western design are shown with the usual spoked wheels; Malakbel's however, has a comical, high back, inviting suspicions that the artist, by accident or design, has reversed the vehicle's body. The frontal chariot on the Malkâ relief is represented 'analytically'. Far more surprising than these is a mid-third-century funerary-relief fragment showing two men standing before the reduced representation of a merchant ship of Roman type, perhaps an Indiaman. And a tessera depicts an anchor.[617]

(iii) Birds

The eagle seems always to be imbued with religious symbolism at Palmyra. It is shown in essentially two ways. With wings outstretched and head (usually) turned to one side in an old Near Eastern manner, it dominates first-century niche lintels and a later divine calathos, and symbolizes either of the great sky gods equated with Zeus – Bel or Ba'alšamin. With wings open, but not spread, whether flying or at rest, often with a crown or leaf in its beak or claws, it becomes a messenger of glory and eternity, frequently present beside deities or priests. On funerary reliefs one perches above a man's head, and a pair holds up a wreath. This type with open wings, current by the early first century and popular thereafter, was widespread in the Roman and Parthian worlds.[618] The crow escorts Greek Apollo on a relief, and perhaps occurs on tesserae, which also show other birds: a cock, dove and surrealist gryllos from the Greek repertoire, and a human-headed cock from the Syrian. As in Greece, on many funerary reliefs a child holds a bird of indeterminate kind, which may be the protective dove of Atargatis, or simply a pet pigeon. More unidentifiable birds peck grapes on a tomb ceiling.[619] The birds, including the peacock, of the Three Brothers' painted exedra dado seem to be taken from some Western copy-book. The presence of Nile waterfowl confirms this.[620]

(iv) Animals

Animals, like birds, mostly have religious associations in Palmyrene art. Throughout our period they are normally shown in profile, but are occasionally turned entirely to the front. After *c.* AD 60 a profile animal may be depicted with its head (only) facing frontwards.[621] The animals adopt one of six poses,

Marginal references: 37; 100, 102; 101; 79, 81; 15; 48; 42; 103; 17; 9, 12; 9; 40; 72; 116; 14, 20, 42

all of ancient Near Eastern ancestry. When walking, stepping or leaping, they may be ridden; otherwise they may attack, sit or recline. The majority move towards our right, but recline facing to our left.

For the walking pose, popular in religious and standard in funerary art, the animal (horse, camel, lion or bull, with or without rider) keeps all four feet on the ground, the two legs furthest from the spectator normally being in advance of the nearer. Apparently the pose was uncommon in Hellenistic and Roman Anatolia but current in Roman Syria and western Parthia, which suggests that it arrived at Palmyra from an oriental source.[622]

For the stepping pose, the animals are depicted with three legs on the ground and the fourth (usually the further foreleg) raised. The pose first appears at Palmyra in the early votive niches, whose animals without riders may have a Near Eastern ancestry. No definite example of stepping animal with rider, a Western innovation, antedates the second century; thereafter the stepping motif is often associated with gods mounted on griffins or horses, and with 'heraldic' rider gods. Current in late Hellenistic art, this pose became very popular in Roman Anatolia for deceased horsemen, rider gods and particularly the 'heraldic' Dioscuri. It was also known in Syria and western Parthia.[623]

For the leap only the hind legs stay on the ground, while the forelegs rise in the air. Once again the further legs are usually in advance of the nearer. Vigorous examples embellish the Foundation T fragments and the Bel temple sculptures, but after this period the motif vanishes. This is all the more surprising in view of its long-lived popularity outside Palmyra, in Hellenistic, Roman, Anatolian, Parthian and later in Sasanian art.[624]

The attack is found only on the dado of the Three Brothers' painted exedra. It seems an enfeebled descendant of earlier Near Eastern animal combats.[625]

Animals sit with their hind quarters on the ground. This pose, rare earlier in the Near East, is virtually confined to the lion and the dog at Palmyra, and may well have arrived from the West.[626]

Sphinx-like reclining poses, however, are commoner both in the ancient Near East and in Palmyrene art, where bulls and felines, particularly, adopt them. Their comparative scarcity in the West need not preclude a Western origin for Palmyrene examples.[627]

One of the first animals to appear at Palmyra was of fabulous stock: the griffin, eagle-headed, with the body of a winged lion, associated at first with Malakbel and later, through Western influence, also with Nemesis. Once current in Assyrian and later Near Eastern art, it had been absorbed into the Greek repertoire at an early date and reached Palmyra in Hellenized form. The goat is portrayed with Malakbel on early reliefs, no doubt because of local tradition; later, the animal reappears on the Gdêm altar.[628]

The lion arrived by several routes. Seated beside the throne of a goddess, usually Allat, it constitutes a borrowing from the iconography of Syrian Atargatis. It may accompany other deities, or allow them to rest or stand on its back, as did north Syrian Jupiter Dolichenus on his bull. Lion-heads are used as architectural ornament, a Western practice. Western again is the appearance of lions in funerary art, as statues with prey between the forepaws (as seen especially in the Danube provinces) or as decorative heads with rings in their mouths.[629] The bull also adopts various forms. It appears early but is somewhat

(margin references:) 13, 42 · 14, 42 · 18 · 15 · 115 · 49, 110 · 52 · 14, 42 · 13, 19 · 31 · 49 · 11 · 110

42, 54 bb) sparsely represented in sculpture, being commoner on tesserae. The breed
usually shown is the Indian humped ox or zebu. Reclining in profile it is nor-
89 mally a divine attribute, but by the early third century it often merely decorates
29 a great lady's armlet. On rare occasions it is shown leaping, or standing with
a deity on its back like Syrian Dolichenus and his bull. The bull's head may
become an architectural ornament as a protome, or be represented on tesserae
as a Hellenistic and Roman *bukranion* (ox-head or skull). All these versions,
43 even the zebu, seem to have come from the West.[630] The horse with Roman
harness is a common mount for gods and men; a rather small one, or perhaps
20 a donkey, leads the Bel 'Religious Procession'. The single-humped camel or
dromedary is usually a divine mount or attribute; mortals appear with or on
33, 143 one only after *c.* AD 100. The representations, given the geographical distribu-
tion of the dromedary, must have developed in the region, especially since
54 m) those on the tesserae are sometimes remarkably lifelike. Parts of the harness,
such as the halter with two reins, are apparently modelled on the Roman type
for horses; but the remainder, understandably, is Arab: the saddle types, saddle
cloths, girths, covering and saddle-bag.[631]

Other animals appear fleetingly. Sheep or rams, or their heads, are depicted
on zodiacs and tesserae, and lambs in the arms of 'serving youths'. Tesserae
also include a calf. The Roman she-wolf appears under a fig-tree on a damaged
stele. A fox-head (?) ornaments a dagger handle (?). A dog, usually seated
upright, and sometimes in pairs on tesserae, is also occasionally seen in sculp-
42 ture. Unidentifiable felines pull the frontal chariot on Malkâ's relief. A cheetah,
panther (?), and sphinx all appear on different plaques, the panther on a ceiling
as well. Most of these animals, if not all, carried religious significance, now often
obscure; the sources for the representations may well be Western.[632]

115, 116 The animals – the antelopes, onagers and rabbits – disporting themselves
along the dado of the Three Brothers' painted exedra must surely, like the
birds, have been inspired by Western models, particularly as their representa-
tions are unique at Palmyra both in subject and liveliness.[633]

(v) Snakes, scorpions, fish

The snake appears in several contexts, mostly early ones. It is sometimes present
Cf. 17 on religious niche lintels before *c.* AD 50, and it is shown on Abgal and Ašar's
43 relief of AD 154, apparently symbolizing the sun in the Syrian way. Snakes
15 pour from a jar beside the head of the monster in the Bel 'Battle' scene; the
monster itself, below its acanthus leaf waistband, sports five snake-legs, a
seemingly local variation on the Greek giants, who usually possess two. Above,
two winged genii with serpent bodies beneficently carry palms. Elsewhere,
27 the snake is the attribute of Šadrafâ: curling round his spear in first-century
sculpture, and his companion on tesserae. Here the symbolism may be con-
nected with the long history of the snake in Mesopotamian art, associated with
life, fertility and the underworld. But whatever its symbolism when accompany-
ing Šadrafâ at Palmyra, the actual motif of the serpent-entwined lance seems
an imitation of the similar staff of the Greek healing god Asklepios; and this
connection is strengthened by Šadrafâ's name, which may mean 'healer'.
Finally, another serpent appears on a pilaster capital of Marônâ's funerary
temple of AD 236, perhaps symbolizing immortality.[634]

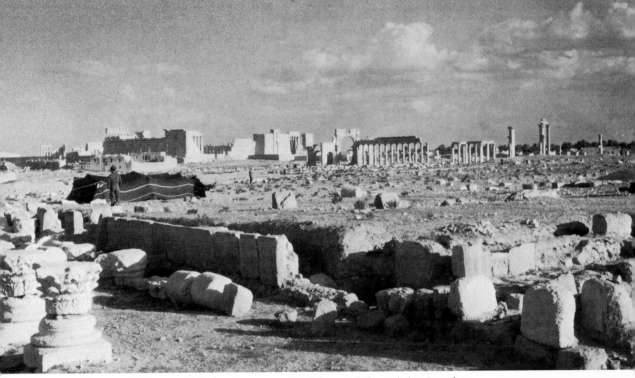

1 Site of ancient Palmyra, with the sanctuary of Bel (centre left) and the Grand Colonnade in the background

2 Temple of Bel, dedicated on 6 April AD 32: south end, with the monumental entrance visible on the left (p. 26)

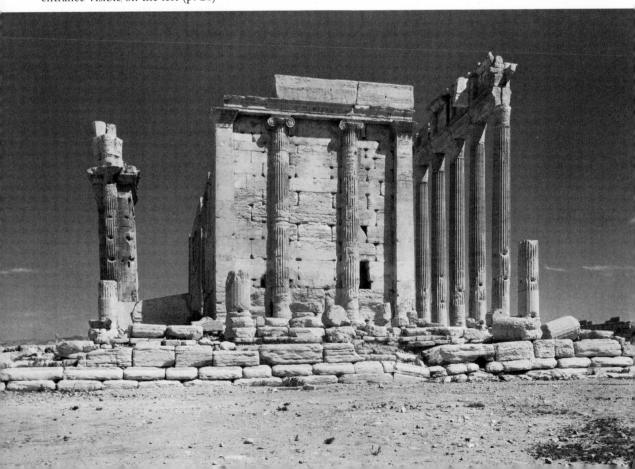

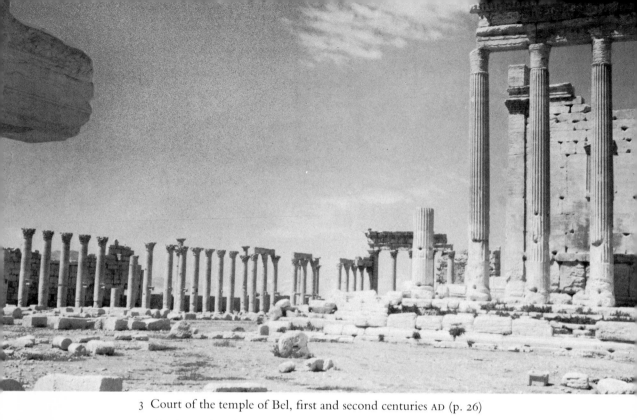

3 Court of the temple of Bel, first and second centuries AD (p. 26)

4 Northern chamber (thalamos) in the temple of Bel, *c.* AD 32 (p. 27)

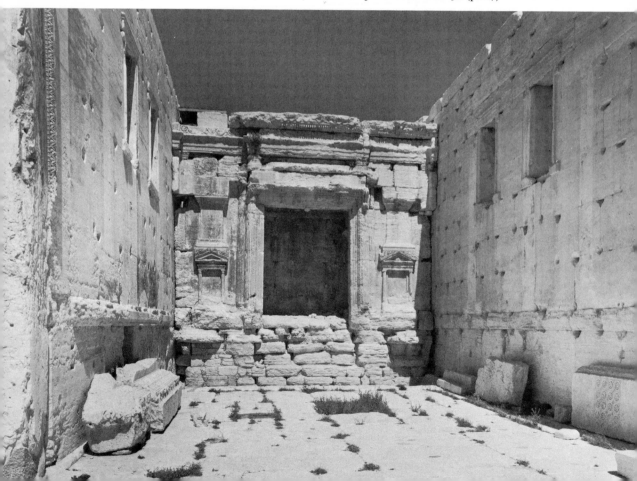

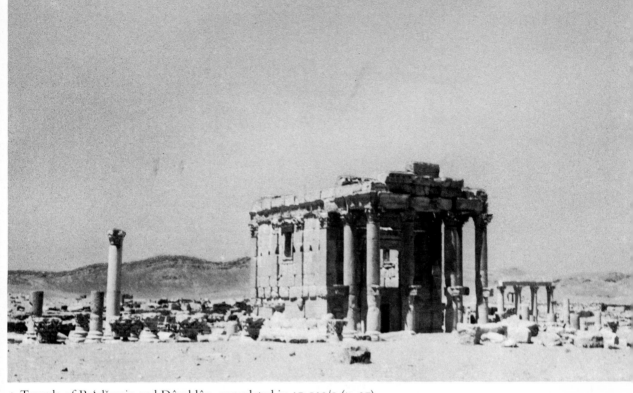

5 Temple of Ba'alšamin and Dûrahlûn, completed in AD 130/1 (p. 27)

6 Fragmentary trunk of an early cuirassed statue (PM T.26; ht. 41 cm.; p. 31)

7 Carved limestone plaques, for attachment to the trunk of an early statue (PM; ht. *c.* 30 cm.; p. 31)

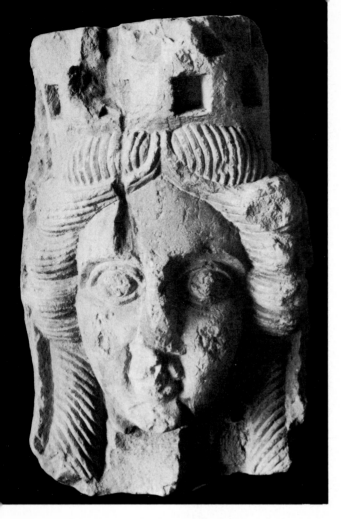

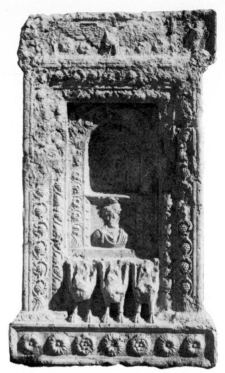

8 Head from a statue of the guardian spirit of Palmyra(?), *c.* AD 100 (PM; ht. 37 cm.; p. 31)

9 First-century carved sanctuary wall-niche (PM B.953; ht. 1·54 m.; p. 32)

10 Fragment of decorative framing from an early sanctuary wall-niche (DM C.5308; width 30 cm.; p. 33)

11 Lower section of a first-century carved sanctuary wall-niche from the Agora (DM C.5312; ht. 99 cm.; p. 33)

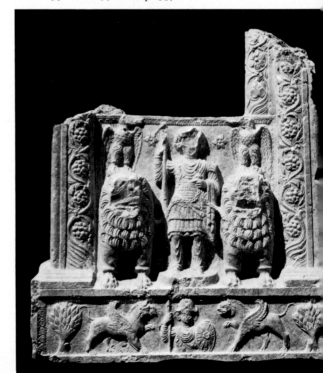

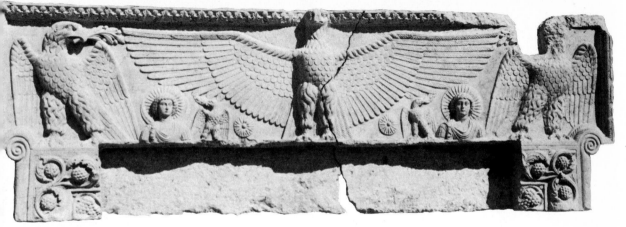

12 First-century niche lintel from the sanctuary of Ba'alšamin, with Ba'alšamin symbolized by the central eagle overshadowing 'Aglibôl (left) and Malakbel (right) (PM 1906/6850; ht. 85 cm.; p. 32)

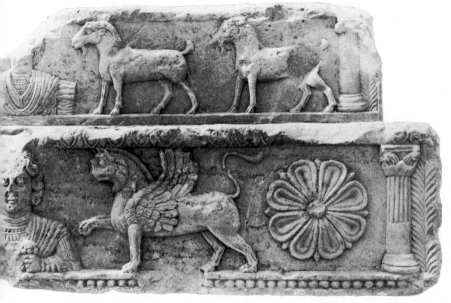

13 Early niche base fragment from the Bel sanctuary, with two busts of Malakbel (?) flanked by goats and a griffin (PM 801/2004; ht. c. 33 cm.; p. 33)

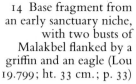

14 Base fragment from an early sanctuary niche, with two busts of Malakbel flanked by a griffin and an eagle (Lou 19.799; ht. 33 cm.; p. 33)

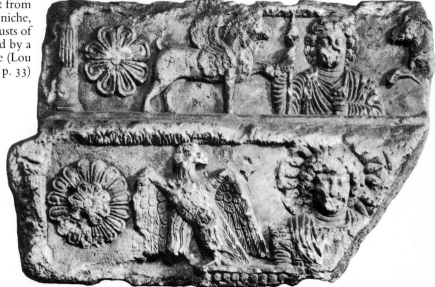

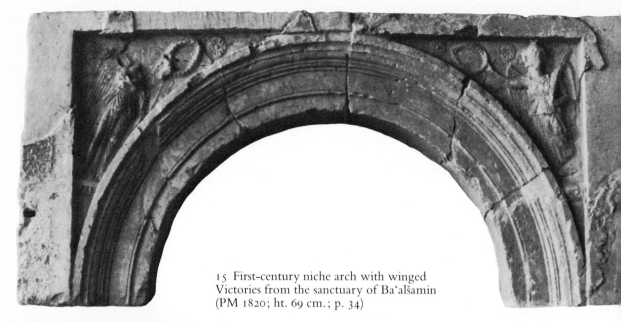

15 First-century niche arch with winged
Victories from the sanctuary of Ba'alšamin
(PM 1820; ht. 69 cm.; p. 34)

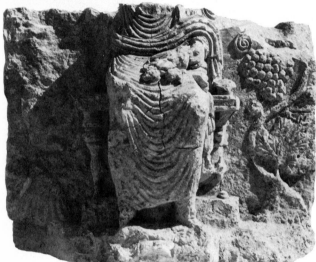

16 First-century stele with a seated god,
probably Ba'alšamin, in relief (DM C.7469;
ht. *c.* 40 cm.; pp. 34, 41–2)

17 Bel temple entrance ceiling, with three
deities, 'Aglibôl, Iarhibôl(?), and Beltî or
Ištar, in relief, *c.* AD 32 (PM; *c.* 2 m. sq.; p. 35)

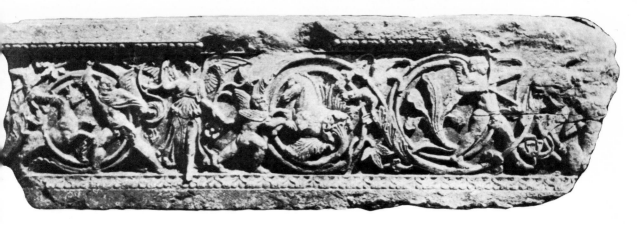

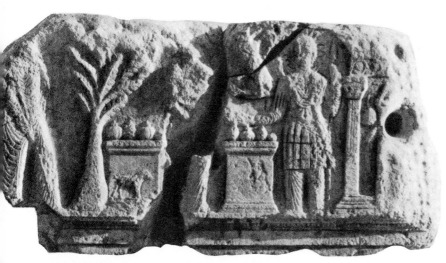

18 Underside of a Bel temple beam, carved with a scroll with Eros, Victory and other figures, *c.* AD 32 (*sub situ*; width *c.* 1 m.; p. 38)

19 Bel temple beam relief representing a sanctuary with two gods, Malakbel (centre) and 'Aglibôl (right), *c.* AD 32 (*sub situ*; ht. *c.* 1·60 m.; p. 36)

20 Bel temple beam relief representing a religious procession, *c.* AD 32 (*sub situ*; ht. *c.* 2 m.; p. 37)

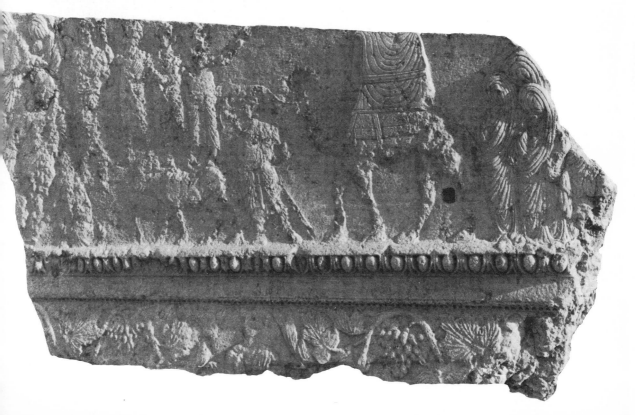

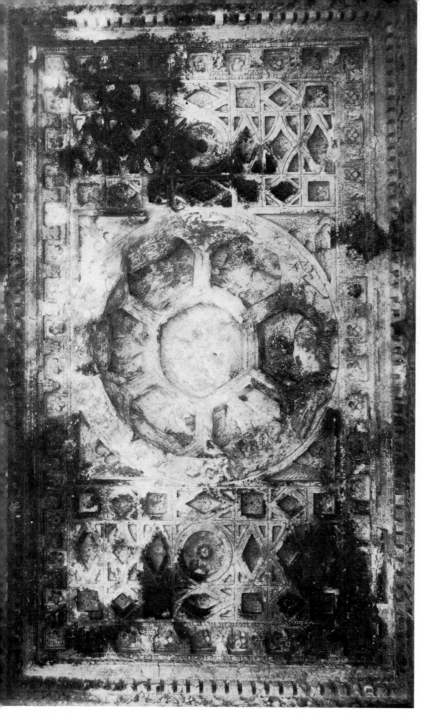

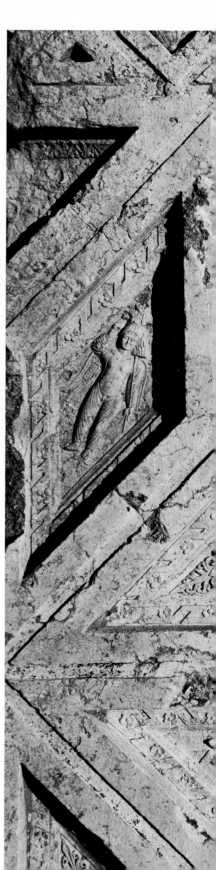

21 Bel temple north thalamos ceiling, *c.* AD 32 (*in situ*; width *c.* 5 m.; p. 38)

22 Bel temple peristyle ceiling relief with winged spirits, *c.* AD 32 (PM; width *c.* 1 m.; p. 38)

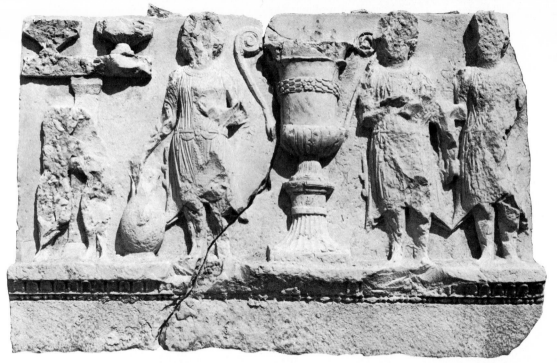

23 Third-century architectural relief with figures beside an urn (PM; ht. *c.* 1·50 m.; p. 39)

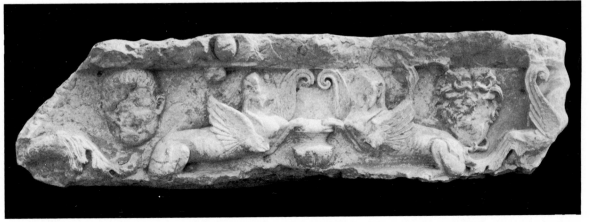

24 Bel sanctuary decorative frieze fragment, with masks and sphinxes (*sub situ*; width *c.* 20 cm.; p. 39)

25 A pair of architectural reliefs with Hermes (right) and Heracles seated (Bel Propylaea; ht. *c.* 50 cm.; pp. 39–40)

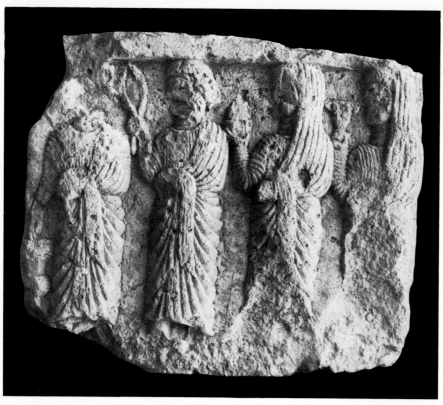

26 Early relief fragment with offering-carriers and a rite of worship (PM; ht. 42 cm.; p. 40)

27 Relief depicting the god Šadrafâ, dated AD 55 (BM 125206; ht. 47 cm.; p. 42)

28 Relief bust of the god 'Aglibôl dedicated to the sun in AD 30/1 (DM C.7939; ht. c. 50 cm.; p. 42)

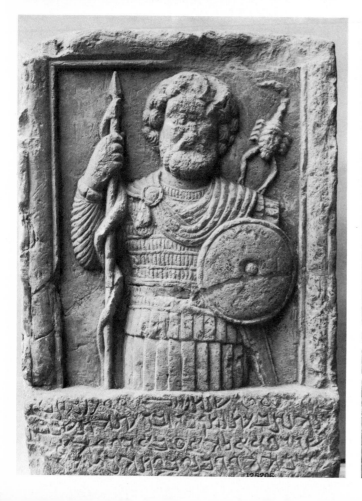

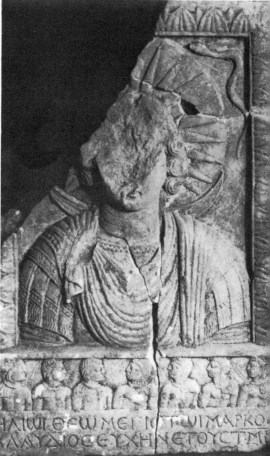

29 Fragment of an early processional relief with a man in profile, from the Bel sanctuary (PM; ht. *c.* 18 cm.; p. 40)

30 Torso of an early palm-carrying figure, probably a priest, from the Bel precinct (PM B.53; ht. *c.* 30 cm.; p. 40)

31 Lower portion of a second-century Priapus-like figure (PM; ht. *c.* 30 cm.; p. 42)

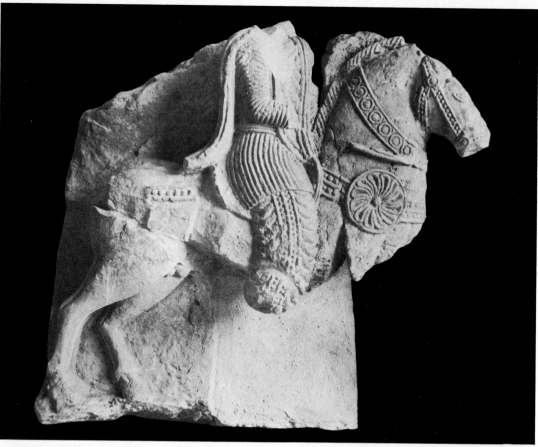

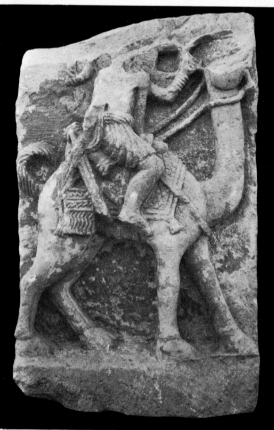

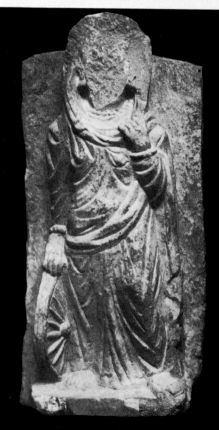

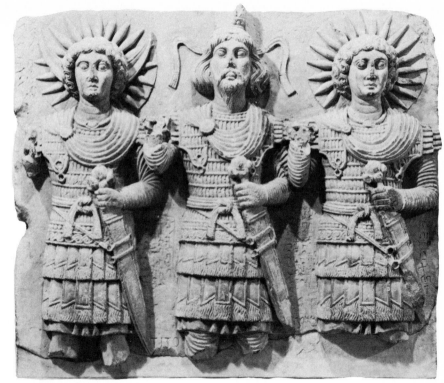

32 Early relief of a horse with a (divine?) rider, from the Bel sanctuary (PM; ht. 66 cm.; p. 43)

33 Relief of a (divine?) camel rider, from the Bel sanctuary (DM; ht. *c*. 70 cm.; p. 43)

34 Third-century relief of Nemesis from north-west of Palmyra (DM; ht. 35 cm.; p. 44)

35 First-century relief of a divine triad, 'Aglibôl, Ba'alšamin and Malakbel (Lou 19801; ht. 56 cm.; p. 44)

36 Early relief depicting a Heracles figure with three other deities (DM; ht. 23 cm.; pp. 45–6)

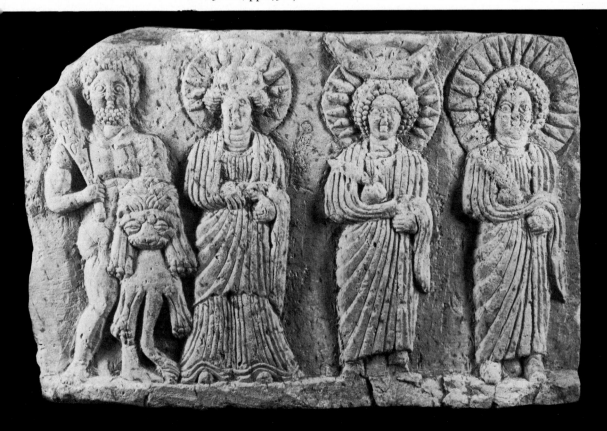

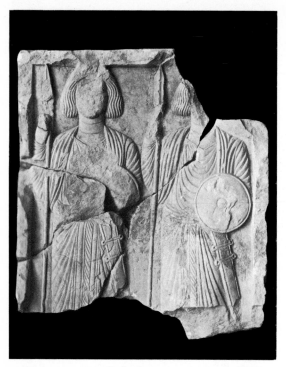

37 First-century relief of two warrior gods (DM; ht. 41 cm.; p. 44)

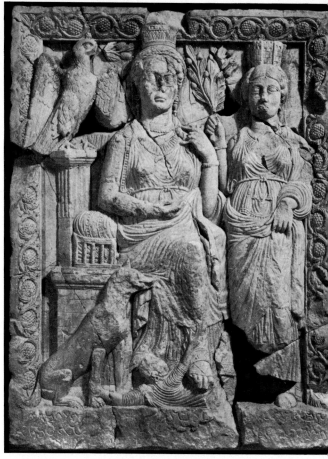

38 Relief depicting two goddesses, perhaps Ištar and the guardian spirit of Palmyra, *c.* AD 50–100 (DM; ht. *c.* 60 cm.; p. 48)

40 End of a second-century relief which included Leto and Apollo (DM; ht. 58 cm.; p. 48)

39 Third-century relief from north-west of Palmyra portraying Allat and the sun before a worshipper (DM; ht. 28 cm.; p. 49)

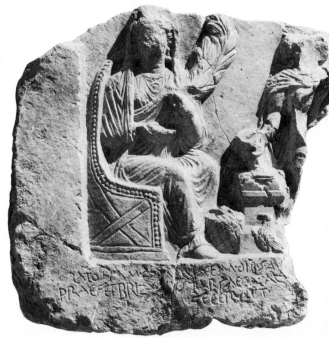

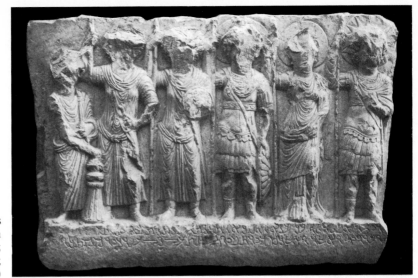

41 Relief with five deities before a worshipper from Wadi el-Miyah, dated AD 225 (DM C.2118; width 68 cm.; p. 51)

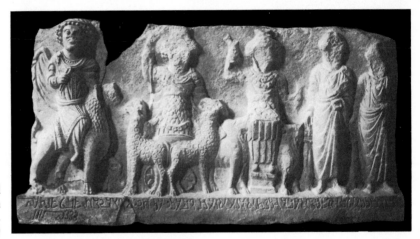

42 Relief dedicated to the god Malkâ (shown at left?) in AD 263 (DM C.3841; ht. 53 cm.; p. 50)

43 Relief representing the Arab gods Abgal and Ašar on horseback flanking a worshipper, dated AD 154 (DM C.2842; width 62 cm.; p. 49)

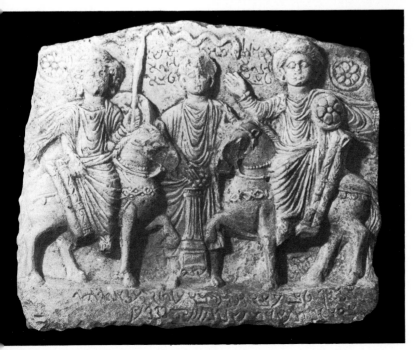

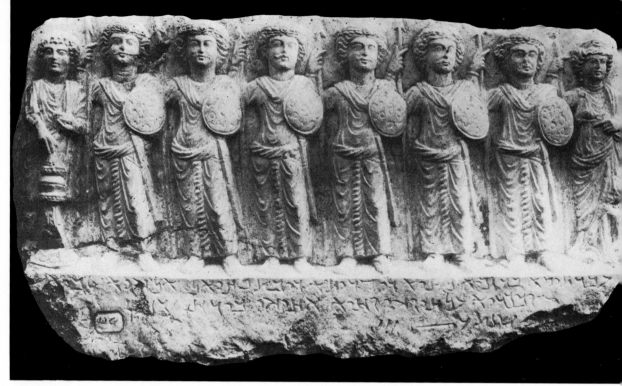

44 Relief from north-west of Palmyra portraying the guardian spirits of Bet-Phaṣi'el,
a worshipper (left) and a goddess (right), dated AD 191 (DM; ht. 37 cm.; p. 51)

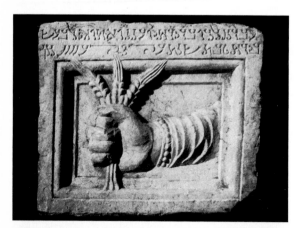

45 Relief offered to Ba'alšamin in AD 228, with a
symbolic hand holding corn (private coll.; ht.
29 cm.; p. 52)

46 Relief of a lion and altar dedicated to
Ba'alšamin in AD 216 (DM; ht. 28 cm.; p. 52)

47 Symbolic eagle relief, c. AD 200 (private coll.;
ht. 26 cm.; p. 52)

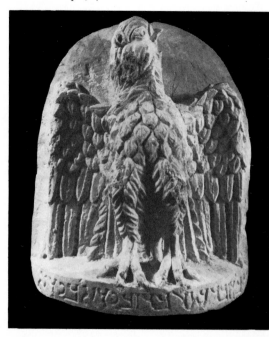

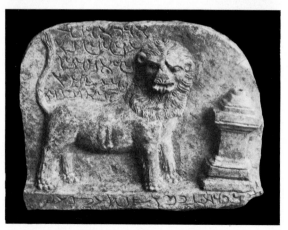

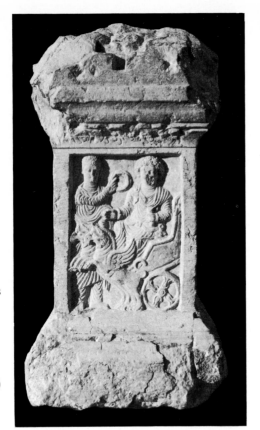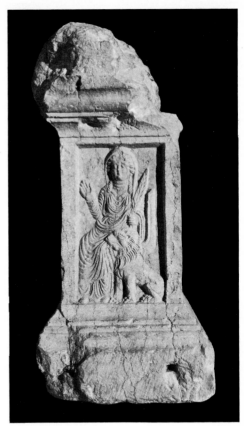

48, 49 Two faces of a first-century altar with reliefs from the Ba'alšamin sanctuary, picturing Malakbel (left, in a chariot) and Allat (right) (PM 1887; ht. 68 cm.; p. 53)

50 Altar with relief busts of a divine triad ('Aglibôl, the 'Nameless god' and Malakbel?) dated AD 240 (Strasbourg Library; ht. c. 60 cm.; p. 53)

51 Third-century altar with up-raised hands in relief (NCG 1161; ht. c. 60 cm.; p. 53)

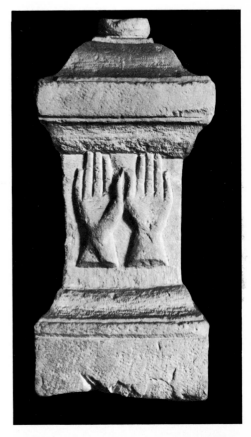

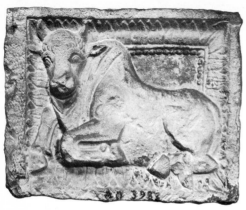

52 Third-century plaque with a reclining bull in relief (Lou 3983; ht. *c.* 35 cm.; p. 54)

53 Second- or third-century bronze running dog from the north-west region (DM; length 9·8 cm.; p. 54)

54 Selection of tesserae, nos. a) 832 b) 390 c) 712 d) 83 e) 252 f) 435 g) 945 h) 934 i) 878 j) 679 k) 174 l) 19 m) 174 n) 725 o) 422 p) 19 q) 396 r) 660 s) 724 t) 777 u) 822 v) 274 w) 313 x) 945 y) 878 z) 792 aa) 254 bb) 1 (BM; roughly actual size; pp. 54–6)

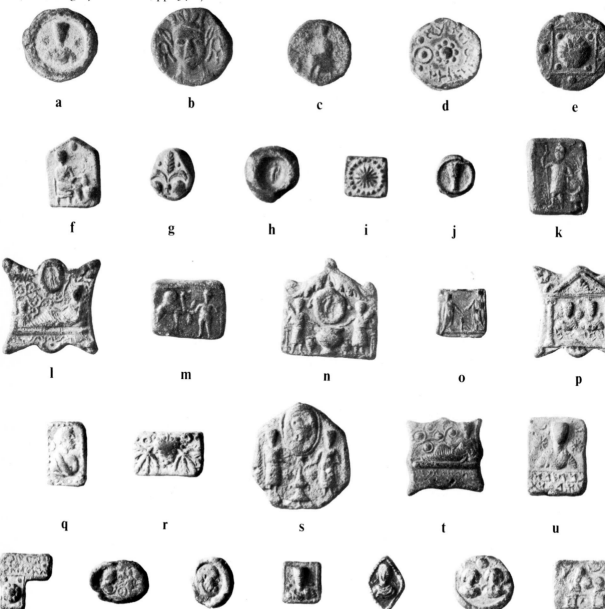

a b c d e

f g h i j k

l m n o p

q r s t u

v w x y z aa bb

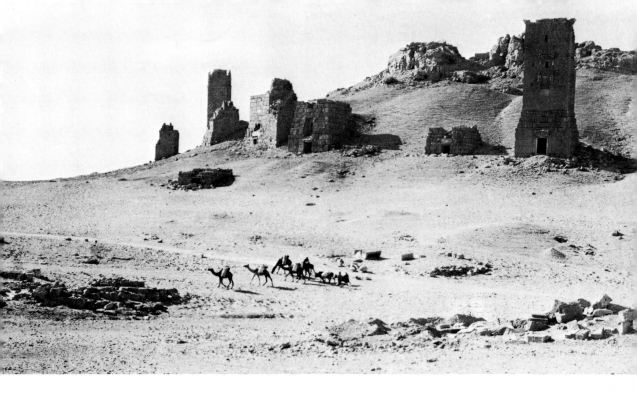

55 The Valley of the Tombs: view
of the west necropolis

56 Tower-tomb of Elahbel,
completed in AD 103 (p. 60)

57 Ground-floor walls and ceiling of
Elahbel's tower-tomb, AD 103 (p. 60)

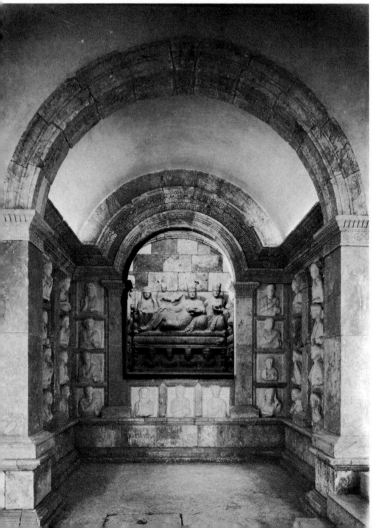

58 Interior of the 'funerary temple'
no. 3, Qasr el-abiad, built towards
AD 150 (pp. 60–1)

59 Palmyrene mummy, first to third
centuries AD (NCG K.1; pp. 61–2)

60 Third-century recess (exedra) within
the underground tomb of Iarḥai (DM;
p. 60)

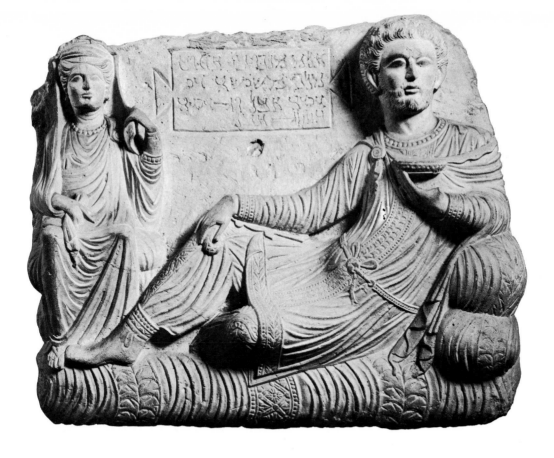

61, 62 Two third-century reliefs showing the funerary banquet scene, both by the same hand (Lou 2000, ht. 45 cm. and Lou 2093, ht. 43 cm.; p. 62)

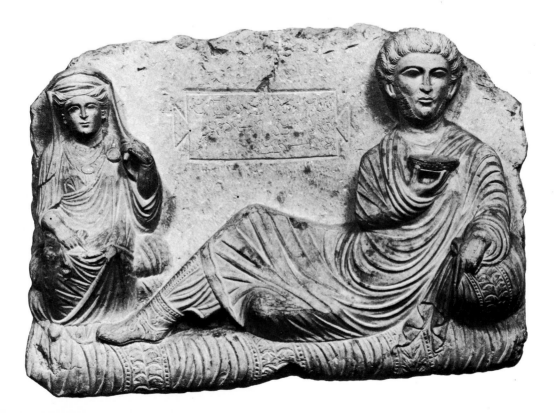

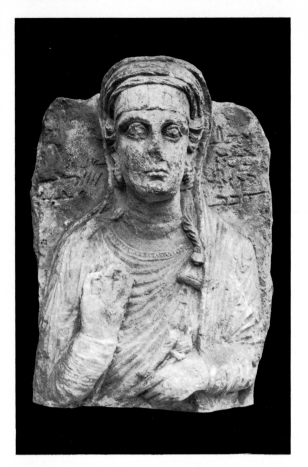

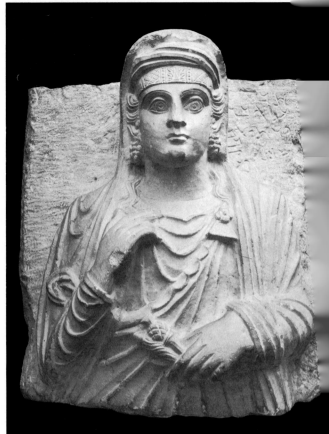

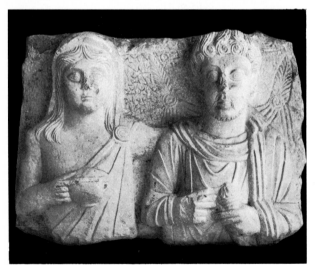

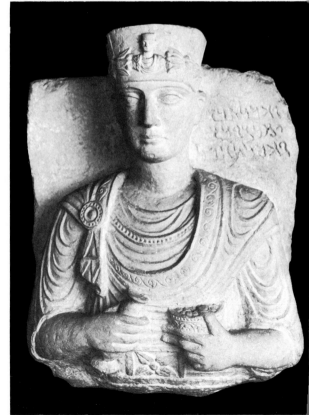

63, 64 Two very different funerary relief busts, both dated AD 113/14, which depict the same woman, 'Alâ the daughter of Iarḥai (BM 125695, ht. 56 cm. and NCG 1079, ht. 58 cm.; pp. 62, 70)

65 Funerary relief with the busts of a deceased man and a mourning woman, *c.* AD 150–75 (AUM 33.12; ht. 43 cm.; pp. 63, 70)

66 Funerary relief bust of the priest Wahballat, towards AD 150 (Toronto, R.O.M.A. 425; ht. 66 cm.; pp. 63, 68)

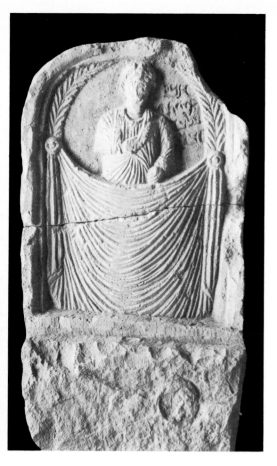

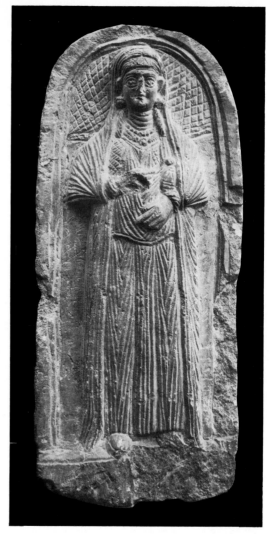

67 Early gravestone with a figure behind a curtain (PM; ht. 50 cm.; p. 64)

68 First-century gravestone of a woman (Lou 5971; ht. 28 cm.; p. 64)

69 Tomb foundation relief of Zabdâ, c. AD 150 (PM 2124/7222; ht. 60 cm.; p. 66)

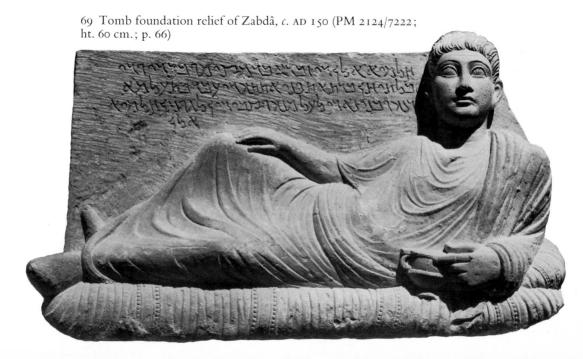

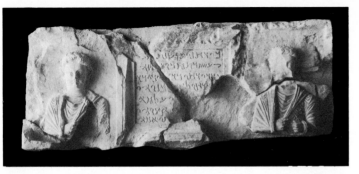

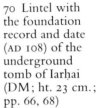

70 Lintel with the foundation record and date (AD 108) of the underground tomb of Iarḥai (DM; ht. 23 cm.; pp. 66, 68)

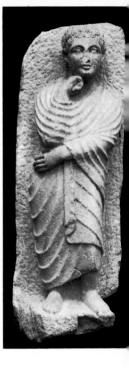

71 Late second-century funerary stele of a young man (NCG 822; ht. 49 cm.; p. 67)

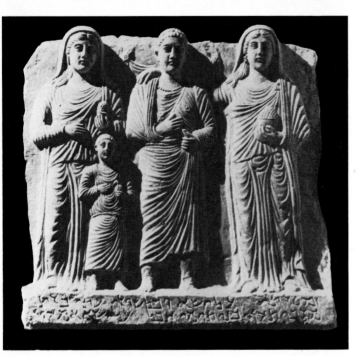

72 Early second-century funerary stele with three children and their nurse in relief (PM; width 56 cm.; p. 67)

73 Early or mid-second-century funerary stele of two boys, shown in Parthian dress (NCG 2776; ht. 48 cm.; p. 67)

74 Early or mid-second-century funerary stele of Raʿateh (NCG 1030; ht. 37 cm.; p. 67)

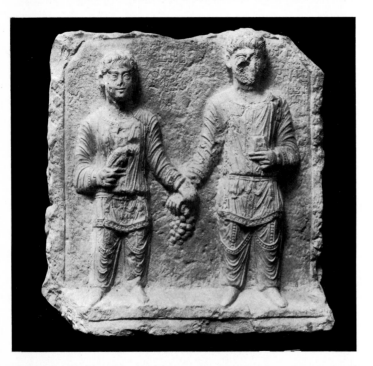

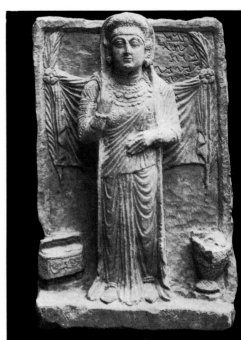

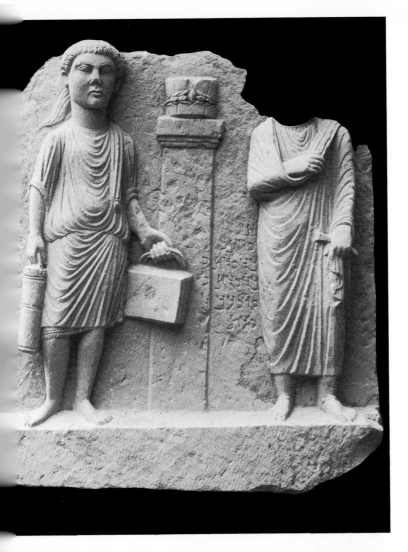

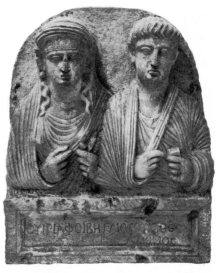

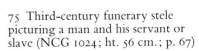

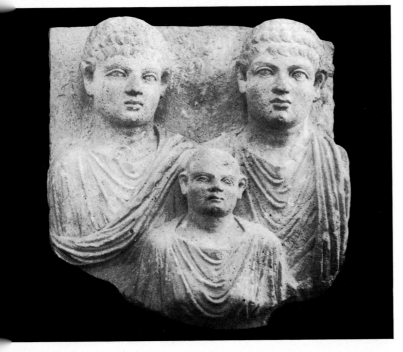

75 Third-century funerary stele picturing a man and his servant or slave (NCG 1024; ht. 56 cm.; p. 67)

76 Early or mid-second-century funerary relief busts of a woman and a man (BM 125036; ht. 70 cm.; pp. 67–8, 70)

77 Head from a female funerary relief bust, dated AD 65/6 (NCG 2816; ht. c. 20 cm.; p. 67)

78 Funerary plaque carved in the late second century with the busts of three boys (DM C.28; ht. 47 cm.; p. 69)

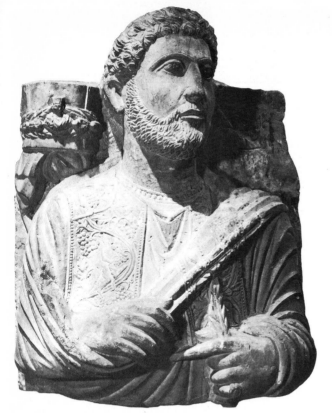

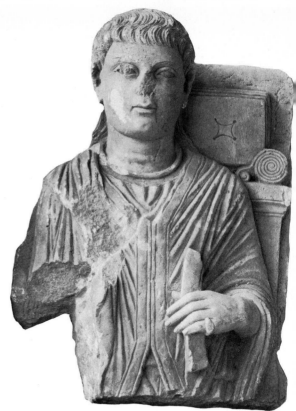

79 Late second-century funerary relief bust of a bearded man (Iarḥai) in a finely embroidered tunic (Lou 2398; ht. 52 cm.; pp. 68–9)

80 A youthful servant or slave shown as a funerary relief bust, c. AD 150–200 (Istanbul 3793; ht. c. 50 cm.; p. 69)

81 The bearded Iarḥibôlâ, son of Rab'el, as a third-century funerary relief bust (BM 125346; ht. 49 cm.; p. 69)

82 Funerary relief bust of an early third-century scribe (Lou 18.174; ht. 46 cm.; p. 69)

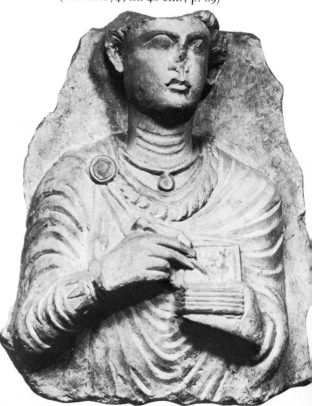

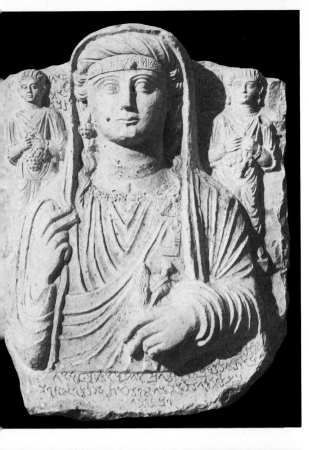

83 Funerary relief bust of Aqmê with her son and daughter, carved towards AD 150 (Istanbul 3751; ht. 58 cm.; pp. 68, 70)

84 Funerary plaque with the armless bust of a girl (Ḥadâ) within a rich medallion, dated AD 125/6 (NCG 1155; ht. 62 cm.; p. 70)

85 Funerary relief bust of the richly dressed Tammâ, carved towards AD 150 (BM 125204; ht. 49 cm.; p. 70)

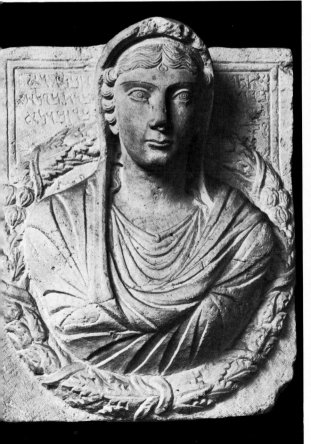

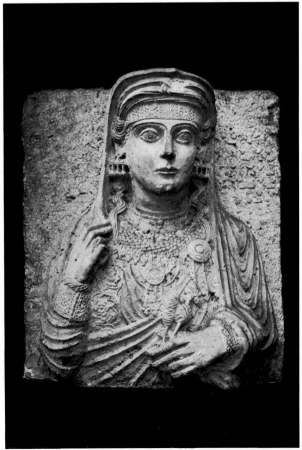

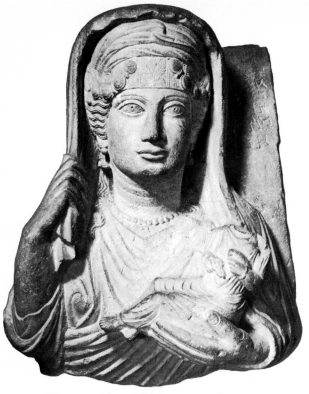

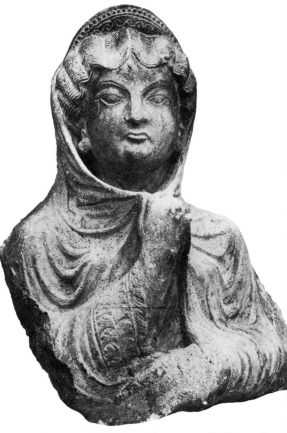

86 Tibnan and her child shown as a funerary relief bust, *c.* AD 150–200 (Lou 1998; ht. 55 cm.; pp. 70–1)

88 Ahâ, daughter of Zabdelah, shown in a 'melon' hairstyle on a funerary relief bust of AD 149 (NCG 2794; ht. *c.* 50 cm.; p. 71)

87 Late second-century funerary relief bust of a woman holding the sides of her veil together (Lou 21.383; ht. *c.* 40 cm.; p. 71)

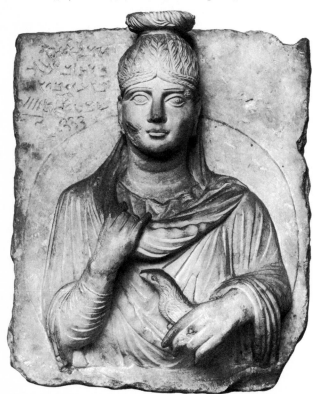

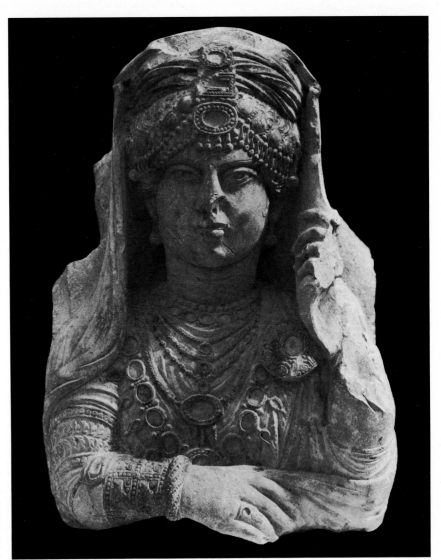

89 Early third-century
funerary relief bust of a
richly jewelled woman, the
'Beauty of Palmyra', with
much original painting still
surviving (NCG 2795;
ht. 55 cm.; pp. 71, 120)

90 Head of a woman in a decorated cap, from a
third-century funerary relief bust (NCG 1102;
ht. 26 cm.; p. 72)

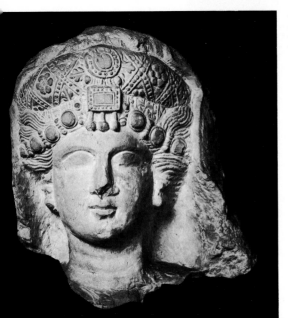

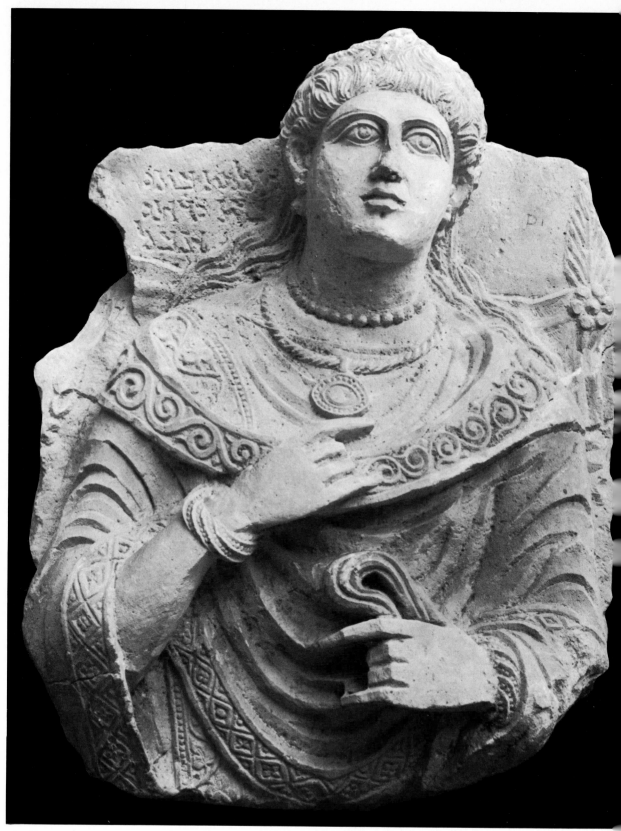

91 Funerary relief bust of a eunuch (?) with 'slave' locks, *c.* AD 200 (NCG 1053; ht. 56 cm.; pp. 72, 266)

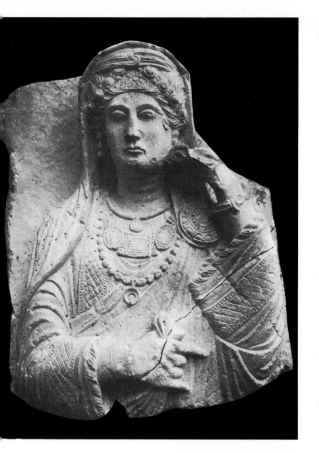

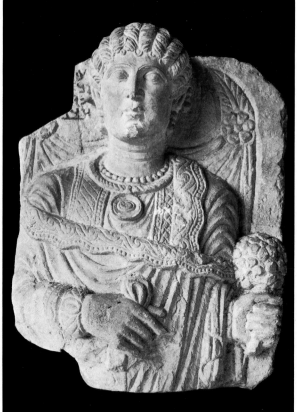

92 Funerary relief with
the bust of a woman in an
embroidered tunic,
c. AD 200–50 (DM C.17;
ht. 54 cm.; p. 71–2)

93 Third-century
funerary relief bust
depicting a woman with
unusual arrangements of
hair and costume
(Strasbourg Library;
ht. *c.* 50 cm.; p. 71)

94 Third-century
funerary plaque with the
busts of a woman and a
servant or slave (NCG
1153; ht. 46 cm.; p. 71)

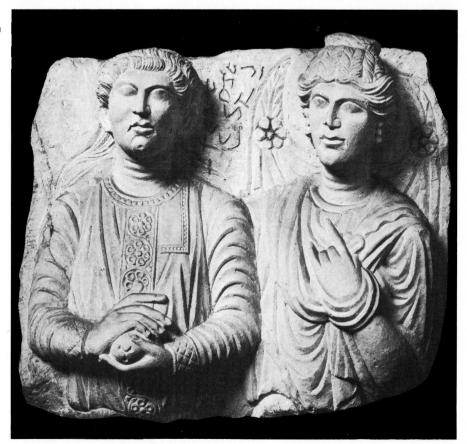

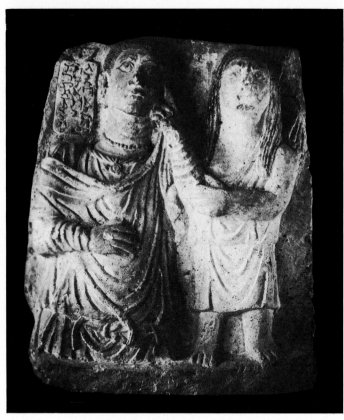

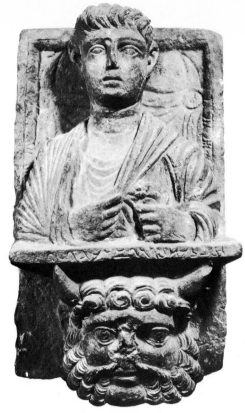

95 Funerary plaque with reliefs of a eunuch (?) (left) and a siren, c. AD 200 (DM; ht. c. 50 cm.; pp. 72, 266)

96 Late second-century architectural relief with funerary bust of 'Atenûrî above a Pan-head (Lou 2067; ht. c. 80 cm.; p. 72)

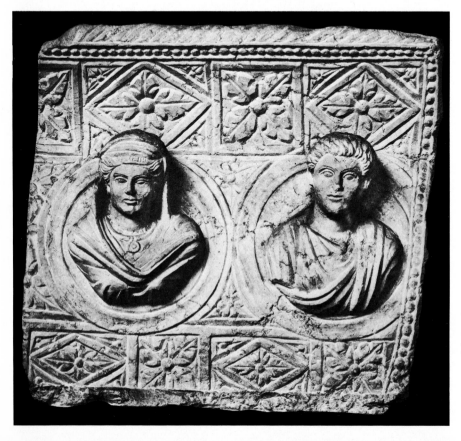

97 Early third-century funerary architectural relief with busts and rosettes (NCG 1148; ht. c. 50 cm.; p. 74)

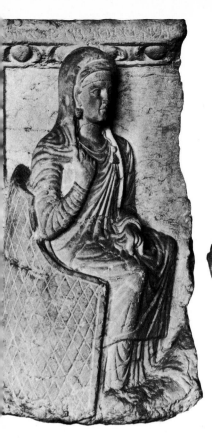
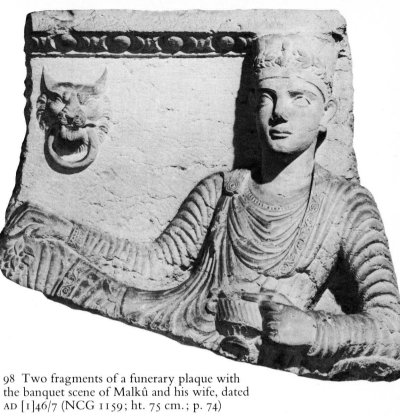

98 Two fragments of a funerary plaque with
the banquet scene of Malkû and his wife, dated
AD [1]46/7 (NCG 1159; ht. 75 cm.; p. 74)

99 Fragment of a funerary composition with
a seated boy in Parthian dress, c. AD 100–50
(NCG 1082; ht. 32 cm.; p. 75)

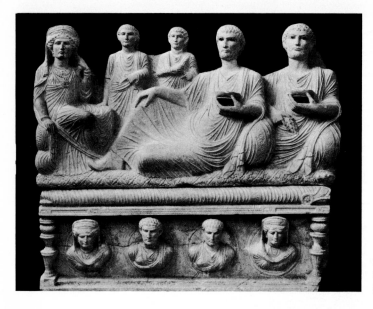

100 Funerary banquet relief from the underground tomb of Malkû, *c.* AD 200 (DM; ht. 1·92 m.; p. 76)

101 Base from a funerary banquet scene with busts and winged Victories in relief, *c.* AD 200–50 (PM; ht. *c.* 90 cm.; p. 76)

102 Carved sarcophagi in the underground tomb chamber (exedra) of Maqqai, *c.* AD 229 (*in situ*; ht. *c.* 2 m.; pp. 77–8)

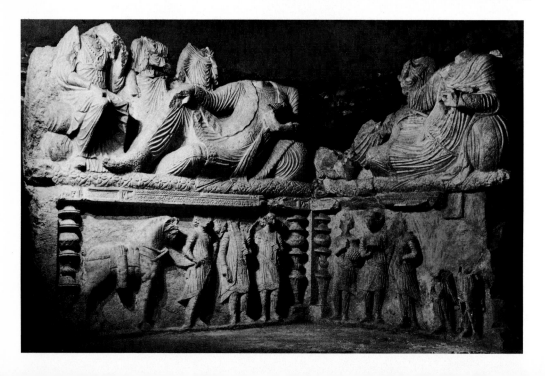

103 Funerary banquet relief base with
figures and a ship, AD 236–72 (PM 1046/
2249; ht. 85 cm.; p. 76)

104 Third-century sarcophagus cover, carved
with a reclining man (on site; ht. 72 cm.; p. 77)

105 Fragment of a funerary banquet relief
with a three-legged table and texts in
Greek, c. AD 200–70 (private coll.;
ht. c. 1·90 m.; p. 77)

106 Third-century sarcophagus base with 'pages' in relief (on site; ht. *c*. 85 cm.; p. 78)

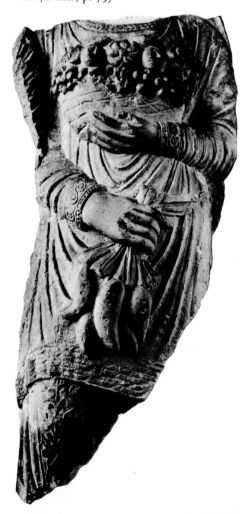

108 Third-century funerary (?) relief of a 'serving youth' with wheat and a basket of fruit (Lou 22249; ht. 70 cm.; p. 79)

107 Third-century 'framed' funerary banquet scene, with a reclining woman (DM C.2153; ht. 49 cm.; p. 79)

109 Architectural (?) relief with a funerary banquet scene of the early third century (PM 2216/7882; ht. 55 cm.; p. 79)

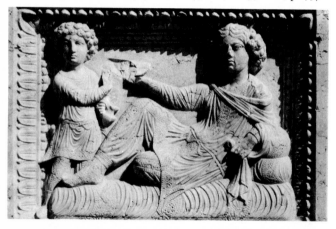

110 Funerary (?) statue of a lion, *c.* AD 150–250 (NCG 1154; ht. *c.* 50 cm.; p. 80)

111 Third-century funerary (?) architectural relief with (in the semi-dome) a goddess seated on a dolphin (on site; width 2·5 m.; p. 82)

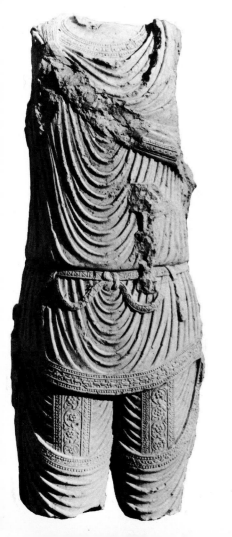

113 Ground-floor ceiling of Iamlikû's tower-tomb, dated AD 83 (pp. 83–4)

< 112 Funerary statue of a priest, carved towards AD 150 (PM A29/1231; ht. 97 cm.; p. 80)

114 Funerary paintings of Ḥairan and his wife, AD 149/50 (PM; ht. *c.* 2 m.; p. 84)

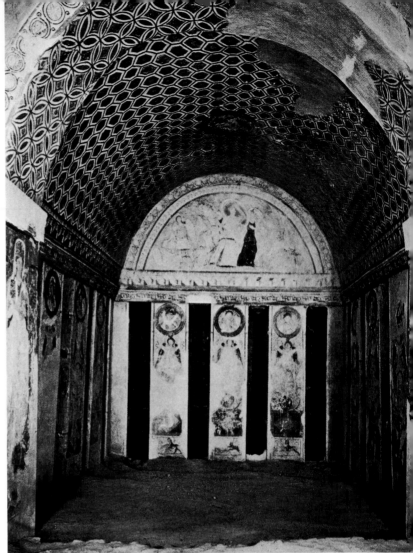

115 Painted recess (exedra) within the underground tomb of the Three Brothers, decorated probably AD 160–91 (pp. 84–7)

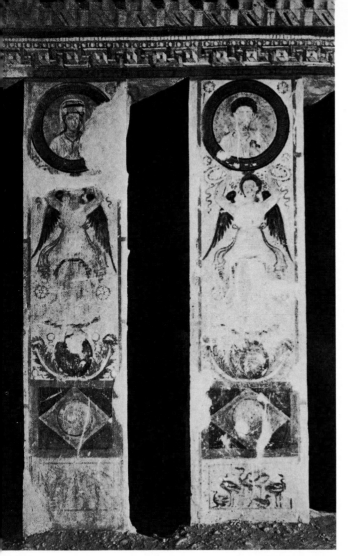

116 Part of the painted recess (exedra) within the Three Brothers' tomb, decorated probably AD 160–91 (pp. 84–7)

117 North pilaster with the figure of a standing woman inside the Three Brothers' painted tomb recess, late second or third century AD (pp. 86–7)

118 Third-century tomb painting of the god Dionysus (*in situ*; ht. *c.* 1·50 m.; p. 87)

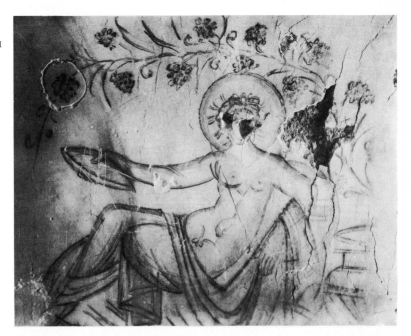

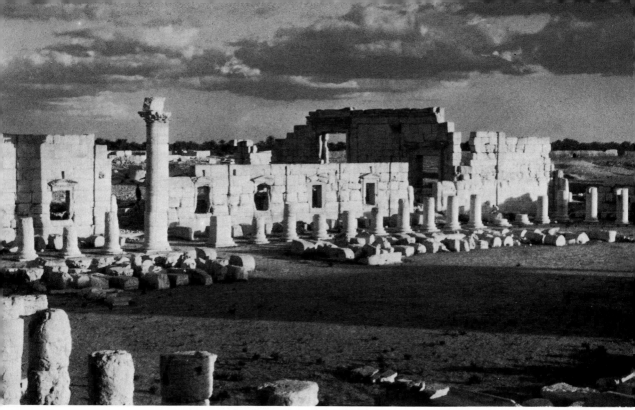

119 The market place (Agora) of ancient Palmyra, as rebuilt in the second century AD (p. 89)

120 Part of the Theatre, with a section of the Grand Colonnade behind, second century AD (p. 89)

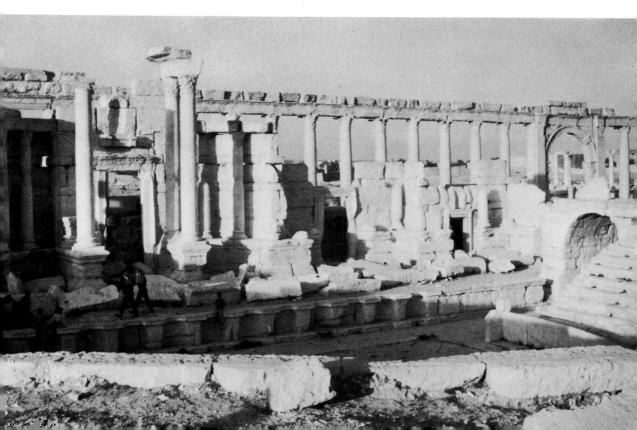

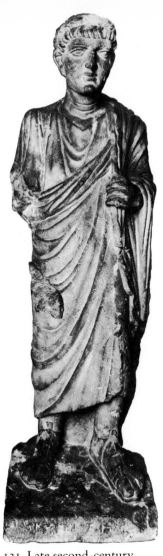

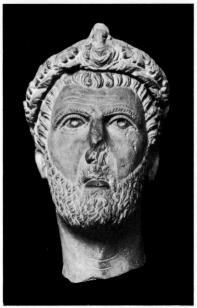

123 Bearded, wreathed head of the late second century AD (NCG 1121; ht. 42 cm.; p. 91)

121 Late second-century honorific (?) statue of a young man (Lou 22252; ht. 94 cm.; p. 91)

124 Sandalled foot in bronze from the Bel sanctuary (PM; ht. *c.* 20 cm.; p. 90)

122 Honorific statue of a priest (?) from the Ba'alšamin sanctuary, *c.* AD 90–150 (PM 1866/ 6786; ht. 1·82 m.; p. 90)

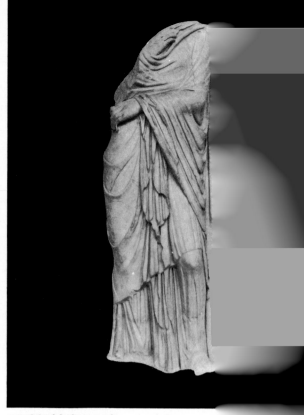

125 Honorific statue of 'Ogeilû, seated, *c.* AD 200 (DM C.4129; ht. 1·18 m.; p. 91)

126 Marble honorific statue of a woma
(DM C.4022; ht. 1·52 m.; pp. 91–2)

127 Honorific statue of a man in a toga, carved locally *c.* AD 200 (PM A23; ht. 1·46 m.; p. 91)

128 Marble honorific statue of a man in *c.* AD 200 (DM C.4024; ht. 1·41 m.; pp.

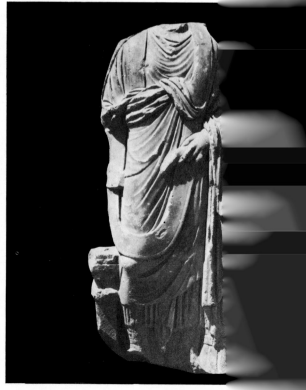

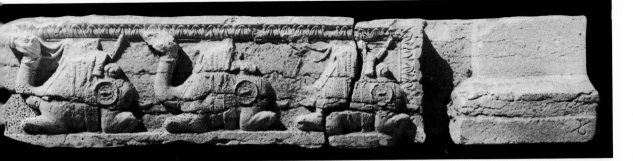

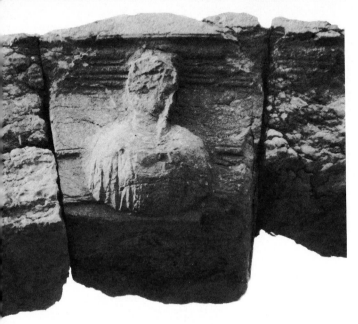

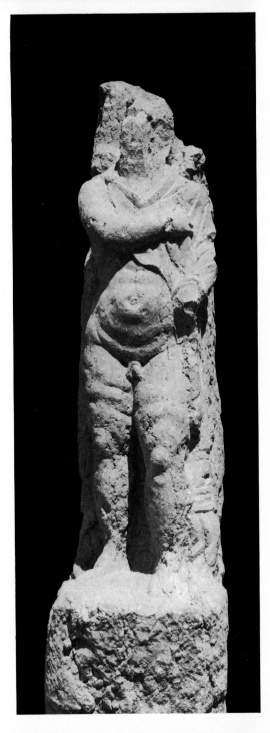

129 Monumental base with three reclining
dromedaries in relief, *c.* AD 150–250 (PM A24/
1226; ht. 37 cm.; p. 92)

130 Arch keystone carved with an honorific (?)
male bust, *c.* AD 150–250 (*in situ*; ht. *c.* 60 cm.;
p. 92)

131 Architectural relief of Eros from the market
place, *c.* AD 150–250 (PM B473/1676; ht. 63 cm.;
p. 93)

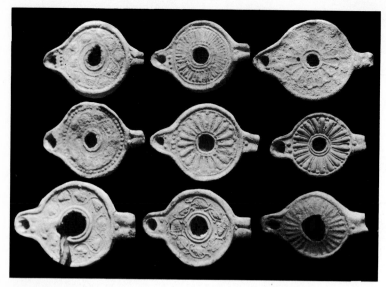

132 Selection of terracotta lamps from the tomb of Iarḥai, second century AD (PM; about 1:3; pp. 94–5)

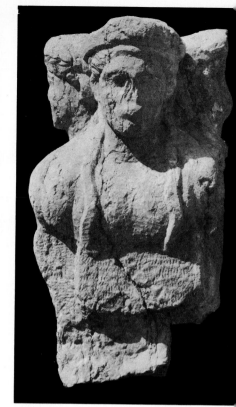

133 Unfinished (?) capital with four busts in relief, c. AD 100–250 (PM; ht. 62 cm.; p. 105)

134 Jewellery from the tomb of Zabdâ, including a necklace with a frog pendant (PM; pp. 96–7)

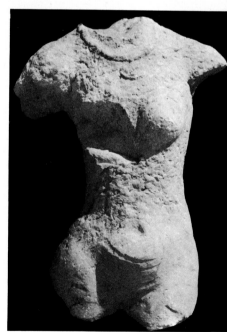

135 Statuette of a nude girl ('dancer'), c. AD 150–250 (PM CD142.60; ht. 44 cm.; p. 105)

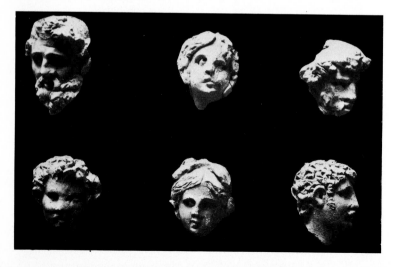

136 Plaster heads found together in a private house (DM C.4984–9; ht. of each c. 5 cm.; p. 104)

137 Painted walls in a house east of the temple of Bel, *c.* AD 160–260 (*in situ*; p. 105)

138 Peristyle walk with mosaics in a house east of the temple of Bel, *c.* AD 160–260 (pp. 105–6)

139 Fragmentary house floor mosaic panel with Queen Cassiopeia, *c.* AD 160–260 (DM C.4945; width 1·65 m.; p. 106)

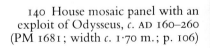

140 House mosaic panel with an exploit of Odysseus, *c.* AD 160–260 (PM 1681; width *c.* 1·70 m.; p. 106)

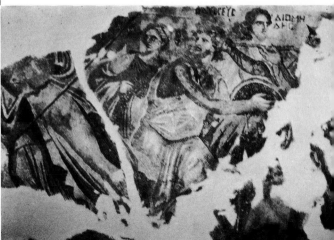

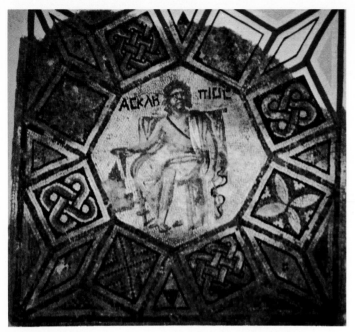

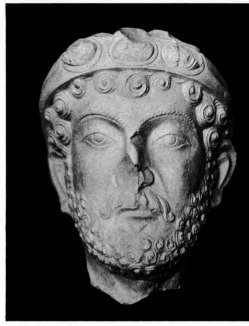

141 Peristyle floor mosaic panel representing the god Asklepios, from a house east of the temple of Bel, *c.* AD 160–260 (PM 1686; width 1·69 m.; p. 105)

142 Third-century head of a bearded man with an unusual headdress (PM 457/1660; ht. 20 cm.; p. 140)

143 Part of an early third-century funerary banquet scene base, with a relief of men beside a dromedary (PM 2093/7431; ht. 75 cm.; pp. 76, 160)

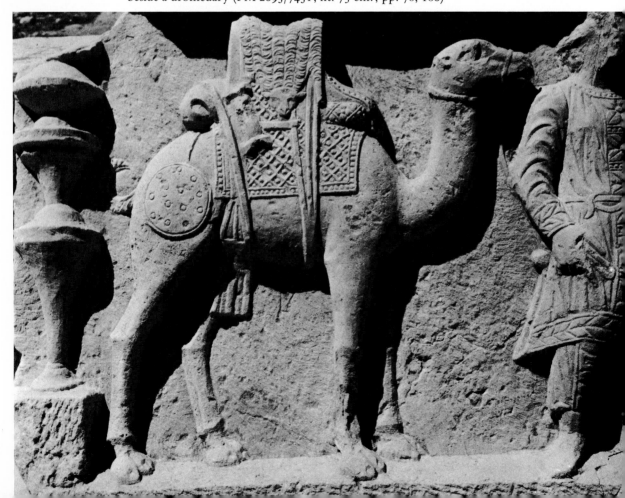

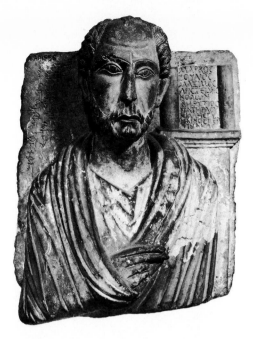

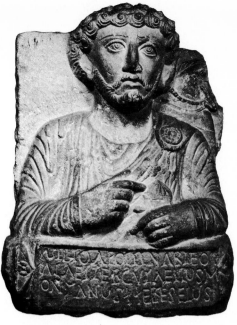

144 Funerary relief bust of an immigrant from Beirut, *c.* AD 200–50 (Lou 1556; ht. *c.* 50 cm.; pp. 69, 225)

145 Funerary relief bust of Vibius Apollinaris, *c.* AD 150–200 (Lou 14924; ht. *c.* 50 cm.; p. 225)

146 Religious relief from Dura-Europos dated AD 159, showing the guardian spirit of Palmyra (DM; ht. *c.* 70 cm.; p. 227)

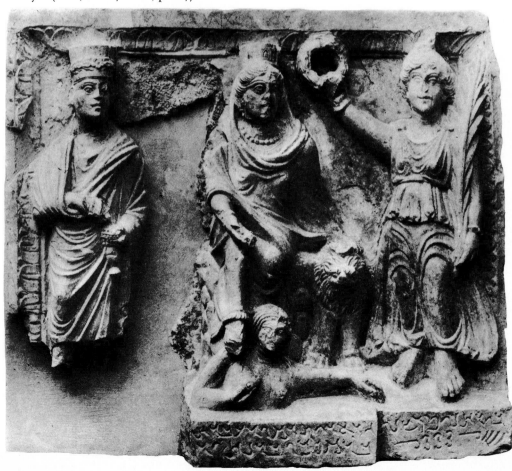

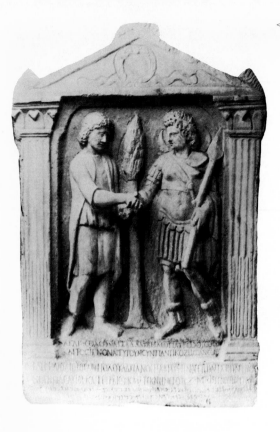

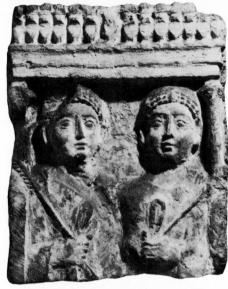

< 147 Relief dedicated by Palmyrenes in Rome, dated AD 236 and picturing the handshake of 'Aglibôl and Malakbel (Rome, Museo Capitolino; ht. 98 cm.; p. 231)

148 Early third-century funerary (?) relief of two men from Koptos, Egypt (Lyons, Musée des Beaux-Arts; ht. *c.* 45 cm.; p. 230)

149 Gravestone of Regina, wife of the Palmyrene Barates, from South Shields, *c.* AD 160–220 (South Shields Museum; ht. 80 cm.; pp. 231–3)

150 Gravestone of Victor, from South Shields, *c.* AD 160–220 (South Shields Museum; ht. 80 cm.; p. 233)

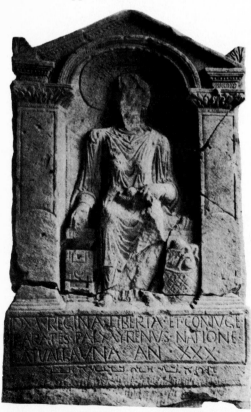

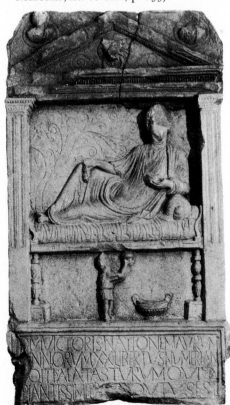

The scorpion, too, is depicted in a variety of contexts; it could be regarded as beneficent or harmful. As the other inseparable companion of Šadrafâ, it might preserve something of its earlier Near Eastern significance as generally beneficent and sometimes apotropaic. A scorpion appears on the Bel zodiac ceiling; another attacks the Evil Eye in the Three Brothers' tomb – here it could either be benign, or noxious, as in Mithraic art. And if harmful when with Šadrafâ, it might represent the opposition of evil to the serpent's good. Both creatures figure in Hatrene art.[635] *27* *18* *48*

The large fish that sometimes accompanies a god or goddess strongly recalls Syrian Atargatis and her myths. An Aphrodite-like figure sits astride a dolphin on a late, Westernized tomb-relief. Otherwise, the fish is zodiacal, like the crab and other creatures.[636] *15*

(vi) Trees, plants, vegetation and fruits

Trees seldom appear in their entirety in Palmyrene art, and then only in religious contexts. One leaning date-palm shades a priestly sacrificer on a Bel beam relief; the tree's distribution ensures the orientalism of the motif, and the patterning of trunk and leaves distantly recalls Assyrian ancestors. Two others, upright, decorate tesserae. The Bel 'Sanctuary' scene includes a leafy tree of indistinct type with the stump of a dead branch projecting from the trunk. This detail is repeated on a tessera representation, where the tree is slimmer and resembles the immortal, evergreen cypress. The 'branch' again, if such it is, could indicate that the mysterious trees (or fruits?) of the Rab Asirê plinth are the cypress(es) of Malakbel. The Roman fig-tree is depicted on a battered religious relief. The 'Seated Heracles' relief and tesserae show other trees, mostly unclassifiable, but one of which is most probably the olive.[637] *14* *19* *11* *25*

More commonly, portions of trees or plants are used, whether symbolically or for decoration. The palm usually appears as a branch. Held by deities of either sex, offered to them by eagles or Victories, or simply accompanying them, it is common in the Syrian and western Parthian areas from the late first century BC. Sometimes it is used on early religious niches to frame a scene or figure. It also occurs in the hands of priests, shown as honorific statues or at the banquet on tesserae. In these various instances the palm would seem to confer a general air of sanctity. In funerary art its appearances are numerous, pinned up in pairs with the curtain, or in the hands of deceased men – normally in the left, but in the right if they recline at the banquet. Here it would seem more likely that the palm symbolizes victory over death, a concept of obscure, perhaps Near Eastern, origin, and widespread in the Roman West.[638] *15, 49* *30, 122* *93, 96* *36* *79*

The enormously popular vine is put to two principal uses. First of all, as a single- and double-scrolled spiral (rinceau), with leaves and bunches of grapes alternating within its convolutions, it functions mainly as an architectural ornament, although it is also seen on ritual cups, bowls and textiles. This spiral presumably had an ultimately Hellenistic origin, as one is present on the Alexander sarcophagus from Sidon; but few Hellenistic examples survive. Among the Palmyrene Foundation T fragments a more and a less naturalistic tradition are discernible. The Bel temple contains more Westernized examples. Until the early second century the spirals rise from a tall, conical trunk, apparently unique to Palmyra. The true architectural heyday of the vine rinceau *10, 20* *37* *79* *18, 20* *11, 16*

is in the third century, when it reflects contemporary Syrian kinds. This spiral also appears on a unique textile fragment showing the Western double 'inhabited scroll' with Erotes in the convolutions. The immediate antecedents of the Palmyrene vine rinceau probably lie in eastern Hellenism, although 'Greco-Buddhist' tradition has been invoked.

Secondly, the spreading vine could provide the background to standing or reclining figures on tesserae and in funerary art, or cover a tomb ceiling in a remarkably Roman way. In these instances, the vine is imbued with Greek and Roman symbolism, signifying the drink of immortality, a foretaste of joy hereafter.[639]

The acanthus is also used in two ways. As a spiral it is another early favourite, again rising from a conical stem and often done with great care. The Bel beam soffits contain particularly elaborate examples of the spiral used to form scrolls full of figures, of purely Hellenistic derivation. The spiral does not maintain its popularity. The acanthus leaf, however, remains in vogue as an architectural ornament, especially for capitals, as in the Hellenistic and Roman worlds, and after *c.* AD 150 it is also used to decorate textile bands. The pomegranate rinceau is a short-lived regional motif, vanishing after the mid-first century AD; a branch, however, appears on a tessera.[640] An ivy spiral, although uncommon, lasts for a long time, as decorative textile bands (especially on mattresses) and a tessera bear witness.[641]

There are other Western imports in the Palmyrene repertoire. Laurel, symbolic of immortality, is sometimes introduced into the ornament around the frames of early religious niches. In the form of overlapping leaves, densely packed in rows, it is another kind of architectural decoration always in use. Later, a sprig of laurel occasionally turns up in the hand of a sculptured figure, or branches in the scenes on tesserae (unless these are olive branches), both presumably acting as religious attributes. But laurel becomes most popular after the mid-first century AD; from then on it is in constant demand, as in the West, for wreaths and garlands of various kinds. Later, laurel-like leaves sometimes fill the ornamental stripes on Parthian textiles. The Western oak, although rarely seen, has at least three uses: oak leaves are woven into the plinth decoration of an early niche, and into a wreath-medallion behind a funerary relief of AD 125/6, where their meaning could be symbolic or simply decorative; and they also ornament textile strips.[642] Other and more indeterminate types of vegetation, such as the *anthemion* (floral ornament), leaf-and-dart and palmette, were taken from the Greek repertoire for architectural decoration.[643]

Flowers were used sparingly. A group of three poppy heads is set into the oak wreath either side of a subject's shoulders – again, are they symbolic, or ornamental? But one group of flower-head types is ubiquitous in Palmyrene art – the rosettes. Constantly employed by Assyrian and Achaemenian artists as ornamental motifs, especially for borders, rosettes could also be used to symbolize stars. Archaic Greek art adopted them as decoration, but their early popularity had already faded by the classical period, never to be regained. The Palmyrenes continued the old Near Eastern practices essentially unchanged. Symbolic rosettes are discernible on many early religious niches, occasionally in later work, and on tesserae. They may be included neatly in a frieze or scene, scattered across it or arranged in a planetary (?) frieze of seven. The

Morning and Evening stars, and the sun and moon, are sometimes distinguished *17*
by greater elaboration or by an attached circle or crescent. Rosettes more
probably ornamental are used in various contexts. They may mark the central
point of a section of architectural decoration, or fill ceiling coffers. They may
occupy a spiral as ornament for architecture, cloaks (especially the priestly 11, 66, 32
chlamys), cups and bowls. They may decorate horse-trappings or the shield
of an Athena figure. The curtains of countless funerary stelae are at first fastened
by pins with circular heads; but by the end of the first century AD these pin- 74, 94
heads are usually rosettes. They are seen frequently among jewellery and
textile motifs (especially on mattresses), often set within rectangles in the 85, 102
Assyrian fashion. They may form the centrepiece to a laurel wreath, a pile of 23
grapes or a priest's waistband. The actual rosette usually contains from four 31, 66
to six petals arranged symmetrically around the circular element at the centre;
but simpler types, notably on tesserae, may shade off into patterns of dots,
and the architectural kinds, in particular, may be more elaborate. Some of the
ornamental uses, especially the rosette within a rectangle, are reproduced
surprisingly far afield: at Amaravati in India, and on Roman stelae from the
Rhine region, doubtless as a result of Eastern influence.[644]

Fruits of the earth, except for the cluster of dates hanging in the temple of
the Bel 'Sanctuary' scene, are drawn from Western stock. They are seldom *19*
shown, except for the ubiquitous bunch of grapes, which appears constantly 10, 16, 18
in the sinuosities of the vine spirals and occasionally in the recesses of other
architectural ornaments. In religious sculpture grapes are rare, although the *31*
late Priapus figure balances several bunches on his phallus. In funerary art
they are, with the bird, one of the two standard attributes of children, as in 73, 86
Greek relief; are they symbolic?[645] The apple appears on the altars of the Bel 19, 108
'Sanctuary' scene, and perhaps in the hands of a third-century 'serving-youth'.
The pomegranate, likewise on these altars, also graces early niche vegetation
spirals, some tesserae, and possibly the Rab Asirê relief plinth. The pine cone is *11*
depicted on the 'Sanctuary' scene altars too, as well as on a very early niche
lintel and, later, perhaps occasionally in the hands of funerary relief busts;
in these instances the cone may symbolize immortality, as in the West. It may
have the same significance on an early capital, the Bel temple frieze and entrance
lintel soffit, and several tesserae. An artichoke makes a surprise appearance on
an early capital.[646] Ears of corn are uncommon: the early 'Ba'alšamin' holds 16, 9
some in his lap, the 'Ba'alšamin' calathos includes two more in its decoration, 45, 108
the god's hand grasps three on his relief of AD 228, and a 'serving-youth' clasps
some more; a few others are shown on tesserae, associated usually with the
great gods.[647]

(E) ABSTRACT DESIGNS

(i) *Designs in general use*
Decorative beading is used in a great variety of contexts at Palmyra, ranging
from architecture to the headdresses and costumes of figures, from jewellery 14, 32, 61–4
to shields, utensils and furniture; particular uses will be considered separately
under the relevant headings. Sometimes, especially in the case of textile orna-
ments, there seem to be precedents earlier in the Near East for the applications

Palmyrenes found for beading; but, by and large, origins remain obscure. During the period of Palmyra's greatness, however, the motif was most at home in the lands east of Palmyra as far as north India. This is essentially the Iranian world, and as a principal inspirer of the motif the pearl industry of the Persian Gulf has been suggested.[648]

The allied and probably local motif, the simple circle (sometimes incomplete), may decorate small Arab shields, or the coats of certain felines. Oriental, perhaps, are the criss-crossing lines that appear in various contexts: on camel saddle cloths, sculptured textile bands, women's diadems and plaited chairs.[649]

Other motifs, imported from the West, had a certain currency. The running dog, an old Greek design popular in the Parthian area, sometimes decorated textiles, cuirasses, belts, women's diadems, couches and horse-trappings. In combination with beading, as on an early cuirass, it is also found in north India.[650] A multiple tongue ornament is seen mostly on the divine calathos, around the bellies of vessels, and on burners and couch legs. Volutes, apart from their more normal architectural functions, decorate the helmets of some Athena figures and the tops of a number of altars.[651]

Many designs, however, occur only, or largely, in particular contexts: to these we shall now turn.

(ii) Religious symbols and marks

Behind the heads and shoulders of many deities a circular nimbus may loom. On tesserae it is uncommon, and in sculpture too it is rendered in its simple, flat, smooth form only occasionally and after c. AD 150; for sculptors from the very beginning normally combined the nimbus with superimposed light rays fanning outwards from the (hidden) centre. The tesserae-makers preferred to show these rays alone. Whether separately or combined, the nimbus and rays denote a celestial, light-bringing deity, normally male and most often solar or lunar. The nimbus, visible already on a neo-Babylonian intaglio, was adopted, often with rays attached, by Greek artists for sky deities from the fourth century BC. Current in Hellenistic Greece, and in the Hellenized Near East as the Nimrud Dagh reliefs reveal, it was popular in the Roman world, where from Nero's time it might be placed behind the Emperor's head, and in the Parthian world, where it continued in use for deities.[652] The crescent is employed in several ways. Often, it is a lunar symbol, the attribute of the moon-god 'Aglibôl; until c. AD 50 its location on the god's body varies from above his forehead, to across his radiate nimbus, to below his bust and to immediately beneath his nimbus, half-hidden by his shoulders; thereafter, the position beneath the nimbus predominates. The crescent may also crown a religious ensign. But sometimes it seems to be without precise lunar significance. It is occasionally placed beneath a divine bust other than that of 'Aglibôl, as for example on a tessera of Bel, and the late Strasbourg altar with its busts of the 'Nameless god' (?), 'Aglibôl and Malakbel. How far does the crescent retain symbolic significance here? 'Aglibôl, on the Strasbourg altar, does not have a second crescent behind his shoulders; so perhaps the one beneath his bust was not totally devoid of meaning. On the Gdêm altar the crescent supports a disc; on tesserae it even appears beneath the busts of priests. On occasion it is attached below a star-rosette, where sometimes it is clearly lunar, and sometimes more

generalized in meaning. Still more problematic is the meaning of the crescent-shaped object on some early funerary stelae, as we are about to see. The crescent, long used in ancient Near Eastern and Hellenistic iconography, continued life in Parthian art and in Roman, where it belongs particularly to deities of oriental and Anatolian origin. So Palmyra presumably received it from a Hellenized Eastern source. In the Three Brothers' tomb and on some tesserae the crescent has a miniature globe or star-symbol fixed on to each pointed end. One theory would see in this crescent a symbol of the sky.[653] The Hellenistic globe on the Ba'alšamin calathos, in the hand of Bel and of other deities, and on which many Palmyrene Victories, like their Western and Durene sisters, are poised, could have a world or celestial, cosmic significance; but the globe on the Gdêm altar might be the sun.[654]

Some of the earliest funerary stelae, with a curved top and featuring the curtain and palms alone, possess five mysterious symbols 'hung' beneath the overarching fronds. These symbols are, alternately, (two) discs covered with a criss-cross pattern, and (three) thick, crescent-like objects. Not only are they remarkably similar to the disc with rays and crescent of late Assyrian stelae, as well as to the radiate disc and crescent of two Parthian funerary stelae from Assur (dated 89/8 B C or a century later), but they are also placed in a similar position beneath the upper frame of the stelae. So perhaps the Palmyrene objects possess the same solar and lunar symbolism as their Assyrian/Parthian counterparts, a hypothesis which is supported by the rare first-century texts connecting the afterlife with sun-worship. Alternatively, they may represent the ritual cakes shown in the hands of second-century funerary busts, seen from a different angle.[655] The dome-shaped contents of the two-handled cup held by some female comforters of the deceased among the funerary reliefs is usually interpreted as food (incised ovals which decorate the dome may represent almonds).[656]

A number of religious symbols, associated with various divinities, appear almost exclusively on tesserae. A little sphere – perhaps the universe-sphere of the Hellenistic Greeks – accompanies several important sky deities, notably Bel. It may be surrounded by an apparently western Asiatic cosmic ring, or by a circlet of globules forming a dot rosette and probably signifying stars or, when these globules number twelve, the zodiac. Smaller and more independent globules presumably also indicate stars, especially when paired as the morning and evening twins. Other symbols are more directly star-like, or are shown as rosettes.[657]

Further symbols, in the form of signs, are far more mysterious. The commonest consists of a circle or closed horse-shoe shape from which descend three prongs. It is confined almost entirely to tesserae, of which more than half refer to Bel. The sign seems exclusively Palmyrene; one interpretation sees in it a 'sign of rain'. The rest of these symbols – the twisted rosette, the Z and its reverse, and the X – are rare, and, like the pronged horse-shoe, hard to parallel. The only sign obviously from outside Palmyra is the swastika, seen on a tessera and on the thigh of a griffin on the Louvre 'stepped base', where it could be a sign of good omen or more probably an indication of the god to whom the animal belongs. Another 'owner's mark' appears on the right shoulder of an early cameleer's mount.[658]

65

Groups of three or more vertical lines engraved on the breasts of several 'mourning women', with red paint often surviving in the incisions, are surely marks of the old Semitic funerary rite of inflicting gashes as a sign of grief.[659]

(iii) Architectural ornament

The history of architectural ornament at Palmyra does not run parallel to that of figured art. Shreds of earlier and doubtless Greco-oriental tradition(s) can be discerned on much early work, particularly religious niches, until the mid-first century AD. Some peculiar decorative mouldings, and the enclosing of relief fields within squat Corinthian pilasters, find astoundingly close parallels in the (slightly later) arts of Gandhara and of distant Mathura, in central-northern India. Similar connections can be established for decorative beading, used between listels in architectural contexts. At Palmyra, such architectural beading dies out early, to reappear in altered form in the third century; the origins of both forms are obscure.[660] Some distorted egg-and-tongue work, seen only in the early period, has Parthian parallels and is descended from an Achaemenian type. The old Near Eastern ornamental interlacing disappears at a similarly early date, by AD 50. The 'stepped merlon', however, from the same repertoire, lasts a long time at Palmyra, especially on temple cornices and around the tops of rectangular altars. Together with other items, such as Near Eastern rosettes and ultimately Hellenistic acanthus and laurel leaves, vine spirals, anthemion, volutes, dentils and mouldings, it arrived at Palmyra as part of a repertoire composed of mixed oriental and Western elements.[661]

9–14

13

52

4

10

3, 48

More purely Hellenistic trimmings begin to edge their way into the artistic vocabulary in the late first century BC. 'Atenatan's funerary tower of 9 BC is given a cornice and dentils, tower 53 a sculptured lintel, and towers 15 and 19 vaults and wall arcades. But the building of the Bel temple sees the greatest influx of Hellenistic traits, for its architectural decoration stems almost entirely from the traditions of the Hellenistic East. The convex *cyma reversa* moulding is of a type closest to examples in Asia Minor; the modillions and thalamoi Corinthian capitals are more Alexandrian. Even those oriental motifs still present from an earlier period become Hellenized. The Greek palmette, anthemion, acanthus, meander, egg-and-tongue, leaf-and-dart, vegetal spirals, dentils and mouldings take root, and for the following century the strongest influence at Palmyra is that of this late Hellenistic repertoire. Later, however, the increasing Romanization of the earlier second century becomes the prelude for a positive invasion of Roman forms after the AD 130s, tempered by the introduction of some local and Near Eastern motifs from *c.* AD 170. By and large, Palmyrene building had joined the mainstream of architectural development in Roman Syria, although the local character and originality of its architectural ornament remained pronounced.[662]

2–4

17–22

(iv) 'Framing' around scenes and figures

The richest framing provided for relief sculptures is that around early religious niches. This has been examined already, as vegetal and architectural ornament. Otherwise, religious reliefs are poorly decorated in this respect. A simple, flat raised frame, akin to those of votive stelae of the Hellenistic and Roman East, is current in the first century, but unfashionable thereafter. The enrichment of

25, 37, 40

this frame with mouldings, leaf-and-dart or a vine or other spiral is occasionally 28, 38
practised in the first and second centuries. In the third century oriental beading
may be added. One relief, perhaps of Ba'alšamin, sets the god before an arch 24
and a criss-cross background, and another encloses the figures entirely within 28
a Western pedimented aedicula. But the great majority have only a projecting 39, 41–3
plinth at the bottom, at once a support for the figure(s) and a place for the dedica-
tion, which was more the Parthian way.[663]

A group of fairly small reliefs of the third century, depicting religious and
funerary subjects, has a different framing: an outer listel encloses a moulding 52, 107
in *cyma recta* (concave) profile with Roman leaf-and-dart ornament, with
oriental beading on the inside. Normally a funerary banquet scene is shown;
armless busts, deities or reclining animals are rarer.[664]

Early funerary stelae are normally surrounded by a raised, flat listel, some- 36
times bevelled or moulded for variety. This could be of Hellenistic descent, 67
although the strikingly similar framing and curved top of Assyrian and earlier
Parthian stelae look equally likely antecedents – perhaps the Hellenistic influence
is confined to the mouldings. From the late first century, the Palmyrene stelae
with full-length figures evolve into two groups, each with framing. The first
retains the curving (or sometimes pedimental) top: here the listel, often with 68
moulding, is usually preserved; its rare omissions, leaving just the plinth project-
ing, are intended to facilitate use within the tomb. The second group, responding
to the needs of the tomb interior, becomes rectangular; but until the late second
century the listel still regularly surrounds these stelae, although generally 74
reduced in prominence or sketched; later it is omitted, although the plinth
survived.[665]

Related to these stelae is the tiny figure of a seated woman within an arched
aedicula. She is set into a field of funerary architectural decoration, between
rosettes and a bust.[666]

Funerary relief busts are normally without framing on the actual block.
But the little stelae surrounds apparently influenced second-century bust
carvers, particularly between *c.* AD 100 and 150, for a raised or sketched listel, 84
sometimes with Western decorative mouldings, not uncommonly encloses
individual busts of this period. The comparative broadness this border often
has may owe something to the Palmyrene busts' Roman forerunners. Par- 76
ticularly deep plinths, moreover, whether or not with other framing, look still
more Roman, especially with a text. But the idea of framing the bust on the
block itself appears to have been locally inspired by the small stelae; it seems
absent from first-century examples. Most busts lack such frames, but many
are placed in an attractive architectural setting, which may include surrounding
mouldings.[667]

A circular medallion sometimes enlivens the background or surroundings
of a carved or painted figure. It is placed in one of two positions – and here
sculpture and painting largely diverge. In sculpture, the lower edge of the
medallion passes beneath the thorax of a normally armless relief bust, the upper
edge occasionally rising above the head but usually disappearing behind it;
these busts are sometimes divine or honorific, but normally funerary. Painted
medallions, which occur from the mid-second century, enclose the subject
entirely, be it a bust, Ganymede or the Evil Eye. Both fashions were inherited

from the West, where the medallion which surrounded the figure entirely was preferred.[668] The medallions are of at least seven kinds, all of Western inspiration. They seem confined to funerary relief sculpture until *c.* AD 150. In use 85 by *c.* AD 100 is a simple raised disc, followed in AD 149 by a similar, but lower, 84 flat disc. First of the more complex kinds is a rich oak wreath, seen behind a girl in AD 125/6: is it symbolic here, or merely decorative? By AD 145 the 100 commonest funerary type has appeared, the ring with multiple mouldings which is used behind relief busts (especially between couch legs) and around a priest's bust on a lavish tomb ceiling; its popularity lasts for over a century.[669] After *c.* AD 150 other medallions are introduced, in various types of sculpture and painting. Laurel wreaths, in sculpture, embellish divine, honorific and 101 funerary relief busts, a lion's head and a funerary inscription. The equivalent 115, 116 in painting is a circle of densely packed, indeterminate leaves. In both minor sculpture and frescoes a plain circle may be used.[670]

The special Roman frame for inscriptions with a swallow-tail motif each side, the *tabula ansata*, is in use at Palmyra from at least AD 52. It is usually associated with Latin inscriptions. Now and again it encloses a second-century 145 Latin funerary text on a relief-bust plinth. Later it may be employed for a 95 Palmyrene inscription beside funerary figures. Another Western framing, an aedicula, surrounds the Latin funerary text of a Roman soldier.[671]

(v) Costume and textile ornament as shown in art
Palmyrene costumes and textiles are decorated in particular places: the hems of tunics and cloaks, frontal bands on tunics and trousers, the woman's diadem and cap, jewellery, mattresses and so on. The floral motifs – principally the oriental rosette, and the Western acanthus, laurel, vine and oak, in spirals or rows – we have already studied.

The favourite abstract motif is beading, usually set between listels. This has 61-4, 91 been regarded as possibly a rendering of decoration with real pearls, attached to costumes and jewellery. But actual textile fragments with the motif woven into them, and metalwork with granulations from Dura-Europos, demonstrate the types of decoration the artists are apparently imitating, and indicate that pearls are not in fact involved here, although they could have provided the original inspiration for the motif. Beading between listels is sparingly repro- 69, 70 duced in first-century Palmyra, but proliferates later: from the second century it commonly provides edging to bands of decoration, and, later still, encloses motifs, especially the rosette, in lozenges and squares. Apparently traditional in Near Eastern textile iconography, the motif was popular in the Iranian world.[672] Simple spirals, doubtless of oriental origin like the architectural interlacing, may fill ornamental trouser bands until the mid-first century AD, 91 and later such items as bow-cases; a particularly rich type ornaments a 'eunuch's' 73, 112 cloak. Motifs set within squares were common in late Assyrian representations 33 of textiles, and fringes and tassels to robes were popular among Assyrians and Achaemenian Persians; all three occur at Palmyra.[673]

Other motifs perhaps belong more to the contemporary Parthian world, such 92 as the motifs of lines criss-crossing or zig-zagging, of triangles as edging to 82 tunics, and the larger textile motifs, such as the arrow-head and the H-shape, 79 and the frontal strip (or strips) of the Parthian tunic.[674]

Borrowings from the West in this sphere are few. The running-dog motif is Greek, and popular in Parthia. Primitive volutes on helmets of Athena figures are also Western. A stripe of varying width not uncommonly falls from the shoulder on the male and female tunic, from the second century. Often the stripe is plain; decoration may consist of wavy horizontal lines, or more fre- ‎79, 81, 114‎ quently of floral (especially vine) spirals, with or without beaded edging. The stripe was presumably inspired by, although it does not exactly copy, the Roman clavus; it is also seen in Egyptian mummy portraits. Perhaps it was a mark of distinction.[675]

(vi) Utensil and furniture ornament as shown in art

The finer types of utensil, such as the ritual bowl and two-handled cup, often bear a vine or rosette spiral around the rim. Most decoration, however, is abstract, and of a few limited kinds, principally a Western multiple-tongue ornament, or more locally inspired rows of chiselled depressions, although multiple ‎62, 102‎ diamonds occur, and beading may be added, as on furniture and burners. ‎98‎ Women's chairs also sometimes have criss-cross decoration.[676]

(vii) Pottery decoration

Palmyrene pottery was clearly made for use rather than ornament, so decoration is simple. Most types of vessel are normally plain; forms are Mesopotamian or more often east Mediterranean, and decoration is rare, and usually in the form of grooves, whether straight, semicircular, wavy or grouped in a circle of 'rays'. Lamps generally bear decoration, which, until the period of Tiberius usually consists of grooved 'rays', with or without a tiny two-handled amphora- ‎51 e)‎ like vessel in addition, in imitation of Hellenistic lamps. Thereafter, Romano- ‎132‎ Syrian kinds dominate, often ornamented with vine spirals and figures.[677]

(viii) Animals in art

The sign occasionally seen on the shoulder or thigh of an animal in art probably ‎14‎ refers to its ownership.

In third-century Palmyra some felines are distinguished by a design of circles ‎42‎ distributed generously over the body, perhaps a local habit.[678]

The value of iconography

The contribution which iconography can make to the study of art should not be overestimated. Motifs are merely the 'words' of the language used by the artists. Such words may be adopted from anywhere, without affecting the nature of the language. They are evidence of cultural contact, but not neces- sarily of cultural dependence. They travelled easily around the ancient world, particularly in copy- or pattern-books.[679] Their adoption in alien arts does not necessarily imply a servitude to, or even an understanding of, the conceptions that originally lay behind them. So, to find out how the Palmyrene artists really thought and what the true affinities of their art were, we must probe not the words but the language itself, the style.

9
Style and Character

The principal characteristics of Palmyrene style have long been recognized; they remained constant throughout Palmyrene art. A hieratic quality imbues both figures and scenes with an aura of unworldly timelessness. The artists were seeking to express the inner life of their creations; their quest was for permanent qualities rather than for transient realism, even though their figures and forms usually approximate to nature in some degree. Palmyrene art is also noteworthy for its linearity, for the reduction of the myriad facets of natural forms to comparatively simple systems and patterns of lines. Paradoxically, it shows too a remarkable preoccupation with detail, or 'verism': certain items such as dress, equipment, and ornament are treated with a minute care, whether the detail shown corresponded with reality or no.[680]

These artistic concerns had been characteristic of Near Eastern art for millennia. So the 'language' of the Palmyrene artists, their mode of thinking, was wholly oriental. It separated them from the Hellenistic- and Roman-influenced artists of the coastal area of Syria, and linked them with the Asiatic regions where Near Eastern styles continued to flourish in one form or another. The particular way the Palmyrenes employed this language is characteristic, however, of a comparatively limited area, stretching from the edge of the Fertile
1 Crescent in the west and north, to the nearer confines of Iran in the east and the plains of Babylonia in the south. Most centres where the style was practised fell within the political boundaries of the empire of Parthia, and for that reason it is usually called 'Parthian'.

This is not to say that Palmyra, the principal western outpost of this 'Parthian' art, remained unaffected by the neighbouring Roman style. Some of the Bel temple reliefs are strongly influenced by Western high relief and modelling. From the mid-first century A D, relief is sometimes deepened. And after c. AD 150 a trend towards the greater use of Western techniques and styles can be discerned: general modelling and depth of cutting increases, drapery folds are 'chopped up'; eyes approximate to reality more closely in size and shape. Inevitably, such dabbling in realism diminishes the unworldly, spiritual quality of the art. But at Palmyra this trend was never more than superficial.

Palmyrene art possessed further striking traits which affirm its kinship with the other centres of 'Parthian' art. To begin with, there was the artists' attitude to space when dealing with a plane surface. This had two aspects. Figures and objects were customarily ranged, without much overlapping, along a

single base line against a neutral, blank background. This kind of presentation, common to classical Greek and Achaemenian reliefs, had survived into earlier 'Parthian' art and reappeared in late Hellenistic reliefs; so either source could have contributed it to Palmyra, although the eastern one might seem more likely. A second aspect is more problematic: the occasional use of vertical perspective, which, as we have seen, seems to be employed in a Hellenistic way, although its recurrence at third-century Dura-Europos hints that it may have become part of Near Eastern usage.[681] Then again, Palmyrene, like 'Parthian' art, is expressed through a conspicuously narrow range of formulae, which extends from an entire scene or action, such as the banquet or the casting of incense, down to the smallest details of appearance and decoration. Those formulae found most acceptable, such as the offering of incense, were simply repeated from beginning to end of Palmyrene art. Others, like the divine cuirasses, banqueters, relief busts and rosettes, were refined or modified as time passed. Others again had a limited life, or, like several genre scenes, appeared only once. The formulae for figures were predominantly of one kind, the frontal. Types of composition were restricted largely to the ubiquitous paratactic and the less common heraldic kinds. By and large, those formulae most popular and most long-lasting at Palmyra were those which coincided most closely with the favoured repertoire of other 'Parthian' centres.

These formulae, motifs and methods of composition were derived from a great variety of sources. The earlier Near East, Hellenistic Greece and contemporary Syria, Parthia and Rome all made significant contributions. These diverse elements were absorbed and welded into a composite, an amalgam, discernible already among the earliest surviving figured fragments of Palmyrene art. Thus the 'stepped' reliefs, for instance, combine the earlier Near Eastern stepping animals, rosettes and heraldic (?) composition with Greek architectural elements and busts (?), Iranian (?) swords, Iranian hairstyles and a cuirass of possibly Syrian manufacture.[682] This composite character was typical of all 'Parthian' art, although the proportion contributed by each source varied from centre to centre.

Within the family of 'Parthian' schools and workshops Palmyra was distinguished, as is every art centre, by the particular range of motifs current among her artists, and by the particular ways in which they exercised their crafts. Thus Palmyra, as a centre of 'Parthian' art close to east Roman workshops, acquired a considerable repertory of motifs from Greek and even Roman sources to add to her Near Eastern stock. This complex balance is reflected throughout the work of her potters, painters, weavers and carvers. The character of her sculpture, furthermore, was partly dictated by the easy availability of soft and hard limestone nearby. The qualities of this stone, its comparative ease of working, its successful effects when crisply carved, go far to explain the Palmyrene sculptors' individual treatment of their 'Parthian' inheritance.

What the artists actually produced was determined by their patrons. Who these were is usually clear from the representations themselves and from inscriptions. Most commissions emanated from the Semitic urban élite, the merchant bourgeoisie, singly or corporately; among the rural communities to the northwest, the rich men of the villages doubtless paid. The élites commissioned not only art, but architecture also: normally portions of structures, sometimes whole

5

2-4

buildings such as Malê's little temple for Ba'alšamin and Dûrahlûn. But one great puzzle remains; who paid for the colossal new temple of Bel, dedicated in AD 32? Palmyrene individuals certainly contributed, but it is doubtful whether their resources, even combined, would have been sufficient to meet the total costs at such an early period. The similarly extensive Ba'alšamin sanctuary, which clearly relied on local funds, proceeded slowly. If a subvention, open or covert, did indeed come from outside to meet a part or most of the cost of building the Bel temple, who provided it? In the temple court, from AD 17-19, stood a statue group headed by the Roman Emperor, Tiberius. In the temple itself was placed the (Tiberian?) relief of the Roman she-wolf. Could not the three, sculptures and temple, be connected? Might not Roman funds have financed the construction and decoration, as so often elsewhere in areas under Roman domination or influence? The Bel temple would then have become a conspicuous mark of Roman generosity and influence in a town of growing commercial importance strategically positioned in a sensitive frontier area. It might even have commemorated Palmyra's inclusion in the Roman province of Syria. So although most of Palmyrene art certainly has a bourgeois character, the Bel temple and its sculptures could represent an imperial intrusion.[683]

The two subjects which seem almost exclusively to have interested the Palmyrene élite as patrons were their deities, and themselves. These interests were expressed primarily through religious, funerary and honorific art; the scantiness of the vestiges of more purely secular work, and their dependence on Western models, cannot be wholly accidental. Much of this art was used to ornament architecture. Most often it was itself two-dimensional and set on, or against, the flat surfaces of a building; even free-standing statues were placed in close relationship to a structure.

The style, and these characteristics, reveal the intentions of the artists clearly. Palmyrene art, in common with earlier and later Near Eastern art, was strictly functional, a means by which ideas could be conveyed to the onlooker, through the language of accepted schemas, of stereotyped motifs and scenes. The schemas were usually quite realistic; but that the Palmyrene artists regarded them, nevertheless, as symbolic is made clear by their habit of abbreviating figures and whole scenes. Thus a worshipping figure, for instance, could be indicated by a pair of upraised hands, and a scene of offering by a burner or altar. That many motifs had been drawn from Greek art, with its entirely different object of satisfying the aesthetic sense, was immaterial. Such motifs, like those from other sources, were reduced to a 'minimum stereotype' for the artists' symbolic purposes. Thus they were all totally absorbed into the language of the Palmyrene artists, whose own mode of thinking remained paramount.[684]

Foreign works and patrons

The mass of material from Palmyra and its environs has provided a vivid insight into the practices and intentions of the Palmyrene artists. But some works stand apart, and demand separate investigation. They fall into three groups: the works found at Palmyra but executed by artists trained in different traditions outside Palmyra – these were mostly imported; the works made and found in Palmyra but commissioned by foreigners, who seem sometimes to have influenced the result; and finally, the works ordered in centres abroad by Palmyrenes, whose tastes reflected the traditions of their native city.

Works of art executed by outsiders

Importation of foreign-made work began early. Indeed, to judge from the small finds made in the Hellenistic tomb beside Ba'alšamin's sanctuary, the introduction of minor art from outside seems in several spheres to have preceded local manufacture. A steady flow of imports continued throughout the 'historical' era of Palmyra. What was introduced, and from where?

Pottery came in at an early date. Lamps of the second century B C were 51 b) buried in the Hellenistic tomb: these had come from the east Mediterranean, probably from the Antioch area. Other Greek wares, found here and in the Bel temple mound, had arrived from the same direction, including a vessel from Rhodes. A plate, made from a mould, with two Greek-looking Erotes 51 f) embracing on it in relief, could also be Western, although parallels are wanting. An equally strong contingent of Mesopotamian origin, however, betokened a powerful Eastern influx by about 100 B C. Prominent among these were examples of the region's distinctive green-glazed pottery. But virtually all 51 e) pottery imports seem to have ceased during the first century A D, when local industry became able to cope with the demand. The same was not true of glassware, for some importation seems to have persisted throughout our period. The three glass bowls from the Hellenistic tomb are surely Greek imports; and later shapes such as the amphora or bottles look sufficiently Western to have come from coastal Syria.[685]

More problematic still are the items of alabaster. Several vessels carved from this stone were discovered in the mud-brick tomb, in use from c. 150 B C to c. A D 60. How did they come to be there? The material, to begin with, is

foreign to Palmyra; nor are these types of vessel known there later. The greatest number of clues to origin, however, is afforded by the three palettes for cosmetics, or 'toilet trays'. These belong to a type of vessel widespread in the late Hellenistic and in the Parthian East; examples have been found principally in Egypt and at Taxila (Sirkap), by the Indus river. Carved usually from less common stones, the circular shape and designs of the Taxila trays have much in common with those found at Palmyra. For the two later Palmyrene examples, local workmanship has been claimed, on grounds of iconography. Let us examine all three, to test this attribution. The earliest (c. 125 BC?) shows the busts of a man and woman, drinking together. Taxila offers some remarkable parallels in schist, one of which is roughly contemporary; although the designs are subdivided, closely similar pairs of busts recur, in a related style. This precise motif is alien to Palmyrene art. The bust of a drinking male does occur later in Palmyrene sculpture, but rarely, only between AD 100 and 150, and never together with a female. The favoured place of this particular motif in the contemporary Taxila repertoire would seem to imply its popularity far to the east of Palmyra, and an ultimately more eastern origin for the Palmyrene piece, which would therefore have been imported. The design of the second palette, of the first century BC, is essentially similar. But here there is one bust, depicting a radiate sun god, and each side of him the front portion of a horse. Again, the representation differs significantly from the known later canons of Palmyrene art. The frontal divine bust with crescent beneath is found, if seldom; the rays alone around the head, without the nimbus, are also met with, not in sculpture but on tesserae. On the tray, however, these rays are peculiarly rectangular, rather than tapered and pointed as was to be normal. And the horse is not a known attribute of any of the Palmyrene sun gods; Malakbel as such has the griffin, and Iarḥibôl and Šamaš none. The plumed tufts of these horses are likewise alien. And the large rosette on the underside of the palette echoes those on Taxila trays. Again a Parthian style, combined with iconographical elements alien to Palmyra, would seem to suggest that this tray too came as an import from further east. The last tray, of the mid-first century AD, is the most Palmyrene in character. Rectangular instead of circular, it houses a subject dear to the Palmyrenes: a rider god, mounted on a horse. But this need not imply Palmyrene workmanship. The rider god was popular in a wide area of the Near East, including Anatolia. Iconographical differences from other representations found at and around Palmyra are small, but they exist. And the style, although Parthian, is not particularly Palmyrene. These factors, when added to the alien material and probably foreign origin of the two circular trays, would seem again to make importation at least a likelihood. Finally, the late fragment of a head in alabaster from the Agora, more Western in style, also looks imported. None of the alabaster objects, therefore, can be shown to have been carved at Palmyra; they all seem to have been brought in from elsewhere.[686]

Jewellery materials, although rare, again testify to early importation. Many necklace beads, of agate, cornelian, schist, faience and so on, must have come from a distance, whether or not they arrived in a made-up state. The frog carved on a necklace pendant of the Roman period introduces a Western motif foreign to Palmyra. Much of the jewellery shown on the busts can claim out-

side, often Western, kinship. And the identifying imprints on many tesserae from the finger-rings of important Palmyrenes indicate that the majority of the rings were Western imports. The general repertoire of the intaglios, from gods to the surrealistic grylloi, is Hellenistic in origin, and common to the whole Roman East. The buyers, however, markedly preferred figures of those Greek divinities which could correspond with Semitic deities. Athena (Allat) with 23 examples was the most popular, Tyche (Atargatis, Gad) and Zeus (Bel, Ba'al-šamin) taking second place with around 20. Helios was also popular, as were Hermes, protector of merchants, and the Victories. Heracles, Apollo, Nemesis and a few other deities were chosen less often. Eagles head a wide variety of Western fauna; the lion, grylloi and griffin are not far behind, but the rest appear more rarely. Other subjects range from a profile head of Socrates to a 54 x) hand pinching an ear-lobe. From the specifically Roman repertoire came Romulus and Remus. Otherwise, another design, showing two heraldically confronted horsemen, could reflect the Anatolian Dioscuri, similar local compositions or Iranian work. And on two are visible the imprints of already ancient Egyptian scarabs, one of the late, twenty-fifth dynasty and the other of the short-lived Tutankhamun. Still older than these, an actual cylinder seal of the Mesopotamian Protoliterate (Jemdet Nasr) period, found in the early tomb, was presumably used as an amulet.[687]

Coins also began to arrive early on, for if any coins were minted in Palmyra at all, they were no more than minute bronzes for small change. Although not very many imported coins have been found, they provide vital dating evidence. Bronze issues predominate. In the early mud-brick tomb were found a bronze coin of the Phoenician coastal town of Aradus (dated 140/139 BC), two coins of Antiochus VII Sidetes (138–129 BC) minted in Antioch, and others now severely corroded, perhaps including an issue of Antiochus VI Epiphanes (c. 145–140 BC). Later finds are mostly Roman with an admixture of Hellenistic, Sasanian and Palmyra's own imperial Antiochene coins. The Roman small change was minted in a variety of towns in Syria and Asia Minor, particularly in Antioch.[688]

Not one of the textile fragments found at Palmyra can be proved to have come from materials made there, although many, especially the coarser cloths, were doubtless woven on the spot. What does the ornament indicate? Most of the linens and woollens, where decorated at all, bear simple, rectangular motifs: striping, whether single or multiplied, and H- or T-shaped patches. These 52, 53 must have been characteristic of the whole Syrian area, for they occur not only in the art of Palmyra and Dura-Europos, but also among Dura textile pieces. Other linens are decorated less severely. One linen tunic in particular bears on 52 the shoulder a complex circular medallion, whose principal feature consists of interlaced squares, spear-shaped leaves around the neck, and a stripe down the tunic proper which ends in a stylized acanthus leaf well above the lower hem. This stripe, therefore, can have no direct connection with the honorific Roman clavus, which reaches from top to bottom of the tunic. These various motifs look vaguely Hellenistic, but if this is their origin they have been thoroughly transmuted, perhaps indeed in the Syrian area. Possibly a similar history lies behind the multicoloured ornaments of the rich woollen tapestries, which 54 are almost entirely floral: repetitive leafage and heart-shaped flowers are par-

ticularly common. The ubiquitous rinceau of the stone-carvers is hardly to be seen, and then only in a simple form. Beading is often used along the edges of the tapestries. But despite the presence of, for instance, the Greek running-dog and wave-pattern motifs, the whole ensemble is not so much Hellenistic as Near Eastern.[689]

The case of silk is more complex. Silk thread from China, as we have seen, was almost certainly imported and then used in Syrian workshops partly in combination with other materials, and partly for plain silk weaves. The decorated silks, however, tell a different story. Where, exactly, were they made? Material, unspun thread, dyes and methods of manufacture are all typical of contemporary Han China. But there are problems. The technique is less sophisticated than that of comparative Chinese fabrics. The decorative designs, both woven and embroidered, in most cases differ in some ways. The woven motifs, the geometric patterns and weird, confronted beasts and birds, vaguely recall the known Han repertoire, but only an exceptional fragment with Chinese clouds, characters and perhaps animals clearly belongs to it. These fabrics are in fact noticeably inferior to known Han pieces, and were perhaps woven in one of the more primitive provinces of China, possibly in the south. Where was the embroidery added? This could have been done at any stage of the journey from China to Palmyra. But the strangeness of the spiky plants and animal claws, and the fact that they were added in silk, would again seem to point far to the east.[690]

An eastern import from rather less far afield takes the form of a mould for making terracotta plaques depicting a Parthian god. It must have arrived from Mesopotamia.[691]

Almost all the marble sculpture found at Palmyra belongs in subject and execution squarely in the eastern Roman repertoire. The erection of a togate statue in the eastern provinces, where Greek dress normally prevailed, implies that the subject is either a member of the imperial family, or a high official. The togas themselves of the pieces found in Palmyra are of late Antonine or Severan type. The cuirass was reserved for the Emperor or his sons; so the fragments of two cuirassed figures indicate that at least two imperial portrait statues stood in Palmyra. The female 'Pudicitia' and 'Petite Herculanaise' types were likewise standard models for honorific pieces. One of the two surviving female heads looks mid- or late Antonine, while the other might be late Severan. The second- and third-century 'apartment sculpture', too, is clearly from stock. The 'Castor' relief, with its surrounding columned aedicula, is also Western in style. No doubt all this work was imported from eastern Roman ateliers, not far distant from Palmyra.[692]

The only work definitely to have been carried out in an alien style on Palmyrene soil were the late house mosaics, obviously laid by artisans of Roman training. Style and execution are fairly homogeneous throughout, mediocre, and thoroughly Roman. The colour palette is wide. The age-old Mediterranean convention of red-brown males and paler females persists, while Cassiopeia's ungainly proportions, emulating the Hellenistic small-breasted and broad-hipped ideal, go far to explain the Nereids' irritation at her boastfulness. But her frontality is striking; so, too, is the shading of figures and garments (where worn) with broad areas of dark and light in contrast, which in eastern

Roman mosaic would indicate a date somewhat after AD 200, as perhaps it does here also. Can the artisans' origin be clarified further? Much of the ornament is 'international', such as the 'shields' (*peltae*), although the Cassiopeia 'twisted ribbon' border type occurs frequently at Antioch from the Severan period. Complex figured scenes, however, establish a Greek atmosphere, as do the Centaurs' tree, an apology for landscape, and Greek subjects and labels. The Odysseus and Cassiopeia scenes, moreover, were alien to the mosaic repertoire of the western provinces and north Africa. And one figure hints at the source of these scenes. The bust of Spring, in the spandrel of the Cassiopeia mosaic, is unusual. First, she carries a kid instead of the usual fruit or vegetable attributes. Secondly, she is winged; mosaic Seasons with wings are rare, and mostly to be met at Antioch. Surely Antiochene influence, and perhaps even craftsmen, dictated the form of the Palmyrene Season, and so doubtless of the rest of these floors. The 'marbling' of the painted walls was equally Roman.[693]

139

137

So both Antioch and Mesopotamia were important sources for Palmyrene imports. And at the acme of Palmyra's prosperity products could arrive from as far afield as the provinces of Han China.

Foreign patrons in Palmyra

The Roman government set up sculptures in various parts of Palmyra, for sound political reasons. Minucius Rufus placed statues of Tiberius, Germanicus and Drusus together as a group in the Bel sanctuary in AD 17–19. The base survives; the figures were probably in bronze, and imported from some east Mediterranean workshop. Inside the temple was raised a relief, now mutilated, quoting the Roman she-wolf beneath the fig tree. Tiberius' government was probably responsible both for this relief and for the statues, and may indeed have contributed significantly towards the cost of Bel's new dwelling. Later, an inscription tells us, Antoninus Pius' figure stood not far away. Septimius Severus and his family adorned the middle gate of the Agora, and perhaps portions of his dedication survive in imported marble statuary found nearby.[694]

Private persons used local craftsmen. Marcus Julius Maximus Aristides, who had exchanged the humidity of Beirut for the dryer atmosphere of Palmyra, received a funerary relief bust of ordinary early third-century type. Some Western touches perhaps reflect his origin: the lengthy Greek text, pilaster, scroll and receding hairline. But such touches, commonly added by Westernized workshops, need not imply special instructions.[695] Some funerary busts, however, of standard types but with Latin inscriptions, do include some apparently deliberate Romanisms. A woman is set within a particularly broad frame, and two men – one a cavalryman of the ala Thracum Herculania – appear above a text framed by a tabula ansata.[696] But other foreigners, notably women from Greece and Egypt, are disguised by stock representations.[697]

144

145

Two Thracian soldiers, doubtless stationed at Palmyra, had a relief erected shortly after the mid-second century to Leto and Apollo, named in a Latin scrawl. The frame is unusually broad, perhaps a Westernism; and although the matronly Leto is from local stock, Apollo appears in Greek nudity.[698]

40

Such obvious departures from the Palmyrene repertoire are rare, and a good proportion seem due to Roman army influence.[699]

Palmyrenes abroad

How did the Palmyrenes themselves fare as patrons, when away from their native city? For a radius of between 50 and 100 km. around the metropolis Palmyrene art itself was predominant. Discoveries made in the rural sanctuaries of the region north-west of Palmyra, along the tracks, at military posts and in lonely desert villages, all confirm this. A temple of obviously Palmyrene workmanship arose at Qasr el-Heir el-Gharbi, on the road to Damascus. The architectural decoration includes the usual vine rinceaux; from the lintel spiral emerge a Silenus mask and a bust of Dionysus. Here, funerary busts of Palmyrene style also came to light.[700] Beyond the local region, Palmyrene patrons had to negotiate for their special needs to be met. Let us see how they got on, following them first to the East.

Palmyrenes were domiciled in the Euphrates garrison town of Dura-Europos from at least the first century B C, when it was in Parthian hands, through its mid-second-century transference to Rome, until its destruction a century later. They were there as traders and soldiers. Evidence for their patronage of art comes principally from four of the town sanctuaries. In summer 33 B C, two Palmyrenes dedicated the first of these projects: the 'Necropolis temple', built for Bel and Iarḥibôl. This was steadily extended, and probably c. AD 173 a chapel (naos 12) was added and wall-painting commissioned. One important fragment survives in a late, local style, preserving a frontal god helmeted like Arṣû. On the floor of naos 1 three insignificant fragments of local sculpture were found – a scene of sacrifice(?), a relief of Heracles and a little altar.[701] Probably during much the same early period, the late first century B C, a wealthy Palmyrene merchant family or families occupied a building near the

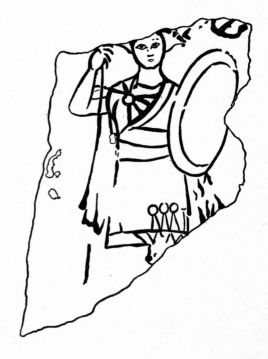

58 Wall-painting of a god in the 'Necropolis temple' at Dura-Europos, c. AD 173 (after 135, VII–VIII, fig. 82)

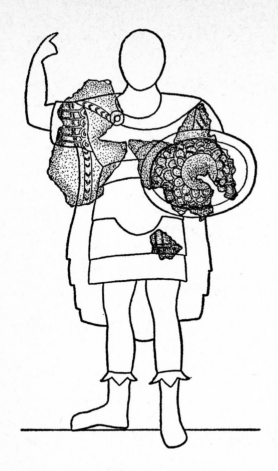

59 Restored figure from
the third-century wall-
paintings in the 'temple of
the Gaddé' at Dura-
Europos (ht. *c.* 95cm.;
from *135*, VII–VIII, fig.
72)

market place – the 'temple of the Gaddé'. Again an original shrine was de-
veloped and enlarged, and again fragmentary wall-paintings and sculptures *59*
survive. From the late first century AD remain numerous small pieces of painted
compositions from a chapel (naos 2b), in which deities stood and worshippers
sacrificed; the painter was Durene. Then in April 159, Ḥairan, the son of
Malkû, dedicated three reliefs, apparently a set, in another chapel (naos 3).
The reliefs are carved in a limestone that resembles Palmyrene. In the centre
of one, between the priestly donor in Palmyrene headdress and a Victory, is *146*
seated the Gad (or Tyche) of Tadmôr (Palmyra). Her figure unconsciously
parodies a standard variant of Eutychides' famous statue, the Tyche of Antioch.
Beneath her feet emerges a female bust, which, by analogy, must personify
the Palmyrene spring, Efqa. Beside the Gad squats a lion, borrowed from the
iconography of Atargatis. A pair to this portrays the Gad of Dura between
the selfsame priest and the youthful figure of the city founder, Seleucus Nicator.
The third (and central?) relief, now shattered, was perhaps larger, and, to
judge by the inclusion of a griffin, figured Malakbel. The limestone, apparently
Palmyrene style and many elements familiar from Palmyrene art set these
pieces apart and suggest that they were produced by a Palmyrene workshop.
If so, the sculptors would have needed guidance over the iconography of

Seleucus Nicator, a cult figure at Dura-Europos, and Dura's masculine Gad. A slightly later stele dedicated to Iarḥibôl, also from naos 3, is, however, Durene; confusingly, the god shown wears behind his shoulders the crescent of 'Aglibôl. In the early third century a nearby chapel (pronaos 2) was painted with deities (Ba'alšamin and Malakbel?) and a chariot. This work was Durene, like that of the remaining sculptures found here, including a surprising pair of red-painted lions (or lionesses?) set back to back in the court – an old Near Eastern arrangement. Finally the Twentieth Palmyrene Cohort of the Roman army, stationed at Dura by AD 209, erected some divine or imperial statues in colonnade 10, of which the plinth survives.[702]

There was less Palmyrene involvement in a third sanctuary. The so-called Temple of Bel (earlier called 'of the Palmyrene Gods') was given a chapel in AD 50/1, where a huge painted figure of the god occupied the rear wall. Later (c. AD 180?), members of the Konon family were depicted as worshippers on the south wall, sternly aligned. Not long afterwards a vestibule was added, and again donors contributed locally executed paintings. Lysias family members lined the south side. But on the north wall Terentius, tribune of the Twentieth Palmyrene Cohort, c. AD 239, dedicated a mural showing him and his men sacrificing to three (Palmyrene?) gods and the Tychai of Palmyra and Dura. The divine figures are puzzling. The Gad of Dura has here become female. The three gods have few distinguishing attributes: is it 'Aglibôl's crescent to the left, and Arṣû's helmet on our right? Is the central figure Bel? Five more

60 Wall-painting of the sacrifice of Terentius in the temple of Bel at Dura-Europos, c. AD 239 (after 47, pl. XLIX)

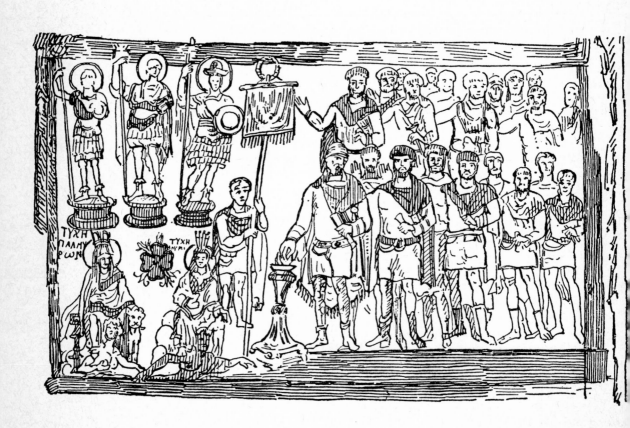

vaguely Palmyrene divine figures dominate another donation, the eunuch Otes' roughly contemporary mural in a side chapel (K); but again they remain enigmatic.[703]

In a fourth sanctuary, Palmyrene mounted archers, stationed at Dura-Europos in Parthian and Roman times, took up, *c.* AD 100–50, the worship of the originally Indo-Iranian god Mithras, now popular among Roman soldiers and traders but foreign to Palmyra, and built him a temple. In AD 168 the commander, Etpanei, dedicated a relief of Mithras performing his mythical slaying of the bull for the sanctuary cult niche; and in AD 170/1 another commander had a second, larger and likewise locally executed relief of the same act placed immediately above. The reliefs were coloured, and the sanctuary gradually came to be painted with Mithraic scenes.[704] One further relief, found elsewhere, was explicitly dedicated by a Palmyrene, Malochas, to Nemesis in AD 228/9. The sacrificing donor is balanced by Nemesis, marked by her spitting gesture, wheel and griffin; between them hangs a bust of the sun. Both style and content seem Palmyrene, so the carver might have come from Palmyra. And statuettes of a girl and boy also look Palmyrene.[705] But in none of these cases can the hand of a Palmyrene artist be proved; and for most commissions, at least, resident Palmyrenes seem to have used local workshops.

Further still to the east, on the island of Kharg 30 km. from the coast of the Persian Gulf, two curious hypogea, with recesses for numerous burials, were discovered. The larger hypogeum is entered through a vestibule and arch. To right and left open the burial recesses, one of them decorated with a vine in relief; and opposite the entrance is a large funerary banquet relief, with a man reclining. Arrangement and decoration have striking Palmyrene precedents. But none of these tomb features are Palmyrene alone; and although the Palmyrenes may have passed this way en route for India, the hypogea are not necessarily their work or even due to their influence.[706]

Southwards, we can follow the Palmyrenes definitely as far as the Syrian Haurân. Here a certain Palmyrene named Ḥalafû ordered a relief depicting Allat as the warrior Athena from a local sculptor. And the cuirass worn by Šadrafâ in representations from this area may well be an iconographical import from Palmyra.[707] Cf. 27

Westwards lay the Roman Empire; and we can trace the Palmyrenes to its furthest boundaries. One visited the Greek island of Cos; others worked in Rome. Not uncommonly they served in the army, in Egypt, north Africa, along the Rhine and Danube frontiers and in Britain.[708] But few commissioned figured monuments. One relief, found at Djoub el-Djarrah, about 100 km. west of Palmyra and so at the limit of, or beyond, the sphere of her artistic influence, is an attractive late first-century piece in yellow limestone. The god 26
(*gny'*), in Parthian dress and labelled, is on horseback to our left; behind him flies an eagle, skilfully holding laurel branch and crown. A conventional goddess poses before him. Between them a flame leaps up from a burner. The delicacy of design, carving and detail is worthy of the metropolis, from which it may have strayed. The god himself strikingly recalls two horsemen on another relief from the Syrian area, who gallop in procession ahead of at least three cameleers. This puzzling frieze, broken at both ends, resembles Palmyrene work in both style and iconography; the carefully distinguished costumes of cameleers

and horsemen, in particular, argue a date *c.* AD 90–150. But the vigorously angled heads, flying cloaks, leaping horses and overlapping figures indicate an atelier more Westernized than any yet known at Palmyra. Perhaps it lay closer to Roman workshops at, for instance, Emesa. Westwards, the Lebanese village of Harbata, 30 km. from Baalbek, yielded an extraordinary cache of miscellaneous sculptures. One relief fragment contains the lower half of a priest in Palmyrene style. Two more comprise funerary stele fragments of Palmyrene type, both perhaps from the same relief. The inscription and most of the designs, indeed, betray nothing untoward. But one figure grates: before a hanging curtain (indicating a deceased person) stands a warrior, carrying a spear and small, round shield. At Palmyra these accoutrements were reserved perhaps exclusively for gods; so this could be a 'provincialism'.[709]

148 In 1912 the excavator of a Roman building at Koptos in upper Egypt discovered a room or court with two small altars, and a dozen curious reliefs which had been set into one mud-brick wall. Each relief presented two frontal male busts in tunic and cloak, with shaven (sometimes wreathed) and originally gilded heads; they carried garlands and, in three cases, a stylized lotus flower on its stem. Mistaking the lotus for an arrow, recalling the Palmyrene funerary relief busts of similarly Roman derivation, and knowing that inscriptions had revealed the presence of Palmyrene merchants and archers elsewhere in Roman Koptos, the excavator attributed both building and reliefs to Palmyrene patronage. Recently, however, the local Egyptian origin (and funerary purpose) of the reliefs has been demonstrated; there is no connection with Palmyra.[710]

Syrian military units, including Palmyrene, were also scattered along Roman north Africa, particularly under the Severan dynasty (AD 193–238). At El Kantara in Numidia a divine statue was put up, possibly representing the favourite deity of the Palmyrenes in the West, Malakbel. Further west, at Castellum Dimmidi (Messad) in Algeria, a Palmyrene unit used a chapel

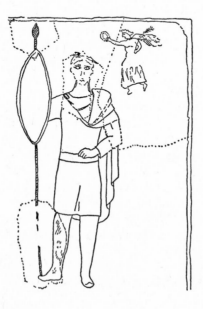
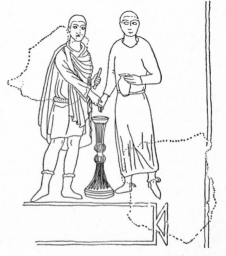

61 Restored figures from wall-paintings of Malakbel and of a sacrifice in a shrine at Castellum Dimmidi, Algeria, AD 225–38 (ht. 1m.; after C. Picard, *Castellum Dimmidi*, Paris, 1949, figs. 15–16)

between AD 225 and 238. On its walls a painting of a standing frontal god in *61*
tunic, chlamys, boots and helmet, crowned by a Victory, perhaps depicted
Malakbel again. Soon a new layer of plaster was laid over this, and a standard
scene of the offering of incense on a burner by two figures was substituted.
The closeness to Palmyrene and Durene work of both the motifs and the
linear technique, principally in red and black, could mean that a painter trained
in Syria, even at Palmyra, executed both scenes.[711]

Palmyrenes also flowed into the Roman capital. Some who belonged to the
third 'cohort' of employees at the granaries of Galba (Horrea Galbae) com-
missioned a fine marble altar, *c.* AD 100, with reliefs in fully Roman style on all
four sides. A Latin text consecrates the altar to the sun, the Aramaic version
to '[the solar] Malakbel and the gods of Tadmôr [Palmyra]'. What is shown on
the altar has long been largely agreed; its symbolism is more enigmatic. On
one face is represented a cypress bound by a sacred ribbon; from its foliage *62*
emerges a youthful figure carrying a kid. Doubtless this presents Malakbel,
in his aspect as a vegetation god, being born from the sacred cypress. Moving
round, we encounter a young man in oriental dress climbing into a chariot *63*
drawn by four winged griffins; behind him a winged Victory places a crown on
his head with one hand, and carries a palm in the other. This must be Malakbel
again, but now as the sun. Above the Latin text we meet him in glory, as a *64*
resplendent bust with seven-rayed nimbus, borne on the back of an eagle
with spread wings symbolizing the heavens. Finally, we see the veiled and *65*
bearded head of Saturn with his sickle. In these scenes four stages of the sun's
course have been recognized. But what course? That of his daily journey across
the heavens? For this, Saturn could be regarded as the Sun of the Night. That
of the four seasons of the year? In the light of Malakbel's dual nature, this might
seem the more probable. The (Roman) sculptor must have needed much special
information about the birth from the cypress, the griffin-drawn chariot and Near
Eastern dress, the nimbus and eagle.[712]

Soon afterwards the Palmyrenes possessed a sanctuary at Rome, outside the
Porta Portese. Here one entire relief, fragments of two others and portions of
inscriptions, all of Roman style and in marble, came to light. The youthful
Malakbel in oriental costume recurs on the complete relief, dated AD 236. *147*
Within a pedimented shrine he clasps the hand of the cuirassed 'Aglibôl before,
again, a sacred cypress. The handshake of these two 'holy brothers' is twice
represented at Palmyra; this, the cypress, the costumes and the position of
'Aglibôl's crescent behind his shoulders would have demanded specialist
knowledge, doubtless offered by the donor.[713] The artist(s) must also have
needed advice for the corners of two other inscribed marble reliefs: for the
god's trousers on one, dedicated by Palmyrenes, and for the veil and calathos
of Ištar (Astarte) on the other, offered by Syrians if not by Palmyrenes.[714]

Palmyrenes were also present on the British frontier. South Shields pro-
duced the tombstone of Regina, freedwoman and wife of Barates of Palmyra. *149*
Above texts in Latin and Aramaic Regina herself is seated frontally on a
wicker chair, within an arched and pedimented niche. A chest and basket rest
beside her feet. Many of the motifs stem from the art of the Western provinces:
the elaborate and pedimented architectural framing, the chair, and Regina's
hairstyle, dress and ornaments. Nor are the box and basket particularly out of

62–5 The four sides of an altar from Rome with reliefs, dedicated to Malakbel *c.* AD 100 (Rome, Museo Capitolino; ht. 85cm.; after *48*, pls. 38–9)

place in Britain. But it is no ordinary Romano-British work. The quality of relief carving is unusually high. The Latin text is noteworthy for its ineptness, while the Aramaic is assured both in its 'cursive' lettering and accuracy of (Palmyrene) formula. The chest and basket can be paralleled on Palmyrene funerary reliefs. But two details, in particular, attract attention. Locks that fall to each shoulder, as do Regina's, were almost the universal fashion at Palmyra till *c.* AD 170–80. And most revealing of all, the spindle and distaff are held together in the left hand across the chest. This motif, known in Roman Syria, is scarcely ever encountered elsewhere; it was especially popular at Palmyra, where it died out, again, *c.* AD 170–80. Most of these motifs can be paralleled

on other Romano-British tombstones: but to find so many that were completely standard at Palmyra gathered together in one relief, and that commissioned by a Palmyrene, strongly argues a close familiarity on someone's part with Palmyrene funerary art.

But on whose part? A second relief from South Shields, of similar quality, 150
discloses the answer. This is the tombstone of the Mauretanian freedman Victor, who had no connection with Palmyra. He reclines on a couch at the funerary banquet, within another pedimented aedicula. Again, portions of the design are Western, notably the framing of subject and Latin text. And the funerary banquet was a popular choice of scene for Romano-British tombstones. But again, this tombstone stands out from the mass of local work: its artistic quality is superior; the Latin is uncertain; and the motifs, taken as a group, look odd beside ordinary Romano-British pieces. Two details give the key to the explanation. First, in his right hand Victor holds a bunch of leaves (or a leaf crown?); this is unparalleled in Britain, but common at Palmyra. Secondly, there is no three-legged table beside the bed, as is usual in British versions; but its omission is almost universal at Palmyra. Once this connection with Palmyra is perceived, other motifs fall easily into place. Victor's pose and costume, the decoration of his mattress and bed with its turned and godrooned legs, the lion's head above him with a ring in its mouth, even the two little medallion busts, all recall the standard repertoire of Palmyrene funerary art. Even the curious stylized tree (?) of the background evokes, for instance, the vine behind the family of Kitôt. 37

So here are two tombstones of unusual quality, both from South Shields and both revealing a familiarity with Palmyrene art. Are they further connected? The idiosyncrasies of the Latin epitaphs link them closely together: especially the curious grammar, the odd use of *natio* and several letter forms, particularly B, R and V. The treatment of architectural details is similar. A predilection for linearity in design is shared between them. So, too, is the sculptural technique, with its strong preference for executing rough work with the point or punch, for drilling and then scoring the outlines of the figures, and for finishing crisply with flat chisels. Such techniques, furthermore, constitute normal Palmyrene practice. So now an explanation is imposing itself. One relief was commissioned by a Palmyrene, whereas the other was made for the local market. Both, however, are technically similar, and both embody many motifs common in Syrian, and especially in Palmyrene art, a few of which are not otherwise represented in Britain. Could one hand have executed both reliefs? There are differences, admittedly: Regina is more crudely carved than Victor, and the Ms of the inscriptions vary. But these differences, which could have resulted from differences in time or purpose, are not so great as to preclude the possibility of one man being responsible for both. Surely, therefore, these two reliefs were carved by one sculptor, trained originally at an important Syrian centre – doubtless Palmyra itself – who had moved westwards and adapted his repertoire somewhat to suit his new surroundings, but who continued to reveal his origins through his choice of figures, motifs and techniques. And no doubt it was these Syrian connections that led the Palmyrene Barates, in the late Antonine or Severan age, to commission from him a tombstone for Barates' British wife Regina.[715]

66 Selection of coins issued by Wahballat and Zenobia from Antioch (b)), Alexandria (a) c) e) f) g)) and Emesa (?) (d)), AD 268–72 (after 38)

66

A last legacy to the Roman world was bequeathed by the greatest family of third-century Palmyra. Odainat, usurper, short-lived 'king of kings', was murdered in 267/8, leaving his queen Zenobia and surviving son(s), principally Wahballat, to extend Palmyra's possessions. Their westward advance was eventually marked by coin issues from Roman mints (for Palmyra, if it minted at all, struck no more than tiny bronze small change). At first Zenobia, although in control of Antioch, was content to continue the issuing of coins from its mints bearing the effigy of the Roman Emperor Claudius Gothicus. But soon after the deaths of Claudius and his transient successor in 270, Zenobia decided to state the Palmyrene position with regard to the new incumbent, Aurelian, by issuing coins – Antoniniani – of a rather different character. On the reverse appeared the bust of Aurelian, certainly, but the front face was occupied by that of her son, the titular ruler Wahballat. The message was soon repeated, after the conquest of Egypt, with an issue from Alexandria – with the legend in Greek, as opposed to the Latin used in Syria. Legends and profile busts were of standard Roman kinds: at Antioch, Wahballat is the youthful prince, at Alexandria, more of a boy. A further bronze issue from Alexandria showed the heads of Wahballat and Aurelian together on one side, facing one another. Aurelian, naturally, found Wahballat's elevation unacceptable. He retook Antioch in spring 272. But before Palmyra fell there was time for two more issues from Syria and Egypt, both apparently ephemeral, and both (according to one suggestion) belonging perhaps to the period after the abandonment of Antioch – possibly May, even June 272. On one of these issues is shown Wahballat's bust with the title Augustus; on the other, Zenobia's bust and the title Augusta. But Wahballat's name in Latin is now spelt differently, perhaps implying a different Syrian workshop, or even a different place of minting – Emesa? Aurelian, moreover, has vanished from the reverse, replaced by stock, but significant, Roman types. Here Wahballat is associated with Victory, Hercules, the sun and other impressive deities. His mother chooses Artemis, Providence, Hope or, more openly on a rare Latin issue, Juno herself, with a strutting peacock. But this was the pride of desperation: almost within weeks, Palmyra had fallen.[716]

History and place

Any attempt to trace the history and affinities of Palmyrene art is naturally hampered by the fact that most of the works have been lost, and that what remains is largely religious and funerary. But enough has survived for a sketch, at least, of the development of the art to be undertaken.[717]

When did Palmyra begin to feel the need for an art of her own, and in what forms? The Bel temple mound, and the early mud-brick tomb beside which the Ba'alšamin sanctuary grew up, throw some light on Hellenistic and 'independent' Palmyra. Culturally, the community was linked with both East and West, in roughly equal measure. From Mesopotamia, lamps, pottery, jewellery and toilet trays were imported. And the early tomb is of Mesopotamian type. From Antioch and the Syrian coast came further lamps, pottery, glassware, jewellery and coins. The extent to which small, domestic items were being imported argues that any local industry was not yet developed enough to fulfil these needs. Yet it existed at least as early as 100 B C, turning out domestic pottery of Near Eastern type together with imitations of Hellenistic lamps. As yet, the community was clearly able to support only minor art, and then not on a large scale. The first signs of change appear soon after the mid-first century B C. The earliest dated inscription from Palmyra, of 44 B C, is carved on a limestone block and surrounded by a mediocre 'interlacing' ornament; others soon followed. The existence of this inscription and its early successors presupposes that there were by now at Palmyra masons sufficiently well trained to execute such a piece and decorate it. And the inscription itself speaks of an individual's 'image'. Soon figured work began to appear; before the end of the first century B C a school of sculptors was active in the service of religion, and perhaps also in gravestone production. Thus work by artists on a major scale had begun. But no previous tradition of stone-carving had existed at Palmyra: so where had these artists learned their trade?

The Foundation T and associated sculptures offer clues. The style is of the Near Eastern family, expressed through stereotyped formulae; a glance eastwards shows it to be a branch of 'Parthian' art. The iconography, even amongst the earliest fragments, is strikingly composite in character; the motifs, studied collectively, can perhaps guide us to Palmyra's source within the Parthian cultural sphere. Signs of the ancient, and especially Assyrian, Near East in the 'snail' curls, animals and rosettes, hints of the Achaemenian heritage in the poses and fall of the draperies of profile figures, the total integration of Greek

4

and Parthian costume and architectural ornament – this remarkable amalgamation is so complete that it must have taken place, somewhere, long before Palmyrene art came into existence. The only area where all these cultures had flourished in turn and could have mixed was the land between the Tigris and the Euphrates, Mesopotamia. This area agrees perfectly with the origin of much of the material from the tomb by the Ba'alšamin sanctuary, and its southern region, Babylonia, with the destination of countless Palmyrene mer-

1 chant caravans. And Babylonia, host to the old Greek capital of Seleucia and to Parthian Ctesiphon, would seem an ideal cultural crucible.[718]

Other centres of 'Parthian' production – notably Dura-Europos and Hatra – offer more evidence, from the early first and from the second century onwards respectively. They reveal similar amalgamations of similar repertoires, which have much in common with that of Palmyra. Could it imply that they were all being influenced by one and the same centre, located perhaps in Babylonia? The repertoires, however, do not coincide so closely as to make this immediately certain. To be sure of it, signs of fresh artistic impulses in iconography or style occurring more or less contemporaneously at each centre would need to be perceptible. This is a problem which demands further probing beyond our present scope. Suffice it to say here that the existence of this one central point of influence, which is sometimes taken rather for granted, remains far from proven.[719]

Confirmation or otherwise of the impression that the role of Babylonia was significant obviously rests on what we can learn of the area under Parthian rule. Unfortunately, Babylonia has as yet produced comparatively little material from this period. It consists primarily of figurines of Greek and 'Parthian' style, some pottery, and brick-and-stucco architecture. A similar dearth afflicts northern Mesopotamia, apart from Hatra (and Dura-Europos); and Iran hardly offers more.[720]

Nevertheless, the internal evidence of early Palmyrene art suggests a generally Mesopotamian origin, and trade connections imply, more precisely, Babylonia. Perhaps the Palmyrene artists were actually trained in a centre closer to home; but the ultimate Mesopotamian source seems clear enough. From this source the Greek motifs present in the earliest Palmyrene sculptures arrived, already intermingled with others. From it, perhaps, came frontality, although the surviving, securely datable monuments mark a different trail, leading eastwards from Palmyra to Dura-Europos, and so to western Parthia.

The first preoccupation of the Palmyrene sculptors was religion. Probably by the turn of our era they were building divine statues from sections of

7, 9-16 carved limestone joined by plaster, producing special niches, with divine busts, figures and attributes, and scenes of offering for the mud-brick sanctuary walls, and surrounding niches and inscriptions with varied architectural ornament. They were also erecting 'images' – perhaps statues or reliefs – of those who served their gods well. By the early first century AD they were extending their

67, 36 repertoire into free-standing gravestones with curving tops. The sculptors worked on a small scale, in soft limestone; their techniques were somewhat hesitant, and workmanship mediocre. As throughout Palmyrene art, sculpture was picked out with colouring. In this early period many reflections of the more ancient Near East are visible. Both the style and the repertoire of art

forms and motifs, as we have seen, betray a wholly Near Eastern outlook and connections. But two primordial differences separate this from earlier Near Eastern work: the incorporation of numerous figures and motifs of Greek origin, and the rise of frontality.

On to this quiet scene exploded the gigantic temple of Bel. No other comparable undertaking was ever even attempted at Palmyra. It was built throughout in hard limestone, whereas before, soft limestone had been the only kind in use. Its immense size, its obvious costliness and the Roman and Romanized sculptures associated with it suggest that outside, Roman, funds underpinned its financing, and that consequently it represented a political gesture by the Roman government of Tiberius. Both architecture and decoration were quite unlike anything known hitherto at Palmyra. The architecture introduced to the growing city a host of forms of eastern Hellenistic type, which had originated in Alexandria and Asia Minor and which henceforth rapidly ousted the mixed, 'Parthian' repertoire of earlier and contemporary work. Its plan and column capitals finished in bronze were seemingly unique at Palmyra, while the use of the Ionic order and of fluting remained rare.[721] The figured decoration is equally novel, but tells a different, and more complex, story. The scale of relief is grand, and its positioning on ceilings and peristyle beams new. The techniques, throughout, are unusual, being sophisticated and well adapted to the hard stone. A variable quality of workmanship, however, betrays that many different hands, perhaps including masters and pupils, took part. The style veers from an almost Hellenistic Greek depth of cutting and sense of modelling, most visible on the north thalamos ceiling and peristyle beam soffits, to the low relief traditional in the Near East and at Palmyra. The scenes introduce further unexpected factors. Some have a surprisingly Greek content, like the zodiac and most of the busts of the north thalamos ceiling, and the 'inhabited scrolls' of the beam soffits. And the motifs even of the 'local' scenes include a striking number of Hellenisms unknown before; some of these, such as the moulded cuirass and the foot position with one foot frontal and one turned to the side, were influential and long-lasting. Other singularities can be found. The only sculptural uses of vertical perspective at Palmyra occur here. The 'Battle', 'Handshake' and 'Procession' scenes are all of a complexity, and include unique elements, never seen again. Moreover, no overall plan is immediately discernible in the arrangement of the peristyle scenes: their placing seems haphazard, as if the priesthood were not in proper control. And, finally, the three men known definitely to have worked on the temple bore Greek names, whereas all other recorded artists' names are Palmyrene. One of these Palmyrenes, Ḥairan the temple decorator, was honoured by the priests of Bel with a statue in AD 56, perhaps for directing some part of the Bel temple decoration for a time; but his role is obscure.[722]

What are we to make of this? From every viewpoint, the temple seems an intruder. It is of a size, splendour and sophistication inconceivable in the context of known earlier and contemporaneous Palmyrene work. This implies that the main artistic direction, and doubtless many if not most of the masons and artisans employed, came from outside. One extraordinary detail lends weight to this impression: the moon, personified correctly throughout most of the reliefs as the Palmyrene and masculine 'Aglibôl, is represented on the north

2, 4

13

18, 21
18

17, 19, 20

14–17

15
19, 20

21
18

thalamos ceiling as the Greek, and female, Selene. Could any local artist have committed such a signal blunder? Surely some outsider, in closer contact with Greek beliefs and lacking guidance at Palmyra, must have been responsible. It is unlikely that the priests of Bel, if properly in control, would have allowed such a misrepresentation. If outsiders did indeed organize the work, where were they from? The handling of the hard limestone is confident, implying long familiarity with the material. The comparatively orthodox Western architectural forms indicate a centre in very close touch with the West, and especially with Antioch. But the style of the figured decoration, by contrast, is essentially 'Parthian', although at times tending strongly towards Hellenism. What of the artists' vocabulary? The Greek content we have noted: some items, such

18 as the 'inhabited scrolls', must have been taken directly from Western pattern-books; others, like the foot positions, are integrated with 'Parthian' figures. But the 'Parthian' repertoire predominates, with frontal figures, scenes of offering and so on. A Syrian bias makes itself felt in the form and decoration of the temple thalamoi, in the veiled Aphrodite/Venus bust, in the subject of the 'Battle' scene and in such items of dress as the cuirass for deities and the broad, priestly waistband. There are also subjects and items of local significance, such

19, 20 as the 'Handshake' and 'Procession' scenes and the priestly modius, over which
14 an outside artist would have needed guidance. If numerous outsiders were indeed involved in this commission, they were doubtless recruited at the nearest possible centre or centres. If from one centre, this was surely situated on the borderlands between Greek and Parthian culture, where Greek architecture and Parthian art rubbed shoulders. Even if, let us say, the architectural masons were drawn from one source and the sculptors from another, the latter, to judge by the range of techniques and motifs they used, must still have come from the Hellenized borderlands of Parthian culture. Can we narrow this down still further? A dearth of material frustrates enquiry. But a cultural borderland, Syrian bias and technical and religious expertise, combined, point to a flourishing religious centre none too distant from Palmyra, and linked by an easy route. Such a centre, for instance, as the Holy City, Hierapolis/Bambyce (Membidj), of northern Syria, where the sculptures, although scanty, are akin to the Palmyrene. From here the patrons – whether the Roman government or the Palmyrenes themselves – could have imported the necessary craftsmen, for the duration of the work.[723]

The construction of the temple of Bel must have required an army of skilled workmen. If our theory is correct, many of these would have left on its completion. The variations in the quality of workmanship might mean that the visiting master-sculptors, if such existed, were training local pupils. Those who assign the temple wholly to local craftsmen must explain what these artisans were doing before its erection, how their standards so suddenly improved, and what they did afterwards.

Whatever the actual explanation, although no more work on this scale was attempted, quality and confidence seem now to have radiated outwards into the Palmyrene workshops. The years from *c.* AD 25 to 50 appear to have witnessed some interesting production. Besides that of Bel, the sanctuaries of

Cf. 21 Ba'alšamin and Nebû were also receiving attention. Some religious and honorific statuary, now gone, was required for them. The religious niche developed.

Some unattached reliefs, like the seated 'Ba'alšamin' stele, and a solar bust and 16, 23
figure from Nebû's precinct, possibly once formed part of such ensembles.
And the splendid eagle niche-lintel, above all, illustrates this growing sophistica- 12
tion. One important problem, however, remains: had the independent religious
relief yet emerged?

In this era funerary art, too, was growing in stature. Perhaps it was now that
the little gravestones began to have full-length human figures included in their 67, 68
designs, and tomb 19 received its painted ceiling. The funerary statue appeared; 47
so did the large banquet relief, possibly in AD 33, certainly by AD 40. The form 37, 39
of the relief, Greek on arrival, was rapidly translated into Palmyrene termi-
nology. As yet it was used mostly to accompany tomb foundation texts.

The mid-first century proved a landmark. Thereafter, the religious niche,
of oriental origin, declined. Hard limestone increasingly ousted soft. Perhaps
the independent religious relief grew more popular; certainly, both deities 27–46
and worshippers were now shown together, participating in the ritual of sacri-
fice. And Western influence became important. Depth of relief increased.
Standing, frontal figures were regularly shown with one foot turned forwards,
and one to the side, instead of generally with both pointing forwards. The 'halo'
hairstyle for men was abandoned for the short, Greek cut. The 'Ištar' relief 38
quotes some startlingly Hellenistic figures, background items and (Romanized)
ornaments. The series of tesserae was under way, and figures and scenes decorated 48–51
limestone altars. And, in the funerary sphere, the relief bust arrived – probably
from a Roman source. Other contemporary signs of Roman influence, small
but significant, such as the trilingual texts of AD 52, 58 and 74 and the Roman
tabula ansata ornaments of 52 and 74, imply the presence of Romans – surely
a detachment from the Roman army. The Palmyrene artists adapted the Roman
relief bust to their own needs, and rendered it through their own formulae.
Concomitantly, the little stele with full-length figure(s) was taken into the
tomb, where it soon became rectangular. Its subject matter now included
children. The newly vertical internal tomb chamber walls allowed such lavish
stone burial sealings. In AD 83 Iamlikû took Westernization a stage further by 113
decorating the ground-floor ceiling of his funerary tower with eagles, Erotes
and combats. Honorific statuary multiplied, as inscriptions record; but much
of it was erected on column consoles, an idiosyncrasy of the Syrian area. Minor
arts flourished, especially pottery.

The years c. AD 90–150 saw further quiet developments. Hard limestone was
generally preferred to soft. The divine statue virtually disappeared, apart from 11
the winged Victory type. The religious wall-niche declined, although a new,
curving thalamos was included in Malê's Romanized temple. The divine relief
bust lost its popularity. The gods' 'strip' cuirass was gradually replaced by 5
Hellenistic kinds. An armed, Western Athena figure supplanted the earlier
civilian representation of Allat. The independent relief continued; so did the 39
custom of honouring the pious with statuary, and the first actual surviving 122
examples, found in the Ba'alšamin sanctuary, are of this period. The little
funerary stele was now mostly used inside the tomb, where it was normally 71–5
rectangular, and shaftless. The subjects were men, women or children. Curtains
and palm alone disappeared, and women and girls were shown sitting. The
relief busts, normally reserved for men and women only, were now usually

64, 77–93 depicted with attributes in the hands, especially the schedula, leaf and sword-hilt for men, the alabastron and bowl for priests, and the spindle and distaff, child and loop of drapery for women. Women also now wore more elaborate hair-styles and ornaments, including a trapezoidal brooch of Syrian design. Behind
83 the busts sometimes appeared the diminutive figures of standing children, as in the Danubian Roman provinces; if a link exists here, it could again have been
84, 97, 100 through the army. The surrounding medallion developed. The banquet relief now became a commonplace of the tomb interior, usually closing off burial
62, 98–108 compartments; the space between the bed legs was often filled with busts. Honorific statuary continued: the Tariff Law, dated AD 137, set a rate for incom-
121–5 ing bronzes which doubtless supplemented local work. Parthian dress was
38 updated: the old decorative stripes for leggings vanished, and a coat appeared.
54 The tesserae seem to have lagged behind, having a tendency to preserve such motifs as the divine bust, profile view and reclining pose with both legs stretched out straight after they had become unfashionable or been abandoned in major art. In much of the development a certain moving away from older Near Eastern and Syrian ideas towards those of the contemporary Roman and Par-thian worlds seems perceptible. But the Palmyrenes were capable of their own
66, 98 interpretations. They adapted the funerary stelae, they placed the wreath round the priest's cap, and created remarkable patterning of drapery.

Changes far more marked than hitherto, however, characterized the next half-century, c. AD 150–200, which was a period of Westernization in style, genre and motif. Palmyrene style took a turn towards realism and modelling. The importation of such art forms as the carved stone sarcophagus, the painted tomb exedra and even, possibly, 'apartment' sculpture was due to Western influence, like the increased attention paid to secular forms – honorific and decorative sculpture and the like. And a wave of Western motifs invaded the
31, 34 artists' repertoire. New figures arrived, like Nemesis and Priapus, or the
79–81 seated and toga types for honorific statues. New fashions for mortals, such as luxuriant hairstyles and the frequent adoption of the beard, aped those of the Roman capital, if a little belatedly. Strict frontality could be tempered in funerary relief by turnings of the head and of the seated woman in banquet scenes. The increased realism affected, most noticeably, the rendering of the eye: its great size was reduced, and the pupil was usually drilled, to conform
41 with Roman practice. Costume was also Westernized: the gods' cuirass took
123 on the new, Romanized form, men sometimes wore the laurel wreath, and women the Greek chiton instead of the long-sleeved Eastern tunic. The trend
77 was the same in jewellery. The old 'ear-covers' had vanished completely by c. AD 125, the Syrian trapezoidal brooch faded into obscurity; a Roman emphasis prevailed, seen in a wide range of types and in the rising popularity of the finger-ring. Many sculptors learned new techniques from their east Mediterranean colleagues: they used the drill much more, even daringly, and
89 sometimes seem to have smoothed their final work with abrasives. But this is far from being the whole story. The contemporary Parthian world continued to supply motifs. The old, cumbersome leggings vanished for good, to reveal
62, 102 the decorated trousers beneath; the tunic was modernized in shape, and acquired a central stripe. The tripartite hairstyle was introduced for men, and 'head chains' for women. At the same time, the Palmyrene artists could still interpret

these ideas in their own way. They renounced much of the older decorative patterning of drapery, to concentrate instead on newer, more 'broken' patterns a little closer to realism; they abandoned many funerary attributes to attend to poses. They attached honorific relief figures to architecture. And the treatment of the sarcophagus was decidedly idiosyncratic. But most important of all, the innovations, although so numerous, were never more than superficial, and never affected the artists' fundamental ways of thought.

 In the final period of Palmyrene production, *c.* A D 200–73, the artists continued the trends of the late second century, but with some differences of emphasis, and signs of retrenchment. Quality of craftsmanship declined. The religious niche and divine statue seem to have disappeared wholly, leaving only the independent relief, the altar and the tessera as flourishing religious genres. In funerary art the little stele, long in decline, was rarely used, the statue not at all. Even among the relief busts the range of poses, attributes and motifs commonly reproduced had noticeably diminished. But funerary painting and plasterwork lived on. And the funerary banquet enjoyed a boom. It flourished independently, not only as the old, large relief but also as a newly devised small one. It flourished also, in its larger form, as an arrangement of three reliefs, the triclinium, around the walls of a funerary chamber. Sarcophagi were also still carved, and placed singly or again to form a triclinium in the tomb. The honorific statue lived on. Thus those art forms which survived in this era were the ones inspired by, and doubtless mostly imported from, the West. This, too, was the era of the Odysseus and Cassiopeia mosaics, laid by artisans probably from the Antioch area. But motifs show continuing contacts with both West and East. Men's more realistic hairstyles, the predominance of beards and the 'gash' method of rendering all followed contemporary Rome. So did the women's hoop bracelets with their frequent amuletic pendants. Western, too, was the device whereby figures in a row alternately placed a different leg forward, so injecting rhythm into the composition. But Eastern contacts are also plain. Iranian dress continued to evolve; an open coat appeared. And beading recurred as architectural ornament. What is more, a slightly greater emphasis on oriental motifs developed, as compared with the extensive Romanization of the late second century. Parthian dress for men seems to have been proportionately more popular than hitherto; women preferred the oriental sleeved tunic to the chiton. The curious, short himation for servants, the women's bag-like cap and the woolly fringes that now sometimes ornamented sleeved tunics and cloaks were further Eastern traits. Evidently the Palmyrenes were beginning to strengthen their Eastern ties again, to reassert their oriental character and difference from their Roman political overlords. The full effects of such an attitude were to become all too clear in the events of 260–73.

 In short, the art of Palmyra emerged initially as a representative of the 'Parthian' group within the Near Eastern family; this its style indicates clearly. But the artists' motifs came from varied sources, principally three: the earlier Near East, oriental Hellenism and the contemporary world of Syria and western Parthia. The mingling of these streams had already been completed in an area where these cultures had successively flourished, probably Mesopotamia, by the time the first Palmyrene artists learned their trade. Perhaps these artists were trained in Mesopotamia, or somewhere else nearer home; wherever it was, it

102, 104

75

81, 82

62, 100

58
102

138–41

81

102, 106

52, 107

106
90, 92

introduced into Palmyrene art an offshoot of this composite 'Parthian' style. But Palmyra also lay close to the hinterlands of Greek culture, in its latest, and increasingly Romanized, phase. Already by the time of the Bel temple a distinctly Hellenized 'Parthian' repertoire had appeared, apparently derived from a different centre close to the Greek world. And the century after the completion of the temple saw a further steady influx of Western ideas and motifs. 'Parthian' influence was correspondingly reduced, although the continuing evolution of 'Parthian' motifs shows that contact with Parthian culture was being maintained. But nothing really dramatic occurred until the latter half of the second century AD, when Western influence reached its peak. Oriental art forms had vanished or were in decline, while Western kinds flourished and increased. Even Palmyrene style, for a while, made some superficial concessions to Western modelling and naturalism. The impetus behind this lasted into the early third century. From where was this Western influence penetrating? Most came, surely, from the nearest important Western region with which Palmyra had official and commercial contact, the homeland of the third-century mosaicists, the area of Antioch and nearby coastal Syria. But sometimes forms and motifs, like the funerary relief bust and togate statue, seem to have penetrated from further west, doubtless often via the Roman army detachments long stationed in Palmyra. Finally, in the third century, the pendulum began to swing back. 'Parthian' style started to regain its full authority, and Iranian and local motifs proliferated once more.

The Palmyrene artists were of course reflecting the ways of thinking, trends and interests of (portions of) their own society. This society was fundamentally Semitic; and such Western influence as the Palmyrene artists succumbed to was only superficial. Their essential way of thought, the 'language' of their art, remained Near Eastern throughout, no matter how many motifs from other cultures had been picked out for use.[724] Their art was employed as an instrument, to express ideas, just as it was at the numerous other centres of 'Parthian' culture. The destruction of many of these centres such as Palmyra, Dura-Europos and Hatra during the third century and the replacement of 'Parthian' with a 'neo-Achaemenian' style by the Sasanian government cannot, however, have meant the total annihilation of 'Parthian' art. For its ideology, and much of its essential content, was to be reincarnated in the art of Byzantium. So other centres less well known to us now, such as Edessa, must have continued to produce works of art long enough to contribute towards the formation of Byzantine style. Thus the art of Palmyra takes its place in the evolution of Near Eastern and European culture. It forms one block in the bridge which served to carry over the artistic ideas of the ancient Near East into our era.

Classification of small funerary stelae

Stelae, both those that were free-standing and those which closed tomb loculi, fall naturally into three main groups according to content: the aniconic, those with non-figural relief and those with full-length human figures in relief. Chronologically, they span virtually the whole period of Palmyrene sculptural production. Within the typological and chronological frameworks, certain variables can be observed, and these have been taken into consideration for the classification offered here. The arrangement is classified by means of a combination of letters and numbers, grouped consecutively, to indicate divisions by period and type. As a prefix to distinguish the general sculptural type from others, the letters FS (Funerary Stele) could be used.

The abbreviations for museums will be found on p. 265.

Chronological periods

FS/Ar: early ('Archaic') period, from around the turn of our era to *c.* AD 50

FS/I: period of the first group of Palmyrene sculptures, *c.* AD 50–150

FS/II: period of the second group of Palmyrene sculptures, *c.* AD 150–200

FS/III: period of the third group of Palmyrene sculptures, *c.* AD 200–73

Variables found with all funerary stelae

C: rectangular in shape but curved, like an arch, at the top

R: fully rectangular in shape

a: complete absence of surrounding listel or 'frame'

f: with surrounding listel or 'frame'

p: with a projecting lower 'platform' or plinth provided as a support for any figure(s)

Additional variables found only in subdivision 3 (below)

1: with one figure only

2: with two figures

3: with three figures

4: with four figures

B: with boy

G: with girl

M: with man

W: with woman

(Note: these letters may be used to indicate each figure in the relief, reading from the spectator's left to the right; thus 3BWM would mean a relief with three figures, from the left a boy, woman and man, and plate 72, for example, would have the full classification FS/I 3b R*p* 4WBMW.)

Subdivisions

1 Aniconic stelae, with inscription only
 Periods and types: Ar: C*a*, C*f*
 I: C*a*, C*f*

 Museum: PM

2 Stelae with the representation in relief of an object or objects, but with no human figure or part of such a figure

 a with curtain hung by two pins, and two arching palm leaves
 Periods and types: Ar: C*f*
 I: C*f*

 Museum: PM

aa as **a**, but doubled, so that two cur-
tains hang side by side
Periods and types: Ar: C*f*
 I: C*f*
Museum: PM

b as **a**, but with several circular objects
placed just below and against the
arching palm leaves
Period and type: Ar: C*f*
Museum: PM

c with a wreath
Period and type: II: R*f*
Museums: PM, BM 104460

3 Stelae with relief representation incor-
porating a human figure or figures

a the standing figures is placed *behind*
a hanging curtain, appearing above
it from the chest upwards (rare)
Period and type: Ar: C*f*: 1M
Museum: PM

b one or more standing figures are
placed in front of a hanging curtain
Periods and types: Ar: C*f*: 1M
 1W

 I: C*f*:1M,
 1W(?); R*f*:
 1W; R*fp*: 1M;
 R*p*: 3WMW,
 4WBMW

 II: R*p*: 1M

Museums: mostly PM; DM; Lou;
NCG 1030; BAM 515

c the figure or figures are placed

seated in front of a hanging curtain
(rare)
Period and type: I: R*p*: 1G
Museum: DM

d the standing figure or figures are set
against a plain background (com-
mon)
Periods and types: Ar: C*f*: 1W;
 R(?):3BWM

 I: C*f*: 1B,
 2GW; C*fp*:
 1G; C*p*:
 3GMB; R*f*:
 1B, 1M;
 R*fp*: 1B,
 2BB, 2BG,
 2GM; R*p*:
 1B, 1G, 1M,
 1W, 2BG,
 2GW, 2WM,
 2WW

 II: R*f*: 1M;
 R*p*: 1B, 1G,
 1M, 2BB,
 2MB

 III: R*p*: 1B,
 1M(?), 2MM
Museums: mostly PM, DM; Lou;
NCG; BM; Istanbul

e the figure or figures are placed
seated in front of a plain background
Periods and types: I: R*p*: 1W;
 2WG
Museums: PM 2125/7223; Istanbul
3717

f the figure appears on horseback
(rare)
Period and type: Ar–I: C*p*: 1M
Museum: PM

Classification of funerary relief busts

A first attempt to group and subdivide the various types of funerary relief bust logically was made by H. Ingholt, *Studier over Palmyrensk Skulptur*, 1928. Since that date hundreds more busts have come to light; although many fit into his categories, others do not. A revised scheme is therefore offered here, based on that of Ingholt but adapted and extended to accommodate the newer discoveries, and meant to be almost indefinitely extensible, so as to take in the discoveries of the future.

The basic division into three groups on iconographical and chronological criteria (I: *c.* AD 50–150; II: *c.* AD 150–200; III: *c.* AD 200–73), based on the dated busts and reliefs, still holds good as a general guide. Many subdivisions have also stood the test of time, although some expansion and rearrangement has proved necessary.

Indications are given where leading examples of each type may be found. The abbreviations for museums will be found on p. 265; numbers in brackets prefixed by PS refer to Ingholt's catalogue.

Male busts

The most obviously classifiable motifs presented by the male busts consist of the arrangement of dress, and in particular the manner in which the cloak is worn. Also important are the objects held in the hand(s), how the eye is rendered, and whether the subject is bearded. Any classification must therefore take all these variables into account.

As most of the basic drapery arrangements last throughout the lifetime of more than one group, it might perhaps prove useful to establish separately and in advance of the chronological classification the whole range of variations so far known, and then to quote them later where they arise.

Arrangements of drapery

Himation

1 The himation covers the arms and most of the chest. It is worn like a sling: a bunch of folds falls vertically from the man's right shoulder, passes beneath his right wrist, and then goes diagonally up to and over his left shoulder. The tunic appears here and there beneath it Pl. 144

2 Himation as in 1, but with a patch of semicircular folds on and a little below one shoulder (dubious examples only)

3 Himation as in 1, but with a patch of semicircular folds on and a little below each shoulder

4 Himation as in 1, but with a patch of semicircular or arrow-head shaped folds on the subject's left side, over his chest Pl. 65

5 Himation as in 1, but with a patch of semicircular or arrow-head shaped folds on the subject's left side, over his chest, and another patch of similar folds on and a little below one shoulder (normally, his left)

6 Himation as in 1, but with a patch of semicircular or arrow-head shaped folds on the subject's left side, over his chest, and a patch of similar folds on and a little below each shoulder Pl. 70

Pls. 79, 81

7 The himation covers the arms and most of the chest; a bunch of folds goes diagonally across the chest from the man's right wrist up to and over his left shoulder, but the himation has 'slipped off' his right shoulder and covers only his right arm

Pl. 78

8 The himation covers the left portion of the man's chest and his left upper arm only. On his right side, the himation appears beneath his right elbow, and then the characteristic bunch of folds rises diagonally across his chest up to and over his left shoulder

9 The himation covers the arms and most of the chest. The characteristic bunches of folds fall vertically from each shoulder. A bunch of folds rises diagonally from the man's right wrist, but passes under the vertical folds that fall from his left shoulder

10 Himation as in 9, but on the subject's right it has 'slipped off' his shoulder and covers only his right arm

11 The himation does not cover the right arm at all. A bunch of folds falls vertically from the man's left shoulder, but on his right the himation appears beneath his right elbow; a bunch of folds rises diagonally from his right wrist and goes up towards his left shoulder, where it passes under the vertical bunch

Pl. 78

12 Himation as in 11, with the himation appearing beneath the man's right elbow and forearm, but from here it crosses his midriff horizontally, and disappears behind the left arm

13 The himation is so arranged that a bunch of folds falls vertically from the man's left shoulder, and another bunch crosses the top of his chest from his right shoulder; where this bunch meets the vertical folds, it passes beneath them

14 The himation does not cover either shoulder. It appears beneath the right elbow and crosses the chest to the left upper arm

Chlamys

15 Instead of the himation or long cloak, a shorter cloak or a Greek chlamys of varying form is worn, pinned on the man's right shoulder by a circular brooch — Pls. 66, 82

16 The short cloak or chlamys is pinned on the man's left shoulder — Pl. 145

Tunic

17 Tunic alone, without a cloak or coat over it — Pl. 78

Coat

18 With a coat over the tunic — Pl. 80

Often the length of tunic sleeve is visible, and so two further possible variables may be added to the above categories

A With long-sleeved tunic — Pl. 82
B With 'short'- or false-sleeved tunic — Pl. 66

Other variables

C A vest is worn, visible at the neck, above the tunic top
D The beard is rendered in the 'gashed', third-century manner — Pl. 81

Types of priestly cap or modius

a Plain
b Surrounded by a wreath, which has a rosette at the centre
c Surrounded by a wreath, which has a miniature bare-headed and beardless bust at the centre
d Surrounded by a wreath, which has a miniature bare-headed and bearded bust at the centre
e Surrounded by a wreath, which has a miniature priest's bust at the centre — Pls. 66, 98
f Surrounded by a wreath, which has an oval stone at the centre

GROUP I (c. AD 50–150)

Typically, the busts in this group are beardless. The eyes are often overlarge; pupils and rises are rendered by two engraved circles. The eyebrows are not indicated,

except as engraved, curving grooves. Both hands rest against the chest, and the left may hold a schedula, leaf, sword-hilt, ritual bowl or bird.

The costume consists of a tunic, more or less covered by a cloak (usually the himation, less often the smaller chlamys), and there is striking patterning of the drapery folds. A mannerism probably introduced in the late first century AD and especially popular till *c.* AD 150 consists of the addition of groups of little semicircular folds to the main fold arrangements. Drapery arrangements characteristic of this group include nos. 1–6, 9, 11–13 and 15. Particular arrangements of drapery are sometimes closely associated with other motifs, such as the holding of a sword-hilt (13) and the priest's cap or modius (15*A*).

Some of the busts have a raised 'frame' around them.

Subdivisions

Busts without the priestly headdress

A No object is held in either hand; no headdress

Pl. 70
 a The man rests both hands against his chest
Drapery: 2 (?), 4–6
Museums: PM; DM; Istanbul 3746 (PS 77)

 b The left hand is pressed against the chest, holding a bunch of himation folds in place; the right hand is omitted (rare)
Drapery: 11
Museum: Istanbul 3730 (PS 127)

B An object or attribute is held in the left hand only; no headdress

Pl. 76
 a A schedula (volumen) is held in the left hand (popular)
Drapery: 1, 4 (common), 5 (common), 6, 9
Museums: many in PM: 1783/6606, 1784/6607, 2000/7125, etc.; many in DM; BM 125036, 125038, 125040; Istanbul 3715, 3721, 3748, 3789, 3817, 3820; Lou 1194; NCG 1026, 1028, 1035, 1037–9, 1042, 1045, 1047, 1049–51, etc. (PS 4–6, 57, 59, 60, 64, 75–6, 79–82, 85–101, 103–7)

 b A leaf is held in the left hand (fairly common)
Drapery: 1, 3–7
Museums: PM 1975; DM; AUM 31.3; Istanbul 3792, 3809, 3839; Lou 5972; Met 01.25.4, etc. (PS 108–115)

 c The hilt of a sword is held in the left hand
Drapery: 3, 12, 13
Museums: PM; DM; etc. (PS 117)

 d A two-handled chiselled cup is held in the left hand
Drapery: 12
Private Collection (PS 121)

 e A writing tablet and schedula are held in the left hand
Drapery: 5 or 6
Museum: Istanbul 3824 (PS 84)

C An object or attribute is held in the right hand only; no headdress

 a A two-handled chiselled cup is held in the right hand (cf. Bd)
Drapery: 12
Museums: PM 1964/7056; Istanbul 3781 (PS 125)

D An object or attribute is held in each hand; no headdress

 a The right hand holds a vessel, the left a writing tablet with schedula
Drapery: ?
Museum: Istanbul 3824 (PS 84)

 b The right hand holds a schedula, the left a bird (rare)
Drapery: 15*A*
Museum: PM

 c The right hand holds a whip, the left the hilt of a sword (cf. Bc)
Drapery: 4, 15*A*
Museums: PM A 214, 1762/6586; Baalbek Museum (PS 116); Istanbul 3749 (PS 119)

E Armless busts without headdress
Drapery: 8, 11, 12, 15
Museums: PM 1938; DM; NCG
1044 (PS 126); private collection (?)
(PS 120)

F Beardless heads without headdress
Museums: widely scattered

G Fragments of ordinary busts

Busts of priests

H Busts of priests with no object in either
hand (no examples known)

J Busts representing priests, who wear the
sacerdotal cap or modius, with an object
or attribute in the left hand only

a A schedula is held in the left hand
Drapery: 4
Museums: DM C.26 (PS 141);
LHO (PS 140)

b A schedula and leaf are both held in
the left hand
Drapery: 1, 2 (?)
Museums: DM C.39 (PS 143) etc.;
NCG 1032 (PS 142)

c A two-handled cup or bowl is held
in the left hand
Drapery: 15
Museums: PM 1780/6603, etc.;
AUM (PS 152), etc. (PS 153, 153A)

K Busts representing priests with an object
or attribute in the right hand only (no
examples known)

L Busts representing priests, who wear
the sacerdotal cap or modius, with an
object or attribute in each hand

Pl. 66 a The right hand holds an alabastron,
and the left a bowl full of small pearl-
like grains (common)
Drapery: 15B
Museums: PM CD91.61, 1755/
6579; DM; BM 125033; Istanbul
3716; Lou 4085-6; NCG 1031;
Toronto, R.O.M.A. 425, etc. (PS
144-51)

M Armless busts of priests, wearing the
sacerdotal cap or modius
Drapery: 15B
Museums: DM; Saint Louis (Mis-
souri) City Art Museum (PS 7)

N Heads of priests, wearing the sacerdotal
cap or modius
Subdivisions: a–e (above, p. 246)
Museums: widely scattered (PS
154-160A)

O Fragments of busts of priests

GROUP II (c. AD 150–200)

Beards now become common, and the
bearded slightly outnumber the beardless.
Hair tends towards greater length and
thickness. Priests, however, remain beard-
less.

The eye is shown differently: the two
concentric circles of group I soon give way
to a single engraved circle, which marks the
iris, often supplemented by a single drill-
hole for the pupil; or else the eyes are left
blank. Eyebrows are often plastically
rendered.

The highly patterned semicircular fold
arrangements 2, 3, 5 and 6 fall into disuse;
instead, the sculptors play with rearrange-
ments of the himation itself, producing
variations on older themes (7 on 11, and 10
on 9) and newer modes (8, 14). Occasionally
the cloak is discarded altogether (17, 18).
Patterning as a whole declines somewhat;
drapery becomes looser and slightly more
naturalistic. Semicircular folds may appear
where the himation covers the left arm. On
the tunic a stripe may be shown.

Most commonly the subject holds in his
left hand a schedula or leaf; sometimes he
may wear a wreath. A modius or wreath
may appear in relief beside a bearded bust.
Raised 'frames' around the bust survive on
a few transitional pieces which show other
earlier characteristics also, but then dis-
appear.

Subdivisions

Beardless busts without the priestly head-
dress

A Beardless busts with nothing in either hand

 a The man rests both hands against his chest
 Drapery: 1 (?), 7–10
 Museums: PM B700, 1760/6584, 1948/7040, 1953/7045; AUM 2516

 b The left hand is omitted
 Drapery: 9
 Museum: Portland, Oregon, Art Museum

B Beardless busts with an object or attribute held in the left hand only

Pl. 80

 a A schedula is held in the left hand (popular)
 Drapery: 1 (common), 3, 4 (common), 5, 7, 9 (common), 10, 11, 18
 Museums: many in PM; DM; Istanbul 3744, 3747, 3790, 3793, 3837–8; LHO 34; Lou 2201; Met 02.29.4, 98.19.4; NCG 1027, 1052, etc. (PS 10, 161–76)

 b A leaf is held in the left hand (popular)
 Drapery: 1, 4, 7, 9–11, 14
 Museums: mostly PM; DM; AUB 2733; BM 125156; Istanbul 3782; NCG 1040, etc. (PS 15, 177, 179, 181–2)

 c A leaf is held in the left hand, while a loop of drapery is pressed against the left side of the chest by the left elbow (rare: cf. Mb)
 Drapery: 9
 Museum: BM 125022 (PS 180)

 d The hilt of a sword is held in the left hand (rare)
 Drapery: 13
 Museum: PM 1746

 e A tablet is held in the left hand (rare)
 Drapery: 1 (?)
 Museum: PM A352

 f A pine-cone (?) is held in the left hand (rare: cf. III Bf)
 Drapery: 18
 Museum: NCG 1153

 g A chiselled bowl is held in the left hand (rare)

 Drapery: 17 (A?)
 Museum: Met 01.25.5 (PS 187)

 h An alabastron and bowl are held together in the left hand (rare)
 Drapery: 4
 Museum: PM 1972

C Beardless busts with an object or attribute held in the right hand only (no examples known)

D Beardless busts with an object or attribute in each hand

 a Right hand holds two keys (?), and the left an alabastron and bowl, together (rare: cf. Bh)
 Drapery: 12B
 Museum: ? (PS 213)

 b Right hand holds a writing tablet, and the left a bird (rare)
 Drapery: 17
 Museum: PM

E Armless, beardless busts Pl. 78
 Drapery: 8, 11, 12B, 17
 Museums: DM C.28; BM 125017; Istanbul 3722, 3795, etc. (PS 184–6, 188–9)

F Detached beardless heads without the priestly headdress
 Museums: PM; DM; BM 125026 (PS 233); NCG; Philadelphia Museum, etc.

G Fragments of ordinary busts
 Museums: mostly PM

Busts of priests, who wear the sacerdotal cap or modius

H Busts of priests, who wear the sacerdotal cap or modius, with nothing in either hand (no examples known)

J Busts of priests, who wear the sacerdotal cap or modius, with an object or attribute in the left hand only

 a A schedula is held in the left hand
 Drapery: 4, 9, 10
 Museums: PM; AUM 2501; BM 125020; Lou 2199, 2002, 6211, etc. (PS 244A–8)

Pl. 79 b A schedula is held in the left hand, while a loop of drapery is pressed against the left side of the chest by the left elbow (rare: cf. Bc)
Drapery: 9
Museum: ?

Pl. 65 c An alabastron with a small round bowl above it full of small pearl-like grains are held together in the left hand
Drapery: 10
Museum: BM 125202

K Busts of priests, who wear the sacerdotal cap or modius, with an object or attribute in the right hand only

 a A leaf is held in the right hand
Drapery: 12A, 15A
Museums: PM; Lou 2200, etc. (PS 12, 14, 254)

L Busts of priests, who wear the sacerdotal cap or modius, with an object or attribute in each hand

 a The right hand holds an alabastron, and the left a bowl full of small pearl-like grains
Drapery: 15B
Museums: PM; BM 125201; Lou 2069, 2202; private collections (PS 250-1, 253)

M Armless busts of priests (no examples of single, independent busts known, only grouped, on banquet relief bases)

N Detached heads of priests, who wear the sacerdotal cap or modius
Subdivisions: b–e (see p. 246)
Museums: mostly PM; Lou 20124, etc.

O Fragments of busts of priests
Museums: mostly PM

Bearded busts

P Bearded busts with nothing in either hand

 a The man rests both hands against his chest (cf. Aa)

Drapery: 1, 9–11
Museums: PM 1955/7047, 1961/7053; AUM 2752; Lou 2068, 22.254, etc.; NCG; etc. (PS 17, 229–32)

 b One arm rests against the chest, and the other on the shoulder of a companion (rare; possibly in fact group III P)
Drapery: 12
Museum: Portland, Oregon, Art Museum

Q Bearded busts with an object or attribute held in the left hand only

 a A schedula is held in the left hand (popular)
Drapery: 1 (common), 4 (fairly common), 7, 9 (common), 12
Museums: PM; DM; AUM 2732, 2736–7, 2747; BM 125031–2, 125046; Istanbul 3821, 3840; Met 98.19.1–2, 01.25.2; NCG 1046, 1146, 2833, etc. (PS 9, 11, 18, 164, 190–205, 207–12, 214–16, 218)

 b A leaf is held in the left hand (popular) Pl. 79
Drapery: 1, 4, 6, 9, 10, 12
Museums: DM; AUM 2745; Istanbul 3822; Lou 2398; Met 02.29.4; etc. (PS 16, 217, 219–26)

 c The hilt of a sword is held in the left hand Pl. 65
Drapery: 4, 9, 13A, 17
Museums: PM 1991/7116; DM; AUM 33.12; Baalbek Museum (PS 118)

R Bearded busts with an object or attribute held in the right hand only

 a A whip is held in the right hand (rare)
Drapery: 15B
Private collection (PS 228)

S Bearded busts with an object or attribute held in each hand

 a The right hand holds a whip, and the left the hilt of a sword (cf. I Dc) Pl. 14
Drapery: 11A, 13A, 16A

Museums: PM; DM; Istanbul 3714; Lou 14924; NCG 1027 (PS 168, 227)

b The right hand holds a stylus, and the left a schedula (rare)
Drapery: 15A
Museums: PM CD 50.63; LHO 33 (PS 19)

T Armless, bearded busts (no independent examples known)

U Detached bearded heads

a Bare-headed
Museums: PM; DM C.18; BM 125030; Istanbul; NCG 1114, etc. (PS 234–40)

b With wreath
Museums: DM (PS 236); Istanbul 3804 (PS 242); NCG 1121 (PS 241)

c With special headdress (if not III Uc)
Museum: PM 213

GROUP III (c. AD 200–73)

Most men now wear the beard. This may be fairly luxuriant, as in group II examples, but a certain number are rendered in a new way, with short strokes or gashes on a raised ground. As in group II, hair varies from short to abundant.

Within the eye we find either a single engraved circle, a circle with a single drill-hole within it to mark both iris and pupil, or a blank eye. Or again, the whole eye may be left blank and the lower lid omitted completely. The plastic rendering of eyebrows largely disappears, replaced by a reversion to the curved groove characteristic of group I.

The number of drapery arrangements employed is reduced, only four being in common use (1, 7, 9 and 10). The folds tend to be a little slapdash; the himation folds over the subject's left arm are mostly either roughly semicircular, or else each one is shortened so that it does not reach completely from one side of the arm to the other.

Something new is placed in the left hand: a looped fold of the himation; but this and

the schedula are the only two attributes now commonly held. The tunic stripe and wreath on the head are still sometimes seen. Priests, still beardless, appear to have given up holding their ritual jug and bowl, and prefer the schedula, leaf and drapery fold common among the laity.

Subdivisions

Beardless busts without the priestly headdress

A Beardless busts with nothing in either hand

a The man rests both hands against his chest
Drapery: 10
Museum: NCG 1048

B Beardless busts with an object or attribute held in the left hand only

a A schedula is held in the left hand
Drapery: 1, 9
Museums: PM 1122; DM C.2148

b A leaf is held in the left hand
Drapery: 1, 10 (?)
Museum: Istanbul, 3805; Portland, Oregon, Art Museum (?)

c A looped fold of the himation is held in the left hand
Drapery: 1, 9, 10
Museums: PM; Istanbul 3783, 3823; Lou 5972B, etc. (PS 23, 27, 68, 255–9)

d A bird is held in the left hand (rare)
Drapery: 7
Museum: PM (?)

e A tablet is held in the left hand (rare)
Drapery: 1
Private collection (PS 261)

f A pine cone (?) is held in the left hand (rare: cf. II Bf) Pl. 94
Drapery: 18
Museum: NCG 1153 (PS 452)

C Beardless busts with an object in the right hand only (no examples known)

D Beardless busts with an object held (or action performed) by each hand

Pl. 82 a The right hand holds a stylus, and the left a tablet-like object (rare)
Drapery: 15*A*
Museum: Lou 18.174

 b A looped fold of the himation is held in the left hand, while the right hand is turned palm-forwards (rare)
Drapery: 10
Museum: Petit musée des Pères Blancs, Jerusalem (PS 183)

E Armless, beardless busts (no independent examples known; only on banquet relief bases)

F Detached beardless heads without the priestly headdress

 a Bare-headed
Museums: PM; AUM 2755; BM 105059; Lou 6213; NCG; etc.

 b With wreath
Museum: NCG 1111, 1118

 c With special headdress
Museum: NCG 1097

G Fragments of ordinary busts
Museums: mostly PM

Busts of priests, who wear the sacerdotal cap or modius

H Busts of priests, who wear the sacerdotal cap or modius, with nothing in either hand
Drapery: 9
Museums: BAM (PS 306); NCG 1034 (PS 305)

J Busts of priests, who wear the sacerdotal cap or modius, with an object or attribute held in the left hand only

 a A schedula is held in the left hand
Drapery: 1
Museums: DM C.22, etc. (PS 24, 301)

 b A leaf is held in the left hand (rare)
Drapery: 7
Museum: NCG 1033 (PS 302)

 c A looped fold of the himation is held in the left hand (rare)

Drapery: 9
Private collection (PS 304)

K Busts of priests with an object in the right hand only (no examples known)

L Busts of priests with an object in each hand (no examples known)

M Armless busts of priests, who wear the sacerdotal cap or modius
Drapery: 15
Museums: Istanbul 3787 (PS 316), etc.

N Detached heads of priests, who wear the sacerdotal cap or modius
Subdivisions: *b* to *f* (see p. 246)
Museums: Istanbul; Lou 2065, 5000, 5003; NCG 1101, 1108, 1112, 1116–17, 1122–4, 1162, etc. (PS 308–28)

O Fragments of busts of priests
Museum: PM

Bearded busts

P Bearded busts with nothing in either hand

 a The man rests both hands against his chest (rare)
Drapery: 9
Museum: Muzeum Narodowym, Warsaw (PS 21)

 b One arm rests against the chest, the other on a companion's shoulder (rare)
Drapery: 12
Museum: Portland, Oregon, Art Museum

 c The left arm is omitted altogether (rare) Pl. 144
Drapery: 1
Museum: Lou 1556

Q Bearded busts with an object or attribute held in the left hand only

 a A schedula is held in the left hand (popular)
Drapery: 1 (common), 7, 9 (?), 10

Museums: PM; DM C.18–19, C.21, etc.; AUM 2735, 2754; Istanbul 3841; Lou 5005; etc. (PS 28–9, 206, 265, 295–300)

b A leaf is held in the left hand (no examples known)

l. 81 c A looped fold of the himation is held in the left hand (very popular)
Drapery: 1 (common), 4, 7, 9, 10
Museums: PM; DM C.2, etc.; AUM 2742, 2748, 32.25; BM 125047, 125346; Istanbul 3743, 3745, 3758, 3796, 3808; Met 01.25.3, 98.19.3; NCG 1036, 1041, 1043, 2775, etc. (PS 20, 25–6, 264, 266–74, 276–87, 289–94)

R Bearded busts with an object held in the right hand only (no examples known)

S Bearded busts with an object or attribute held in each hand

a The right hand holds a whip, and the left, the hilt of a sword (rare)
Drapery: 15
Museum: Istanbul 3823 (PS 259)

b The right hand holds a whip, and the left a schedula (rare)
Drapery: 15
Museum: Petit musée des Pères Blancs, Jerusalem (PS 183)

c The right hand holds a long stick or goad, and the left, the hilt of a sword (rare)
Drapery: 15A
Museum: NCG C 24

d The right hand holds a jug, the left, a looped fold of the himation (rare)
Drapery: 8
Museum: PM CD 89.61

T Armless, bearded busts
Drapery: 11, 15
Museums: FMC; KMV 1523 (PS 70)

U Detached, bearded heads
a Bare-headed
Museums: mostly PM; Lou A.R.21; NCG 1094, 1105, 1114, etc.

b With wreath (no examples known)
c With special headdress
Museums: PM 457/1660, CD 134.62 = 2186/7670

Female busts

The logical classification of the female relief busts presents special difficulties because of the large number of variables, in pose, costume, object held and types of jewellery. An attempt is made below, based on Ingholt's study, to pick out the more significant motifs, and to categorize them.

As with the male busts, the arrangements of drapery greatly engaged the sculptors' attention, and frequently lasted throughout the lifetime of more than one group. These, therefore, will be established in advance of the chronological classification. The same is true of jewellery accessories, which will be similarly treated here.

Arrangements of drapery

The veil falls vertically from each shoulder

1 The veil descends vertically from each shoulder to the wrist, covering each arm to the wrist. Folds range from the vertical to diagonal in direction. They are arranged in parallel or nearly parallel lines Pl. 76

2 As 1, but with a patch of semicircular folds introduced on the woman's left shoulder

3 As 1, but with a patch of semicircular folds introduced on the woman's right shoulder

4 As 1, but with a patch of semicircular or arrow-head shaped folds introduced on each shoulder, descending a little from it

The veil falls vertically from the left shoulder only

5 As 1, but the veil on the subject's right has been slipped back a little so as to expose the right forearm Pl. 83

6 As 5, but with a patch of semicircular or arrow-head-shaped folds introduced Pl. 86

on the woman's left shoulder, and descending a little from it

Pl. 64 7 As 5, but with a patch of semicircular or arrow-head-shaped folds introduced on the woman's right shoulder, and descending a little from it

8 As 5, but with a patch of semicircular or arrow-head-shaped folds introduced on each shoulder, and descending a little from each

9 As 1, but the veil has been slipped back sufficiently far on the woman's right to expose the right forearm and upper arm, although it still covers the woman's right shoulder

10 As 9, but with a patch of semicircular or arrow-head-shaped folds on, and descending from, the woman's left shoulder

11 The veil falls vertically from the left shoulder. On the right, it has been slipped entirely behind the shoulder. Folds vary from vertical to diagonal

Pl. 63 12 As 11, but with a patch of semicircular or arrow-head-shaped folds on and below her left shoulder

Variations on 5–12

13 On the woman's left, the veil falls almost vertically, but it has been slipped back towards her left elbow so as to expose her left forearm; on the right, it has been slipped back so as to expose her right forearm

14 As 5, but the woman's right hand pulls the left hand side of the veil across the chest towards the right

Pl. 87 15 The two sides of the veil are held together by the woman's right hand over the centre of the chest

Pls. 84, 94 16 The veil falls vertically from the right shoulder, curves round immediately over the top of her chest below her neck, and so up to the left shoulder, behind which it disappears

17 The veil falls vertically from the woman's right shoulder down to her right wrist, and then passes up to and over her left shoulder, behind which it disappears

18 The veil falls more or less vertically from the right shoulder. On her left, however, it has been pushed back so as to expose her left forearm

19 As 18, but with one or more patches of semicircular or arrow-head-shaped folds on and below the shoulder(s)

The woman's left forearm is exposed

20 The veil falls almost vertically from her right shoulder, but it falls to her right elbow, exposing her right forearm. On the left, however, it has been pushed back so as to expose her left forearm

21 The veil on her right just covers her right shoulder and upper arm; on the left it has been slipped back so as to expose the left forearm Pls. 8 92

22 On her right, the veil is thrown back so that it does not cover any of the right shoulder; on her left, it is slipped back so as to expose the left forearm Pl. 6

23 The left forearm is exposed; the left hand pulls the veil across the upper part of her chest from her right

24 The woman's left hand at neck height holds a section of the veil which she has pulled across from the right shoulder

Other arrangements

25 The woman's left hand holds the two sides of the veil together over the centre of her chest (cf. 15, above)

26 The cloak falls vertically from the left shoulder. It has slipped off her right shoulder, but passes across from her right to her left upper arm horizontally, and outside the vertical section Pl. 93

27 A V-shaped section of the veil is drawn across the chest from the woman's right upper arm and pressed against the left-hand side of her chest by her left forearm

Tunic

We may add three further variables to this range, according to the type of tunic worn or its absence

Pl. 64 *A* Tunic with long sleeves
Pl. 83 *B* Tunic with 'short' or false sleeves
Pl. 65 *C* With no tunic at all

Accessories

Brooches

Pl. 63 *a* Trapezoidal with animal-head finial
Pl. 64 *b* Trapezoidal with rosette finial
 c Triangular
 d Hexagonal
Pl. 85 *e* Circle enclosing a hexagon
 f Circular with a beaded circle within the outer edge
 g Circular with a rosette within it
Pl. 65 *h* Circular and button-like
 i Circular, but with a design different from the above
 j Brooches of different shapes altogether

Earrings

Pl. 77 A Ear 'hooks', forming a cover around the outer edge of the ear
 B Large circular earring
 C Crescent-shaped
 D Bell-shaped
Pl. 83 E Shaped like a miniature bunch of grapes
 F Horizontal bar with two globular pendants
Pl. 85 G Horizontal bar with three globular pendants
Pl. 86 H 'Dumbbell'
 J Single ball
 K Three juxtaposed balls
 L Other types
 W Without any earrings at all

GROUP I (*c.* AD 50–150)

The basic pose, with the arms resting against the chest and the hands close and more or less opposite each other, is the same as that of the men, although the variations are different. The pupil and iris of the often overlarge eye are normally rendered by two engraved, concentric circles, although rare examples of a single circle and blank eye exist. The eyebrows are not shown, except as engraved, curving grooves. There is striking patterning of drapery folds. The arrangements characteristic of this group include 1–9, 11, 12, 14 and 16. They exhibit the same patches of semicircular folds as the males. This again seems typical of the decades *c.* AD 90–150. Some of the busts are 'framed'.

Peculiar to the women are the costume and headdress, the spindle and distaff commonly seen in the left hand, and a long shoulder-lock falling on to each shoulder, as well as some jewellery: a trapezoidal brooch, decorative hooks fixed round the outer edges of the ears to form 'covers', and earrings, especially in the shapes of a little bunch of grapes or a crossbar with two or three globular pendants. They occasionally permit themselves coquettish forehead and cheek locks.

Subdivisions

A The left hand holds the spindle and distaff; the right hand is in various positions

 a The right hand holds nothing, but rests against the chest more or less opposite the left Pl. 76
Drapery, etc.: 1, 4, 5, 6, 12*B*; *a, b, i*; A, B, C, E, F
Museums: PM; DM C.2654, etc.; BM 125036 (PS 60); Istanbul 3784 (PS 352), 3815; NCG 1064 (PS 348)

 b The right hand holds against the chest a loop of the veil falling vertically from the right shoulder opposite the left hand (very common)
Drapery, etc.: 1, 2, 4, 9, 11; *a, b, i*; A, B, E, G
Museums: PM A151, 1782/6650, 1992/7117, CD 92.60; DM; Istanbul 3712–13, 3753, 3759; Lou 1557–8; NCG 1026, 1055, 1156, etc. (PS 33, 59, 336–8, 340–3, 345–7, 349–51, 353–4, 356–7, 361)

 c The right hand holds a key (rare)
Drapery, etc.: 1; *a*; A
Museum: NCG 1072 (PS 344)

 d The right hand is held palm forwards (fairly common) Pl. 63

Drapery, etc.: 1, 2, 4, 7, 7*A*, 12; *a*, *b*; A, B, E

Museums: PM; DM C.32; BM 125203, 125695; Istanbul 3817; Met 01.25.1; NCG 1057, 1076, etc. (PS 30–1, 329–34)

Pls. 64, 85

e The right hand holds the veil at shoulder height (very common)
Drapery, etc.: 4–8, 12*A*; *a*, *b*, *d*, *e*; A, E, F, G
Museums: PM; DM; AUM 2740; BM 125125, 125204; Istanbul 575/ 205, 3751; Lou 1562, 1757, 5004, 7476, 14925, etc.; NCG 1078–9, etc. (PS 32, 35, 57, 358–60, 362–76)

f The right hand pulls the veil across from the left (uncommon)
Drapery, etc.: 1; A, E
Museums: Istanbul 3786, etc. (PS 377)

g The right hand rests against the right cheek (rare)
Drapery, etc.: 11; E
Museum: Berlin, Kaiser Friedrich Museum V.A.51 (PS 378)

B The left hand rests against the chest, holding nothing; the right is held in various positions across the chest

a The right hand rests in the centre of the chest (rare)
Drapery, etc.: 13*B*
Museum: PM

b The right hand holds a loop of the veil coming from the left shoulder in the centre of the chest (rare)
Drapery, etc.: 14*B*
Museum: Met 02.29.3 (PS 37)

C The left hand rests against the chest, holding various attributes (other than the spindle and distaff); the right hand is held in various positions

a The left hand holds a loop of drapery from the left shoulder; the right hand also holds a loop of drapery, and rests just below the left (rare)
Drapery, etc.: 11*A*; *b*; E
Museum: Istanbul 3816 (PS 355)

b The left hand holds a child; the right hand holds a loop of drapery from the right shoulder in the centre of the chest (rare)
Drapery, etc.: 12
Museum: Istanbul 3798

c The left hand holds a large circlet resembling a wreath or tambourine; the right holds a loop of drapery from the right shoulder (rare)
Drapery, etc.: 1; *b*; A + E
Museum: PM 1936/7028

d The left hand holds a loop of drapery from the left shoulder; the right rests on the right shoulder of a companion (rare)
Drapery, etc.: 22
Museum: PM

e The left hand holds a bird; the right rests against the right cheek (rare: stele only)
Drapery, etc.: tunic only
Museum: DM

D The right hand holds the veil at shoulder height; the left holds various attributes (cf. A*e*)

a The right hand rests against the chest, holding a loop of the veil (rare)
Drapery, etc.: 1, 8; *a*, *d*; G
Museums: PM; NCG

b The left hand rests against the chest, holding a small box-like object (rare)
Drapery, etc.: 5*A* or 9*A*; *a*; A + E
Museum: DM (old no. 8365)

E The left hand holds the veil at shoulder height; the right is in various positions

a The right hand is held across the chest, pulling the part of the veil which falls from the left shoulder from beneath the left elbow (uncommon)
Drapery, etc.: 3*B*, 18*B*, 19*B*
Museums: DM C.3600, etc.; LHO 39, etc. (PS 64, 381)

F Women in mourning, or 'pleureuses'; the right shoulder and arm are bare, and the woman usually accompanies another

person, shown beside her, whom she comforts by laying a hand on the other's shoulder

a With nothing in either hand (rare)
Drapery, etc.: 11 or 12C
Museum: Berlin, Kaiser Friedrich Museum V.A.51 (PS 378)

b With ritual cup piled with food in the left hand (rare)
Drapery, etc.: 12C; b; E
Museum: NCG 1084 (PS 382)

c With spindle and distaff in the left hand, and a box-like object in the right (rare)
Drapery, etc.: 11; b
Museum: PM (128 (p. 308) 412)

G Armless busts

Pl. 84

a Without turban or diadem: the head is covered only by the veil
Drapery, etc.: 16; c
Museums: DM; NCG 1070, 1155; Vatican Museum, etc. (PS 34, 36, 383–4)

b The woman wears the normal turban and diadem beneath the veil
Drapery, etc.: 16; G
Museums: PM 1780/6603, etc.; DM

H Detached heads

a With no head-covering at all: bare-headed (rare)
Museum: NCG 1095

b Without turban or diadem: the head is covered by the veil only (rare)
Museum: Boston, Museum of Fine Arts 1071 (PS 384A)

c Head covered by the veil and turban, but without a diadem (rare)
Museum: DM C.43

Pl. 77

d Head covered by the veil, turban and diadem (earrings A–G)
Museums: PM; BM 125027–9; Lou 5002; NCG 1082, 1095, 2816, etc. (PS 385–93)

J Fragments

Museum: PM

GROUP II (c. AD 150–200)

The most important innovations in this group are made in pose and drapery arrangement. An overwhelming majority adopt one basic new pose: the right hand clasps the veil on the right side at shoulder, soon rising to neck, height (a development of group I Ae). A few reverse this position. The old basic drapery arrangement with folds falling vertically from each shoulder is therefore cast aside. Some of the later group I modes survive, however, notably 5 and 6 (with a new variation: 13), 14 and 16, suitably modernized. But the way is open for invention, and many new modes occur. 10 appears tentatively; 17 and 19–22 are interesting innovations, and 15 and 23 rather more daring. In this period, the 'short'- or false-sleeved chiton largely displaces the long-sleeved one.

As with the male busts, the eye becomes more natural in size and may be left blank (with very occasionally the lower lid omitted); it may be provided with a single engraved circle for the iris, or given the circle for the iris and a bored circle for the pupil. Eyebrows, however, are not plastically rendered: they remain as curved grooves, or at most as raised, curved, flat protuberances. Drapery becomes less rigidly patterned, and slightly more naturalistic; the patches of semicircular folds vanish.

The range of attributes diminishes. The spindle and distaff are gradually abandoned; other items, such as a bird or pine-cone, are extremely rare, except for the child which often appears on the left arm. The fashion for wearing two shoulder-locks dies away, although some for a time wear one on the right shoulder only. The brooches are commonly trapezoidal, polygonal or circular. For earrings, the miniature bunch of grapes is almost completely dropped; some continue the older fashion for bars with pendants. But the vast majority prefer the vertical 'dumbbell' type, consisting of two pearls or beads joined by a vertical bar. Others wear no earrings at all. The taste for the lavish display of jewellery continues, but among a minority only.

Subdivisions

Groups with two shoulder-locks

A With two shoulder-locks: the right hand holds the veil at shoulder height (as in group I Ae)

 a The left hand holds a spindle and distaff
Drapery, etc.: 5, 6*A*; *a, b, f*; G
Museums: PM; KMV 1524 (PS 63); NCG 1061 (PS 400), etc.

 b The left hand holds a loop of the veil coming from the woman's left shoulder
Drapery, etc.: 5*B, d*; F
Museums: PM; DM

 c The left hand supports a little child
Drapery, etc.: 6*B*; *b*; F, w
Museums: PM 1788/6637; ? (PS 40)

 d The left hand holds nothing at all (rare)
Drapery, etc.: 5*A*; *a*; F
Museum: BAM 514

B With two shoulder-locks; the right hand holds the veil above the shoulder, at neck height

 a The left hand holds a spindle and distaff
Drapery, etc.: 5, 6 (mostly *B*); *a, b, e*; F, H, W
Museums: Geneva Museum 8193; Istanbul 3752; NCG 2774, etc. (PS 45, 394–6, 398–9)

 b The left hand holds a loop of the veil coming from the left shoulder
Drapery, etc.: 5*B*, 6*B*; *a, f*; H, W
Museums: PM; AUM 2734; BM 125023; Istanbul 3723; NCG 1056, etc. (PS 42, 401–2, 404–6, 408)

Pl. 86 c The left hand supports a little child
Drapery, etc.: 6*B*; H
Museum: Lou 1998 (PS 409)

 d The left arm is held fairly high on the left side of the chest
Drapery, etc.: 5*B*; F
Museum: Paris, De Clercq collection (PS 407)

C With two shoulder-locks; left hand holds the veil at neck height

 a The right hand is held across the chest, pulling the veil from the left elbow
Drapery, etc.: 18*B*, 19*B*; E, G
Museums: PM (PS 410); Istanbul 3801 (PS 411)

 b The right hand holds a loop of the veil coming from the right shoulder; the left hand holds a spindle and distaff as well as the veil at neck height (rare)
Drapery, etc.: 20*B*; *a*; W
Museum: KMV 1503 (PS 397)

D With two shoulder-locks; the arms are in positions different from the above

 a The right hand rests against the right cheek, while the left holds a spindle and distaff (cf. I Ag)
Drapery, etc.: 21*B*; G
Museum: Lou 1562

 b The right arm holds across the chest a cup heaped with food; the left is omitted (rare)
Drapery, etc.: 3; *d*; G
Museum: DM

 c The left hand holds a little child, which the right also touches (rare)
Drapery, etc.: 11*B*; E
Museum: PM

 d The left hand holds a large circlet resembling a wreath, which the right also touches (cf. I Cc)
Drapery, etc.: 11*B*
Museum: PM 1972

E With two shoulder-locks; mourning women, or 'pleureuses'

 a The left hand rests on the shoulder of the person to the woman's left; the right arm is held across the chest (rare)
Drapery, etc.: 18*B*
Private collection

 b The left hand rests on the shoulder of the person to the woman's left; the right hand is laid against the chest Pl. 65

holding a two-handled cup (rare)
Drapery, etc.: 22*B*
Museum: AUM

F With two shoulder-locks; armless busts
(no examples known)

G With two shoulder-locks; detached
heads (no examples known)

Groups with one shoulder-lock only, on
the woman's right shoulder

H With shoulder-lock on the right
shoulder only; the right hand holds the
veil at shoulder height

 a The left hand holds a loop of the
veil coming from the left shoulder
Drapery, etc.: 6*A*; G
Museum: PM

J With shoulder-lock on the right
shoulder only; the right hand holds the
veil at neck height

 a The left hand holds the veil, pulling
it from the right elbow
Drapery, etc.: 10*B*, 21*B*; *b*, *d*; H, W
Museums: DM (PS 44); BM 102612
(PS 412)

 b The left hand supports a little child
Drapery, etc.: H
Museum: FMC GR 9.1888 (PS 413)

K With shoulder-lock on the right
shoulder only; the left hand holds the
veil at neck height

 a The right hand holds the veil, pulling
it from the left elbow (rare)
Drapery, etc.: 18
Museum: Boston, Museum of Fine
Arts 1077 (PS 414)

 b The right hand holds a loop of the
veil coming from the right shoulder
Drapery, etc.: 18–22, mostly *B*; *e*,
f, *k*; E, F, H, J
Museums: Istanbul 3741, 3801;
NCG 1068, etc. (PS 415–19)

L With shoulder-lock on the right
shoulder only; armless busts (no ex-
amples known)

M With shoulder-lock on the right
shoulder only; detached heads (no
examples known)

Groups with no shoulder-locks

N With no shoulder-locks; the right hand
holds the veil at shoulder height

 a The left hand holds the spindle and
distaff
Drapery, etc.: 5*A*, *B*, 6*B*; *a*, *b*, *d*; H,
W
Museums: PM 7119; Met 02.29.5
(PS 420); NCG 1077 (PS 423)

 b The left hand holds a loop of the veil
coming from the left shoulder
Drapery, etc.: 5*A*, 6*B*; *a*, *e*, *f*; H
Museums: PM 1958/7050, etc.;
Lou 4148 (PS 422)

 c The left hand supports a little child
(rare)
Drapery, etc.: 5*A*; *f*; G
Museum: PM 1790/6639

 d The left hand rests against the chest
Drapery, etc.: 5*A*, 6*B*; *b*, *e*, *f*; F, W
Museum: PM A146, etc.

O With no shoulder-locks; the right hand
holds the veil at neck height

 a The left hand holds the spindle and
distaff
Drapery, etc.: 5*A*, *B*; *a*, *b*; F, H, W
Museums: PM 1904/6848; AUM
2738; Geneva Museum 8192, etc.
(PS 41, 424–6)

 b The left hand holds a loop of the veil
coming from the left shoulder
(popular)
Drapery, etc.: 5*B*, 6*B*, 16*B*; *b*, *c*, *e*, *f*;
F, H (mostly), W
Museums: PM 1937, 1963/7055;
Istanbul 3818; Lou 1144, 2197–8;
NCG 1060, 1062, 1067, etc. (PS
65, 421, 427–39, 441–4)

 c The left hand supports a little child
(only examples dubious: cf. III Db)

 d The left hand holds an object re-
sembling a pine-cone (rare)
Drapery, etc.: 5*B*; *e*
Museum: Lou 14926

e The left hand is held across the chest, pulling the veil from beneath the right elbow
Drapery, etc.: 5*B*; *f*; H
Museums: PM 7114; Istanbul 3740 (PS 446)

f The left hand rests against the chest
Drapery, etc.: 5*B*; *b, d, e, f*; H (mostly), W
Museums: mostly PM; Baalbek Museum (PS 440 – if not III Ad)

P With no shoulder-locks; the left hand holds the veil at neck height (no examples known)

Q With no shoulder-locks; the right hand rests on the right cheek

a The left hand is held across the chest, pulling the veil from the right elbow
Drapery, etc.: 8*B*, 21*B*; *c, f*; F, H
Museums: PM 1762/6586; AUM 2739 (PS 43)

b The left hand holds a loop of the veil coming from the left shoulder (rare)
Drapery, etc.: 6*B*; *b*; F
Museum: Lou 2196 (PS 403)

c The left hand supports a little child (rare)
Drapery, etc.: 13*B*; *c*; F
Museum: PM (Šalamallat hypogeum no. 22: see *14*, p. 305)

R With no shoulder-locks; the right hand pulls the veil from the left across the woman's chest towards her right

a The left hand pulls the drapery of the veil from her right elbow and forearm towards her left
Drapery, etc.: 14*B*; W
Museums: PM; Istanbul 3806

b The left hand holds a loop of the veil coming from the left shoulder (rare)
Drapery, etc.: 23*B*; H
Museum: PM 1774/6598

c The left hand supports a little child (rare)

Drapery, etc.: 14
Museum: PM (Šalamallat hypogeum no. 21)

d The left hand rests against the chest
Drapery, etc.: 14*A, B*; E, W
Museums: PM (Šalamallat hypogeum no. 12); Geneva Museum 8191

S With no shoulder-locks; the right hand holds both sides of the veil together across the centre of the chest

a The left hand holds a spindle and distaff (rare)
Drapery, etc.: 15*A*; W
Museum: BM 125150 (PS 46)

b The left hand is held across the chest, pulling the veil from beneath the right elbow towards the left (rare)
Drapery, etc.: 15*B*
Museum: Lou 21.383

 Pl. 87

T With no shoulder-locks; the right arm and hand are held against the chest in a variety of positions

a The right hand is held palm forwards; the left is held across the chest beneath the right (rare)
Drapery, etc.: 17; H
Museum: PM 432/1635

b The left hand is held across the chest beneath the right; both hold drapery (rare): perhaps group III: cf. III Gd)
Drapery, etc.: 11*A*
Museum: PM (Bibliography *128*, 450)

c The right forearm and hand rest across the centre of the chest, above the left; the left hand supports a little child
Drapery, etc.: 21*B*; *e*; H
Museums: Istanbul, etc. (PS 510, 513)

U With no shoulder-locks; the right hand holds the veil, which passes from the right across the top of the chest to the left shoulder, in the centre of the chest, below the neck

a The left hand rests against the chest (rare)
Drapery, etc.: 16B; H
Museum: PM 1193

b The left hand holds a loop of the veil coming from the left shoulder (rare)
Drapery, etc.: 16B; H
Museum: PM 1967/7059

V With no shoulder-locks; with special 'melon' hairstyle; and with no head-covering except for the veil attached at the back of the head

a The right hand holds the veil in the centre of the chest, beneath the neck; the left holds a loop of the veil coming from the left shoulder
Drapery, etc.: 16B; H (mostly), w
Museums: PM; AUM 2733, 2753; BM 126016; Istanbul 3740; NCG 1074, etc. (PS 15, 445–9)

Pl. 88

b The right hand holds the veil in the centre of the chest, beneath the neck; the left holds a bird (rare)
Drapery, etc.: 16B; H
Museum: NCG 2794 (PS 39)

c The left hand holds the veil in the centre of the chest, beneath the neck; the right is held in various positions. (Note: stylistically, all these are closer to group III than II, and should probably be placed in III: see III Ha)

W With no shoulder-locks: armless busts
Drapery, etc.: 16; H, w
Museums: PM; Budapest Museum; Philadelphia Museum CBS 8912, etc.

X With no shoulder-locks: detached heads (earrings mostly H)

a Bare-headed, with hair parted in the centre
Museums: PM 2170–6; NCG 1113

b Bare-headed, with 'melon' hairstyle
Museums: Lou 22248; NCG 1090; Warsaw, Muzeum Narodowym (PS 454–6)

c With veil only covering the head (no examples known)

d With veil and turban only
Museum: PM CD.120, 2089/7426

e With veil and semicircular diadem only (rare)
Museum: KMV 1520

f With veil, turban and diadem
Museums: mostly PM; DM; BAM 693, 2743; Philadelphia Museum CBS 8909, 8911

Y Fragments
Museums: PM; Istanbul

GROUP III (c. AD 200–73)

The most important development that now takes place is again one of pose. In the great majority of cases the left (instead of the right) hand takes the veil at neck height, a simple reversal of the most popular group II gesture. Some rest the left hand against the left cheek. The main group II poses, with the right hand holding the veil or resting against the cheek, linger on, but among a small minority only. Subdivision F, if it exists, constitutes a further reversal of a group II pose. Ba is an attractive minor innovation. The long-sleeved chiton becomes fairly popular again, and is often used as a vehicle for introducing details of embroidery and trimmings. Most of the drapery arrangements are familiar already, but 24–7 are interesting new ones. Overall, however, the range in use is narrower than in groups I or II, with 5, 16, 18 and 20–2 as the favourite kinds.

On the head the diadem is abandoned in a number of instances, and in others the turban (or turban and diadem) is replaced (or covered?) by a striking, embroidered headcloth. Head ornaments, chains of cabochons and pendants, are not uncommon. The 'melon' hairstyle may linger on (unless subdivision H really belongs to group II), and little forehead and cheek locks are fairly frequently seen. Shoulder-locks have disappeared altogether, except, seemingly for women in mourning.

For earrings, the 'dumbbell' variety is still overwhelmingly the favourite, with other kinds far behind. Again, some prefer not to wear earrings at all. The circular types of brooch are now the most popular; the polygonal are unfashionable, and the trapezoidal has almost disappeared. For the wrist the twisted, beaded bracelet is widely favoured, often accompanied by a decorated clasp set behind it on the forearm. The bracelet may have a pendant, especially a bell. Some display jewellery lavishly – particularly those wearing an embroidered, long-sleeved chiton.

The eye is shown as before. It is quite realistically shaped; it may be left blank (sometimes with the lower lid omitted); a single engraved circle may indicate the iris; and a single bored hole may be added as the pupil. Drapery patterning persists, but within the demands of the style 'naturalism' slightly increases.

Subdivisions

A The left hand holds the veil at neck height

a The right hand, laid against the chest, holds a looped fold of the veil coming from the right shoulder (very popular)
Drapery, etc.: 18*B*, 20*A*, *B*, 21*A*, *B* (common), 27*B*; *b* (?), *d*, *e*, *f*; H (common, J (?), L (commonest combination 21*B*eH)
Museums: PM; DM; BM 125717; Istanbul 3724, 3797, 3800; NCG 1054, 1058, 1069, 1071, 1073, etc.; private collections (PS 48–9, 51, 68, 459–61, 464–7, 471–8)

Pl. 89 b The right arm is held across the chest, and the right hand pulls the veil from the left elbow towards the woman's right (very popular)
Drapery, etc.: 18*A*, *B*, 19*B*, 20*A*, *B*, 21*B* (common); *c*, *d*, *e* (common), *f*, *g* (?), *i*; D, F, H (common; popular combinations *B*eH and *B*fH)
Museums: PM; DM; BM 125019; Istanbul 3783, 3791, 3833; Lou 1575, 1758, 4449; NCG 2795, etc. (PS 23, 47, 69, 482–7, 492–9)

c The right hand is laid against the chest, holding nothing; but with the right forearm the figure presses a loop of the veil coming from the right shoulder against the chest (rare)
Drapery, etc.: 21*A*; *e*; L
Museum: PM 1772/6596

d The right hand is laid against the chest, holding nothing
Drapery, etc.: 18*B*, 21*A*, *B*; *e*, *g*; H, W
Museums: PM; Istanbul 3750; NCG 1059, etc. (PS 479–81)

e The right hand rests on the shoulder of a companion (rare)
Drapery, etc.: 18 (?); W
Museum: Istanbul 3805 (PS 260)

B The left hand, at neck height, holds on the left shoulder a section of the veil coming from the right shoulder (cf. Eb)

a The right hand, laid against the chest, holds a looped fold of the veil (rare)
Drapery, etc.: 24*B*
Museum: PM CD.37.62

C The left hand rests against the left cheek

a The right hand, laid against the chest, holds a looped fold of the veil
Drapery, etc.: 20*B*, 21*A*, *B*; *c*, *e*, *f*; G, H (common)
Museums: PM 1777; DM C.17; Istanbul 3725, 3794, etc. (PS 50, 52, 462–3, 468–9)

Pl. 92

b As a, but the left hand also holds a section of the veil coming from the right shoulder (rare: cf. Ba)
Drapery, etc.: 24*B*; H
Museum: NCG 1025

c The right hand is held across the chest, and pulls the veil from beneath the left elbow
Drapery, etc.: 20*B*, 21*B*; *f*; H
Museums: DM; BM 125024; Warsaw, Muzeum Narodowym 199576, etc. (PS 488, 490–1)

D The right hand holds the veil at shoulder or neck height

a The left hand rests across the chest (rare)
Drapery, etc.: *5B*; *d*; H
Museum: BM 125717 (PS 49)

b The left hand supports a little child
Drapery, etc.: *5B*, *21B*; *f*; H
Museums: DM; Istanbul; Lou 4147, etc. (PS 53, 509, 511–12)

c The left hand both supports a little child and pulls the veil across from the right elbow (rare)
Drapery, etc.: *5B*
Museum: PM (Bibliography *128*, 437)

E The right hand rests against the right cheek

a The left hand laid against the chest holds a looped fold of the veil (rare)
Drapery, etc.: *5B*; *e*; H
Museum: Washington, Freer Gallery 08.236 (PS 54)

F The left hand holds the two sides of the veil together over the centre of the chest. (The only known example is badly damaged, and may possibly have been of another type)
Drapery, etc.: 25; *e*; H
Museum: Istanbul 3785

G The hands are held in a variety of positions across the chest

a The right hand is laid against the chest, holding a looped fold of the veil; the left hand supports a little child
Drapery, etc.: H
Museum: BAM (PS 508)

Pl. 93

b The right hand is laid against the chest, holding a looped fold of the veil; the left holds vertically a globular object on a stick (rare)
Drapery, etc.: *26A*; H
Museum: Strasbourg Library

c The right hand protrudes from the veil as it swings across the chest from the right shoulder to the left shoulder; the left rests across the chest beneath the right elbow (rare)

Drapery, etc.: 16; H
Private collection

d The left hand is held across the chest beneath the right; both hold drapery (rare: perhaps group II: cf. II Tb)
Drapery, etc.: *11A*
Museum: PM (Bibliography *128*, 450)

H With the special 'melon' hairstyle, and with the veil attached at the back of the head (unless these examples belong to group II, subdivision Vc)

a The left hand holds the curve of the veil in the centre of the chest below the neck
Drapery, etc.: *16B*; F (?), H
Museums: PM CD.4.59; DM C.4946; NCG 1150 (PS 450), 1153 (PS 452)

Pl. 94

b The left hand rests against the left cheek (rare)
Drapery, etc.: *27A*; G
Museum: DM C.12

J Mourning women or 'pleureuses'

a The left hand holds the veil at neck height (rare)
Drapery, etc.: *22C*; w
Museum: NCG 1025

b The left hand rests against the left cheek; the right hand is laid against the chest, holding a looped fold of the veil coming from the right shoulder (rare)
Drapery, etc.: *21C*; K
Museum: PM (Ta'ai hypogeum no. 21: Bibliography no. *80*)

c The right arm is laid across the chest; the left is out of sight (rare)
Drapery, etc.: *22C*; H
Museum: Istanbul 3725 (PS 468)

d The left arm is held across the chest; the right is out of sight (rare: note that this is found only on a strange relief where a winged siren is depicted as the mourning female)
Drapery: *C*; w?
Museum: DM

Pl. 95

K Armless busts

 a With veil, turban and diadem
Drapery, etc.: 16; H
Museum: KMV 1523 (PS 70)

 b With veil and turban, but without a
diadem (rare)
Drapery, etc.: 16; w (?)
Museum: Istanbul 3734

L Detached heads

 a Bare-headed, with central parting
Museum: PM CD.71.61

 b Bare-headed, with 'melon' hairstyle
(no examples known)

 c With veil only covering the head
(no examples known)

 d With veil and turban, but with no
diadem
Museums: PM CD.120.61; NCG
1115

 e With veil, turban and diadem
Museums: PM; DM; AUM 2741;
Lou 1002, 1192, 6212, A.R.16;
NCG 1091, 1100, 1109–10; Boston,
Museum of Fine Arts 1072 (PS 489)

Pl. 90 f With veil and decorated headcloth
or cap
Museums: NCG 1099, 1102, 1104,
1115, etc. (PS 500–7)

M Fragments

 Museum: PM

Busts of eunuchs (?)

A small and puzzling group of busts com-
bines certain features taken from both male
and female busts, and would appear to
represent eunuchs. The face is beardless.
The hairstyle is male, but costume and pose
are female (two as in group II Va). Further-
more, some form of jewellery is also worn:
earrings, necklaces and bracelets, in varying
combinations. The names, where given, are
feminine.

Style, motifs and lettering date these
pieces to *c.* AD 200.

A The right hand holds the veil in the Pl. 91
centre of the chest, beneath the neck;
the left holds a loop of the veil coming
from the left shoulder (cf. female group
II Va)
Drapery, etc.: 16*B*; H
Museum: NCG 1053, 1075

B The left hand rests against the left cheek, Pl. 95
holding a section of the garment; the
right rests across the chest (cf. female
group III Cb)
Drapery, etc.: no veil
Museum: DM

Notes on the text

Abbreviations

AAAS	*Annales Archéologiques Arabes Syriennes*
AAS	*Annales Archéologiques de Syrie*
AJA	*American Journal of Archaeology*
'Ant. Syr.'	'Antiquités Syriennes', with paragraph number: reference to article by H. Seyrig in *Syria* and *AS* (q.v.)
AS	SEYRIG, H. *Antiquités Syriennes*, vols. I–VI, Paris, 1934–66
AUM	Beirut, American University Museum
BAM	Beirut, National Archaeological Museum
BM	London, British Museum
CD	Camp of Diocletian: reference number of sculpture in *109*
CIL	*Corpus Inscriptionum Latinarum* (= Bibliography, no. *45*)
CIS	*Corpus Inscriptionum Semiticarum*: see Bibliography, no. *46*
CRAI	*Comptes rendus de l'Académie des inscriptions et belles-lettres*
CSIR	*Corpus Signorum Imperii Romani*
DM	Damascus Museum
FMC	Cambridge, Fitzwilliam Museum
FGW	Washington, Freer Gallery of Art

Inv.	Inventory number
Istanbul	Istanbul Archaeological Museum
KMV	Vienna, Kunsthistorisches Museum
LHO	Leningrad, Hermitage, Oriental Department
Lou	Paris, Louvre, A(ntiquités) O(rientales)
Met	New York, Metropolitan Museum of Art
MUSJ	*Mélanges de l'Université Saint-Joseph*
n. (nn.)	note(s)
NCG	Copenhagen, Ny Carlsberg Glyptotek
p. (pp.)	page(s) in this volume
PM	Palmyra Museum
PS	Reference number of sculpture in Bibliography, no. *88*
RES	*Répertoire d'épigraphie sémitique*: see Bibliography, no. *39*
RTP	Reference number of individual tessera in Bibliography, no. *100*
SEG	*Supplementum Epigraphicum Graecum*, Leyden, 1923–
YUM	New Haven, Yale Gallery of Fine Arts

Notes

One note may refer to several different consecutive items in the text, in which case references within the note are separated by dashes (—). Square brackets enclose material which does not, strictly speaking, refer to the text. Italicized numbers refer to entries in the Introductory Bibliography; for example, *43*, I, 191–6 means Collart, P. and Vicari, J. *Le Sanctuaire de Baalshamin à Palmyre*, volume I, pages 191–6.

1 Pliny, *Natural History*, V, 83.

2 See E.Dhorme, *Revue Biblique*, XXXIII, 1924, 106–8; *181*, 27–30; *26*, 162, 181–4. Palmyrene history generally: *60*. Biblical: *181*, 27–30; *180*, 33.

3 Arab names: A.Caquot, *Syria*, XXXIX, 1962, 231–56, esp. 233–7; *182*. —Arabic terms: *34*, 149–51.—Tell: *26*, 184.—Settlement: *59*, 131–5. —Tomb: *59*; p. 58. —[Importance of community *c.*250 BC: cf. A. Dupont-Sommer, *CRAI*, 1970, 158–73, esp. 163. —Pre-Roman religion: cf. *115*, 288–309.]

4 Parthians: *44*. —Greek inscription: *151*, 322–3 fig. 11, cf. 321–2 fig. 10; *75a*, 56.

5 Seleucid era: *181*, 20. —Aramaic: *34*, 5–8, 168; *181*, 22–3, 26. —Semitic nationalism: *34*, 7, 168; *181*, 22 —Script: *34*, 17, 168; *181*, 20–2; J. Pirenne, *Syria*, XL, 1963, 101–37. —Spoken Aramaic: *181*, 23. —Greek: *34*, 5; cf. *44*, 95–6. —Latin: *34*, 4–5.

6 Inscription of 44 BC: PM A959: *185*, no.100. —Early inscriptions: e.g. *185*, nos.88–99.

7 Antony: Appian, *Civil Wars*, V, 9; cf. *53*, 159–60.

8 Independence: Pliny, *Natural History*, V, 83; cf. *150*, 272–4; *142*, 297 n.1; G. W. Bowersock, *Journal of Roman Studies*, LXIII, 1973, 133–40. —Silanus: *142*, 296; *143*, 61–3; *160*, 170. —Germanicus: Tacitus, *Annals*, II, 53–83. —Alexandros: *32*, 139. —Minucius Rufus: *31*, IX, no.2. —Germanicus' provision: *CIS* II, 3913, lines 181–6 (Greek), lines 102–4 (Aramaic). —Corbulo: *ibid.*, lines 194–7 (Greek), lines 118–21 (Aramaic). —Mari[a]nus: *ibid.*, lines 63–5 (Aramaic); *160*, 155–75.

9 Names for Palmyra, *181*, 30; *179*, —Treasurers: 31, IX, nos.11, 12, 8; *181*.

37. —Wall: *75a*, 12–20. —Annexation: *160*, 168–70; *180*, 33–4; *75a*, 44–5; G. W. Bowersock, *loc.cit.* (n.8). —Antioch: *53*, 144. —Senate, tribes: *75a*, 45–8.

10 Inscriptions: *151*, 152–68; *160*, 223–70; *176*, nos.17, 22, 27, 34, etc. —Vespasian: *150*, 269–74; *181*, 33–4; G. W. Bowersock, *loc.cit.* (n.8). —Nero and 'Claudias': *160*, 168–75; *115*, 257–61. —Edict: *CIS* II, 3913, (Greek) lines 127–30 (a 'tetagmenos'); *142*, 294–7; *160*, 166–75; *181*, 82–3. —Trilingual texts: PM A1126: *RES*, 2159; M. Rodinson, *Syria*, XXVII, 1950, 137–42, fig.1 (AD 52). *CIS* II, 4235 (AD 58). *33*, 174–6 (AD 74). Cf. *176*, no.113 (AD 74); *150*, 271. —Militia: *181*, 34, 36.

11 Nomads: *176*, no.44; H. Ingholt, *Syria*, XIII, 1932, 289–92. —Patrons: e.g. 31, IX, no.6a = *CIS* II, 3924 (AD 19); 31, IX, no.11 (AD 24), etc.; *202*. —[Half-way station at Hît: A. Poidebard, *Syria*, XII, 1931, 101–15.] —Seleucia: 31, IX, 6a; A. Maricq, *Syria*, XXXVI, 1959, 275. —Babylon: *32*, 122–3. —Vologasias: A. Maricq, *op.cit.*, 264–6. —Alexandros: *32*, 139. —Spasinu Charax: *30*, no.34 = *176*, no.107 (AD 50/1 or 70/1?); but see *115*, 20.

12 Taxes: cf. *CIS* II, 3913. —Treasurers: 31, IX, no.12 (AD 25). —Assembly: 31, IX, nos.8, 11, 12; *181*, 37. —Tribes: *181*, 36–7; 149; *115*, 16–41 etc.; *75a*, 47; *65* (van Berchem). —Senate: *33*, 174–6 (AD 74); *176*, no.39 (AD 75/6); *181*, 37; *75a*, 45–6.

13 Trajan: *181*, 69–70. —Hadrian: 31, I, no.2; A. Piganiol, *Histoire de Rome*, Paris, 1939, 306; *181*, 38. —Hadriana: *176*, no.38 (AD 131); *CIS* II, 3913 (AD 137), etc. — Curator: *176*, no.34; *181*, 38. —Tariff Law: *CIS* II, 3913 (AD 137); *160*, 155–75; *181*, 78–84. —Senate: *CIS* II, 3913; *176*, nos.45, 55, 57, 63, 69, 106 etc.; *181*, 39. —Ala Herculania: *151*, 153–4, 159–61; *AS*, III, *185*; *181*, 39–40, 42.

14 Destinations: e.g. (all AD 131–57): Babylonia: Vologasias and Forat: *31*, IX, no.14a = *CIS* II, 3916; Spasinu Charax: *CIS* II, 3928; Thilwana: *176*, no.38; Khoumana (?): *176*, no.88. Iran: Elymais and Susa: *176*, no.114. India or 'Scythia': *SEG*, VII, no.156 = *33*, 187; *160*, 258–63. —Other traces of sea travel: cf. PM A622: *36*, 78–9 (AD 39: but 'Poseidon' is not necessarily a sea god). —Commodities: *CIS* II, 3913; *181*, 78–81.

15 Archon: D. Schlumberger, *Syria*, XXXVIII, 1961, 256–60. —Satrap: *176*, no.38. —Cos: R. du Buisson, *Syria*, XXIII, 1942–3, 133–4, fig. —Horrea Galbae: p.231. —Officers: *160*, 223–70. —Cameleers: *176*, no.128; cf. *CIL* XVI, Diploma 106; *181*, 43. —Native area: Syria: cf. *176*, no.99. —[Mesopotamia: *181*, 46.] —North Africa: *CIS* II, 3908–10; *34*, 13; *181*, 43–4; cf. pp.229–31. —Danube: *CIS* II, 3906–7; *34*, 13; *181*, 44–6.

16 Villages: *144*.

17 Greek: *34*, 154–6 (add e.g. *glwp*['], 'sculptor': *176*, no.110); cf. *56*, 13. —Latin: *34*, 157–8 (add e.g. *bnpqyr*, 'beneficiarius': PS 19, AD 189). —Iranian: *34*, 153–4, etc.

18 Syria: *181*, 47; cf. *165*, 184–92, fig.1. —Septimius' statues: *176*, nos. 64, 67. —Caracalla: *60*, 27; *181*, 47–8. —Colony: see also *176*, no.12; *CIS* II, 3942 ('Metrocolony').

19 Caravans: *181*, 75–6; *180*, 34. —Texts: H. Ingholt, *Syria*, XIII, 1932, 278–92; *176*, no.44.

20 Senate, etc.: e.g. *176*, no.44 (AD 199). —Magistrates: *ibid.*; H. Ingholt, *Syria*, XIII, 1932, 278–92; *181*, 75–6. —Greek: *34*, 153. —Jews: *37*, 376; *38*, 80–1; *30*, nos.72, 77; *34*, 153; *78a*, IX, 14n. and X, 208. —Latin: *34*, 4–5. —Persian: *34*, 153; cf. *88*, 71. —Roman army: see n.15 —[Immigrant from Hatra (?): *93*, 106–7, pl.XXI.3.]

21 Colonnade: *181*, 48; *114*, 16–17.

22 Political history: see esp. *181*, 53–62; *53*, 262–9; *166*, 159–72; J. Schwartz, *Bulletin soc. royale d'Alexandrie*, XL, 1963, 1ff.; *149a*, 1–30; *115*, 316–21. —Trade routes: *181*, 84. —August 272: *75*, 420.

23 Cf. *181*, 64–6; *204*; *75a*, 103–4.

24 Diocletian: *CIL* III, Supplement I, no.6661 = *31*, VI, no.2; *140a*, 282–3. —Colonnade: *31*, III, no.27. —Later history: *141*; *181*, 66–8; *204*; *43*, I, 88; cf. A. Bounni, *MUSJ*, XLVI, 1970–1, 329–39.

25 History: cf. *181*, 68; *114*, 8. —Exploration: *181*, 15–19; *114*, 9–10.

26 *31*, IX, no.4a; *31*, IX, no.35; *33*, 174 = *31*, IX, no.36; see *57*, V, 917, and below, p.237.

27 Iarḥai: *CIS* II, 3974 = *57*, V, 917 (AD 113?). —Moqîmû: *140*, 18–21: cf. *CIS* II, 4258 = PS 37; *57*, V, 917 (AD 148). —Ḥairan: *33*, 174–6 (AD 74); cf. R. du Buisson, *Syria*, XXIII, 1942–3, 133–4. —Stoneworkers: *176*, no.110; *144*, inscriptions 52, 57. —Corporation: *31*, III, no.17 (April AD 258). —[Other Semitic artisans: *54*, 95, no.196; *47*, 81; *115*, 388–94.]

28 Bel: *31*, IX, no.1. —Criteria: *43*, I, 171–2. —Groups: *88*.

29 No reliable guide to the religions of Palmyra has yet been produced, although J. Teixidor has promised a work on the subject. The best short account is: *181*, 85–106. See also *100*, 181–3, 191–202; *152*; *144*, esp. 121–8; *115*. Two other works can be used only with the greatest caution: *61*, on which see H. Seyrig, *Syria*, XVI, 1935, 393–402, and *24*, which is marred by much unfounded speculation, often presented as dogma. Ritual: cf. *115*, 145–7, 288–309.

30 For divine origins see *61* and *115* under individual deities; *181*, 85–106; *168*, 81, 83, 87, 90–2. —Bôl: cf. *115*, 50–5. —Iarḥibôl: see esp. *169*, 91–3; *115*, 42–6; *106a*. —'Aglibôl: *169*, 92–3, 96. —Malakbel: *169*, 100–4; J. Wais, *Studia Palmyreńskie*, ,V 1974, 97–101 (unconvincing). —Bel: *169*, 85–7. —Ba'alšamin: *169*, 94–6. —Šadrafâ: *177*; A. Caquot, *Syria*, XXIX, 1952, 74–88. —Arṣû: *115*, 49. —Western deity named: e.g. Nemesis: *17*, 318; cf. *169*, 89, n.6. —[Cf. also *148*.]

31 Deities of city: *181*, 85–101. —Of north-west: *144*, 124–8. —Arab gods: *168*, 77–92. —Bel: *169*, 85–114. —Triad groupings: *169*, 89–101. The 'Triad of Iarḥibôl' of *24*, 209, and *106a*, 17–24, is not supported by any significant evidence: cf. *169*, III, n.5. —Arṣû: cf. *169*, 112. —Goddesses: *169*, 112–13.

32 Militarization: *201*, 258–67; *168*, 77–92, 107–10. —Arab: *168*, 77–92.

33 Character of Bel: *169*, 88–9; cf. *78a*, VIII, 134. —Bel Triad: *169*, 89–94.

34 Bel's precedence: *168*, 91; *169*, 97, 101 n.1, 349–50. —Character of Ba'alšamin: *151*, 249; *181*, 94–101; *43*, I, 201–4, 212–13.

35 See *43*, I, 215–20; *169*, 94–101; *115*, 95–8.

36 Malakbel: see esp. *48*; *155*, 198–209; *43*, I, 222–3; *195*, 5–6 (goes far beyond the evidence); *169*, 100–4, 350–1; *115*, 1–77, 194–6, 428. —'Holy brothers': *CIS* II, 4001–2; *151*, 279 no.7. Cf. J. Cantineau, *Syria*, XIII, 1932, 135; *115*, 194–6, 428.

37 See *100*, 195, *s.v.* SHAMASH; cf. *31*, V, no.8; *169*, 349; *78a*, XIII, 182–5, *s.v.* solar, sun.

38 *181*, 85; *163*, 79–83; cf. *78a*, XIII, 72, *s.v.* cavalier gods; *115*, 49.

39 Typical examples in the Ba'alšamin sanctuary: *43*, I, 237.

40 Impulse to build: *169*, 94. —Dedication: *31*, IX, no.1. —'Dwelling': *31*, IX, nos.8, 12. —Buildings: *75a*, 20–1, 53–86; *106b*, 93, 193, 251; *170*. —Thalamoi: *43*, I, 133–7; *106b*, 193. —Roof: cf. *181*, 114–15.

41 Plan: *43*, I, 191–6; *75a*, 17–19, 22. —Courts: *43*, I, 71–3, 88–93, 101–36.

42 Temple: *43*, I, 102–11; *106b*, 248–9. —[Altar: *43*, I, 214.] —Local foot: *43*, I, 102–7, 109–11, 177. —[Inscriptions: *56*, 7–68.] —Temple in general: J. M. Dentzer, *Revue Archéologique*, Paris, 1973, 315–20.

43 *20*, 126–35, pls.V–X; *19*, 48–9; *43*, I, 135.

44 See *72*, 315–16.

45 Sacred area: *111*; *114*, 23–7; *140a*, 282–3. Cf. *31*, V, no.8; A. Sadurska, *AAAS*, XXIII, 1973, 111–20. Surely Zenobia's 'palace' stood not here, but E. of the Bel temple. See *113*, 58–61; p. 94, n.319. —Efqa: *75a*, 10–11.

46 *144*, 13–22, 51–62, 94–7, 143–52.

47 *144*, 114.

48 Tessera: RTP 513.

49 *151*, 254; *155*, 375; *157*, 278, fig.; *43*, I, 235.

50 See e.g. *43*, I, 237; J. Balty, *Gnomon*, 1974, 82.

51 *151*, 277–9, fig.10; *31*, VI, no.13; *181*, 102; *43*, I, 236; *115*, 3–4, 145–7.

52 *144*, 109–12; *43*, I, 236–7; *78a*, IV, 198–200, and XIII, 121 *s.v.* incense.

53 *159*, 238; *177*, 59–62; *181*, 102–3; *144*, 100–5; *43*, I, 64–5, 238–9. —Bowls: *144*, 112–13.

54 Banquets: *181*, 102–6; *43*, I, 239–43. Note the prominent role of particular tribes in the life of certain sanctuaries: cf. *75a*. —Use of tesserae: *158*, 52–6; *100*, iv; *166*, 172 n.4. —Colleges: *24*, 465–74; *115*, 31–41, 118–316. Cf. *78a*, XIII, 199–200 *s.v.* wine.

55 *43*, I, 239; cf. *75*, 421; *115*, 155–6.

56 Statuary: PM T.26, 150, etc.: *160*, 34–6, figs.4, 5; *170*.

57 PM B337–8, etc.: *160*, 37, figs.6, 7; *116*, 64 no.19, fig.17.

58 PM: *111*, 1963–4, 55–6 no.6, fig.62 (*c*.AD 50?); *111*, 1959, 114 no.38, fig.127 (*c*.AD 100? The limestone is soft: see pp.23, 109). Here again the cuirasses probably indicate divine status.

59 Cloak: PM. —Headdress: NCG: *162*, 34–5 fig.4. —Apollo Nebû: *43*, I, 227; *43*, II, pl.CIX.5 (sculpture 12).

60 Veiled: PM: *93*, 114–15 no.13, pl.XXIII.1; *154*, 139; *116*, 71 no.31, fig.27 (*c*.AD 100?). —Locks: PM B1892/6838: *43*, I, 227; *43*, II, pl.CX.1 (sculpture 14: early 2nd century AD?).

61 Leafy: NCG 1107: *172*, 52 no.G18, pl.XIII. Damaged: examples in PM: e.g. *111*, *1959*, 91 no. 9, fig.98.

62 PM: one from Agora; the other: *15*, 41, pl.5.

63 In sculpture: see p.137. —Bronze: see pp.89–90.

64 See *43*, I, 165–72, 175.

65 PM B953, unnumbered and B954 respectively: *43*, I, 157–8, 209, 227; *43*, II, pls.XCV.1–3, XCVI.4.

66 PM B449, B450, B451: *170*; cf. *43*, I, 161, 167; *43*, II, pls.XCVI.1, 6, XCVIII.1.

67 Examples: PM: *43*, I, 161, 165; *43*, II, pls. XCVI.5, XCVII.4, XCVIII.2. —*20*, pl.X (Nebû). —Tessera: RTP 508; add *111*, *1960*, 122–3 no.4, figs.135–45; *111*, *1961*, 163 no.58, fig.215.

68 PM B1906/6850: *145*, 266–8, pl.XI.1; *43*, I, 162–4, 173–5, 209, 217–19, 222, 227; *43*, II, pl.XCVII.1–3.

69 PM, DM: *157*, 282–97 esp. nos.2, 3, 9, pls. XXIX–XXXI; *81*, 43, no.40.

70 Reliefs: PM 801/2004, Lou 19.799 (from Bel sanctuary?): *160*, 39–44, pls.II, III. See also *145*, 267–8; *24*, 115–21, figs.70–4 (dubious interpretation, not argued); *43*, I, 168; *195*, 7–9, fig.1 (restoration unconvincing).

71 DM C.5312: *181*, 81, 130, fig.11; *81*, 45, no.48; *101*, 177–8, fig.70; *24*, 276–8, fig.170; *43*, I, 161, 168, 227; *43*, II, pl. XCVIII.2 ('pomegranate'). —Tariff Law: *CIS* II, 3913, line 11 (Greek), line 10 (Aramaic); cf. p.17.

72 'Aglibôl: PM B1845: *43*, I, 221; *43*, II, pl.CVII.4 (sculpture 5). —Archaism: cf. p.212. —Lions: PM 1833/6748: *43*, I, 171, 174, 227; 43, II, pl. CIX.3 (sculpture 30). —Gad: PM: *43*, I, 171, 226; *43*, II, pl. CIX.3 (sculpture 15). —Bulls: PM 1907–8: *43*, I, 171, 210–11, 227; *43*, II, pl.CIII.5; *56*, 71 no.59. —Victories: PM: *43*, I, 171, 174–5, 210; *43*, II, pl.CII.3 (sculpture 19). —[Cf. also *43*, I, 159; *43*, II, pl.XCVI.3 and *195*, 48, figs.41–2.]

73 Earliest Victories: Foundation T: PM C159; *157*, 326 no.52; *128*, F2645. —Carrying palms: PM B1820: *43*, I, 165, 168, 172–5, 210; *43*, II, pl.CII.1, 2 (sculpture 16). Ba'alšamin fragment: *43*, I, 165, 168, 174, 210; *43*, II, pl.CII.4 (sculpture 17); cf. *43*, I, 165, 169 (sculpture 55). —Abgal fragment: DM: *144*, 57 no.20, pl.XXIII.1.

74 *43*, I, 157–8. Cf. RTP 508.

75 Ba'alšamin stele: DM 7469: *43*, I, 171, 210; *43*, II, pl.CIII.1 (sculpture 1). —Šadrafâ stele: DM 7453: *43*, I, 171, 175, 225, 227; *43*, II, pl.CVIII.4 (sculpture 9). Cf. PM B1909: *43*, I, 225, 227 (sculpture 10).

76 Ceiling: *153*, 178–81 fig.2; *169*, 112. —'Iarḥibôl': Malakbel is another candidate, less likely because of the central, and thus too important, position, and because he is not associated with Bel: *169*, 100–4. —['Triad of Iarḥibôl': see n.31.] —Dionysus: *169*, 105–6, fig.8.

77 *153*, 182, pl.XXIII.

78 *153*, 173–8, pl.XXII; H. Seyrig, *Syria*, XIX, 1938, 364; *24*, 264–5, fig.164. —'Holy brothers': n.36.

79 *153*, 165–73, pls.XX, XXIV.1; *155*, 37–8; *177*, 72–3, fig. 8; *24*, 190–5, 250, figs.132, 161. Seyrig identifies the two fish-deities as Artemis/Atargatis-Derceto and Ichtys; du Buisson sees them as Artemis-Nanaï and Elqônerâ.

80 *153*, 159–65, pl.XIX; cf. R. de Vaux, *Revue Biblique*, XLIV, 1935, 397–412, pl.XV; R. Dussaud, *La pénétration des Arabes*, Paris, 1930, 113ff. —[As part of Arṣû's cult: *24*, 233, fig.150.] —As arrival of Ba'alšamin: *168*, 91. —Ba'alšamin precinct date: *43*, I, 89. —*149*, 129–31 is invalidated by *75a*, 46–7.

81 *153*, 156–9, pl.XVIII; *23*, 539.

82 Unpublished: see *170*. —Another plane: cf. p.128.

83 *153*, 184, pl.XXI.3.

84 Winged: *133*, 81, 116. —Remainder: unpublished: see *170*.

85 *151*, 253–6, fig.2; *24*, 153–4, fig.115. Seyrig interprets the two marked rosettes as the sun and moon; du Buisson sees them as the Morning and Evening Star. Without the now obliterated rosette it is impossible to decide: if it represented the moon, it would probably have been enclosed by a little crescent, as on the Nebû sanctuary niche lintel fragment: see n.67.

86 N. Thalamos: *151*, 258–60; *AS* IV, frontispiece; *195*, 31–2 fig.26 (dubious identification of Saturn with Malakbel). —S. Thalamos: *170*.

87 See pp. 220, 237–8.

88 See *170*.

89 Lintel: *43*, I, 130, 168–9; *43*, II, pl.78,1–4. —Fragments: PM. Bearded: *111*, 1963–4, 76 no.27, fig.85; 2nd century? funerary? cf. solar (?) head: *195*, 49 fig.44. Remainder: unpublished: 2nd century?

90 Scroll: PM (*128*, F4050: leopard?). —Urn: PM. —Hermes, Heracles: *161*, 75–6 pl.IV: 2nd century? Cf. *176*, no.102 (gymnasiarch).

91 PM: *160*, 31–2 fig.1; *116*, 57 no.5, fig.5.

92 DM: *140*, 17–18, pl.I.1.

93 DM: *160*, 31–3 fig.2; *116*, 56–7 no.2, fig.2.

94 PM: *160*, 30–1 pl.I.1; *116*, 56 no.1, fig.1.

95 PM T4, B53: *160*, 44 figs.10, 11; *116*, 57 no.3, fig.3.

96 Nebû priests: PM 2228/7957: *20*, 133–4, no.39 B/63, pl.X; *115*, 164. —[Later medallion, with priest's bust (?): *144*, 68 no.3, pl. XXIX.4.]

97 Placing of reliefs: *144*, 31, 71, 114, pl.XXXII.1–3; *43*, I, 166–71.

98 Protection: see p.25.

99 Standing: PM 2227/8956: *168*, 108, pl.IX.2. —'Ba'alšamin': *43*, I, 171, 210; *43*, II, pl.CIII.1. [Cf. relief fragment of beardless cloaked male: *154*, 138 fig.1; *116*, 65 no.23, fig.21.]

100 Polos gods: DM (?): *154*, 138, pl.33.1. PM: *168*, 79 (*c*.AD 50?). —Strip shield: DM: *144*, 88 no.4, 116, pl.XLI.4; *12*, 117 no.37 (1st century AD?). —Sword and spear: PM: *111*, 1961, 110 no.1, fig.157 and 138 no.29, fig.186. —Taimarṣû: DM: *144*, 78 no.9, 162, pl.35.5 ('funerary'); *43*, I, 225 (Ša'ar?) (late 1st century AD?). —Abgal: DM: *144*, 64 no.1, pl.27.4; *12*, 120 no.47 (*c*.AD 100–50); cf. *144*, 57–8 no.22, pl.23.3. —Ašar: PM A840: *185*, no.66.

101 Stele AD 55: BM 125206 = PS 1; *154*, 137–40, pl.XXX; *24*, 342; *12*, 118 no.39, fig.15. —Ba'alšamin pieces: DM 7453: *43*, I, 171, 175, 225–7; *43*, II, pl.CVIII.4 (sculpture 9). PM B1909: *43*, I, 225, 227 (sculpture 10).

102 Sun god: PM. —Warrior gods: DM: *144*, 71 nos.2–4, pl.32.2–4; *12*, 119 nos.41–3 and *144*, 77 nos.7–8, pl.35.3–4; *12*, 119 nos.44–5, all dated by Borkowska to the late 1st or early 2nd century AD, but perhaps later: the style is too crude to indicate much, and the use of soft limestone for the first three might be due more to unskilfulness than to earliness.

103 Heracles: DM: *144*, 68 no.1, pl. XXX.1; *12*, 119 no.46 ('*c*.AD 100'). — 'Priapus': PM (2nd century AD?).

104 Stele AD 30/1: DM C.7939: *165*, 58–60, pl.XI.5; *24*, 212–13, fig.142 (identifies the crescent as the Mesopotamian sky symbol and the god as the solar Iarḥibôl; but there are no parallels for the crescent with this meaning at Palmyra, whereas images of one deity are occasionally dedicated to another: *165*, 58–60). —Nebû reliefs: PM 1724/6534. PM 2226/8955: *20*, 35ff. pl.IV. —Fragment: *111*, 1960, 136 no.10, fig.152; *12*, 120–1 no.53, fig.18.

105 Fragments: *154*, 138 fig.1; *116*, 65 no.23, fig.21. —'Ba'alšamin': Lou 18.175: M. I. Rostovtzeff, *AJA*, XXXVIII, 1933, 63, pl.IX.10; *24*, 320–1, fig.187. —Solar radiate heads: NCG: *93*, 116 no.15, pl.XXIII.3; *12*, 122 no.56, fig.20. PM: *111*, 1961, 170 no.65, fig.223; *12*, 121 no.55, fig.19. —Lunar head (''Aglibôl'): PM

B1899: *43*, I, 222; *43*, II, pl.CVII.3 (sculpture 4). —'Horus': NCG: *93*, 115 no.14, pl.XXIII.2.

106　Foundation T: PM T71, T226: *160*, 33–4 fig.3; (T71): *116*, 58 no.6, fig.6. —Bel: PM A150/1253: *155*, 14, 52–3, pl.III.1; *116*, 58 no.7, fig.7. —Archer: PM: *155*, 14, 53, pl.III.4.

107　[2]30: R. P. de Rotrou and H. Seyrig, *Syria*, XIV, 1933, 16, pl.V.1; *12*, 114 no.31, fig.9. Cf. fragments dated AD 180/1: DM: *144*, 90 nos.14–15, pl.XLII.7, 6. —[Ca]stor: DM: *144*, 56 no.17, pl. XXI.4; *171*, 236–7. Cf. fragment with eagle, dedicated to Abgal: *144*, 89 no.13, pl.XLIV.4; *12*, 114 no.29.

108　PM A62, no. unknown and DM: *160*, 33–4, pl.I.2–3; *116*, 58–9 nos.10–11, figs.9, 10.

109　Fragment: PM A839: *176*, no.87, pl.X; *115*, 172–3 ('82 BC'!). —Beltî: PM B1864: *43*, I, 227; *43*, II, pl.CIX.4 (sculpture 7); *56*, no.56. —Early female: PM. —Gad: *144*, 76–7 no.3, pl.XXXV.1; *12*, 120 no.49. —Ensign: DM: *144*, 77 no.5, pl.XXXV.2; cf. RTP 277. —Nemesis: DM: R. P. de Rotrou and H. Seyrig, *Syria*, XIV, 1933, 15 fig.2, pl.IV.2; *144*, 78 no.7; *12*, 120 no.52, fig.17. Cf. H. Seyrig, *Syria*, XXVII, 1950, 242–7 = 'Ant. Syr.' 45.6 = *AS* IV, 137–42.

110　Early, seated: PM: *111*, *1961*, 172 no.66, fig. 224; *12*, 118–19 no.40, fig.16. —Later, seated: DM: *144*, 67 no.2, pl.XXIX.3; *12*, 120 no. 51. —Standing: PM (3rd century). Cf. Lou 21.114: n.119, and relief heads in DM: R. P. de Rotrou and H. Seyrig, *Syria*, XIV, 1933, 16, pl.V.3; *144*, 78 no.8; *144*, 73 no.18, pl.XXXI.4; *12*, 122 no.57.

111　Twin gods: DM: *81*, 37 no.23, pl.XIII.2; *168*, 79 n.1, pl.IX.1. —Two reliefs: PM: *168*, 79, fig.2.

112　Lou 19801: *162*, pl.II; *24*, 314 fig.181; *12*, 116–17 no.35, fig.12; *168*, 109 fig.29; probably *c*.AD 1–50.

113　Ingholt coll.: *96*, no.1, pl.; *116*, 62–3 no.15, fig.13; *24*, 315, fig.183; *12*, 117 no.38, fig.11; *43*, I, 203, 219; *43*, II, pl.CVI.2; *168*, 109 n.2 ('Bel'); cf. *169*, 87. Dated by Ingholt *c*.AD 50. —Order of precedence in a triad: *150*, 190–5; *162*, 31.

114　Berlin, Antiquarium: *150*, 261–6 pl.LVII; *154*, 137; *160*, 37–8; *164*, 149; *116*, 61–2 no.14, fig.12; *24*, 242, 377–8, fig.142 (first identified the outer two figures as divine; but the attempts to assign names are not convincing: the central figure as Iarḥibôl, 242, and Bel, 377; the female as Beltî and the male as Arṣû); *168*, 109 n.2 (reasserts that the two outer figures are worshippers, surely wrongly).

115　Early: DM: *161*, 62–3, pl.I; *81*, 34 no.15; *116*, 59 no.12, fig.10; *24*, 209–10, fig.140 (incomplete?); *168*, 107–8 fig.28. —Bel: PM: *150*, 190–5, pl.XLII; *24*, 173, fig.125.

116　PM 2195B: *17*, 313–14, fig.2; *18*; *169*, 97, 113, fig.4.

117　DM (?) (lost): *38*, 71, pl.XXIII.2; *47*, 132, fig.29; *150*, 190–5 fig.2, no.6; *144*, 91 no.1, pl.XLI.3; *24*, 173, fig.4; *12*, 116 no.34; T. Borkowska, in *Mélanges K. Michalowski*, Warsaw, 1966, 307–9, fig.1. Borkowska's attempt to date the relief to AD 19 on the basis of the single detail of Bel's 'strip' cuirass fails through (a) the fact, revealed by the Al Maqate' relief (n.116), that Bel could retain this archaic dress as late as the early 2nd century, particularly (as is apparently the case here) when his acolytes had already adopted the more up-to-date Western breastplate, and (b) the general sophistication of figures, framing and letter forms (especially the M of Malkû), hardly possible in AD 19.

118　Lou 14.927: *150*, 258, pl.LV; R. Dussaud, *Syria*, XVI, 1935, 323–4; *162*, 31; *24*, 315–16, fig.184; *40*, 114, fig.; *43*, I, 203, 219; *43*, II, pl.CVI.4.

119　Local dress: PM: *168*, 79–80. —Allat: Lou 21.114: *157*, 327–8, figs.35–6; *12*, 122 no.58, fig.21. —Abgal: DM: *144*, 58 no.23, pl.23.4; *12*, 121 no.54. Cf. *144*, 52 no.2, pl.XLV.10. —Ba'alšamin: DM: *144*, 62 no.1, pl.XXVII.1; *24*, 325; *12*, 120 no.50; *43*, I, 203; *43*, II, pl.CVI.5: drapery and

hairstyles suggest *c.*AD 150–200. —Cf. *186,* 178 no.2, pl.I.2.

120 'Ba'alšamin': DM: *144,* 76 no.2, pl.36.2; *162,* 31; *24,* 321, fig.188; *12,* 120, no.48 (dates it too early as *c.*AD 100–50); *43,* I, 203; *43,* II, pl.CVI.1. —Nemesis, etc.: Brussels, Mus. Cinq.: *150,* 51–3, pl. XVIII.4; *150,* 192 fig.3; *155,* 5 n.5; *115,* 43–4. R. Dussaud, *Syria,* XVI, 1935, 323–4, is nonsensical.

121 DM: *144,* 57 no.19, pl.XXII.3.

122 Goddess with dog: DM: *16,* pl.I; *115,* 164–5; inscription: opinion of J. Starcky.—Leto: PM: *151,* 162–4, pl.XXI.1; *12,* 113 no.26, fig.8 (high-quality limestone, not marble).

123 AD 68–78; PM A415: *36,* 81 no.31; *12,* 112 no.24, fig.6. —Worôd: PM A453: *93,* 93 no.4, pl.XIX.1; cf. D. Schlumberger, *Syria,* XLIX, 1972, 339–41.

124 DM, unless otherwise stated. *c.*AD 100: *144,* 55–6 no. 16, pl.XXI.3; *12,* 107 no.1. *144,* 77 no.4, pl.34.2; *12,* 107 no.2. —Dated AD 198/9: *144,* 55 no.14 ter, pl.XXI.1; *12,* 108 no.11. 2nd–3rd century: *144,* 55 no.15, pl.XXI.2. 3rd century: PM: *111, 1960,* 137 no.11, fig.153; R. du Buisson, *Bibliotheca Orientalis,* XX, 1963, 175 no.3/4 (dated correctly); *12,* 109 no.15. —Fragments, perhaps *c.*AD 100–50: *144,* 84 no.4, pl.39.5–6; *12,* 107 no.5. *144,* 89 no.12, pl.39.4; *12,* 107 no.4. —God on lion (Malkâ?): *144,* 88 no.2, pl.XLI.1; *24,* 353; *12,* 110 no.18.

125 Allat: DM C.2351: R. P. de Rotrou and H. Seyrig, *Syria,* XIV, 1933, 14, 181 no.5, pl.IV.1; *144,* 78 no.1, pl.37.1; *81,* 31 no.7, pl.XIII.1; *12,* 110–11 no.19; *168,* 83 fig.5.—Woman: *144,* 64 no.3, pl.XXVII.2; *12,* 107 no.6.

126 Handclasp: PM A1106: J. Starcky, *Semitica,* III, 1950, 45–52; *12,* 108 no.9, fig.1 (note: sacrificer is dedicant's son, not the dedicant). —Statue: PM A1286: *43,* I, 225–6; *43,* II, pl.CIX.1 (sculpture 11); *56,* no.58 (Šadrafâ and Du'anat). —Allat and sun: DM: *144,* 73 no.17, pl.XXXI.2; H. Ingholt, *Gandharan Art in Pakistan,* New York, 1957, 27, pl.VIII.1; *12,* 108 no.8. —Allat and sun gesturing: DM: *144,* 74 no.1, pl.XXXI.1; *81,* 36 no.6, pl.XII.1; *12,* 111 no.20.—Two warrior goddesses: DM: R. P. de Rotrou and H. Seyrig, *Syria,* XIV, 1933, 15, pl.V.2; *144,* 78 no.2; *12,* 114 no.32, fig.10.

127 Graffito: DM: *144,* 79–81, fig.36, pl.38.1; *24,* 322–3, fig.189. —Two rider gods: DM: *144,* 74 no.1, pl.34.1; *81,* 38 no.26, pl.XVI.2; *12,* 111 no.21: probably 3rd century. —Arṣû: DM: PS 22; *137; CIS* II, 3974; *12,* 110 no.16, fig.4.

128 Abgal: DM C.2842: *144,* 56 no.18, pl.XXII.1; *81,* 55 no.18, pl.XIV.2; *145,* 300, pl.XI.2; *12,* 107 no.7. —Ma'an: DM: *144,* 66 no.1, pl.XXVII.3; *81,* 40 no.32, pl.XVIII.1; *12,* 109 no.12.

129 Handshake: DM: *144,* 76 no.1, pl.XXXVI.1; *24,* 225, 389; *12,* 111–12 no.22. *24* identifies the female as Nemesis, not wholly convincingly. —Gad: PM A1121: J. Starcky, *MUSJ,* XXXVIII, 1962, 124–5, pl.II; *12,* 109 no.13, fig.2. —Malkâ; DM C.3841: *144,* 82 no.9, pl.38.2; *81,* 41 no.34, pl.XVIII.2; *24,* 270–3, fig.169 (the two obscure gods unconvincingly identified as Du'anat and Hadad); *12,* 112 no.23.

130 Bel etc.: PM 1233A: *17,* 317–18, fig.3; *18.* —Wadi el-Miyah: DM C.2118: *150,* 259–60, pl.LVI; *153,* 166 n.2; *155,* 5 n.5; *33,* 178 no.4 (inaccurate); *81,* 37–8 no.24, pl. XVI.1; *24,* 241; *12,* 110 no.17, fig.5; *168,* 84 fig.7; *115,* 64, 343. —Bet-Phaṣi'el: DM: *144,* 55 no.1, pl.XXIX.1; *145,* 300, pl.XII.1; *12,* 108 no.10; *148.* —Eight divinities: PM 1234A: *17,* 317–19, fig.4; *18.* Note Iarḥibôl's absence, due to the presence of the other solar god Malakbel.

131 Worshipper: Lou 5006 (*c.*AD 100?). DM: *144,* 57 no.21, pl.23.2. DM: *144,* 96 no.15*bis,* pl.XLI.2; *12,* 109 no.14 ('*c.*AD 200'). —Worshipper and god: DM: *144,* 64 nos.2, 2*bis,* pl.XXVIII.1; *12,* 107 no.3: *c.*AD 100? —Parthian dress and dog: PM: *111, 1959,* 116 no.39, fig.128, 211 no.6; *12,* 112–13 no. 25, fig.7; *69.* [Inscription: *75b,* no.147 (Feb. 89–189)]; lettering, style and

costume indicate a date probably after
*c.*AD 160. —*Sella curulis*: PM CD1/69:
121a, 83–5 (*c.*AD 50–150). —God by couch:
144, 88 no.1, pl.XL.4.

132 *157*, 335; *170* (Tiberian period?).

133 *186*, 178 no.5, pl.I.5.

134 Corn: private coll.: *162*, 33, pl.I.6;
12, 123 no.59, fig. 22; *43*, I, 202–3, 210; *43*,
II, pl.CIII.4; cf. *115*, 431–40. —'Sacred
Law' stele: thunderbolt: PM: *151*, 277–9,
fig.10; *31*, VI, no.13; *115*, 145–7. —Lion:
DM: *144*, 84 no.7, pl.XL.2; *24*, 353; *12*,
114 no.28; *43*, I, 202; *43*, II, pl.CIV.3
—Another image: *see* 155, 203–4 fig.1
with *CIS* II, 3979 (image of Malakbel
dedicated to Šamaš); *165*, 58–60; p.57,
n.164.

135 Rider god: DM: *144*, 77 no.6,
pl.37.2; *12*, 114 no.27.

136 BAM 519: *93*, 98 no.7, pl.XIX.2; *12*,
115 no.33, fig.11. NCG E2: *172*, 46 no.E2,
pl.XIV, inscription 35 (June 191). Both are
dedicated to the 'Nameless god'.

137 *144*, 109–12; *43*, I, 236–7.

138 Ba'alšamin precinct: PM B1887/
6831: *43*, I, 222–5; *43*, II, pl.LIX.2,
CVIII.1–3 (sculpture 3). —Octagonal: PM:
111, *1960*, 134 no.9, figs. 150–1 (inaccurate
description). —Triad: Strasbourg Library:
151, 281–2, pl.XXVI; *CIS* II, 4037; *43*, I,
218, 222; *43*, II, pl.CVI.3.

139 *155*, 203–4, fig.1; *CIS* II, 3979: an
altar of *c.*AD 100–50 dedicated to Šamaš,
but with a picture of a sacrifice to the solar
Malakbel. Cf. n.134.

140 Hand: e.g. two altars from Karassi
(20km. from Palmyra), offered by the city
on 21 April 114: *38*, 77–9, pl.XXIII.5, 6.
—Gdêm, 55km. from Palmyra: *151*, 267–9,
fig.7; *33*, 188–90: has leaping goats and
disc above crescent: AD 187–95. —From
Khirbet Semrin: DM: *144*, 51 no.1,
pl.XXIV.1. —From Palmyra: *111*, *1963–4*,
80–2, no.31, fig.90, inscription 6.

141 E.g. goats: Gdêm altar: n.140.

142 Hand: PM (lettering *c.*AD 100–50).

—Bed: *38*, 77–8, pl.XXIII.7; *151*, 275–6,
fig.9 (from Karassi: see n.140).

143 Oxford, Ashmolean Museum C2–9:
M. Lidzbarski, *Handbuch der Nordsemitische
Epigraphik*, Giessen, 1902, 474 no.2,
pl.38.6; *38*, 71; *47*, 128, fig.27; *CIS* II,
3978.

144 E.g. single worshipper: BAM: *93*,
92–3 no.3, pl.XVIII.2–3. Pair: Lou 11450.
—Man before arch: NCG 1080: *172*, 45
no.E1, pl.XIV; *38*, 79, 86, pl.XXIII.4.
—Two priests: PM A1175–6: D. Al
Hassani and J. Starcky, *AAS*, III, 1953,
156–9, pl.II (May 240 and 243/4). —Cf.
Iarḥai hypogeum fragment: *4*, 257, fig.14.

145 One pair of hands: NCG 1161: *38*,
86, pl.XXIV.11, 11a. NCG: *38*, 82,
pl.XXIV.2 (June 191). NCG: *38*, 79,
pl.XXIV.5; cf. *38*, 83, pl.XXIV.2 (227/8).
Istanbul 3703, 3708; BAM; PM. —Two
pairs: *38*, 72–3, pl.XXIV.1, 1a (Dec. 188).

146 DM C.4942: *44*, pl.21. Cf. also e.g.
PM A622: *36*, 78–9 (June AD 39); *37*, 374–5,
fig.; *38*, 70, pl.XXIV.3. PM 1189, etc.

147 Humped bulls: Lou 3983: PS 532.
Private coll.: R. P. Savignac, *Revue
Biblique*, XXIX, 1920, 364; PS 533.
—Felines: Philadelphia Museum CBS
8907: *104*, 350, pl.15; PS 534. Private coll.:
R. P. Savignac, *loc.cit.* —Lion head: AUM
4808: *40*, 24, fig.

148 PM: *111*, *1961*, 222 no.16, fig.261
(tower 19). PM: *111*, *1962*, 169 no.13,
fig.201 (tower 15). PM: *111*, *1960*, 130 no.5,
fig.46 (Tetrapylon). PM: *111*, *1963–4*,
78–9 no.29, fig.88, Inv. CD 47. PM:
ibid., 77 no.28, figs.86–7, Inv. CD 34.
—Abgal: DM: *144*, 53–4 no.12, fig.23.

149 All in PM. Protomai: *111*, *1960*, 130
no.6, fig.147. *111*, *1963–4*, 75 no.26, fig.84.
Zodiac ceiling coffer: *111*, *1962*, 111 no.50,
fig.151.

150 PM: *111*, *1961*, 223 nos.17–19,
figs.262–4 (tower 19). *111*, *1960*, 132 no.7,
fig.148. *111*, *1961*, 164–5 nos.59–60,
figs. 216–17; *111*, *1963–4*, 79 no.30, fig.89.
—Abgal: *144*, 53 no.11, pl.XLIV.1, 2.

151 DM: *144*, 85 no.12, pl.XL.1, 3.

152 Published: *100*; *55*. Commentary: read *24* with great caution (see n.29). Metal tesserae are mostly 3rd century and imitate Roman coinage: *24*, 711ff., pls.XCI–CX. —Purpose: p.29. —Dates: RTP 32, 645, 691, 737, 785.

153 RTP 198, 754, 606 and 612. —List of shapes: *24*, 23–6.

154 Iranian dress: e.g. RTP 274, 806, 983. —Local: e.g. RTP 153, 249. See *24*, 36–7.

155 Arṣû: *24*, 230–6. —Nebû: *24*, 285–9. —Šadrafâ: *24*, 343. —Animal and plant attributes: *100*, 200–1.

156 *100*, 201, *s.v.* DIVERS, rep. du profil; *24*, 40–2; pp.125–8.

157 *100*, 196–201, with references.

158 Jeweller: RTP 36; *24*, 612, fig.287. —Well: RTP 722. —Man (baker?): RTP 758. —Bull: RTP 170. —Camel: seated: e.g. RTP 175, 181; rising: RTP 179; standing: e.g. RTP 176, 178; drinking 187. See *24*, 38.

159 Symmetry: e.g. RTP 141, 313, 463, 538, 547, 613, etc.

160 Priest with servant: compare RTP 19 with 10, 12, 17, 22 and 760. —City wall: RTP 515. —Derrick: RTP 722. On this see *24*, 38; p.130.

161 Temple façade: e.g. RTP 118. —Seated figure: e.g. RTP 164, 205, 207, 224, 434, 439. —Wreath: RTP 16; *24*, 554, fig.264. —Altars: RTP 162: see *55*, 107 no.23, pl.XIV; *24*, 38.

162 See *100*, 202; *24*, 527–40. —Impressions on both sides: RTP 998–1132. —Selene: RTP 483, 586, here female as on the Bel temple north thalamos ceiling (fig.18). —Socrates: RTP 945. —Romulus and Remus: RTP 1072, 1128. —Egyptian: RTP 998; *24*, 534–5.

163 RTP 15 (= 22), 289, 311–13 (Nemesis), 581, 727, 842 (gryllos with name Etpanei), 1045, 1056, 1090, 1124; see *24*, 387–92, 537.

164 DM, except no.7 (Louvre): *164*,

147–56, fig.1, pls.I–II. Note the dedication of the image of one god (here, 'Aglibôl) to another (here, Ba'alšamin), not unknown at Palmyra: *164*, 147–56, no.7; nn.104, 134.

165 All in PM. Ba'alšamin: *42*, 83; *43*, IV (forthcoming). —House: p.104. —Parthia: cf. N. C. Debevoise, *AJA*, XLV, 1941, 45ff.; *44*, 134–6, pl.24, bibliography.

166 Tombs and burial methods in general: *197*, 45–84; *71*; *106b*, 252–3.

167 J. Starcky, *MUSJ*, XXVIII, 1949–50, 45ff.; *71*, 34.

168 Not yet formally published; see *31*, VIII; *98*, 460; *71*, 34–40.

169 *71*, 107–9; *168*, 88–9; *59*; *75a*, 17–19.

170 Tomb numbers: refer to catalogue in *197*, 45–84. —Development: *71*, 52–60.

171 *71*, 60–8, with references. Cf. *31*, VII, no.6a = *CIS* II, 4122 (AD 79/80), which seems to refer to this combination.

172 *197*, 52–3 no.44; *71*, 71–4.

173 Tower 63: *197*, 55–6 no.63. —Iamlikû: *197*, 54 no.51; *CIS* II, 4123, 4123*bis*; *71*, 84–7 (ground floor ceiling incorrectly described) with references. —Elahbel: *197*, 48 no.13; *CIS* II, 4134; *71*, 87–91.

174 *197*, 57 no.69 *may* have been built in AD 166: *31*, IV, no.2; but this is unlikely: *71*, 46, point 9. The three problematical towers nos.25–7 may be later, but contain no burials: so they seem to continue the tradition of the earliest 'tower' no.52, and to constitute huge stelae or nefeš, perhaps with burials beneath: *71*, 42–3. Cf. in general: *106b*, 252–3.

175 Dated examples are listed in *71*, 49–50.

176 *71*, 107–28; *140a*, 273–6.

177 *71*, 51, 129–46.

178 Cf. *71*, 18–33, 126–7, 129–30; N. Saliby, *MUSJ*, XLVI, 1970–1, 271–83; *115*, 385–6; *149a*, 28–9.

179 Today, evidence of where the deceased were laid is sparse. Tammâ transfers loculi to Abgar (in Aramaic; AD 279): *92*, 106–7. 'Tomb of Dionysus' graffiti (in

Greek; AD 312, 333): *90*, 14–20. Here and there sketched crosses suggest late Roman or Byzantine usage: e.g. in *197*, 57–8 no.70; see *71*, 99.

180 Mummy: NCG K.1: *172*, no.K.1. —Processes: *127*, I, 8, 9, 12, pl.IIa; *127*, II, 9; *127*, III, 8; *71*, 177–8. Cf. *59*, 122–3. —[Cremation (rare): *59*, 123.]

181 Examples: toys: e.g. doll: *14*, 40, fig.16. —Various finds, including a wooden pipe: *98*, 458; *59*.

182 Sun: *31*, VIII, nos.6, 8, 37; *169*, 351. See F. Cumont, *After-Life in Roman Paganism*, New Haven, 1922, 101–9, 156–64; *49*, 202–52; *78a*, VIII, 179–80. —'Monument': *31*, IV, nos.7a, 19, 27b.

183 'Soul': e.g. *31*, VIII, nos.6, 8, 37 (aniconic stelae); *CIS* II, 4328 (= PS 202) and 4597 (both male funerary relief busts). See *71*, 40–3.

184 The limestone plaque could be superimposed later over an earlier sealing of brick: e.g. in Bôlḥâ tomb, built AD 89: *6*; *119*, *154*. —Form: *124*.

185 Certain female souls were given two separate effigies, so that they had a choice of residence: e.g. 'Alâ (dated AD 113/4): BM 125695 (PS 31, group I Ad12*A*) and NCG 1079 (PS 32, group I Ae7*A*); Tadmôr (dated 29 June 148): Met 02.29.3 (PS 37, group II Bb14*B*) and DM (group I Gb16); Hadîrâ (3rd century): Lou 2000 (PS 73, pl.63) and Lou 2093 (PS 74, pl.64); Habbê (3rd century): PS 467 and 498: *115*, 43. This presumably came about only in special instances, such as when a married woman was commemorated in the tombs both of her own family and of her husband. —Usurpation: e.g. PM: *31*, VIII, no.25 (stele); DM: *128*, 889: curtain erased, then inscription placed over it; PM: *80*, 229 no.19, pl.2 (head replaced); FMC GR 8.1888 (PS 441, group II Ob): L. Budde and R. Nicholls, *Cat. Fitzwilliam Museum*, Cambridge, 1964, no.140.

186 'Portraits': e.g. *107*, 161–2 (subjective 'feeling' used as an argument). —Changing function: *71*, 40–2.

187 Identical features, different persons: e.g. PM 1937/7029 and 1963/7055. —Different features, same person: see 'Alâ, Tadmôr, Hadîrâ and Habbê, n.185. —Priest: private coll.: *CIS* II, 4562 (PS 12, 4 March 161; group II Ka15*B*).

188 See *67*.

189 See *71*, 177–81; *73*, 85. Roman comparisons: see esp. *189*, 33–64.

190 Formal publication awaited; see *31*, VIII, nos.1–54; *98*, 460; *71*, 34–40. —AD 140/1: *31*, VIII, no.2. —Curtain: e.g. PM 172: *154*, 140, pl.32.3; *116*, 69 no.27. —Double-stele: *31*, VIII, 20–1 and nos.49–50. —Symbols: e.g. PM: *154*, 140, pl.33.2; *116*, 69 under no.27. PM 263.

191 Man behind curtain: PM: unpublished, and PM 191: *31*, VIII, no.51; *154*, 140, pl.32.2; J. Starcky, *MUSJ*, XXIV, 1941, 40 fig.34; *116*, 69 no. 26. —Figure in foreground: e.g. KMV 1525; Grenoble Museum: *154*, 139, pl.32.1; Lou 5971; several in PM, unpublished except for *154*, 140, pl.33.3; *145*, 255, pl.X.3. —Late 1st century: PM B431, etc.: see e.g. *15*, 53 pl.10; DM: *98*, 459–63, fig.2, etc.

192 See Appendix I. Occasionally a group I stele with shaft is found inside a tomb, through re-use, slow adaptation or special need: e.g. *6*, 94.

193 Kitôt: *197*, no.44; *CIS* II, 4115, 4115*bis* (year read as 352 = AD 41); *200*; *71*, 71–4 (agrees with *200* that year is 351 = April AD 40).

194 'Ogeilû: *197*, no.194; *CIS* II, 4193 (why called 'Palmyrenes'?); *200*, 83, fig.3. —Iamlikû: *197*, no.51; *38*, 94–5; *71*, 84–7. —Elahbel: *197*, no.13; see esp. *71*, 87–91. —Anonymous priest: PM A3: *200*, 89, fig.11. —Three priests: PM 1/1703 + 2/1703: *200*, 99, fig.16.

195 Iarḥai: *4*, 242 no.12, pl.XXXVII.5. —Zabdâ: *111*, *1959*, 178–80 no.1, fig.197.

196 Examples in PM: e.g. stele of Ḥairâ; cf. *80*, 210 = *75b*, no.2. —Shaft surviving: see also n.192.

197 Transitional (arch within rectangle): PM 1997/7122: *15*, 51, pl.9. —Rectangular: e.g. Lou 1555: RES 1034 = *CIS* II, 4398 (PS 516, FS/I 3d R*f* 1B).

198 See n.197. Add e.g. PM 12, etc.

199 Ta'ai: PM: *80*, 244–5 nos.10, 36, fig.15. Cf. DM (*128*, 878).

200 PM A215: *CIS* II, 4126–7; *73*, 83–5, fig.14.

201 Warrior: PM (*128*, 1684; FS/I 3b C*f* 1M). Cf. Taimarṣû, n.100. —Archer: PM (*128*, F521; FS/Ar-I 3f C*p* 1M).

202 AD 114: LHO 41: *38*, 131 pl.28.14; PS 2 (boy and girl). —AD 130, with 3 figures: BAM 515: PS 3; *178*, 42 no.11, pl.XX. —4 figures: private coll.: *75*, 421–6, pl.XXIV.1.

203 Seated: e.g. PM 295/1498; DM (*128*, 877). —Parthian dress: e.g. NCG: PS 513; *92*, 69, pl.XXX.1; *44*, pl.44.

204 Coat: *155*, 22, fig.13.

205 Girls: e.g. private coll.: *186*, 178–9 no.7, pl.II.7. PM: *80*, 223 no.3, pl.II.1. —Grapes: e.g. LHO 41 (n.202); NCG (n.203).

206 Priest: e.g. Istanbul 3825. —Seated woman: cf. PM 2125/7223: *111*, *1959*, 180 no.2, figs. 199–200 (wife of Zabdâ, n.195). —'Framing': e.g. PM: *6*, 98 no.3, pl. —Curved: e.g. Istanbul 3727: PS 451.

207 Chin: e.g. NCG 822; Istanbul 3826: PS 526. —Himation: NCG 822. —Parthian dress: e.g. Istanbul 3826: PS 526.

208 Wreath encircling name: PM (FS/II 2c R*f*).

209 Boys: PM: 97, 104. BAM 692: *178*, 33 no.2, pl.XVII.3. —Man with servant: NCG 1024: PS 303; *92*, 73, pl.33.2.

210 Head: NCG 2816: *89*, 191, fig. — Earliest complete dated relief busts: Iamlikû tower (AD 83: priests and women). —Earliest complete independent dated relief: woman: NCG 1057: PS 30; *107*, pl.LII.2 (March AD 96 (?); group I Ad1). —Relief busts: *88*; cf. *124*.

211 Different workshops, same motifs: see Appendix II, subdivisions. —One workshop, varied motifs: see e.g. the busts produced for family tombs, many obviously from the same workshops: e.g. Iarḥai: *4*; Ta'ai: *80*; Šalamallat: *14*. —Individual sculptor's repetition: compare e.g. NCG 1047 (PS 85) with Istanbul 3789 (PS 86: group I Ba5); or NCG 2833: *44*, pl.41, with PM: *174*, 29 fig.8 (group II Qa4). Individual sculptor's variation: compare e.g. PM 1949/7041 (group II Ba4) with PM 1950/7042 (group II Qa9); or Lou 2000 (PS 73) with Lou 2093 (PS 74: pls.61–2).

212 Early examples: Iamlikû tower (AD 83: group I M): p.60. PM 902: *98*, 463–4 fig.5 (*c*.AD 90?). PM: *6*, 94–5 no.4, pl. (AD 103). Elahbel tower (AD 103): p.60. DM: *4*, 242 no.12 (AD 108).

213 Priests: see Appendix II, male groups I–III, subdivisions H–O.

214 Head turned: e.g. PM: *111*, *1961*, 138 no.30, fig.187. Lou 2398: PS 221; *CIS* II, 4381. —Cloak discarded: e.g. Met 01.25.5: PS 187; *38*, 129, pl.XXXI.5; DM: PS 189. —Objects: Appendix II. —Beneficiarius: LHO 33: PS 19: *CIS* II, 4292 (Jan. 189).

215 Objects: Appendix II. —Hair: pp. 141–4.

216 Poses, objects, jewellery: Ch. 8 and Appendix II.

217 Poses, objects, jewellery: Ch. 8 and Appendix II. —Technique: Ch. 7.

218 See Appendix II. —AD 240/1: private coll.: PS 53; *CIS* II, 4307. —AD 241/2: FGW 08.236: PS 54; *CIS* II, 4460. —Bareheaded: Strasbourg Library: *38*, 131, pl.XXX.9. —Grande dame: e.g. NCG 2795: cf. *107*, pl.LVIII.2. —Fringe: e.g. DM C.17: *81*, 37, pl.XV.2b.

219 See *91*, 35 n.31; Appendix II. Examples: NCG 1075: *92*, 70, pl. XXXI.2 (child). NCG 1053: *38*, 120 no.26, pl. XXIX.13. With Siren: DM: *80*, 236, fig.14; *CIS* II, 4444.

220 'Atenûrî: Lou 2067. A'ailamî tomb: *197*, 59 no.85b; *29*.

221 See *70*, 47–58, figs.1–4, with references. Cf. *197*, 56 no.65 (3 busts).

222 Priest in medallion: in 'funerary temple' 39d: *71*, 133, fig.78. —Another medallion fragment: PM: *111*, *1962*, 108 no.44, fig.45.

223 Tomb: n.220; this piece unpublished. —Pair before rosettes (from same tomb?): NCG 1148. —Framed: PM: *111*, *1959*, 113 no. 36, fig.125.

224 Belšûrî: *73*, 81–5, fig.12. —By towers 17 and 18: *73*, 85–6, figs.15–17.

225 Cf. rejection of Greek costume for Parthian: p.121.

226 Illustrated: *38*, pl.XI.1. Contemporary: *70*, 47–9.

227 Inscription: *35*, 354–5. Illustrated: *200*, 88–9, fig.10.

228 DM: *4*, 237–41, fig.7.3, pl.XXXVI.1, 2; *81*, 54, cf. pl.XXI. W. niche: *164*, 36, fig.3.

229 Priest and wife: NCG 1159: PS 8 + 38; *CIS* II, 4458 (AD [1]46/7, 'framed'). —Moqîmû: DM: *140*, 18–21, pl.I.2 (29 June 148). —Woman: *6*, 45–6; *75b*, no.71, pl.III.

230 PM. PM 1780/6603: *14*, 37, fig.10; *15*, 43, pl.6.

231 Rich decoration: e.g. 'Atenatan hypogeum fragment: *155*, 14, fig.5.

232 E.g. DM: *4*, 242 no.6, pl.39.2 and 250–1, pl.48.1. PM CD 55.59: *111*, *1959*, 98 no.16, fig.105. PM CD 21.59: *ibid.*, 96 no.15, fig.104. PM 1720/6391, 1724/6395.

233 NCG 1082 (old no.F1): *38*, 120 no.35.

234 E.g. PM A910/911: *99*, 182–9, pls.III–V (March 188). —[Greek dress: e.g. PM 1786/6609: *14*, 34–5, fig.9.] —Bolster: *155*, 16, fig.7.

235 Met02.29.1 (PS67): *38*, pl.XXVII.11; *CIS* II, 4259. Cf. his mother (PS 37) and brother (PS 16).

236 Base: PM: *111*, *1960*, 141 no.14, fig.156 and 142 no.15, fig.157, where they are wrongly dated to the early 2nd century

by false analogy with Attic sarcophagus techniques: cf. pp.109–18. If by Palmyrene hands, they would represent extreme examples of the use of chisel, drill and modelling seen on many relief busts of *c.*AD 150–230. Or did imported artisans execute them? And when? There would have been no call for such elaborate pieces at Palmyra before *c.*AD 150; no other examples of unusual compositions between couch legs seem to occur before *c.*AD 200, so perhaps these pieces are of the early 3rd century AD.

237 Costume: see e.g. *155*, 17–20, figs.10, 12, 16. —Girth: fragment in *197*, 59 no.85b.

238 Two on right: e.g. DM C.4947: *81*, 46 no.51, pl.XIX.2; *44*, pl.46. —Symmetrical: PM 1795/6644 (AD 238/9).

239 Woman: fragment in *197*, 59 no.85b. —Man: PM A217. —With box: NCG 1066: PS 457. —With keys: NCG 1065: PS 458.

240 Two examples in PM.

241 Banquet: examples in *197*, 59 no.85b; see *200*, 88 fig.9. —Victories: PM: R. Mouterde, *MUSJ*, XII, 1927, 281; *24*, 415. —Eagles: Istanbul 3802.

242 Weathered: lying near tombs: *197*, 71–6 no.86 and 65 no.150. —Friezes: p.81.

243 Jugs and cups: e.g. PM 882/2085. Others in PM: *111*, *1960*, 151 no.22, fig.166; *ibid.*, 153 no.23B, fig.168; *ibid.*, 154 no.24, fig.169; *111*, *1961*, 156 no.49, fig.206; *111*, *1962*, 192 no.16, fig.137. —Lamb: PM: *111*, *1960*, 153 no.23A, fig.167. Private coll.: F. Sarre, in J. Strzygowski, *Studien zur Kunst des Ostens*, Berlin, 1923, 69–71, pl.III.2.

244 PM: *98*, 458; *128*, F546. —[Another fragment, with syrinx: PM: *128*, F517.]

245 Wreath: Lou 15.556: *13*, no.536. —Bow, etc.: PM 1045/2248.

246 Officer, etc.: PM 2093/7431: *111*, *1960*, 143 no.16, figs.158–60. —Two cameleers: DM: *81*, 38 no.25. —Cameleer: *111*, *1960*, 157 no.27, fig.172.

247 PM 1046/2249: H. Ingholt, *Gandharan Art in Pakistan*, New Haven, 1957, 26, pl.VI.2. Tomb dated March AD 236: *197*, 65 no.150; *CIS* II, 4209; *71*, 201 no.65.

248 Only known example: private coll.: central fragment of a banquet relief, inscribed in Greek ('Alexandros').

249 See e.g. *38*, pl.XVII.1. Standing figure: n.253. Lion: *197*, I, 49, *s.v.* 17b.

250 All these 2nd-century sarcophagi are in tombs or on site, unpublished.

251 Fragments outside *197*, 65 no.150 and in *197*, 59 no.85b.

252 'Abissai: *92*, 79ff. —Maqqai: *92*, 63ff., pls.26–7; *155*, 28, 40, pl.V.1, 2; *71*, 200 no.62.

253 Banquet: *94*, 117–19, pls.XLIII.2, XLIV.1–3; *200*, 86, 88, fig.5. —Figures: on site. —'Pages': *92*, 73, pl.XXXIV.1, 2. —Maqqai: n.252.

254 Identical: *94*, 138–9, pl.L.1 ('Abd-'astôr). —'Abissai: *92*, 78–82. —Šoraikû: *73*, 77–81, figs.7–11.

255 E.g. Istanbul 231: *94*, 70, pl.XXXII.1; Istanbul 3788; BM 132614; Strasbourg Library: *38*, 131 pl.XXVII.12 (PS 72).

256 E.g. Lou 2000: *38*, 122 no.11, pl.XXXII.12 (PS 73); Lou 2093: *38*, 122 no.12, pl.XXXII.13 (PS 74); Lou 5001: A. Vigneau and A. Ozenfant, *Encyclopédie photographique de l'art*, Paris, 1936, vol.II, 120A (PS 71); FMC GR.6.1888: n.185.

257 Ta'ai: DM: *80*, 233–5 no.20, pl.II.2. —Malkû: Philadelphia Museum CBS 8902: *104*, 348, pl.5; *13*, 557 (PS 262).

258 Mostly PM and DM. —Three men: PS 22A. —Priestly headdress: PM: *200*, 89 fig.12. —Conical cap: YUM: *136*, 152, pl.XXIII.1; *96*, no.11, pl.

259 Bowl: e.g. Lou 4999. —Tambourine (?): PM: *111*, 1960, 159 no.28, fig.173; *111*, 1963–4, 49–50 n.6. —Libation horn: PM: *ibid.*, 49 no.3, fig.57. —Modius headdress: PM 1793/6642: *15*, 43 pl.6.

260 DM C.2153: *81*, 35 no.17, pl.XIV.1. Istanbul 3728: PS 528.

261 With decoration: PM 2216/7882: *111*, 1963–4, 50 no.4, figs.58–60.

262 With lamb: private coll.: R. P. Savignac and J. B. Chabot, *Revue Biblique*, XXIX, 1920, 364, fig.1. —Lamb on platter: Philadelphia Museum CBS 8903: *104*, 348, pl.6. —Plate: R. P. Savignac, *loc.cit.* —Cup: BAM, photo 23. —Bowl and rhyton: Lou 4084: *92*, 72, pl.XXXIII.1; *13*, no.553. —Fruits, etc.: A. de Ridder, *Collection de Clercq*, IV, Paris, 1906, 71–2 no.55, pl.XXX; *13*, no.538.

263 Finds in tombs: see esp. *155*, 34–7, figs. 21–2, pl.I; *111*, 1961, 1962. —Inscribed base: PM A416: *185*, no.60.

264 All in PM. Man: *111*, 1959, 184–5 no.5, fig.203. —Woman: PM 2026/7224: *ibid.*, 182–5 no.4, fig.203. —Heads and fragments: *111*, 1961, 1962.

265 Jug and ladle: PM: H. Ingholt, *Syria*, VII, 1926, 140, pl.XXXIV. —With scroll and leaf: DM C.3064: *92*, 68–9, pl.XXIX.1. —Headless: in *197*, 56 no.65. —Qasr el-abiad: tomb: *197*, 46 no.3. Statues: PM A29/1231: *155*, 34–7, figs.21–2, pl.I. —[Two base fragments: PM A416: *185*, no.60. PM: *111*, 1961, 219 no.11, fig.257.]

266 Headless, standing: DM. —Seated: *4*, 251, pl.XLIX.

267 Istanbul 3737 and 3807, BM 125058 (except head, which does not belong); *140a*, 275–7, fig.3 ('Pudicitia').

268 PM: *111*, 1962, 84 no.18, fig.118 (fragment).

269 Horse from 176: *197*, 68 no.176, fig.67. —Another horse fragment: PM. —Lion: NCG 1154.

270 Gorgoneion (?): *199*, 99 fig.9; *71*, 69–71. —Garlands: *197*, 71–6 no.86, pls.XXXVIII–XLIV; *71*, 140–5, figs.87–9.

271 Lion-head: Lou 2067. —Bearded: *197*, 56 no.65; *71*, 103–4. —Youth: PM: *111*, 1961, 166 no.61, figs.218–19. —Iarhai youth: *4*, 242 no.13, pl.39.3, 4.

272 Victories as tomb reliefs: *197*, 66 no.164, 69–70 no.186; *71*, 92, 136–7. —As statuettes. With palm: PM. On half-globe:

PM: *111*, *1960*, 118–22 no.3, figs.132–4.
With wreath: *15*, 41, pl.5. —Inscription:
4, 260ff.; p.109.

273 Friezes: *197*, 75 no.86, figs.73–4; *71*,
144. Also in *197*, 56 no.65 (row of eight
men below the cornice of the ground-floor
chamber). —Priests: PM: *200*, 99 fig.16.
—Snake: *197*, 65 no.150; *71*, 145–6 (AD
236).

274 Iarḥai: *4*, 235–43, pls.31–7; *81*, 54,
pl.XXI.1. —Goddess: on site, near *197*,
no.150. —'Silhouette': *ibid.* —Three fig-
ures: on site: *200*, 99. —Dolphin: on site,
near the three figures.

275 PM: *111*, *1960*, 114 no.1, figs.129–30
(suggests it may be from same tomb as
'Calydonian boar' relief, p.75). From the
ceiling's data the patron's birthday may be
calculable. Cf. priest, 39d: n.222.

276 Colouring: see e.g. pp.37, 83, 86.
Discussion: pp.118–20.

277 *200*, 74, fig.1, pls.VII–VIII. Cf.
pp.118–20.

278 Paintings: *in situ*; mentioned by *197*,
49 no.19; *111*, *1961*, 77, 198, fig.242; *71*,
61, fig.25. Wiegand's 'stars' are obviously
the four-leaf rosettes, and Gawlikowski's
'busts' must be the masks.

279 Garland: *71*, 66. Tomb 62: *197*, 55
no.62 (where this Victory is misinterpreted
as vegetation). There are more red stripes
inside this hypogeum, and a roughly
painted red plant.

280 Iamlikû: *38*, pl.XIII.3; *197*, 54–5
no.51 (accurate); *71*, 84 ('floral', partly
corrected, 87).

281 Elahbel: *38*, pl.XII.1; *197*, 48 no.13;
71, 87–91. Could the same company have
decorated the interior of *197*, 46 no.3; *71*,
130–2, figs.74–6?

282 PM: *89*; *181*, pl.XIII.1; *71*, 118.

283 Older publications reproduce por-
tions of the paintings now faded or
damaged: J. Strzygowski, *Orient oder Rom*,
Leipzig, 1901, 11ff., 24ff., figs.2–3, pl.I; *58*;
A. Djemal Pascha, *Denkmäler aus Syrien*,
Berlin, 1918, pl.68; *38*, 96–105, pls.XIV–

XVIII; M. H. Swindler, *Ancient Painting*,
New Haven, 1929, 391–2, pl. 605. —More
recent discussion and photographs: *47*, 166;
88, 68 n.2; *135*, II, 181–93, esp. 190; *92*,
62–3, 74–5; M. Borda, *La pittura romana*,
Rome, 1958, 331–2; *105*, I, 404, 409, 414
n.12, 551ff.; *7*, VIII.1, 244–6; *103*; *71*,
118–20; *189*, 223–4. —Inscriptions: *CIS* II,
4171–86; *35*, 354–5.

284 Iamlikû: p.83. Elahbel: p.84.
Ḥairan: p.84. Maqqai: p.87.

285 See pp.72–3.

286 *CIS* II, 4171–3.

287 Cf. F. Wirth, *Römische Wandmalerei*,
Darmstadt, 1934, esp. 142–52, 183–99.

288 Pose with child: cf. Appendix II,
female groups II Rc and Tc, and III Ga.
—Pose with veil: cf. *ibid.*, III F and G.
—Inscriptions: *CIS* II, 4178–9.

289 'Abd'astôr: *94*, 139–40, pl.L.2, 3; *71*,
117–18, fig.69 (*sic*).

290 *92*, 62–3, 74–5, pl.25; *71*, 113, fig.67
(SW necropolis).

291 *90*, 14–20, pl.IV; *71*, 117.

292 Local: cf. *90*, 18–20.

293 Urbanization, etc.: *66*; *76*; *141*; *146*;
62; 19, 43–4; *139*; *43*, I, 96–7; *8*; *71*,
147–66; *59*, 116–21, 134–5; *140a*, 282–3;
75a; *106b*, 247–54; *65* (Van Berchem,
Gawlikowski, Frézouls). —[Inscriptions:
CIS II, 3913–71; *31*, III; *31*, V, 19; *176*,
4–5; *111*, *1959*, 208, etc.] —See also
G. W. Bowersock, *loc.cit.* (n.8), esp. 137
(wall Vespasianic); J. B. Ward Perkins,
Papers of the British School at Rome, XXVI,
1958, 181–2 (Kaisareion?).

294 Image: PM A959: *176*, no.100; cf.
PM A958: *ibid.*, no.95. —Bel court: *31*, IX.
—Tiberius: *31*, IX, no.2.

295 Consoles: cf. *163*, 4. —Column: *CIS*
II, 3930–1; *31*, II, nos.1–3 (AD 64, 139).
—Lettering: *176*, 4–5; *43*, I, 44.

296 Sanctuaries: Bel: e.g. *CIS* II, 3914–
23; *31*, IX. Ba'alšamin: cf. *43*, I, 96–7.
—Agora: *114*, 20. —Severans: *176*, nos.64,
67; *181*, 47. —Odainat: *31*, III, nos.16–20;

CIS II, 3944–7. —Equestrian: e.g. *35*, 277–82, pl.LIII.

297 Empty consoles: cf. *43*, I, 72. —Iarḥai: *CIS* II, 3960; *176*, nos. 86–90, 107, 111; *30*, nos. 8, 9.

298 *CIS* II, 3913, lines 128–30 (Aramaic).

299 All in PM. —Largest foot: PM 4803/3. —Bel court foot: *155*, 38 n.3. —Miniature bust: *20*, pl.IV (from Nebû sanctuary; height *c.*4·5cm.).

300 See esp. PM 1863, 1865, 1866/6786, 1875, 1888; cf. nos. A929, 949, 719, etc.; *42*, 85, pl.IX; *43*, IV (forthcoming). The fragment of a similar statue from the Bel sanctuary, with lower cloak and calves, may also have been honorific: see p.31.

301 Priestling: Istanbul 3799: PS 244 or) funerary?). —Heads: moulded features: NCG 1151: PS 321. Eyebrows: AUM 50.16.

302 Woman: PM CD.36.61: *111*, *1961*, 173–4 no.67, figs.225–6. —Bare heads: late 1st to early 2nd century: NCG 1093: PS 130; *172*, 46 no.G4, pl.XII. PM: *9*, 73–4, pl.III top. Mid-2nd century: PM CD 20.63: *111*, *1963–4*, 56 no.7, figs.63–4. —Wreathed: PM.

303 PM 1056. Lou 22252: A. de Ridder, *op.cit.* (n.262), no.57, pl.XXXII; *13*, no.539. Cf. also another sandalled fragment: PM 1404.

304 Trousered: PM B51. —'Ogeilû: DM 4129: *81*, 80 no.8, pl.XXXIX.1 (*c.*AD 200). —Other examples: PM A138; statue on site, at south end of Transverse Colonnade. Both wear Greek costume and sit on cushioned stools (*c.*AD 200).

305 Bearded, gazing left: NCG 1145: PS 243. —Pair, bearded: NCG 1121: PS 241. Istanbul. —[Some beardless heads: PM 1744. PM CD 37.63: *111*, *1963–4*, 62 no.12, fig.69. PM CD 1.59: *111*, *1959*, 86 no.5, fig.94 (late 3rd century?). —Other male statue fragments: base with left foot: PM CD 41.60: *111*, *1960*, 138 no.12, fig.154 (after AD 150). PM CD 64.60: *ibid.*, 156 no.26, fig.171 (or funerary?).]

306 PM A22, A23; cf. *155*, 38 n.5. Cf. also Westernized fragments: *111*, *1962*, 113 no.51, fig.152. —[Date: cf. *205*, 74–82.]

307 Feet and base: PM CD 75.60: *111*, *1960*, 141 no.13, fig.155. —Torso: PM A2. —Busts: see Appendix II, female group I Ad.

308 'Herculanaise': PM 2062. —'Pudicitia': on site. Cf. the lower portion of another on a semicircular, moulded base: PM A1.

309 Togate men: DM C.4025: *81*, 42 no.39; *3*, 122 no.2. DM C.4024: *81*, 45 no.49 (why 'a priest'?). —'Pudicitia': DM C.4022: *81*, 44 no. 47. —'Herculanaise': DM C.4021: *81*, 43 no.41. —Agora: *93*, 124–5, pls.XXV–XXVI.

310 Heads: DM. With curls: DM C.4026: *81*, 44 no.44. —Cuirassed torso: PM 1806. —Cuirassed fragments: PM. —Female statue fragment: PM.

311 Texts: *176*, nos.64, 67; *181*, 47; *CIS* II, 3970 (AD 203). —Heads: DM. —'Aphrodite': PM (ht. 55cm.). —Ablutions: J. Carcopino, *Daily Life in Ancient Rome*, London, 1956, 257–9.

312 PM. Cf. Tetrarchic (?) head: PM: *111*, *1959*, 86 no.5, fig.94.

313 All on the site, unpublished.

314 Man: PM (late 2nd century). —Legs: *155*, 22, fig.14 (probably 3rd century).

315 Women: PM 454: *93*, 95 no.5, pl.XX.3. —Ḥaddûdan: BAM 520: *93*, 88–91, pl.XX.2; *178*, 43 no.14. —[Two more in Ba'alšamin precinct: *43*, I, 153–4 no.1.]

316 PM A24/1226: *93*, 116–23 no.16, pl.XXIV.1; *174*, 14 no.14, 30–2 (*c.*AD 175–225).

317 Woman: PM CD 72.61: *111*, *1961*, 167 no.62, fig.220. —Cornice: PM CD 41.61: *ibid.*, 169 no.64, fig.222. —Boys: PM 457, A5. —Urn: PM 2179. —Horse: PM. —Agora boy: PM. —Eros: PM B473/1676 (ht. 63cm.).

318 2nd century BC: *59*, 137. 1st century

AD: *111*, *1962*, 12; K. Michalowski, *AAS*, XIII, 1963, 81 fig.2; *111*, *1963–4*, 10–14, fig.3; *62*; M. Gawlikowski considers them sanctuary banqueting rooms.

319 See *66*; *197*, 17–44; *181*, 109; *59*, 134–5. —Bel quarter: *170*. Is it not possible that one of these great houses was converted into the as yet undiscovered 'palace of Zenobia'? Cf. p.21.

320 Pottery: Hellenistic: *26*, 184; *59*, 71–93, 137. Roman period: vessels: *111*, *1959*, 186–98 nos.9–34; *111*, *1961*, 174–9 nos.68–77; *111*, *1962*, 18–20, figs.15–18, and 119–36, nos.61–107; *111*, *1963–4*, 90–2 nos. 43–50; *5*, 83ff., pl.; *84*; *59*, 71–93, 137. —Lamps: Hellenistic: *59*, 87–93. Roman: *4*, 262–4; *111*, *1960*, 208–12 nos.94–104. With figures: *111*, *1962*, 132–6 nos.95–107, pls.IV, V; *140a*, 276, fig.2.

321 Glassware: Hellenistic: *59*, 93–5, 136. Roman: *111*, *1959*, 199–200 nos. 35–7, figs.222–3. —Glass working: *107*, 178.

322 Tomb: p.58. —Alabaster: *59*, 95–103, 137. —Iconography: p.222.

323 Reluctance: *80*, 250–1. —Finds: *c*.150 BC–AD 50: *59*, 103–6, 109–10. Roman period: *111*, *1959*, 200–4 nos.38–49, figs.224–8; *111*, *1961*, 180–2 nos.78–89. —Imprints: p.223.

324 Representations: see *88*; *107*; *68*.

325 Dura jewellery: *135*, II, 78–82, pls.44–6; *135*, IV, 246–59, pl.26; *7*, IV, Part IV, 40–69, pls.8–15; *147*, 70, pl. —'Pearls': p.97.

326 Glass working: *107*, 178. —Corporation: *CIS* II, 3945; *31*, III, no.17.

327 Malkû: *98*, 458. —Šalamallat: *14*, 40, fig.16. —Mould: *115*, 217, pl.VIII.1 (dated ludicrously early: letters BL could equally be of the first three centuries AD).

328 Detailed scientific study: *127*.

329 Graffito: *135*, IV, 79–145, esp. 139–41; *SEG* VII, nos.381–430.

330 *127*, II, 16, T.63; *127*, III, 18, T.96; *7*, IV, Part II, 2.

331 Dura-Europos: see *7*, IV, Part II, 14–15.

332 Maqqai: see pp.77–8, 87.

333 Wool: *127*, nos.L.1–129, and comment, esp. I, 26–8, 31–7, and III, 29–38.

334 *127*, nos.S.1–50; cf. *198*, 26–7, 44–5, fig.42.

335 Statues: p.80. —Elahbel: p.84.

336 See p.217.

337 Triangular: e.g. PM CD 50.61: *111*, *1961*, 128–9 no.19, fig.176. PM A214. Private coll.: Sotheby's, *Catalogue of Sale*, 1 July 1963, frontispiece. Lou 18.174. —Woollen hem: *127*, III, 26–8 no.L.124. —Banqueter: PM: *155*, 20, fig.12; *127*, III, 31, fig.16. —Linen: cf. *127*, I, 19, T.20. —Wool: *127*, III, 22, L.95.

338 Band: *127*, III, 25–6, L.121. —'Running dog'; p.217. —Beaded border: *127*, III, 26–8, L.124–5. —'Beading': p.216. —H: *127*, III, 16, T.89; 22, L.92; 30; *140a*, 275–7, figs.4–5. —Banqueter: *127*, III, 30, pl.Xc; *155*, 24, fig.16 (mid-3rd century). Cf. also Lou 2398: PS 221 (pl.79).

339 Useful discussion: *127*, III, 30–7.

340 PM 1003, etc.; DM C.4984–9. Discovery: *47*, 218, fig.45; *3*, 127.

341 E.g. PM 1003. —Pergamon: E. Schmidt, *The Great Altar of Pergamon*, Leipzig, 1962, *passim*.

342 Distortion: e.g. *193*, 397 no.5. —Ba'alšamin: p.57.

343 PM, gallery.

344 Bearded statuette: PM 36.B.17Y8 (ht. 28cm.). —Cloaked statuette: PM 48.B.1779 (ht. 26cm.). —[Cf. marble Greek inscription fragment: *111*, *1960*, 238 no.2, fig.289.]

345 Eros: p.93. —Pan: BM B482 (ht. 30cm.).

346 Frieze: PM: *111*, *1960*, 117 no.2, fig.131. —Capital: PM (ht. 62cm.). —Shoulder: AUM 50.3: *107*, 177, fig.6b (ht. 13cm.). —Torso: PM: *111*, *1960*, 133 no.8, fig.149. All 2nd–3rd centuries AD.

—Dancing girls: see e.g. E. W. Lane, *The Manners and Customs of the Modern Egyptians*, London, 1836, ch.XIX; *106*, s.v. GHÂZIYA.

347 Houses and mosaic: *170*. —Mosaic: PM. Odysseus and Deidameia: PM 1681. Asklepios: PM 1686. PM B1687–8, etc. —View of mosaic *in situ*: *128*, F3354.

348 See *170*. Cassiopeia: DM C.4945: *81*, 47 no.52, pl.XX; *3*, 122–3, pl.IX. Andromeda: PM 1684. Centaurs: PM 1682.

349 Techniques: *90*, 18–20; *103*, 18. —Dura: *138*, 256; *7*, VIII, Part I, 364–5. —Parthia: cf. *44*, 160–3; *147*, 54–9, 69, 72, 88, 92–4, 102–11.

350 Corporation: n.326. —Tariff Law: *CIS* II, 3913, lines 129–30 (Aramaic). —Small objects: *59*, 103–8.

351 Technical details: *127*; cf. *198*.

352 Linen: cf. *198*, 13–14, 27–9. —Wool: *198*, 4–5, 10, 22–6. —Gold thread: *198*, 39. —Cotton: *198*, 17–19, 30. —Silk: *198*, 10–13, 26–7. —'Gilded membrane': *198*, 39.

353 Spin direction: cf. *198*, 38, 44–5.

354 Dyes: *198*, 79–82. —Purple: *127*, I, 22–30; III, 31, T.1–95; *198*, 81.

355 *127*, nos.T.14, T.15, T.92; *127*, I, 23–4 and III, 19; *198*, 39.

356 Techniques: *127*. —Weaves: cf. *198*, 45–55. —Diamond twill: *198*, 49. —Tapestry: *198*, 54–5. —Near East: cf. *198*, 47, 49–51, 53, 55. —Damasks: *198*, 51–2. —Drawloom: cf. *198*, 78. —Embroidered motifs: p.224.

357 Techniques: cf. *196*, 405–6, 433–8.

358 Roman glass: cf. p.221.

359 Quarries: *5*, 109. *Parinos* 'of high quality limestone' at Palmyra: *111*, *1959*, 208 no.2; *111*, *1960*, 121, 261; *75a*, 83–4, 100; cf. *115*, 54. In support is the rarity of marble at Palmyra. *Parinos* as 'of marble': *4*, 260; *204*, 1410; *19*, 43; *115*, 315–16.

360 See *1*, Part One.

361 Early history of the claw chisel: much

depends on the precise dating of recognizably early sculptures; e.g. horseman PM 2007, with traces of a small claw under the front rosette; or Foundation T sculptures, flat chisel and rasp work easily discernible, other tool marks less so.

362 Rough carving: *1*, 104–7. Examples: relief busts: PM 1992/7117 (woman: on background and shoulders; group I Ab). PM 1990/7115 (woman: face, I Ae). PM 2001/7126 (face and hand). Lou 2201: PS 10 (man, II Ba): chisel with *c*.6 teeth to 1cm.

363 E.g. Istanbul 3749: PS 119 (man, group I Dc). Toronto, R.O.M.A. 424: PS 394 (woman, II Ba). Cf. NCG 1077: PS 423 (woman, II Na).

364 E.g. Lou 7476: PS 373 (woman, I Ae): for earrings.

365 Methods: cf. *1*, 61–73. —Early Palmyrene examples: e.g. horseman reliefs PM 2005 and 2007: trouser seams, horse trappings.

366 Architectural ornament: see blocks on site, and in PM: e.g. PM 6708 (merlon, simple and 'running' drill); 'priests' niche': p.66. —Drill unnecessary for limestone: suggestion of Dr J. J. Coulton.

367 E.g. AUM 2739: PS 43; *44*, pl.45. NCG 2795: *44*, pl.42. Cf. AUM 2736: PS 196. I am grateful to Miss Amanda Claridge for discussion of many of these points.

368 PM A959: *185*, no.100.

369 PM B53: n.95.

370 PM 2007: cf. p.43, n.106.

371 PM 801/2004, Lou 19.799: n.70.

372 Pp.35–8.

373 Surround: *1*, 19, 22. —Lintel: n.68.

374 Lou 19801: n.112.

375 PM 72/71; cf. p.64, n.190.

376 Qasr el-abiad: n.265. —Ba'alšamin: n.300.

377 PM, gallery. —Point: cf. PM 2000/7125, around head. —Claw, 5 teeth/10mm.:

PM 2001/7126. —Claw, c.6 teeth/20mm.: PM 1991/7116. —Background unsmoothed: PM 1999/7124. Cf. families of Ta'ai: *80*; and Nebûšûrî: *6*.

378 PM, gallery: *14*. —Woman: PM 1762/6586: *14*, pl.V.1.

379 PM 2170–9: *111*, *1962*, 90–8 nos.24–33, figs.124–34. Cf. PM 2089/7426: *111*, *1960*, 175–6 no.45, fig.192; PM CD 26.63: *111*, *1963–4*, 64–5 nos. 14–15, figs.71–3.

380 AUM 2739: PS 43: *44*, pl.45.

381 PM 2216/7882: *111*, *1963–4*, 50–4 no.4, figs.58–60 (c.AD 200–25).

382 PM 876/2079, from SE necropolis (1·9m. by 1·93m.; c.AD 200–50). Cf. the unfinished 3rd-century heads: KMV 608, 610, also flat-worked.

383 *1*, 104–7.

384 Cf. p.118. I am grateful to Miss Amanda Claridge for discussion of these points. Useful comparative material: e.g. the limestone sculptures of Aquileia, N. Italy.

385 'Gashed': see pp.69, 142. —[Cf. Hatra: *85*, 8–9.]

386 PM A1286: n.126.

387 Veneers: PM. —Castor: n.107. —Statuettes: n.344. —Statues: nn.309–11. —Woman: DM 8810/C.4021: n.309. —Female head: DM 8815/C.4026: n.310.

388 'Parinos': p.109. —Alabaster: pp.95–6, 222.

389 All in PM. —Victory: n.73. —'Red Head': PM 180/1272: *154*, 139, pl.31.3. —'Aglibôl: PM 1899/6843.

390 'Battle': n.79. —Kitôt: *200*, 74, fig.1, pls.VII–VIII. —Horseman: PM A150/1253: n.106.

391 See n.100.

392 Eyes, intaglio: e.g. PM 1904. —Ta'ai: *80*, 225 no.5, 240–1 no.29. —Red stripe: DM C.12: PS 453. —Colourful woman: p.116, n.378. —Priests: PM: *111*, *1959*, 85 no.3, fig.92. PM: *111*, *1960*, 165 no.36, fig.182.

393 Banquet: DM C.4947: *81*, 46, pl.XIX.2. —Maqqai: nn.252, 290. —'Beauty': NCG 2795: *107*, pl.LVIII.2. —Forearms: H. Seyrig, *Syria*, XXIX, 1952, 232–4, figs.13–15 = 'Ant.Syr.' 53.3.

394 Cf. Hatra (similar): *85*, 9–11. Greek, Roman: G. M. A. Richter, *AJA*, 48, 1944, 321–33; P. Reuterswärd, *Studien zur Polychromie der Plastik: Griechenland und Rom*, Stockholm, 1960, esp. 191–247.

395 Plaques: n.56. —Triad: n.114. —Ta'ai: *80*, 229, pl.II.

396 'Ba'alšamin': n.112. —Cuirass: DM: n.120 (but with similar holes in hair and shields). PM (*128*, F551). —Heads: NCG 1121; PM (*128*, F493). —Earlier Near East: e.g. *64*, ills.39–49, 52–60, 90, 108, 119, 131, 148, 252–3, 284–6, 322, 338, 343, 345, 373. —Contemporary Near East: Hatra: *85*, pls.I.1, II.1–2, III.1–4, V.4, VIII.5, etc. —Ta'ai: *80*, 221 no.1, pl.I.1.

397 Iarḥai: *94*, 99–103, pls.XXXVI.1, XXXVII. Parthenon: B. Ashmole, *Architect and Sculptor in Classical Greece*, London, 1972, 126–42.

398 Siting: Near East: *64*. Western: A. W. Lawrence, *Greek and Roman Sculpture*, London, 1972, 21–2.

399 Its affinities are vague. It could be related to the large architectural thalamos or adyton, especially the Bel temple type, whose origins have been traced to Assyria: n.401. Note also similarity to niches of Ptolemaic Egypt: e.g. E. A. Wallis Budge, *Egyptian Sculptures in the British Museum*, London, 1914, pl.L. (146–117 BC).

400 *54*, 28ff. nos.30, 33–5, 36–8(?).

401 Ancestry: *43*, I, 133–6.

402 Parallels: e.g. Rome, Forum of Nerva: E. Nash, *Pictorial Dictionary of Ancient Rome*, London, 1961–2, *s.v.* Baths of Agrippa: *79*, pl.IV.

403 Roman East: e.g. Baalbek: D. Krencker *et al.*, *Baalbek*, Berlin, 1923, vol.II, pls.XL–XLVIII; *133*.

404 Hatra: W. Andrae, *Hatra*, vol.II, Berlin, 1912, 148–50, fig.251, pl.XII.1

(N. iwan). Cf. reliefs at Karnak, Hypostyle Hall.

405 Parallels: cf. n.403.

406 Cf. Dura niche: *135*, V, 103–16, pl.XIII (AD 54). —Cult images: *144*, 114; cf. *201*, 226.

407 Northern extent: cf. F. Chapouthier, *Les Dioscures au service d'une déesse*, Paris, 1935; *201*, 457–9. —Western: Djoub el-Djarrah: n.709. —Eastern: Dura: *135*, VII–VIII, 91–100, 163–7, 258–68, 290–302, pls.29–31, 33–5, 37, etc. Hatra: cf. *77*, pls.2, 98. —Roman Empire: *201*, 19–23, 48–51, 456–64.

408 Altars: Hauranese: e.g. *54*, nos.164, 170–3, 175–9, 191–2, etc. —Tesserae: parallels: *196*, 388; *24*, 540, 712.

409 Repertoire: *63*. —Niches: cf. e.g. *189*, 117–18, 245, pls.29–30. —Syria: *149a*, 29.

410 Coffers: cf. nn.403, 409. —Hypogea: Western: cf. M. H. Swindler, *Ancient Painting*, London, 1929, 349–52, figs.556–9, 601–4 etc.

411 W. Syria: *13*, nos.491, 511; *71*, 33. —Assur: Istanbul 1071–2, cf. 1759: W. Andrae and H. Lenzen, *Die Partherstadt Assur*, Leipzig, 1933, 105ff., pl.59a, c, d, cf. b; E. Herzfeld, *Iran in the Ancient East*, Oxford, 1941, 289, pl.CV; *44*, 146, pl.32.

412 Transference: p.66. —Position in tomb: cf. F. Poulsen, *Probleme der römischen Ikonographie*, Copenhagen, 1937, fig.54; *189*, 117–18, 245–6, nn.385, 625. —Roman: *124*. [Edessa: *149a*, 28.]

413 See *200*; pp.131–2.

414 Position: cf. pp.89–90, 124–5, n.418.

415 Roman: *189*, 278–9.

416 Greek, Roman: *188*, 95–105; *189*, 270–7; cf. *78a*, XIII, 174 *s.v.*; *149a*, 28.

417 Western: cf. *189*, 216–44.

418 Brackets: earliest: AD 32 (column), AD 49 (wall?): *43*, I, 43–4, 97; *56*, nos.37, 38. —Syrian region: *145*, 282. —Mesopotamia: Hatra: cf. W. Andrae, *Hatra*, vol.I, Berlin,

1908, 16, 129–32, fig.216; mostly unpublished.

419 W. Syria: cf. carved column-stele of Abidallat from Qartaba, Lebanon: BAM. —Busts: cf. *149a*, 28 (funerary).

420 P.105. —Parallels: E. von Mercklin, *Antike Figuralkapitelle*, Berlin, 1962, *passim*. Parthian capitals: *ibid.*, 30–1, 91–6.

421 Figurines: p.104.

422 Pottery: pp.94–5. Roman: *196*, 458–73. Parthian: R. C. Thompson, *Archaeologia*, LXXIX, 1929, 107, 138; N. C. Debevoise, *Parthian Pottery from Seleucia*, Ann Arbor, 1934; A. U. Pope, *A Survey of Persian Art*, vol.I, Oxford, 1938, 646ff.; *7*, IV, Parts I–III; D. and J. Oates, *Iraq*, XX, 1958, 114ff. Cf. L. van den Berghe, *Archéologie de l'Iran ancien*, Leiden, 1959, 225–33; D. Oates, *Studies in the Ancient History of N. Iraq*, London, 1968, 122–59. —Glassware: p.95. Cf. *7*, IV, Part V, esp. 146–50. —Alabaster: pp.95–6.

423 Textiles: pp.98–104. —Jewellery: pp.96–8.

424 Processional: ancient Near East: *64*. —Contemporary Near East: *160*, 31–44, pls.I–III; *44*, 143–55, 184–7.

425 Complex scenes: e.g. 'Battle': n.79. —Inward turn: e.g. n.118. —Alternate: e.g. n.252 (Maqqai). Cf. Gandhara: *96*, 5, no.22; *145*, pl.XII.3.

426 See n.424.

427 Victories: n.72. —Head turned: e.g. n.214. —Trunk: cf. n.425. —Mythological: cf. nn.236, 274, 291, 452–5. —Tesserae: profile: p.55, n.156. Attendants: RTP 193, 422, 424–5, 429, 751, 760. Cf. *24*, 40–2.

428 Dura: *135*, VII–VIII, 292–302, pl.37; *126*, 123–4. —Frontal reliefs: *138*, 158–86; *145*; *77*, 15–117; *85*, 11–12; *44*, 143–65; *147*, 196–9; M. A. R. Colledge, *Parthian Art*, London, forthcoming. —Revolution: *201*, 229. —Sasanians: *203*.

429 Cf. A. Parrot, *Nineveh and Babylon*, London, 1961, figs.9, 34B, 36–7, 40A, 82–3, 97B, 98B, 99D, 180A, 318, 358, 375, 395; *147*, 197–8.

430 Greek origin: *201*, 219–55; cf. *145*, 254–64; *147*, 196–201. —Feet: cf. C. Hopkins, *Ars Islamica*, III, 1936, 187–96. Note, however, that the feet of Foundation T, Agora and other early processional reliefs are gone.

431 See M. Avi-Yonah, *Oriental Art in Roman Palestine*, Rome, 1961, 87–96; *44*, 148–53; *126*, 123–4. Cf. *23*. —Greater contact: cf. name 'tpny, or Etpanei, 'He [the god] turned [towards his worshipper]'; *135*, VII–VIII, 83; *182*, *s.v.* —[Cf. N.W. Indian frontality, *c.*250–50 BC: B. Rowland, *Art and Architecture of India*, London, 1953, 50–5, pls.14–19 etc.; V. Dehejia, *Early Buddhist Rock Temples*, London, 1972, 114–17, 208, pls.9–16.]

432 Tesserae: symmetry: p.55; cf. RTP 141: *169*, 109–11, fig.11. —Banquet reliefs: p.76.

433 Achaemenian symmetry: e.g. *64*, pls.416, 435, 443, 446. Hatra: *77*, pl.103; *44*, pls.54, 60, 64. —Dioscuri: F. Chapouthier, *loc.cit.* (n.407); *201*, 30, 45, 89, ch.VI; H. Metzger, *Cat. mus. Adalia*, Paris, 1962, nos.8–11.

434 Tessera: RTP 515; cf. *24*, 38.

435 Near East: *64*, ch.7, pls.182–5, 194, 200–2, 206–8, 212, 215–16, ch.12. —Telephos: E. Schmidt, *op.cit.* (n.341), pls.60, 62, 67. —Roman: e.g. Cancellaria: J. M. C. Toynbee, *The Flavian Reliefs from the Palazzo della Cancellaria*, London, 1957. Trajan col.: K. Lehmann-Hartleben, *Die Trajansäule*, Berlin, 1926; L. Rossi, *Trajan's Column*, London, 1971. Marcus col.: G. Becatti, *La Colonna di Marco Aurelio*, Rome, 1957. Lepcis: M. Squarciapino, *Leptis Magna*, Basle, 1966, 63–9, pls.8–12.

436 Horses: PM (*128*, F474). —Six deities: n.118. —Tesserae: bull: RTP 161, 604; bed: RTP 490. Cf. RTP 292 (ring). —[Furniture in perspective: *130*, 136–43.]

437 Caskets: e.g. NCG 1030 (PS 328), Istanbul 3728 (PS 528).

438 'Stage space': cf. 7, VIII, Part I, 368. —Dura: *ibid.*

439 Ears: cf. p.64. —Derrick: RTP 722.

—Temple: RTP 214; *75a*, 13. —Scattered: RTP 162. —Nemesis: *150*, 51–3, pl.18.4, cf. 53–61, pl.18.5. —Cf. also p.222.

440 Analytical representation: *155*, 43–50; *24*, 38; A. D. E. Cameron, *Porphyrius the Charioteer*, Oxford, 1973.

441 Processions: more recent intermediaries are few: e.g. *77*, pls.64–5; *44*, fig.4 (123–110 BC). —Eagle lintels: cf. *145*, 266–7. —Incense: cf. *78a*, IV, 198–200. Origin of scene: *24*, 495ff. Hellenistic: M. Bulard, *Exploration archéologique de Délos*, vol.IX, Paris, 1926, pls.III.1, XI.1, XVII.2 etc.; *201*, 239–42. Parthian: *77*, pls.59, 60, 66.

442 Precedents: *64*, *10*, *82*. Flavian: *188*, 56, etc.

443 Hellenistic reliefs: *201*, 245, fig.47. —Soueida relief: *54*, 31–2 no.36; *153*, 165–73, pls.XX, XXIV.1; *78a*, XIII, 53–4 *s.v.* anguipede. —Procession: Dura: S. B. Downey, *AAAS*, XX, 1970, 139–40, fig.

444 Scrolls: pp.38, 39; *153*, 184. Hellenistic: J. M. C. Toynbee, *Papers of the British School at Rome*, XVIII, 1950, 1–43, esp. 6–9, 32; M. Wegner, *Ornamente Kaiserlicher Bauten Roms*, Cologne, 1957, 9–11. —Textile: Lou 2398: n.214. [Cf. Hatra: *190*, 109–10, n.21.]

445 Paratactic: *201*, 234–9; *82*, 188–90, cf. nos.163, 170–1, 175. —Dioscuri: n.433.

446 Handshake: cf. *169*, 101. In West, mostly between mortals: e.g. *120*, pls.VIII.2, IX.1, 3, XI.2, etc. In Commagene, between gods and royalty: e.g. *77*, pls.79–80; *147*, 196. Note that the (Greek) divine handshake, with right hand clasping right, differs from most Palmyrene funerary handshakes. —Crowning: in Greek art from 4th century BC: e.g. *51*, *s.v.* CORONA, fig.1992, etc.; cf. *86*, 4. —Seated: cf. e.g. 7, III, Part I, Fascicule I, 78. —Cf. also p.132, n.451.

447 Cf. *111*, *1962*, III no.50, fig.151. Western: n.86; 57, VII, *s.v.* Zodiaco; *78a*, XIII, 202–3 *s.v.*

448 Belšûrî: *73*, 81–6, figs.12–17. —Kitôt etc.: *200*. —Tessera: RTP 19. —Roman

sarcophagi: see esp. J. M. C. Toynbee, *The Hadrianic School*, Cambridge, 1934, 161–230, pls.37–56. —Asia Minor: *109*, III, 244–81 nos.1029–56, cf. 412 no.1170. [—Edessa: *149a*, 28.]

449 Significance of banquet scene: *164* 32–40; *96*, 2; J. M. C. Toynbee, *Art in Roman Britain*, London, 1962, 159; *73*, 85; *71*, 180–1; *147*, 84; *169*, 107; *189*, 51, 61–4; cf. *78a*, VI, 67–8; VIII, 228–32; XIII, 61 *s.v.* banquet.

450 Stele: Mesopotamian form: p.124, n.411. —Precedence: cf. *120*, 65. Correspondence with Roman practice could be accidental.

451 Right-left: e.g. *80*, 223, 244–5, fig.15, pl.II.1; PS 2, etc. —Other ways: *90*, 10, fig.5. Cf. above, p.131, n.446.

452 Copy-books: see e.g. J. M. C. Toynbee, *Collection Latomus*, VI, 1951, esp. 40–1, 46–7; *190*, 109–10. —Erotes: ubiquitous in West since classical times: cf. e.g. *51*, *s.v.* CUPIDO, etc. Funerary: *49*, 347–50, 407–12. —Arimasp: cf. *51*, *s.v.*

453 Ganymede: parallels: S. Reinach, *Répertoire de peintures grecques et romaines*, Paris, 1922, 14 nos.10 and 11, 15 nos.3 and 7; *49*, 98–9, pl.VIII.1; L. Foucher, *Inventaire des mosaiques*, *Sousse*, Tunis, 1960, D4 no.57.043, pl.IXa (*c.*AD 150), 43 no.57.092, pl.XXa (*c.*AD 200); L. Foucher, *Hadrumetum*, Tunis, 1964, 176–80, pls.XVI-XVII, etc. —Symbolism: ascension: *49*, 97–9. Rape: suggestion of J. M. C. Toynbee.

454 Parallels: cf. S. Reinach, *op.cit.* (n.453), 166; *105*, 111–12; L. Curtius, *Die Wandmalerei Pompejis*, Hildesheim, 1960, 206ff. and Index, *s.v.* Gemälde: Achill auf Skyros. —Symbolism: *49*, 22 n.3.

455 Winged figures: parallels: single: J. Strzygowski, *op.cit.* (n.283), 25–6; *135*, II, 181–93; cf. S. Reinach, *op.cit.* (n.453), 327; M. Borda, *op.cit.* (n.283), 46ff., 94, colour pl.4. Paired: cf. p.135, n.469. —Meleager: symbolism: *49*, 67, 333. —Aphrodite: parallels: cf. e.g. *Guide de Thasos*, Athens, 1968, 133 no.33, fig.73.

—Dionysus: Western models: cf. e.g. *82*, 266, pl.XVIII, etc.

456 Fauna: p.85; *103*. Near Eastern: *7*, VIII, Part I, 244–6.

457 Tesserae: p.55.

458 Cf. pp.126–7. —Near Eastern: cf. *44*, pls.16, 19, etc.

459 Local dress on mortals: cf. RTP 36, 758? —Monster: Origin: *153*, 166, 183. Cf. *78a*, XIII, 53–4 *s.v.* anguipede.

460 Cuirass types: cf. C. C. Vermeule, *Berytus*, XIII, 1959, 1–82. —Pose: e.g. *10*, figs.332, 684–5, cf. 690; *82*, nos.19, 168. —Cuirass over Parthian dress: e.g. *153*, 28, pl.XXI.2; *168*, 94 fig.13. —Militarization of deities: *201*, 258–67; *168*, 77–100, 107–11. —Coin: *168*, 97–100, fig.21. [Copied from officers (?): *169*, 88–9.] —Dolichenus: cf. *110*.

461 Heracles: *161*; *24*, 291–6. Dura, Hatra: *7*, III, Part I, Fascicule I, 9, 75, 77–80, 97. A clothed Heracles (?): *69* (AD 89–188; but the 'club' is surely a sword, and so the identification as Heracles fails). —Eros: *24*, 416. —Apollo: *183*. —Parallels: *51*, *s.v.* CUPIDO, etc.; *57*; *78a*, XIII, Index, *s.v.*

462 Bel: *169*, 85–114. —Malakbel: *155*, 198–209, pls.31–2; *43*, I, 222–3. —Tesserae: e.g. Arṣû: *24*, 227–46. Apollo: *24*, 285–90, figs.175–6; *183*. —In general: *24*, 171–398.

463 Processional: Achaemenian: cf. e.g. *64*, ch.12. Phoenician: cf. A. W. Lawrence, *Later Greek Sculpture*, London, 1927, 69, pl.104b. —Frontal figures on funerary stelae: cf. *120*, 105. Pose: Hellenistic: *88*, 27; *10*, fig.197; *82*, no.173. E. Roman: e.g. G. von Kieseritzky and C. Watzinger, *Griechische Grabreliefs aus Südrussland*, Berlin, 1909, nos.353, 355, 460, 464, 468, 486, etc.; A Conze, *Die Attischen Grabreliefs*, vol.IV, Berlin, 1922, nos.2042–3, 2075, 2079, 2081, 2085, 2098, etc. —Costume: mortals in local dress: cf. RTP 36, 758?

464 Lamb-carriers: Syrian: *135*, VII-VIII, 295. Greece: C. Blumel, *Greek Sculptors at Work*, London, 1969, fig.6; J. Martha, *Cat. des figurines . . . du musée*

d'*Athènes*, Athens, 1880, no.264. Dura: *135*, VII–VIII, 292–302, pl.37. Roman period: R. P. Savignac, *loc.cit.* (n.147); F. Sarre, *loc.cit.* (n.243; confuses two types).

465 Allat: cf. *24*, 374–7; *78a*, XIII, 59, *s.v.* Stance: cf. e.g. *82*, no.19, etc.

466 Victory: Western parallels: J. Strzy-gowski, *op.cit.* (n.283), 25–6; *57*, *s.v.* Nike; R. Brilliant, *Memoirs of the American Academy in Rome*, XXIX, 1967, 107ff., ch.VII, etc. Dura: *135*, II, 181–93, pl.I; *24*, 414–15; *147*, 72, pl. Edessa: *149a*, 28. —Nemesis: cf. p.44; RTP 311–13; *24*, 387–92. Western: *57*, *s.v.* —[Goddess figures' origins: cf. G. Lippold, *Kopien und Umbildungen griechischer Statuen*, Berlin, 1923, 212–24; R. Horn, *Römische Mitteilungen*, Supplement 2, 1931, 76ff.; *24*, 360–96; *78a*, XIII, Index, *s.v.*]

467 Origins: cf. n.466. —Note popularity of 'Pudicitia' and 'Petite Herculanaise' types in Roman East. Asia Minor: common. Athens: e.g. *120*, 101–2. Cyrene: G. Traversari, *Statue iconiche femminili Cirenaiche*, Rome, 1960, 66–7, 77–80, etc.

468 Cf. *78a*, XIII, 73–4 *s.v.* child; *149a*, 33.

469 Poses: Nearly upright: Western: cf. e.g. E. Nash, *op.cit.* (n.402), I, figs.138, 143, 145, etc. Almost horizontal: Western: e.g. G. Pesce, *Sarcofagi romani di Sardegna*, Rome, 1957, 72–4, fig.63; *57*, *s.v.* Nike, fig.609, etc. [Also Parthian: e.g. *44*, pl.64.] —Head: cf. *92*, 62–3; *43*, I, 174. —Profile head: p.34. —Upright: p.38. Western: cf. *49*, pl.XLVII.1.

470 Ba'alšamin: RTP 203, 205, 207, 210; *24*, 318–19. —Hellenistic: e.g. *10*, figs.490, 704; *82*, no.175 (50–30 BC). —[Roman: e.g. *109*, III, no.363. —Dura: n.464 (AD 31).] —Artisan: RTP 36.

471 Hellenistic: e.g. J. Lauer and C. Picard, *Les statues ptolemaiques du Sarapeion de Memphis*, Paris, 1955, figs.57–8, 61, 63; *10*, figs. 163–6, 173–4.

472 Boys on arms: see Appendix II, female groups I Cb; II Ac, Bc, JB, Nc, Oc, Qc, Rc, Tc; III Db, Dc, Ga; p.85, n.283. —Origin: n.607. —Legs crossed: NCG

1082: n.233. Private coll.: *186*, 178–9 no.7, pl.II.7. —Parthian: 77, pl.352. Sasanian: 77, pls.214, 225–6, 242, 244–6, 401, cf. 402.

473 Hellenistic prototypes: cf. e.g. *109*, III, no.867, cf. 927; *10*, figs.497, 632, 655; *82*, nos.166, 173. —Tyche of Antioch: T. Dohrn, *Die Tyche von Antiochia*, Berlin, 1960; cf. *47*, pl.L. —Tyche: RTP 432; *24*, 370.

474 Both ends: p.76. Daughter: DM (*128*, 877). —E. Roman: e.g. C. von Kieseritzky, *op.cit.* (n.463), nos.156–283; A. Conze, *op.cit.* (n.463), nos.1836–86; *149a*, 33, etc.

475 Man: RTP 758.

476 Poses in general: *24*, 502–3. —'Hercules Cubans': RTP 245. —Hellenistic: 7, III, Part I, Fasc.I, 33–4, nos.40, 41, where the figures are more Western than the Palmyrene.

477 Tessera: RTP 18. —Parthia: e.g. W. van Ingen, *Figurines from Seleucia*, Ann Arbor, 1939, nos.613–90; 77, pl.121; *44*, pl.20ff.; it is almost universal in Babylonia.

478 Parthia: e.g. *44*, pl.64.

479 E.g. PM 2253/8113: *Guide de l'exposition des dernières découvertes classiques en Syrie*, Damascus, 1969, pl.5.

480 E.g. DM: *81*, 35 no.17, pl.XIV.1. DM: *80*, 233–5 no.20, pl.II.2. Istanbul 3728: PS 528; *107*, pl.LIII.1.

481 Tesserae: *24*, 230–6, 352–5.

482 Plinth: e.g. p.33; PM 1286: n.126. Cf. *47*, 96, pls.L–LI.

483 Winds: n.275; cf. *24*, 419, (unconvincingly) on RTP 444. Roman: *57*, *s.v.* Venti; *78a*, XIII, 199–200 *s.v.* winds. —Consoles: p.81. Roman: cf. *132*, 225, fig.96. Syria: cf. *54*, 67–8 nos.133–5; *78a*, XIII, 114 *s.v.* head.

484 Masks: RTP 522 (?). Roman: decorative: e.g. M. Borda, *op.cit.* (n.283), 80, fig.82, etc. Symbolic: *49*, index *s.v.* 'Masques'; 7, VIII, Part I, 246–50, esp. n.985–90. East: Dura: *ibid.*, *50*, 246–50; cf. 77, pls.183–5; *78a*, XIII, 139–40 *s.v.*

—Medusa: pp.81, 57; RTP 375, 399 (?), 934–8, 1025; *24*, 421–2. Western: *57*, *s.v.*
—Pan; RTP 56–7, 982. Western: *57*, *s.v.*
Local: RTP 75, 256, 259, 332, 359, 444, 465, 655, 958. Tesserae: *24*, 434, 599–604 (many dubious interpretations).

485 Eye: *38*, 101, pl.XVI.3; *47*, 138, cf. fig.31. 'Much-suffering': *78a*, II, 238.
—Roman: R. Cagnat and V. Chapot, *Manuel d'archéologie romaine*, vol.II, Paris, 1920, 197–201 (daily needs: fig.449); *54*, 63 no.20; *105*, pl.IVc; E. Nash, *op.cit.* (n.402), 185, pl.207; *78a*, V, 33, 54 and VII, 23, etc.

486 Hand alone: altar in PM: p.53, Tessera: RTP 444: single hand, but vertical. like those of worshippers; see *24*, 419–20; n.487. —Hand with thunderbolt: p.53. —With corn: p.52. —Symbolism: *61*, 126–7; *156*, 189–94, figs.9–13; cf. *115*, 431–40; *78a*, XIII, 112–13 *s.v.*

487 Pp.52, 53. Tessera: RTP 444: vertical but single hand. —Meaning: p.138; cf. *78a*, XIII, 112–13 *s.v.*

488 Origin: *201*, 290–5. —Roman: *ibid.* —[S. Syrian: *54*, 22ff., nos.18–19, 24, 39, 40, 43, 46.] —Parthian: e.g. *77*, pls.2, 53, cf. 82; *44*, 153–62, pls.56, 62, 66.

489 Arch: p.34. —Roman bust: n.490. —Funerary: Appendix II, male groups I, II and III H–O.

490 Roman: e.g. W. Altmann, *Die römischen Grabaltäre der Kaiserzeit*, Berlin, 1905, 196–222, figs.156–78, 182–4; C. Blümel, *Staatliche Museen zu Berlin: Römische Bildnisse*, Berlin, 1933, pl.4; F. Poulsen, *op.cit.* (n.412), figs.51–4; B. Schweitzer, *Die Bildniskunst der römischen Republik*, Leipzig, 1947, pls.181, 200; *Greek and Roman Portraits*, Boston, 1959, nos.30, 50; V. Poulsen, *Les portraits romains*, vol.I, Copenhagen, 1962, nos.113–17; *188*, 29; *189*, 117–18, 245–6, etc.

491 Roman provinces: Egypt: *123*, 114–15; Asia Minor: *109*, III, 159–75, nos. 943–61; Danube: both hands shown: A. Schober, *Die römischen Grabsteine von Noricum und Pannonien*, Vienna, 1923, pls.84–7, 89–101, 103–6, 108–14, 119, 121,

123–5, 127–34; H. Schoppa, *Die Kunst der Römerzeit in Gallien, Germanien und Britannien*, Munich, 1957, pl.50; *189*, pl.61; CSIR, Österreich, II, 2, nos.106–7, etc. Additional figures: A. Schober, *op.cit.*, no.170, pl.84; no.232, pl.119. Cf. *149a*, 33.

492 E.g. DM; Soueida Museum: *54*, 51ff., nos.79, 82–5, 87–90, 93, 98–9, 119; AUM 3524 (N. Syria): R. Mouterde, *MUSJ*, VIII, 1922, 94 no.13, pl.4; AUM 35.35 (S. Syria): *134*, 156, pl.LXIX.4. Cf. also *101*, 104–5, St 53, pl.43; *149a*, 33.

493 Right palm forwards: God: n.126. Mortals: Appendix II, male group III Db, female groups I Ad, II Ta. Symbolism: *47*, 70–1; *88*, 53; H. Seyrig, *Syria*, XIX, 1938, 363 = 'Ant. Syr.' 23 = *AS* II. Parthia: 77, pls.36, 68, 100, 103–6, 110, 123; *169*, 118–20, fig.4. [India (Buddha): *96*, 6, etc.] 'Saviour' gods: cf. *144*, 70–1. —Both hands raised: pp.134, 137. Symbolism, etc.: *47*, 70–1; F. Cumont, *Syria*, XIV, 1933, 385–95; *93*, 98–9.

494 Reliefs: DM: p.226. Tesserae: RTP 14, 202. —Greek: e.g. *10*, 18, figs.19–20, 576, 624, 680–1.

495 One hand on shoulder (uncommon): see Appendix II, male group II Pb, female groups I F, II E, III J; stelae. Both hands on shoulders (rare): female group II Ea: private coll. (n.337). Antecedents: Italy: e.g. A. Giuliano, *Cat. museo profano Lateranense*, Vatican, 1957, no.1; *Greek and Roman Portraits*, Boston, 1959, no.29; cf. A. Frova, *op.cit.* (n.393), figs.106, 108, etc. Danube area: e.g. H. Riedl, *Jahreshefte des österreichischen archäolog. Instituts in Wien*, III, 1900, Beiblatt, 78–9, fig.15; CSIR, Österreich, II, 2. —Cheek: p.67, n.207; Appendix II, female groups I Ag, II Da, Q, III C, E, Hb, Jb. History: *88*, 70–1, 88. Roman funerary art, e.g. *23*, 9, fig.14.

496 Gestures: Appendix II, female groups. —'Pleureuses': O. Hamdy Bey and T. Reinach, *Une nécropole royale à Sidon*, Paris, 1892, 238–71, pls.VI–IX. —Hand at neck/shoulder: late Hellenistic Greece (?): *101*, 15, G1 (left). Ubiquitous in Roman East: e.g. *109*, III, nos.901, 906, 911, 919,

927, 930, 933, 935ff.; cf. V. Poulsen, *op.cit.* (n.490), no.117. Danube: cf. *CSIR*, Österreich, II, 2. The hand is usually the left (as at Palmyra mainly in the 3rd century), rarely the right (as mainly in 2nd-century Palmyra). —Two sides together: Hellenistic: e.g. 'Pleureuses' sarcophagus, W. face: O. Hamdy Bey, *loc.cit.*; *82*, no.113, etc. Cf. *88*, 76. —Pulling: cf. A. Schober, *op.cit.* (n.491), 193, figs.199, 201, etc.

497 History etc.: *51*, *s.v.* CALATHUS; *24*, 188. —Dura, Hatra: *77*, pls.115, 123; *85*, 19: *44*, pls.61, 67.

498 Cf. p.228; RTP 415 (?), 432; *24*, 370–2. —Origin: T. Dohrn, *op.cit.* (n.473). —[Dura: *47*, pl.L. Hatra: *85*, 20. Susa (?): *44*, 233–4.]

499 Band: Near East: *64*, fig.418. Hellenistic: cf. *82*, no.24. —Stephane: *171*, 230–5, pl.XI.

500 Iranian: *24*, 230–1. —Cheek pieces: RTP 220, 332. Western: e.g. *51*, *s.v.* CASSIS, GALEA and deities: MARS, MINERVA; *57*, *s.v.* Ares, Atena, Marte, Minerva. —[Parthia: *85*, 21.]

501 Dadophoroi: RTP 463: but see *24*, 502. Western: F. Cumont, *The Mysteries of Mithra*, London, 1956, 128–32, 211–14; cf. *106b*, 40. —'Horus': n.105.

502 E.g. nn.112, 114, 120. Tesserae: gods: RTP 406; priests: *100*, 199, *s.v.* 'couronne de Bel'. Cf. *169*, 87–8. —Hellenistic: see nn.112, 114, 120 (H. Seyrig). Royalty: G. M. A. Richter, *The Portraits of the Greeks*, III, London, 1965, 252–79. —Parthians: *77*, pls.70, 82, 99, 107(A), 108, 135–53; *85*, 18; *44*, pls.6, 47–9, 51, 73.

503 Tesserae: *100*, 199, *s.v.* 'couronne de Bel'. Around modius: cf. Appendix II, male groups I–III, H–O. Worn by men: e.g. DM: *140*, 22–4, pl.II.2, etc. 'Cushion': e.g. Lou 2398: n.214. Circlet: Appendix II, female groups I Cc, II Db. Genii: p.51, n.130. See *91*, 33–5; *67* (heroïzation). —Roman: cf. esp. miniature busts: J. Inan and E. Rosenbaum, *Roman and Early Byzantine Portrait Sculpture in Asia Minor*, London, 1966, 124 no.143, n.2, pl.LXXXV.

1–2 and 204 no.282, pl.CLVII; *78a*, XIII, 202 *s.v.*; collected by L. Robert, *CRAI*, 1967, 284; Roman coin wreath on RTP 16: *24*, 554, fig.264.

504 Genii: n.84. Boys (funerary): e.g. Istanbul 3729 (PS 527), 3826 (PS 526); NCG 1097. Iranian: *155*, 25, pl.III.2; *85*, 19; cf. *149a*, 40.

505 Veil: goddesses: e.g. nn.86, 109–10. Women: e.g. nn.92–4; Appendix II, female group I Hb, etc.

506 E.g. Appendix II, male groups I–III H–O, etc. See *88*, 30–2; *91*, 33–6. Phoenicia: A. W. Lawrence, *loc.cit.* (n.463); *88*, 30–2; *13*, no.1071a. Persia: *67*, 78. —Skull cap: *88*, 35; cf. *136*, 152, pl.XXIII.1. —'Cone': cf. *ibid.*; *153*, 158–9; *100*. —Syrian: *47*, pls.XXXI–XXXV; *153*, 158–9; *135*, V, pl.XIII; *13*, no.404; *131*, 102 no.7, pl.; *77*, pl.59; *126*, pl.10.

507 Conical: YUM: *136*, 152, pl.XXIII.1; *92*, 70–1; cf. *149a*, 40. —Hemispherical: PM 457/1660: *145*, 268, pl.XIII.3. PM CD.134.62 = 2186/7670: *111*, 1962, 80–1 no.14, fig.114. Male group III Uc. —Bust: cf. L. Robert, *CRAI*, 1967, 284.

508 Over hair: e.g. nn.92–4; Appendix II, group I Hb, etc. Diadem: p.150. —Turban: *88*, 52. 3rd century: *88*, 84–5 (PS 51). Cf. for Syria and W. Parthia: *47*, pls.35–6, 39; *88*, 52–5; *77*, pls.104, 106; *85*, 19–20; *44*, pls.53, 55; *149a*, 39; *126*, 36–42, pl.10 (*c.*AD 180?). —Cap: NCG 1030 (PS 379, *c.*AD 130–60). Parthian: F. Poulsen, *Tidskrift för Konstvetenskap*, VI, 1921, 88–90, fig.13; *96*, 2.

509 Tiara: e.g. Lou 21.383; Appendix II, group II Sb, Xe. —Cap: p.72. E.g. NCG 1073 (PS 475); Philadelphia Museum CBS 8904 (PS 499), 8910 (PS 502); also PS 491, 500–7; Appendix II, group III Lf.

510 Cf. p.37.

511 Below neck: n.115. Central parting: PM 1724/6534. Wavy: e.g. PM: nn.120, 128. —Achaemenian: cf. A Parrot, *op.cit.* (n.429), fig.249. —Parthian: cf. *77*, pls.2, 51, 60, 62, 68, 70, 98, 101, 110; *44*, fig.4, pls.19, 55–6, 63a–b, 67, 73, cf. 6d.

512 Do the genii of the Helios relief wear it (n.104)? —Assyrian etc.: *64*, chs.7, 12. —Parthian: e.g. coin (AD 26/7): W. Wroth, *British Museum Cat. Greek Coins: Parthia*, London, 1903, 148–9, pl.XXV.5, 6; *44*, pl.6i.

513 E.g. nn.127–9. —Parthian: *77*, pls.36, 67–9, 99, 105, 107, 115, 138–55, 157, 164–8, 171, etc.; *44*, pls.6d, 6h, 6l, 47–8, 51, 65, 74–5.

514 N.84; cf. 'Horus', n.105. —Western: n.516. —Lock: n.530.

515 Dishevelled: n.80. Desert: cf. pp.68–9, 154. —Origin: n.511. Cf. *149a*, 40–1.

516 Short hairstyle: almost universal for men *c*.AD 33–150, popular until *c*.200, and not uncommon later. *c*.AD 33: n.224. —Roman East: e.g. *109*, III, 104ff., no.888ff. —Parthia: *77*, pl.109; *44*, pls.32, 61, 67, 69.

517 See esp. Appendix II, male groups II, III. —Antonine: J. J. Bernoulli, *Römische Ikonographie*, II, Stuttgart, 1891, pls. XLII–XLV; M. Wegner, *Die Herrscherbildnisse in antoninischer Zeit*, Berlin, 1939, pls.1–9, 15–33. The Palmyrene fashion is closer to Pius' than to Hadrian's. —Roman East: e.g. *109*, III, 104ff.; no.888ff.; cf. *120*, 73–5.

518 See esp. Appendix II, male group III. —Roman: e.g. L. Goldscheider, *Roman Portraits*, London, 1940, pls.72–3; B. M. Felletti Maj, *Iconografia romana imperiale da Sev. Alessandro a M. Aur. Carino*, Rome, 1958, pls.XI.38, XII.39–40, etc.

519 Shaven: cf. n.506. —[Dura: not shaven: *135*, V, 111–12, pl.XIII; *44*, pl.67.]

520 Chamfer: e.g. NCG 1049: PS 4; *13*, no.547. Near East: groove: e.g. *64*, figs.39–60, 365–8, 380, 383, etc. Cf. *88*, 26–7; *114*, 10. Later, the Assyrians and Achaemenians preferred a simple raised listel. —Plastic: Roman: e.g. G. M. A. Hanfmann, *Roman Art*, London, 1964, nos.74, 76–80, 82–3, cf. 85–98. Athens: P. Graindor, *Bulletin de Correspondance Hellénique*, XXXIX, 1915, 274, 276; *88*, 34. Gudea, etc.: *64*, figs.99, 133; cf. 104–5, 109, 446.

521 Western: e.g. G. M. A. Hanfmann, *op.cit.* (n.520), no.69.

522 Gods: e.g. two, local dress: PM: n.119; Bet-Phaṣi'el: n.130; Malkâ: n.129. —Mortals: e.g. DM: *151*, 167–8, pl.XX.1; *174*, 28, fig.7. PM: *80*, 240 no.29, pl.IX.2. Istanbul 3714 (PS 227), etc. —Arab/Parthian: *77*, pls.36, 99, 109–10; *85*, 44; *44*, pls.47–8, 51.

523 See *169*, 87, 96. Dura: *135*, VII–VIII, pl.37. —Parthian antecedents: e.g. *77*, pls.36, 99, 135–45; *44*, fig.4, pls.6a–j, 32, cf.47.

524 Beards: e.g. Appendix II, groups II–III, P–U. —Roman: e.g. M. Wegner, *op.cit.* (n.517), pls.1–9, 41–6, 53–6.

525 Light beard: see n.522, 'Mortals', etc. —Close-cut: e.g. PM 1950; NCG 2833, etc. Parthian: cf. *77*, pls.36, 99–102; *44*, pls.32, 47, 50–2, 65, cf. 67. —Gashed: e.g. NCG 2775; KMV 1523 (PS 70); Istanbul 3743 (PS 277); DM C.21. Roman: e.g. B. M. Felletti Maj, *op.cit.* (n.518), pl.IX.29, XI.37, XII.39–40, XV.49–50, XXIX.95, XXX.94, etc.

526 Assyrian, etc.: e.g. G. Walser, *Die Völkerschaften auf den Reliefs von Persepolis*, Berlin, 1966, pls.3–16, 18–30, 35–9, 43–9, 51–2, 54–6, etc.; *64*, figs.168, 176–80, 186, 195, 197–9, 211, 229–30, 442, cf. 99–100, etc. Hatra: *85*, 44. At Rome, it seems to have been considered oriental: cf. E. H. Swift, *Roman Sources of Christian Art*, New York, 1951, 56, pl.VIII. —Mortals: see Appendix II.

527 See e.g. nn.70, 101 (Šadrafâ).

528 Long: e.g. nn.80, 111, 112–14 (centre). Parthian: *77*, pls.36, 78, 82, 98–9, 107, 109, 120, 123, 138; *44*, pls.6i, 47–8. —Moustache ends: e.g. AUM 33.12. Origin: *135*, VII–VIII, 296; G. Walser, *op.cit.* (n.526), pls.59–61, etc. Parthian: *77*, pl.51.

529 E.g. n.95. Hellenistic: *88*, 20–2; K. Michalowski, *Exploration archéologique de Délos*, vol.XIII, Paris, 1932, 13ff., pls.X–XI, XXIII–XXIV, XXVI–XXVIII, cf. XIII; F. Poulsen, *op.cit.* (n.412), 19–32. Roman:

G. Hafner, *Späthellenistische Bildnisplastik*, Berlin, 1954, nos.R4–7, etc.

530 Child-lock: 'Horus', n.105. Funerary; Istanbul 3795: PS 186; *94*, pl.XLIX.4. PM: *94*, pl.XLIX.3. PM: *94*, 138. Hellenistic: *51*, I, 2, 1358, fig.1810; *94*, 138. —Slave: NCG 1024: n.209. Istanbul 3793: PS 170. NCG 1053 (eunuch?): n.219. See P. Arndt, *La Glyptotek Ny Carlsberg*, Munich, 1912, 221; *88*, 125; *92*, 73.

531 Two shoulder-locks: e.g. n.122; Appendix II, groups I, II A–G. One: Appendix II, group II H–M. —Parallels: Near East: *13*, nos.453–4, 655, 659, 663, etc. Greece: G. M. A. Richter, *Korai*, London, 1968, figs.149–62, 232ff.; *10*, figs.70–1; *82*, nos.103, 127, 166, pl.XX. Italy: A. Hekler, *Greek and Roman Portraits*, London, 1912, pls.207b, 211, 212b, 213; L. Goldscheider, *op.cit.* (n.518), pl.47; H. von Heintze, *Römische Porträt-Plastik*, Stuttgart, 1961, pl.10, etc. Asia Minor: G. Hafner, *op.cit.* (n.529), NK 13–14. Syria: *109*, III, 103 no.887 (Homs, AD 109); DM (Hauran).

532 On goddess (?): Bet-Phaṣi'el: n.130. Women: Appendix II, groups II V, Xb, III H, Lb. —Origin: F. Poulsen, *loc.cit.* (n.508), fig.12; *88*, 64–5; *94*, 117 n.11. Faustina: M. Wegner, *op.cit.* (n.517), pls.10–13; E. Rosenbaum, *Cat. Cyrenaican Portrait Sculpture*, London, 1960, no.48. Provinces: R. Espérandieu, *Rec. gén. bas-reliefs de la Gaule romaine*, Paris, 1907, I no.483, II nos.985, 1158, 1162–3; H. Schoppa, *op.cit.* (n.491), pls.110–11; E. Rosenbaum, *op.cit.*, nos.57–62, cf. *32*, 39–41, etc.

533 Bust: Strasbourg Library: *38*, 131, pl.XXX.9. —Severan: e.g. J. J. Bernoulli, *op.cit.* (n.517), pls.XVI–XIX; A. Hekler, *op.cit.* (n.531), pls.284–9; K. Buchholz, *Die Bildnisse der Kaiserinnen der severischen Zeit*, Frankfurt, 1963.

534 Forehead locks: e.g. NCG 1155: PS 34 (AD 125/6). Cheek locks: e.g. PM: *14*, 49 no.19, pl.V.1. Greek: *88*, 59. —Forehead hairline curls: Strasbourg Lib.: n.533. Roman: esp. E. provinces: cf. *123*, 187,

pls.42–3; J. Inan, *op.cit.* (n.503), 130 no.156, pl.XCI, 134–6 nos.163–6. Cf. n.694.

535 Not portraiture: p.62. —Furrowing: e.g. private coll.: *91*, 42–3 no.VI, pl.X.2. West: common since late Hellenistic portraiture. Parthia: e.g. *77*, pls.76, 101, 107, 109; *85*, 46. —Eyebrows: p.142.

536 Lentoid: n.115. Achaemenian: cf. *64*, figs.397, 442. —Triangular: n.70. Upper eyelid: e.g. AD 65/6: pl.76. Iris alone: e.g. NCG 1057: PS 30. Western bronzes: e.g. *10*, figs.141–9, 175, etc. Western engraving: K. Kluge and K. Lehmann-Hartleben, *Grossbronzen der röm. Kaiserzeit*, Berlin, 1927, II 1–2, III pl.I; *101*, 55, B4 (Julio-Claudian). Parthian engraving: e.g. *44*, pl.47. —Hole: general from *c.* AD 150–75. Note, however, that its shape is circular, as sporadically in Assyrian sculpture, and not semicircular, as in Hadrianic and later Roman portraiture: cf. *88*, 18–19. Under upper eyelid: e.g. PM CD 1.61: *111*, *1961*, 122 no.12, fig.169; in Roman work most noticeable from Commodus' era. —Depression: e.g. NCG 1121 (PS 241), NCG 1151 (PS 321): *88*, 76. —Lachrymal caruncle: cf. p.116, n.379; normal in West since late Archaic Greek art. —Blank: e.g. DM C.4947, etc.

537 Small mouth: e.g. n.115. —Parted lips: e.g. NCG 1121 (PS 241), 1145 (PS 243). Western: cf. e.g. J. Inan, *op.cit.* (n.503), *13*, 57–8, no.4. —Facial groove: e.g. NCG 1049 (PS 4: AD 133/4). —Engraved line: e.g. BM 125022 (PS 180). Western: Greek bronzes: e.g. R. Lullies and M. Hirmer, *Greek Sculpture*, London, 1954, pls.213, 237. This detail seems to enter Western marble sculpture only in the Roman period, towards AD 200: e.g. H. Schoppa, *op.cit.* (n.491), pl.101; A. Hekler, *op.cit.* (n.531), pl.292. Paint: suggestion of Amanda Claridge.

538 Ears: cf. p.64. Near East: *64*, figs.119, 148, 178, 180, 249, 253, 380, 383. —Neck: wrinkles: e.g. p.33, n.70, p.40, n.94 etc. Hellenistic: W. van Ingen, *op.cit.* (n.477), 50; *116*, 79. Roman Syria: e.g. DM: C. Virolleaud, *Syria*, V, 1924, pl.XIX.3; *131*, 101 no.5, pl. V-shape: e.g. n.115; NCG

1049 (PS 4, AD 133/4). Hellenistic: *10*, figs. 141–3, 682–5; cf. G. Hafner, *op.cit.* (n.529), R10, etc. Parthia: *77*, pl.2; *44*, pl.56.

539 Nude males: p.133. Mourning women: esp. Appendix II, groups I F, II E, III J. 'Dancer': n.329. Laceration: *91*, 41; *80*, 235–7, cf. pl.V.2.

540 In general: cf. *78a*, XIII, 82–3 *s.v.* costume. —Sleeved: e.g. pp.38, 40, etc. —Smock: with strip: in painting: p.84; in sculpture: e.g. NCG (PS 514). Shape: cf. Shami bronze's coat: *156*, 177–83, figs.1, 2, pl.XXV; *77*, pl.99; *44*, pl.51. —Skirted: see esp. banquet reliefs. Decoration: p.217. Ribbon: PM: *155*, 17 fig.9. Flap: *ibid.*; NCG 1153 (PS 452). —Iranian: *155*, 14–18. Parthian: *77*, pls.60, 62, 66, 68, 98, 105, 110, 123; *85*, 21–3; *149a*, 40; J. Gutmann, ed., *The Dura-Europos Synagogue*, Montana, 1973, 53–77. Central strip: *77*, pls.36, 69, 70. Two strips: *77*, pl.110. —Local: e.g. nn.80, 106, 108, cf. 130 (Bet-Phaṣi'el). See *174*, 18–21.

541 Plain: nn.77, 82, 96. Phoenicia: A. W. Lawrence, *loc.cit.* (n.463); *153*, 156–9, pl.XVIII. Hierapolis: DM: *156*, 183–8, pl.XXV. Cf. J. Gutmann, *loc.cit.* (n.540). —Chiton: common from *c*.AD 100. Stripe: p.217. —Roman: *51*, *s.v.* TUNICA; cf. *78a*, XIII, 74 *s.v.*

542 History: *155*, 10–13. Parthian: *77*, pls.60, 70, 98, 105, 110, 123; *85*, 23–4; *149a*, 40; J. Gutmann, *loc.cit.* (n.540). Omitted: *77*, pl.100.

543 History: *155*, 6–10; J. Gutmann, *loc.cit.* (n.540). Assur: W. Andrae, *op.cit.* (n.411), pl.LIX. Shami: n.540. Commagene (cord between legs): *77*, pls.79, 80.

544 See nn.84, 282, cf. 78 (attendants). Attis: *57*, *s.v.*

545 E.g. nn.70–1, 101, 112–14. 2nd century: nn.116–17. —Hellenistic form: C. C. Vermeule, *Berytus*, XIII, 1959, 13–15, 32–3, nos.1, B7, pls.I.5, II.6 (of Pergamene origin). —Greaves: *135*, VI, 450–2, pl. XXIII. —Origins: Assyrian: cf. British Museum, *Assyrian Sculptures from Shal-*

maneser II to Sennacherib, London, 1938, pls.18, 38–9, 41–3, 45, 57–61, 63–4. Cf. also G. M. A. Hanfmann, *Etruskische Plastik*, Stuttgart, 1956, pl.31. Parthian: cf. Dura greave, above. Local: *168*, 83–7, 107–10; *169*, 88, 93 (imitated from Roman officers' breastplates?).

546 Hellenistic: cf. C. C. Vermeule, *loc.cit.* (n.545). Navel: *ibid.*, 33 no.5, pl.II.8. Cf. *168*, 110: imitated from the supposedly cuirassed statue of Tiberius in the court (pp.16–17, n.8)? —Romanized: e.g. n.120. See C. C. Vermeule, *op.cit.* (n.545), 18–28, 43–72, nos.76–315A, and esp. pls.VII.23, XVIII–XXI. —Scale: n.129. Roman: cf. *51*, *s.v.* LORICA, type XXXV. —Further East: Dura: *47*, pls.L, LV; *135*, V, 107, pl.XIII; *44*, pl.67. Hatra: *77*, pl.1; *85*, 26, pl.I.2a; *44*, pl.54 (Hellenistic type). Membidj (?): *169*, 115–16, fig.1. Parthia: *168*, 110, fig.30. Roman Empire: *201*, 258–67. —[Arṣû's 'Iranian cuirass and mail coat', *24*, 230 (on RTP 170), is in fact the normal cuirass, tunic and trousers.]

547 Himation: Greek: *125*, *s.v.*; cf. *78a*, XIII, 117 *s.v.* and 168–9 *s.v.* robe; *149a*, 40. H: pp.98–9, 216. Short: n.253. Tassels: e.g. O. Hamdy Bey, *op.cit.* (n.496), pl.VII (E. face, right); *106b*, 40. —'Chlamys': popular throughout. Greek: *51*, *s.v.* Brooch on left: Lou 14924: *151*, 160–1, pl.XX.2. With cuirass: in West: cf. C. C. Vermeule, *op.cit.* (n. 545), 15 B7, 32 no.1, pls.I.5, II.6 etc. In Syria: e.g. *169*, 115–16 fig.1. Parthia: *85*, 25; cf. J. Gutmann, *loc.cit.* (n.540). Priests: Appendix II, groups I–III, H–M.

548 Desert: nn.80, 100, 106–8, etc. Fastening: p.229 (Djoub el-Djarrah); cf. E. H. Swift, *loc.cit.* (n.526). Fringed: bust: NCG C 24. Origin: *174*, 11–22, 27. Cf. *78a*, IX, 168–73. —Toga: n.306.

549 Knotted: Hellenistic cuirass: p.147. Chiton: e.g. n.193. Dura, etc.: n.546. Parthia: *77*, pls.60, 98–100, 105, 110; fringed ends: *77*, pl.68. But see *85*, 25–6. —Wide: p.146. —Looped: see esp. funerary stelae and banquet reliefs. Hellenistic: n.545; the loose ends are tucked *beneath* the girdle. Commagene: *77*, pls.79–80 (68–34 BC). Antonine variation: C. C. Vermeule,

op.cit. (n.545), nos.202, 263, 292, pls.XIV, XX, XXI.

550 Unknotted: cf. C. C. Vermeule, *op.cit.* (n.545), 26 G1, pl.XXII.68. —No belt: e.g. n.120, as with highly decorated Roman types. —Narrow: e.g. n.108. —Hidden: cf. short himation: p.78. —Floral band: esp. Appendix II, groups I–III, H–M. Local? Cf. *80, 221* (of metal?); *149a,* 40.

551 Sword-strap: e.g. n.113. Iranian: *155,* 27–8. —Baldric: e.g. n.120. Hellenistic: C. C. Vermeule, *op.cit.* (n.545), 33 no.3, pl.II.7. Roman: *ibid.* nos.202, G1, 308, pls.XIV, XXII, etc.

552 E.g. n.204, 253. Origin: *155,* 22–4 fig.13. Parthian: *156,* 177–83 figs.1, 2, pl.XXV; *77,* pls.99–100, 138–45; *85,* 24–5; *44,* pls.6c–h, *51; 149a,* 40; *169,* 118–20, fig.4; cf. *78a,* XIII, 69 *s.v.* caftan. Sasanian: *77,* pls. 208–9, etc.

553 Waistcoat: n.70. Local? —Shirt: gods: e.g. nn.128, n.709. Men: e.g. Lou 2398: n.214; NCG 1033 (PS 302).

554 Ankles: e.g. nn.128, 130 (Bet-Phaṣi̇ʾel), 138 (Šaʿarû). Knee: e.g. n.108. —Origin: *174,* 11–21. Zinjirli: A. Moortgat, *Die bildende Kunst des alten Orients,* Berlin, 1932, 60–1, pl.XLVIII. Tell Halaf: *13,* nos.466, 468, 470, 482. Hatra: *85,* 26, pl.IV.1. Note: *54,* 37 no.42 = *168,* 91 n.3, fig.11: himation rolled round waist: influenced by this garment?

555 Greek, Roman: see esp. *51,* under following types. —Endromis (?): e.g. *76,* 79 (surely not a caliga?); n.130 (Wadi el-Miyah). —Sandal: e.g. Istanbul 3727. Cf. Hatra: *85,* 29–30 (Hellenistic types). Embas: e.g. DM: *144,* 69 no.2, pl.XXX.4; 88 no.1, pl.XL.4. —Calceus: PM A22, A23. Cf. *47,* 253–4, pl.XCIV.

556 Persian: see *155,* 24–5 fig.17. Parthia: *85,* 29; *169,* 118–20, fig.4; *149a,* 40. —Barefoot: common among Greek deities. —[Cf. *85,* 30.)

557 Early: e.g. nn76, 92–4, 115. Decorated: e.g. Grenoble Museum: *154,* 139, pl. XXXII.1. Straps: *144,* 77 no.5, p.XXV.2. Fringed: e.g. DM: PS 51; *CIS* II, 4244

(AD 226/7). [Rome: PS 467; C. Pietrangeli, *Museo Barracco di scultura antica,* 3rd edn., Rome, 1963, 120. Edessa: *149a,* 39.]

558 E.g. nn.86 (?), 110, etc. Athena: e.g. *10,* fig.460, cf. 491, 498; E. Schmidt, *op.cit.* (n.341), pls.7, 10. Parthia: *77,* pls.104, 106; *85,* 27–8, pls.VII.2, VIII.5.

559 Undecorated: e.g. relief busts, female group I Ae, etc. Stripe: e.g. n.282. Decorated: e.g. NCG 1030: PS 379; *107,* pl.LXI.1, 2.

560 Girls: cf. Appendix I. —No tunic: e.g. Appendix II, female groups I F, II E, III J, and small funerary stelae. Cf. p.145.

561 Early: e.g. nn.86,92–4,115. Attached: e.g. n.122. Pinned: e.g. Appendix II, female groups I F, II E, III J, etc. Later reliefs: cf. Appendix II, female groups. —Himation: cf. e.g. *10,* figs.497–504, 507–25, etc. —Semitic veiling: R. de Vaux, *loc.cit.* (n.80); Hatra: *85,* 28; Edessa: *149a,* 39.

562 Himation: *88,* 59. —Syria: e.g. DM (Hauran). —Parthia: cf. *47,* 49, pl.XXXV; *77,* pl.103; *44,* pl.60.

563 Syro-Anatolian origin (?): cf. N. Arsan, *Belleten,* X, 1946, pls.52, 67 (centre). 'Parthian': *88,* 74 (on PS 15).

564 Cuirass: cf. also RTP 415: Tyche (?), cuirassed (?): *24,* 312. —Aegis: cf. p.134. Origin: *51, s.v.; 57, s.v.* EGIDA. —Waistbands: cf. p.147. Hatra: *85,* 28. —Sandals, shoes: cf. p.148, nn.555–6; *149a,* 39.

565 Decorative folds: see esp. Appendix II, male group I, arrangements 2–6; female group I, arrangements 2–4, 6–8, 10, 12. —'Transparent': Hellenistic: e.g. *10,* figs. 499–502, 510–15, 520–1. —Peplos: e.g. nn. 110, 122, etc. 4th century BC: e.g. G. M. A. Richter, *A Handbook of Greek Art,* London, 1959, fig.189. Hellenistic: e.g. *10,* figs.489, 491, 498–9, 501, etc.

566 Central leg folds: see esp. small funerary stelae: cf. Appendix I. Late Hellenistic: G. M. A. Hanfmann, *Anatolia,* IV, 1959, 60–3, pl.XI. Parthia: e.g. *77,* pls.103, 106, cf. 123; *85,* 27, pl.VI.3, 4. Gandhara: e.g. *77,* pl.16. —Hemline: e.g.

nn.122 ('Ištar'), 191, 264; cf. Appendix I. Near East: e.g. *101*, 196 n.7, fig.118; 195 n.9, fig.120. Hellenistic: G. M. A. Hanfmann, *loc.cit.*; *10*, fig.501. Parthia: *85*, 27. Gandhara: *77*, pl.16.

567 Figurines: p.104.

568 See esp. Appendices I, II, female groups. —History: *88*, 52–5; *83*, 105–6, 183. Syria, Parthia: e.g. *47*, pls.35–6, 39; *88*, 52–5 *77*, pls.104, 106; *44*, pls.53, 55.

569 Simple chain: e.g. Toronto, R.O.M.A. 424: PS 394. Beading: e.g. Lou 1562: *107*, pl.LXI.3. —Dura: *47*, pls.35–6. Hatra: *77*, pls.104, 106.

570 Frontal ornament: common. Roman (Tunis): *83*, 183, pls.D, 62C. —Semicircular: Lou 21.383; KMV 1520. —Ear: *88*, 69–70, 75, 78, 84–5.

571 E.g. nn.128, 709 (Djoub el-Djarrah).

572 Distribution: Appendix II. Types: *107*, 167–8, 171, 180–1. —Ear-covers: *88*, 53; cf. *147*, 47, pl. (bottom). —Amphora: n.122. Hellenistic: *83*, 166 type 5(*c*). —Hoops: *83*, 161–4 type 2, 183 type 1; *59*, 105 nos.3–5. —Grapes: *88*, 55; *83*, 184 type 7; cf. *123*, pls.31.1, 32.2; *59*, 104–5 no.1. —Bell: *88*, 20. —Ball: *83*, 184 type 6. —Bar with pendants: *88*, 69–70; *83*, 185 type 10; *123*, pls.15.2, 18.2, 20.4, 49.2, etc. Hatra: *85*, 32.

573 Distributions: Appendix II. —'Dumbbell': *88*, 74; cf. *83*, 185 type 9; cf. *123*, pls.18.1, 20.1, 21.5, 30.2, etc. —Triple balls: *107*, 180–1 type 2; cf. *123*, pls.14, 48.2, 51.3–4. —Cubes: *88*, 76–7.

574 Collar: *162*, 30. Parthia: *77*, pls.99–100, 105, 110; *85*, 32. —Necklet: e.g. Lou 1555: PS 516. Cf. *78a*, 13, 53 *s.v.* amulets; *149a*, 40.

575 See esp. Appendix II. Types: *107*, 170, 173–6. —Knobbed crescent: origin: *83*, 186 type 3 (*c*). —Beads: *83*, 169 type 3, 179. —Chains: *83*, 169 type 2, 186–7 type 3. —Straps: *83*, 168–9 type 1, 179. —Plaques: *107*, 175; *83*, 169 type 4, 186 type 1. —Pectorals: e.g. Lou 14.925: *107*, 176. —Pendants: *88*, 79–80 (crescent); *107*, 174–6. Cf. *47*, pls.35–6; *83*, 168–9, 186.

—Medallions: e.g. NCG 1054: PS 465; *13*, no.552. BM 125019: *38*, pl.XXXII.11; PS 483. Cf. *83*, 170–1, 186 type 3(*d*). Parthia: *77*, pls.103–4, 106. —Cf. *78a*, XIII, 53 *s.v.* amulets.

576 Development: *68*, Women's kinds: Appendix II. —Key: *107*, 167. —Chains: *68*, 417. —Hellenistic: cf. *83*, 176. —Roman: *68*, 415; cf. *123*, pl.19.1. —Sarmatian: *88*, 69–71. —Dura: p.97. Cf. Hatra (button-like): *85*, 33.

577 Gods: e.g. n.129 (Malkâ). —Female: see *107*, 171, 176–7. —Hoop: cf. *83*, 171–3, 187–8, esp. 172 type 3, 187 type 4 ('two-part'); *59*, 105–6 nos.2, 3, 5, 6, 8. —Globules: *154*, 139, pl.32.1. Parthia: *77*, pl.104. —Twisted: *88*, 71. Hellenistic: cf. *83*, 172 types 1, 5; *59*, 105–6 nos.1, 4, 7. Dura: p.97. Hatra: *77*, pl.106; *85*, 33. Cf. similar N.W. Indian bracelets: V. Dehejia, *op.cit.* (n.431), 119, pl.20.

578 See Appendix II. —Plaited: e.g. NCG 1074: *38*, 121 no.41, pl.XXIX.11; PS 445. Cf. *83*, 188 types 5, 6. —Cabochon: *107*, 177; cf. *83*, 189 type 10. —Circular: e.g. BM 125024: PS 488. Roman: *88*, 148; *83*, 188 type 6. —Bell: *88*, 82–3; *107*, 174; cf. *59*, 104, nos. 4–7.

579 Armlet: *107*, 176–7; H. Seyrig, *Syria*, XXIX, 1952, 232–4, figs.13–15 = 'Ant. Syr.' 53.3 = *AS* V. Iranian: cf. *ibid.*, 227–34. —Armband: *107*, 177, fig.6b.

580 See Appendix II. Types: *107*, 169, 172, 176. —Filigree: *107*, 172 (woman). —Roman: *88*, 27; *135*, II, 82; *135*, IV, 249–51; *83*, 190. Hellenistic: cf. *59*, 106 nos.1–2.

581 E.g. LHO 41: *38*, 131, pl.XXVIII.14; PS 2 (AD 114). Berlin: *90*, 10, fig.5 (PS 378). NCG 1030: n.559. DM. —See *88*, 20.

582 Sword: gods: e.g. n.112. Men: e.g. nn.245–7. Divine bust: e.g. n.70. Mortal: Appendix II, male groups I Bc, Dc; II Bd, Qc, Sa; III Sa, Sc. Iranian: *155*, 27–9; *85*, 35; *174*, 22–3, 27–30, 37, 44–5. Hellenistic: *153*, 178–81. Romanized: e.g. nn.120, 130. —Dagger: *155*, 29–31; *85*, 35; *174*, 45. —Ornamental: *155*, 26–7.

583 Spear: cameleer: PM 2093/7431: n.246; cf. *78a*, XIII, 183 *s.v.* [Hatra: *85*, 35.] Blade: *153*, 180. —Club: 'Heracles': cf. n.461 RTP 227, 229, 231. [Hatra: *85*, 36.] —Axe: RTP 231–6. Heracles/Nergal: *161*; *24*, 291–6; *85*, 36; cf. *78a*, XIII, 60 *s.v.* axe.

584 Simple bow: rider gods: e.g. nn.106–8, 127–8. Regional: *174*, 23, 36–7, 44. —Compound: youth: PM 1045/2248. Origin (?): *51*, *s.v.* ARCUS. Cf. Dura: *135*, V, 51, pl.XV.1: probably a bow: S. B. Downey, in *7*, III, Part I (forthcoming). —Bow-case: *174*, 23, 36–7, 44. —Quiver: Bel statue: n.56; cf. RTP 286, 310; cf. *51*, *s.v.* DIANA; *57*, *s.v.* Young men: n.253. Palmyrene usage: *174*, 23, 36–7, 44.

585 Circular: Arab: 93, 120–2; *174*, 23, 37, 44. —'Greek': cf. n.465 (Allat). Origin: *51*, *s.v.* MINERVA; *57*, *s.v.* Atena. Similarly at Hatra: *85*, 35–6.

586 Knobbed: e.g. nn.117, 119 (Ba'al-šamin). Floral: e.g. nn.117, 709 (Djoub el-Djarrah); *160*, 41. Origins: *135*, V, 110–11; *86*, 6; cf. *82*, nos.168, 170, etc.

587 Crescent: n.109; RTP 277. Statuettes: RTP 175, 177–81. Others: RTP 215 (?), 287, 298, 343, 469. —[Parallels: *135*, III, 114–18; *95*, 18–39; A. Caquot, *Syria*, XXXII, 1955, 59–69; *24*, 129–32, 425–30; *85*, 39–42.]

588 Wingless: n.140; RTP 203, 210; cf. n.129 (Malkâ). Winged: n.140 (Palmyra); *151*, 277–9, fig.10. —Origins: cf. *51*, *s.v.* FULMEN, V; *156*, 189–94.

589 Trumpet: Western: *51*, *s.v.* TIBIA, XXI. —Ears: n.134; RTP 210, 397, 680–2, 684, cf. 926? Hellenistic: cf. *79*, pl.70. —Bouquet: p.34, n.75. Western: e.g. S. Reinach, *Rép. statuaire grecque et romaine*, II, Paris, 1897, 252–3; VI, Paris, 1930, 16, etc.

590 Horn: Victories: PM. 'Tyche': RTP 207, 344, 507 (?). Western: *51*; *78a*, XIII, 82 *s.v.* CORNUCOPIA. [Hatra: *85*, 36.] —Thyrsus: RTP 14, cf. 1007. Western: *51*, *s.v.* BACCHUS; *57*, *s.v.* Dioniso; *78a*, XIII, 190 *s.v.* —Wheel: nn.109, 120, 466 (Nemesis). —Bag etc.: n.90; RTP 174, 282–4, 507.

Western: *51*, *s.v.* MERCURIUS, esp. 1818ff.; *57*, *s.v.* Hermes. [Hatra: *85*, 36.]

591 Lyre: RTP 119, 237, 301–2, 310. Western: *51*, *s.v.* APOLLO; *57*, *s.v.* Apollo. —Torches: RTP 463. Western: *57*, *s.v.* Cautes, Cautopates. —Tiller: RTP 207, 344, 507 (?). Western: *51*, *s.v.* FORTUNA; *57*, *s.v.* Fortuna, Tyche. —Trident: RTP 343. Western: *51*, *s.v.* NEPTUNUS; *57*, *s.v.* Poseidon. —Sickle: RTP 155, 274, 278; cf. p.231, n.712. Western: *51*, *s.v.* SATURNUS; *57*, *s.v.* Saturno.

592 Bowl: nn.103, 262. Western: cf. n.589 (bouquet). —Sword-hilt: n.582. —Stick/goad: gods: n.108 (DM); RTP 177. Men: n.80; Appendix II, male group III Sc. Origin: *174*, 24. —Whip: god: e.g. n.129 (Malkâ); at wrist: n.709 (Djoub el-Djarrah); cf. RTP 397. Men: male groups I Dc, II Ra, Sa, III Sa, Sb. See *91*, 41–2; *174*, 27–8, nn.104–10.

593 Balance: n.86; RTP 687, 689. —Hammer: RTP 36, 395–6. —Leaf etc.: pp.209, 210.

594 See esp. Appendix II.

595 Above shoulder: cf. e.g. *10*, fig.150. —In hand: cf. Appendix II, male groups I Ba, Db, Ja, Jb, II Ba, Ja, Jb, Qa, Sb, III Ba, Ja, Qa. Sb. In West: *51*, *s.v.* VOLUMEN; K. Hoffman, *Römische Militärgrabsteine der Donauländer*, Vienna, 1905, 86; T. Birt, *Die Buchrolle in der Kunst*, Leipzig, 1907, 71, 108; A. Schober, *op.cit.* (n.491), 177; *88*, 23–4; *49*, 306; *78a*, XIII, 175 *s.v.* scroll; *CSIR*, Österreich, II, 2, Register, *s.v.* Schriftrolle. Syria: DM: R. P. Mouterde, *Syria*, VI, 1925, 216–18, pl.XXVI; DM. S. Syria: DM (seated statue of basalt, bookroll open in lap); DM: *131*, 101, pl.4; DM.

596 Tablet: esp. Appendix II, male groups I Be, Da, II Be, III Be, Da (?). Western: cf. *51*, *s.v.* TABELLA, TABULA; *CSIR*, Österreich, II, 2, no.144. —Stylus: male groups II Sb, III Da. Western: *51*, *s.v.* STILUS; *88*, 40. —Ruler: n.229. Western: *51*, *s.v.* STRUCTOR. —Capsa: Western: *51*, *s.v.* —Triptychon: Western: *51*, *s.v.* TABELLA, fig.6714. —Knives, etc.: RTP 131–2.

597 Tesserae: *100*, 199, *s.v.* cratère. Western: *51*, *s.v.* CRATER; *196*, 464; *79*, pl.105; M. Wegner, *op.cit.* (n.444), pls.3b, 31a, etc. cf. *78a*, XIII, 111 *s.v.* Greek vases, 195 *s.v.* bases.

598 Amphora: on lamps: *59*, 86–91, fig.31. On tesserae: *100*, 199, *s.v.* On reliefs: PM; n.257 (Malkû). Western: *51*, *s.v.*; *196*, 460–3. —Jugs: nn.259, 265, etc.; *100*, 199, *s.v.* cruches. Western: *196*, 466–7. —Ladles: nn.193, 257, 265; *100*, 199, *s.v.* louche. Cf. *59*, 103 n.1. Western: *196*, 467, 471 (simpulum, simpurium). —Vases: *100*, 199 *s.v.*

599 Psykter: RTP 704. Greek: G. M. A. Richter, *Attic Red-Figured Vases*, 2nd edn., New Haven, 1958, 12, fig.1. —Barrel: 693. RTP —Water-skin (?): RTP 28, 713. —Cup: nn.94, 225, 232, etc. Western: *196*, 467–8, 471. [Hatra: *85*, 38, pl.VII.4. Symbolism (?): cf. *169*, 107.]

600 Kantharos: e.g. PM 2179: Plate 24 (on shelf?). Cf. *24*, 336, fig.194 (symbolic of Dionysus?). Western: cf. R. M. Cook, *Greek Painted Pottery*, London, 1960, 238–9; *78a*, XIII, 70 *s.v.* —Cup with lid: n.94. —Deep bowl: e.g. nn.81; 92–4, 96; Appendix II, male groups I Jc, La. Cf. DM: *131*, 102, pl.7 (Hauran). Greek: cf. skyphos: G. M. A. Richter, *op.cit.* (n.599), 13, fig.2; cf. *196*, 471. —Alabastron: e.g. nn81, 92–4, 96; Appendix II, male groups I La, II Jc, La; cf. AUM 2739, background: PS 43; *44*, pl.45 (AD 161). Greek: G. M. A. Richter, *loc.cit.*

601 Shallow bowl: cf. *196*, 471. —Cup: e.g. n.257 (Malkû); *103*, pl.XIV. Roman: *196*, 467, cf. 475. —Rhyton: tessera: RTP 792. Relief: e.g. Lou 4084: n.262. Greek: *51*, *s.v.* Roman: cf. *79*, pl.68. Parthian: *77*, pl.41. —Libation horn: n.259. —Platter, bowl or basket: n.262; cf. *78a*, XIII, 62 *s.v.* —Thymiaterion: n.320. Western: *125*, *s.v.* —Lamps: n.320. Western: *196*, 393–429; cf. *78a*, XIII, 130 *s.v.* —Mould: n.327.

602 Double-flute: RTP 230, 562, 581, 727. Syrinx: tesserae: RTP 230 (?), 581–3. Reliefs: n.244. Greece: common for centuries.

603 Pine-cone (?): p.211. —Key: in hand: Appendix II, male group II Da and female group I Ac. From brooch: e.g. AUM 2740: PS 35, etc. Symbolism: *88*, 61; *125*, *s.v.* Kleidoukhos.

604 See esp. Appendix II, male groups II Bc, Jc, III Bc, Db, Jc, Qc, Sd, and female groups I Ab, Bb, Ca–b, Da, II Ab, Bb, Cb, Ha, Kb, Nb, Ob, Qb, Rb, Ub, Va, III Aa, Ac, Ba, Ca–b, Ea, Ga–b, Hb. 'Pleureuses': O. Hamdy Bey, *op.cit.* (n.496), pl.IX.1.

605 Mortals: e.g. NCG 1030: n.559. Istanbul 3728: *107*, pl.LIII.1. Strasbourg: n.533.

606 Esp. Appendix II, groups I A, Fc, II Aa, Ba, Cb, Da, Na, Oa, Sa; earliest datable (AD 83): n.280. —Functions, types: *198*, 31–3. —History: *51*, *s.v.* LUNUS; *88*, 57. —Roman: Hungary: E. Kalinka, *Jahreshefte des österreich. archäol. Instituts*, III, 1900, Beiblatt, 11, fig.5; A. Schober, *op.cit.* (n.491), no.181, fig.90. Phrygia: G. Mendel, *Cat. du musée de Brousse*, Athens, 1908, 40–7 = *Bulletin de Corresp. Hellénique*, XXXIII, 1909, 288ff.; *109*, III, 314–16 no.1077. Syria: e.g. *109*, III, 103 no.887 (Homs, AD 109); DM.

607 Early example; DM (*128*, 878; *c.*AD 100–25). See Appendix II, groups I Cb, II Ac, Bc, Jb, Nc, Oc, Qc, Rc, III Db–c. History: *88*, 66. Near East: D. Nielsen, *Der dreieinige Gott*, Copenhagen, 1942, 105, 338, figs.4, 43, cf. 42. Hellenistic: J. Martha, *op.cit.* (n.464), Index, *s.v.* Femmes: portant un enfant. Parthian: W. van Ingen, *op.cit.* (n.477), nos.42–59. Roman Syria: AUM 3524: n.492; AUM 35.35: *134*, 156, pl.LXIX.4. Egypt: F. W. Kelsey, *CRAI*, 1927, 87, fig.1.

608 Circlet: esp. Appendix II, groups I Cc, II Db. 'Wreath': *93*, 95 no.5, pl.XX.3. Or a key-ring? Rattle? Tambourine? Cf. *85*, 37; *24*, 59. One female figurine has a huge circlet: n.343. —'Box': Appendix II, group I Db.

609 Casket: e.g. n.257; cf. *107*, 164. Greek, Roman: *130*, 72–7, 114. —Basket: e.g. DM: n.607; *103*, pl.XIV. —'Mirror': PM: *111*, *1960*, 159–60 no.28, fig.173; *111*, *1963–4*, 49–50 n.6 (but must be female:

rests head against cheek (female gesture), and veil visible on her right shoulder).

610 Bird: p.158. Grapes: p.211. See *88*, 20–1, 65.

611 Corinthian: Sacred Law stele: p.52, n.134. In West: e.g. *132*, Index, *s.v.* Corinthian. —Pilaster: funerary: e.g. PM 1760/6584: *14*, 46 no.10, pl.II.5; Istanbul 3793: PS 170; n.695. Western: *132*. —Shell semi-dome: *4*, 257, fig.14; n.274; RTP 438. Conch: *132*, 230; *11*, 420, 443; cf. *78a*, VIII, 97 (vulva!) and XIII, 178–9 *s.v.* shell. —Tesserae: *100*, 201 *s.v.* édifices. Temple façades: n.161. Cf. *78a*, XIII, 56–7 *s.v.* arch.

612 Rock: nn.90, 121. Near East: cf. *64*, esp. ch.7, p.12. Hellenistic: tree: e.g. *82*, pls.168–9, 174, XI, etc. Rock: *82*, pls.160, 166, 170, etc.

613 Tesserae: *100*, 199, 'Matériel du culte', *s.v.* autel, pyrée. —[Parallels: cf. *51*, *s.v.* FOCUS, TURIBULUM; *47*, 48, 91; *86*, 3–4; *144*, 109–12.]

614 Palmyrene usage: see *88*, 24–6; *31*, VIII A, 21. —Roman: e.g. E. Strong, *Roman Sculpture*, London, 1907, 307–9, 319, pls.XCIV, XCIX; A. Hondius-Crone, *The Temple of Nehalennia at Domburg*, Amsterdam, 1955, nos.5, 6, 10, 14; R. P. Wright and I. A. Richmond, *Cat. Grosvenor Museum*, Chester, 1955, 12 no.5, pl.III (dedicators from Samosata); *101*, 35, nos.S6, S8; J. M. C. Toynbee, *Art in Britain under the Romans*, Oxford, 1964, 223, pl.LIVa. —Roman Syria: e.g. AUM 4803 (Muhin, Lebanon, AD 116); cf. *7*, VIII, Part I, 129, pls.18–19, 48, 60, 63, 67–8.

615 Not symbolic, but ornamental: A. Hondius-Crone, *op.cit.* (n.614), 108. —Symbolic: house interior: *51*, *s.v.* VELUM. Tomb interior: *91*, 37; *96*, 2. Boundary: *31*, VIII A, 21; J. M. C. Toynbee, *loc.cit.* (n.614). Ritual apparel: *154*, 140. Glory: *49*, 476, fig.103. Sky: *24*, 74–5; J. M. C. Toynbee, *loc.cit.* (n.614).

616 Throne: solid-sided: Western: *130*, 28–33, 99–101. Plaited: Western: *130*, 101. —Chair: Western: *130*, 101–2. Sella curulis: *121a*, 83–5 (AD 50–150). —Stool: Western: *130*, 38–40, 102–3. —Folding

stool: RTP 36. Western: *130*, 46 (type 2), 103. —Couch: mortal: see esp. ch.3. Divine: RTP 60, 124; n.131. West: *130*, 56–8, 105–9; cf. *78a*, XIII, 83 *s.v.* —Table: West: *130*, 70–1 (type 4), 111–12 (type 3). —Mattress: cf. *130*, figs.317, 457, 550–3, etc. —Bunch of drapery: priestly cap: e.g. Lou 2398: n.214. Wreath: e.g. AUM 2736: PS 196; PM A1175–6: n.144.

617 Chariot: West: *51*, *s.v.* CURRUS; cf. *78a*, XIII, 72 *s.v.* 'Analytical': p.000 —Ship: Roman: e.g. C. Torr, *Ancient Ships*, Cambridge, 1894, esp. pl.6; G. Contenau, *Syria*, I, 1920, 35–45, figs.11–12, pl.VI; L. Casson, *Ships and Seamanship in the Ancient World*, London, 1971. —Anchor: RTP 939; cf. *78a*, 53 *s.v.*

618 Stretched: e.g. nn.65–8, 59. Origins: cf. *ibid.*; *24*, 41–2, 413; *43*, I, 167, 227. —Open: religious: e.g. nn.66, 68, 89, 107; *100*, 200 *s.v.* aigle, etc. Funerary: single: PM (*128*, 424); pair: Istanbul 3802. Western: common: cf. *78a*, XIII, 45–6 *s.v.* Parthian: cf. *149a*, 28, etc.

619 Crow: tesserae (?): RTP 287, 291, 298; cf. 57, 191, 271, 462, 468. See *24*, 436–7; *191*, 273–4. —Cock: RTP 620, 1003, 1008. See *24*, 436–7; *191*, 256–7. —Dove: RTP 123–4, 437 (?), 538. See *24*, 436–7; *191*, 258–9; *78a*, XIII, 91 *s.v.* —Gryllos: p.56. —Human-headed cock: RTP 603. See *24*, 423. —Children's bird: cf. p.66, Appendix II, male group III Bd, female II Vb; *88*, 20–1, 65, 152–3. Pet: Libanius, *Oration* i, 8. —Tomb: 'Abd'astôr: n.289. Cf. *78a*, XIII, 64–5 *s.v.* birds.

620 See p.133; *191*, 243–6, 250–3, 264–73; *78a*, XIII, 92 *s.v.* duck.

621 Frontality: cf. *24*, 41. [Frontal head: cf. lion, 69–34 BC: *87*, pl.XI; *147*, fig.20 (Commagene).]

622 Religious: e.g. nn.107–8. Funerary: e.g. nn.201, 246–7, 253. —Near East: e.g. *86*, 19–20; *64*, figs.168, 171, 182, 189, 216, 348, 379, 402, 415, 418, 439; cf. 178, 438. Anatolia: *109*, III, no.1035. Syria: e.g. *162*, 235–7, pl.XII; cf. p.229, n.709, Parthia: e.g. *86*, 19–20; *77*, pls.90, 103, 169, 206: *44*, pl.60.

623 E.g. nn.70-1, 127-9. —Hellenistic: *155*, 39-40, fig.23. Anatolia: *109*, III, nos.852, 963-5, 970, etc. Dioscuri: F. Chapouthier, *op.cit.* (n.407); H. Metzger, *op.cit.* (n.433), nos.8, 9. Syria: e.g. C. Virolleaud, *Syria*, V, 1924, 120-1, pl. XXXI.4; R. Mouterde, *MUSJ*, XI, 1926, 309-22, pl.II.1, 2; *144*, 56 no.17, pl.XXI.4. Parthia: *86*, 21; *77*, pl.69, cf. 113-14, 168, 196; *44*, pl.20b.

624 Nn.79, 158; cf. 222. —Near East: cf. *86*, 10-19; *64*, pls.182, 185, 191, etc. Hellenistic: e.g. *10*, figs.4, 252, 488, 702-3; *82*, nos.150-2, 157-8. Roman: e.g. *188*, pl.43. Anatolian: e.g. *109*, III, nos. 846 (?), 847, 962, 966-8, etc. (5th to 4th centuries BC), 1055-6, 1059, 1087, cf. 1142. Parthia: e.g. *47*, pl.XCVIII; *138*, 265-7; *86*, 10-19; *77*, pls.55, 62-3, 119, 122, cf. 61, 111; *44*, pl.69. Sasanian: e.g. *77*, pls.156, 163, 165; *44*, pl.75.

625 See pp.85, 133.

626 E.g. nn.131, 269. —Near East: e.g. *64*, pl.213. West: e.g. *10*, 155-6, figs.660-1.

627 E.g. nn.72, 147. —Near East: *64*, pls.221, 304, 372, etc.

628 Griffin: e.g. nn.70-1, 129; *100*, 200 *s.v.* griffon, cf. 202. History: *135*, VII–VIII, 263 n.7; C. Picard, *Monuments Piot*, XL, 1944, 107ff.; *101*, 171-9, 185; *24*, 387-92, 431; *43*, I, 222-3, 227; *64*, and *78a*, XIII, Index, *s.v.* Griffin. —Goat: nn.70, 140; *191*, 164-6; *78a*, XIII, 108 *s.v.*

629 By Allat: e.g. nn.110, 125, 138. Atargatis: cf. *151*, 15; *135*, VII–VIII, 260-2, pl.XXXIV; *57*, *s.v.* —With other deities: e.g. nn.71-2, 124, 134; *100*, 200; *78a*, XIII, 132-3 *s.v.* —Deity on back: RTP 260. Dolichenus: *110*. —Architectural: e.g. n.150. —Funerary statue: West: *189*, 278-9. —Funerary, decorative: e.g. n.229. Decorative: *49*, 338; cf. W. Altmann, *op.cit.* (n.490), 14, 101-2, no.83, fig.85; *79*, pl.38; *24*, 83 (unconvincing). Lion in general: *191*, 61-9.

630 Reclining: history: *105*, 319. —Seated: n.129. —Standing: n.121. Dolichenus: *110*. —Leaping: RTP 170. —Pro-tomai: n.149. Roman: *ibid.* —Bukranion: e.g. RTP 20, 89, 122, 149. —Tesserae: *100*, 200 *s.v.* taureau; *24*, 399-400, 431-3. Cf. also *43*, I, 227. —West: *191*, 149-62; cf. *78a*, XIII, 67-8 *s.v.*

631 Horse: e.g. nn.79, 106-7, 127-8, 201, 246; RTP 114, 215, 221, 474, 637-9, cf. 1028, 1062, 1087. Harness: *93*, 118; *191*, 167-85; cf. *51*, *s.v.* EPHIPPIUM; *78a*, XIII, 118 *s.v.* —'Donkey': n.80; *191*, 192-7. —Dromedary: e.g. nn.80, 108, 127-8, 246; *100*, 200 *s.v.* chameau, cf. 202. Lifelike: e.g. RTP 179, 187. Harness: *93*, 116-23; *174*, 34-6. Cf. *191*, 137-40.

632 Sheep: e.g. nn.86, 262; *100*, 200 *s.v.* bélier. Cf. R. Savignac, *loc.cit.* (n.147); *78a*, XIII, 178 *s.v.*; *191*, 163-4. —Calf: RTP 161 (?). —She-wolf: n.132; *191*, 101-2. —Fox-head (?): *111*, *1959*, 118 no.40, fig.129. —Dog: nn.79, 131; RTP 393, 461, 643. Roman: *49*, 402-6; *191*, 102-24; cf. *78a*, XIII, 90 *s.v.* Hatra: *85*, 56 no.34, pl.IV.1 (cf. no.33, pl.VIII.4); *85*, 61 no.73; *115*, 166-70. —Felines: n.129. —Cheetah: n.147; *191*, 182-6. —Panther: nn.147, 275, 447; cf. *78a*, XIII, 156 *s.v.* —Sphinx: n.164; cf. *57*, *78a*, XIII, 183 *s.v.*

633 Cf. *191*, 145-7, 192-3, 202-3; *78a*, XIII, 54 *s.v.* antelope.

634 Lintels: nn.66, 85. —Šadrafâ: nn.75, 79, 101; *100*, 195 *s.v.* See *61*, 139-47; *177*, esp. 73-6; cf. *169*, 115-16, fig.1. Asklepios: *24*, 438. —Tesserae: *100*, 200 *s.v.* serpent. —Pilaster: n.273. Immortality: *49*, 88. Cf. *78a*, XIII, 181 *s.v.*; *191*, 223-36.

635 Šadrafâ: nn.75, 101. See n.634; *100*, 200 *s.v.* scorpion. —Mithraic: F. Cumont, *op.cit.* (n.501), 137. —Opposition: suggestion of J. M. C. Toynbee. —Hatra: 77, pl.98; *85*, 56-7, nos.32-3, 42, pls.VII.3, VIII.1, 4; *44*, 158, fig.46. Cf. *78a*, XIII, 175 *s.v.*; coins of Commagene. —Symbolism: E. D. Van Buren, *Archiv für Orient-forschung*, XII, 1936-7, pp. 1ff.

636 Fish: n.79; *100*, 200 *s.v.* poisson. Atargatis: *153*, 170-1. —Dolphin: n.274; p.132. —Crab: nn.86, 275; RTP 1014. Cf. *191*, 206-15; *78a*, XIII, Index *s.v.* crab, dolphin, fish.

637 Date-palm: n.77; RTP 137, 681. Assyrian: e.g. H. R. Hall, *Babylonian and Assyrian Sculpture*, British Museum, 1928, pls.29, 36–7, 41.2, etc.; *64*, pls. 183, 193–4, 203, etc. Cf. (different) Greek type: *10*, fig.656. —Cypress: RTP 162, 199; cf. p.231; *169*, 101–3. Immortal: *49*, 219–20. —Fig: n.132. —Olive (?): RTP 18. See *169*, 89. Cf. *78a*, XIII, 152 *s.v.* —Unclassifiable: RTP 265, 273, 410, 417, etc. Cf. *78a*, 13, 192–3 *s.v.* tree.

638 Religious relief: e.g. nn.115, 698; *144*, 89 no.13, pl.XLIV.4. Victories: e.g. n.73. Niches: n.66. Tesserae: *100*, 200–1 *s.v.* palme. Sanctity: *151*, 162–4; *161*, 62 n.2; H. Seyrig, *Syria*, XXVII, 1950, 231 = *AS* IV, 126. —Funerary relief: common. Early: e.g. nn.190–1. Male busts: Appendix II, groups I Bb, Jb, II Bb–c, Ka, Qb, III Bb, Jb. Victory over death: *88*, 25–6; *91*, 37; *154*, 140; *49*, 429, 476, 481–2; *7*, VIII, Part I, 129; *98*, 465–7. —Hatra: *85*, 39. —Cf. *78a*, XIII, 155–6 *s.v.*

639 Spiral: architectural: e.g. nn.64, 66, 69, 119, 193, etc.; see *157*, 292–5, 301–2; J. M. C. Toynbee, *loc.cit.* (n.444: Hellenistic); *63*, 32–4 ('Greco-Buddhist'); *43*, I, 165–6. Cup: e.g. *4*, 247–50, pl.XLVI. Bowl: e.g. BM 125201: *38*, pl.XXXI.13; PS 251. Textile ('peopled'): Lou 2398: n.214; *190*, 109–10 n.21; cf. *190*, 108–9 (Hatra); n.83; p.131. Tesserae: RTP 673, 749. —Spreading: tesserae: *100*, 201 *s.v.* vigne. Funerary: e.g. nn.193, 273–4, 289, 291. Symbolism: F. Cumont, *op.cit.* (n.182); 120; *78a*, XIII, 197 *s.v.*; *24*, 335–8; *169*, 107. Roman ceiling: M. Swindler, *op.cit.* (n.283), 406, fig.628, etc. Edessa: *149a*, 28.

640 Acanthus: spiral: e.g. nn.65, 83 ('inhabited'); RTP 676; see *157*, 294, 296; *63*, 10–16; *43*, I, 165–6, 174; *78a*, XIII, Index *s.v.* Textiles: e.g. *111*, *1960*, 150 no.20, fig.164, etc. Cf. Hatra: *85*, 39; *190*, 109. —Pomegranate: n.69; RTP 55. See *157*, 285–6, 296; *43*, I, 174; cf. *78a*, XIII, 162–3 *s.v.*

641 E.g. p.64, n.193 (mattress); *140*, 18, pl.I.2 (2nd century); Lou 22249: p.79, n.262 (3rd century); RTP 673. —[In West,

could symbolize immortality: *49*, 219–20. —Cf. Hatra: *190*, 108; also *78a*, XIII, 123 *s.v.*]

642 Laurel: niches: e.g. n.69; cf. *43*, I, 166. Architectural: *157*, 282, 300; *63*, 25–6. In hand: e.g. NCG 1159: n.229; PM 1975. Tesserae: RTP 26, 251, 298, 303. Wreaths: p.140. Funerary garlands: e.g. tomb 86, col. pedestals: *197*, 71–6, pls.38, 40, 43C; *71*, 141; 'banquet' bases: PM (*128*, 362–3). Textiles: cf. *169*, 118–20, fig.4. Immortality: *49*, 219–20. —Oak: niche: PM B954: n.66. Wreath: NCG 1155: n.534. Textile: e.g. *111*, *1961*, 159 no.52, fig.209. Cf. *78a*, I, 134 and VII, 87–8.

643 See *93*, 117; *63*, 16–32.

644 Poppy: NCG 1155: n.534. —Rosettes: symbolic: e.g. nn.65, 68, 70–1, 85, 128; cf. *24*, 37, 45–128, 153–63; *43*, I, 161, 163, 167, 173. Ornamental: esp. n.106 (trappings); p.134 (Athena); Lou 2200: PS 14 (AD 176: cloak and bowl); *24*, 37, 45–128, 153–63 (tesserae); PM C131: *157*, 326, pl.34.53 (elaborate). Types: *63*, 29–32; cf. *43*, I, 157. Assyrian, etc.: *64*, pls.149, 153, 164, 176, 180, 190–1, 196, 198–9, 218, 223–4, 231, 233, 366–7, 411, 417–18, 426, 434–6, 442. Greek: cf. R. M. Cook, *op.cit.* (n.600), 40, 48–50, etc. Indian: *157*, 306–7, 326. Roman (Rhine): E. Will, *Syria*, XXXI, 1954, 271–85. Cf. *78a*, XIII, 104–5 *s.v.* flowers, 170–1 *s.v.* rosette, 183–4 *s.v.* star; *149a*, 28.

645 Dates: p.36; cf. 201. —Grapes: vine: p.210. Architectural: e.g. PM C131: *157*, 326. Children: cf. p.156; Appendix I. Symbolic: cf. *49*, 343; *78a*, XIII, 109–10 *s.v.*

646 Pomegranate: spiral: *43*, I, 174. Tesserae: RTP 101, 668, 678 (?), 680. Rab Asirê: p.33, n.71. Also Lou 22249 (?): n.262. —Pine cone: niche: PM B449: n.66. Busts: Appendix II, male groups II Bf, III Bf, female II Od. Capital: *157*, 317 no.43, 319. Bel: *157*, 327. Tesserae: RTP 79, 101, 671, 682, 917 (?), 927 (?), 941, 944. Also Lou 22249 (?): n.262. Immortality: *49*, 219–20; cf. *78a*, XIII, 161 *s.v.* —Artichoke: D. Schlumberger, *Syria*, XIV, 1933, pl. XXVII.4; *157*, 319. —Cf. *78a*, VII, 87–8.

647 RTP 210, 397, 680–2, 684, 926 (?).
—Roman: cf. e.g. *101*, 205, fig.130; cf.
78a, IX, 50–1, 66–7.

648 Near East: e.g. *13*, no.676; *64*,
pl.365. —Iranian, pearls: *155*, 18–20; cf.
169, 118. Hatra: *85*, 33–4.

649 Circle: e.g. nn.129–30, 147. —Lines:
e.g. n.108; Strasbourg: n.533; KMV 1519:
PS 392; NCG 1159: n.229.

650 E.g. textiles: Strasbourg: n.533.
Cuirass: Lou 19801: n.112. Diadem: PM
CD32.59: *111*, *1959*, 87–8 no.6, fig.95.
Couch: n.252 (Maqqai). Trappings: n.269,
etc. —Parthia: *115*, 18. —India: *162*, 30 n.1.

651 Tongue: calathos: e.g. n.114. Vessels:
e.g. *111*, *1960*, 152–3 no.23, fig.168; in
West: esp. metal: e.g. A. de Ridder, *Les
bronzes antiques du Louvre*, Paris, 1915,
vol.II, no.2756, etc. Burners, legs: common;
in West: e.g. *130*, figs.350–2, 354, 356–7,
574. —Altars: e.g. *38*, 70, pl.XXIV.3;
155, 203–4, fig.1. West: *132*, 46, 390.

652 Smooth: e.g. RTP 502; nn.115 (Bel),
119, 130 (Wadi el-Miyah). With rays:
early: e.g. nn.70, 78, 104, 115, etc. Tesserae:
cf. *24*, 173–4, 210, 234, 337–8, 553. —His-
tory: P. Collimet-Guérin, *Histoire du nimbe
des origines aux temps modernes*, Paris, 1961;
24, 765. Neo-Babylonian: L. J. Delaporte,
Cat. des cylindres orientaux du Louvre, Paris,
1910, no.A1158; *61*, 220. Roman art: cf.
51, *s.v.* NIMBUS; *78a*, XIII, 112 *s.v.* halo.
Parthia: 77, pls.2, 80, cf. 67; *85*, 20; *44*,
pls.56, 63b, 74, etc.

653 'Aglibôl: *100*, 191, *s.v.* Ensign: n.109;
RTP 277. Bel tessera: RTP 17. Priests:
RTP 696, 703. Rosette: n.67 (Nebû); cf.
n.85. Stelae: p.64, nn.190, 655. History:
51, *s.v.* LUNA, LUNUS; *150*, 55–6; *151*, 243;
E. D. van Buren, *Symbols of Gods*, New
Haven, 1945, 63–4; *201*, 135, fig.21, 272–
311; *78a*, XIII, 145, *s.v.* moon. Hatra: *85*,
37; *44*, pls.62, 66. —With globes: *103*, pls.
II–VI. Tesserae: e.g. RTP 105, 146, 694,
703. See *24*, 129–43.

654 Globe in hand: Bel: *169*, 88; others:
RTP 207, 435, 441. Victories: e.g. nn.73,

272, 279, 283, 290. History, symbolism:
47, 129; F. Cumont, *Syria*, VIII, 1927,
164–5; *135*, III, 187–91; J. O. Thomson, *A
History of Ancient Geography*, Cambridge,
1948, 203; *24*, 46–9; *85*, 37–8.

655 Stelae: n.190. Assyrian: e.g. E.
Bezold, *Nineveh und Babylon*, Leipzig,
1903, pls.46, 86, cf. 53–4; A. Parrot, *op.cit.*
(n.429), pls.14, 39B, 39C, 85–6, etc.; *64*,
pls.230–1, cf. 358. Assur: n.411. Sun (pro-
tective?): n.182. Cakes: *154*, 140; cf. *78a*,
XIII, 69 *s.v.*

656 E.g. NCG 1084: PS 382. See *164*,
33–4, fig.2.

657 Sphere: *24*, 37, 46–9. Cosmic ring:
24, 53–61. Dot rosettes: *24*, 54–5. Globules:
24, 74–9, 87, 96–110. Star: e.g. RTP 111,
293. Rosettes: cf. pp.210–11.

658 Pronged sign: on 85 tessera types: *24*,
147–50. Twisted rosette: RTP 301: cf. *160*,
41 ('spiral star'); *24*, 158. Z: RTP 276.
Reversed Z: RTP 52. X: RTP 722.
Swastika: RTP 545; p.33, n.70; *160*, 41;
78a, XIII, 185 *s.v.* Owner's mark: DM:
n.108; *160*, 34, 41.

659 See n.539; *107*, 173, n.2.

660 Mouldings: *157*, 285–91. Beading:
157, 303–5; *43*, I, 174.

661 Egg-and-tongue: *157*, 312; cf. *63*, 22.
—Interlacing: *157*, 295–6, 302–3; *63*, 29;
43, I, 174. —Merlon: *157*, 313–14. —In
general: *63*, 10–37.

662 See *63*, esp. 10–37, 115, 153–8; *71*, 67;
106b, 93, 247–54. Note: painted intersect-
ing circles and continuous hexagons of
tomb ceiling (p.85) from Roman mosaic-
ists: *190*, 110 n.21.

663 Flat: e.g. nn.100–1, 115. West: e.g.
109, III, nos.837–9, 841, 849–54, 856, 861–3,
866, etc. Cf. *135*, VII–VIII, 292–302, pl.37.
—Moulded: e.g. n.100 (Taimarṣû); n.101
(BM 125206). Cf. *135*, V, 106, pl.XIII; *101*,
no.G8. —Leaf-and-dart: DM C.7939:
n.104. —Vine: n.119; cf. p.210. —Beading:
n.138 (octagonal). Cf. p.211; *93*, 117; *44*,
pl.21. —Plinth: Roman East: e.g. *109*, III,
nos.840–1, 865. Parthian: e.g. *44*, pls.30,
55–6, 61.

664 Banquet: nn.258–61. Busts: n.223. Deities: *144*, 70 no.1, pl.XXXI.5. Animals: n.147. Cf. *88*, 43; *93*, 117.

665 Frame: nn. 190–2, 196–209. Assyrian, etc.; cf. nn.411, 655.

666 See *29*, 13, pl.IV.1; cf. n.223.

667 Raised listel: e.g. (all male group I Ba): Geneva Museum 8188 (PS 79), 8195 (PS 99); PM 2000/7195; Istanbul 3715 (PS 88: hexagonal). —Sketched listel: e.g. (male group I Ba4): NCG 1035 (PS 76), 1051 (PS 75). —Decorative mouldings: e.g. PM 2020/7197 (astragal). Cf. e.g. *101*, no.G8. —Deep plinth: with listel: e.g. PM 1193 (female group II Ua16B; Latin text). Without: e.g. PM A214 (male I Dc15A; Latin text); Lou 14924: *151*, 160–1, pl.XX.2 (Latin text); NCG 1072: PS 344. —Roman: cf. p.124; 138. —Setting: cf. p.60.

668 Above head: sculpture: n.222; *74*, 87–90, fig.2. Painting: nn.282–3. Western: *101*, pls.7–9, 25, 27, 37, 44, etc.; *74*, 87–90; *CSIR*, Österreich, II, 2. —Behind head: e.g. p.34, nn.72, 313, 669.

669 Raised disc: *74*, 87–90, fig.2. —Flat: NCG 2794: PS 39 (AD 149). Western: cf. *101*, pl.25, etc. —Oak: NCG 1155: PS 34 (AD 125/6). West: *88*, 58–9; cf. *101*, 90–1, St 36. —Mouldings: e.g. Vatican: PS 36 (AD 145); *4*, 242 no.11; n.222, etc. Western: cf. J. Bolten, *Die Imago Clipeata*, Berlin, 1937; *101*, pls.7, 9, etc.

670 Laurel: divine: n.72. Honorific: n.313. Lion: n.147. Funerary: n.208. Cf. *144*, 68, 68 no.3, pl.XXIX.4. West: e.g. *101*, 91–2, St 28; *CSIR*, Österreich, II, 2, no.106, etc. —Leaves: e.g. n.283. West: cf. W. Altmann, *op.cit.* (n.490), fig.161, etc. —Circle: sculpture: e.g. PM *111*, *1962*, 108 no.44, fig.145. Painting: e.g. n.283 (Eye). West: cf. V. Tusa, *I sarcofagi romani in Sicilia*, Palermo, 1957, figs. 19–20, 58–9, 139–40, 142, 153; *101*, pls. 8, 27; G. M. A. Richter, *op.cit.* (n.502), vol.II, fig.1528, etc.

671 Inscriptions (AD 52, 74): n.10. Bust plinth: Lou 14924 and PM A214: n.667. Beside: n.219 (Siren). Western: e.g. *CIL*

VI, 33914; IX, 2438; XIV, 21 etc.; *126*, 42, 125. —Aedicula: *151*, 166, pl.XXI.2.

672 On costumes: cf. n.338. Jewellery: cf. p.96–7. 'Pearls', Iranian: p.212, n. 648.

673 Spirals: e.g. n.78; PM T.71, T.226: nn.106, 107 ([2]30); NCG 1053: n.219. Interlacing: n.661. —Squares: e.g. PM 1755/6579: *14*, 43, pl.I.1; PM: *155*, 4ff., figs.5, 10, cf. 9. Assyrian: *64*, pls.180, 197–9, etc. —Fringes: e.g. NCG 1054: PS 465; *13*, no. 552. Near East: *64*, pls.175, 180, 186–8, 195, 197–9, 230, 427, etc. —Tassels: e.g. DM: p.43, n.108. Near East: *64*, pls.175, 180, 186–8, 195, 197–9, etc.; cf. *78a*, IX, 171–3.

674 Criss-cross lines: n.649. —Zig-zag: e.g. DM: n.108; *78a*, XIII, 202 *s.v.* —Triangles, arrow-head: n.337. —H: n.338. Parthian: cf. *7*, VIII, Part I, pls.59, 61–2, 64–6, 71, 77–8; *147*, 109, pl.; *78a*, XIII, 106 *s.v.* gam; J. Gutmann, *op.cit.* (n.540), 121. —Strip: n.540.

675 Running dog: n.650. —Volutes: n.651. —Stripe: narrow: e.g. n.282; *88*, PS 25–6, 28, 48, 294; *91*, 36–8, pl.IX.1. Broad: e.g. PM: *14*, 48, pl.IV.2; BM 125346: PS 286. Spirals: e.g. Lou 2398: n.214; DM: PS 51; cf. n.639. Roman: cf. *51*, *s.v.* CLAVUS LATUS, TUNICA; *78a*, XIII, 76 *s.v.* clavi, 184 *s.v.* stripes. Egypt: e.g. *123*, pls.6.1; 7.1,2,4; 8.1; 10.2; 12.1; 13.3, etc.

676 Spiral: n.639. —Tongue: n.651. —Depressions: esp. bowl: nn.237–8, 252, etc. —Diamonds: e.g. PM 882/2025. —Beading: cf. p.212, n.648. Burners: e.g. n.130 (Bet-Phaṣi'el). Furniture: e.g. n.122 (Leto). —Criss-cross lines: n.649.

677 See n.320.

678 Sign: n.658. —Circles: n.649.

679 J. M. C. Toynbee, *Collection Latomus*, VI, 1951, 40–1, 46–7; *190*, 109–10, n.21; J. Gutmann, *op.cit.* (n.540), 31–52, 117–54.

680 Cf. *138*, 236–8; *147*, 196; *126*, 114–26. Realism: cf. pp.97, 101–4.

681 Neutral: p.284. 'Parthian': cf. E. Herzfeld, *Am Tor von Asien*, Berlin,

1920, fig.11; *77*, fig.65; *44*, fig.4 (123–110 BC). Hellenistic: e.g. *82*, 189–90, 203. —Vertical: cf. pp.128–9. Dura: cf. *7*, VIII, Part I, 367–8 (Synagogue): interpreted as the old Near Eastern method, with upper figures regarded as being in the background. This was not necessarily so in Assyrian relief: cf. p.129. Then (*ibid.*, 369–70) immediate origin is apparently attributed to Roman work of *c.*AD 100–250, ignoring occurrences in 1st-century Palmyra.

682 Cf. *145*, 266–8; *126*, 114–26. Iconographical details: see ch.8.

683 Bourgeois: cf. *147*, 202. —Bel: date: *31*, IX, no.2. Contributions: *31*, IX, no.6a = *CIS* II, 3924 (AD 17: see *75a*, 21, 68); *31*, IX, no.11 (AD 24). Tiberius: *31*, IX, no.2. Wolf: p.52. Roman funds: cf. I. T. Hill, *The Ancient City of Athens*, London, 1953, 205–6, n.1; *193*, 2, 15; an ingenious suggestion of M. Gawlikowski would connect the Bel temple's foundation with Germanicus' mission to the East (AD 17–19). Inclusion: p.17.

684 Cf. *155*, 32–3; *78*, 99–125, esp. 121–5; *126*, 114–26. —Abbreviations: cf. nn.133–6, 142, 145, 484–9.

685 Pottery: n.320. —Glassware: n.321.

686 Vessels: p.96. Taxila: J. H. Marshall, *Taxila*, Cambridge, 1951, II, 493ff. esp. nos.67–71; III, pl.144; *59*, 95–103. Bust: n.232. Divine bust: n.104; p.138. Horses: note: if intended to be part of the sun god's chariot, they could be in 'analytical representation': p.130. —Iconographical parallels: ch.8, and Index *s.v.* rays, crescent, rosette, rider god. —Agora head: n.312.

687 See nn.162–3, 323–6, 568–81. Intaglio motifs: *100*, 202; *24*, 527–40. Horsemen: p.131. Roman: G. M. A. Richter, *The Engraved Gems of the Greeks, Etruscans and Romans*, London, 1968, I, 133–72; J. Boardman, *Greek Gems and Finger Rings*, London, 1970, 359–72. Seal: *59*, 67 no.11, 108 no.a, pl.19.8. Cf. *78a*, XIII, 53 *s.v.* amulets.

688 Finds: early: *59*, 106–7. Later: *111*, *1959*, 122–3; *111*, *1960*, 217–21, fig.252;

111, *1961*, 184–91, 231, pls.I–III; *111*, *1962*, 140–3, pl.VII; *111*, *1963–4*, 103–8, 183–6, pls.V–VI. Imperial: cf. nn.22, 716.

689 Nn.328–39, 351–6, 672–5. Medallion: *127*, I, 24–6 T.20. Woollen: *127*, II–III, L.62–3, L.121–7; III, 33–8.

690 Nn.334, 351–6. Parallels: cf. O. Maenchen-Helfen, *The Art Bulletin*, XXV, 1943, 358–62; *7*, IV, Part II, 2–3, 53–4 nos.263–4.

691 See n.164.

692 Statuary: nn.306, 309–12, 344, cf. 387. —Female types: nn.466–7. —Heads: one in DM distantly recalls M. Wegner, *op.cit.* (n.517), pls.13, 47. DM C.4026: problematic (veil obscures hairstyle): forehead curls recall G. M. A. Richter, *Metropolitan Museum of Art. Roman Portraits*, New York, 1948, and Severan: nn.533–4. Veiling: signifies empress or princess as priestess? I am grateful to J. M. C. Toynbee for help over these points. —'Castor': n.107.

693 East Roman: cf. *105*. Peltae: e.g. V. von Gozenbach, *Die römischen Mosaiken der Schweiz*, Basle, 1961, 153 no.86.1, pl.68. —Ribbon: cf. R. P. Hinks, *Cat. Greek, Etruscan and Roman Paintings and Mosaics*, British Museum, 1933, lix and n.6; *105*, 127ff., fig.174, pl.CXLII.c. Antioch and area: e.g. *7*, VIII, Part I, pls.; M. Dunand, *Syria*, VII, 1926, pls.67–8; S. Reinach, *op.cit.* (n.453), 166. —Centaurs: cf. *105*, 137, 140–1. —Tree: cf. *105*, 16, 337, etc.; —Odysseus: cf. *105*, 74, 120–1; *57*, *s.v.* Ulisse, 1051. —Spring: *105*, 36, pl.V.b and 230–6, pls.LII.b, LIV.a, LVII.b; cf. M. Dunand, *Syria*, VI, 1925, 296, and *loc.cit.* —'Marbling': Roman: e.g. J. M. C. Toynbee, *op.cit.* (n.614), 217, pl.LII.a. —[For local 'Parthian' style mosaics, cf. Edessa: *149a*, 33.]

694 Statues: *31*, IX, no.2. Wolf: n.132. Cost: p.220. Pius: PM A922: *156*, 321. Severans: nn.309–11, 692.

695 Lou 1556: *38*, 122 no.4; *77*, pl.88. Greek: n.5. Pilaster: p.156. Workshops: pp.68, 115.

696 Woman: PM 1193: n.667. —Men: Lou 14924 (Apollinaris: probably a Syrian: Palmyrene?), PM A214: n.667. —Ala: n.13. —Tabula: n.671.

697 Greek: Paris: PS 480; *CIS* II, 4546. Egyptian: New York: PS 424; *CIS* II, 4547.

698 Frame: cf. pp.214, 215. Leto: cf. p.136. Apollo: cf. n.461. —Cf. also fragmentary relief of Nemesis, set up by Flavius Domitianus: H. Seyrig, *Syria*, XXVII, 1950, 242–7 = 'Ant. Syr.' 45.6 = *AS* IV, 137–42.

699 Army: cf. nn.13, 15; *150*, 255–77.

700 Qasr el-Heir: temple: *169*, 106, figs.9, 10. Vine: p.137. Mask: p.137. Dionysus: cf. p.139, n.494. —Busts: *143*, 70; *144*, 117.

701 *135*, VII–VIII, 310–25, figs.80–2, pl.38.3–5. Arṣû's helmet: n.500.

702 *135*, VII–VIII, 218–83 (esp. 257–74), figs.52–72, pls.26–7, 33–6; 365–6; M. Gawlikowski, *Berytus*, XVIII, 1969, 105–9; R. du Mesnil, *Bibliotheca Orientalis*, XXIX, 197, 201–4; *126*, 79–84, 101–2, pls.32–3, 42.

703 47, 89–145, pls.49–51, 55–8; *150*, 190–5, pl.XLIII; M. I. Rostovtzeff, *Dura-Europos and its Art*, Oxford, 1938, 71–4; *135*, VII–VIII, 365–7; *126*, 36–47, 115–16, pls.10–13. Tyche: n.473. Crescent: n.653. Helmet: n.500.

704 *135*, VII–VIII, 83–116, pls.13–18, 29–30; L. Campbell, *Berytus*, XI, 1954, 27, 29, 49, pl.VI (subtypes D and E); *126*, 49–52, 84–8, pls.15–16, 34–5.

705 Relief: *150*, 53–61, pl.XVIII.5; *23*, fig.43; *206*; *126*, 89–90, pl.36. Nemesis: cf. n.466. Griffin: n.628. Solar bust: n.488. —Statuettes: *135*, IV, 245, pl.IX.5; *135*, V, 56ff., pls.XVII.1, XVIII.1; *138*, 224, n.87; *126*, 110–11, pl.50. Palmyrene: cf. n.266–8.

706 E. Herzfeld, *Archaeological History of Iran*, London, 1935, 103–4, pl.XIX; R. Ghirshman, *Revue Archéologique*, 1959, I, 70–7, figs.1–8. —Precedents: Hypogeum: nn.175–6. Vine: n.639. Banquet: nn.448–9.

707 Allat: R. Dussaud, *loc.cit.* (n.118); p.134. —Šadrafâ: *168*, 85–6, fig.8. —[Cf. *54*, 53 no.85, pl.XXIV.]

708 Cos: n.15. Rome: cf. n.712–14. Army etc.: *CIL* III, 7728; *38*, 10–12, 72, 142; *34*, 13ff.; *CIS* II, 3901–10; *160*, 223–9; E. Will, *Syria*, XXIX, 1952, 69, etc.

709 Djoub el-Djarrah: DM: *171*, 230–5, 248, pl.XI; *81*, 47; *24*, 351–2; *148*. Parthian dress: cf. nn.540–3, 547. Horseback: cf. n.631. Eagle: n.613. Laurel: n.642. Goddess: cf. p.134. Burner: n.613. Cf. whip: n.592. —Riders: *Bulletin of the Cleveland Museum of Art*, 1971, 26, fig.1 and 64 no.1; *191*, 138. Note esp. cameleers' local 'skirt' (n.540) and horsemen's leggings (n.543). —Harbata: BAM 2625–6: *134*, 73ff. nos.8–10, pl.XXII; *178*, 41 no.10, pl.XIX (Palmyrene colony?). Inscription: lettering c.AD 150–220. Stelae: cf. nn.202–9. Curtain: nn.614–15. Warrior: cf. n.201; *54*, 53 no.85, pl.XXIV.

710 All in Lyons, Musée des beaux arts: A. J. Reinach, *Bulletin de la société francaise des fouilles archéol.*, III, 1912, 61ff., pl.9; *ibid.*, *Cat. des antiquités égypt. rec. dans . . . Koptos*, Lyons, 1913, 47ff., pls.16–18; *181*, 50, 77; B. Fayolle, *Le livre de Musée Guimet de Lyon*, Lyons, 1958, 71–4; *123*, 115 n.155, cf. 196–7; *99*, 199, pl.VI. Egyptian: H. Seyrig, *Syria*, XLIX, 1972, 120–5 (= 'Ant. Syr.', 102). Cf. E. Drioton, *Bulletin de la société d'archéologie copte*, III, 1937, 20–40.

711 Units: J. Carcopino, *Syria*, VI, 1925. 30–57, 118–49. —Statue: *ibid.*, 130 n.1. —Paintings: C. Picard, *Castellum Dimmidi*, Paris, 1949, 159–72, figs.15–16; cf. *ibid.*, 102–24; *195*, 53–5, fig.48. 'Malakbel': cf. p.134. Victory: cf. p.134. Incense: cf. p. 138. Technique: cf. n.349.

712 Rome, Museo Capitolino. Reliefs: *48*; *155*, 199; *24*, 115ff., figs.70–3. —Inscriptions: Latin: *CIL* VI, 710. Aramaic: *CIS* II, 3903 (lettering c.AD 100). —Interpretation: daily journey: *48*; *24*, 115ff. Four seasons: *169*, 350 n.3.

713 Sanctuary inscriptions: L. Moretti, *Inscriptiones graecae urbis Romae*, Rome, 1968, nos.117–23. —Malakbel: *155*, 201–2, pl.XXXI. Inscriptions: Greek: L. Moretti,

op.cit., n.119; Aramaic: *CIS* II, 3902. Iconography: Palmyrene parallels: aedicula: cf. n.611. Handshake: n.446. Cuirass: n.460; nn.545–6. Cypress: n.637. Crescent: n.653.

714 C. Pietrangeli, *Musei Capitolini: I monumenti dei culti orientali*, Rome, 1951, 14 no.15. Inscriptions: Greek: L. Moretti, *op.cit.* (n.713), nos.120–1; Aramaic: *CIS* II, 3904; *115*, 266–8 (early 2nd century). Trousers: n.542. Veil: n.561. Calathos: n.497. Another Palmyrene (?) commission: *CIL* VI, 3174; *115*, 321–2.

715 Reliefs: South Shields Museum: see esp. *173*; J. M. C. Toynbee, *op.cit.* (n.449), n.85, pl.89 and no.87, pl.85; *ibid.*, *op.cit.* (n.614), 199–200, 206. —Inscriptions: Latin: *Ephemeris Epigraphica*, IV, 1881, no.718a; *ibid.*, VII, 1892, no.1002. Aramaic (Regina): *CIS* II, 3901 (lettering: Palmyrene type *c.*AD 150–250). —Iconography: Palmyrene parallels: (a) Regina: chair ('throne'): cf. n.616. Chest, basket: n.609. Locks: n.531. Spindle, distaff: n.606. (b) Victor: banquet: n.448. Leaves: cf. nn.638, 642. Crown (?): nn.503, 642. Table: nn.448, 616. Reclining: n.476. Tunic: n.541. Cloak: n.547. Mattress, bed: n.616. Lion's head: n.629. Medallion: n.669. Busts: cf. nn.490–1, 669. 'Tree': n.639. —Technique: cf. pp.109–18, esp. 117. —Barates: note: the Barates of *Ephemeris Epigraphica*, IX, 1913, 578 no.1153a, is not necessarily Regina's husband. —Date: though the sculptor includes motifs that died out in Palmyra *c.*AD 180, he may have continued to reproduce them in Britain later, unaware of current trends at home.

716 Zenobia: cf. n.22. —Coins: chronology: cf. *24*, 755–7; *167*; M. Price, *Numismatic Chronicle*, XIII, 1973, 75–86.

—[Note: rock relief of 11 female figures, Elmadağ, Anatolia, as 'imperial (?) Palmyrene': E. Bacon, *Archaeology: Discovery in the 1960s*, London, 1971, 128 (unconvincing).]

717 For references throughout this chapter to Palmyrene material already discussed, see illustration references, and Index.

718 Babylonia: *157*, 328–37; *147*, 145–52, 202.

719 Material: cf. *44*, 148–65, 180–7. Hatra: dating: *115*, 353–71. —Discussion: cf. *147*, 145–52, 202; but evidence from outside Babylonia not used, nor are common 'impulses' sought: cf. *126*, 117–26, and M. A. R. Colledge, *Parthian Art* (forthcoming).

720 Evidence: cf. *44*, 148–64, 180–7; *147*, 145–60.

721 Roman funds (?): n.683; *65* (Colledge). —Architecture: *63*, esp. 91–7; *71*, esp. 44–77; *75a*, 54–6, 67–8; *106b*, 93, 193, 251–4. —Fluting: *75a*, 101.

722 Perspective: n.434. —Scenes: n.443. —Plan: cf. *7*, VIII, Part I, 364ff.; *44*, 150; *149*, 128–33 is invalidated by *75a*, 46–7. —Names: n.26. Ḥairan: *75a*, 71.

723 Membidj: cf. *156*, 183–8; *169*, 115–16, fig.1; G. Goossens, *Hiérapolis de Syrie*, Paris, 1943; also Lucian, *De dea Syra*, §10, 55–6. Edessa is another possibility: cf. *149a*, 20–33, 46–51. —Route: cf. *118*, map 1 = *53*, pl.4. —Patrons: cf. n.683.

724 For such fundamental cultural resistance to change, cf. C. Renfrew, *The Emergence of Civilisation*, London, 1972, 23–6.

Introductory bibliography

1 ADAM, S. *The Technique of Greek Sculpture*, London and Toronto, 1966.

2 ALTHEIM, F. and REHORK, J., eds. *Der Hellenismus im Mittelasien*, Darmstadt, 1969.

3 AL-ʿUSH, M. A., JOUNDI, A. and ZOUHDI, B. *Catalogue du musée national de Damas*, Damascus, 1969.

4 AMY, R. and SEYRIG, H. *Syria*, XVII, 1936, 228–66.

5 ASSʿAD, K. and TAHA, O. *Welcome to Palmyra*, Damascus, 1966.

6 —— *AAS*, XVIII, 1968 (2), 83–108.

7 BELLINGER, A. R. *et al.*, eds. *The Excavations at Dura-Europos*, Final Report, vols.I–VIII, New Haven, 1943–.

8 BERCHEM, D. VAN *CRAI*, 1970, 231–7.

9 BERNHARD, M. L. *AAS*, XIX, 1969, 71–5.

10 BIEBER, M. *The Sculpture of the Hellenistic Age*, 2nd edn., New York, 1961.

11 BOETHIUS, A. and WARD PERKINS, J. B. *Etruscan and Roman Architecture*, London, 1970.

12 BORKOWSKA, T. *Studia Palmyreńskie*, I, 1966, 96–122, figs.1–22.

13 BOSSERT, H. *Altsyrien*, Tübingen, 1951.

14 BOUNNI, A. *AAS*, VII, 1957, (2) 25–52.

15 ——*The Art of Palmyra*, Damascus, 1962 (in Arabic).

16 —— *AAS*, XV, 1965, (1) 87–98, (2) 3–14, pls.I–II.

17 —— in *Mélanges K. Michalowski*, Warsaw, 1966, 313–20.

18 —— *AAS*, XVII, 1967, (2) 25ff.

19 —— *Archeologia* (Paris), XVI, 1967, 40–9.

20 BOUNNI, A. and SALIBY, N. *AAS*, XV, 1965, (1) 123–38, (2) 35–58.

21 —— *AAS*, XVIII, 1968, 93–102.

22 BRÜNNOW, R. E. and DOMASZEWSKI, A.v. *Die Provincia Arabia*, Strasbourg, 1904–9.

23 BUDDE, L. *Belleten*, XVIII, 1954, 523–43, republished as monograph: *Die Entstehung des antiken Repräsentationsbildes*, Berlin, 1957.

24 BUISSON, R. DU MESNIL DU. *Tessères et monnaies de Palmyre*, Paris, 1944–62.

25 —— *MUSJ*, XXXIX, 1964, 169–95.

26 —— *CRAI*, 1966, 158–90.

27 —— *Archeologia* (Paris), XVI, 1967, 50–1.

28 BUTLER, H. C. *Architecture and other Arts. Publications of an American Archaeological Expedition to Syria, 1899–1900*, vol.II, New York, 1903.

29 CANTINEAU, J. *Mélanges de l'Institut français de Damas*, I, 1929, 1–15.

30 —— *Inscriptions palmyréniennes*, Damascus, 1930.

31 —— *Inventaire des inscriptions de Palmyre*, vols.I–IX, Beirut, 1930–3.

32 —— *Syria*, XII, 1931, 116–42.

33 —— *Syria*, XIV, 1933, 169–202 (Tadmorea).

34 —— *Grammaire du palmyrénien épigraphique*, Paris and Cairo, 1935.

35 —— *Syria*, XVII, 1936, 267–82, 346–55 (Tadmorea).

36 —— *Syria*, XIX, 1938, 72–82, 153–71 (Tadmorea).

37 CHABOT, J. B. *Revue Biblique*, XXIX, 1920, 374–82.

38 —— *Choix d'inscriptions de Palmyre*, Paris, 1922.

39 —— et al., eds. *Répertoire d'épigraphie sémitique*, Paris.

39a CHAD, C. *Les dynastes d'Emèse*, Beirut, 1972.

40 CHAMPDOR, A. *Les ruines de Palmyre*, Paris, 1955.

41 CLERMONT-GANNEAU, C. *Revue Biblique*, XXIX, 1920, 382–419.

42 COLLART, P. *AAS*, VII, 1957, (1) 67–90.

43 COLLART, P. and VICARI, J. *Le sanctuaire de Baalshamin à Palmyre*, vols.I–II, Rome, 1969.

44 COLLEDGE, M. A. R. *The Parthians*, London and New York, 1967.

45 CORPUS INSCRIPTIONUM LATINARUM.

46 CORPUS INSCRIPTIONUM SEMITI-CARUM, vol.II, Paris, 1926–47.

47 CUMONT, F. *Fouilles de Doura-Europos*, Paris, 1926.

48 —— *Syria*, IX, 1928, 101–9.

49 —— *Recherches sur le symbolisme funéraire des romains*, Paris, 1942.

50 DAMASCUS MUSEUM: *Guide de l'exposition des dernières découvertes classiques en Syrie*, Damascus, 1969.

51 DAREMBERG, C., SAGLIO, E. and POTTIER, M. *Dictionnaire des antiquités grecques et romains*, Paris, 1877–1919.

51a DASZEWSKI, W. A. *AAAS*, XXII, 1972, 129–50.

52 DAWKINS, A. and WOOD, R. *Les ruines de Palmyre*, Paris and London, 1753.

53 DOWNEY, G. B. *A History of Antioch in Syria*, Princeton, 1961.

54 DUNAND, M. *Le musée de Soueïda*, Paris, 1934.

55 DUNANT, C. *Syria*, XXXVI, 1959, 102–10.

56 —— *Le sanctuaire de Baalshamin à Palmyre*, vol.III, Rome, 1971.

57 *Enciclopedia dell'arte antica classica e orientale*, Rome, 1958–66.

58 FARMAKOWSKY, B. V. *Bulletin of the Russian Archaeological Institute in Constantinople*, VIII, 1903, 172–98.

59 FELLMANN, R. *Le sanctuaire de Baalshamin à Palmyre*, vol.V, Rome, 1970.

60 FÉVRIER, J. G. *Essai sur l'histoire politique et économique de Palmyre*, Paris, 1932.

61 —— *La religion des palmyréniens*, Paris, 1932.

62 FILARSKA, B. *Studia Palmyreńskie*, I, 1966, 59–73.

63 —— *Studia Palmyreńskie*, II, 1967, 1–158.

64 FRANKFORT, H. *The Art and Architecture of the Ancient Orient*, 4th edn., London, 1970.

65 FRÉZOULS, E., ed. *Actes du colloque international sur Palmyre, Strasbourg, 1973*, Strasbourg, 1975.

66 GABRIEL, A. *Syria*, VII, 1926, 71–92.

67 GAWLIKOWSKI, M. *Studia Palmyreńskie*, I, 1966, 74–96.

68 —— in *Mélanges K. Michalowski*, Warsaw, 1966, 411–19.

69 —— *Académie polonaise des sciences, Études et travaux*, III, 1966, 141–9.

70 —— *Studia Palmyreńskie*, III, 1969, 47–58, 59–69.

71 —— *Monuments funéraires de Palmyre*, Warsaw, 1970.

72 —— *Syria*, XLVII, 1970, 313–25.

73 —— *Berytus*, XIX, 1970, 65–86.

74 —— *Studia Palmyreńskie*, IV, 1970, 87–92.

75 —— *Syria*, XLVIII, 1971, 407–26.

75a —— *Le temple palmyrénien*, Warsaw, 1973.

75b —— *Recueil d'inscriptions palmyréniennes* (Mémoires présentés par divers savants à l'Académie des inscriptions, tome XVI, 263–377), Paris, 1974.

76 GERKAN, A. VON *Berytus*, II, 1935, 7–33.

77 GHIRSHMAN, R. *Iran: Parthians and Sassanians*, London and New York, 1962.

78 GOMBRICH, E. *Art and Illusion*, London and New York, 1962.

78a GOODENOUGH, E. R. *Jewish Symbols in the Greco-Roman Period*, vols. I–XIII, New York and Princeton, 1953–68.

79 GUSMAN, P. *L'art décoratif de Rome*, Paris, 1910.

80 HAK, S. ABDUL *AAS*, II, 1952, 193–251.

81 HAK, S. and A. ABDUL. *Catalogue illustré du département des antiquités gréco-romaines au musée de Damas*, Damascus, 1951.

82 HAVELOCK, C. M. *Hellenistic Art*, London and New York, 1971.

83 HIGGINS, R. A. *Greek and Roman Jewellery*, London, 1961.

84 HIRSCH, O. *Studia Palmyreńskie*, III, 1969, 85–99.

85 HOMÈS-FREDERICQ, D. *Hatra et ses sculptures parthes*, Istanbul, 1963.

86 HOPKINS, C. *Berytus*, III, 1936, 1–30.

87 HUMANN, K. and PUCHSTEIN, O. *Reisen in Kleinasien und Nordsyrien*, Berlin, 1890.

88 INGHOLT, H. *Studier over Palmyrensk Skulptur*, Copenhagen, 1928.

89 —— *Acta Archaeologica*, I, 1930, 191–6.

90 —— *Acta Archaeologica*, III, 1932, 1–20.

91 —— *Berytus*, I, 1934, 32–43.

92 —— *Berytus*, II, 1935, 57–120.

93 —— *Berytus*, III, 1936, 83–125.

94 —— *Berytus*, V, 1938, 93–140.

95 —— *Parthian Sculptures from Hatra*, New Haven, 1954.

96 —— *Palmyrene and Gandharan Sculpture*, New Haven, 1954.

97 —— *MUSJ*, XXXVIII, 1962, 100–19.

98 —— in *Mélanges K. Michalowski*, Warsaw, 1966, 457–76.

99 —— *MUSJ*, XLVI, 1970–1, 173–200.

100 INGHOLT, H., SEYRIG, H. and STARCKY, J. *Recueil des tessères de Palmyre*, Paris, 1955.

101 JUCKER, H. *Das Bildnis im Blätterkelch*, Olten, 1961.

101a KISS, Z. *Acta Conventus Eirene*, XI, 1971, 447–58.

101b KLENGEL, H. *The Art of Ancient Syria*, New York, London, 1972.

102 KOKOVTZOFF, P. K. *Bulletin of the Russian Archaeological Institute in Constantinople*, XIII, 1908, 277–302 (in Russian).

103 KRAELING, C. H. *AAS*, XI–XII, 1961–2, 13–18.

103a KRZECHOWICZ, G. *Studia Palmyreńskie*, V, 1974, 45–82.

104 LEGRAIN, L. *The Museum Journal*, December 1927, 325–50.

105 LEVI, D. *Antioch Mosaic Pavements*, Princeton, 1947.

106 LEWIS, B. *et al.*, eds. *The Encyclopedia of Islam*, vol.II, London, 1965.

106a LUKASIAK, E. *Studia Palmyreńskie*, V, 1974, 7–44.

106b LYTTELTON, M. *Baroque Architecture in Classical Antiquity*, London, 1974.

107 MACKAY, D. *Iraq*, XI, 1949, 160–87.

108 MASSON, M. E. *East and West*, 17, 1967, 239–47.

109 MENDEL, G. *Catalogue des sculptures grecques, romaines et byzantines*, Constantinople, vols. I–III, Istanbul, 1912–14.

110 MERLAT, P. *Jupiter Dolichenus*, Paris, 1960.

111 MICHALOWSKI, K. *Palmyre: Fouilles polonaises 1959* (= vol.I), Paris and Warsaw, 1960; *1960* (= II), 1962; *1961* (= III), 1963; *1962* (= IV), 1964; *1963–4* (= V), 1966.

112 —— *AAS*, XVII, 1967, 9–16.

113 —— *Archeologia* (Paris), XVI, 1967, 57–62.

114 —— *Palmyra*, London and New York, 1970.

115 MILIK, J. T. *Dédicaces faites par des dieux*, Paris, 1972.

116 MOREHART, M. *Berytus*, XII, 1956–7, 53–83.

117 MOUTERDE, R. and POIDEBARD, A. *Syria*, XII, 1931, 101–15.

118 —— *Le Limes de Chalcis*, Paris, 1945.

119 MUDARRÈS, J. *Berytus*, XIX, 1970, 151–8.

120 MUEHSAM, A. *Berytus*, X, 1952, 51–114.

121 MUSIL, A. *Palmyrena: A Topographical Itinerary*, New York, 1928.

121a MYŚLIWIEC, K. *Studia Palmyreńskie*, V, 1974, 83–96.

122 NODELMAN, S. A. *Berytus*, XIII, 1960, 83–121.

123 PARLASCA, K. *Mumienporträts und verwandte Denkmäler*, Wiesbaden, 1966.

124 —— *Archäologische Anzeiger*, 1967, 547–68.

125 PAULY, A. and WISSOWA, G. *Real-Encyclopädie der klassischen Altertumswissenschaft*, Stuttgart, 1893–.

126 PERKINS, A. *The Art of Dura-Europos*, Oxford, 1973.

127 PFISTER, R. *Les textiles de Palmyre*, vols.I–III, Paris, 1934, 1937, 1940.

128 Reference number of photograph in the collection (Photothèque) of the Institut français d'archéologie, Beirut.

129 POIDEBARD, A. *La trace de Rome dans le désert de Syrie*, Paris, 1934.

130 RICHTER, G. M. A. *The Furniture of the Greeks, Etruscans and Romans*, 2nd edn., London, 1966.

131 RIHAOUI, A. *AAS*, XI–XII, 1961–2, (2) 99–106.

132 ROBERTSON, D. S. *A Handbook of Greek and Roman Architecture*, 2nd edn., Cambridge, 1954.

133 ROBINSON, D. M. and HOYNINGEN-HUENE *Baalbek – Palmyra*, New York, 1946.

134 RONZEVALLE, S. *MUSJ*, XXI, 1937, 1–181.

135 ROSTOVTZEFF, M. I. et al., eds. *The Excavations at Dura-Europos: Preliminary Report*, vols.I–IX, New Haven, 1929–46.

136 ROSTOVTZEFF, M. I. *Caravan Cities*, Oxford, 1932.

137 —— *Journal of Roman Studies*, XXII, 1932, 107–16.

138 —— *Yale Classical Studies*, V, 1935, 157–304.

139 OSTRAZ, A. *AAAS*, XIX, 1969, 109–20.

140 SABEH, J. *AAS*, III, 1953, 17–26.

140a SADURSKA, A. *Académie polonaise des sciences, Études et travaux*, VII, 1973, 273–84.

141 SCHLUMBERGER, D. *Berytus*, II, 1935, 149–67.

142 —— *Syria*, XVIII, 1937, 271–97.

143 —— *Syria*, XX, 1939, 43–73.

144 —— *La Palmyrène du nord-ouest*, Paris, 1951.

145 —— *Syria*, XXXVII, 1960, 131–66, 253–319.

146 —— *MUSJ*, XXVIII, 1962, 79–97.

147 —— *L'orient hellénisé*, Paris, 1970.

148 —— *MUSJ*, XLVI, 1970–1, 209–22.

149 —— *Syria*, XLVIII, 1971, 121–33.

149a SEGAL, J. B. *Edessa, the Blessed City*, Oxford, 1970.

150 SEYRIG, H. *Syria*, XIII, 1932, 51–64, 190–5, 258–66, 266–77 = 'Ant. Syr.' 4, 6, 8, 9, = *AS* I, 12–14, 27–32, 36–44, 44–55.

151 —— *Syria*, XIV, 1933, 152–68, 239–82 = 'Ant. Syr.' 12–14 = *AS* I, 70–86, 88–131.

152 —— *Antiquités syriennes*, vols. I–VI, Paris, 1934–66 (= *AS*).

153 —— *Syria*, XV, 1934, 155–86 = 'Ant. Syr.' 17 = *AS* II, 30–61.

154 —— *Berytus*, III, 1936, 137–40.

155 —— *Syria*, XVIII, 1937, 4–31, 31–53, 198–209, 369–78 = 'Ant. Syr.' 20, 21, 22, 23 = *AS* II, 46–73, 73–94, 94–105, 107–16.

156 —— *Syria*, XX, 1939, 177–83, 183–8, 189–94, 302–23 = 'Ant. Syr.' 26, 27, 28, 30 = *AS* III, 8–14, 15–20, 21–6, 33–54.

157 —— *Syria*, XXI, 1940, 277–328, 328–37 = 'Ant. Syr.' 32, 33 = *AS* III, 64–115, 115–24.

158 —— in *Mémorial Lagrange*, Paris, 1940, 51–8.

159 —— *CRAI*, 1940, 237–49.

160 —— *Syria*, XXII, 1941, 31–44, 155–75, 223–70 = 'Ant. Syr.' 34, 36, 38 = *AS* III, 123–37, 148–68, 188–235.

161 —— *Syria*, XXIV, 1944–5, 62–80 = 'Ant. Syr.' 39 = *AS* IV, 1–18.

162 —— *Syria*, XXVI, 1949, 29–41 = 'Ant. Syr.' 41 = *AS* IV, 32–44.

163 —— *Journal of Roman Studies*, XL, 1950, 1–7.

164 —— *AAS*, I, 1951, 32–40, 147–56.

165 —— *Syria*, XXXVI, 1959, 58–60, 184–92 = 'Ant. Syr.' 72, 76 = *AS* VI, 31–3, 63–71.

166 —— *AAS*, XIII, 1963, 159–72.

167 ——— in *Mélanges K. Michalowski*, Warsaw, 1966, 659–62.

168 ——— *Syria*, XLVII, 1970, 77–112 = 'Ant. Syr.' 89.

169 ——— *Syria*, XLVIII, 1971, 85–114, 115–20, 337–73 = 'Ant. Syr.' 93, 94, 95.

170 ——— (Publication of the Bel sanctuary excavations: forthcoming).

171 SEYRIG, H. and STARCKY, J. *Syria*, XXVI, 1949, 230–57.

172 SIMONSEN, D. *Sculptures et inscriptions de Palmyre à la Glyptothèque de Ny Carlsberg*, Copenhagen, 1889.

173 SMITH, D. *Archaeologia Aeliana*, series 4, XXXVIII, 1959, 203–7.

174 SOLTAN, A. *Studia Palmyreńskie*, III, 1969, 5–46.

175 STARCKY, J. *Syria*, XXV, 1946–8, 334–6.

176 ——— *Inventaire des inscriptions de Palmyre*, vol. X, Damascus, 1949.

177 ——— *Syria*, XXVI, 1949, 43–85.

178 ——— *Bulletin du musée de Beyrouth*, XII, 1955, 29–44.

179 ——— in *Dictionnaire de la Bible*, Paris, 1957, Supplément VI, 1066–1103.

180 ——— *Archeologia* (Paris), XVI, 1967, 30–9.

181 STARCKY, J. and MUNAJJED, S. *Palmyre*, Paris, 1952.

182 STARK, J. K. *Personal Names in Palmyrene Inscriptions*, Oxford, 1971.

183 STUCKY, R. A. *Syria*, XLVIII, 1971, 135–41.

184 SUPPLEMENTUM EPIGRAPHICUM GRAECUM, Leyden, 1923–.

185 TEIXIDOR, J. *Inventaire des inscriptions de Palmyre*, vol. XI, Beirut, 1965.

186 ——— *MUSJ*, XLII, 1966, 177–9.

187 ——— *Syria*, XLIV, 1967, 163–95; XLV, 1968, 353–89; XLVI, 1969, 319–58; XLVII, 1970, 357–81; XLVIII, 1971, 453–85; XLIX, 1972, 413–45.

188 TOYNBEE, J. M. C. *The Art of the Romans*, London and New York, 1965.

189 ——— *Death and Burial in the Roman World*, London and New York, 1971.

190 ——— *Journal of Roman Studies*, LXII, 1972, 106–10.

191 ——— *Animals in Roman Life and Art*, London and New York, 1973.

192 VERMEULE, C. C. *Proceedings of the American Philosophical Society*, 108 no.2, April 1964, 99–134.

193 ——— *Roman Imperial Art in Greece and Asia Minor*, Cambridge (Mass.), 1968.

194 VOGÜÉ, M. DE *La Syrie centrale*, Paris, 1865–77.

195 WAIS, J. *Studia Palmyreńskie*, IV, 1970, 5–67.

196 WALTERS, H. B. *History of Ancient Pottery*, vol.II, London, 1905.

197 WIEGAND, T. *et al. Palmyra. Ergebnisse der Expeditionen von 1902 und 1917*, Berlin, 1932.

198 WILD, J. P. *Textile Manufacture in the Northern Roman Provinces*, Cambridge, 1970.

199 WILL, E. *Syria*, XXVI, 1949, 87–116, 258–313.

200 ——— *Syria*, XXVIII, 1951, 70–100.

201 ——— *Le relief cultuel gréco-romain*, Paris, 1955.

202 ——— *Syria*, XXXIV, 1957, 262–77.

203 ——— *Syria*, XXXIX, 1962, 45–63.

204 ——— in *Mélanges A. Piganiol*, Paris, 1966, 1409–16.

205 WILSON, L. M. *The Roman Toga*, Baltimore, 1924.

206 ZOUHDI, B. *AAS*, XI–XII, 1961–2, 71–88.

207 (Various) *Actes du IXe congrès d'archéologie classique*, *AAAS*, XXI, 1971.

Index

The definition of an unusual or technical term is normally to be found at its first mention in the text, *q.v. Italic* numerals refer to plates; **bold**-face numerals indicate text figures.

310